ices

Camb

- FE

The Routledge Langua
Cultural Theory Reader

The Routledge Language and Cultural Theory Reader is a core introduction to the most innovative and influential writings that have shaped and defined the relations between language, culture and cultural identity in the twentieth century.

Selected theoretical texts are grouped together in themed sections:

- Theorising the Sign
- Language in History
- Language and Subjectivity
- Language and Gender
- Language and Sexuality
- Order and Difference

- Language Communities
- Englishes
- Language and Creativity
- Languages/Cultures
- Language and Colonialism
- Language, Class and Education

Each section is prefaced by an editorial introduction which concludes with suggestions for further reading. The *Reader* adopts a problem-based approach and offers extensive cross-referencing.

The Routledge Language and Cultural Theory Reader is essential for students at undergraduate and postgraduate level working within the disciplines of language studies, literary studies, cultural studies, cultural theory and linguistics.

Essays by: Chinua Achebe, Mikhail Bakhtin, Roland Barthes, Basil Bernstein, Leonard Bloomfield, Franz Boas, Pierre Bourdieu, Edward K. Brathwaite, Judith Butler, Deborah Cameron, Hélène Cixous, Brian Cox, Benedetto Croce, David Dabydeen, Jacques Derrida, Frantz Fanon, Michel Foucault, Sigmund Freud, Antonio Gramsci, Luce Irigaray, Roman Jakobson, Braj B. Kachru, Julia Kristeva, William Labov, Jacques Lacan, Robin Lakoff, Claude Lévi-Strauss, Bronislaw Malinowski, H.L. Mencken, Jan Mukařovský, Tom Paulin, Paul Ricoeur, Denise Riley, Edward Sapir, Ferdinand de Saussure, Muriel R. Schulz, Dale Spender, Hortense J. Spillers, Leo Spitzer, Ngũgĩ wa Thiong'o, G.I. Vinokur, V.N. Voloshinov, Karl Vossler, L.S. Vygotsky, Edmund White, Benjamin Lee Whorf, Raymond Williams.

Lucy Burke is Lecturer in English Literature at the University of Manchester. **Tony Crowley** is Professor of English at the University of Manchester and his publications include *The Politics of Discourse* (Macmillan), *Proper English? Readings in Language, History and Cultural Identity*, *Language in History: Theories and Texts* and *The Politics of Language in Ireland, 1366–1922: A Sourcebook* (all Routledge). **Alan Girvin** is Lecturer in Literary Studies at the University of Str

The Politics of Language

Series editors: Tony Crowley, *University of Manchester* and Talbot J. Taylor, *College of William and Mary, Williamsburg, Virginia*

> *In the lives of individuals and societies, language is a factor of greater importance than any other. For the study of language to remain solely the business of a handful of specialists would be a quite unacceptable state of affairs.*
>
> Ferdinand de Saussure

The Politics of Language series covers the field of language and cultural theory and will publish radical and innovative texts in this area. In recent years the developments and advances in the study of language and cultural criticism have brought to the fore a new set of questions. The shift from purely formal, analytical approaches has created an interest in the role of language in the social, political and ideological realms and the series will seek to address these problems with a clear and informed approach. The intention is to gain recognition for the central role of language in individual and public life.

Other books in the series include:

Broken English: Dialects and the Politics of Language in Renaissance Writings
Paula Blank

Verbal Hygiene
Deborah Cameron

Linguistic Ecology: Language Change and Linguistic Imperialism in the Pacific Region
Peter Mühlhäusler

Language in History: Theories and Texts
Tony Crowley

Linguistic Culture and Language Policy
Harold F. Schiffman

English and the Discourses of Colonialism
Alastair Pennycook

The Politics of Language in Ireland 1366–1922: A Sourcebook
Tony Crowley

The Routledge Language and Cultural Theory Reader

Edited by Lucy Burke, Tony Crowley and Alan Girvin

London and New York

First published 2000
by Routledge
11 New Fetter Lane, London EC4P 4EE

Simultaneously published in the USA and Canada
by Routledge
29 West 35th Street, New York, NY 10001

Routledge is an imprint of the Taylor & Francis Group

The edited collection © 2000 Lucy Burke, Tony Crowley and Alan Girvin;
individual essays © the individual authors

Typeset in Perpetua and Bell Gothic by J&L Composition Ltd, Filey, North Yorkshire
Printed and bound in Great Britain by TJ International Ltd, Padstow, Cornwall

British Library Cataloguing in Publication Data
A catalogue record for this book is available from the British Library

Library of Congress Cataloging in Publication Data
The Routledge language and cultural theory reader / edited by Lucy Burke, Tony Crowley, and
Alan Girvin.
p. cm.
Includes bibliographical references and index.
ISBN 0-415-18680-3 (hardbound) — ISBN 0-415-18681-1 (pbk.)
1. Language and culture. 2. Linguistics. I. Burke, Lucy, 1968–
II. Crowley, Tony, 1960– . III. Girvin, Alan, 1965–
P35.L265 2000
400–dc21 99–047377

ISBN 0–415–18680–3 (hbk)
ISBN 0–415–18681–1 (pbk)

For Hannah

CONTENTS

PART TWO
Unity and Diversity in Language

PART THREE
Languages, Cultures, Communities

ACKNOWLEDGEMENTS

The editors and publishers wish to thank the following for permission to use copyright material.

Academic Press for material from V.N. Voloshinov, *Marxism and the Philosophy of Language,* trans. L. Matejka and I.R. Titunik.

Athlone Press Ltd for material from Jacques Derrida, *Positions*, trans. Alan Bass, 1987.

The estate of Roland Barthes and Jonathan Cape for material from Roland Barthes, *Mythologies,* first published in French by Editions du Seuil in 1957.

Blackwell Publishers for material from: Pierre Bourdieu, *Language and Symbolic Power*, ed. and intro. John B. Thompson, trans. G. Raymond and M. Adamson; William Labov, *Language in the Inner City: Studies in the Black English Vernacular*.

Chatto and Windus for material from Edmund White, 'The Political Vocabulary of Homosexuality', from *The Burning Library*.

Columbia University Press for material from Julia Kristeva, *Revolution in Poetic Language*, trans. Margaret Waller © 1984.

Sigmund Freud © the Institute of Psychoanalysis and the Hogarth Press for permission to quote from *The Standard Edition of the Complete Psychological Works of Sigmund Freud*, translated and edited by James Strachey.

Georgetown University Press for material from Jan Mukařovský, 'Standard Language and Poetic Language', in *A Prague School Reader on Esthetics, Literary Structure and Style*, ed. and trans. Paul L. Garvin.

Harper Collins Publishers Inc. for excerpts (pp.8–19) from Robin Lakoff, *Language and Woman's Place* © 1975 Robin Lakoff; Raymond Williams, *Keywords: A Vocabulary of Culture and Society*.

Heinemann Educational Publishers, a division of Reed Educational and Professional Publishing Ltd for material from Chinua Achebe, *Morning Yet on Creation Day*.

Hill and Wang, a division of Farrar, Straus and Giroux, LLC, for an excerpt from 'Myth Today' from *Mythologies* by Roland Barthes, trans. Annette Lavers. Translation © 1972 by Jonathan Cape Ltd.

Ken Hirschkop for material from G.I. Vinokur, 'The Futurists – constructors of language', trans. Ken Hirschkop.

Hodder & Stoughton Educational for material from Brian Cox, *Cox on Cox: An English Curriculum for the 1990s*.

James Currey Publishers for material from Ngũgĩ wa Thiong'o, *Decolonising the Mind: The Politics of Language in African Literature*.

Richard Kearney for material from Paul Ricoeur, 'The creativity of language', from Richard Kearney, *States of Mind: Dialogues with Contemporary Thinkers on the European Mind*.

Kegan Paul International for material from Karl Vossler, *The Spirit of Language in Civilization*, trans. Oscar Oeser.

Lawrence & Wishart for material from Antonio Gramsci, *Selections from Cultural Writings*, ed. David Forgacs and Geoffrey Nowell-Smith, trans. William Boelhower.

Les Éditions de Minuit for material from Jacques Derrida, *Positions*.

Macmillan Press Ltd for material from: Benedetto Croce, *Aesthetic as Science of Expression and General Linguistic*, trans. Douglas Ainslie; Denise Riley, *'Am I That Name?': Feminism and the Category of 'Women' in History*.

Mucchi Editore for material from Leo Spitzer, 'The Individual Factor in Linguistic Innovations' in *Cultura Neolatina*.

M.I.T. Press for material from: Roman Jakobson, 'Closing Statement: Linguistics and Poetics', in *Style in Language*, ed. T.A. Sebeok; L.S. Vygotsky, *Thought and Language*, ed. and trans. Eugenia Hanfmann and Gertrude Vakar; Benjamin Lee Whorf, *Language, Thought and Reality*, ed. John B. Carroll.

New Beacon Books for material from Edward K. Brathwaite, *History of the Voice: The Development of Nation Language in Anglophone Caribbean Poetry*, 1984.

Peter Owen Ltd for material from Ferdinand de Saussure, *Course in General Linguistics*, trans. Wade Baskin.

Pluto Press for material from Frantz Fanon, *Black Skin White Masks*, trans. Charles Lamm Markmann.

Random House Inc. for material from H.L. Mencken, *The American Language* © 1936 Alfred Knopf Inc. and renewed 1964 by August Mencken and Mercantile-Safe Deposit and Trust Co: material from *The Burning Library* by Edmund White,© 1994 by Edmund White. Reprinted by permission of Alfred A. Knopf, a division of Random House, Inc.

Rivers Oram & Pandora Press for material from: Dale Spender, *Man Made Language*, London, Pandora, 1980; Hortense J. Spillers, 'Interstices: a small drama of words', reproduced from *Pleasure and Danger: Exploring Female Sexuality*, edited by Carol Vance, London, Pandora, 1992.

Routledge for material from: Franz Boas, *Handbook of American Indian Languages, Part 1*, ed. Roy Harris; Judith Butler, *Gender Trouble: Feminism and the Subversion of Identity*; Deborah Cameron, *Verbal Hygiene*; Jacques Lacan, *Ecrits: A Selection*, trans. Alan Sheridan; Bronislaw Malinowski, 'The problem of meaning in primitive languages' from C.K. Ogden and I.A. Richards *The Meaning of Meaning: A Study of the Influence of Language upon Thought and of the Science of Symbolism*.

Tavistock Pulications for material from: Basil Bernstein, *Class, Codes and Control, Volume 1: Theoretical Studies Towards a Sociology of Language*; Michel Foucault, *The Archaeology of Knowledge*, trans. Alan Sheridan and Rupert Sawyer.

Tom Paulin for *Ireland and the English Crisis*.

University of Alabama Press for material from Deborah Cameron, 'Naming of Parts: Gender, Culture and Terms for the Penis Among American College Students', in *Feminist Cultural Studies II*, ed. Terry Lovell, Cheltenham: Edward Elgar, 1995, pp. 367–83.

University of California Press for material from Edward Sapir, *Selected Writings of Edward Sapir in Language, Culture and Personality*, ed. D.G. Mandelbaum.

University of Chicago Press for material from Jacques Derrida, *Positions*, trans. Alan Bass; Hélène Cixous, 'The Laugh of the Medusa', trans. K. and P. Cohen, in *Signs* 1:4 (1976); Luce Irigaray, from 'When Our Lips Speak Together', trans. C. Burke in *Signs* 6:1 (1980); Claude Lévi Strauss, 'Linguistics and Anthropology', in *International Journal of American Linguistics* 19 (1953).

University of Illinois Press for material from Braj. B. Kachru, *The Alchemy of English: The Spread, Functions, and Models of Non-native Englishes.* Copyright 1990 Braj Kachru.

University of Minnesota Press for material from Denise Riley, 'Does Sex have a History?' in *'Am I That Name? Feminism and the Category of 'Women' in History,* 1998.

University of Pennsylvania Press for material from William Labov, *Language in the Inner City: Studies in the Black English Vernacular* © 1972.

University of Texas Press for material from Mikhail Bakhtin, *The Dialogic Imagination: Four Essays*, ed. Michael Holquist, trans. Caryl Emerson and Michael Holquist © 1981.

Leonard Bloomfield, *Language*.

Claude Lévi-Strauss, *Structural Anthropology*, trans. Claire Jacobson and Brooke Grundfest Schoepf.

While the publishers and editors have made every effort to contact authors and copyright holders of works reprinted in *The Routledge Language and Cultural Theory Reader*, this has not been possible in every case. They would welcome correspondence from individuals or companies they have been unable to trace.

LIST OF SOURCES

Ferdinand de Saussure, 'The nature of the linguistic sign', 'Language and linguistics', and Linguistic value', from *Course in General Linguistics*, ed. Charles Bally and Albert Sechehaye, trans. Wade Baskin (London: Peter Owen, 1960), pp. 7–23, 65–100, pp. 111–22.

Benedetto Croce, 'The identity of linguistic and aesthetic', from *Aesthetic as Science of Expression and General Linguistic*, trans. Douglas Ainslie, 2nd edn (London: Macmillan, 1922), pp. 142–51.

V.N. Voloshinov, 'Multiaccentuality and the sign', from *Marxism and the Philosophy of Language*, trans. L. Matejka and I.R. Titunik (Cambridge, Mass.: Harvard University Press, 1986), pp. 9–24.

Leo Spitzer, 'The individual factor in linguistic innovations', from *The Individual Factor in Linguistic Innovations*, Cultura Neolatina, vol. 16 (1956), pp. 71–89.

Raymond Williams, 'Introduction to Keywords', from *Keywords: A Vocabulary of Culture and Society*, rev. edn (London: Fontana, 1983) pp. 15–25.

Muriel R. Schulz, 'The semantic derogation of woman', from *Language and Sex: Difference and Dominance*, ed. B. Thorne and N. Henley (Rowley, Mass.: Newbury House, 1975), pp. 64–75.

Deborah Cameron, 'Problems of prescriptivism', from *Verbal Hygiene* (London: Routledge, 1995), pp. 3–10.

Benjamin Lee Whorf, 'Science and linguistics', from *Language, Thought and Reality*, ed. John B. Carroll (Cambridge, MA: M.I.T. Press, 1956), pp. 207–19.

L.S. Vygotsky, 'Thought and word', from *Thought and Language*, ed. trans. Eugenia Hanfmann and Gertrude Vakar (Cambridge, MA: M.I.T. Press, 1962), pp. 249–56.

Sigmund Freud, 'Slips of the tongue', from *The Psychpathology of Everyday Life*, trans. Alan Tyson (Harmondsworth: Penguin, 1975), pp. 94–100.

Jacques Lacan, 'The signification of the phallus', from *Ecrits: A Selection*, trans. Alan Sheridan (London: Tavistock, 1977), pp. 282–91.

Dale Spender, 'Language and reality: who made the world', from *Man Made Language* (London: Routledge and Kegan Paul, 1980), pp. 139–51.

Robin Lakoff, 'Talking like a lady', from *Language and Woman's Place* (New York: Harper and Row, 1975), pp. 8–19.

Helene Cixous, 'The laugh of the medusa', from *New French Feminisms: An Anthology*, ed. Elaine Marks and Isabel Courtivron (Brighton: Harvester Wheatsheaf, 1981), pp. 245–51.

Denise Riley, 'Does a sex have a history?', from *'Am I That Name?': Feminism and the Category of 'Women' in History* (Basingstoke: Macmillan, 1988), pp. 1–9.

Judith Butler, 'From parody to politics', from *Gender Trouble: Feminism and the Subversion of Identity* (London: Routledge, 1990), pp. 142–49.

Luce Irigaray, 'When our lips speak together', trans. Carolyn Burke, from *This Sex Which Is Not One*, trans. Catherine Porter with Carolyn Burke (Ithaca NY: Cornell University Press, 1985), pp. 205–15.

Edmund White, 'The political vocabulary of homosexuality', from *The State of the Language*, ed. Leonard Michaels and Christopher Ricks (London: Faber & Faber, 1980), pp. 237–46.

Hortense J. Spillers, 'Interstices: a small drama of words', from *Pleasure and Danger: Exploiting Female Sexuality*, ed. Carole Vance (London: Pandora, 1992), pp. 74–80.

Deborah Cameron, 'The naming of parts', from 'The Naming of Parts: Gender, Culture and Terms for the Penis Among American College Students', in *Feminist Cultural Studies II*, ed. Terry Lovell (Cheltenham: Edward Elgar, 1995), pp. 367–83.

Jan Mukařovský, 'Standard language and poetic language', from *A Prague School Reader on Esthetics, Literary Structure and Style*, ed. and trans. Paul L. Garvin (Washington, DC: Georgetown University Press, 1964), pp. 17–23.

Michel Foucault, 'The discourse on language', from *The Archaeology of Knowledge*, trans. Alan Sheridan and Rupert Sawyer (New York: Pantheon Books, 1972), pp. 216–27.

Jacques Derrida, 'Semiology and grammatology: interview with Julia Kristeva', from *Positions*, trans. Alan Bass (London: Athlone Press, 1987), pp. 17–29.

Karl Vossler, 'Language communities', from *The Spirit of Language in Civilization*, trans. Oscar Oeser (London: Kegan Paul, 1932), pp. 115–23.

Leonard Bloomfield, 'Speech communities', from *Language* (London: George Allen & Unwin, 1933), pp. 42–54.

Mikhail Bakhtin, 'Unitary language', from *The Dialogic Imagination: Four Essays*, ed. Michael Holquist, trans. Caryl Emerson and Michael Holquist (Austin: University of Texas Press, 1981), pp. 269–95.

Antonio Gramsci, 'Normative grammar', from *Selections from Cultural Writings*, ed. David Forgacs and Geoffrey Nowell-Smith, trans. William Boelhower (London: Lawrence & Wishart, 1985), pp. 180–87.

H.L. Mencken, 'English or American?', from *The American Language* (New York: Alfred Knopf, 1936), pp. 392–97.

Tom Paulin, 'A new look at the language question', from *Ireland and the English Crisis* (Newcastle-upon-Tyne: Bloodaxe Books, 1984), pp. 178–93.

David Dabydeen, 'On not being Milton: nigger talk in England today', from *The State of the Language*, 1990s edition, ed. Christopher Ricks and Leonard Michaels (London: Faber & Faber, 1990), pp. 3–14.

Edward K. Brathwaite, 'Nation language', from *History of the Voice: The Development of Nation Language in Anglophone Caribbean Poetry*, (London: New Beacon, 1984), pp. 5–19.

Braj B. Kachru, 'The alchemy of English', from *The Alchemy of English: The Spread, Functions and Models of Non-Native Englishes* (Oxford: Pergamon Institute, 1986), pp. 3–15.

Roman Jakobson, 'Linguistics and poetics', from *Closing Statement: Linguistics and Poetics, in Style in Language*, ed. T.A. Sebeok (Cambridge, MA: M.I.T. Press, 1960), pp. 350–59.

GENERAL INTRODUCTION

Finally, of what use is linguistics? Very few people have clear ideas on this point, and this is not the place to specify them. But it is evident, for instance, that linguistic questions interest all who work with texts – historians, philologists, etc. Still more obvious is the importance of linguistics to general culture: in the lives of individuals and societies, speech is more important than anything else. That linguistics should continue to be the prerogative of a few specialists would be unthinkable – everyone is concerned with it in one way or another.
(Ferdinard de Saussure *Course in General Linguistics* [1916], 1960: 7)

THE RELATIONS BETWEEN LANGUAGE and culture, and language and cultural identity, were not discovered in the twentieth century. Instances from Irish history will demonstrate the point. In the late sixteenth century, Edmund Spenser, the English poet and colonial servant, commented on the appropriateness of the model given by Roman colonial practice with regard to language. He noted that 'it hath ever been the use of the conqueror to despise the language of the conquered, and to force him by all means to use his' (Spenser 1949: pp. 118–19). It was a lesson which the English colonists applied with enthusiasm. A little later, in the early seventeenth century, Fynes Moryson, an English adventurer in Ireland, made the observation that 'in general all nations have thought nothing more powerful to unite minds than the Community of language' (Moryson 1903: 191). It was a perceptive point, and one which was to become highly influential in a whole range of cultural nationalist movements from Europe to Africa. It was indirectly taken up by an eighteenth-century Irish exile bemoaning the gradual disuse of the Irish language and the culture that went with it. He made an apparently simple connection between language and cultural identity: '*Irish-Men* without *Irish* is an incongruity, and a great Bull' (Donlevy 1742: 506). In the nineteenth century, Irish women were told that 'they owe much to [the Irish] language, which was for ages and ages unceasingly employed in singing their praises and lauding ... their charms, attractions, beauty and virtues' (Barron 1835: 14). They were invited, on these grounds, to join the campaign which

sought to prevent the death of the Irish language and to rescue Ireland from its colonial subjection. In the early twentieth century the same appeal was made to that constituency on the basis that because they talked all day, their role in the struggle was central: 'Verily, a language movement is of all movements one in which woman is fitted to take part' (Butler 1900: 2).

What these quotations show is that language and culture have long been intertwined, and that the links between them are based on particular theoretical suppositions (though they are rarely made explicit) which are traceable in specific historical examples. Yet it has been in the twentieth century that the interrelationships of language and culture have been the focus of a great deal of sustained attention in fields as diverse as the general study of signification and the practical formation of nations. How did this come about? Why did the twentieth century turn to the study of language in the way that the eighteenth and nineteenth centuries respectively turned to reason and history?[1] What were the main developments in this process? It is the aim of this *Reader* to provide the materials with which these questions, and others, can be considered and answered. The texts selected will demonstrate recurrent concerns not simply with matters such as those raised in the quotations given above (the connections between language and colonialism, the nation, cultural identity and gender) but others which have markedly come to the fore in the present century (language and race and language and class). The *Reader* will also introduce two of the twentieth century's innovatory fields of knowledge: the attempts to formulate the general principles of signification, and the analysis of the deep linkage between language and subjectivity.

One way of beginning in this field is to sketch the work and interests of three linguists working at the end of the nineteenth century. The first worked within the first discipline to call itself a science of language, nineteenth-century comparative philology, known later as historical linguistics; it was devoted to the study of the evolution of languages, that is, how they changed in time. He published, at the age of twenty-one, a scholarly masterpiece which confirmed his status as a distinguished expert in the field. He published nothing else during his life except this essay in historical linguistics, a subject defended by one of his contemporaries with a stridently confident claim:

> It has been objected that there is another view of language possible besides the historical. I must contradict this. What is explained as an unhistorical and still scientific observation of language is at bottom nothing but one incompletely historical, through defects partly of the observer, partly of the material to be observed.
>
> (Paul 1890: xlvi–xlvii)

The second linguist asserted, in 1894, his dissatisfaction with the methods of this dominant mode of language study in the late nineteenth century by declaring that 'there is not a single term used in linguistics today which has any meaning for me whatsoever'. He went on to complain:

The utter ineptness of current terminology, the need for reform, and to show what kind of an object language is in general – these things over and over again spoil whatever pleasure I can take in historical studies, even though I have no greater wish than not to have to bother myself with these general linguistic considerations.

In turn this caused him to admit that

in the last analysis, only the picturesque side of a language still holds my interest, what makes it different from all others insofar as it belongs to a particular people with a particular origin, the almost ethnographic side of language.

And following from this he stipulated the topics which he considered 'important things – the very ones we think of when we begin the study of speech'. They included the relations between language and ethnicity, language and the nation, language and political history (conquest, colonisation, and the internal politics of a State) language and institutions, literary languages and dialects, and linguistic types and group mentalities. He even went so far as to ask 'of what use is linguistics?' and to provide the bold answer that the study of language is not simply of importance to specialists but is properly the concern of everyone.

Finally, the third linguist came to be known as the revolutionary founder of a new discipline, described as an anti-historical linguistics. He took it as axiomatic that language must be studied 'in itself and for its own sake' and therefore that it had to be considered without regard to the social contexts in which it was used and with no attention either to its historical evolution. He made his position clear with the assertion that the linguist,

can enter the mind of speakers only by completely suppressing the past. The intervention of history can only falsify his judgement.

Three linguists then: one working with an historical perspective on language change, another interested in language from a social and political standpoint, the third rejecting the historical stance of his two colleagues in favour of the study of language from the point of view of a language user in the present. It is hard to see them being able to talk to each other professionally in any meaningful way. And yet these three linguists are in fact one and the same person: Ferdinand de Saussure. Saussure published the *Mémoire sur le système primitif des voyelles dans les langues indo-européennes* in 1878. He also composed the letter of complaint on the methods of historical linguistics to his colleague Meillet in 1894, in which he also confessed his preference for the 'ethnographic side of language'. And his lectures on language, published posthumously in 1916 as the *Course in General Linguistics*, expressed his interest in the relations between language and cultural formations (nationality, ethnicity, colonialism, state politics and so on) *as well as* his apparently anti-historical stance in language study.[2] That text was also

to become one of the central texts of modern linguistics and to engender a new area of study: semiology.

This may all of course be of interest to anyone interested in Saussure, or in linguists with complicated personalities, but why is it worth mentioning here? The reason is not that Saussure should be regarded as the 'founding father' of linguistics in the twentieth century, an over-simple claim which is often made. Nor even that he is a central figure in all of the fields to which the *Reader* will provide access. The reason he has been introduced in this way is that, in a sense, Saussure's varying interests can be said to demarcate fields of inquiry which have been taken up in the twentieth century, in one way or another, in the general study of language and culture. And the fact that one and the same person worked in these areas demonstrates that though methodologically distinct, they are closely related. What Saussure's intellectual history encapsulates is the twentieth century's linguistic turn in three of its main modes: first, the consideration of the history of language and languages (though the twentieth century has not pursued this field necessarily, as we shall see, from the standpoint of nineteenth-century historical linguistics). Second, the examination of the relations between language and cultural and political history. Third, and this was the area which was not a legacy from the nineteenth century and which *was* therefore Saussure's genuine breakthrough and major achievement, the systematic study of the way in which signification itself, the creation of sense, takes place. These three intellectual spheres together, and the ways in which they have developed in the twentieth century, sometimes crossing fruitfully, at other times frustratingly, form the basis of this *Reader*. It will be useful to consider them in reverse order.

In the twentieth century the study of language has produced a new discipline, the second to call itself a science of language: linguistics. This was in part brought about by Saussure's *Course in General Linguistics* published in 1916, but it is important to stress, and the *Reader* will show, that the history of this discipline in the twentieth century has been complex and multifaceted. During the course of the twentieth century, linguistics has borrowed elements from the first science of language, and it has created new areas of interest. It has worked in specialised areas such as syntax, phonology and semantics. And it has also spawned various subdisciplines formed from the intercourse of the newcomer with other fields of knowledge: applied linguistics, sociolinguistics, psycholinguistics, educational linguistics and so on.[3] These are significant developments in their own right, of course, but the turn to language in the twentieth century has been more extensive than the appearance of new departments of intellectual enquiry. For across the humanities, from philosophy to social science, from anthropology to the study of film, from psychoanalytical theories of subjectivity to literary studies, language has become a central focus of attention. And it can properly be said that such was the effect of certain questions which were raised and at least partially answered by Saussure in the *Course in General Linguistics*, that the last third of the twentieth century has witnessed what has been termed a 'crisis of the humanities'. Whether it was, or is, a crisis, however, rather depends on one's standpoint; it could equally be described as the overdue challenge to dated methodologies. Be that as it may, it is certainly the

case that many disciplines have been forced by Saussure's work on signification and the production of meaning to reconsider the theoretical presuppositions upon which their approach to their object of study was based; and indeed the constitution of that object. Delineating that 'structural revolution', which as we shall see is probably better described as the revolution facilitated by the discovery of structure, will be an important part of this *Reader*'s task.

The second area marked out by Saussure, for which he expressed an exasperated preference, is the study of language in history. As noted at the beginning of this introduction, the articulation of the linkage between language and history was not radically new. Indeed the Irish examples given in the first paragraph fall into a number of the categories given by Saussure in his brief description of the field. That is, the roles played by language in relation to colonialism, nationality and ethnicity; being a man of his time, of course, the category of gender is missing from his list. Colonialism and nationalism were in fact central to the development of an interest in language in history. Colonialism because the anthropological research which often accompanied it was bound to take note of linguistic and cultural difference, particularly the functioning of language within a conquered culture. And nationalism was important, specifically in the nineteenth-century European context, because the legitimation of opposition to colonial rule was often grounded in precisely the same interest in linguistic and cultural difference as that shown by the colonists. Colonialism of course wanted to eradicate such difference; cultural nationalism insisted upon it. Once this stress on language as a marker of difference and identity had been noticed and developed, and the principle is there in the words of Fynes Moryson (see earlier), it became highly significant. Language became the vehicle of culture in the eyes of many different groups; it carried history and identity and was thus taken to be a site of social and political struggle. As one nineteenth-century linguist put it, language was 'material history' (Latham 1862: 750). For those engaged in challenging various forms of oppression, and indeed those interested in their conservation, language thus emerged as a key concern. No longer simply the neutral medium for the conveyance of thought, as the idealist tradition had held in one way or another, language became a battleground for the contestation of political and cultural identities and values. A good contemporary example of this is the infamy attached to 'political correctness' (is there anyone who does not want to be correct in their political choices?) the debate around which has drawn attention to the alleged 'politicising' of language and culture. But it is noticeable in this particular debate that language only becomes 'political' (almost a reproach) when used by groups challenging currently existing power structures and formations of identity. What is often missed in this is that dominant groups also 'politicise' language, but that they do so in such a way as to 'naturalise' (and thus make *a*historical) their own historical values and positions. What the study of language in history does then is to analyse how language, and forms of language, have been, to give just a few examples, institutionalised, codified, gendered, linked to specific groups in education, privileged and downgraded.

Saussure's third area of interest, the one he rejected so vehemently, was pursued by others in the twentieth century. Again, it would be wrong to imply that

Saussure's re-invention of the study of language dominated all other interest in linguistic affairs. For while Saussure's legacy in our understanding of the signifying process has had profound effects, even in terms of the reaction against it, there were other schools and traditions which developed in this century along different lines. The study of the history of language and languages for example has developed in ways which saw it depart from its nineteenth-century predecessor. This is in fact linked to the Saussurean revolution in that he made a clear distinction in his work between studying a language synchronically (at a fixed point in time) and considering it diachronically (how it evolved through time). The first he saw as the basis of a scientific approach, the second he saw as simply able to give an account of how linguistic forms changed from one point in time to another. Saussure's scientific view initially swept almost all before it, though it is also true to say that diachronic linguistics progressed without him and achieved important insights. But Saussure's synchronic–diachronic distinction opened the way for a different approach to linguistic change. An example will illustrate: diachronic linguistics might take linguistic forms such as the Greek form ἱστορία, which in Latin is *historia*, in Middle English is *historie*, and which appears in contemporary English as *history*. Now the evolution of these forms took place over thousands of years, but diachronic linguistics shows us that, despite this, they are actually closely related. In other words, what diachronic linguistics can tell us, according to a set of laws derived from careful analysis of how words change over time, is that in this example, the Greek, Latin, and English forms are in a sense the 'same'. It must be remembered, however, that what is being described here, and this is a crucial point, is change through *time* as opposed to change in *history*. And this is where another method of studying the history of language and languages comes in (one which appeared in this century, though it is important to say too that this in itself was a continuation of earlier work). Rather than the study of language in *time*, what developed in the twentieth century was a field which paid careful attention to the ways in which the meaning(s) of words changed in *history*. Again an example can demonstrate the point (it is taken from Williams' *Keywords*, 1976). Diachronic linguistics will tell us, to take a very simple case, that the Latin *persona* is directly linked to the modern English *person* across time. The historical study of language, however, would be more interested in the shift of meaning of a word like *personality*, viewed in specific historical contexts. Derived from *persona* (meaning a mask used by an actor) in its earliest English usage *personality* meant the quality of being a person, a human being. Significantly, given the historical point at which it started to shift to its new meaning, it came to refer to the specific qualities of an *individual* human being. This is evident from the eighteenth century onwards and in modern use the word has narrowed even further; now only certain people are accorded the status of *personality*, a quality which once belonged to us all. In this way the study of the history of language allows us to understand the distinctions of sense and meaning which have been, and are being, made in the vocabulary of our practical social life.

The view of language as an historical battleground, the location in which the contestation of forms, values and meanings takes place in all sorts of socially enshrined practices and institutions, is based on insights rendered by theoretical

work on the process of signification. And evidence for the fact that language has been seen as such an arena can be provided by the study of language in history. What this demonstrates is that these three modes of study are closely interrelated rather than purely distinct; the way in which they were segmented above by following the path of Saussure's intellectual development was simply an artificial way of delineating the different areas. In fact each illuminates the others and this is something which has been built into the structure of the *Reader*. By organising the text into sections, the aim has been to encourage readers to approach the subject of language and cultural theory by means of a set of categorical problems and issues rather than to follow a chronology or the development of schools of thought. The intention has been to enable readers to make sense of the material by comprehending the relations between the linguistic and cultural debates in the light of the specific political and historical situations in which they have emerged.

The categories themselves were produced in response to the kinds of problems and questions raised by students working in courses in the field of language and cultural theory at both undergraduate and postgraduate levels. A persistent area of concern, for example, because it challenges commonly held assumptions about the connections between language, the social world and subjectivity, is the relationship between language and thought. The more radical implications of Saussure's tenet that language articulates thought, rather than the 'common sense' view that language reflects thought processes which exist prior to, and independent of, the determinants of linguistic structure, culture, and history, are difficult to grasp. Thus several of the pieces in the *Reader* address this issue from various perspectives: the linguistic determinism of the Sapir–Whorf hypothesis, Vygostky's formulation of the notion of inner-speech, the post-structuralist model of the linguistic constitution of the subject, and the historical materialist position, as rendered by Voloshinov, which takes inter-subjectivity and dialogue as central areas of ideological struggle and historical process. From a different perspective, the sections on language and gender, sexuality, colonialism and education and class, feature accounts which illustrate the psychic and social violence inflicted upon those who struggle with languages of oppression. Dominant languages and forms of discourse, in these contexts, have operated historically to disempower, to disenfranchise and to perpetuate and de-historicise those signs of 'otherness' which are attributed to subordinate or marginalised groups. But the texts selected also provide accounts of counter-struggle, resistance and self-empowerment by way of rejection and/or appropriation of the instruments of domination, or the invention of new, emancipatory languages and forms of discourse.

It is important to stress that while the classifications into which the text is divided possess a certain logic, there are many more ways in which the pieces selected could have been organised and grouped. Indeed it is hoped that readers will engage with the anthology creatively by forging links between material in different sections and by cutting across the demarcations which are given in order to produce alternative ways of categorising and understanding. For example, although there is a section on language and gender, the aim has not been (nor could it have been) to exhaust the insights, strategies and debates which the material raises in a

discrete, self-contained section, but to present arguments which have resonances with issues and positions elsewhere; work on language in history, and language and creativity, is also addressed from a gendered perspective. Likewise, the insights and debates around language, class and education might be used in conjunction with feminist debates around language in order to produce readings of the intersection of class and gender in a pedagogical context. In a sense this hybridity of the ideas and arguments in the different sections (their complicated refusal to be contained in just one sphere) is instructive. For the resistance to easy classification under one category or label is akin to the way in which forms of cultural identity and subjectivity are themselves complex, sometimes contradictory, and always (since they are grounded in history) in process.

The *Reader* is divided into three parts, of which 'Structure and Agency' is the first. This presents the ways in which language has been taken to be a constitutive force in the construction of subjectivity, as well as social and cultural being – how it enables us to see, as it were, but also how it might limit our sight. Related to this is the important question of whether, and if so how, individuals and social groups can engage with, or act upon, the categories and forms of representation with which they are provided in order to further their political and cultural ends. Various approaches to the problems of structure and agency are given, including exemplary accounts of structuralist, idealist and Marxist models of signification and the production of meaning. It is important again to note here (and this is repeated in the other two parts) the clear connections between the study of signification, language in history, and the historical study of language. Indeed a number of pieces fit into all three categories.

The second part of the *Reader*, 'Unity and Diversity in Language', focuses on the question of whether language is a centralising cultural force (through its unified, normative structure) or a site of diversity and difference. This question of unity and/or multiplicity in language is addressed from various perspectives. And the aim here is not to attribute a fixed politics either to the use of norms or centralising practices, nor to the exploration of difference and diversity (the pieces by Bakhtin and Gramsci are particularly pertinent in this respect). Another issue raised under this heading is that of the theorisation of language as the key to national identity, and, related to this, the possibilities of appropriation and change within languages which had been the vehicles of colonisation and racial oppression. This in turn offers insights into the practice of innovation, appropriation and resistance in the spheres of gender and sexuality. From a different perspective, the section on language and creativity seeks to explore the relationships between norms in language and the creation of new forms of signification. Questions of value and authority are at stake in these debates and they may be read productively alongside the texts which discuss the interplay between individual innovation and the social and historical factors in linguistic change.

'Languages, Cultures, Communities', the final part of the *Reader*, brings together work which considers the prestige and value accorded to languages or forms of language in the construction of cultural identity. Anthropology is one field in which this process has taken place and the crucial role language has had in the

ascription of cultural difference is demonstrated here. But the responses to the forced imposition of languages in the colonial context are many and varied and are not reducible to one formula; in fact they are often contradictory. When the anthropological analysis of structures of signification is turned on the cultural practices and mythologies of the West, this too produces significant insights. One such hierarchical structure in which language has a central position is of course that which delimits authoritative and non-authoritative discourse, particularly in the realm of education. In this context there arise important vexed questions around the idea of a standard language or an 'official' language and its status as a specified, validated form of the language or/and its use by a particular social group.

As noted earlier, the 'turn to language' has had a major impact not simply upon the methodologies used in a number of disciplines, but also upon the very constitution of disciplines themselves. New areas of knowledge have appeared, others have disappeared; older techniques have been questioned – and sometimes survived; new analytical tools have been appropriated and used. In short, twentieth-century intellectual life has been transformed; in some cases, perhaps, rather too hastily. But it is also important to note that in specific cultural enterprises and political struggles, language has been the prize to be won. Finding or articulating a voice has been a key aim of many previously silenced groups; insisting on a cultural identity, no matter how unfashionable that might seem, has been the priority of others; fighting for the right to use a language has been an issue from Africa to Ireland. It is a modern fact that in situations of civil conflict or war, whereas in the past soldiers were used to defend (or storm) the palace or parliament buildings, in the last half century it has been at least as likely that they would have been employed to guard (or commandeer) the television and radio stations. Control over language has been a key priority. There have been grotesque costs too, as even a cursory glance at the twentieth century's record of barbarism shows. Even among the theorists included in this *Reader*, a number suffered seriously for the perceived dangers of their work: Gramsci was imprisoned by Italian fascist leaders for the last eleven years of his life, Bakhtin, Ngũgĩ and Achebe were exiled, Voloshinov died in the Stalinist purges in the Soviet Union. The *Reader* engages with both aspects of this lineage: the intellectual and the more directly political.

It is intended that the materials selected in the *Reader* will supply an essential resource for students at the undergraduate and postgraduate levels working in disciplines such as English (Language and Literature) and Cultural Studies as well as Cultural Theory and History and Sociology. Other interdisciplinary degree programmes in the Arts and Humanities – Feminist and Post-Colonial Studies for example – will also be able to use the book productively. All of these subjects in one way or other (though it might go under different titles) take Language and Cultural Theory as part of their intellectual remit. The aim of the *Reader* is to provide the means by which this field can be opened up to intellectual analysis from various viewpoints. But it is also worth remembering that, as Saussure noted, it impacts upon us all, in our everyday practice in the societies and histories in which we live. Perhaps the last words of introduction should be given to one of the pioneers in this field: Raymond

Williams' succinct and deceptively simple assertion that 'a definition of language is always, implicitly or explicitly, a definition of human beings in the world' (Williams 1976: 21).

Notes

1 It is important not to attach too much weight to these convenient labels. Language was one of the persistent intellectual preoccupations of the eighteenth and nineteenth centuries. And the twentieth century has had its own confrontations with reason and history.

2 The quotations complaining of the inadequate methodology of contemporary linguistics, and stating the preference for the 'picturesque' side of language are taken from Saussure's letter to Meillet in 1894 (Saussure 1964: 93). His assertion of the 'important things' in the study of language is taken from the *Course in General Linguistics* (Saussure 1960: 21). And the comment on the difficulties caused by 'the intervention of history' is also taken from the *Course* (Saussure 1960: 81).

3 Other examples include areal linguistics, biological linguistics, forensic linguistics, mathematical linguistics and statistical linguistics.

PART ONE

Structure and agency in language

THEORISING THE SIGN

The limits of my language mean the limits of my world.
(Ludwig Wittgenstein, *Tractatus Logico-Philosophicus*, 1961: 115)

THE FIRST PART of the *Reader* introduces one of the key problems in the field of language and cultural theory, although it is in fact a problem which is the concern of all forms of social thought ranging from sociology to theology. 'Structure and agency' essentially deals with the relationship between two opposing tendencies: 'structure' can be thought of in a roughhand way as a system of rules, 'agency' as the extent to which people are, or are not, able to act within a given structure. In sociology, this opposition might be cast as social norms and individual behaviour; in theology, it could refer to the problem of free will and determination, or, on another level, we could think of it in terms of the relationship between the moral code and what people do on a Friday night. In language and cultural theory, the problem of structure and agency revolves around the extent to which language is viewed as a structure which orders and defines social reality, constituting us as social beings and thus mapping the 'limits of our world' as the quotation from Wittgenstein suggests. For instance, some theorists suggest that language determines the ways in which we perceive the world around us, and argue that language 'speaks us' rather than *vice versa*. Others have accorded language users a much greater power over the language they use, emphasising our potential to engage creatively with language. The first three texts in this part of the *Reader* provide us with access to the complex problem of structure and agency in relation to language by way of three very different definitions of what language is, and how it should be studied.

Another way of approaching the issue of structure and agency is to ask the question: 'how is it that people come to do what they do, rather than something else?' To put it in linguistic terms: 'why is it that when French people speak French, they seem to use the words in regular sorts of ways, when, presumably, they could utter any words they wanted in whatever order they want?' One answer to the last question would be that they *are* potentially free to utter any words they want, in any order, but if they did then they would not be speaking French. What are they

doing when they utter particular words in regular sorts of ways? *Then* they are speaking French. Accepting the fact that you have to utter French words in regular ways is the price you pay in a sense, the freedom to utter just anything is that which you lose, in order to speak French. On the other hand, however, we know that no two French speakers utter the words in exactly the same way (it may be impossible for even one person to say the same thing twice in *exactly* the same way) and that speakers differ in all sorts of ways: their pronunciation of words, their knowledge of the vocabulary, their willingness to speak certain words, or about certain subjects. But if this is the case, then the freedom which speakers seem to have appears to be very significant. How can this square with the apparent restriction which applied earlier? This is the difficulty around structure and agency – rules versus freedoms – which is the focus of the first part of this *Reader*, but which will be treated in a variety of ways throughout.

The first extract in this section is taken from Saussure's *Course in General Linguistics* (1916). It is helpful when reading Saussure to remember the aim of his project: it was nothing less than to create a science of language, given his rejection of what had gone under that title (as mentioned in the General Introduction). He began with the question: 'where is the linguist to start?' Given the freedom which people do have to express things in different ways, and the errors which creep into everyone's use of the language, it is problematic to start with practice – how would we know when an error was an error for example unless we surveyed everyone? So he argued that the linguist had to aim to study the linguistic system which facilitates the practice of speech, that which enables us to judge on matters of correctness and incorrectness. And Saussure's theoretical breakthrough was that he asserted the aim of scientific language study to be the description of '*langue*', or 'linguistic structure' as it is termed in some translations of the *Course*; that is, the structural knowledge of our particular language which we share with all other speakers of it. It is an abstract form of knowledge of a closed system of signs which are in themselves meaningful not because of any inherent quality, but by virtue of their differential relations within that closed system. Meaning is, in this way, produced by the differences created by the system of signs and by no other cause. Where does this leave agency? In fact Saussure's treatment of linguistic agency is both complicated and at times seemingly paradoxical – as in the principle of the mutability and immutability of the sign. This principle attempts to account for both the stability of language and its potential for change and innovation. In his account of the 'immutability of the sign', Saussure contends that although the relationship between signifier and signified, or sound pattern and concept, is arbitrary, members of a given linguistic community are free neither to choose, nor to replace, particular signs at will. This, he argues, is because the language we speak is always inherited, and thus something linguistic communities tend to accept without critical reflection. Moreover, the arbitrary nature of the sign means, for Saussure, that language users have little cause to discuss their language because there is no reason to prefer one sign over another. However, it is precisely because the sign is arbitrary that Saussure is able to argue that it is also characterised by its 'mutability'. That is to say, that as a consequence of the passage of time, and the social forces which

act upon language, it is possible to identify within particular signs a change in the relationship between signifier and signified. On an everyday level, we experience the 'mutability' of the sign as words changing their meanings, and this is explored in detail in the extracts presented in 'Language in History'.

It is important to remember that Saussure also expresses an interest in the relations between language and culture, and indeed language and history; both, however, are ruled out of the project to create a science of language. The problem which emerges in relation to the principle of the mutability and immutability of the sign resides in the role we accord to human agency in the process of linguistic change. The idea of language as a systematic structure does have implications for agency which need to be addressed. Is it persuasive to think of ourselves as having no control over meaning, if meaning is produced by the system rather than reflecting what we want or intend to say? Are we, in effect, trapped in the 'prison house of language', to borrow the Marxist critic Frederic Jameson's term? On another level, given that members of a linguistic community share the same linguistic structure, and no other, how can translation between languages be possible if we understand languages as discrete and closed systems of signs? There are genuine questions and difficulties raised here both in terms of thinking about linguistic creativity, and, of course more importantly, for those who wish to make active interventions within language and culture for political purposes. This very problem is the subject of a number of sections in the *Reader* (see, for instance, 'Language and Gender', 'Language and Sexuality', 'Language and Colonialism', 'Englishes').

An alternative, indeed an opposed view, to that of Saussure is formulated by his contemporary, the Italian philosopher Benedetto Croce. Croce's central thesis is that the philosophy of language and the philosophy of art share the same objects of enquiry. 'Whoever', he notes, 'studies general Linguistic, that is to say philosophical Linguistic, studies aesthetic problems, and vice versa'. His fundamental claim in this respect, is that 'language is expression'. But what exactly does it mean to claim that language is expression? In everyday terms, expression suggests the transformation of ideas (or, more loosely, feelings or moods) into words or some other artistic medium, for instance, music or painting. However, this presupposes that ideas exist prior to, and independently of, language, and that language is no more than a medium or vehicle for ideas. As a philosophical concept for Croce, however, expression does not transform ideas into language because expression is logically prior to conceptualization – expression is not the means by which ideas are conveyed in some more tangible form, rather it is that which makes it possible to produce ideas in the first place. How then does Croce conceive of expression?

Croce's philosophy of spirit is idealist, that is, it is grounded in the belief that the foundations of all human knowledge are to be found in the active powers and faculties of the human mind rather than in the passive operations of sensory perception. Our knowledge of the world is arrived at, not through our senses passively registering the external stimuli we receive, but through our minds actively responding to, and acting upon, those stimuli in various ways. Without such activity of the human mind, shaping and organizing sensory experience, knowledge of the world in which we live is rendered impossible. Aesthetic activity is the power the mind has

to impose order and form on the external stimuli which we receive through the senses. When a stimulus presents itself to us, the mind gives it shape and order by creating mental representations of it, thereby producing objects of experience for our understanding: 'in making representations we articulate and make the world comprehensible to ourselves. We are no longer its subject, but its master' (Lyas, Translator's Introduction, in Croce 1992: p.xx).

'Expression' then, is the term Croce uses to refer to the act of producing representations, and it has two basic characteristics. First, it is creative activity in as much as it constitutes the production of representations and the shaping of experience. Second, it operates in the realm of particulars, producing representations of specific things, rather than abstract general concepts. It brings before the mind unique and individual objects of understanding. General concepts are the province of another theoretical activity of the spirit, the Logical (explored by Croce in other philosophical works), which operates to extract and delineate them from the representations of specific things produced by the mind in aesthetic activity.

Croce's argument that 'language is sound articulated, circumscribed and organized for the purposes of expression' is founded upon a view of the creation of meaning as the property of the speaking individual, rather than as the effect of differences within a closed system of signs. If, then, Saussure's language user is locked into the shared system of language, unable to create meanings of their own, then Croce's is a free spirit, unhindered by anything as restrictive, or determining, as grammar or norms. Rather than Saussure's argument that meaning is produced by linguistic structure, here it resides in the individual language user. Croce's work thus offers a contrasting perspective upon the question of the linguistic creativity and agency of the individual to that offered by Saussure.

The third extract in this section, taken from Voloshinov's *Marxism and the Philosophy of Language*, provides us with yet another way of approaching the relationship between structure and agency by offering a different theoretical account of the linguistic sign. This piece needs to be read in the context of Voloshinov's critique of 'two trends of thought in the philosophy of language', 'abstract objectivism' (typified by the formulations of Saussure) and 'individualistic subjectivism' (of which Croce's piece is representative). Working within a marxist theoretical paradigm, Voloshinov argues that both 'abstract objectivism' and 'individualistic subjectivism' fail, in different respects, to account for the thoroughly social dimension of language. He thus insists that the production of meaning is a social rather than an individual phenomenon (in contrast to Croce), but also that it is actively produced by historically situated human beings rather than being the function of an abstract system, 'independent of *any* individual consciousness' (in contrast to Saussure). However, Voloshinov's alternative, which raises its own problems and questions, is not simply to put abstract objectivism and individualist subjectivism together. Rather he offers a theory of the sign which sees it as neither stable and given, nor free floating and indeterminate. Crucially, he contends that an analysis of the 'particular, concrete context' of speech should take precedence over the study of linguistic structure. 'Linguistic form', he argues, 'exists only in the context of specific utterances, exists, consequently, only in a specific ideological context' (Voloshinov

1986: 70). His emphasis upon the context-bound and ideological character of the utterance underpins his theory of 'evaluative accentuation'. Meaningful only in the context of a concrete utterance, the sign is never completely fixed because it is open to negotiation, contestation and change. As such, the properties he attributes to the sign mean that it is subject to a social struggle, as it is fought over by differing social groups, each wanting to 'accent' it for its own ideological ends. His term for this process of contestation is 'multiaccentuality'. Victory in this struggle over the sign would presumably be to convince the opponent that the sign was in fact 'uni-accentual', as the dominant social group strives to naturalise its own meanings. We might consider the changing meanings of the signs 'socialism', 'community', or 'queer' in recent years as examples of precisely such an ideological struggle.

The problem of how to account for the relationship between 'structure' and agency in language recurs in a number of the pieces in the *Reader*. It is possible to identify diverse perspectives upon this issue, and different ways of addressing the conflict between the idea that language encodes and perpetuates forms of oppression, and the notion that it can also operate as the site of contestation and social change

Further reading

Saussure

Saussure, F. de (1960) *Course in General Linguistics*, ed. C. Bally and A. Sechehaye, trans. W. Baskin, London: Peter Owen.

—— (1983) *Course in General Linguistics*, ed. C. Bally and A. Sechehaye, trans. R. Harris, London: Duckworth, Introduction, chapters 2–5, Part 1.

Gadet, F. (1989) *Saussure and Contemporary Culture*, trans. G. Elliott, London: Radius, Part 1, chapters 3 and 5.

Holdcroft, D. (1991) *Saussure: Signs, System and Arbitrariness*, Cambridge: Cambridge University Press, chapters 2–4.

Culler, J. (1976) *Saussure*, Glasgow: Fontana, chapter 2.

Harris, R. (1987) *Reading Saussure: A Critical Commentary on the 'Cours de linguistique générale'*, London: Duckworth, pp. 11–40, 55–102.

Koerner, E.F.K. (1973) *Ferdinand de Saussure: Origin and Development of his Linguistic Thought in Western Studies of Language*, Braunschweig: Vieweg, pp. 311–77.

Hodge, R. and G.R. Kress (1988) *Social Semiotics*, Cambridge: Polity, chapter 2.

Voloshinov, V.N. (1986) *Marxism and the Philosophy of Language*, trans. L. Matejka and I.R. Titunik, Cambridge, MA: Harvard University Press, pp. 52–62.

Engler, R. (1975) 'European Structuralism: Saussure', in *Current Trends in Linguistics*, ed. T.A. Sebeok, Vol. 13: *Historiography of Linguistics*, The Hague: Mouton, pp. 829–86.

Thibault, P.J. (1997) *Re-reading Saussure: The Dynamics of Signs in Social Life*, London: Routledge, chapters 1, 3 and 9.

Sign and system

Peirce, C.S. (1991) *Peirce on Signs: Writings on Semiotics,* ed. J. Hoopes, Chapel Hill: University of North Carolina Press.

Ogden, C.K. and I.A. Richards (1923) *The Meaning of Meaning: A Study of the Influence of Language upon Thought and of the Science of Symbolism*, London: Routledge & Kegan Paul, chapter 1.

Benveniste, E. (1971) *Problems in General Linguistics*, trans. M.E. Meek, Florida: University of Miami Press, chapters 3–4.

Jakobson, R. (1980) 'Sign and System of Language: A Reassessment of Saussure's Doctrine', *Poetics Today*, 2(1), pp. 33–8.

Halliday, M.A.K. (1978) *Language as Social Semiotic: The Social Interpretation of Language and Meaning*, London: Edward Arnold, chapter 6.

Voloshinov, V.N. (1986) *Marxism and the Philosophy of Language,* trans. L. Matejka and I.R. Titunik, Cambridge, MA: Harvard University Press, pp. 65–82.

Barthes, R. (1967) *Elements of Semiology*, trans. A Lavers and C. Smith, New York: Hill and Wang, chapter 1.

Lacan, J. (1977) *Ecrits: A Selection,* trans. A. Sheridan, London: Tavistock, pp. 146–78.

Derrida, J. (1976) *Of Grammatology*, trans. G.C. Spivak, Baltimore: Johns Hopkins University Press, pp. 27–73.

Structuralism and semiotics

Gadet, F. (1989) *Saussure and Contemporary Culture*, trans. G. Elliott, London: Radius, Part 2, chapters 3–5.

Lepschy, G.C. (1970) *A Survey of Structural Linguistics*, London: Faber and Faber.

—— (1975) 'European Structuralism: Post-Saussurean Schools', in *Current Trends in Linguistics*, ed. T.A. Sebeok, Vol. 13: *Historiography of Linguistics*, The Hague: Mouton, pp. 887–902.

Hawkes, T. (1977) *Structuralism and Semiotics*, London: Methuen, chapters 2 and 4.

Silverman, K. (1983) *The Subject of Semiotics*, New York: Oxford University Press, chapter 1.

Belsey, C. (1980) *Critical Practice*, London: Methuen, chapter 2.

Coward, R. and J. Ellis (1977) *Language and Materialism: Developments in Semiology and the Theory of the Subject*, London: Routledge & Kegan Paul, chapters 1–3 and 7.

Culler, J. (1973) 'The Linguistic Basis of Structuralism', in D. Robey (ed.) *Structuralism: An Introduction*, Oxford: Clarendon Press, pp. 20–36.

Lyons, J. (1973) 'Structuralism and Linguistics', in D. Robey (ed.) S*tructuralism: An Introduction*, Oxford: Clarendon Press, pp. 5–19.

Jameson, F. (1972) *The Prison-House of Language: A Critical Account of Structuralism and Russian Formalism*, Princeton: Princeton University Press, pp. 3–39.

Croce

Croce, B. (1966) 'The Philosophy of Language', in *Philosophy, Poetry, History: An Anthology of Essays*, trans. C. Sprigge, London: Oxford University Press, pp. 248–60.

—— (1922) *Aesthetic as Science of Expression and General Linguistic*, 2nd edn, trans. D. Ainslie, London: Macmillan, pp. 324–33.

Orsini, G.N.G. (1961) *Benedetto Croce: Philosopher of Art and Literary Critic*, Carbondale, ILL: Southern Illinois University Press, pp. 68–80.

Iordan, I. (1937) *An Introduction to Romance Linguistics, its Schools and Scholars*, rev. and trans. J. Orr, London: Methuen, pp. 115–20.

Leroy, M. (1967) *The Main Trends in Modern Linguistics,* trans. G. Price, Oxford: Basil Blackwell, pp. 100–6.

Mayo, B. (1955) 'Art, Language and Philosophy in Croce', *Philosophical Quarterly* 5, pp. 245–60.

Hall Jr, R.A. (1947) 'Benedetto Croce and "Idealistic Linguistics"', *Studies in Linguistics* 6, pp. 24–35.

—— (1963) *Idealism in Romance Linguistics,* Ithaca, NY: Cornell University Press, pp. 21–36.

Sheppard, A. (1987) *Aesthetics: An Introduction to the Philosophy of Art,* Oxford: Oxford University Press, chapter 3.

Wimsatt, W.K. and C. Brooks (1957) *Literary Criticism: A Short History,* London: Routledge & Kegan Paul, chapter 23.

Roberts, D.D. (1987) *Benedetto Croce and the Uses of Historicism,* Berkeley: University of California Press, pp. 46–9, 62–76.

Idealism and language

Christmann, H.H. (1981) 'Idealism', in R. Posner and J.N. Green (eds) *Trends in Romance Linguistics and Philology, Volume 2: Synchronic Romance Linguistics,* The Hague: Mouton, pp. 259–83.

Iordan, I. (1937) *An Introduction to Romance Linguistics, its Schools and Scholars,* rev. and trans. J. Orr, London: Methuen, chapter 2.

Albrecht, J. (1994) 'Neolinguistic School in Italy', in R.E. Asher and J.M.Y. Simpson (eds), *The Encyclopedia of Language and Linguistics,* 10 vols, Oxford and New York: Pergamon Press, vol. 5, pp. 2774–77.

Voloshinov, V.N. (1986) *Marxism and the Philosophy of Language,* trans. L. Matejka and I.R. Titunik, Cambridge, MA: Harvard University Press, pp. 47–52, 83–98.

Hall Jr, R.A. (1963) *Idealism in Romance Linguistics,* Ithaca, NY: Cornell University Press, pp. 47–71.

—— (1946) 'Bartoli's "Neolinguistica"', *Language* 22, pp. 273–83.

Bonfante, G. (1947) 'The Neolinguistic Position', *Language* 23, pp. 344–75.

Leroy, M. (1967), *The Main Trends in Modern Linguistics,* trans. G. Price, Oxford: Basil Blackwell, pp. 100–11.

Ivic, M. (1965) *Trends in Linguistics,* trans. M. Heppel, The Hague: Mouton, pp. 89–97.

Malmberg, B. (1964) *New Trends in Linguistics: An Orientation,* trans. E. Carney, Stockholm: Lund, pp. 69–73.

Voloshinov

Voloshinov, V.N. (1986) *Marxism and the Philosophy of Language,* trans. L. Matejka and I.R. Titunik, Cambridge, MA: Harvard University Press, Parts 1 and 2.

—— (1983) 'Literary Stylistics', trans. N. Owen and J. Andrew, in A. Shukman (ed.) *Bakhtin School Papers,* Oxford: RPT Publications, pp. 93–152.

Bakhtin, M.M. (1981) *The Dialogic Imagination: Four Essays,* ed. M. Holquist, trans. C. Emerson and M. Holquist, Austin: University of Texas Press.

Dentith, S. (1995) *Bakhtinian Thought: An Introductory Reader,* London: Routledge, pp. 22–40.

Bennett, T. (1979) *Formalism and Marxism,* London: Methuen, pp. 75–82.

Williams, R. (1977) *Marxism and Literature,* Oxford: Oxford University Press, pp. 35–42.

Jameson, F. (1974) 'Review of Marxism and the Philosophy of Language by V.N. Voloshinov', *Style* 8(3), pp. 535–43.

Holquist, M. (1990) *Dialogism: Bakhtin and his World*, London: Routledge, pp. 40–51.

Matejka, L. (1986) 'On the First Russian Prolegomena to Semiotics', in V.N. Voloshinov, *Marxism and the Philosophy of Language*, trans. L. Matejka and I.R. Titunik, Cambridge, MA: Harvard University Press, pp. 161–74.

Thibault, P.J. (1997) *Re-reading Saussure: The Dynamics of Signs in Social Life*, London: Routledge, pp. 251–54.

Ferdinand de Saussure

THE NATURE OF THE LINGUISTIC SIGN (1916)

The object of linguistics

1. Definition of language

What is both the integral and concrete object of linguistics? The question is especially difficult; later we shall see why; here I wish merely to point up the difficulty.

Other sciences work with objects that are given in advance and that can then be considered from different viewpoints; but not linguistics. Someone pronounces the French word *nu* "bare": a superficial observer would be tempted to call the word a concrete linguistic object; but a more careful examination would reveal successively three or four quite different things, depending on whether the word is considered as a sound, as the expression of an idea, as the equivalent of Latin *nudum*, etc. Far from it being the object that antedates the viewpoint, it would seem that it is the viewpoint that creates the object; besides, nothing tells us in advance that one way of considering the fact in question takes precedence over the others or is in any way superior to them.

Moreover, regardless of the viewpoint that we adopt, the linguistic phenomenon always has two related sides, each deriving its values from the other. For example:

1 Articulated syllables are acoustical impressions perceived by the ear, but the sounds would not exist without the vocal organs; an *n*, for example, exists only by virtue of the relation between the two sides. We simply cannot reduce language to sound or detach sound from oral articulation; reciprocally, we cannot define the movements of the vocal organs without taking into account the acoustical impression.

2 But suppose that sound were a simple thing: would it constitute speech?

No, it is only the instrument of thought; by itself, it has no existence. At this point a new and redoubtable relationship arises: a sound, a complex acoustical-vocal unit, combines in turn with an idea to form a complex physiological-psychological unit. But that is still not the complete picture.

3 Speech has both an individual and a social side, and we cannot conceive of one without the other. Besides:

4 Speech always implies both an established system and an evolution; at every moment it is an existing institution and a product of the past. To distinguish between the system and its history, between what it is and what it was, seems very simple at first glance; actually the two things are so closely related that we can scarcely keep them apart.[. . .]

From whatever direction we approach the question, nowhere do we find the integral object of linguistics. Everywhere we are confronted with a dilemma: if we fix our attention on only one side of each problem, we run the risk of failing to perceive the dualities pointed out above; on the other hand, if we study speech from several viewpoints simultaneously, the object of linguistics appears to us as a confused mass of heterogeneous and unrelated things. Either procedure opens the door to several sciences – psychology, anthropology, normative grammar, philology, etc. – which are distinct from linguistics, but which might claim speech, in view of the faulty method of linguistics, as one of their objects.

As I see it there is only one solution to all the foregoing difficulties: *from the very outset we must put both feet on the ground of language and use language as the norm of all other manifestations of speech.* Actually, among so many dualities, language alone seems to lend itself to independent definition and provide a fulcrum that satisfies the mind.

But what is language [*langue*]? It is not to be confused with human speech [*langage*], of which it is only a definite part, though certainly an essential one. It is both a social product of the faculty of speech and a collection of necessary conventions that have been adopted by a social body to permit individuals to exercise that faculty. Taken as a whole, speech is many-sided and heterogeneous; straddling several areas simultaneously – physical, physiological, and psychological – it belongs both to the individual and to society; we cannot put it into any category of human facts, for we cannot discover its unity.

Language, on the contrary, is a self-contained whole and a principle of classification. As soon as we give language first place among the facts of speech, we introduce a natural order into a mass that lends itself to no other classification.

[. . .]

2. Place of language in the facts of speech

In order to separate from the whole of speech the part that belongs to language, we must examine the individual act from which the speaking-circuit can be reconstructed. The act requires the presence of at least two persons; that is the minimum number necessary to complete the circuit. Suppose that two people, A and B, are conversing with each other:

Suppose that the opening of the circuit is in A's brain, where mental facts (concepts) are associated with representations of the linguistic sounds (sound-images) that are used for their expression. A given concept unlocks a corresponding sound-image in the brain; this purely *psychological* phenomenon is followed in turn by a *physiological* process: the brain transmits an impulse corresponding to the image to the organs used in producing sounds. Then the sound waves travel from the mouth of A to the ear of B: a purely *physical* process. Next, the circuit continues in B, but the order is reversed: from the ear to the brain, the physiological transmission of the sound-image; in the brain, the psychological association of the image with the corresponding concept. If B then speaks, the new act will follow – from his brain to A's – exactly the same course as the first act and pass through the same successive phases.

[. . .]

Among all the individuals that are linked together by speech, some sort of average will be set up: all will reproduce – not exactly of course, but approximately – the same signs united with the same concepts.

How does the social crystallization of language come about? Which parts of the circuit are involved? For all parts probably do not participate equally in it.

The nonpsychological part can be rejected from the outset. When we hear people speaking a language that we do not know, we perceive the sounds but remain outside the social fact because we do not understand them.

Neither is the psychological part of the circuit wholly responsible: the executive side is missing, for execution is never carried out by the collectivity. Execution is always individual, and the individual is always its master: I shall call the executive side *speaking* (*parole*).

Through the functioning of the receptive and co-ordinating faculties, impressions that are perceptibly the same for all are made on the minds of speakers. How can that social product be pictured in such a way that language will stand apart from everything else? If we could embrace the sum of word-images stored in the minds of all individuals, we could identify the social bond that constitutes language. It is a storehouse filled by the members of a given community through their active use of speaking, a grammatical system that has a potential existence in each brain, or, more specifically, in the brains of a group of individuals. For language is not complete in any speaker; it exists perfectly only within a collectivity.

In separating language from speaking we are at the same time separating: (1) what is social from what is individual; and (2) what is essential from what is accessory and more or less accidental.

Language is not a function of the speaker; it is a product that is passively assimilated by the individual. It never requires premeditation, and reflection enters in only for the purpose of classification. [. . .]

Speaking, on the contrary, is an individual act. It is wilful and intellectual. Within the act, we should distinguish between: (1) the combinations by which the speaker uses the language code for expressing his own thought; and (2) the psychophysical mechanism that allows him to exteriorize those combinations.[. . .]

To summarize, these are the characteristics of language:

1 Language is a well-defined object in the heterogeneous mass of speech facts. It can be localized in the limited segment of the speaking-circuit where an auditory image becomes associated with a concept. It is the social side of speech, outside the individual who can never create nor modify it by himself; it exists only by virtue of a sort of contract signed by the members of a community. Moreover, the individual must always serve an apprenticeship in order to learn the functioning of language; a child assimilates it only gradually. It is such a distinct thing that a man deprived of the use of speaking retains it provided that he understands the vocal signs that he hears.

2 Language, unlike speaking, is something that we can study separately. Although dead languages are no longer spoken, we can easily assimilate their linguistic organisms. We can dispense with the other elements of speech; indeed, the science of language is possible only if the other elements are excluded.

3 Whereas speech is heterogeneous, language, as defined, is homogeneous. It is a system of signs in which the only essential thing is the union of meanings and sound-images, and in which both parts of the sign are psychological.

4 Language is concrete, no less so than speaking; and this is a help in our study of it. Linguistic signs, though basically psychological, are not abstractions; associations which bear the stamp of collective approval – and which added together constitute language – are realities that have their seat in the brain.

[. . .]

3. Linguistics of language and linguistics of speaking

The study of speech is then twofold: its basic part – having as its object language, which is purely social and independent of the individual – is exclusively psychological; its secondary part – which has as its object the individual side of speech, i.e. speaking, including phonation – is psychophysical.

Doubtless the two objects are closely connected, each depending on the other; language is necessary if speaking is to be intelligible and produce all its effects; but speaking is necessary for the establishment of language, and historically its actuality always comes first. How would a speaker take it upon himself to associate an idea with a word-image if he had not first come across the association in an act of speaking? Moreover, we learn our mother language by listening to others; only after countless experiences is it deposited in our brains. Finally, speaking is what causes language to evolve: impressions gathered from listening to others modify

our linguistic habits. Language and speaking are then interdependent; the former is both the instrument and the product of the latter. But their interdependence does not prevent their being two absolutely distinct things.

Language exists in the form of a sum of impressions deposited in the brain of each member of a community, almost like a dictionary of which identical copies have been distributed to each individual. Language exists in each individual, yet is common to all. Nor is it affected by the will of the depositaries. Its mode of existence is expressed by the formula:

$$1 + 1 + 1 + 1 \ldots = I \text{ (collective pattern)}$$

What part does speaking play in the same community? It is the sum of what people say and includes: a) individual combinations that depend on the will of speakers, and b) equally wilful phonational acts that are necessary for the execution of these combinations.

Speaking is thus not a collective instrument; its manifestations are individual and momentary. In speaking there is only the sum of particular acts, as in the formula:

$$(1 + 1' + 1'' + 1''' \ldots)$$

For all the foregoing reasons, to consider language and speaking from the same viewpoint would be fanciful. Taken as a whole, speech cannot be studied, for it is not homogeneous; but the distinction and subordination proposed here clarify the whole issue.

Such is the first bifurcation that we find in trying to formulate the theory of speech. We must choose between two routes that cannot be followed simultaneously; they must be followed separately. [...]

Nature of the linguistic sign

1. Sign, signified, signifier

Some people regard language, when reduced to its elements, as a naming-process only – a list of words, each corresponding to the thing that it names. For example:

ARBOR

EQUUS

etc. etc.

This conception is open to criticism at several points. It assumes that ready-made ideas exist before words (on this point, see below, p. 105), it does not tell us whether a name is vocal or psychological in nature (*arbor*, for instance, can be considered from either viewpoint); finally, it lets us assume that the linking of a name and a thing is a very simple operation – an assumption that is anything but true. But this rather naive approach can bring us near the truth by showing us that the linguistic unit is a double entity, one formed by the association of two terms.

We have seen in considering the speaking-circuit (see p. 23) that both terms involved in the linguistic sign are psychological and are united in the brain by an associative bond. This point must be emphasized.

The linguistic sign unites, not a thing and a name, but a concept and a sound-image.[1] The latter is not the material sound, a purely physical thing, but the psychological imprint of the sound, the impression that it makes on our senses. The sound-image is sensory, and if I happen to call it "material," it is only in that sense, and by way of opposing it to the other term of the association, the concept, which is generally more abstract. [...]

The linguistic sign is then a two-sided psychological entity that can be represented by the drawing:

The two elements are intimately united, and each recalls the other. Whether we try to find the meaning of the Latin word *arbor* or the word that Latin uses to designate the concept "tree," it is clear that only the associations sanctioned by that language appear to us to conform to reality, and we disregard whatever others might be imagined.

Our definition of the linguistic sign poses an important question of terminology. I call the combination of a concept and a sound-image a *sign*, but in current usage the term generally designates only a sound-image, a word, for example (*arbor*, etc.). One tends to forget that *arbor* is called a sign only because it carries the concept "tree", with the result that the idea of the sensory part implies the idea of the whole.

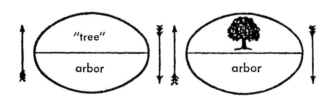

Ambiguity would disappear if the three notions involved here were designated by three names, each suggesting and opposing the others. I propose to retain the word *sign* [*signe*] to designate the whole and to replace *concept* and

sound-image respectively by *signified* [*signifié*] and *signifier* [*signifiant*]; the last two terms have the advantage of indicating the opposition that separates them from each other and from the whole of which they are parts. As regards *sign*, if I am satisfied with it, this is simply because I do not know of any word to replace it, the ordinary language suggesting no other.

The linguistic sign, as defined, has two primordial characteristics. In enunciating them I am also positing the basic principles of any study of this type.

2. Principle I: The arbitrary nature of the sign

The bond between the signifier and the signified is arbitrary. Since I mean by sign the whole that results from the associating of the signifier with the signified, I can simply say: *the linguistic sign is arbitrary*.

The idea of "sister" is not linked by any inner relationship to the succession of sounds *s-ö-r* which serves as its signifier in French; that it could be represented equally by just about any other sequence is proved by differences among languages and by the very existence of different languages: the signified "ox" has as its signifier *b-ö-f* on one side of the border and *o-k-s* (*Ochs*) on the other.

No one disputes the principle of the arbitrary nature of the sign, but it is often easier to discover a truth than to assign to it its proper place. Principle I dominates all the linguistics of language; its consequences are numberless. It is true that not all of them are equally obvious at first glance; only after many detours does one discover them, and with them the primordial importance of the principle. [. . .]

The word *symbol* has been used to designate the linguistic sign, or more specifically, what is here called the signifier. Principle I in particular weighs against the use of this term. One characteristic of the symbol is that it is never wholly arbitrary; it is not empty, for there is the rudiment of a natural bond between the signifier and the signified. The symbol of justice, a pair of scales, could not be replaced by just any other symbol, such as a chariot.

The word *arbitrary* also calls for comment. The term should not imply that the choice of the signifier is left entirely to the speaker (we shall see below that the individual does not have the power to change a sign in any way once it has become established in the linguistic community); I mean that it is unmotivated, i.e. arbitrary in that it actually has no natural connection with the signified.

[. . .]

3. Principle II: The linear nature of the signifier

The signifier, being auditory, is unfolded solely in time from which it gets the following characteristics: (a) it represents a span, and (b) the span is measurable in a single dimension; it is a line.

While Principle II is obvious, apparently linguists have always neglected to state it, doubtless because they found it too simple; nevertheless, it is fundamental, and its consequences are incalculable. Its importance equals that of Principle I; the whole mechanism of language depends upon it. In contrast to visual signifiers (nautical signals, etc.) which can offer simultaneous groupings in

several dimensions, auditory signifiers have at their command only the dimensions of time. Their elements are presented in succession; they form a chain. This feature becomes readily apparent when they are represented in writing and the spatial line of graphic marks is substituted for succession in time. [. . .]

Immutability and mutability of the sign

1. Immutability

The signifier, though to all appearances freely chosen with respect to the idea that it represents, is fixed, not free, with respect to the linguistic community that uses it. The masses have no voice in the matter, and the signifier chosen by language could be replaced by no other. This fact, which seems to embody a contradiction, might be called colloquially "the stacked deck." We say to language: "Choose!" but we add: "It must be this sign and no other." No individual, even if he willed it, could modify in any way at all the choice that has been made; and what is more, the community itself cannot control so much as a single word; it is bound to the existing language.

No longer can language be identified with a contract pure and simple, and it is precisely from this viewpoint that the linguistic sign is a particularly interesting object of study; for language furnishes the best proof that a law accepted by a community is a thing that is tolerated and not a rule to which all freely consent.

Let us first see why we cannot control the linguistic sign and then draw together the important consequences that issue from the phenomenon.

No matter what period we choose or how far back we go, language always appears as a heritage of the preceding period. We might conceive of an act by which, at a given moment, names were assigned to things and a contract was formed between concepts and sound-images; but such an act has never been recorded. The notion that things might have happened like that was prompted by our acute awareness of the arbitrary nature of the sign.

No society, in fact, knows or has ever known language other than as a product inherited from preceding generations, and one to be accepted as such. That is why the question of the origin of speech is not so important as it is generally assumed to be. The question is not even worth asking; the only real object of linguistics is the normal, regular life of an existing idiom. A particular language-state is always the product of historical forces, and these forces explain why the sign is unchangeable, i.e. why it resists any arbitrary substitution.

Nothing is explained by saying that language is something inherited and leaving it at that. Can not existing and inherited laws be modified from one moment to the next?

To meet that objection, we must put language into its social setting and frame the question just as we would for any other social institution. How are other social institutions transmitted? This more general question includes the question of immutability. We must first determine the greater or lesser amounts of freedom that the other institutions enjoy; in each instance it will be seen that a different proportion exists between fixed tradition and the free action of society.

The next step is to discover why in a given category, the forces of the first type carry more weight or less weight than those of the second. Finally, coming back to language, we must ask why the historical factor of transmission dominates it entirely and prohibits any sudden widespread change.

There are many possible answers to the question. For example, one might point to the fact that succeeding generations are not superimposed on one another like the drawers of a piece of furniture, but fuse and interpenetrate, each generation embracing individuals of all ages – with the result that modifications of language are not tied to the succession of generations. One might also recall the sum of the efforts required for learning the mother language and conclude that a general change would be impossible. Again, it might be added that reflection does not enter into the active use of an idiom – speakers are largely unconscious of the laws of language; and if they are unaware of them, how could they modify them? Even if they were aware of these laws, we may be sure that their awareness would seldom lead to criticism, for people are generally satisfied with the language they have received.

The foregoing considerations are important but not topical. The following are more basic and direct, and all the others depend on them.

1 *The arbitrary nature of the sign.* Above, we had to accept the theoretical possibility of change; further reflection suggests that the arbitrary nature of the sign is really what protects language from any attempt to modify it. Even if people were more conscious of language than they are, they would still not know how to discuss it. The reason is simply that any subject, in order to be discussed, must have a reasonable basis. It is possible, for instance, to discuss whether the monogamous form of marriage is more reasonable than the polygamous form and to advance arguments to support either side. One could also argue about a system of symbols, for the symbol has a rational relationship with the thing signified; but language is a system of arbitrary signs and lacks the necessary basis, the solid ground for discussion. There is no reason for preferring *soeur* to *sister*, *Ochs* to *boeuf*, etc.

2 *The multiplicity of signs necessary to form any language.* Another important deterrent to linguistic change is the great number of signs that must go into the making of any language. A system of writing comprising twenty to forty letters can in case of need be replaced by another system. The same would be true of language if it contained a limited number of elements; but linguistic signs are numberless.

3 *The over-complexity of the system.* A language constitutes a system. In this one respect (as we shall see later) language is not completely arbitrary but is ruled to some extent by logic; it is here also, however, that the inability of the masses to transform it becomes apparent. The system is a complex mechanism that can be grasped only through reflection; the very ones who use it daily are ignorant of it. We can conceive of a change only through the intervention of specialists, grammarians, logicians, etc.; but experience shows us that all such meddlings have failed.

4 *Collective inertia toward innovation.* Language – and this consideration surpasses all the others – is at every moment everybody's concern; spread

throughout society and manipulated by it, language is something used daily by all. Here we are unable to set up any comparison between it and other institutions. The prescriptions of codes, religious rites, nautical signals, etc., involve only a certain number of individuals simultaneously and then only during a limited period of time; in language, on the contrary, everyone participates at all times, and that is why it is constantly being influenced by all. This capital fact suffices to show the impossibility of revolution. Of all social institutions, language is least amenable to initiative. It blends with the life of society, and the latter, inert by nature, is a prime conservative force.

But to say that language is a product of social forces does not suffice to show clearly that it is unfree; remembering that it is always the heritage of the preceding period, we must add that these social forces are linked with time. Language is checked not only by the weight of the collectivity but also by time. These two are inseparable. At every moment solidarity with the past checks freedom of choice. We say *man* and *dog*. This does not prevent the existence in the total phenomenon of a bond between the two antithetical forces — arbitrary convention by virtue of which choice is free and time which causes choice to be fixed. Because the sign is arbitrary, it follows no law other than that of tradition, and because it is based on tradition, it is arbitrary.

2. Mutability

Time, which insures the continuity of language, wields another influence apparently contradictory to the first: the more or less rapid change of linguistic signs. In a certain sense, therefore, we can speak of both the immutability and the mutability of the sign.[2]

In the last analysis, the two facts are interdependent: the sign is exposed to alteration because it perpetuates itself. What predominates in all change is the persistence of the old substance; disregard for the past is only relative. That is why the principle of change is based on the principle of continuity.

Change in time takes many forms, on any one of which an important chapter in linguistics might be written. Without entering into detail, let us see what things need to be delineated.

First, let there be no mistake about the meaning that we attach to the word change. One might think that it deals especially with phonetic changes undergone by the signifier, or perhaps changes in meaning which affect the signified concept. That view would be inadequate. Regardless of what the forces of change are, whether in isolation or in combination, they always result in a *shift in the relationship between the signified and the signifier*. [. . .]

Language is radically powerless to defend itself against the forces which from one moment to the next are shifting the relationship between the signified and the signifier. This is one of the consequences of the arbitrary nature of the sign.

Unlike language, other human institutions — customs, laws, etc. — are all based in varying degrees on the natural relations of things; all have of necessity adapted the means employed to the ends pursued. Even fashion in dress is not entirely arbitrary; we can deviate only slightly from the conditions dictated by

the human body. Language is limited by nothing in the choice of means, for apparently nothing would prevent the associating of any idea whatsoever with just any sequence of sounds.

To emphasize the fact that language is a genuine institution, Whitney quite justly insisted upon the arbitrary nature of signs; and by so doing, he placed linguistics on its true axis. But he did not follow through and see that the arbitrariness of language radically separates it from all other institutions. This is apparent from the way in which language evolves. Nothing could be more complex. As it is a product of both the social force and time, no one can change anything in it, and on the other hand, the arbitrariness of its signs theoretically entails the freedom of establishing just any relationship between phonetic substance and ideas. The result is that each of the two elements united in the sign maintains its own life to a degree unknown elsewhere, and that language changes, or rather evolves, under the influence of all the forces which can affect either sounds or meanings. The evolution is inevitable; there is no example of a single language that resists it. After a certain period of time, some obvious shifts can always be recorded.

Mutability is so inescapable that it even holds true for artificial languages. Whoever creates a language controls it only so long as it is not in circulation; from the moment when it fulfills its mission and becomes the property of everyone, control is lost. Take Esperanto as an example; if it succeeds, will it escape the inexorable law? Once launched, it is quite likely that Esperanto will enter upon a fully semiological life; it will be transmitted according to laws which have nothing in common with those of its logical creation, and there will be no turning backwards. A man proposing a fixed language that posterity would have to accept for what it is would be like a hen hatching a duck's egg: the language created by him would be borne along, willy-nilly, by the current that engulfs all languages.

Signs are governed by a principle of general semiology: continuity in time is coupled to change in time; this is confirmed by orthographic systems, the speech of deaf-mutes, etc.

But what supports the necessity for change? I might be reproached for not having been as explicit on this point as on the principle of immutability. This is because I failed to distinguish between the different forces of change. We must consider their great variety in order to understand the extent to which they are necessary.

The causes of continuity are *a priori* within the scope of the observer, but the causes of change in time are not. It is better not to attempt giving an exact account at this point, but to restrict discussion to the shifting of relationships in general. Time changes all things; there is no reason why language should escape this universal law.[. . .]

Notes

1 The term sound-image may seem to be too restricted inasmuch as beside the representation of the sounds of a word there is also that of its articulation, the

muscular image of the phonational act. But for F. de Saussure language is essentially a depository, a thing received from without. The sound-image is par excellence the natural representation of the word as a fact of potential language, outside any actual use of it in speaking. The motor side is thus implied or, in any event, occupies only a subordinate role with respect to the sound-image. [Ed.]

2 It would be wrong to reproach F. de Saussure for being illogical or paradoxical in attributing two contradictory qualities to language. By opposing two striking terms, he wanted only to emphasize the fact that language changes in spite of the inability of speakers to change it. One can also say that it is intangible but not unchangeable. [Ed.]

Benedetto Croce

THE IDENTITY OF LINGUISTIC AND AESTHETIC (1902)

[...] But although Æsthetic as science of expression has been studied by us in its every aspect, it remains to justify the sub-title which we have added to the title of our book, *General Linguistic*, to state and make clear the thesis that the science of art and that of language, Æsthetic and Linguistic, conceived as true sciences, are not two distinct things, but one thing only. Not that there is a special Linguistic; but the much-sought-for science of language, general Linguistic, *in so far as what it contains is reducible to philosophy*, is nothing but Æsthetic. Whoever studies general Linguistic, that is to say, philosophical Linguistic, studies æsthetic problems and *vice versa*. *Philosophy of language and philosophy of art are the same thing.*

Were Linguistic really a *different* science from Æsthetic it would not have for its object expression, which is the essentially æsthetic fact; that is to say, we must deny that language is expression. But an emission of sounds which expresses nothing is not language. Language is sound articulated, circumscribed and organized for the purposes of expression. If, on the other hand, Linguistic were a *special* science in respect to Æsthetic, it would necessarily have for its object a *special class* of expressions. But the non-existence of classes of expression is a point which we have already demonstrated.

The problems which Linguistic tries to solve, and the errors in which Linguistic has been and is involved, are the same that respectively occupy and complicate Æsthetic. If it be not always easy, it is on the other hand always possible to reduce the philosophic questions of Linguistic to their æsthetic formula.

The disputes themselves as to the nature of the one find their parallel in those as to the nature of the other. Thus it has been disputed whether Linguistic be a historical or a scientific discipline, and, the scientific having been distinguished from the historical, it has been asked whether it belong to the order of the natural or of the psychological sciences, understanding by these latter empirical

Psychology as well as the Sciences of the spirit. The same has happened with Æsthetic, which some have looked upon as a natural science (confusing the æsthetic and the physical sense of the word expression). Others have looked upon it as a psychological science (confusing expression in its universality with the empirical classification of expressions). Others again, denying the very possibility of a science of such a subject, change it into a simple collection of historical facts; not one of these attaining to the consciousness of Æsthetic as a science of activity or of value, a science of the spirit.

Linguistic expression, or speech, has often seemed to be a fact of *interjection*, which belongs to the so-called physical expressions of the feelings, common alike to men and animals. But it was soon perceived that an abyss yawns between the "Ah!" which is a physical reflex of pain and a word; as also between that "Ah!" of pain and the "Ah!" employed as a word. The theory of the interjection being abandoned (jocosely termed the "Ah! Ah!" theory by German linguists), the theory of *association* or *convention* appeared. This is liable to the same objection which destroyed æsthetic associationism in general; speech is unity, not multiplicity of images, and multiplicity does not explain, but indeed presupposes the expression to be explained. A variant of linguistic associationism is the imitative, that is to say, the theory of *onomatopœia*, which the same philologists deride under the name of the "bow-wow" theory, from the imitation of the dog's bark, which, according to the onomatopœists, must have given its name to the dog.

The most usual theory of our times as regards language (apart from mere crass naturalism) consists of a sort of eclecticism or mixture of the various theories to which we have referred. It is assumed that language is in part the product of interjections and in part of onomatopœia and convention. This doctrine is altogether worthy of the philosophical decadence of the second half of the nineteenth century.

We must here note an error into which have fallen those very philologists who have best discerned the activistic nature of language, when they maintain that although language was *originally a spiritual creation*, yet that it afterwards increased by *association*. But the distinction does not hold, for origin in this case cannot mean anything but nature or character; and if language be spiritual creation, it must always be creation; if it be association, it must have been so from the beginning. The error has arisen from having failed to grasp the general principle of Æsthetic, known to us: that expressions already produced must descend to the rank of impressions before they can give rise to new impressions. When we utter new words we generally transform the old ones, varying or enlarging their meaning; but this process is not associative, it is *creative*, although the creation has for material the impressions, not of the hypothetical primitive man, but of man who has lived long ages in society, and who has, so to say, stored so many things in his psychic organism, and among them so much language.

The question of the distinction between the æsthetic and the intellectual fact appears in Linguistic as that of the relations between Grammar and Logic. This problem has been solved in two partially true ways: the *inseparability* and the *separability* of Logic and Grammar. But the complete solution is this: if the logical form be inseparable from the grammatical (æsthetic), the grammatical is separable from the logical.

If we look at a picture which for instance portrays a man walking on a country road we may say: "This picture represents a fact of *movement*, which, if conceived as voluntary, is called *action*; and since every movement implies a *material object*, and every action a *being* that acts, this picture also represents a *material object* or *being*. But this movement takes place in a definite place, which is a piece of a definite heavenly body (the Earth), and precisely of a piece of it which is called *terra-firma*, and more precisely of a part of it that is wooded and covered with grass, which is called *country*, cut naturally or artificially into a form called *road*. Now, there is only one example of that star, which is called Earth: the earth is an *individual*. But *terra-firma, country, road* are genera or *universals*, because there are other terra-firmas, other countries, other roads." And it would be possible to continue for a while with similar considerations. By substituting a phrase for the picture that we have imagined, for example one to this effect: "Peter is walking on a country road," and by making the same remarks, we obtain the concepts of *verb* (motion or action), of *noun* (material object or agent), of *proper noun, of common noun*; and so on.

What have we done in both cases? Neither more nor less than submit to logical elaboration what first presented itself only æsthetically; that is to say, we have destroyed the æsthetic for the logical. But since in general Æsthetic error begins when we wish to return from the logical to the æsthetic and ask what is the *expression* of motion, action, matter, being, of the general, of the individual, etc.; so in the case of language, error begins when motion or action are called *verb*, being or matter, *noun* or *substantive*, and when linguistic categories, or *parts of speech*, are made of all these, noun and verb and so on. The theory of the parts of speech is really identical with that of artistic and literary kinds already criticized in our Æsthetic.

It is false to say that the verb or noun is expressed in definite words, truly distinguishable from others. Expression is an indivisible whole. Noun and verb do not exist in it, but are abstractions made by us, destroying the sole linguistic reality, which is the *sentence*. This last is to be understood, not in the way common to grammars, but as an organism expressive of a complete meaning which includes alike the simplest exclamation and a great poem. This sounds paradoxical, but is nevertheless the simplest truth.

And since in Æsthetic the artistic productions of certain peoples have been looked upon as imperfect, owing to the error above mentioned, because the supposed kinds have seemed not yet to have been discriminated, or to be in part wanting; so in Linguistic, the theory of the parts of speech has caused the analogous error of judging languages as *formed* and *unformed*, according to whether there appear in them or no some of those supposed parts of speech, for example, the verb.

Linguistic also discovered the irreducible individuality of the æsthetic fact, when it affirmed that the word is what is really spoken, and that two truly identical words do not exist. Thus were synonyms and homonyms destroyed, and thus was shown the impossibility of really translating one word into another, from so-called dialect into so-called language, or from the so-called mother tongue into the so-called foreign tongue.

But the attempt to classify languages ill agrees with this just view. Languages

have no reality beyond the propositions and complexes of propositions really written and pronounced by given peoples at definite periods; that is to say, they have no existence outside the works of art (whether little or great, oral or written, soon forgotten or long remembered, does not matter) in which they exist concretely. And what is the art of a given people but the whole of its artistic products? What is the character of an art (for example of Greek art or Provençal literature) but the whole physiognomy of those products? And how can such a question be answered, save by narrating in its particulars the history of the literature, that is to say, of the language in its actuality?

It may be thought that this argument, although possessing validity as against many of the usual classifications of languages, yet is without any as regards that queen of classifications, the historico-genealogical, that glory of comparative philology. And this it certainly is; but why? Precisely because that historico-genealogical method is not a mere classification. He who writes history does not classify, and the philologists themselves have hastened to say that languages which can be arranged in historical series (those whose series have hitherto been traced) are not distinct and separate species but a single whole of facts in the various phases of its development.

Language has sometimes been regarded as a voluntary or arbitrary act. But at others the impossibility of creating language artificially, by an act of will, has been clearly seen. "*Tu, Caesar, civitatem dare potes homini, verbo non potes*" was once said to a Roman Emperor. And the æsthetic (and therefore theoretic as opposed to practical) nature of expression supplies the method of discovering the scientific error which lies in the conception of a (normative) *Grammar*, establishing the rules of correct speech. Good sense has always rebelled against this error. An example of such rebellion is the "So much the worse for grammar" attributed to Monsieur de Voltaire. But the impossibility of a normative grammar is also recognized by those who teach it, when they confess that to write well cannot be learned by rules, that there are no rules without exceptions, and that the study of Grammar should be conducted practically, by reading and examples, which should form the literary taste. The scientific reason of this impossibility lies in the principle that we have demonstrated: that a technique of the theoretical amounts to a contradiction in terms. And what could a (normative) grammar be, but precisely a technique of linguistic expression, that is to say of a theoretic fact?

The case in which Grammar is understood merely as an empirical discipline, that is to say, as a collection of schemes useful for learning languages, without any claim whatever to philosophic truth, is quite different. Even the abstractions of the parts of speech are in this case both admissible and useful. And we must tolerate as merely didascalic many books entitled "Treatises of Linguistic," where we generally find a little of everything, from the description of the vocal apparatus and of the artificial machines (phonographs) which can imitate it, to summaries of the most important results obtained by Indo-European, Semitic, Coptic, Chinese, or other philologies; from philosophical generalizations as to the origin or nature of language, to advice on format, calligraphy and the arrangement of notes relating to philological work. But this mass of notions, here administered in a fragmentary and incomplete manner about language in its essence, about language as expression, resolves itself into notions of Æsthetic. Nothing exists

outside *Æsthetic*, which gives knowledge of the nature of language, and *empirical Grammar*, which is a pedagogic expedient, save the *History of languages* in their living reality, that is to say, the history of concrete literary productions, which is substantially identical with the *History of literature*.

The same error of taking the physical for the æsthetic, from which the search for the *elementary forms* of the beautiful originates, is made by those who go in search of *elementary linguistic facts*, decorating with that name the divisions of the longer series of physical sounds into shorter series. Syllables, vowels and consonants, and the series of syllables called words, all these elements of speech, which give no definite sense when taken alone, must be called not *facts of language*, but mere sounds, or rather sounds abstracted and classified physically.

Another error of the same sort is that of *roots*, to which the most distinguished philologists now accord but small value. Having confused physical with linguistic or expressive facts, and considering that the simple precedes the complex in the order of ideas, they necessarily ended by thinking that the smallest physical facts indicated the simplest linguistic facts. Hence the imaginary necessity that the most ancient primitive languages had a monosyllabic character, and that historical research must always lead to the discovery of monosyllabic roots. But (to follow up the imaginary hypothesis) the first expression that the first man conceived may have had not a phonetic but a mimetic physical reflex; may have been externalized not in a sound but in a gesture. And assuming that it was externalized in a sound, there is no reason to suppose that sound to have been monosyllabic rather than polysyllabic. Philologists readily blame their own ignorance and impotence, when they do not always succeed in reducing polysyllabism to monosyllabism, and rely upon the future to accomplish the reduction. But their faith is without foundation, and their blame of themselves is an act of humility arising from an erroneous presumption.

For the rest, the limits of syllables, as those of words, are altogether arbitrary, and distinguished somehow or other by empirical use. Primitive speech, or the speech of uneducated man, is a *continuum*, unaccompanied by any consciousness of divisions of the discourse into words or syllables, imaginary beings created by schools. No true law of Linguistic can be founded on such divisions. Proof of this is to be found in the confession of linguists, that there are no truly phonetic laws of the hiatus, of cacophony, of diæresis or synæresis, but merely laws of taste and convenience: that is to say, *æsthetic* laws. And what are laws of *words* which are not at the same time laws of *style*?

Finally, the search for a *model language*, or for a method of reducing linguistic usage to *unity*, arises from the superstition of a rationalistic measure of the beautiful, from that concept which we have called false æsthetic absoluteness. In Italy we call this the question of the *unity of the language*.

Language is perpetual creation. What has been linguistically expressed is not repeated, save by reproduction of what has already been produced. The ever-new impressions give rise to continuous changes of sound and meaning, that is, to ever-new expressions. To seek the model language, then, is to seek the immobility of motion. Everyone speaks and should speak according to the echoes which things arouse in his soul, that is, according to his impressions. It is not without reason that the most convinced supporter of any one of the solutions of the

problem of the unity of language (whether by adopting a standard Italian approximating to Latin, or to fourteenth-century usage, or to the Florentine dialect) feels repugnance in applying his theory, when he is speaking to communicate his thoughts and to make himself understood. The reason is that he feels that in substituting the Latin, fourteenth-century Italian, or Florentine word for that of different origin, but which answers to his natural impressions, he would be falsifying the genuine form of truth. He would become a vain listener to himself instead of a speaker, a pedant in place of a serious man, an actor instead of a sincere person. To write according to a theory is not really to write: at the most, it is making *literature*.

The question of the unity of language is always reappearing, because, stated as it is, it is insoluble, being based upon a false conception of what language is. Language is not an arsenal of arms already made, and it is not a *vocabulary*, a collection of abstractions, or a cemetery of corpses more or less well embalmed.

Our dismissal of the question of the model language, or of the unity of the language, may seem somewhat abrupt, and yet we would not wish to appear otherwise than respectful towards the long line of literary men who have debated this question in Italy for centuries. But those ardent debates were fundamentally concerned with debates of aestheticity, not of aesthetic science, of literature rather than of literary theory, of effective speaking and writing, not of linguistic science. Their error consisted in transforming the manifestation of a need into a scientific thesis, the desirability, for example, of easier mutual understanding among a people divided by dialects into the philosophic demand for a single, ideal language. Such a search was as absurd as that other search for a *universal language*, a language possessing the immobility of the concept and of abstraction. The social need for a better understanding of one another cannot be satisfied save by the spread of education becoming general, by the increase of communications, and by the interchange of thought among men.

These scattered observations must suffice to show that all the scientific problems of Linguistic are the same as those of Æsthetic, and that the truths and errors of the one are the truths and errors of the other. If Linguistic and Æsthetic appear to be two different sciences, this arises from the fact that people think of the former as grammar, or as a mixture between philosophy and grammar, that is, an arbitrary mnemonic schematism or a pedagogic medley, and not of a rational science and a pure philosophy of speaking. Grammar, or something not unconnected with grammar, also introduces into the mind the prejudice that the reality of language lies in isolated and combinable words, not in living discourse, in the expressive organisms, rationally indivisible.[. . .]

V.N. Voloshinov

MULTIACCENTUALITY AND THE SIGN (1929)

The study of ideologies and philosophy of language

Problems of the philosophy of language have in recent times acquired exceptional pertinence and importance for Marxism. Over a wide range of the most vital sectors in its scientific advance, the Marxist method bears directly upon these problems and cannot continue to move ahead productively without special provision for their investigation and solution.

First and foremost, the very foundations of a Marxist theory of ideologies – the bases for the studies of scientific knowledge, literature, religion, ethics, and so forth – are closely bound up with problems of the philosophy of language.

Any ideological product is not only itself a part of a reality (natural or social), just as is any physical body, any instrument of production, or any product for consumption, it also, in contradistinction to these other phenomena, reflects and refracts another reality outside itself. Everything ideological possesses *meaning*: it represents, depicts, or stands for something lying outside itself. In other words, it is a *sign*. *Without signs, there is no ideology*. A physical body equals itself, so to speak; it does not signify anything but wholly coincides with its particular, given nature. In this case there is no question of ideology.

However, any physical body may be perceived as an image; for instance, the image of natural inertia and necessity embodied in that particular thing. Any such artistic-symbolic image to which a particular physical object gives rise is already an ideological product. The physical object is converted into a sign. Without ceasing to be a part of material reality, such an object, to some degree, reflects and refracts another reality.

The same is true of any instrument of production. A tool by itself is devoid of any special meaning; it commands only some designated function – to serve this or that purpose in production. The tool serves that purpose as the

particular, given thing that it is, without reflecting or standing for anything else. However, a tool also may be converted into an ideological sign. Such, for instance, is the hammer and sickle insignia of the Soviet Union. In this case, hammer and sickle possess a purely ideological meaning. [. . .]

Any consumer good can likewise be made an ideological sign. For instance, bread and wine become religious symbols in the Christian sacrament of communion. But the consumer good, as such, is not at all a sign. Consumer goods, just as tools, may be combined with ideological signs, but the distinct conceptual dividing line between them is not erased by the combination. Bread is made in some particular shape; this shape is not warranted solely by the bread's function as a consumer good; it also has a certain, if primitive, value as an ideological sign (e.g., bread in the shape of a figure eight (*krendel*) or a rosette).

Thus, side by side with the natural phenomena, with the equipment of technology, and with articles for consumption, there exists a special world – the *world of signs*.

Signs also are particular, material things; and, as we have seen, any item of nature, technology, or consumption can become a sign, acquiring in the process a meaning that goes beyond its given particularity. A sign does not simply exist as a part of a reality – it reflects and refracts another reality. Therefore, it may distort that reality or be true to it, or may perceive it from a special point of view, and so forth. Every sign is subject to the criteria of ideological evaluation (i.e. whether it is true, false, correct, fair, good, etc.). The domain of ideology coincides with the domain of signs. They equate with one another. Wherever a sign is present, ideology is present, too. *Everything ideological possesses semiotic value*.

Within the domain of signs – i.e., within the ideological sphere – profound differences exist: it is, after all, the domain of the artistic image, the religious symbol, the scientific formula, and the judicial ruling, etc. Each field of ideological creativity has its own kind of orientation toward reality and each refracts reality in its own way. Each field commands its own special function within the unity of social life. *But it is their semiotic character that places all ideological phenomena under the same general definition.*

Every ideological sign is not only a reflection, a shadow, of reality, but is also itself a material segment of that very reality. Every phenomenon functioning as an ideological sign has some kind of material embodiment, whether in sound, physical mass, color, movements of the body, or the like. In this sense, the reality of the sign is fully objective and lends itself to a unitary, monistic, objective method of study. A sign is a phenomenon of the external world. Both the sign itself and all the effects it produces (all those actions, reactions, and new signs it elicits in the surrounding social milieu) occur in outer experience. [. . .]

The idealistic philosophy of culture and psychologistic cultural studies locate ideology in the consciousness. Ideology, they assert, is a fact of consciousness; the external body of the sign is merely a coating, merely a technical means for the realization of the inner effect, which is understanding.

Idealism and psychologism alike overlook the fact that understanding itself can come about only within some kind of semiotic material (e.g., inner speech), that sign bears upon sign, that *consciousness itself can arise and become a viable fact*

only in the material embodiment of signs. The understanding of a sign is, after all, an act of reference between the sign apprehended and other, already known signs; in other words, understanding is a response to a sign with signs. And this chain of ideological creativity and understanding, moving from sign to sign and then to a new sign, is perfectly consistent and continuous: from one link of a semiotic nature (hence, also of a material nature) we proceed uninterruptedly to another link of exactly the same nature. And nowhere is there a break in the chain, nowhere does the chain plunge into inner being, nonmaterial in nature and unembodied in signs.

This ideological chain stretches from individual consciousness to individual consciousness, connecting them together. Signs emerge, after all, only in the process of interaction between one individual consciousness and another. And the individual consciousness itself is filled with signs. Consciousness becomes consciousness only once it has been filled with ideological (semiotic) content, consequently, only in the process of social interaction.

[...]

Signs can arise only on *interindividual territory*. It is territory that cannot be called "natural" in the direct sense of the word:[1] signs do not arise between any two members of the species *Homo sapiens*. It is essential that the two individuals be *organized socially*, that they compose a group (a social unit); only then can the medium of signs take shape between them. The individual consciousness not only cannot be used to explain anything, but, on the contrary, is itself in need of explanation from the vantage point of the social, ideological medium.

The individual consciousness is a social-ideological fact. Not until this point is recognized with due provision for all the consequences that follow from it will it be possible to construct either an objective psychology or an objective study of ideologies. [...]

The only possible objective definition of consciousness is a sociological one. Consciousness cannot be derived directly from nature, as has been and still is being attempted by naive mechanistic materialism and contemporary objective psychology (of the biological, behavioristic, and reflexological varieties). Ideology cannot be derived from consciousness, as is the practice of idealism and psychologistic positivism. Consciousness takes shape and being in the material of signs created by an organized group in the process of its social intercourse. The individual consciousness is nurtured on signs; it derives its growth from them; it reflects their logic and laws. The logic of consciousness is the logic of ideological communication, of the semiotic interaction of a social group. If we deprive consciousness of its semiotic, ideological content, it would have absolutely nothing left. Consciousness can harbor only in the image, the word, the meaningful gesture, and so forth. Outside such material, there remains the sheer physiological act unilluminated by consciousness, i.e., without having light shed on it, without having meaning given to it, by signs.

[...]

It is owing to this exclusive role of the word as the medium of consciousness that *the word functions as an essential ingredient accompanying all ideological*

creativity whatsoever. The word accompanies and comments on each and every ide-
ological act. The processes of understanding any ideological phenomenon at all
(be it a picture, a piece of music, a ritual, or an act of human conduct) cannot
operate without the participation of inner speech. All manifestations of ideolog-
ical creativity – all other nonverbal signs – are bathed by, suspended in, and can-
not be entirely segregated or divorced from the element of speech.

 This does not mean, of course, that the word may supplant any other ideo-
logical sign. None of the fundamental, specific ideological signs is replacable
wholly by words. It is ultimately impossible to convey a musical composition or
pictorial image adequately in words. Words cannot wholly substitute for a reli-
gious ritual. [. . .] Nonetheless, at the very same time, every single one of these
ideological signs, though not supplantable by words, has support in and is accom-
panied by words, just as is the case with singing and its musical accompaniment.

 No cultural sign, once taken in and given meaning, remains in isolation: it
becomes part of the *unity of the verbally constituted consciousness*. It is in the capac-
ity of the consciousness to find verbal access to it. Thus, as it were, spreading
ripples of verbal responses and resonances form around each and every ideolog-
ical sign. Every *ideological refraction of existence in process of generation*, no matter
what the nature of its significant material, *is accompanied by ideological refraction in
word* as an obligatory concominant phenomenon. Word is present in each and
every act of understanding and in each and every act of interpretation. [. . .]

Concerning the relationship of the basis and superstructures

The problem of the *relationship of basis and superstructures* – one of the fundamental
problems of Marxism – is closely linked with questions of philosophy of language
at a number of crucial points. [. . .]

 No cognitive value whatever adheres to the establishment of a connection
between the basis and some isolated fact torn from the unity and integrity of its
ideological context. It is essential above all to determine the *meaning of any, given
ideological change in the context of ideology appropriate to it*, seeing that every domain
of ideology is a unified whole which reacts with its entire constitution to a change
in the basis. Therefore, any explanation must preserve *all the qualitative differences*
between interacting domains and must trace all the various stages through which
a change travels. Only on this condition will analysis result, not in a mere out-
ward conjunction of two adventitious facts belonging to different levels of things,
but in the process of the actual dialectical generation of society, a process which
emerges from the basis and comes to completion in the superstructures. [...]

 The problem of the interrelationship of the basis and superstructures – a
problem of exceptional complexity, requiring enormous amounts of preliminary
data for its productive treatment – can be elucidated to a significant degree
through the material of the word.

 Looked at from the angle of our concerns, the essence of this problem comes
down to *how* actual existence (the basis) determines sign and *how* sign reflects and
refracts existence in its process of generation.

 The properties of the word as an ideological sign (properties discussed in the

preceding chapter) are what make the word the most suitable material for viewing the whole of this problem in basic terms. What is important about the word in this regard is not so much its sign purity as its *social ubiquity*. The word is implicated in literally each and every act or contact between people – in collaboration on the job, in ideological exchanges, in the chance contacts of ordinary life, in political relationships, and so on. Countless ideological threads running through all areas of social intercourse register effect in the word. It stands to reason, then, that the word is the most sensitive *index of social changes*, and what is more, of changes still in the process of growth, still without definitive shape and not as yet accomodated into already regularized and fully defined ideological systems. The word is the medium in which occur the slow quantitative accretions of those changes which have not yet achieved the status of a new ideological quality, not yet produced a new and fully-fledged ideological form. The word has the capacity to register all the transitory, delicate, momentary phases of social change. [. . .]

The transitional link between the sociopolitical order and ideology in the narrow sense (science, art, and the like), is, in its actual, material existence, *verbal interaction*. [. . .]

Production relations and the sociopolitical order shaped by those relations determine the full range of verbal contacts between people, all the forms and means of their verbal communication – at work, in political life, in ideological creativity. In turn, from the conditions, forms, and types of verbal communication derive not only the forms but also the themes of speech performances.

Social psychology is first and foremost an atmosphere made up of multifarious *speech performances* that engulf and wash over all persistent forms and kinds of ideological creativity: unofficial discussion, exchanges of opinion at the theatre or a concert or at various types of social gatherings, purely chance exchanges of words, one's manner of verbal reaction to happenings in one's life and daily existence, one's inner-word manner of identifying oneself and identifying one's position in society, and so on. Social psychology exists primarily in a wide variety of forms of the "utterance," of little *speech genres* of internal and external kinds – things left completely unstudied to the present day. All these speech performances, are of course, joined with other types of semiotic manifestation and interchange – with miming, gesturing, acting out, and the like.

All these forms of speech interchange operate in extremely close connection with the conditions of the social situation in which they occur and exhibit an extraordinary sensitivity to all fluctuations in the social atmosphere. And it is here, in the inner workings of this verbally materialized social psychology, that the barely noticeable shifts and changes that will later find expression in fully fledged ideological products accumulate.

From what has been said, it follows that social psychology must be studied from two different viewpoints: first, from the viewpoint of content, i.e., the themes pertinent to it at this or that moment in time; and second, from the viewpoint of the forms and types of verbal communication in which the themes in question are implemented (i.e., discussed, expressed, questioned, pondered over, etc.)

Up till now the study of social psychology has restricted its task to the first

viewpoint only, concerning itself exclusively with definition of its thematic makeup. Such being the case, the very question as to where documentation – the concrete expressions – of this social psychology could be sought was not posed with full clarity. Here, too, concepts of "consciousness," "psyche," and "inner life" played the sorry role of relieving one of the necessity to try to discover clearly delineated material forms of expression of social psychology.

Meanwhile, this issue of concrete forms has significance of the highest order. The point here has to do, of course, not with the sources of our knowledge about social psychology at some particular period (e.g., memoirs, letters, literary works), nor with the sources for our understanding of the "spirit of the age" – the point here has to do with the forms of concrete implementation of this spirit, that is, precisely with the very forms of semiotic communication in human behavior. [. . .]

Each period and each social group has had and has its own repertoire of speech forms for ideological communication in human behavior. Each set of cognate forms, i.e., each behavioral speech genre, has its own corresponding set of themes.

An interlocking organic unity joins the form of communication (for example, on-the-job communication of the strictly technical kind), the form of the utterance (the concise, businesslike statement) and its theme. Therefore, *classification of the forms of utterance must rely upon classification of the forms of verbal communication*. The latter are entirely determined by production relations and the sociopolitical order. Were we to apply a more detailed analysis, we would see what enormous significance belongs to the *hierarchical factor* in the processes of verbal interchange and what a powerful influence is exerted on forms of utterance by the hierarchical organization of communication. Language etiquette, speech tact, and other forms of adjusting an utterance to the hierarchical organization of society have tremendous importance in the process of devising the basic behavioral genres.[2]

Every sign, as we know, is a construct between socially organized persons in the process of their interaction. Therefore, *the forms of signs are conditioned above all by the social organization of the participants involved and also by the immediate conditions of their interaction*. When these forms change, so does sign. And it should be one of the tasks of the study of ideologies to trace this social life of the verbal sign. Only so approached can the *problem of the relationship between sign and existence* find its concrete expression; only then will the process of the causal shaping of the sign by existence stand out as a process of genuine existence-to-sign transit, of genuine dialectical refraction of existence in the sign.

To accomplish this task certain basic, methodological prerequisites must be respected:

1 *ideology may not be divorced from the material reality of sign* (i.e., by locating it in the "consciousness" or other vague and elusive regions);
2 *the sign may not be divorced from the concrete forms of social intercourse* (seeing that the sign is part of organized social intercourse and cannot exist, as such, outside it, reverting to a mere physical artifact);
3 *communication and the forms of communication may not be divorced from the material basis*.

Every ideological sign – the verbal sign included – in coming about through the process of social intercourse, is defined by the *social purview* of the given time period and the given social group. So far, we have been speaking about the form of the sign as shaped by the forms of social interaction. Now we shall deal with its other aspect – the *content* of the sign and the evaluative accentuation that accompanies all content.

Every stage in the development of a society has its own special and restricted circle of items which alone have access to that society's attention and which are endowed with evaluative accentuation by that attention. Only items within that circle will achieve sign formation and become objects in semiotic communication. What determines this circle of items endowed with value accents?

In order for any item, from whatever domain of reality it may come, to enter the social purview of the group and elicit ideological semiotic reaction, it must be associated with the vital socioeconomic prerequisites of the particular group's existence; it must somehow, even if only obliquely, make contact with the bases of the group's material life.

Individual choice under these circumstances, of course, can have no meaning at all. The sign is a creation between individuals, a creation within a social milieu. Therefore the item in question must first acquire interindividual significance, and only then can it become an object for sign formation. In other words, *only that which has acquired social value can enter the world of ideology, take shape, and establish itself there.*

For this reason, all ideological accents, despite their being produced by the individual voice (as in the case of word) or, in any event, by the individual organism – all ideological accents are social accents, ones with claim to *social recognition* and, only thanks to that recognition, are made outward use of in ideological material.

Let us agree to call the entity which becomes the object of a sign the *theme* of the sign. Each fully fledged sign has its theme. And so, every verbal performance has its theme.[3]

An ideological theme is always socially accentuated. Of course, all the social accents of ideological themes make their way also into the individual consciousness (which, as we know, is ideological through and through) and there take on the semblance of individual accents, since the individual consciousness assimilates them as its own. However, the source of these accents is not the individual consciousness. Accent, as such, is interindividual. The animal cry, the pure response to pain in the organism, is bereft of accent; it is a purely natural phenomenon. For such a cry, the social atmosphere is irrelevant, and therefore it does not contain even the germ of sign formation.

The theme of an ideological sign and the form of an ideological sign are inextricably bound together and are separable only in the abstract. Ultimately, the same set of forces and the same material prerequisites bring both the one and the other to life.

Indeed, the economic conditions that inaugurate a new element of reality into the social purview, that make it socially meaningful and "interesting," are exactly the same conditions that create the forms of ideological communication (the cognitive, the artistic, the religious, and so on), which in turn shape the forms of semiotic expression.

Thus, the themes and forms of ideological creativity emerge from the same matrix and are in essence two sides of the same thing.

The process of incorporation into ideology – the birth of theme and birth of form – is best followed out in the material of the word. This process of ideological generation is reflected two ways in language: both in its large-scale, universal-historical dimensions as studied by semantic paleontology, which has disclosed the incorporation of undifferentiated chunks of reality into the social purview of prehistoric man, and in its small-scale dimensions as constituted within the framework of contemporaneity, since, as we know, the word sensitively reflects the slightest variations in social existence.

Existence reflected in sign is not merely reflected but *refracted*. How is this refraction of existence in the ideological sign determined? By an intersecting of differently oriented social interests within one and the same sign community, i.e., *by the class struggle*.

Class does not coincide with the sign community, i.e., with the community which is the totality of users of the same set of signs for ideological communication. Thus various different classes will use one and the same language. As a result, differently oriented accents intersect in every ideological sign. Sign becomes an arena of the class struggle.

This social *multiaccentuality* of the ideological sign is a very crucial aspect. By and large, it is thanks to this intersecting of accents that a sign maintains its vitality and dynamism and the capacity for further development. A sign that has been withdrawn from the pressures of the social struggle – which, so to speak, crosses beyond the pale of the class struggle – inevitably loses force, degenerating into allegory and becoming the object not of live social intelligibility but of philological comprehension. The historical memory of mankind is full of such worn out ideological signs incapable of serving as arenas for the clash of live social accents. However, inasmuch as they are remembered by the philologist and the historian, they may be said to retain the last glimmers of life.

The very same thing that makes the ideological sign vital and mutable is also, however, that which makes it a refracting and distorting medium. The ruling class strives to impart a supraclass, eternal character to the ideological sign, to extinguish or drive inward the struggle between social value judgments which occurs in it, to make the sign uniaccentual.

In actual fact, each living ideological sign has two faces, like Janus. Any current curse word can become a word of praise, any current truth must inevitably sound to many other people as the greatest lie. This *inner dialectic quality* of the sign comes out fully in the open only in times of social crises or revolutionary changes. In the ordinary conditions of life, the contradiction embedded in every ideological sign cannot emerge fully because the ideological sign in an established, dominant ideology is always somewhat reactionary and tries, as it were, to stabilize the preceding factor in the dialectical flux of the social generative process, so accentuating yesterday's truth as to make it appear today's. And that is what is responsible for the refracting and distorting peculiarity of the ideological sign within the dominant ideology.

This, then, is the picture of the problem of the relation of the basis to superstructures. Our concern with it has been limited to concretization of certain of

its aspects and elucidation of the direction and routes to be followed in a productive treatment of it. We made a special point of the place philosophy of language has in that treatment. The material of the verbal sign allows one most fully and easily to follow out the continuity of the dialectical process of change, a process which goes from the basis to superstructures. The category of mechanical causality in explanations of ideological phenomena can most easily be surmounted on the grounds of philosophy of language.

Notes

1 Society, of course, is also a *part of nature*, but a part that is qualitatively separate and distinct and possesses its own *specific* systems of laws.

2 The problem of behavioral speech genres has only very recently become a topic of discussion in linguistic and philosophical scholarship. One of the first serious attempts to deal with these genres, though, to be sure, without any clearly defined sociological orientation, is Leo Spitzer's *Italienische Umgangssprache*, 1922.

3 The relationship of theme to the semantics of individual words shall be dealt with in greater detail in a later section of our study.

LANGUAGE IN HISTORY

Often where history is utterly dumb concerning the past, language speaks.

(William Mathews, *Words, Their Use and Abuse*, 1882:226)

MATHEWS' COMMENT (above) encapsulates a notion of language as an index of historical change and implies, moreover, that the 'history *in* words' may be more reliable than 'the historical narratives constructed *by* words' (Crowley 1989a: p. 57). In addressing the role of language as the bearer of history, this section looks further at problems which have already been raised in the general introduction and the previous section, particularly the tension between structure and agency in the theorisation of linguistic change. For one of the key issues raised by the pieces by Saussure, Croce and Voloshinov is the extent to which individuals, or social groups, are able actively to intervene within language, and thus to facilitate the production of new linguistic meanings.

In the extracts from Saussure to follow, the problem of the demarcation of the science of language appears once again. Having isolated the study of linguistic structure as the key to linguistics, we see him further establishing the methodology which was to give linguistics scientificity. Put simply, he defines the linguist's task as studying only the internal arrangement of elements which taken together form '*langue*' or the linguistic structure. He also argues that the linguist must look at the language from the point of view of the user in the present, rather than addressing the historical development of the language. This is because the language user does not need to know historical facts about the language in order to use it effectively in the present. We do not, for instance, need to know that 'punk' used to mean prostitute in order to use it in the present to refer to a particular youth subculture (the current meaning of the sign). For Saussure then, an analysis of historical changes in language represents a different area of enquiry from the study of linguistic structure, for such an analysis would not aid the linguist in the task of establishing the relationship between signs within the signifying system in the present. Whether, in fact, users of a language are quite as ignorant of anything other than the linguistic structure in the present is a question for discussion. A particular group of speakers, for example, might be aware that previous generations had spoken a different language which had been suppressed, or forbidden, and this might, in turn, affect their knowledge and use of language in the present. The extracts in the sections on 'Englishes' and 'Language and Colonialism' certainly testify to the significance of historical experience to the ways in which post-colonial writers engage with language. However, although such considerations seem to be banished from the study of language by Saussure, it is inaccurate to characterise his work as rejecting the

significance of the relations between language and history. For whilst historical facts are excluded from the *scientific* study of language, he does not exclude them from language study *per se*.

Although he did not consider it to be unimportant, for Saussure the evolution of language through time could not be treated scientifically since it was unsystematic, occurring, in other words, in an *ad hoc* or arbitrary fashion. As discussed in the introduction to the previous section (pp. 28–39), his principle of the mutability and immutability of the sign gives a clue to what is in essence a conservative view of change. Arguing that the linguistic community is characterised by 'inertia' with regard to matters of language, he casts the social and historical forces which bring about linguistic change in the naturalising metaphor of language as a flowing river. This metaphor, of course, serves implicitly to deny human agency a role within linguistic change, raising the question as to what, precisely, the forces which act upon language are.

An alternative way of thinking about change would be to posit the individual as the agent of linguistic innovation; this is Spitzer's view, and the links with Croce's work (presented in the previous section) are clear. Croce's idealist account of language is based upon a notion of expressivity which accords primacy to the individual utterance as a creative expression. In a similar manner, Spitzer sees linguistic change as taking place because there happen to be individuals who are motivated to initiate change and who happen to find themselves in a position to introduce it. The role of advertising in the production of neogolisms is worth consideration in this regard; as is the question as to why some words from this source are picked up in the language, whilst others are not.

The other three texts in the following section can be thought of initially together, in that they each express scepticism towards both the Saussurean and Spitzerian models. For Williams, Schulz and Cameron, linguistic change is neither simply fortuitous, random, natural nor the province of the individual alone, but rather the product of historical and social conditions and transformations. The notion that tracing the meanings which have accrued historically around key terms enables one to gain insight into the shape and concerns of contemporary society is central to the extract from Williams' introduction to *Keywords*. The cultural and political significance of the practice of historical semantics was first posited in his earlier work *Culture and Society* (published in 1958), an enormously influential text, not least in that it began to define a new, historically and politically engaged mode of literary and cultural criticism. It defined its field, and justified it, as an inquiry 'into our common language, on matters of common interest'. That inquiry started as an analysis of just five key words: 'industry', 'democracy', 'class', 'art' and 'culture'; it ended, almost thirty years later, with his tantalising claim that 'a fully historical semiotics would be very much the same thing as cultural materialism' (Williams 1991: p. 210). The principle that change in language tells us of important social changes is taken up by Schulz in her analysis of one way in which language has been used historically to denigrate women. By looking at the historical development and changing meanings of words referring to women, and the patterns of those changes, she argues that language encodes the ways in which women

have been excluded and belittled within patriarchal society. One question, however, which might apply to both Schulz and Williams, is the quantity and reliability of their evidence, since even using the *Oxford English Dictionary* is problematic as Williams notes. However, as both pieces indicate, even though we have only fragments of the past, they do speak to us. As of course does the language of the present, as we shall see later.

Cameron's piece concerns the question of authority and value in language, points also discussed, though from a different perspective, by Williams. She posits the question as to whether all language about language is prescriptive, which raises problems for modern linguistic theory's claim (after Saussure) to be interested in only descriptivism (describing a language rather than prescribing what it should be). It also addresses the question of what types of prescriptivism are helpful and harmful. Although Cameron suggests that 'we are all of us closet prescriptivists', or 'verbal hygienists', she also asserts that our norms and values differ. This is an important point when we consider the very different political agendas which motivate different social groups to reflect critically upon language. This issue also returns us to the question of structure and agency and the role of language users in effecting, or impeding, linguistic change.

Further reading

Saussure

Saussure, F. de (1960) *Course in General Linguistics*, ed. C. Bally and A. Sechehaye, trans. W. Baskin, London: Peter Owen.
—— (1983) *Course in General Linguistics*, ed. C. Bally and A. Sechehaye, trans. R. Harris, London: Duckworth, Part 3, chapters 1–8, Part 4, Part 5, chapters 1 and 4.
Crowley, T. (1996) *Language in History: Theories and Texts*, London: Routledge, chapter 1.
Hodge, R. and G.R. Kress (1988) *Social Semiotics*, Cambridge: Polity, chapter 2.
Harris, R. (1987) *Reading Saussure: A Critical Commentary on the 'Cours de linguistique générale'*, London: Duckworth, pp. 139–66, 171–92.
Koerner, E.F.K. (1973) *Ferdinand de Saussure: Origin and Development of his Linguistic Thought in Western Studies of Language*, Braunschweig: Vieweg, pp. 263–310.
Gadet, F. (1989) *Saussure and Contemporary Culture*, trans. G. Elliott, London: Radius, chapters 6 and 7.
Thibault, P. J. (1997) *Re-reading Saussure: The Dynamics of Signs in Social Life*, London: Routledge, chapter 4.
Jakobson, R. (1990) *On Language*, ed. L.R. Waugh and M. Monville-Bunston, Cambridge, MA, Harvard University Press, pp. 102–8.
Barthes, R. (1988) 'Saussure, the Sign, Democracy', in *The Semiotic Challenge*, trans. R. Howard, Oxford: Basil Blackwell, pp. 151–6.

Spitzer and historical semantics

Spitzer, L. (1943) 'Why Does Language Change?', *Modern Language Quarterly* 4, pp. 413–31.

—— (1948) 'Linguistics and Literary History', in *Linguistics and Literary History: Essays in Stylistics*, Princeton, NJ: Princeton University Press, pp. 1–39.

—— (1948) *Essays in Historical Semantics*, New York: S.F. Vanni

Wellek, R. (1960) 'Leo Spitzer (1887–1960)', *Comparative Literature* 12, pp. 310–34.

Uitti, K.D. (1969) *Linguistics and Literary Theory*, Englewood Cliffs, NJ: Prentice-Hall, pp. 132–41.

Iordan, I. (1937) *An Introduction to Romance Linguistics, its Schools and Scholars*, rev. and trans. J. Orr, London: Methuen, pp. 135–42.

Hall Jr, R.A. (1963) *Idealism in Romance Linguistics*, Ithaca, NY: Cornell University Press, pp. 71–8.

Hatzfeld, H. (1958) 'Recent Italian Stylistic Theory and Stylistic Criticism', in A.G. Hatcher and K.L. Selig (eds) *Studia Philologica et Litteraria in Honorem L. Spitzer*, Bern: Francke, pp. 227–43.

Wellek R. and A. Warren (1963) *Theory of Literature*, Harmondsworth: Penguin, chapter 14.

Malkiel, Y. (1954–55) 'Etymology and Historical Grammar', *Romance Philology* 8, pp. 187–208.

Geeraerts, D. (1994) 'Historical Semantics', in R.E. Asher and J.M.Y. Simpson (eds) *The Encyclopedia of Language and Linguistics*, 10 vols, Oxford and New York: Pergamon Press, vol. 3, pp. 1567–70.

Williams and social semiotics

Williams, R. (1977) *Marxism and Literature*, Oxford: Oxford University Press, pp. 21–44.

—— (1979) *Politics and Letters: Interviews with New Left Review*, London: New Left Books, pp. 175–85.

—— (1961) *Culture and Society 1780–1950*, Harmondsworth: Penguin, pp. 13–19, 285–323.

—— (1976) *Keywords: A Vocabulary of Culture and Society*, London: Fontana, passim.

Crowley, T. (1989) 'Language in History: That Full Field', *News From Nowhere* 6, pp. 23–37.

Eldridge, J. and L. Eldridge (1994) *Raymond Williams: Making Connections*, London: Routledge, pp. 40–7.

Fairclough, N. (1989) *Language and Power*, London: Longman, chapter 8.

Hodge, R. and G.R. Kress (1988) *Social Semiotics*, Cambridge: Polity, pp. 182–92 and passim.

Halliday, M.A.K. (1978) *Language as Social Semiotic: The Social Interpretation of Language and Meaning*, London: Edward Arnold, pp. 60–92.

Leith, D. (1997) *A Social History of English*, 2nd edn., London: Routledge, chapter 3.

Briggs, A. (1967) 'The Language of "Class" in Early Nineteenth-Century England', in A. Briggs and J. Saville (eds) *Essays in Labour History*, London: Macmillan, pp. 43–73.

—— (1979) 'The Language of "Mass" and "Masses" in Nineteenth-Century England', in D.E. Martin and D. Rubinstein (eds) *Ideology and the Labour Movement*, London: Croom Helm, pp. 62–83.

Elias, N. (1994) *The Civilising Process: The History of Manners and State Formation and Civilization*, trans. E. Jephcott, Oxford: Blackwell, pp. 1–41.

Prescriptivism

Cameron, D. (1995) *Verbal Hygiene*, London: Routledge.

Milroy, J. (1992) *Linguistic Variation and Change*, Oxford: Blackwell, chapter 1.

Milroy, J. and L. Milroy (1992) *Authority in Language: Investigating Language Prescription and Standardisation*, 2nd edn, London: Routledge.

Leith, D. (1997) *A Social History of English*, 2nd edn., London: Routledge, chapter 2.

Baugh, A.C. and T. Cable (1978) *A History of the English Language*, 3rd edn., London: Routledge & Kegan Paul, chapters 9–10.

Crowley, T. (1989) *The Politics of Discourse: The Standard Language Question in British Cultural Debates*, London: Macmillan, chapters 3–5.

—— (1991) *Proper English? Readings in Language, History and Cultural Identity*, London: Routledge.

—— (1996) *Language in History: Theories and Texts*, London: Routledge, chapter 3.

Barrell, J. (1983) *English Literature in History 1730–80: An Equal Wide Survey*, London: Hutchinson, chapter 2.

Honey, J. (1983) *The Language Trap*, Middlesex: National Council for Educational Standards.

—— (1997) *Language is Power: The Story of Standard English and its Enemies*, London: Faber & Faber, chapter 6.

Marenbon, J. (1987) *English Our English: The New Orthodoxy Examined*, London: Centre for Policy Studies.

Language in history

Crowley, T. (1989) *The Politics of Discourse: The Standard Language Question in British Cultural Debates*, London: Macmillan, chapter 1.

—— (1996) *Language in History: Theories and Texts*, London: Routledge.

Corfield, P. J. (1991) 'Introduction: Historians and Language', in P.J. Corfield (ed.) *Language, History and Class*, Oxford: Basil Blackwell, Introduction and passim.

Burke, P. and R. Porter (eds) (1987) *The Social History of Language*, Cambridge: Cambridge University Press.

—— (eds) (1991) *Language, Self and Society: A Social History of Language*, Cambridge: Polity.

Smith, O. (1984) *The Politics of Language 1791–1819*, Oxford: Clarendon Press.

Hodge, R. and G.R. Kress (1988) *Social Semiotics*, Cambridge: Polity, chapter 6.

Attridge, D. (1988) *Peculiar Language: Literature as Difference from the Renaissance to James Joyce*, London: Methuen, chapter 4.

Goad, H. (1958) *Language in History*, Harmondsworth: Penguin.

Hoijer, H. (1948) 'Linguistic and Cultural Change', *Language*, 24 (4), pp. 335–45.

Aitchison, J. (1981) *Language Change: Progress or Decay?*, London: Fontana.

Ferdinand de Saussure

LANGUAGE AND LINGUISTICS (1916)

Internal and external elements of language

My definition of language presupposes the exclusion of everything that is outside its organism or system – in a word, of everything known as "external linguistics." But external linguistics deals with many important things – the very ones that we think of when we begin the study of speech.

First and foremost come all the points where linguistics borders on ethnology, all the relations that link the history of a language and the history of a race or civilization. The close interaction of language and ethnography brings to mind the bonds that join linguistic phenomena proper (see p. 21). The culture of a nation exerts an influence on its language, and the language, on the other hand, is largely responsible for the nation.

Second come the relations between language and political history. Great historical events like the Roman conquest have an incalculable influence on a host of linguistic facts. Colonization, which is only one form that conquest may take, brings about changes in an idiom by transporting it into different surroundings. All kinds of facts could be cited as substantiating evidence. For instance, Norway adopted Danish when she united politically with Denmark; the Norwegians are trying today to throw off that linguistic influence. The internal politics of states is no less important to the life of languages; certain governments (like the Swiss) allow the coexistence of several idioms; others (like the French) strive for linguistic unity. An advanced state of civilization favors the development of special languages (juridical language, scientific terminology, etc.).

Here we come to a third point: the relations between language and all sorts of institutions (the Church, the school, etc). All these institutions in turn are closely tied to the literary development of a language, a general phenomenon that is all the more inseparable from political history. At every point the literary language oversteps the boundaries that literature apparently marks off; we need only consider the influence of *salons*, the court, and national academies. Moreover, the

literary language raises the important question of conflicts between it and local dialects [. . .]; the linguist must also examine the reciprocal relations of book language and the vernacular; for every literary language, being the product of the culture, finally breaks away from its natural sphere, the spoken language.

Finally, everything that relates to the geographical spreading of languages and dialectal splitting belongs to external linguistics. Doubtless the distinction between internal and external linguistics seems most paradoxical here, since the geographical phenomenon is so closely linked to the existence of any language; but geographical spreading and dialectal splitting do not actually affect the inner organism of an idiom.

Some have maintained that the foregoing issues simply cannot be separated from the study of language proper. The viewpoint has been prevalent especially since the placing of so much emphasis on "Realia."[1] Just as the inner organism of a plant is modified by alien forces (terrain, climate, etc.) does not the grammatical organism depend constantly on the external forces of linguistic change? It seems that we can scarcely give a satisfactory explanation of the technical terms and loan-words that abound in language without considering their development. Is it possible to distinguish the natural, organic growth of an idiom from its artificial forms, such as the literary language, which are due to external, and therefore inorganic forces? Common languages are always developing alongside local dialects.

I believe that the study of external linguistic phenomena is most fruitful; but to say that we cannot understand the internal linguistic organism without studying external phenomena is wrong. Take as an example the borrowing of foreign words. We observe from the outset that borrowing is not a constant force in the life of a language. In certain isolated valleys there are dialects that have never taken a single artificial term from the outside. Should we say that such idioms are outside the conditions of normal speech and that they require "teratological"[2] study inasmuch as they have never suffered admixture? More important still, a loan-word no longer counts as such whenever it is studied within a system; it exists only through its relation with, and opposition to, words associated with it, just like any other genuine sign. Knowledge of the circumstances that contributed to the development of a language, generally speaking, is never indispensable. For certain languages – e.g. Zend and Old Slavic – even the identity of the original speakers is unknown, but lack of such information in no way hinders us in studying these languages internally and learning about the transformations that they have undergone. In any case, separation of the two viewpoints is mandatory, and the more rigidly they are kept apart, the better it will be.

The best proof of the need for separating the two viewpoints is that each creates a distinct method. External linguistics can add detail to detail without being caught in the vise of a system. Each writer, for instance, will group as he sees fit facts about the spreading of a language beyond its territory. If he looks for the forces that created a literary language beside local dialects, he can always use simple enumeration. If he arranges the facts more or less systematically, he will do this solely for the sake of clarity.

In internal linguistics the picture differs completely. Just any arrangement will not do. Language is a system that has its own arrangement. Comparison with

chess will bring out the point. In chess, what is external can be separated relatively easily from what is internal. The fact that the game passed from Persia to Europe is external; against that, everything having to do with its system and rules is internal. If I use ivory chessmen instead of wooden ones, the change has no effect on the system; but if I decrease or increase the number of chessmen, this change has a profound effect on the "grammar" of the game. One must always distinguish between what is internal and what is external. In each instance one can determine the nature of the phenomenon by applying this rule: everything that changes the system in any way is internal. [...]

Static and evolutionary linguistics

1. Inner duality of all sciences concerned with values

Very few linguists suspect that the intervention of the factor of time creates difficulties peculiar to linguistics and opens to their science two completely divergent paths.

Most other sciences are unaffected by this radical duality; time produces no special effects in them. Astronomy has found that the stars undergo considerable changes but has not been obliged on this account to split itself into two disciplines. Geology is concerned with successions at almost every instant, but its study of strata does not thereby become a radically distinct discipline. Law has its descriptive science and its historical science; no one opposes one to the other. The political history of states is unfolded solely in time, but a historian depicting a particular period does not work apart from history. Conversely, the science of political institutions is essentially descriptive, but if the need arises it can easily deal with a historical question without disturbing its unity.

On the contrary, that duality is already forcing itself upon the economic sciences. Here, in contrast to the other sciences, political economy and economic history constitute two clearly separated disciplines within a single science; the works that have recently appeared on these subjects point up the distinction. Proceeding as they have, economists are – without being well aware of it – obeying an inner necessity. A similar necessity obliges us to divide linguistics into two parts, each with its own principle. Here as in political economy we are confronted with the notion of *value*; both sciences are concerned with *a system for equating things of different orders* – labor and wages in one and a signified and signifier in the other.

Certainly all sciences would profit by indicating more precisely the coordinates along which their subject matter is aligned. Everywhere distinctions should be made, according to the following illustration, between (1) *the axis of simultaneities* (AB), which stands for the relations of coexisting things and from which the intervention of time is excluded; and (2) *the axis of successions* (CD), on which only one thing can be considered at a time but upon which are located all the things on the first axis together with their changes.

For a science concerned with values the distinction is a practical necessity and sometimes an absolute one. In these fields scholars cannot organize their research rigorously without considering both co-ordinates and making a

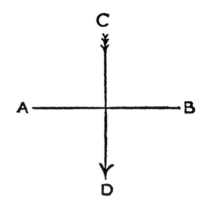

distinction between the system of values *per se* and the same values as they relate to time.

This distinction has to be heeded by the linguist above all others, for language is a system of pure values which are determined by nothing except the momentary arrangement of its terms. A value – so long as it is somehow rooted in things and in their natural relations, as happens with economics (the value of a plot of ground, for instance, is related to its productivity) – can to some extent be traced in time if we remember that it depends at each moment upon a system of coexisting values. Its link with things gives it, perforce, a natural basis, and the judgments that we base on such values are therefore never completely arbitrary; their variability is limited. But we have just seen that natural data have no place in linguistics.

Again, the more complex and rigorously organized a system of values is, the more it is necessary, because of its very complexity, to study it according to both co-ordinates. No other system embodies this feature to the same extent as language. Nowhere else do we find such precise values at stake and such a great number and diversity of terms, all so rigidly interdependent. The multiplicity of signs, which we have already used to explain the continuity of language, makes it absolutely impossible to study simultaneously relations in time and relations within the system.

The reasons for distinguishing two sciences of language are clear. How should the sciences be designated? Available terms do not all bring out the distinction with equal sharpness. "Linguistic history" and "historical linguistics" are too vague. Since political history includes the description of different periods as well as the narration of events, the student might think that he is studying a language according to the axis of time when he describes its successive states, but this would require a separate study of the phenomena that make language pass from one state to another. *Evolution* and *evolutionary linguistics* are more precise, and I shall use these expressions often; in contrast, we can speak of the science of *language-states (états de langue)* or *static linguistics*.

But to indicate more clearly the opposition and crossing of two orders of phenomena that relate to the same object, I prefer to speak of *synchronic* and *diachronic* linguistics. Everything that relates to the static side of our science is synchronic; everything that has to do with evolution is diachronic. Similarly, *syn-*

chrony and *diachrony* designate respectively a language-state and an evolutionary phase.

2. Inner duality and the history of linguistics

The first thing that strikes us when we study the facts of language is that their succession in time does not exist insofar as the speaker is concerned. He is confronted with a state. That is why the linguist who wishes to understand a state must discard all knowledge of everything that produced it and ignore diachrony. He can enter the mind of speakers only by completely suppressing the past. The intervention of history can only falsify his judgment. It would be absurd to attempt to sketch a panorama of the Alps by viewing them simultaneously from several peaks of the Jura; a panorama must be made from a single vantage point. The same applies to language; the linguist can neither describe it nor draw up standards of usage except by concentrating on one state. When he follows the evolution of the language, he resembles the moving observer who goes from one peak of the Jura to another in order to record the shifts in perspective.

[. . .]

3. Inner duality illustrated by examples

The opposition between the two viewpoints, the synchronic and the diachronic, is absolute and allows no compromise. A few facts will show what the difference is and why it is irreducible. [. . .]

In Old High German the plural of *gast* "guest" was first *gasti*, that of *hant* "hand" was *hanti*, etc. Later the final *–i* produced an umlaut, i.e. it resulted in the changing of the *a* of the preceding syllable to *e*: *gasti* → *gesti*; *hanti* → *henti*. Then the final *–i* lost its timbre: *gesti* → *geste*, etc. The result is that today German has *Gast: Gäste*, *Hand: Hände*, and a whole group of words marked by the same difference between the singular and the plural. A very similar fact occurred in Anglo-Saxon: the earlier forms were *fōt*: **fōti*, *tōþ*: **tōþi*, *gōs*: **gōsi*, etc. Through an initial phonetic change, umlaut, **fōti* became **fēti*; through a second, the fall of final *–i*, *fēti* became *fēt*; after that, *fōt* had as its plural *fēt*; *tōþ*, *tēþ*; *gōs*, *gēs*, etc. (Modern English *foot: feet, tooth: teeth, goose: geese*.)

Previously, when speakers used *gast: gasti, fōt: fōti*, the simple addition of an *i* marked the plural; *Gast: Gäste* and *fōt: fēt* show a new mechanism for indicating the plural. The mechanism is not the same in both instances; in Old English there is only opposition between vowels; in German there is in addition the presence or absence of final *–e*; but here this difference is unimportant.

The relation between a singular and its plural, whatever the forms may be, can be expressed at each moment by a horizontal axis:

$$\cdot \longleftrightarrow \cdot \ \text{Period A}$$
$$\cdot \longleftrightarrow \cdot \ \text{Period B}$$

Whatever facts have brought about passage from one form to another should be placed along a vertical axis, giving the overall picture:

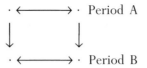

Our illustration suggests several pertinent remarks:

1 In no way do diachronic facts aim to signal a value by means of another sign; that *gasti* became *gesti*, *geste* (*Gäste*) has nothing to do with the plural of substantives; in *tragit* → *trägt*, the same umlaut occurs in verbal inflection, and so forth. A diachronic fact is an independent event; the particular synchronic consequences that may stem from it are wholly unrelated to it.

2 Diachronic facts are not even directed toward changing the system. Speakers did not wish to pass from one system of relations to another; modification does not affect the arrangement but rather its elements.

 Here we again find the principle enunciated previously: never is the system modified directly. In itself it is unchangeable; only certain elements are altered without regard for the solidarity that binds them to the whole. It is as if one of the planets that revolve around the sun changed its dimensions and weight: this isolated event would entail general consequences and would throw the whole system out of equilibrium. The opposition of two terms is needed to express plurality: either *fōt: fōti* or *fōt: fēt*; both procedures are possible, but speakers passed from one to the other, so to speak, without having a hand in it. Neither was the whole replaced nor did one system engender another; one element in the first system was changed, and this change was enough to give rise to another system.

3 The foregoing observation points up the ever *fortuitous* nature of a state. In contrast to the false notion that we readily fashion for ourselves about it, language is not a mechanism created and arranged with a view to the concepts to be expressed. We see on the contrary that the state which resulted from the change was not destined to signal the meaning with which it was impregnated. In a fortuitous state (*fōt: fēt*), speakers took advantage of an existing difference and made it signal the distinction between singular and plural; *fōt: fēt* is no better for this purpose than *fōt: *fōti*. In each state the mind infiltrated a given substance and breathed life into it. This new perspective, inspired by historical linguistics, is unknown to traditional grammar, which could never acquire it by its own methods. Most philosophers of language are equally ignorant of it, and yet nothing is more important from the philosophical viewpoint.

4 Are facts of the diachronic series of the same class, at least, as facts of the synchronic series? By no means, for we have seen that changes are wholly unintentional while the synchronic fact is always significant. It always calls forth two simultaneous terms. Not *Gäste* alone but the opposition *Gast: Gäste* expresses the plural. The diachronic fact is just the opposite: only one term is involved, and for the new one to appear (*Gäste*), the old one (*gasti*) must first give way to it.

To try to unite such dissimilar facts in the same discipline would certainly be a fanciful undertaking. The diachronic perspective deals with phenomena that are unrelated to systems although they do condition them.

[...]

To summarize:

Language is a system whose parts can and must all be considered in their synchronic solidarity.

Since changes never affect the system as a whole but rather one or another of its elements, they can be studied only outside the system. Each alteration doubtless has its countereffect on the system, but the initial fact affected only one point; there is no inner bond between the initial fact and the effect that it may subsequently produce on the whole system. The basic difference between successive terms and coexisting terms, between partial facts and facts that affect the system, precludes making both classes of fact the subject matter of a single science.

4. The difference between the two classes illustrated by comparisons

To show both the autonomy and the interdependence of synchrony we can compare the first to the projection of an object on a plane surface. Any projection depends directly on the nature of the object projected, yet differs from it – the object itself is a thing apart. Otherwise there would not be a whole science of projections; considering the bodies themselves would suffice. In linguistics there is the same relationship between the historical facts and a language-state, which is like a projection of the facts at a particular moment. We do not learn about synchronic states by studying bodies, i.e. diachronic events, any more than we learn about geometric projections by studying, even carefully, the different types of bodies.

Similarly if the stem of a plant is cut transversely, a rather complicated design is formed by the cut surface; the design is simply one perspective of the longitudinal fibers, and we would be able to see them on making a second cut perpendicular to the first. Here again one perspective depends on the other; the longitudinal cut shows the fibers that constitute the plant, and the transversal cut shows their arrangement on a particular plane; but the second is distinct from the first because it brings out certain relations between the fibers – relations that we could never grasp by viewing the longitudinal plane.

But of all comparisons that might be imagined, the most friutful is the one that might be drawn between the functioning of language and a game of chess. In both instances we are confronted with a system of values and their observable modifications. A game of chess is like an artificial realization of what language offers in a natural form.

Let us examine the matter more carefully.

First, a state of the set of chessmen corresponds closely to a state of language. The respective value of the pieces depends on their position on the chessboard just as each linguistic term derives its value from its opposition to all the other terms.

In the second place, the system is always momentary; it varies from one position to the next. It is also true that values depend above all else on an unchangeable convention, the set of rules that exists before a game begins and persists after each move. Rules that are agreed upon once and for all exist in language too; they are the constant principles of semiology.

Finally, to pass from one state of equilibrium to the next, or – according to our terminology – from one synchrony to the next, only one chesspiece has to be moved; there is no general rummage. Here we have the counterpart of the diachronic phenomenon with all its peculiarities. In fact:

a In each play only one chesspiece is moved; in the same way in language, changes affect only isolated elements.

b In spite of that, the move has a repercussion on the whole system; it is impossible for the player to foresee exactly the extent of the effect. Resulting changes of value will be, according to the circumstances, either nil, very serious, or of average importance. A certain move can revolutionize the whole game and even affect pieces that are not immediately involved. We have just seen that exactly the same holds for language.

c In chess, each move is absolutely distinct from the preceding and the subsequent equilibrium. The change effected belongs to neither state: only states matter.

In a game of chess any particular position has the unique characteristic of being freed from all antecedent positions; the route used in arriving there makes absolutely no difference; one who has followed the entire match has no advantage over the curious party who comes up at a critical moment to inspect the state of the game; to describe this arrangement, it is perfectly useless to recall what had just happened ten seconds previously. All this is equally applicable to language and sharpens the radical distinction between diachrony and synchrony. Speaking operates only on a language-state, and the changes that intervene between states have no place in either state.

At only one point is the comparison weak: the chessplayer *intends* to bring about a shift and thereby to exert an action on the system, whereas language premeditates nothing. The pieces of language are shifted – or rather modified – spontaneously and fortuitously. The umlaut of *Hände* for *hanti* and *Gäste* for *gasti* (see p. 57) produced a new system for forming the plural but also gave rise to verbal forms like *trägt* from *tragit*, etc. In order to make the game of chess seem

at every point like the functioning of language, we would have to imagine an unconscious or unintelligent player. This sole difference, however, makes the comparison even more instructive by showing the absolute necessity of making a distinction between the two classes of phenomena in linguistics. For if diachronic facts cannot be reduced to the synchronic system which they condition when the change is intentional, all the more will they resist when they set a blind force against the organization of a system of signs.

5. The two linguistics contrasted according to their methods and principles

Everywhere the opposition between diachrony and synchrony stands out.

For instance – and to begin with the most apparent fact – they are not of equal importance. Here it is evident that the synchronic viewpoint predominates, for it is the true and only reality to the community of speakers (see pp. 56–7). The same is true of the linguist: if he takes the diachronic perspective, he no longer observes language but rather a series of events that modify it. People often affirm that nothing is more important than understanding the genesis of a particular state; this is true in a certain sense: the forces that have shaped the state illuminate its true nature, and knowing them protects us against certain illusions (see pp. 58 ff.); but this only goes to prove clearly that diachronic linguistics is not an end in itself. What is said of journalism applies to diachrony: it leads everywhere if one departs from it.

The methods of diachrony and synchrony also differ, and in two ways.

1 Synchrony has only one perspective, the speakers', and its whole method consists of gathering evidence from speakers; to know to just what extent a thing is a reality, it is necessary and sufficient to determine to what extent it exists in the minds of speakers. Diachronic linguistics, on the contrary, must distinguish two perspectives. One of these, the *prospective*, follows the course of time; the other, the *retrospective*, goes back in time; the result is a duplication in methodology. [...]

2 A second difference results from delimiting the fields embraced by each of the two disciplines. Synchronic study has as its object, not everything that is simultaneous, but only the totality of facts corresponding to each language; separation will go as far as dialects and subdialects when necessary. The term *synchronic* is really not precise enough; it should be replaced by another – rather long to be sure – *idiosynchronic*. Against this, diachronic linguistics not only does not need but even rejects such specialization; the terms that it studies do not necessarily belong to the same language (compare Proto-Indo-European *esti*, Greek *esti*, German *ist*, and French *est*). The succession of diachronic events and their multiplication in space are precisely what creates the diversity of idioms. To justify the associating of two forms, it is enough to show that they are connected by a historical bond, however indirect it may be.

The foregoing oppositions are neither the most striking nor the most profound. One consequence of the radical antimony between the evolutionary and the static fact is that all notions associated with one or the other are to the same extent mutually irreducible. Any notion will point up this truth. The synchronic and diachronic "phenomenon," for example, have nothing in common (see p. 58). One is a relation between simultaneous elements, the other the substitution of one element for another in time, an event. [...]

6. Synchronic and diachronic law

It is a popular practice to speak of laws in linguistics. But are the facts of language actually governed by laws? If so, what are they like? Since language is a social institution, one might assume *a priori* that it is governed by prescriptions analogous to those that control communities. Now every social law has two basic characteristics: it is *imperative* and it is *general*; it comes in by force and it covers all cases – within certain limits of time and place, of course.

Do the laws of language fit this definition? The first step in answering the question – in line with what has just been said – is to separate once more the synchronic and diachronic areas. The two problems must not be confused. [...]

The synchronic law is general but not imperative. Doubtless it is imposed on individuals by the weight of collective usage (see p. 29), but here I do not have in mind an obligation on the part of speakers. I mean that *in language* no force guarantees the maintenance of a regularity when established on some point. Being a simple expression of an existing arrangement, the synchronic law reports a state of affairs; it is like a law that states that trees in a certain orchard are arranged in the shape of a quincunx. And the arrangement that the law defines is precarious precisely because it is not imperative. In short, if one speaks of law in synchrony, it is in the sense of an arrangement, a principle of regularity.

Diachrony, on the contrary, supposes a dynamic force through which an effect is produced, a thing executed. But this imperativeness is not sufficient to warrant applying the concept of law to evolutionary facts; we can speak of law only when a set of facts obeys the same rule, and in spite of certain appearances to the contrary, diachronic events are always accidental and particular.

[...]

7. Conclusions

Linguistics here comes to its second bifurcation. We had first to choose between language and speaking (see p. 24); here we are again at the intersection of two roads, one leading to diachrony and the other to synchrony.

Once in possession of this double principle of classification, we can add that everything diachronic in language is diachronic only by virtue of speaking. It is in speaking that the germ of all change is found. Each change is launched by a certain number of individuals before it is accepted for general use. Modern German uses *ich war, wir waren*, whereas until the sixteenth century the conjugation was *ich was, wir waren* (cf. English *I was, we were*). How did the substitution of *war* for *was* come about? Some speakers, influenced by *waren*, created *war*

through analogy; this was a fact of speaking; the new form, repeated many times and accepted by the community, became a fact of language. But not all innovations of speaking have the same success, and so long as they remain individual, they may be ignored, for we are studying language; they do not enter into our field of observation until the community of speakers has adopted them.

An evolutionary fact is always preceded by a fact, or rather by a multitude of similar facts, in the sphere of speaking. This in no way invalidates but rather strengthens the distinction made above since in the history of any innovation there are always two distinct moments: 1) when it sprang up in individual usage; and 2) when it became a fact of language, outwardly identical but adopted by the community. [. . .]

One must recognize that the ideal, theoretical form of a science is not always the one imposed upon it by the exigencies of practice; in linguistics these exigencies are more imperious than anywhere else; they account to some extent for the confusion that now predominates in linguistic research. Even if the distinctions set up here were accepted once and for all, a precise orientation probably could not be imposed on investigations in the name of the stated ideal. [...]

The two parts of linguistics respectively, as defined, will be the object of our study.

Synchronic linguistics will be concerned with the logical and psychological relations that bind together coexisting terms and form a system in the collective mind of speakers.

Diachronic linguistics, on the contrary, will study relations that bind together successive terms not perceived by the collective mind but substituted for each other without forming a system.

Notes

1 *Realien* is used in German to refer to all material facts of life, the shape, dimensions, and the like of objects, things, etc. Cf. the numerous works in German entitled Reallexicon. [Tr.]
2 'Pertaining to the study of monsters.'

Leo Spitzer

THE INDIVIDUAL FACTOR IN
LINGUISTIC INNOVATIONS (1956)

[...] Why does language change? – this basic question which the layman is entitled to ask the linguistic scholar who knows so much about change, is still ultimately unanswered, and I have the impression that the recent prevalence in certain countries (e.g. North America) of the descriptive approach to language must in principle by-pass this essential question, since the descriptivist must ignore change and posit only well balanced situations and systems in language to a degree which a historicist could never admit: are the couples *it is I* – *it's me*, *je ne puis* – *je ne peux pas* not historical stratifications in English or French speech today? is not the remark *v* (= *vieilli*), which some informants of Edmont and Gilliéron added to certain words, an indication of their own historical consciousness? Any speaker of a language carries with himself a historically stratified consciousness.

If we choose for the harrowing question 'why does language change?' another, more adequate wording (one that does not involve a personification of language), namely 'why does a community change its language?', we are led to an answer which explicits [*sic*] the dialectics implied in the concept 'community': the *community* would not change its language were it not for certain *individuals* who have reasons to change it in a certain way and who, for some reason, have the possibility (power, influence, etc.) of imposing the change they have devised. We cannot imagine any community in possession of an adequate system of expression in a language inherited from its ancestors moving suddenly like a 'goose-stepping row of grenadiers'[1] from one linguistic expression to another (surely not from *rēge* to *rei* or *roi*, from *je puis* to *je peux*, or from *ponere* 'to put' to *mittere* (Fr. *mettre*)). There must have existed forerunners and stragglers and a mass of people in the middle who slowly and hesitantly followed the proponents of linguistic innovation.

Even in the case of dynamic historical events that would change drastically

the racial, national and sociological characters of a linguistic community (by imposing a new superstratum or by giving in to a new substratum), the fact of language mixture (*Sprachmischung*) is not likely to explain entirely the linguistic change. Against Schuchardt who by his life in the Austro-Hungarian empire was conditioned to see language mixture as the basic factor in linguistic change (and who therefore saw no difference between Creole and the great cultural languages), a less gifted pupil of his, von Ettmayer, was right when he once said to me: 'The speaker does not mix languages, he speaks'. 'He speaks' must mean here, I suppose: he speaks his language, one language whose continuity he feels to be uninterrupted, he does not speak two languages at the same time; if he accepts, under the influence of his bilingual setting, certain features of the other language *he is selective*. The German Swiss who may accept certain Romanisms in his *Schwyzer Dütsch* still speaks basically German (and vice versa the French Swiss a French only rarely tinged with Germanisms). Similarly there must have existed in the linguistic leader in a period of bilinguality (which must precede the mixed status of a language) a will to speak basically a certain language and not another, a linguistic consciousness which adopts certain features, rejects others.

Thus it seems to me characteristic, in the cases of superstrata and substrata influencing Vulgar Latin so as to produce what von Wartburg has called the 'Ausgliederung' of the Romance languages, a certain reserve in the acceptance of local ways of speech. The speaker of Romance in Gaul who accepted certain words of the Frankish superstratum (*honte, orgueil, guerre, heaume*, etc.) and thus was led to learn some German sounds (*w–h*) preserved the whole morphological system of Vulgar Latin (declension, conjugation, word-formation) intact. Indeed there must have existed linguistic leaders (for us anonymous) who, accepting new influences from outside, stopped the invasion of the Germanic tongue at the exact point at which a radical Germanization threatened to [overwhelm] their Romance. The same arresting forces were influential in Rumanian resisting the Slavization of the structure of the Romance language, while condoning borrowings in the realm of the vocabulary. Again, in the case of a substratum, if *u > ü* and some other sound shifts are Gaulish in origin (as certain lexicological elements surely are), yet the Romance character of the skeleton of the language (its morphology) was not contaminated while some of the flesh was, can we doubt the activity of a puristic élite that kept French and Romanian from becoming Germanic, Gaulish, Slavic languages while opening these languages to the alloglottic influences in vocabulary (and, less, in phonetics)? Is it not as though the innovators of those early periods made a difference between the *factual content* of their civilization (which might be enriched) and the *forms of apperception* laid down unshakably in the 'grammar'? Thus we discover a certain conservatism in the innovator, a fear of shaking up the whole structure of the language.

What encourages me in this speculation about relatively 'conservative innovators' is the fact, observable in our own times, of a linguistic revolution in the vocabulary (and word-formation) of our European languages coupled with conservatism in the grammatical (and here also the phonetic) realm. To give a rapid orientation about the modern situation I wish to discuss: The Eastman firm created the new word *Kodak*, but would never have thought of replacing *taught* by

teached, however logical or practical the latter may be, or of changing the pronunciation of English!

With the word *Kodak* we have given an example of a relatively recent individual innovation in word-formation ratified by a community (indeed by a world-community). This case stands for thousands of modern words in our languages designating objects in the commercial, industrial, scientific, technological, social, and political areas of our civilisation which did not exist before: indeed, the number of these new words (corresponding to the number of new objects) is a startling phenomenon in our modern times – in whichever period of world history have individuals (like the Eastman Kodak firm) enjoyed the power of disseminating new, arbitrarily coined terms in such number and over such large areas? How rarely has an individual in the past been able thus to influence linguistically the whole world? A case such as the renaming of the months *Quintilis* and *Sextilis* as *Julius* and *Augustus* in honor of the ruler of the Roman empire is distinguished by its exceptionality (our modern scientific names for measures in newly discovered fields of physics such as *ohm*, *ampère*, *volt*, etc., come in groups). And if the name of the ruler who introduced a new coin was often used for that coin (*napoléon*, *louis d'or*) how much more daring is the procedure of the producers of cameras who reach *outside* of the accepted language when launching a new term! The causes in our civilisation of such new linguistic power given to certain individuals are, of course, the multiplication of new objects which must be named,[2] the need felt by large populations for these objects, the easier ways of communication made possible for us, the prestige enjoyed by the particular field of technology and science, the democratic character of our society in which, also linguistically, no select set of society can rule. And it is also remarkable that the neologisms created in the technical commercial world today are not only infinitely more numerous than those coined by all the rulers of the world, the Alexanders, Caesars, Augustuses, Napoléons, taken together, but are also infinitely less respectful of the laws of the language: only since the nineteenth century do we find in all European languages – a feature anticipated only by the 'clipped words' in seventeenth century English, such as *mob* < *mobile (vulgus)*, *punch* < *puncheon* – the systematic abbreviation of long words that no longer correspond to the accelerated tempo of our hasty civilization (*bus* < *omnibus*, *métro[politain]*, *radio*); or the 'letter words' (*CGT*, *GOP*, *URSS*) which are spoken, not only written like the *nomina sacra* of the Middle Ages of the *Inri* type; or the free handling of word-formation (*kleenex*, *lastex*, with a 'commercial suffix' *-ex; laundr-o-mat* formed after *automat; revenescence*, a perfume trademark formed after *evanescence, rejuvenescence*), the indulgence in foreign word-elements freely introduced, the puns, the colloquialisms introduced into the written text, the juggling with spelling (*kleenex* instead of *cleanex*; *Koll*, a cigarette brand, for *cool* – *k-* is more exotic than *c-*) – and finally the reach beyond the limits of language in cases such as, precisely, *Kodak*, a deliberate procedure which must have imposed great effort on the coiners of this word, since it is very difficult to imagine words which are not found in any actual language (it is, for example, very difficult to improvise absolute nonsense language): it is only the fanatical desire of the commercial world to make appear their products as totally new and unheard-of that encourages them to create words that we would otherwise only expect from victims of hallucinations.

One may doubt, however, the entirely individual origin of names such as *Kodak*, not only in the sense that, unless some memoirs of the persons connected with that invention are preserved and have been, or will be, published, we do not know exactly how and by whom the trademark was actually coined (and the same uncertainty, unless I am mistaken, remains probably about the actual coining of *Julius* and *Augustus* as names of months), but also in the sense that the creation of the trademark, though an arbitrary one, is not entirely 'individual' in nature, but respects certain linguistic patterns not unknown to the general language: the aforementioned predilection for *k* in the language of advertising; the bisyllabic stem which has an onomatopoeic quality (the first syllable symbolizing the making ready of the camera for the snapshot, the second, the snapshot itself with its final 'click'). If words such as *click* had not existed, *Kodak* could not have been formed! If then *Kodak* is sometimes listed as an *Urschöpfung* (along with van Helmont's *gas*), this is justified only as far as this neologism cannot be linked to any existing word family, but not as though it could transcend entirely our linguistic habits. Indeed, what made the trademark popular was (in addition to the factual linkedness of the name with the product) the fact that it fitted so well into the framework of our linguistic habits (by its onomatopeic effect). We are here faced with the constitutional limitation of any linguistic innovation: an innovation is always relative, with it a certain conservatism is always given. And the 'innovating individual' carries in himself the mind of the people to whom he addresses his innovation: he knows their linguistic habits and anticipates their (favorable) reaction to his innovation; the latter he can do only by a deft appraisal of the dosage of both innovation and conservatison that will 'go over' in the community.

Thus we have discovered within the mind of the linguistic innovator today the presence of a popular language-consciousness which guides him. This is, of course, only a variant (in reduced size) of the current opinion as to the relationship between a great historical individual who shaped the destiny of his people and this people itself: one always points out that the great reformers would not have been able to succeed had they not felt in themselves the need of their peoples for a reformation.

It is, of course, possible that the term coined by a certain innovator with a certain effect on the people in mind is adopted by the latter for another reason (it is theoretically possible that memoires of those responsible for the coinage of *Kodak* would bring out the fact that my 'onomatopeic' interpretation was alien to their minds and that *Kodak* was in reality perhaps a 'letter-word' of the type of *Unesco*). Hans Sperber in his *Bedeutungslehre* distinguished two stages in the history of a neologism: the 'creative moment' in which a coinage devised by an individual appears for the first time and certain 'fixing factors' which make the community accept the coinage, the fixing factors being for example the need for a term that was generally felt before the neologism was created, the emotional qualities that attach themselves to the term once coined, etc. For example, whoever might have applied for the first time the term 'taste' (which was originally used only of the perception of certain sensations by means of the tongue) to aesthetic appreciation (we know that this metaphorical use is first attested in Spain: the one [sic] of the Catholic kings, Isabel of Castille, used thus *gusto*), the

fixing factor in the metaphorical broadening of the term must have been the necessity felt by Renaissance aesthetics to establish a code of appreciation not founded on medieval or Aristotelian canons, but on personal judgment. The metaphor thus fitted into the thinking of the period. But I would say that the 'fixing factor' is in the majority of cases already given with the creation of the term – the term being created precisely by the creative individual in view of an existing need which will be filled thereby. Linguistic creation, just as creation in other fields, is intended as a lasting contribution to mankind and in cases in which the creation has not met with success we have to do with 'creation' aborted, not at the moment of the creation, but by ulterior historical development. The ill-famed American senator MacCarthy who coined (or at least we think that he coined) the term *fifth-amendment communist* for those citizens who, asked to appear before his investigating committee, took refuge in the fifth amendment in order not to answer the question whether they were or had been communists, must have counted in advance with the effectiveness of such a term (its association with *fifth-columnist*; the impression given by the compound which has a rather technical flavor that there exists indeed a very easily definable and rather wide-spread category of people falling under this definition), and it has gained currency exactly to the degree that it seemed to the citizenry to constitute an adequate description of a reality; if, as it seems likely as of today, the term should soon fall into oblivion, the outward situation that would offer a 'fixing factor' would have changed – but it cannot be denied that the junior senator from Wisconsin anticipated the 'fixing factor' correctly *at the time when he coined the term*. It is recent 'history' that has overruled him.

Now in all the cases mentioned of a neologism coined by an individual (or individuals), *Kodak, gusto* (if indeed Isabel of Castille was the coiner), *fifth-amendment communist, know-how*, the coiner felt a need (which, according to his opinion was wide-spread) to go beyond the general language and thus to enrich it by his new term. He would not, I insist again, have found it necessary or advisable to introduce a new form such as *teached* (or its like in other languages). What is it ultimately in the coiner of a new word (or of a new use of a word) that drives him beyond the pale of the accepted language and causes him to lead others toward acceptance of his term? It is ultimately a dissatisfaction with the accepted language which certain individuals may feel more keenly than others and may feel more keenly in certain areas of expression. A dissatisfaction with *which quality* of the general language? Its ever waning *expressivity*. It is a paradox that precisely the well-orderedness of any constituted language system, the good functioning of its grammatical rules and the availability of words for all that we wish to talk about, – that all these elements that invite stability and conservatism, are also those which curtail or hamstring or suppress our expressive faculties. We find here then the conflict between the communicative aspect of language which is satisfied with the existing order and the expressive aspect which must spurn it. And there will ever exist in any community those individuals in whom the urge to express in a new fashion overpowers the urge to communicate by traditional means, in whom the feeling that the *novelty* of a situation justifies a break of the linguistic tradition, and, on the other hand, that less emotional, or motoric, surely more numerous, group that feels that the situation before it does not require any transgression of the linguistically given.

We may only surmise that in any linguistic innovation that is accepted, there have been active motoric-minded individuals in the community who overpowered the conservatives – who, in turn, when gratuitously offered a new term, followed suit (not so much because they sensed the absolute *necessity* of the term, but because they understood the relative *possibility* of using the term, especially when it has come into existence *via facti*). We are often able to watch also a resistance of the community against a 'new-fangled' term, generally based, not so much on properly linguistic aversion but on aversion of the type of the coiners whom they suspect to be responsible for it. I am not sure whether *know-how* is at the moment already acceptable to all Americans, surely there is still hesitancy to be found about using the transitive verb *to contact* (instead of *to get in contact with*), too much reminiscent of the travelling salesman whose 'business' it is to 'contact people' – which means that certain strata of American society do not wish to be confused with salesmen nor to take their linguistic dictation without resistance. On the other hand, immediately when American meteorologists started calling hurricanes by girls' names (a practice that aroused polemics in many newspapers), I heard a quite well-educated lady saying seriously: '*Hazel* did us terrible damage'. Linguistic dictation by the 'weather-man' (who is supposed to be scientifically trained for his profession) is then not equally resented by the general public. Still more confusing, the current expression 'I agree with you 100 per cent', of doubtless commercial origin, has, become quite general in the United States (in spite of the '100 per cent American' that is hated here as elsewhere), probably because the exaggeration inherent in the expression is taken as a *polite* way of speech so that the commercial origin can be disregarded. In general, we may be allowed to state that acceptance of a neologism is conditioned among other things by the sociological status in the nation of the group to which the coiner belongs or is supposed to belong: in itself to *contact somebody* is not more reprehensible than *to coach somebody* and thousands of similar English verbs derived from nouns.

We know also that whole nations are more inclined toward linguistic innovation than others: the so-called 'younger' nations ('young' in the political sense) show a tendency to transgress the given linguistic framework more easily that the 'older ones' witness the frequent neologism with German or American writers in comparison with Italians or Frenchmen (it is as if a longer historical experience suggested that 'nothing is new under the sun' and that therefore the new experience can be fitted into the old word): the existentialism of Heidegger needs many more new coinages than that of Sartre although Sartre in his new vocabulary may look very 'German' to the Frenchman. But the innovations of both testify to an increased restlessness in our civilization which flows over even into the meditations of philosophy: how quietly conservative the writing of a Bergson or a Croce or of pre-Nietzschian German philosophers is in comparison with that of our contemporary philosophers! It is surely astonishing to find the contemporary philosophers infected with a restlessness that manifests itself only quantitatively less than in the contemporary commercial-technological world that capitalizes on the general restlessness of the modern *homo novarum rerum cupidus* (in its 'advertising', that is, its announcing of ever new things). If then the need for neologisms varies according to periods, nations, strata of society, individuals, it cannot be denied that variation of the given language is due to the desire for renewed

expressivity, that dissatisfaction with the constituted language is a basic feature of *all* speaking and the feature mainly responsible for linguistic change.

And now we may introduce the term that the reader may have expected to appear in connection with individual innovation: *style*. Style is usually defined either as the ensemble of those linguistic features found in a particular member of a community (generally a writer) which deviate from the generally accepted grammar, or, with Bally, the emotional (*affectif*) deviations from a more normal pattern, deviations that are available to all speakers of the particular language. Thus we have two 'stylistics': the treatment of the style of a writer which some- how defines his writing personality (this is the same concept of style as in the arts: 'Gothic style', 'Rabelais' style'), and the treatment of the variations imposed by emotion on the average speaker ('emotional style' being akin to 'emotional behavior'). While these two stylistics require different talents from those who cultivate them (artistic sensibility *vs.* sensitivity to linguistic nuances), they can be brought under one common denominator: in both cases style is *bent toward* emo- tionality and innovation (less so in Bally's 'general' *style affectif* than in the style that stems from the individual emotion of a writer) – it is the *creative* aspect of language which is not satisfied with the codified intellectualized language. 'Bally's style' is, of course, more on the way toward codification and grammar than the daring neologisms of artists of the word, but the *style affectif* may be expected to lead toward linguistic innovation of a more daring character. And very often what was once a daring innovation has become in the course of time codified, or grammaticized.

This fact is generally recognized in historical semantics (and has been best formulated by Hans Sperber): an expression which had originally possessed an emotional appeal becomes trite when repeated, it is deprived of that freshness that seems to correspond to a new impression. Our strong emotions are charac- terized by the feeling that something *unheard-of* has happened and would ask for words entirely free from the burden of the 'already known'; ultimately for 'proper names' or 'nonce-words' – this explains the wear and tear to which all originally emotional words, or stylistic innovations, are exposed: Latin *ponere* 'to put' was replaced in France by *mittere* 'to send' (a more dynamic word), but this in turn gives way in dialects to *bouter* 'to beat, slap' and in colloquial language to *foutre* 'coire' and its euphemistic companion *ficher* 'to stick'; but even here the stylistic innovation does not stop, and words such as *balancer* may attempt to nose into a situation which seems to consist in replacement becoming institutional. Here a note of caution is in order: while the new words give more emotional release to the listener it is not said that the first inventors of the neologisms were entirely under the sway of emotion: experience tells us that in truly emotional situations the most usual word will present itself; it is not conceivable that when faced with actual danger for our lives any other expression than the most com- mon one could be used: *fire!* or *safe!* [sic] would tolerate no paraphrase[3]. Also in expressions of mere functionality there is rarely found an emotional expansion entailing new coinages: witness the relatively unaltered preservation in all our languages through many centuries of such words as 'hand', 'foot', 'father', 'son', 'have', 'be', or the numerals and pronouns. In such cases the speaker seems truly dependent on the language as a communicative, not an expressive medium. Only

when the speaker dominates the situation and finds some, as it were, superfluous energy left to him, when he feels somewhat detached from the situation, will his linguistic imagination expand in words such as *mettre, bouter, foutre, balancer* (which are all exaggerations, or surplus-formations, in comparison with the concept they are called upon to replace). Thus we find again the innovator counting with an effect on his public, indeed aware of the fact that he is not using the proper word, that he is transgressing the boundary of common usage. This is indeed the meaning of the quotation-marks with which a stylistic neologism in its initial stage is introduced ('I am using this new term though I know it to be inappropriate; I know however that from a certain angle it could be said'). In this consciousness of the barriers imposed by the general word usage at the moment when these are in fact transcended, lies again that conservative impulse in the innovator which we saw before repeatedly in action. Any stylistic neologism at the moment of its creation is a daring leap into a world of 'as if', of irreality, the unchanged order of the language representing a well-known understandable reality – a risk taken by the speaker only in that generous *artistic* mood that admits more than one world as possible.

I was able to study the whole phenomenon of the stylistic neologisms, its artistic-expressive and its conservative-limited side, its emotional creation by individuals and its acceptance and trivialization by a community, under particularly favourable circumstances, when I was an Austrian censor of the correspondence of Italian prisoners in the first world war (cf. my book *Die Umschreibungen des Begriffes 'Hunger'* ... published in 1919). The poor prisoners had been forbidden to write to their Italian relatives that they were suffering hunger, but attempted all possible ways of linguistic subterfuge to make this fact known to them in order to receive food packages. And surely enough, the less imaginative prisoners (perhaps also the most pitifully suffering ones) hid the blunt statement *ho fame* in a corner of their letters, but others, more detached from their dire fate and more artistically gifted, found ingenious stylistic, in this case periphrastic, ways to circumvent *la Signora Censura*. The simplest device was to have recourse to idiomatic synonyms known to their relatives (but supposedly not to the censors) such as *la spazzola* (originally: '[we may as well use]'), the brush [because the meal is finished, because there is nothing to eat]'). So far the linguistic ground of common speech, even in this idiomatic form, was not yet transgressed, and the recourse to such a form was probably taken in different prison camps independently by individual speakers who gave the suggestion to their fellow prisoners (this is what Paul Kretschmer called the phenomenon of '*die Sprachschöpfer*'), of several independent speakers who dig up latent language material in a situation which calls for it: he observed the nearly simultaneous appearance, at several places in World War I Germany and Austria of the verb *to hamster* for 'to hoard' cigarettes, sugar, etc.). But then the artistic instinct (inborn in any Italian) took hold of the letter-writers and they varied the *spazzola*-motif stylistically with such a richness of imagination, such insistence and such exaggeration of the fantastic that their purpose of deceiving the censors was defeated. What had been intended as communication to their relatives, became a pure matter of artistic self-expression, a leap into an 'as if' world of fancy, of *préciosité*, of punning and allegory, of mixed metaphors, and it may also be suspected that, the more the expressive force of

the term *la spazzola* was gradually waning, the more sophisticated *fioriture* were used and ever new lustre was given to the by then trite metaphor. Here is just a small selection of such variations:

> 'my health is good, but *la spazzola* works night and day, for there are many clothes to brush'
>
> 'we have the brush, but not the grease to shine it'
>
> 'You say you want to send me a brush for my clothes; I don't need one; I have one with me, ever new, all the time; it is a nice brush'
>
> 'I have made the acquaintance of the lieutenants *Spazzola, Magrini* and *Stecchetti*'
>
> 'Give my love to the barber Gregorio and to the pharmacist Antonio, and also to *la signora Spazzola* of whom I dream every night. I feel her near, but am never able to see her; and she will not let me sleep because she is not satisfied'.
>
> '*La Spazzola* here sounds its dull grey notes'.

In all these passages with their recourse to devices of popular art (themselves easily cataloguable) one feels the mostly unwritten quotation-marks that designate the individual transgression of the usual framework of the common language and the individual's leap into the irreality of a world of words. This purely artistic urge to create new words and word-usages differs, of course, from the utilitarian coinage of terms of the type *Kodak*. Here a new *thing* that has been produced is to be named, there the word (or word-usage) names a thing (or aspect of a thing) that comes into being *thanks to the word*, thanks to the illusion that 'a thing' must correspond to the word. And there exists also a difference between the ulterior fate of a utilitarian and a poetic word: the former, the more it is linked with an outward, definite thing, the more it deteriorates in emotional-evocational power (the trademark is indeed fixed for ever – only a *new* trademark would be able to produce new emotional appeal); the poetic word, the poetically lived word (for example, *la spazzola*) on the contrary is susceptible of infinitely varied expansion and suggests a 'reality of irreality' that leaves the world of things far behind.

With the creation of pseudo-names by the prisoners of war such as *Spazzola, Magrini, Stecchetti* we have come to daring neologistic *Word-Formation* as the result of an emotion of dissatisfaction with the existing terms of the language. [...]

Notes

1 I appropriate this simile from Thurneysen who used it in the battle about the phonetic laws, contending that the latter do not act equally in all *words* of the language (the principle 'each word has its own history').

2 Is it too rash to suggest that in this innovating boldness as to 'naming things' coupled with conservatism as to the rest of the language, a basic structure of English, the language that engaged first in 'radical advertising', is reflected: the

rich word material of English coupled with a relatively simplified grammar, an openness to lexicological enrichment coupled with a closedness of the systematic structure? I think that we do not know yet whether at all in what manner these two contradictory features of English are connected: was the grammar of English simplified because of the rich vocabulary (that was imposed on the language because of historical reasons) or was the rich vocabulary made possible by the simplified grammar?

In any case, today all European languages share more or less with English an overswollen vocabulary called upon to designate the rich material content of our civilization while their basic structure remains intact. It was the deed of a genius, as Croce ironically wrote, that Stalin, toward the end of his life, with one stroke of the pen destroyed all previous Soviet ideology in declaring that the Soviet Russian language of today is still basically the language of Pushkin while the enormous economic and political change wrought by the Russian revolution only provided for some new words that were easily inserted into that structure.

3 An American lady reports to me on her feelings, in the moment of what seemed to her to be an imminent automobile accident, in the following terms: 'We've started running into something: so far, it isn't too bad; please don't let it go any farther; if it stops here it's OK'. One will notice the absence of any neologism: the simplest and most conventional conversational language was chosen (notice the American colloquialism 'OK'). It is as though when *things* narrated are beyond our imagination no linguistic embellishment were needed.

Raymond Williams

INTRODUCTION TO *KEYWORDS* (1976)

[...] I have emphasized this process of the development of *Keywords* because it seems to me to indicate its dimension and purpose. It is not a dictionary or glossary of a particular academic subject. It is not a series of footnotes to dictionary histories or definitions of a number of words. It is, rather, the record of an inquiry into a *vocabulary*: a shared body of words and meanings in our most general discussions, in English, of the practices and institutions which we group as *culture* and *society*. Every word which I have included has at some time, in the course of some argument, virtually forced itself on my attention because the problems of its meanings seemed to me inextricably bound up with the problems it was being used to discuss. I have often got up from writing a particular note and heard the same word again, with the same sense of significance and difficulty: often, of course, in discussions and arguments which were rushing by to some other destination. I began to see this experience as a problem of *vocabulary*, in two senses: the available and developing meanings of known words, which needed to be set down; and the explicit but as often implicit connections which people were making, in what seemed to me, again and again, particular formations of meaning – ways not only of discussing but at another level of seeing many of our central experiences. What I had then to do was not only to collect examples, and look up or revise particular records of use, but to analyse, as far as I could, some of the issues and problems that were there inside the vocabulary, whether in single words or in habitual groupings. I called these words *Keywords* in two connected senses: they are significant, binding words in certain activities and their interpretation; they are significant, indicative words in certain forms of thought. Certain uses bound together certain ways of seeing culture and society, not least in these two most general words. Certain other uses seemed to me to open up issues and problems, in the same general area, of which we all needed to be very much more conscious. Notes on a list of words; analyses of certain formations: these were the elements of an active vocabulary – a way of recording, investigating and pre-

senting problems of meaning in the area in which the meanings of *culture* and *society* have formed.

Of course the issues could not all be understood simply by analysis of the words. On the contrary, most of the social and intellectual issues, including both gradual developments and the most explicit controversies and conflicts, persisted within and beyond the linguistic analysis. Yet many of these issues, I found, could not really be thought through, and some of them, I believe, cannot even be focused unless we are conscious of the words as elements of the problems. This point of view is now much more widely accepted. When I raised my first questions about the differing uses of *culture* I was given the impression, in kindly and not so kind ways, that these arose mainly from the fact of an incomplete education, and the fact that this was true (in real terms it is true of everyone) only clouded the real point at issue. The surpassing confidence of any particular use of a word, within a group or within a period, is very difficult to question. I recall an eighteenth-century letter:

> What, in your opinion, is the meaning of the word *sentimental*, so much in vogue among the polite ...? Everything clever and agreeable is comprehended in that word ... I am frequently astonished to hear such a one is a *sentimental* man; we were a *sentimental* party; I have been taking a *sentimental* walk.

Well, that vogue passed. The meaning of *sentimental* changed and deteriorated. Nobody now asking the meaning of the word would be met by that familiar, slightly frozen, polite stare. When a particular history is completed, we can all be clear and relaxed about it. But *literature, aesthetic, representative, empirical, unconscious, liberal*: these and many other words which seem to me to raise problems will, in the right circles, seem mere transparencies, their correct use a matter only of education. Or *class, democracy, equality, evolution, materialism*: these we know we must argue about, but we can assign particular uses to sects, and call all sects but our own *sectarian*. Language depends, it can be said, on this kind of confidence, but in any major language, and especially in periods of change, a necessary confidence and concern for clarity can quickly become brittle, if the questions involved are not faced.

The questions are not only about meaning; in most cases, inevitably, they are about meanings. Some people, when they see a word, think the first thing to do is to define it. Dictionaries are produced and, with a show of authority no less confident because it is usually so limited in place and time, what is called a proper meaning is attached. I once began collecting, from correspondence in newspapers, and from other public arguments, variations on the phrases 'I see from my Webster' and 'I find from my Oxford Dictionary'. Usually what was at issue was a difficult term in an argument. But the effective tone of these phrases, with their interesting overtone of possession ('my Webster'), was to appropriate a meaning which fitted the argument and to exclude those meanings which were inconvenient to it but which some benighted person had been so foolish as to use. Of course if we want to be clear about *banxring* or *baobab* or *barilla*, or for that matter about *barbel* or *basilica* or *batik*, or, more obviously,

about *barber* or *barley* or *barn*, this kind of definition is effective. But for words of a different kind, and especially for those which involve ideas and values, it is not only an impossible but an irrelevant procedure. The dictionaries most of us use, the defining dictionaries, will in these cases, and in proportion to their merit as dictionaries, list a range of meanings, all of them current, and it will be the range that matters. Then when we go beyond these to the historical dictionaries, and to essays in historical and contemporary semantics, we are quite beyond the range of the 'proper meaning'. We find a history and complexity of meanings; conscious changes, or consciously different uses; innovation, obsolescence, specialization, extension, overlap, transfer; or changes which are masked by a nominal continuity so that words which seem to have been there for centuries, with continuous general meanings, have come in fact to express radically different or radically variable, yet sometimes hardly noticed, meanings and implications of meaning. *Industry*, *family*, *nature* may jump at us from such sources; *class*, *rational*, *subjective* may after years of reading remain doubtful. It is in all these cases, in a given area of interest which began in the way I have described, that the problems of meaning have preoccupied me and have led to the sharpest realization of the difficulties of any kind of definition.

The work which this book records has been done in an area where several disciplines converge but in general do not meet. It has been based on several areas of specialist knowledge but its purpose is to bring these, in the examples selected, into general availability. This needs no apology but it does need explanation of some of the complexities that are involved in any such attempt. These can be grouped under two broad headings: 'problems of information' and 'problems of theory'.

The problems of information are severe. Yet anyone working on the structures and developments of meaning in English words has the extraordinary advantage of the great *Oxford English Dictionary*. This is not only a monument to the scholarship of its editors, Murray, Bradley and their successors, but also the record of an extraordinary collaborative enterprise, from the original work of the Philological Society to the hundreds of later correspondents. Few inquiries into particular words end with the great dictionary's account, but even fewer could start with any confidence if it were not there. I feel with William Empson, who in *The Structure of Complex Words* found many faults in the dictionary, that 'such work on individual words as I have been able to do has been almost entirely dependent on using the majestic object as it stands'. But what I have found in my own work about the *OED*, when this necessary acknowledgment has been made, can be summed up in three ways. I have been very aware of the period in which the dictionary was made: in effect from the 1880s to the 1920s (the first example of the current series of Supplements shows addition rather than revision). This has two disadvantages: that in some important words the evidence for developed twentieth-century usage is not really available; and that in a number of cases, especially in certain sensitive social and political terms, the presuppositions of orthodox opinion in that period either show through or are not far below the surface. Anyone who reads Dr Johnson's great dictionary soon becomes aware of his active and partisan mind as well as his remarkable learning. I am aware in my own notes and essays that, though I

try to show the range, many of my own positions and preferences come through. I believe that this is inevitable, and all I am saying is that the air of massive impersonality which the *Oxford English Dictionary* communicates is not so impersonal, so purely scholarly, or so free of active social and political values as might be supposed from its occasional use. Indeed, to work closely in it is at times to get a fascinating insight into what can be called the ideology of its editors, and I think this has simply to be accepted and allowed for, without the kind of evasion which one popular notion of scholarship prepares the way for. Secondly, for all its deep interest in meanings, the *Dictionary* is primarily philological and etymological; one of the effects of this is that it is much better on range and variation than on connection and interaction. In many cases, working primarily on meanings and their contexts, I have found the historical evidence invaluable but have drawn different and at times even opposite conclusions from it. Thirdly, in certain areas I have been reminded very sharply of the change of perspective which has recently occurred in studies of language: for obvious reasons (if only from the basic orthodox training in dead languages) the written language used to be taken as the real source of authority, with the spoken language as in effect derived from it; whereas now it is much more clearly realized that the real situation is usually the other way round. The effects are complex. In a number of primarily intellectual terms the written language is much nearer the true source. If we want to trace *psychology* the written record is probably adequate, until the late nineteenth century. But if, on the other hand, we want to trace *job*, we have soon to recognize that the real developments of meaning, at each stage, must have occurred in everyday speech well before they entered the written record. This is a limitation which has to be recognized, not only in the dictionary, but in any historical account. A certain foreshortening or bias in some areas is, in effect, inevitable. Period indications for origin and change have always to be read with this qualification and reservation. I can give one example from personal experience. Checking the latest Supplement for the generalizing contemporary use of *communications*, I found an example and a date which happened to be from one of my own articles. Now not only could written examples have been found from an earlier date, but I know that this sense was being used in conversation and discussion, and in American English, very much earlier. I do not make the point to carp. On the contrary, this fact about the *OED* is a fact about any work of this kind, and needs especially to be remembered when reading my own accounts.

For certain words I have added a number of examples of my own, from both general and deliberate reading. But of course any account is bound to be incomplete, in a serious sense, just as it is bound to be selective. The problems of adequate information are severe and sometimes crippling, but it is not always possible to indicate them properly in the course of an analysis. They should, nevertheless, always be remembered. And of one particular limitation I have been very conscious. Many of the most important words that I have worked on either developed key meanings in languages other than English, or went through a complicated and interactive development in a number of major languages. Where I have been able in part to follow this, as in *alienation* or *culture*, its significance is so evident that we are bound to feel the lack of it when such tracing has not been possible. To do such comparative studies adequately would be

an extraordinary international collaborative enterprise, and the difficulties of that may seem sufficient excuse. An inquiry into the meanings of *democracy*, sponsored by UNESCO and intended to be universal and comparative, ran into every kind of difficulty, though even the more limited account that Naess and his colleagues had to fall back on is remarkably illuminating. I have had enough experience of trying to discuss two key English Marxist terms – *base* and *superstructure* – not only in relation to their German originals, but in discussions with French, Italian, Spanish, Russian and Swedish friends, in relation to their forms in these other languages, to know not only that the results are fascinating and difficult, but that such comparative analysis is crucially important, not just as philology, but as a central matter of intellectual clarity. It is greatly to be hoped that ways will be found of encouraging and supporting these comparative inquiries, but meanwhile it should be recorded that while some key developments, now of international importance, occurred first in English, many did not and in the end can only be understood when other languages are brought consistently into comparison. This limitation, in my notes and essays, has to be noted and remembered by readers. It is particularly marked in very early developments, in the classical languages and in medieval Latin, where I have almost invariably simply relied on existing authorities, though with many questions that I could not answer very active in my mind. Indeed, at the level of origins, of every kind, this is generally true and must be entered as an important reservation.

This raises one of the theoretical problems. It is common practice to speak of the 'proper' or 'strict' meaning of a word by reference to its origins. One of the effects of one kind of classical education, especially in conjunction with one version of the defining function of dictionaries, is to produce what can best be called a sacral attitude to words, and corresponding complaints of vulgar contemporary misunderstanding and misuse. The original meanings of words are always interesting. But what is often most interesting is the subsequent variation. The complaints that get into the newspapers, about vulgar misuse, are invariably about very recent developments. Almost any random selection of actual developments of meaning will show that what is now taken as 'correct' English, often including many of the words in which such complaints are made, is the product of just such kinds of change. The examples are too numerous to quote here but the reader is invited to consider only *interest* or *determine* or *improve*, though *organic*, *evolution* and *individual* are perhaps more spectacular examples. I have often found a clue to an analysis by discovery of an origin, but there can be no question, at the level either of practice or of theory, of accepting an original meaning as decisive (or where should we be with *aesthetic*?) or of accepting a common source as directive (or where should we be as between *peasant* and *pagan*, *idiot* and *idiom*, or *employ* and *imply*?). The vitality of a language includes every kind of extension, variation and transfer, and this is as true of change in our own time (however much we may regret some particular examples) as of changes in the past which can now be given a sacral veneer. (*Sacral* itself is an example; the extension from its physical sense of the fundament to its disrespectful implication of an attitude to the *sacred* is not my joke, but it is a meaningful joke and thence a meaningful use.)

The other theoretical problems are very much more difficult. There are quite

basic and very complex problems in any analysis of the processes of meaning. Some of these can be usefully isolated as general problems of signification: the difficult relations between words and concepts; or the general processes of sense and reference; and beyond these the more general rules, in social norms and in the system of language itself, which both enable sense and reference to be generated and in some large degree to control them. In linguistic philosophy and in theoretical linguistics these problems have been repeatedly and usefully explored, and there can be no doubt that as fundamental problems they bear with real weight on every particular analysis.

Yet just because 'meaning', in any active sense, is more than the general process of 'signification', and because 'norms' and 'rules' are more than the properties of any abstract process or system, other kinds of analysis remain necessary. The emphasis of my own analyses is deliberately social and historical. In the matters of reference and applicability, which analytically underlie any particular use, it is necessary to insist that the most active problems of meaning are always primarily embedded in actual relationships, and that both the meanings and the relationships are typically diverse and variable, within the structures of particular social orders and the processes of social and historical change.

This does not mean that the language simply reflects the processes of society and history. On the contrary, it is a central aim of this book to show that some important social and historical processes occur *within* language, in ways which indicate how integral the problems of meanings and of relationships really are. New kinds of relationship, but also new ways of seeing existing relationships, appear in language in a variety of ways: in the invention of new terms (*capitalism*); in the adaptation and alteration (indeed at times reversal) of older terms (*society* or *individual*); in extension (*interest*) or transfer (*exploitation*). But also, as these examples should remind us, such changes are not always either simple or final. Earlier and later senses coexist, or become actual alternatives in which problems of contemporary belief and affiliation are contested. It is certainly necessary to analyse these and other consequent problems as problems of general signification, but my emphasis here is on a vocabulary of meanings, in a deliberately selected area of argument and concern.

My starting point, as I have said, was what can be called a cluster, a particular set of what came to seem interrelated words and references, from which my wider selection then developed. It is thus an intrinsic aim of the book to emphasize interconnections, some of which seem to me in some new ways systematic, in spite of problems of presentation which I shall discuss. It can of course be argued that individual words should never be isolated, since they depend for their meanings on their actual contexts. At one level this can be readily conceded. Many of the variable senses that I have analysed are determined, in practice, by contexts. Indeed this is why I mainly illustrate the different senses by actual examples in recorded use.

Yet the problem of meaning can never be wholly dissolved into context. It is true that no word ever finally stands on its own, since it is always an element in the social process of language, and its uses depend on complex and (though variably) systematic properties of language itself. Yet it can still be useful to pick out certain words, of an especially problematical kind, and to consider, for the

moment, their own internal developments and structures. This is so even when the qualification, 'for the moment', is ignored by one kind of reader, who is content to reassert the facts of connection and interaction from which this whole inquiry began. For it is only in reductive kinds of analysis that the processes of connection and interaction can be studied as if they were relations between simple units. In practice many of these processes begin within the complex and variable sense of particular words, and the only way to show this, as examples of how networks of usage, reference and perspective are developed, is to concentrate, 'for the moment', on what can then properly be seen as internal structures. This is not to impede but to make possible the sense of an extended and intricate vocabulary, within which both the variable words and their varied and variable interrelations are in practice active.

To study both particular and relational meanings, then, in different actual speakers and writers, and in and through historical time, is a deliberate choice. The limitations are obvious and are admitted. The emphasis is equally obvious and is conscious. One kind of semantics is the study of meaning as such; another kind is the study of formal systems of signification. The kind of semantics to which these notes and essays belong is one of the tendencies within *historical semantics*: a tendency that can be more precisely defined when it is added that the emphasis is not only on historical origins and developments but also on the present – present meanings, implications and relationships – as history. This recognizes, as any study of language must, that there is indeed community between past and present, but also that *community* – that difficult word – is not the only possible description of these relations between past and present; that there are also radical change, discontinuity and conflict, and that all these are still at issue and are indeed still occurring. The vocabulary I have selected is that which seems to me to contain the key words in which both continuity and discontinuity, and also deep conflicts of value and belief, are in this area engaged. Such processes have of course also to be described in direct terms, in the analysis of different social values and conceptual systems. What these notes and essays are intended to contribute is an additional kind of approach, through the vocabulary itself.

For I believe that it is possible to contribute certain kinds of awareness and certain more limited kinds of clarification by taking certain words at the level at which they are generally used, and this, for reasons related to and probably clear from all my other work, has been my overriding purpose. I have more than enough material on certain words (for example *class* and *culture*) and on certain formations (for example *art, aesthetic, subjective, psychological, unconscious*) to write, as an alternative, extended specialist studies, some themselves of book length. I may eventually do this, but the choice of a more general form and a wider range was again deliberate. I do not share the optimism, or the theories which underlie it, of that popular kind of inter-war and surviving semantics which supposed that clarification of difficult words would help in the resolution of disputes conducted in their terms and often evidently confused by them. I believe that to understand the complexities of the meanings of *class* contributes very little to the resolution of actual class disputes and class struggles. It is not only that nobody can 'purify the dialect of the tribe', nor only that anyone who really knows himself to be a member of a society knows better than to want, in those terms, to

try. It is also that the variations and confusions of meaning are not just faults in a system, or errors of feedback, or deficiencies of education. They are in many cases, in my terms, historical and contemporary substance. Indeed they have often, as variations, to be insisted upon, just because they embody different experiences and readings of experience, and this will continue to be true, in active relationships and conflicts, over and above the clarifying experiences of scholars or committees. What can really be contributed is not resolution but perhaps, at times, just that extra edge of consciousness. In a social history in which many crucial meanings have been shaped by a dominant class, and by particular professions operating to a large extent within its terms, the sense of edge is accurate. This is not a neutral review of meanings. It is an exploration of the vocabulary of a crucial area of social and cultural discussion, which has been inherited within precise historical and social conditions and which has to be made at once conscious and critical – subject to change as well as to continuity – if the millions of people in whom it is active are to see it as active: not a *tradition* to be learned, nor a *consensus* to be accepted, nor a set of meanings which, because it is 'our language', has a natural authority; but as a shaping and reshaping, in real circumstances and from profoundly different and important points of view: a vocabulary to use, to find our own ways in, to change as we find it necessary to change it, as we go on making our own language and history. [...]

Muriel R. Schulz

THE SEMANTIC DEROGATION
OF WOMAN (1975)

The question of whether or not language affects the thought and culture of the people who use it remains to be answered. Even if we were to agree that it does, we would have difficulty calculating the extent to which the language we use influences our society. There is no doubt, on the other hand, that a language reflects the thoughts, attitudes, and culture of the people who make it and use it. A rich vocabulary on a given subject reveals an area of concern of the society whose language is being studied. The choice between positive and negative terms for any given concept (as, for example, in the choice between *freedom fighter* and *terrorist*) reveals the presence or absence of prejudicial feelings toward the subject. The presence of taboo reveals underlying fears and superstitions of a society. The occurrence of euphemism (*passed away*) or dysphemism (*croaked*) reveals areas which the society finds distasteful or alarming. To this extent, at least, analysis of a language tells us a great deal about the interests, achievements, obsessions, hopes, fears, and prejudices of the people who created the language.

Who are the people who created English? Largely men – at least until the present generation. Stuart Flexner (1960: xii) points out that it is mostly males who create and use slang, and he explains why. A woman's life has been largely restricted to the home and family, while men have lived in a larger world, belonged to many sub-groups, and had acquaintances who belonged to many other sub-groups. That men are the primary creators and users of the English language generally follows from the primary role they have traditionally played in English-speaking cultures. They have created our art, literature, science, philosophy, and education, as well as the language which describes and manipulates these areas of culture.

An analysis of the language used by men to discuss and describe women reveals something about male attitudes, fears, and prejudices concerning the female sex. Again and again in the history of the language, one finds that a per-

fectly innocent term designating a girl or woman may begin with totally neutral or even positive connotations, but that gradually it acquires negative implications, at first perhaps only slightly disparaging, but after a period of time becoming abusive and ending as a sexual slur.

That disparagement gravitates more toward terms for women than for men is evident from some matched pairs designating males and females. Compare, for example, the connotations of *bachelor* with those of *spinster* or *old maid*. Or compare the innocuousness of *warlock* with the insinuations of *witch*. *Geezer* "an eccentric, queer old man"[1] and *codger* "a mildly derogatory, affectionate term for an old man" carry little of the opprobrium of such corresponding terms for old women as *trot, hen, heifer, warhorse, crone, hag, beldam*, and *frump*. Furthermore, if terms designating men are used to denote a woman, there is usually no affront. On the other hand, use a term generally applied to women to designate a man, and you have probably delivered an insult. You may call a woman a *bachelor* without implying abuse, but if you call a man a *spinster* or an old maid, you are saying that he is "a prim, nervous person who frets over inconsequential details." If you speak of a woman as being a *warlock*, you may be corrected; if you say a man is a *witch*, he is presumed to have a vile temper. Or call a woman an old *man* and you have simply made an error of identification. Call a man an *old woman or a granny* and you have insulted him.

The term used to denote a semantic change whereby a word acquires debased or obscene reference is *pejoration*, and its opposite is *amelioration*. It is the purpose of this paper to study the pejoration of terms designating women in English and to trace the pattern whereby virtually every originally neutral word for women has at some point in its existence acquired debased connotations or obscene reference, or both.

The mildest form of debasement is a democratic leveling, whereby a word once reserved for persons in high places is generalized to refer to people in all levels of society. Even this mild form of derogation is more likely to occur with titles of women than with titles of men. *Lord*, for example, is still reserved as a title for deities and certain Englishmen, but any woman may call herself *a lady*. Only a few are entitled to be called Baronet and only a few wish to be called *Dame*, since as a general term, *dame* is opprobrious. Although *governor* degenerated briefly in nineteenth century Cockney slang, the term still refers to men who "exercise a sovereign authority in a colony, territory, or state." A *governess*, on the other hand, is chiefly "a nursemaid," operating in a realm much diminished from that of Queen Elizabeth I, who was acknowledged to be "the supreme majesty and governess of all persons" (OED). We might conceivably, and without affront, call the Queen's Equerry *a courtier*, but would we dare refer to her lady-in-waiting as *a courtesan*? Sir and Master seem to have come down through time as titles of courtesy without taint. However, *Madam, Miss*, and *Mistress* have all derogated, becoming euphemisms respectively for "a mistress of a brothel," "a prostitute," and "a woman with whom a man habitually fornicates."

The latter titles illustrate the most frequent course followed by pejorated terms designating women. In their downhill slide, they slip past respectable women and settle upon prostitutes and mistresses. When *abbey, academy*, and *nunnery* became euphemisms for "brothel," *abbess* acquired the meaning "keeper of a

brothel," *academician*, "a harlot," and *nun*, "a courtesan." (Here, at last, one male title was also pejorated. *Abbott* at the same time came to mean "the husband, or preferred male of a brothel keeper.") Although technically *queen* has withstood pejoration in English (*princess* has not), a thinly veiled homonym has existed side-by-side with it since Anglo-Saxon times. The *queen* is "the consort of the king" or "a female sovereign," whereas *quean* means "prostitute." Spelling has kept the two terms apart visually (both derived from the same Old English root, *cwen* "woman"), but as homonyms they have long provided writers with material for puns. Thus, in *Piers Plowman* (IX, 46) we are told that in the grave one cannot tell "a knight from a knave, or a quean from a queen," and Byron calls Catherine the Great "the Queen of queans" (*Don Juan*, Canto 6, Stanza xcvi).

Female kinship terms have also been subject to a kind of derogation which leaves the corresponding male terms untouched. *Wife* was used as a euphemism for "a mistress" in the fifteenth century, as was *squaw* in America during World War II. Niece has been used as a euphemism for "a priest's illegitimate daughter or concubine," and surely Humbert Humbert was not the first man to hide his mistress behind the locution, *daughter*. Browning uses *cousin* as an evasive term for Lucrezia's lover in "Andrea del Sarto" (1. 200). As a term for a woman, it was cant for "a strumpet or trull" in the nineteenth century. And *aunt* was generalized first to mean "an old woman" and then "a bawd or a prostitute." It is the latter meaning which Shakespeare draws upon in the lines: "Summer songs for me and my aunts/As we lie tumbling in the hay" (*Winter's Tale*, IV, 3, 11–12). Even *mother* was used as a term for "a bawd" and *sister* as a term for "a disguised whore" in the seventeenth century.

Terms for domestics are also more subject to pejoration if they denote females. *Hussy* derives from Old English *huswif* "housewife" and at one time meant simply "the female head of the house." Its degeneration was gradual. It declined in reference to mean "a rustic, rude woman"; then it was used as an opprobrious epithet for women in general; and finally it referred to "a lewd, brazen woman or a prostitute." In their original employment, a *laundress* made beds, a *needlewoman* came in to sew, a *spinster* tended the spinning wheel, and a *nurse* cared for the sick. But all apparently acquired secondary duties in some households, because all became euphemisms for "a mistress" or "a prostitute" at some time during their existence.

One generally looks in vain for the operation of a similar pejoration of terms referring to men. *King, prince, father, brother, uncle, nephew, footman, yeoman, or squire*, for example, have failed to undergo the derogation found in the history of their corresponding feminine designations. Words indicating the station, relationship, or occupation of men have remained untainted over the years. Those identifying women have repeatedly suffered the indignity of degeneration, many of them becoming sexually abusive. It is clearly not the women themselves who have coined and used these terms as epithets for each other. One sees today that it is men who describe and discuss women in sexual terms and insult them with sexual slurs, and the wealth of derogatory terms for women reveals something of their hostility.

If the derogation of terms denoting women marks out an area of our culture found contemptible by men, the terms they use as endearments should tell us

who or what they esteem. Strangely enough, in English the endearments men use for women have been just as susceptible to pejoration as have the terms identifying the supposedly beloved object itself. *Dolly, Kitty, Biddy, Gill* (or *Jill*), and *Polly* all began as pet names derived from nicknames. All underwent derogation and eventually acquired the meaning of "a slattern," "a mistress," or "a prostitute." *Jug* and *Pug*, both originally terms of endearment, degenerated to apply contemptuously to "a mistress or a whore," *Mopsy*, a term of endearment still found in Beatrix Potter's *Peter Rabbit*, for centuries also meant "a slatternly, untidy woman," as well. *Mouse* began as a playful endearment, but came to mean "a harlot, especially one arrested for brawling or assault." Even *sweetheart* meant "one loved illicitly" in the seventeenth century, although it has ameliorated since. Duncan MacDougald (1961:594) describes the course all of these endearments seem to have followed: "'*Tart*,' referring to a small pie or pastry, was first applied to a young woman as a term of endearment, next to young women who were sexually desirable, then to women who were careless in their morals, and finally – more recently – to women of the street."

If endearments for young girls have undergone pejoration, so have terms denoting girls and young women. *Doll* "a small-scale figure of a human being" referred first to "a young woman with a pretty babyish face," then became an insulting epithet for women generally, and finally acquired the meaning of "a paramour." *Minx* originally meant "a pert, young girl," and this meaning exists today, despite its pejoration to "a lewd or wanton woman; a harlot." *Nymph* and *nymphet* both referred to beautiful young girls, or women. *Nymph* became a euphemism in such phrases as "nymph of the pave" and "nymph of darkness," while *nymphet* acquired the derogated meaning of "a sexually precocious girl; a loose young woman." *Peach* is an enduring metaphor for "a luscious, attractive girl or woman," but around 1900 it, too, degenerated to mean "a promiscuous woman." *Broad* was originally used with no offensive connotations for "a young woman or a girl" (Wentworth and Flexner, 1960), but it acquired the suggestion of "a promiscuous woman" or "a prostitute." *Floozie*, first "an attractive but uncultivated girl," pejorated to mean "an undisciplined, promiscuous, flirtatious young woman; cynical, calculating." *Girl*, itself, has a long history of specialization and pejoration. It meant originally "a child of either sex"; then it was specialized to mean "a female child"; later it meant "a serving girl or maidservant"; and eventually it acquired the meanings "a prostitute," "a mistress," or "the female sex – or that part of it given to unchastity." Today *girl* has ameliorated (but *girlie* has sexual undertones), and we can call a female child, a *sweetheart*, or even a woman a *girl* without insult (although the emcee who jollies along the middle-aged "girls" in the audience is plainly talking down to them).

That emcee has a problem, though. There just aren't many terms in English for middle-aged or older women, and those which have occurred have inevitably taken on unpleasant connotations. Even a relatively innocuous term like *dowager* is stigmatized. *Beldam* is worse. Formed by combining the English usage of *dam* "mother" with *bel* indicating the relationship of a grandparent, it simply meant "grandmother" in its earliest usage. It was later generalized to refer to any "woman of advanced age," and, as so frequently happens with words indicating "old woman," it pejorated to signify "a loathsome old woman; a hag." *Hag*, itself,

originally meant simply "a witch" and was later generalized as a derisive term for "an ugly old woman," often with the implication of viciousness or maliciousness. Julia Stanley (1973) records it as a synonym for "a prostitute." *Bat* followed the opposite course. Originally a metaphor for "prostitute" (a "night bird"), it has become a generalized form of abuse meaning simply "an unpleasant woman, unattractive." It still bears the taint of its earlier metaphoric use, however, and is banned on TV as an epithet for a woman (Wentworth and Flexner, 1960) *Bag* meant "a middle-aged or elderly slattern" or "a pregnant woman" before it came to mean "a slatternly prostitute" or "a part-time prostitute" in the late nineteenth century. In the U.S. it has ameliorated slightly and refers (still derisively) to "an unattractive, ugly girl; an old shrew."

To be fat and sloppy is just as unforgivable in a woman as is being old, and the language has many terms designating such a person (are there any designating slovenly men?) – terms which have undergone pejoration and acquired sexual overtones at one time or another. A *cow* "a clumsy, obese, coarse, or otherwise unpleasant person" became specialized to refer chiefly to women and then acquired the additional sense of "a degraded woman" and eventually "a prostitute." *Drab* (also occurring as *drap*) originally referred to "a dirty, untidy woman," but was further pejorated to refer to "a harlot or prostitute." Both *slut* and *slattern* were first used to designate "a person, especially a woman, who is negligent of his appearance." Both acquired the more derogatory meaning "a woman of loose character or a prostitute," and both are currently polysemantic, meaning concurrently "a sloppy woman" or "a prostitute." *Trollop*, another word for "an unkempt woman," extended to mean "a loose woman," and eventually, "a hedge whore," *Mab*, first "a slattern" and then "a woman of loose character" seems to have withstood the third logical step of degeneration in England. In the U.S., however, it is used as an epithet for "a prostitute," as well.

Horse metaphors used to denote women have also undergone sexual derogation. *Harridan* "a worn-out horse" seems to have originally been used as a metaphor for "a gaunt woman," then "a disagreeable old woman," and later "a decayed strumpet" or "a half-whore, half-bawd." A *jade* was originally "a broken-down, vicious or worthless horse," or else such a man, as is illustrated in the lines from *The Taming of the Shrew*: "Gremio: What! This gentleman will outtalk us all. / Lucentio: Sir. Give him head. I know he'll prove a jade" (I, 2, 249). It became a contemptuous epithet for women, however, and was eventually another synonym for "whore." A *hackney* (or *hack*) was first "a common riding horse, often available for hire." Its meaning was extended to encompass, with derogatory connotations, anyone who hires himself out (hence *hack writer*), but when used for women it acquired sexual overtones as a metaphor for "a woman who hires out as a prostitute" or for "a bawd." A *tit* referred either to "a small horse" or "a small girl," but degenerated to mean "a harlot." There is in all of these horse metaphors, perhaps, the sense of a woman as being a *mount*, a term used indifferently for "a wife" or "a mistress" in the nineteenth century.

All these terms originated as positive designations for women and gradually degenerated to become negative in the milder instances and abusive in the extremes. A degeneration of endearments into insulting terms for men has not occurred. Words denoting boys and young men have failed to undergo the

pejoration so common with terms for women. *Boy, youth, stripling, lad, fellow, puppy*, and *whelp*, for example, have been spared denigration. As for terms for slovenly, obese, or elderly men, the language has managed with very few of them. A similar sexual difference is evident in terms which originated as words denoting either sex. Often, when they began to undergo pejoration they specialized to refer solely to women in derogatory terms. Later they frequently underwent further degeneration and became sexual terms of abuse. *Whore* is a well-known example of the process. Latin *carus* "dear" is a derivative of the same Indo-European root. It was probably at one time a polite term (Bloomfield, 1933: 401). Originally it seems to have referred to "a lover of either sex," but eventually it specialized to refer solely to women. Later it degenerated to meaning "a prostitute," and it became a term occurring only in "coarse, abusive speech" (*OED*). A *harlot* was originally "a fellow of either sex," referring more to men than to women in Middle English and characterizing them as "riffraff." It degenerated further, and Shakespeare's *harlot King* (*Winter's Tale,* II, 3, 4) was characterized as "lewd." However, after Elizabethan times the word was specialized for women only, meaning first "a disreputable woman" and later, specifically, "a prostitute." *Bawd*, similarly, originally referred to a "go-between or panderer of either sex," but after 1700 it was used only for women, either as "a keeper of a brothel" or "a prostitute." *Wench*, "a child of either sex," had sufficient prestige to appear in *Piers Plowman* in the phrase *Goddes Wench* "the Virgin Mary" (I.336). Later it was specialized to refer to "a rustic or working woman." As do so many terms referring to rustics, male or female (compare *villain*, *boor*, *peasant*, *churl*, for example), the term degenerated. Then it acquired sexual undertones, coming to refer first to "a lewd woman" and finally to "a wanton." *Wench* has been rehabilitated and has lost its stigma. Today it can be used to refer to a woman without suggesting wantonness. Another term which specialized to refer to women, then degenerated to the point of abusiveness, and later ameliorated is *cat*. Originally it was a term of contempt for "any human being who scratches like a cat." Later it was specialized to refer to "a spiteful, backbiting woman" (a usage which survives). For a period it meant "a prostitute," but this sexual taint was lost in the nineteenth century, and only the less denigrating (but still pejorative) sense of "spiteful woman" remains.

A comparison of the metaphors *cat* and *dog* illustrates the difference evident in many terms designating male and female humans. The term for the female is more likely to become pejorative, more likely to acquire sexual suggestions, and less likely to be transferable to a male. *Cat* originally meant "any spiteful person," but specialized to refer only to women. It remains an abusive term for women. *Dog* is only "sometimes used contemptuously for males." More frequently it is used "in half-serious chiding" (Farmer and Henley, 1965) as in *He's a sly dog*, or to mean "a gay, jovial, gallant fellow" (*OED*), as in *Oh, you're a clever dog!* However, *dog* has recently been transferred to women, and it occurs in totally negative contexts, meaning either "a woman inferior in looks, character, or accomplishments" or "a prostitute." Or compare the use of *bitch*. It is an abusive term when applied to a woman, meaning either "a malicious, spiteful, domineering woman" or "a lewd or immoral woman." When applied to a man it is "less opprobrious and somewhat whimsical – like the modern use of *dog*" (*OED*). *Pig*, applied contemptuously to men, means "a person who in some way behaves

like a pig." When applied to a woman, it means "a woman who has sloppy morals." *Sow* is not transferable to men. It is an abusive metaphor for "a fat, slovenly woman," which in the U.S. has acquired the additional sense of "a promiscuous young woman or a prostitute."

Robin Lakoff (1973) has pointed out that metaphors and labels are likely to have wide reference when applied to men, whereas metaphors for women are likely to be narrower and to include sexual reference. She uses as an example the term *professional*. If you say that a man is a *professional*, you suggest that he is a member of one of the respected professions. If you call a woman a *professional*, you imply that she follows "the oldest profession." In a similar way, if you call a man a *tramp* you simply communicate that he is "a drifter." Call a woman a *tramp* and you imply that she is "a prostitute." Historically, terms like *game, natural, jay, plover*, and *Jude* have meant merely "simpleton or dupe" when applied to men, but "loose woman or prostitute" when applied to women. A male *pirate* is "one who infringes on the rights of others or commits robbery on the high seas," whereas a female *pirate* is "an adultress who chases other women's men."

What is the cause of the degeneration of terms designating women? Stephen Ullman (1967: 231–32) suggests three origins for pejoration: association with a contaminating concept, euphemism, and prejudice. As for the first possibility, there is some evidence that contamination is a factor. Men tend to think of women in sexual terms whatever the context, and consequently any term denoting women carries sexual suggestiveness to the male speaker. The subtle operation of this kind of contamination is seen in the fortunes of such words as *female, lady*, and *woman. Woman* was avoided in the last century, probably as a Victorian sexual taboo, since it had acquired the meaning "paramour or mistress" or the sense of intercourse with women when used in plural, as in *Wine, Women, and Song*. It was replaced by *female*, but this term also came to be considered degrading and indelicate. Freyer (1963: 69) tells that "When the Vassar Female College was founded in 1861, Mrs. Sarah Josepha Hale, editor of *Godey's Lady's Book*, spent six years in securing the removal of the offending adjective from the college sign." The *OED* recorded *female* as a synonym "avoided by writers," and the Third identifies it as a disparaging term when used for women. It was replaced in the 19th century by *lady*, which Mencken (1963: 350) called "the English euphemism-of-all-work." *Lady* also vulgarized, however, and by the time Mencken wrote, it was already being replaced by *woman*, newly rehabilitated. Even so neutral a term as *person*, when it was used as a substitute for *woman*, suffered contamination which Greenough and Kittredge found amusing (1901: 326): "It has been more or less employed as a substitute for *woman* by those who did not wish to countenance the vulgar abuse of *lady* and yet shrank from giving offense. The result has been to give a comically slighting connotation to one of the most innocent words imaginable."

Despite this repeated contamination of terms designating women, we cannot accept the belief that there is a quality inherent in the concept of *woman* which taints any word associated with it. Indeed, the facts argue against this interpretation. Women are generally acknowledged to be – for whatever reasons – the more continent of the two sexes, the least promiscuous, and the more monogamous. Nevertheless, the largest category of words designating humans in sexual

terms are those for women — especially for loose women. I have located roughly a thousand words and phrases describing women in sexually derogatory ways.[2] There is nothing approaching this multitude for describing men. Farmer and Henley (1965), for example, have over five hundred terms (in English alone) which are synonyms for *prostitute*. They have only sixty-five synonyms for *whoremonger*.

As for the second possibility, one must acknowledge that many terms for "women of the night" have arisen from euphemism — a reluctance to name the profession outright. The majority of terms, however, are dysphemistic, not euphemistic. For example, the bulk of terms cited by Farmer and Henley (1965) as synonyms for *prostitute* are clearly derogatory: *broadtail, carrion, cleaver, cocktail, flagger, guttersnipe, mutton, moonlighter, omnibus, pinchprick, tail trader, tickletail, twofer* and *underwear* are just a few.

The third possibility — prejudice — is the most likely source for pejorative terms for women. They illustrate what Gordon Allport calls (1954: 179) "the labels of primary potency" with which an in-group stereotypes an out-group. Certain symbols, identifying a member of an out-group, blind the prejudiced speaker to any qualities the minority person may have which contradict the stereotype. "Most people are unaware of this basic law of language — that every label applied to a given person refers properly only to one aspect of his nature. You may correctly say that a certain person is *human, a philanthropist, a Chinese, a physician, an athlete*. A given person may be all of these but the chances are that *Chinese* stands out in your mind as the symbol of primary potency. Yet neither this nor any other classificatory label can refer to the whole of a man's nature." Antifeminism, he points out, contains the two basic ingredients of prejudice: denigration and gross overgeneralization (p. 34).

Derogatory terms for women illustrate both qualities which Allport attributes to prejudice. And what is the source or cause of the prejudice? Several writers have suggested that it is fear, based on a supposed threat to the power of the male. Fry (1972: 131) says of male humor: "In man's jokes about sex can be found an answer as to why man is willing to forgo to a large extent the satisfactions of a reality and equality relationship with his fellow mortal, woman. Part of this answer has to do with the question of control or power." He theorizes that power becomes a question because the male is biologically inferior to the female in several respects. Girls mature earlier than boys physically, sexually, and intellectually. Boys are biologically frailer in their first years of life than girls. At the other end of their life span, they also prove to be weaker. More men have heart attacks, gout, lung cancer, diabetes, and other degenerative diseases than women. Finally, they deteriorate biologically and die earlier than women. Fry (1972: 133) continues: "The jokes men tell about the relationships between the sexes — especially the frankly sexual jokes — reveal awareness and concern, even anxiety, about the general presence of these biologic disadvantages and frailties."[3] Grotjahn (1972: 53) concurs that anxiety prompts man's hostility, but he believes the source is fear of sexual inadequacy. A woman knows the truth about his potency; he cannot lie to her. Yet her own performance remains a secret, a mystery to him. Thus, man's fear of woman is basically sexual, which is perhaps the reason why so many of the derogatory terms for women take on sexual connotations.

I began with the acknowledgment that we cannot tell the extent to which any

language influences the people who use it. This is certainly true for most of what we call *language*. However, words which are highly charged with emotion, taboo, or distaste do not only reflect the culture which uses them. They teach and perpetuate the attitudes which created them. To make the name of God taboo is to perpetuate the mystery, power, and awesomeness of the divine. To surround a concept with euphemisms, as Americans have done with the idea of death, is to render the reality of the concept virtually invisible. And to brand a class of persons as obscene is to taint them to the users of the language. As Mariana Birnbaum (1971: 248) points out, prejudicial language "always mirror[s] generalized tabloid thinking which contains prejudices and thus perpetuates discrimination." This circularity in itself is justification for bringing such linguistic denigration of women to a conscious level. The semantic change discussed here, by which terms designating women routinely undergo pejoration, both reflects and perpetuates derogatory attitudes toward women. They should be abjured.

Notes

1 Citations are based upon, but are not necessarily direct quotations from, the *Oxford English Dictionary*, cited henceforth as (OED), *Webster's Third International* (Third), the *Dictionary of American slang* (Wentworth and Flexner, 1960), *Slang and its Analogues* (Farmer and Henley, 1965), *A Dictionary of Slang and Unconventional English* (Partridge, 1961), and the *American Thesaurus of Slang* (Berrey and Van den Bark, 1952). Sources are only indicated if the source is other than one of the above, or if the citation contains unusual information.

2 I have restricted myself in this paper to terms which have undergone the process of pejoration or amelioration – terms which have not always been abusive. The majority of derogatory words for women, of course, were coined as dysphemisms and are, hence, outside the scope of my study. In Farmer and Henley (1965), the chief entry containing synonyms for "prostitute" is *tart*, while for "whoremonger" it is *mutton-monger*. There are, in addition to the English synonyms, over 200 French phrases used to refer to women in a derogatory and sexual way, and another extended listing occurs under the entry *barrack-hack*. Stanley (1973) lists 200, and I found another 100, culled chiefly from Fryer (1963), Sagarin (1962), Berrey and Van den Bark (1952), Partridge (1961), and Wentworth and Flexner (1960).

3 Bettelheim and Janowitz (1950: 54–55) also cite anxiety as the source of prejudice. They argue that the prejudiced person "seeks relief through prejudice, which serves to reduce anxiety because prejudice facilitates the discharge of hostility, and if hostility is discharged anxiety is reduced. Prejudice reduces anxiety because it suggests to the person that he is better than others, hence does not need to feel so anxious."

References

Allport, Gordon W. (1954) *The Nature of Prejudice*, Cambridge, MA: Addison-Wesley.

Berrey, Lester V. and Van den Bark, Melvin (1952) *The American Thesaurus of Slang*, New York: Thomas Y. Crowell.

Bettelheim, Bruno and Janowitz, Morris (1950) *Dynamics of Prejudice*, New York: Harper & Row.

Birnbaum, Mariana D. (1971) "On the language of prejudice", *Western Folklore*, 30, pp. 247–68.

Bloomfield, Leonard (1933) *Language*, New York: Henry Holt.

Farmer, J. S. and Henley, W. E. (1965) *Slang and its Analogues*, Repr. of 7 vols. publ. 1890–1904, New York: Kraus Reprint Corp.

Flexner, Stuart (1960) Preface to Harold Wentworth and Stuart Flexner (eds), *Dictionary of American Slang*, New York: Thomas Y. Crowell.

Fry, William P. (1972) "Psychodynamics of sexual humor: man's view of sex", *Medical Aspects of Human Sexuality* 6, pp. 128–34.

Fryer, Peter (1963) *Mrs. Grundy: Studies in English Prudery*, London: Dennis Dobson.

Gove, Philip (ed.) (1971) *Webster's Third New International Dictionary*, Springfield, MA: G. & C. Merriam.

Greenough, James Bradstreet and Kittredge, George Lyman (1901) *Words and Their Ways in English Speech*, New York: Macmillan.

Grotjahn, Martin (1972) "Sexuality and humor. Don't laugh!", *Psychology Today* 6, pp. 51–3.

Lakoff, Robin (1973) "Language and woman's place", *Language in Society* 2, pp. 45–80.

Lewis, C. S. (1961) "Four-letter words," *Critical Quarterly* 3, pp. 118–22.

MacDougald, Duncan, Jr. (1961) "Language and sex", in Albert Ellis and Albert Abarbanel (eds), *The Encyclopedia of Sexual Behavior*, London: Hawthorne Books, Vol. II.

Mencken, H. L. (1963) *The American Language. The Fourth Edition and the Two Supplements.* Abridged and ed. by Raven I. McDavid, Jr., New York: Knopf.

Oxford English Dictionary (1933) Oxford: Clarendon Press.

Partridge, Eric (ed.) (1961) *A Dictionary of Slang and Unconventional English*, 5th edn., New York: Macmillan.

Sagarin, Edward (1962) *The Anatomy of Dirty Words*. New York: Lyle Stuart.

Stanley, Julia (1973) "The metaphors some people live by", Unpublished mimeo.

Thass-Thienemann, Theodore (1967). *The Subconscious Language*, New York: Washington Square Press.

Ullman, Stephen (1967) *Semantics. An Introduction to the Science of Meaning*, New York: Barnes & Noble.

Wentworth, Harold and Flexner, Stuart Berg (eds) (1960) *Dictionary of American Slang*, New York: Thomas Y. Crowell.

Deborah Cameron

PROBLEMS OF 'PRESCRIPTIVISM' (1995)

[...] In the discourse of linguistics (a phrase I use advisedly, acknowledging that some linguists dissent from the received views of their discipline) the term 'prescriptivism' has a particular value attached to it, a negative connotation that is almost impossible to avoid. This is problematic for me because it tends to pre-empt certain questions I particularly want to ask.

Prescriptivism is negative for linguists in two senses. First, it is negative in the everyday sense of being a bad or wrong thing. The typical attitude to it among linguists runs the gamut from despair at prescribers' ignorance to outrage at their bigotry, and is aptly if apocalyptically summed up in the title of a 1950 book by Robert Hall, *Leave Your Language Alone*. Apart from its sternly negative tone, which is obvious enough, this title also implies a separation of language from its users: rather like those shop assistants and bank clerks who complain that if only the customers would stop bothering them they would be able to get on with some work, the phrase 'leave your language alone' suggests that language would be better off without the constant unwelcome attentions of its speakers.

This is an attitude that I would want to question. When I suggested earlier that making value judgements on language is an integral part of using it and not an alien practice 'perversely grafted on', I was implicitly taking issue with the assumptions made in this finger-wagging tradition, where the evaluative concerns of speakers (embodied in their 'prescriptivism') are by implication seen as both alien and perverse.

One important point to make about the anti-prescriptivist 'leave your language alone' tradition within linguistics is that in a certain sense it mirrors the very same value-laden attitudes it seems to be criticizing. All attitudes to language and linguistic change are fundamentally ideological, and the relationship between popular and expert ideologies, though it is complex and conflictual, is closer than one might think.

As an illustration of this, let us consider the following observation on popular folklinguistic attitudes made by the sociolinguist James Milroy (1992: 31–2):

> The belief that language change is dysfunctional is most clearly expressed in popular attitudes to language. These commonly conceive of languages as ideal and perfect structures, and of speakers as awkward creatures who violate these perfect structures by misusing and corrupting 'language.' . . . These attitudes are strongly expressed and highly resistant to rational examination.

A striking thing about this observation is that, with only a few modifications, it could equally stand as an account of prevailing attitudes to prescriptivism among linguists (the changes are marked here by the use of italics):

> The belief that *prescriptivism* is dysfunctional is most clearly expressed in *expert* attitudes to language. These commonly conceive of languages as *naturally variable and changing* structures, and of speakers as awkward creatures who violate these *natural* structures by misusing and corrupting 'language.' . . . These attitudes are strongly expressed and highly resistant to rational examination.

Clearly, there are significant differences between these two versions. The 'folk' version valorizes some unspecified quality of 'perfection', and advocates active intervention to protect it, while the 'expert' version valorizes what linguists regard as 'natural' – variability – and therefore advocates leaving languages alone. But we can surely agree that there are also similarities: neither the folk nor the expert view is neutral with respect to what is 'good' linguistically speaking, and both views distinguish between language (perfect/natural) and speakers (corrupters of perfection/naturalness). Linguists and non-linguists each defend what they consider to be the natural order of things. The result is that the folk view of all language change is displaced in linguistics on to one particular sort of change: that which results from prescriptive 'interference'.

An excellent example of this attitude (and one which I will discuss in more detail later on) can be found in a recent popular book by the linguist Robin Lakoff, *Talking Power* (1990). Lakoff asserts (p. 298):

> For change that comes spontaneously from below, or within, our policy should be, Let your language alone, and leave its speakers alone! But other forms of language manipulation have other origins, other motives, other effects, and are far more dangerous.

For Lakoff there is a difference between 'spontaneous' changes, which should be 'let alone', and 'other forms of language manipulation' which do not arise spontaneously but are engineered deliberately, and are 'far more dangerous'. In other words language change is healthy only when it comes 'from below, or within' – that is, without the conscious agency of language-users.

The idea of language as a natural phenomenon existing apart from its users is associated historically with the nineteenth-century precursor of modern linguistics, comparative philology. It has 'expert' rather than 'folk' roots, though by now it is part of folk wisdom as well. James Milroy cites it precisely in order to

challenge it: as he says (1992: 23), 'it is not true that language is a living thing (any more than swimming, or bird song, is a living thing): it is a vehicle for communication *between* living things, namely human beings.' His own approach places emphasis on the activities of speakers and stresses that 'the language' is always an abstraction or idealization.

On the other hand, Milroy does appear to share the expert view of prescription as unnatural interference that sets arbitrary limits on the inherent variability of languages (cf. Milroy and Milroy 1985). While he castigates earlier historians of language for their own unnoticed, prostandard prejudices, he seems less acutely aware of the value judgement implied by the conventional use of such terms as 'natural' in relation to variation and change. If 'natural' here means something like 'observed to occur in all speech communities to a greater or lesser extent', then the kind of norm-making and tinkering linguists label 'prescriptive' is 'natural' too: not all languages and varieties undergo the institutional processes of standardization, but all are subject to some normative regulation. If we accept Milroy's point that language is not a living thing but a social practice of living things, then the processes affecting it are social processes.[1]

The linguist's (often extreme) distaste for prescriptivism is, I have been arguing, an ideologically non-neutral one dependent on value judgements that are 'highly resistant to rational examination'. But there is more to this anti-prescriptive stance than moral indignation. Prescriptivism is also a negative term for linguists in a more technical sense. It is the disfavoured half of a binary opposition, 'descriptive/prescriptive'; and this binarism sets the parameters of linguistics as a discipline. The very first thing any student of linguistics learns is that 'linguistics is descriptive not prescriptive – concerned, in the way of all science, with objective facts and not subjective value judgements. Prescriptivism thus represents the threatening Other, the forbidden; it is a spectre that haunts linguistics and a difference that defines linguistics.

Again, this absolute binary distinction is something I prefer not to take for granted. I have already tried to show that anti-prescriptive discourse makes value judgements about language, just as prescriptive discourse does; but there are additional reasons to be sceptical of the claims of linguistics to be 'descriptive not prescriptive'. Those claims have been criticized as incoherent by a number of linguists and philosophers. To put in a nutshell what is argued at length in their various critiques (e.g. Baker and Hacker 1984; Harris 1980, 1981; Taylor 1990), the standard notion of linguistic rules as 'descriptive' – crudely, 'natural' rather than normative – is either disingenuous or it is a category mistake.

'Descriptive rules' are formulae which capture the patterned regularities in language. That such regularities exist is not in doubt, nor is the fact that many are below the level of speakers' consciousness. Yet this is hardly a warrant for claiming that the same rules the linguist formulates are either 'in the language' (as a structural linguist might assume) or 'in the speaker' (as a post-Chomskyan mentalist might claim). Language-using is a social practice: the human capacity for acquiring and using language is necessarily actualized within social relationships. Thus the sort of behavioural regularity captured in a rule must arguably arise in the first place from speakers' apprehending and following certain norms.

One of the factors at stake in this argument is the nature and scope of author-

ity in language. Both in traditional grammar and in modern linguistics, the conventional way of expressing a rule is in a simple declarative statement, such as 'a verb agrees with its subject in number' – a convention suggesting naturalness rather than normativity. But as Talbot Taylor (1990) observes, we are not fooled when other injunctions are phrased in this way into thinking they embody some kind of natural law instead of mere temporal authority. 'There is no smoking anywhere on the London Underground', for example, means not that lighting up has been rendered impossible by a convenient act of God, nor that a scientist has ascertained the empirical validity of the generalization, but that smoking has been forbidden by the relevant authority, London Transport. In more general matters of social behaviour it is not always so easy to identify the relevant authority, or to know whence it derives its legitimacy. But to deny that authority could be at work (by saying, for instance, that such-and-such a usage is 'just a fact about the grammar of x') is a mystification.

Mystification on this point occurs in various forms and to varying degrees. For example, the psychologist Michael Billig identifies one form when he notes a general tendency for social scientists to take the efficacy of rules for granted and to neglect questions about their origins and the reasons for their hold on us:

> Psychologists and sociologists often tend to assume that the essential aspect of rules lies in the fact that rules are followed. Yet there is an equally important, but sometimes neglected aspect to rules: namely that rules arise from and themselves give rise to arguments.
>
> (Billig 1991: 50)

Billig exemplifies the point with reference to the Talmud, surely one of the world's most exhaustive attempts to regulate every aspect of existence by means of rules – its catalogue of prescriptions for pious Jews runs to more than sixty volumes. But as Billig points out, a huge proportion of the Talmud is taken up not with the rules themselves but with interminable rabbinical arguments about them. This 'argument – rules – argument' sequence is endlessly self-perpetuating, since every rule generates further argument, which in turn necessitates laying down more rules, which themselves become the focus for new arguments, and so on.

Mainstream linguistics exemplifies a rather different and perhaps stronger from of mystification. Linguists are even less interested in the arguments surrounding rules than the psychologists and sociologists Billig mentions, for the dominant concept of a rule in linguistics is one that brooks no argument at all. Such rules are not injunctions that we can follow or flout. They are as definitive as 'E = mc²'. The types of rules that do give rise to arguments – in other words, prescriptions – are often not seen as proper linguistic rules at all.

This attitude marginalizes questions of authority, making its workings difficult to perceive, let alone to challenge. It also has the effect of concealing the authority of linguistic science itself. Most linguists would repudiate the charge of authoritarianism, for they claim to have abjured all prescription on principle. Yet if 'leave your language alone' is not a prescription, what is it?

James Milroy (1992) addresses the confusion that exists around the question

of normativity when he asserts that 'all language descriptions, no matter how objective they are, must be *normative* … because to be accurate they have to coincide with the consensus norms of the community concerned' (pp. 8–9).[2] He goes on to criticize the way linguists often equate 'normative' with 'prescriptive', claiming there is a distinction between observing norms (which is what linguists are doing whether they admit it or not) and enforcing them (as precriptivists try to do).

Milroy notes that descriptive (norm-observing) statements are often treated by language users as if they were prescriptive (norm-enforcing) – for example, people often use a work like the *English Pronouncing Dictionary*, which records the norms of Received Pronunciation (RP), as a guide to 'correct' pronunciation – but he dismisses this as 'irrelevant', a question of social attitudes to RP and not of the kinds of statements being made about it in the dictionary. (No one, he drily informs us, has used his own account of Belfast pronunciation in this way.) I think he is right up to a point, in that attitudes to the phenomenon being described do affect the way a description is taken. But I also think Milroy fails to follow his own argument to its logical conclusion.

I do not find it irrelevant for our understanding of language and linguistic change that norm-observing is so often interpreted as, or turned into, norm-enforcement. Indeed, it is striking that among present-day users of English the most revered authorities are those that claim most unequivocally to be 'descriptive', and therefore disinterested (the most obvious example is *The Oxford English Dictionary*, which is usually taken to settle any argument about the existence, meaning and spelling of English words). Because science itself has authority in modern society, while at the same time the discourse of value remains a highly salient one for everyday talk about language, the absolute distinction between observing norms and enforcing them cannot be maintained in practice.

Nor, it must be said, has this distinction been rigorously maintained by professional linguists, some of whose activities are overtly normenforcing. An obvious instance is the field of 'language planning', where linguists either advise, or work directly for, governmental agencies concerned with solving language problems in a given society (the Hebrew Language Academy in Israel, which oversees the development for modern purposes of a language that was once 'dead', is a well-known example of the language-planning enterprise). Presumably this kind of normative endeavour is considered acceptable among linguists because of its basis in expert scientific knowledge. However, there is a double standard here: apparently it is other people's 'prescriptivism' that linguists find deplorable; their own expert prescriptions should be accorded a different status.[3] The very fact that 'language planning' is distinguished from 'prescriptivism' in the scholarly literature underlines the point made earlier, that 'prescriptivism' is less a neutral description of certain activities than a value judgement on them.

These observations on the instability of the descriptive/prescriptive opposition in theory and practice do not imply that linguists must stop investigating language use, nor even that they should necessarily refrain from engaging in norm-enforcing activities like language planning. But perhaps the arguments put forward above should make linguists think twice about denying the normative character either of what they study or of their own activity in studying it. For

what these arguments imply is that the overt anti-prescriptive stance of linguists is in some respects not unlike the prescriptivism they criticize. The point is that *both* prescriptivism *and* anti-prescriptivism invoke certain norms and circulate particular notions about how language ought to work. Of course, the norms are different (and in the case of linguistics, they are often covert). But both sets feed into the more general arguments that influence everyday ideas about language. On that level, 'description' and 'prescription' turn out to be aspects of a single (and normative) activity: a struggle to control language by defining its nature. My use of the term 'verbal hygiene' is intended to capture this idea, whereas to use the term 'prescriptivism' would just recycle the opposition I am trying to deconstruct.

Not only is 'prescriptivism' too negative a term for my purposes, and too dependent for its meaning on the problematic 'descriptive/prescriptive' opposition; it is also too narrow to capture the full range of my concerns. In theory, 'prescriptivism' could refer to any form of linguistic regulation, but in practice it is strongly associated with those forms that are most conservative, elitist and authoritarian. Attempts to promote an elite standard variety, to retard linguistic change or to purge a language of 'foreign' elements are the instances most readily evoked by the epithet 'prescriptive', for linguists and non-linguists alike.

Yet it is crucial to see that this narrowly conceived 'prescriptivism' – elitist, conservative and purist – is only one kind of verbal hygiene among many, only one manifestation of the much more general impulse to regulate language, control it, make it 'better'. This impulse takes innumerable forms, not all of which are conservative, authoritarian or (arguably) deplorable. A random list of verbal hygiene practices in which present-day speakers of English are engaged might include, for example, campaigning for the use of plain language on official forms; belonging to a spelling reform society, a dialect preservation society or an artificial language society; taking courses in 'communication arts' or 'group discussion', going for elocution lessons, sending for correspondence courses on 'good English' or reading self-improvement literature on how to be a better conversationalist; editing prose to conform to a house style; producing guidelines on non-sexist language, or opposing such guidelines. And these are only the institutional cases: the group of schoolchildren cruelly mimicking a classmate's 'posh' accent are also practising verbal hygiene, as are the workers who institute a 'swear box' and fine one another for using 'bad language'.

Few of these practices feature in the literature on 'prescriptivism', and collectively they cannot be made to illustrate any single coherent political ideology or perspective on language. What unites them is their defiant refusal to 'leave your language alone' – a refusal that is grounded in a strong concern with *value*.

Verbal hygiene comes into being whenever people reflect on language in a critical (in the sense of 'evaluative') way. The potential for it is latent in every communicative act, and the impulse behind it pervades our habits of thought and behaviour. I have never met anyone who did not subscribe, in one way or another, to the belief that language can be 'right' or 'wrong', 'good' or 'bad', more or less 'elegant' or 'effective' or 'appropriate'. Of course, there is massive disagreement about what values to espouse, and how to define them. Yet however people may pick and choose, it is rare to find anyone rejecting altogether

the idea that there is *some* legitimate authority in language. We are all of us closet prescriptivists – or, as I prefer to put it, verbal hygienists.

I hope it will be clear already that in saying this I am not suggesting that we are all closet elitists and authoritarians. Our norms and values differ: what remains constant is only that we *have* norms and values. There are, for example, many people who disapprove strongly of what they call 'prescriptivism', meaning the pedantry of traditional grammarians, while at the same time accepting the equally normative arguments of George Orwell's 'Politics and the English language' (1946), and taking all due care to ensure their own usage is free from any taint of 'bias'. There are scholars who have spent their careers championing the cause of linguistic tolerance, yet who nevertheless, as editors and contributors to scholarly journals, impose on themselves the obligation not merely to write in standard English, but to conform to every arbitrary convention laid down in the *Chicago Manual of Style*. I am not accusing such people of hypocrisy and bad faith. I am arguing that in a crucial sense things could not be otherwise; there is no escape from normativity.

It follows that if we find some particular verbal hygiene practice objectionable, the solution is not simply to denounce all prescription. If normativity is an inalienable part of using language, to abandon prescription in the broad sense is to abandon language itself. Let us be clear, though, that this is not an apologia for every kind of linguistic authoritarianism. On the contrary, it might pave the way for more effective intervention in politically important linguistic debates. Anti-prescriptivists have too often fought the battle against authoritarianism on the wrong terrain, and in consequence their challenge has been too easily brushed aside.

[...]

Notes

1 The theoretical perspective that informs the present study is one in which the term 'natural' will be approached with the utmost caution. Therefore, to clarify one possible confusion: the term 'natural' applied by linguists to linguistic change can mean either, loosely, that change itself is natural, or more technically it can refer to particular kinds of change that are explained in terms of systemic tendencies within languages. Conversely, there are kinds of change that are less 'natural' (in this technical sense) because they violate what seem to be inherent constraints. However, as Milroy points out, to specify a class of 'natural' changes is not to explain any particular instance of change. Natural changes are always waiting to happen, as it were, but they only actually happen sometimes, when *social* conditions are favourable.

2 While I welcome Milroy's statement here, I am dubious about his concept of a 'consensus norm', agreed on in a kind of social contract to which all speakers in a community are party. Milroy insists that the social formation overall is characterized by conflict, but he seems to feel there is consensus at the micro-level of the (homogeneous) community. No doubt some communities are more consensual in their values than others, but an a priori assumption of consensus can mask the coercive workings of power and authority (which is

not always institutional, of course). A high level of conformity need not mean everyone assents to the relevant norms: it could mean rather that they live within social relations that make deviance and resistance particularly difficult.

3 I am indebted to Roy Harris (personal communication) for making me appreciate the full force of this point. Citing Saussure and Bloomfield, Harris also notes that '[a] prescriptive role was never at any point in the history of modern linguistics rejected by the leading theorists'.

References

Baker, G. and Hacker, P. (1984) *Language, Sense and Nonsense*, Oxford: Blackwell.

Billig, M. (1991) *Ideology and Opinions*, London: Sage.

Hall, R. (1960) *Linguistics and Your Language* (2nd revised edn of *Leave Your Language Alone*), Garden City, NJ: Anchor.

Harris, R. (1980) *The Language Makers*, London: Duckworth.

——— (1981) *The Language Myth*, London: Duckworth.

Joseph, J. and Taylor, T. (eds) (1990) *Ideologies of Language*, London: Routledge.

Lakoff, R. (1990) *Talking Power: The Politics of Language*, New York: Basic Books.

Miller, C. and Swift, K. (1980) *A Handbook of Nonsexist Writing*, London: Women's Press.

Milroy, J. (1992) *Language Variation and Change*, Oxford: Blackwell.

Milroy, J. and Milroy, L. (1985) *Authority in Language*, Oxford: Blackwell.

Orwell, G. (1946) 'Politics and the English language', in *The Collected Essays, Journalism and Letters of George Orwell, Vol. 4, In Front of Your Nose, 1945–50*, (1968), ed. S. Orwell and I. Angus, Harmondsworth: Penguin.

Taylor, T. (1990) 'Who's to be master? The institutionalization of authority in the science of language', in *Ideologies of Language*, ed. J. Joseph and T. Taylor, London: Routledge.

LANGUAGE AND SUBJECTIVITY

> This passion of the signifier now becomes a new dimension of the human
> condition in that it is not only man who speaks, but in man and through
> man *it* speaks (*ça parle*), that his nature is woven by effects in which is
> to be found the structure of language, of which he becomes the mater-
> ial, and that therefore there resounds in him, beyond what could be con-
> ceived of by a psychology of ideas, the relation of speech.
>
> (Jacques Lacan, *Ecrits*, 1977: 284)

RE-READING THE WORK of Freud in the light of the linguistic theories
of Saussure and Roman Jakobson, Lacan's contention that our 'nature is
woven by effects in which is to be found the structure of language' accords lan-
guage a central role in the formation of subjectivity or selfhood. Rather than exert-
ing a mastery over the language we speak, he suggests, on the contrary, that
language 'speaks us', constituting us as subjects. This is a difficult idea to grasp
given the 'common sense' belief that we have thoughts, feelings and a sense of self
which exist above and beyond the language we speak. Perhaps the first question to
ask then is whether we can evoke, articulate, or make sense of those thoughts and
feelings without language? Drawn from linguistics, anthropology (or more accu-
rately, anthropological linguistics) psychology and psychoanalysis, the extracts in
this section are all concerned with this question of the role language plays in the
development of the self and the formation and operations of the conscious and
unconscious mind. In this respect, the extracts raise some important issues which
relate once again to our central concern with the relationship between 'structure
and agency'. Can we, for instance, ever escape or contest the logic, or conceptual
categories, of the particular language community into which we were born? Or, put
another way, are we simply the powerless subjects of a linguistic structure which
speaks through us? And if so, how are we to account for linguistic and social
change, or translation and dialogue between different language communities?

Saussure's account of the relationship between language and thought is an
important starting point and the extract presented here demonstrates the radical
nature of his argument, certainly within the study of language of his day. Rather
than working with the notion that we have ideas which precede language and which
language is then used to convey, Saussure argues that thought without language is
simply a vague, nebulous, shapeless flux; and sound is simply a range of noise. Only
language can bring order to this chaos. It does so by uniting signified and signifier,
in order to make clarity and distinction possible. However, we should be careful not
to make the mistake of thinking that the signified–signifier relationship is just new
terminology for the idea–word model. As we have seen, signs are not intrinsically

meaningful self-contained units, they produce meaning precisely by dint of the fact that they form part of a structured system. For it is a particular sign's structural, or differential, relation to other signs within the system which gives it value, or meaning. If this were not the case then we would be back to the old model: I have an idea which I need to express, therefore I find the right word and that does the job. However, as Saussure's model suggests, it is not possible to separate a particular sound pattern from the concept it conveys. It is for this reason that translation between languages is problematic. To speak of meaning being 'lost in translation' is to recognise that the meanings and resonances of the signs which constitute a particular language cannot easily be conveyed or reproduced in another.

The problem of translation brings us to the work of Whorf (one half of a double act which lends its name to the Sapir–Whorf hypothesis, the essence of which is illustrated in the extract reprinted here). To understand Whorf we need to refer back to the Enlightenment philosopher Kant. Kant argued that we can only make sense of the world by imposing a structure upon it which derived from the mind itself; or put another way, the mind has a set of categories which are *a priori* (not derived from experience) which enable it to think and reason. If we did not have that, he said, everything would appear as the sort of chaotic random flux which Saussure describes. The neo-Kantians, including Whorf, agreed with Kant that we need categories in order to impose a structure on the world and thus to make sense of it, but they argued that these categories were not built into the mind, but were taken instead from the language (*langue*, or the linguistic structure in Saussure's terms) which we learn. This clearly has important implications. For when human beings learn their specific native language, they derive from it only the categories for making sense of the world which are built into its structure. But precisely because languages differ, it must then follow that the categories which are derived from any specific language must also differ. This means that the ways of making sense of the world which we take from our language will be distinct, depending on which language we learn. And that has significance when thinking about the reproduction and perpetuation of particular social hierarchies within language, as we shall see in the following two sections, 'Language and Gender' and 'Language and Sexuality'.

In contrast to the rather static treatment of language in relation to thought and speech which is given in the first two texts in this section, the last three extracts offer more complex accounts. The relation between language and consciousness in the work of Vygostky is a radical displacement of the existing dominant models, behaviourist, idealist and indeed historical materialist (for example in the work of Voloshinov). Vygotsky's research was in the field of the acquisition of language and concept formation in child development. His distinctive theoretical contribution was the notion of 'inner speech', a median stage between thought itself, word meanings, and as a last stage words. His stress on the complexity and the dynamic nature of this process continues to make his work significant even given the advances made in this field during the late twentieth century.

Freud's work does not attempt to give an account of language but language is clearly a necessary area of investigation for him. In this piece, parapraxes, or slips

of the tongue, are investigated symptomatically. That is to say, a mistake in language – which at first sight might appear as simply a mispronunciation, or an error of vocabulary – is considered instead to reveal something which, at an unconscious level, is desired or feared. Most people will have had the experience of saying exactly the opposite of what they meant to say, for example by missing the word 'not' out (or leaving it in); or saying one person's name rather than another. This discovery of the unconscious, working beyond the control of the autonomous, stable, subject was a major intellectual development and had a significant impact on cultural theory as we shall see. It is interesting to note too how Freud's method here is very similar to that used by the historical semanticists in their reading of language. The quotation from William Mathews (given at the beginning of the introduction to the 'Language in History' section) could be adapted for Freud: often where the rational self is dumb concerning the past, through language speaks the unconscious. In fact Freud's analysis on occasion relies explicitly on philology: in the *Introductory Lectures on Psychoanalysis* (1922: 134–5), for example, he offers an analysis of a dream about wood. His interpretation is based upon tracing the etymology of the word 'madeira', which is Portuguese for wood, but which derives from the Latin 'materia' (meaning material in general), and which in turn stems from the Latin 'mater' meaning mother. The dream, he suggests, is not in fact about wood but about a woman or a mother. This analysis, of course, is not unproblematic. We may ask, following Saussure's assertion that the language user in the present does not need to know about the historical development of a language in order to use it in the present, whether or not the patient needs to know the etymology of a particular sign in order to produce a dream worthy of a Freudian interpretation.

Though Freud did not attempt explicitly to use a linguistic model, Lacan's work, as mentioned above, brings together the theoretical insights of psychoanalysis and Saussurean linguistic theory in order to argue that the unconscious is structured like a language. His theoretical formulations are notoriously difficult and resist simplification. In the extract here, he offers an account of the castration complex and thus of the development of gender identification. Freud's account of the oedipal complex sees the male child develop a sexual attachment to his mother which is foreclosed by his recognition of the threat of castration represented by the father. The child comes to understand that he can neither have nor desire his mother, but also that his father has the power to make him experience the 'lack' or absence of a penis which characterises the female genitals. The child's 'originary' attachment to his mother must, as a consequence, be realised only through socially legitimate substitutes. Lacan takes Freud's model and argues that the threat of castration serves metaphorically to signify the concept of lack as a defining characteristic of linguistic structure. This, in other words, refers to the Saussurean principle that in language there are no positive values, only differential relations within a signifying system. Entry into language, and therefore the process of becoming a 'self', or an 'I', is predicated upon a recognition of loss or lack and upon submission to the 'law of the father'. The phallus (which is not to be confused with the penis, the anatomical organ) thus serves for Lacan as the primary signifier of sexual identification and sexual difference which facilitates

the child's entry into language, and thus, subjectivity. That girls experience this process in a different manner to boys is one of the central problems explored in the extract below.

Lacan's work has proved enormously influential in its foregrounding of the centrality of linguistic structure to the production of gendered subjects and in challenging the notion of human subjectivity as stable and coherent. It has also been highly contentious for many feminists who have rejected it on the grounds of its phallocentrism; other feminists, however, have used his work productively to explore and interrogate the constitution of gendered subjects in language and culture. We will see the importance of Lacan's work later, in the pieces by the French feminists Cixous, Irigaray and Kristeva.

Further reading

Saussure

Saussure, F. de (1960) *Course in General Linguistics*, ed. C. Bally and A. Sechehaye, trans. W. Baskin, London: Peter Owen.
—— (1983) *Course in General Linguistics*, ed. C. Bally and A. Sechehaye, trans. R. Harris, London: Duckworth, Part 2 chapters 1–6.
Harris, R. and T. Taylor (1989) *Landmarks in Western Thought: The Western Tradition from Socrates to Saussure*, London: Routledge, chapter 14.
Harris, R. (1987) *Reading Saussure: A Critical Commentary on the 'Cours de linguistique générale'*, London: Duckworth, pp. 103–33.
Holdcroft, D. (1991) *Saussure: Signs, System and Arbitrariness*, Cambridge: Cambridge University Press, chapters 5–6.
Gadet, F. (1989) *Saussure and Contemporary Culture*, trans. G. Elliott, London: Radius, chapter 4.
Thibault, P.J. (1997) *Re-reading Saussure: The Dynamics of Signs in Social Life*, London: Routledge, chapters 7–8.

Sapir–Whorf hypothesis

Whorf, B.L. (1956) *Language, Thought and Reality*, ed. J.B. Carroll, Cambridge, MA: M.I.T. Press, pp. 112–24, 134–59, 246–70.
Sapir, E. (1949) *Selected Writings of Edward Sapir in Language, Culture and Personality*, ed. D.G. Mandelbaum, London: Cambridge University Press, pp. 160–6.
Werner, O. (1994), 'Sapir–Whorf Hypothesis', in R.E. Asher and J.M.Y. Simpson (eds) *The Encyclopedia of Language and Linguistics*, 10 vols, Oxford and New York: Pergamon Press, vol. 5, pp. 2774–77, vol. 7, pp. 3656–62.
Wardhaugh, R. (1992) *An Introduction to Sociolinguistics*, 2nd edn., Oxford: Basil Blackwell, pp. 218–25.
Hoijer, H. (1954) 'The Sapir–Whorf Hypothesis', in H. Hoijer (ed.) *Language in Culture: Conference on the Interrelations of Language and Other Aspects of Culture*, Chicago: University of Chicago Press, pp. 92–105.
Sampson, G. (1980) *Schools of Linguistics: Competition and Evolution*, London: Hutchinson, chapter 4.
Montgomery, M. (1995) *An Introduction to Language and Society*, 2nd edn., London: Routledge, chapter 11.

Cameron, D. (1985) *Feminism and Linguistic Theory*, London: Macmillan, chapter 6.
Hodge, R. and G.R. Kress (1998) *Language as Ideology*, 2nd edn., London: Routledge, chapters 4–6.

Language and psychoanalysis

Lacan, J. (1977) *Ecrits: A Selection*, trans. A. Sheridan, London: Tavistock, pp. 146–78.
—— (1968) *The Language of the Self: The Function of Language in Psychoanalysis*, trans. A. Wilden, New York: Dell.
Sarup, M. (1993) *An Introductory Guide to Post-Structuralism and Postmodernism*, 2nd edn, Hemel Hempstead: Harvester Wheatsheaf, chapter 1.
—— (1992) *Jacques Lacan*, Hemel Hempstead: Harvester Wheatsheaf.
Bowie, M. (1991) *Lacan*, London: Fontana.
Grosz, E. (1990) *Jacques Lacan: A Feminist Introduction*, London: Routledge.
Laplanche, J. and J-B. Pontalis (1973) *The Language of Psychoanalysis*, trans. D. Nicholson-Smith, New York: Norton.
Forrester, J. (1980) *Language and the Origins of Psychoanalysis*, London: Macmillan.
Wright, E. (1984) *Psychoanalytic Criticism: Theory in Practice*, London: Methuen, pp. 9–36, 107–13.
Coward, R. and J. Ellis (1977) *Language and Materialism: Developments in Semiology and the Theory of the Subject*, London: Routledge & Kegan Paul, chapter 6.
Jameson, F. (1982) 'Imaginary and Symbolic in Lacan: Marxism, Psychoanalytic Criticism, and the Problem of the Subject', in S. Felman (ed.) *Literature and Psychoanalysis. The Question of Reading: Otherwise*, Baltimore: Johns Hopkins University Press, pp. 338–95.

Language and subjectivity

Weedon, C., A. Tolson and F. Mort (1980) 'Theories of Language and Subjectivity', in *Culture, Media, Language: Working Papers in Cultural Studies, 1972–1979*, Centre for Contemporary Cultural Studies, London: Hutchinson, chapter 2 and pp. 195–216.
Silverman, D. and B. Torode (1980) *The Material Word: Theories of Language and its Limits*, London: Routledge & Kegan Paul, chapter 2.
Silverman, K. (1983) *The Subject of Semiotics*, New York: Oxford University Press, chapters 4–5.
MacDonell, D. (1986) *Theories of Discourse*, Oxford: Basil Blackwell, chapter 6.
Weedon, C. (1987) *Feminist Practice and Poststructuralist Theory*, Oxford: Basil Blackwell.
Althusser, L. (1971) 'Ideology and Ideological State Apparatuses', in *Lenin and Philosophy and Other Essays*, trans. B. Brewster, London: New Left Books.
Voloshinov, V.N. (1986) *Marxism and the Philosophy of Language*, trans. L. Matejka and I.R. Titunik, Cambridge, MA: Harvard University Press, Part 1.
Hodge, R. and G.R. Kress (1988) *Social Semiotics*, Cambridge: Polity, chapter 8.
Hall, K. and M. Bucholtz (1995) *Gender Articulated: Language and the Socially Constructed Self*, New York: Routledge.
See also Further reading for the Introductions to 'Language and Gender' section and 'Language and Sexuality' section.

Ferdinand de Saussure

LINGUISTIC VALUE (1916)

1. Language as organized thought coupled with sound

To prove that language is only a system of pure values, it is enough to consider the two elements involved in its functioning: ideas and sounds.

Psychologically our thought – apart from its expression in words – is only a shapeless and indistinct mass. Philosophers and linguists have always agreed in recognizing that without the help of signs we would be unable to make a clear-cut, consistent distinction between two ideas. Without language, thought is a vague, uncharted nebula. There are no pre-existing ideas, and nothing is distinct before the appearance of language.

Against the floating realm of thought, would sounds by themselves yield pre-delimited entities? No more so than ideas. Phonic substance is neither more fixed nor more rigid than thought; it is not a mold into which thought must of necessity fit but a plastic substance divided in turn into distinct parts to furnish the signifiers needed by thought. The linguistic fact can therefore be pictured in its totality – i.e. language – as a series of contiguous subdivisions marked off on both the indefinite plane of jumbled ideas (*A*) and the equally vague plane of sounds (*B*). The following diagram gives a rough idea of it:

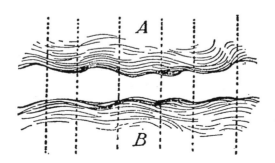

The characteristic role of language with respect to thought is not to create a material phonic means for expressing ideas but to serve as a link between thought and sound, under conditions that of necessity bring about the reciprocal delimitations of units. Thought, chaotic by nature, has to become ordered in the process of its decomposition. Neither are thoughts given material form nor are sounds transformed into mental entities; the somewhat mysterious fact is rather that "thought-sound" implies division, and that language works out its units while taking shape between two shapeless masses. Visualize the air in contact with a sheet of water; if the atmospheric pressure changes, the surface of the water will be broken up into a series of divisions, waves; the waves resemble the union or coupling of thought with phonic substance.

Language might be called the domain of articulations, using the word as it was defined earlier [. . .][1]. Each linguistic term is a member, an *articulus* in which an idea is fixed in a sound and a sound becomes the sign of an idea.

Language can also be compared with a sheet of paper: thought is the front and the sound the back; one cannot cut the front without cutting the back at the same time; likewise in language, one can neither divide sound from thought nor thought from sound; the division could be accomplished only abstractedly, and the result would be either pure psychology or pure phonology.

Linguistics then works in the borderland where the elements of sound and thought combine; *their combination produces a form, not a substance.*

These views give a better understanding of what was said before (see p. 26) about the arbitrariness of signs. Not only are the two domains that are linked by the linguistic fact shapeless and confused, but the choice of a given slice of sound to name a given idea is completely arbitrary. If this were not true, the notion of value would be compromised, for it would include an externally imposed element. But actually values remain entirely relative, and that is why the bond between the sound and the idea is radically arbitrary.

The arbitrary nature of the sign explains in turn why the social fact alone can create a linguistic system. The community is necessary if values that owe their existence solely to usage and general acceptance are to be set up; by himself the individual is incapable of fixing a single value.

In addition, the idea of value, as defined, shows that to consider a term as simply the union of a certain sound with a certain concept is grossly misleading. To define it in this way would isolate the term from its system; it would mean assuming that one can start from the terms and construct the system by adding them together when, on the contrary, it is from the interdependent whole that one must start and through analysis obtain its elements.

To develop this thesis, we shall study value successively from the viewpoint of the signified or concept (Section 2), the signifier (Section 3), and the complete sign (Section 4).

Being unable to seize the concrete entities or units of language directly, we shall work with words. While the word does not conform exactly to the definition of the linguistic unit..., it at least bears a rough resemblance to the unit and has the advantage of being concrete; consequently, we shall use words as specimens equivalent to real terms in a synchronic system, and the principles that we evolve with respect to words will be valid for entities in general.

2. Linguistic value from a conceptual viewpoint

When we speak of the value of a word, we generally think first of its property of standing for an idea, and this is in fact one side of linguistic value. But if this is true, how does *value* differ from *signification*? Might the two words be synonyms? I think not, although it is easy to confuse them, since the confusion results not so much from their similarity as from the subtlety of the distinction that they mark.

From a conceptual viewpoint, value is doubtless one element in signification, and it is difficult to see how signification can be dependent upon value and still be distinct from it. But we must clear up the issue or risk reducing language to a simple naming-process (see p. 25).

Let us first take signification as it is generally understood and as it was pictured on page 26. As the arrows in the drawing show, it is only the counterpart of the sound-image. Everything that occurs concerns only the sound-image and the concept when we look upon the word as independent and self-contained.

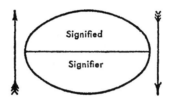

But here is the paradox: on the one hand the concept seems to be the counterpart of the sound-image, and on the other hand the sign itself is in turn the counterpart of the other signs of language.

Language is a system of interdependent terms in which the value of each term results solely from the simultaneous presence of the others, as in the diagram:

How, then, can value be confused with signification, i.e. the counterpart of the sound-image? It seems impossible to liken the relations represented here by horizontal arrows to those represented above by vertical arrows. Putting it another way – and again taking up the example of the sheet of paper that is cut in two (see p. 106) – it is clear that the observable relation between the different pieces A, B, C, D, etc. is distinct from the relation between the front and back of the same piece as in A/A′, B/B′, etc.

To resolve the issue, let us observe from the outset that even outside language all values are apparently governed by the same paradoxical principle. They are always composed:

1 of a *dissimilar* thing that can be *exchanged* for the thing of which the value is to be determined; and

2 of *similar* things that can be *compared* with the thing of which the value is
to be determined.

Both factors are necessary for the existence of a value. To determine what a
five-franc piece is worth one must therefore know: 1) that it can be exchanged
for a fixed quantity of a different thing, e.g. bread; and 2) that it can be com-
pared with a similar value of the same system, e.g. a one-franc piece, or with
coins of another system (a dollar, etc.). In the same way a word can be
exchanged for something dissimilar, an idea; besides, it can be compared with
something of the same nature, another word. Its value is therefore not fixed so
long as one simply states that it can be "exchanged" for a given concept, i.e. that
it has this or that signification: one must also compare it with similar values, with
other words that stand in opposition to it. Its content is really fixed only by the
concurrence of everything that exists outside it. Being part of a system, it is
endowed not only with a signification but also and especially with a value, and
this is something quite different.

A few examples will show clearly that this is true. Modern French *mouton*
can have the same signification as English *sheep* but not the same value, and this
for several reasons, particularly because in speaking of a piece of meat ready to
be served on the table, English uses *mutton* and not *sheep*. The difference in value
between *sheep* and *mouton* is due to the fact that *sheep* has beside it a second term
while the French word does not.

Within the same language, all words used to express related ideas limit each
other reciprocally; synonyms like French *redouter* "dread," *craindre* "fear," and *avoir
peur* "be afraid" have value only through their opposition: if *redouter* did not exist,
all its content would go to its competitors. Conversely, some words are enriched
through contact with others: e.g. the new element introduced in *décrépit* (*un vieil-
lard décrépit...*)[2] results from the co-existence of *décrépi* (*un mur décrépi*). The value
of just any term is accordingly determined by its environment; it is impossible
to fix even the value of the word signifying "sun" without first considering its
surroundings: in some languages it is not possible to say "sit in the *sun*."

Everything said about words applies to any term of language, e.g. to gram-
matical entities. The value of a French plural does not coincide with that of a
Sanskrit plural even though their signification is usually identical; Sanskrit has
three numbers instead of two (*my eyes, my ears, my arms, my legs,* etc. are dual);
it would be wrong to attribute the same value to the plural in Sanskrit and in
French; its value clearly depends on what is outside and around it.

If words stood for pre-existing concepts, they would all have exact equiva-
lents in meaning from one language to the next; but this is not true. French uses
louer (*une maison*) "let (a house)" indifferently to mean both "pay for" and "receive
payment for," whereas German uses two words, *mieten* and *vermieten*; there is
obviously no exact correspondence of values. The German verbs *schätzen* and
urteilen share a number of significations, but that correspondence does not hold
at several points.

Inflection offers some particularly striking examples. Distinctions of time,
which are so familiar to us, are unknown in certain languages. Hebrew does not
recognize even the fundamental distinctions between the past, present, and

future. Proto-Germanic has no special form for the future; to say that the future is expressed by the present is wrong, for the value of the present is not the same in Germanic as in languages that have a future along with the present. The Slavic languages regularly single out two aspects of the verb: the perfective represents action as a point, complete in its totality; the imperfective represents it as taking place, and on the line of time. The categories are difficult for a Frenchman to understand, for they are unknown in French; if they were pre-determined, this would not be true. Instead of pre-existing ideas then, we find in all the foregoing examples *values* emanating from the system. When they are said to correspond to concepts, it is understood that the concepts are purely differential and defined not by their positive content but negatively by their relations with the other terms of the system. Their most precise characteristic is in being what the others are not.

Now the real interpretation of the diagram of the signal becomes apparent. Thus

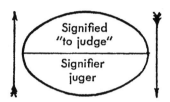

means that in French the concept "to judge" is linked to the sound-image *juger*; in short, it symbolizes signification. But it is quite clear that initially the concept is nothing, that is only a value determined by its relations with other similar values, and that without them the signification would not exist. If I state simply that a word signifies something when I have in mind the associating of a sound-image with a concept, I am making a statement that may suggest what actually happens, but by no means am I expressing the linguistic fact in its essence and fullness.

3. Linguistic value from a material viewpoint

The conceptual side of value is made up solely of relations and differences with respect to the other terms of language, and the same can be said of its material side. The important thing in the word is not the sound alone but the phonic differences that make it possible to distinguish this word from all others, for differences carry signification.

This may seem surprising, but how indeed could the reverse be possible? Since one vocal image is no better suited than the next for what it is commissioned to express, it is evident, even *a priori*, that a segment of language can never in the final analysis be based on anything except its noncoincidence with the rest. *Arbitrary* and *differential* are two correlative qualities.

The alteration of linguistic signs clearly illustrates this. It is precisely because the terms *a* and *b* as such are radically incapable of reaching the level of consciousness – one is always conscious of only the *a/b* difference – that each term is free to change according to laws that are unrelated to its signifying function.

No positive sign characterizes the genitive plural in Czech *žen*;[3] still the two forms *žena: žen* function as well as the earlier forms *žena: ženъ; žen* has value only because it is different.

Here is another example that shows even more clearly the systematic role of phonic differences: in Greek, *éphēn* is an imperfect and *éstēn* an aorist although both words are formed in the same way; the first belongs to the system of the present indicative of *phēmí* "I say," whereas there is no present *stēmi*; now it is precisely the relation *phēmí: éphēn* that corresponds to the relation between the present and the imperfect (cf. *déiknūmi: edéiknūn*, etc.). Signs function, then, not through their intrinsic value but through their relative position.

In addition, it is impossible for sound alone, a material element, to belong to language. It is only a secondary thing, substance to be put to use. All our conventional values have the characteristic of not being confused with the tangible element which supports them. For instance, it is not the metal in a piece of money that fixes its value. A coin nominally worth five francs may contain less than half its worth of silver. Its value will vary according to the amount stamped upon it and according to its use inside or outside a political boundary. This is even more true of the linguistic signifier, which is not phonic but incorporeal — constituted not by its material substance but by the differences that separate its sound-image from all others.

The foregoing principle is so basic that it applies to all the material elements of language, including phonemes. Every language forms its words on the basis of a system of sonorous elements, each element being a clearly delimited unit and one of a fixed number of units. Phonemes are characterized not, as one might think, by their own positive quality but simply by the fact that they are distinct. Phonemes are above all else opposing, relative, and negative entities.

Proof of this is the latitude that speakers have between points of convergence in the pronuciation of distinct sounds. In French, for instance, general use of a dorsal *r* does not prevent many speakers from using a tongue-tip trill; language is not in the least disturbed by it; language requires only that the sound be different and not, as one might imagine, that it have an invariable quality. I can even pronounce the French *r* like German *ch* in *Bach*, *doch*, etc., but in German I could not use *r* instead of *ch*, for German gives recognition to both elements and must keep them apart. Similarly, in Russian there is no latitude for *t* in the direction of *t'* (palatalized *t*), for the result would be the confusing of two sounds differentiated by the language (cf. *govorit'* "speak" and *goverit* "he speaks"), but more freedom may be taken with respect to *th* (aspirated *t*) since this sound does not figure in the Russian system of phonemes.

Since an identical state of affairs is observable in writing, another system of signs, we shall use writing to draw some comparisons that will clarify the whole issue. In fact:

1 The signs used in writing are arbitrary; there is no connection, for example, between the letter *t* and the sound that it designates.

2 The value of letters is purely negative and differential. The same person can write *t*, for instance, in different ways:

The only requirement is that the sign for *t* not be confused in his script with the signs used for *l*, *d*, etc.

3 Values in writing function only through reciprocal opposition within a fixed system that consists of a set number of letters. This third characteristic, though not identical to the second, is closely related to it, for both depend on the first. Since the graphic sign is arbitrary, its form matters little or rather matters only within the limitations imposed by the system.

4 The means by which the sign is produced is completely unimportant, for it does not affect the system (this also follows from characteristic 1). Whether I make the letters in white or black, raised or engraved, with pen or chisel – all this is of no importance with respect to their signification.

4. The sign considered in its totality

Everything that has been said up to this point boils down to this: in language there are only differences. Even more important: a difference generally implies positive terms between which the difference is set up; but in language there are only differences *without positive terms*. Whether we take the signified or the signifier, language has neither ideas nor sounds that existed before the linguistic system, but only conceptual and phonic differences that have issued from the system. The idea or phonic substance that a sign contains is of less importance than the other signs that surround it. Proof of this is that the value of a term may be modified without either its meaning or its sound being affected, solely because a neighboring term has been modified (see p. 108).

But the statement that everything in language is negative is true only if the signified and the signifier are considered separately; when we consider the sign in its totality, we have something that is positive in its own class. A linguistic system is a series of differences of sound combined with a series of differences of ideas; but the pairing of a certain number of acoustical signs with as many cuts made from the mass of thought engenders a system of values; and this system serves as the effective link between the phonic and psychological elements within each sign. Although both the signified and the signifier are purely differential and negative when considered separately, their combination is a positive fact; it is even the sole type of facts that language has, for maintaining the parallelism between the two classes of differences is the distinctive function of the linguistic institution.

Certain diachronic facts are typical in this respect. Take the countless instances where alteration of the signifier occasions a conceptual change and where it is obvious that the sum of the ideas distinguished corresponds in principle to the sum of the distinctive signs. When two words are confused through phonetic alteration (e.g. French *décrépit* from *dēcrepitus* and *décrépi* from *crispus*), the ideas that they express will also tend to become confused if only they have

something in common. Or a word may have different forms (cf. *chaise* "chair" and *chaire* "desk"). Any nascent difference will tend invariably to become significant but without always succeeding or being successful on the first trial. Conversely, any conceptual difference perceived by the mind seeks to find expression through a distinct signifier, and two ideas that are no longer distinct in the mind tend to merge into the same signifier.

When we compare signs – positive terms – with each other, we can no longer speak of difference; the expression would not be fitting, for it applies only to the comparing of two sound-images, e.g. *father* and *mother*, or two ideas, e.g. the idea "father" and the idea "mother"; two signs, each having a signified and signifier, are not different but only distinct. Between them there is only *opposition*. The entire mechanism of language, with which we shall be concerned later, is based on oppositions of this kind and on the phonic and conceptual differences that they imply.

What is true of value is true also of the unit. A unit is a segment of the spoken chain that corresponds to a certain concept; both are by nature purely differential.

Applied to units, the principle of differentiation can be stated in this way: *the characteristics of the unit blend with the unit itself*. In language, as in any semiological system, whatever distinguishes one sign from the others constitutes it. Difference makes character just as it makes value and the unit.

Another rather paradoxical consequence of the same principle is this: in the last analysis what is commonly referred to as a "grammatical fact" fits the definition of the unit, for it always expresses an opposition of terms; it differs only in that the opposition is particularly significant (e.g. the formation of German plurals of the type *Nacht: Nächte*). Each term present in the grammatical fact (the singular without umlaut or final *e* in opposition to the plural with umlaut and –*e*) consists of the interplay of a number of oppositions within the system. When isolated, neither *Nacht* nor *Nächte* is anything: thus everything is opposition. Putting it another way, the *Nacht: Nächte* relation can be expressed by an algebraic formula a/b in which a and b are not simple terms but result from a set of relations. Language, in a manner of speaking, is a type of algebra consisting solely of complex terms. Some of its oppositions are more significant than others; but units and grammatical facts are only different names for designating diverse aspects of the same general fact: the functioning of linguistic oppositions. This statement is so true that we might very well approach the problem of units by starting from grammatical facts. Taking an opposition like *Nacht: Nächte*, we might ask what are the units involved in it. Are they only the two words, the whole series of similar words, *a* and *ä*, or all singulars and plurals, etc.?

Units and grammatical facts would not be confused if linguistic signs were made up of something besides differences. But language being what it is, we shall find nothing simple in it regardless of our approach; everywhere and always there is the same complex equilibrium of terms that mutually condition each other. Putting it another way, *language is a form and not a substance* (see p. 106). This truth could not be overstressed, for all the mistakes in our terminology, all our incorrect ways of naming things that pertain to language, stem from the involuntary supposition that the linguistic phenomenon must have substance.

Notes

1 In Latin, *articulus* means a member, part, or subdivision of a sequence; applied to speech, articulation designates either the subdivision of a spoken chain into syllables or the subdivision of the chain of meanings into significant units. [. . .] Using the second definition, we can say that what is natural to mankind is not oral speech but the faculty of constructing a language, i.e. a system of distinct signs corresponding to distinct ideas.

2 Latin *crispus* "crisp" provided French with the root *crép-* from which were formed the verbs *crépir* "rough-cast" and *décrepir* "remove mortar." Against this, at a certain moment the word *dēcrepitus*, of unknown origin, was borrowed from Latin and became *décrépit* "decrepit." Certainly today the community of speakers sets up a relation between *un mur décrépi* "a wall from which mortar is falling" and *un homme décrépit* "a decrepit man," although historically the two words have nothing in common; people often speak of the *façade décrépite* of a house. And this is static, for it concerns the relation between two coexisting forms of language. For its realization, the concurrence of certain evolutionary events was necessary. The pronunciation of *crisp-* had to become *crép-*, and at a particular moment a new word had to be borrowed from Latin. It is obvious that the diachronic facts are not related to the static facts which they produced. They belong to a different class.

3 Here is an even more striking example. In Old Slavic, *slovo* "word" has in the instrumental singular *slovem'ъ*, in the nominative plural *slova*, in the genitive plural *slov'ъ*, etc.; in the declension each case has its own ending. But today the weak vowels *ъ* and *'ъ*, Slavic representatives of Proto-Indo-European *ĭ* and *ŭ*, have disappeared. Czech, for example, has *slovo, slovem, slova, slov*; likewise *žena* "woman": accusative singular *ženu*, nominative plural *ženy*, genitive plural *žen*. Here the genitive (*slov, žen*) has zero inflection. We see then that a material sign is not necessary for the expression of an idea; language is satisfied with the opposition between something and nothing. Czech speakers recognize *žen* as a genitive plural simply because it is neither *žena* nor *ženu* nor any of the other forms. It seems strange at first glance that such a particular notion as that of the genitive plural should have taken the zero sign, but this very fact proves that everything comes about through sheer accident. Language is a mechanism that continues to function in spite of the deteriorations to which it is subjected.

Benjamin Lee Whorf

SCIENCE AND LINGUISTICS (1940)

Every normal person in the world, past infancy in years, can and does talk. By virtue of that fact, every person – civilized or uncivilized – carries through life certain naïve but deeply rooted ideas about talking and its relation to thinking. Because of their firm connection with speech habits that have become unconscious and automatic, these notions tend to be rather intolerant of opposition. They are by no means entirely personal and haphazard; their basis is definitely systematic, so that we are justified in calling them a system of natural logic – a term that seems to me preferable to the term common sense, often used for the same thing.

According to natural logic, the fact that every person has talked fluently since infancy makes every man his own authority on the process by which he formulates and communicates. He has merely to consult a common substratum of logic or reason which he and everyone else are supposed to possess. Natural logic says that talking is merely an incidental process concerned strictly with communication, not with formulation of ideas. Talking, or the use of language, is supposed only to "express" what is essentially already formulated nonlinguistically. Formulation is an independent process, called thought or thinking, and is supposed to be largely indifferent to the nature of particular languages. Languages have grammars, which are assumed to be merely norms of conventional and social correctness, but the use of language is supposed to be guided not so much by them as by correct, rational, or intelligent *thinking*.

Thought, in this view, does not depend on grammar but on laws of logic or reason which are supposed to be the same for all observers of the universe – to represent a rationale in the universe that can be "found" independently by all intelligent observers, whether they speak Chinese or Choctaw. In our own culture, the formulations of mathematics and of formal logic have acquired the reputation of dealing with this order of things: i.e., with the realm and laws of pure thought. Natural logic holds that different languages are essentially parallel methods for expressing this one-and-the-same rationale of thought and, hence, differ

really in but minor ways which may seem important only because they are seen at close range. It holds that mathematics, symbolic logic, philosophy, and so on are systems contrasted with language which deal directly with this realm of thought, not that they are themselves specialized extensions of language. [...]

The familiar saying that the exception proves the rule contains a good deal of wisdom, though from the standpoint of formal logic it became an absurdity as soon as "prove" no longer meant "put on trial." The old saw began to be profound psychology from the time it ceased to have standing in logic. What it might well suggest to us today is that, if a rule has absolutely no exceptions, it is not recognized as a rule or as anything else; it is then part of the background of experience of which we tend to remain unconscious. Never having experienced anything in contrast to it, we cannot isolate it and formulate it as a rule until we so enlarge our experience and expand our base of reference that we encounter an interruption of its regularity. The situation is somewhat analogous to that of not missing the water till the well runs dry, or not realizing that we need air till we are choking.

For instance, if a race of people had the physiological defect of being able to see only the color blue, they would hardly be able to formulate the rule that they saw only blue. The term blue would convey no meaning to them, their language would lack color terms, and their words denoting their various sensations of blue would answer to, and translate, our words "light, dark, white, black," and so on, not our word "blue." In order to formulate the rule or norm of seeing only blue, they would need exceptional moments in which they saw other colors. The phenomenon of gravitation forms a rule without exceptions; needless to say, the untutored person is utterly unaware of any law of gravitation, for it would never enter his head to conceive of a universe in which bodies behaved otherwise than they do at the earth's surface. Like the color blue with our hypothetical race, the law of gravitation is a part of the untutored individual's background, not something he isolates from that background. The law could not be formulated until bodies that always fell were seen in terms of a wider astronomical world in which bodies moved in orbits or went this way and that.

Similarly, whenever we turn our heads, the image of the scene passes across our retinas exactly as it would if the scene turned around us. But this effect is background, and we do not recognize it; we do not see a room turn around us but are conscious only of having turned our heads in a stationary room. If we observe critically while turning the head or eyes quickly, we shall see, no motion it is true, yet a blurring of the scene between two clear views. Normally we are quite unconscious of this continual blurring but seem to be looking about in an unblurred world. Whenever we walk past a tree or house, its image on the retina changes just as if the tree or house were turning on an axis; yet we do not see trees or houses turn as we travel about at ordinary speeds. Sometimes ill-fitting glasses will reveal queer movements in the scene as we look about, but normally we do not see the relative motion of the environment when we move; our psychic makeup is somehow adjusted to disregard whole realms of phenomena that are so all-pervasive as to be irrelevant to our daily lives and needs.

Natural logic contains two fallacies: First, it does not see that the phenomena of a language are to its own speakers largely of a background character and

so are outside the critical consciousness and control of the speaker who is expounding natural logic. Hence, when anyone, as a natural logician, is talking about reason, logic, and the laws of correct thinking, he is apt to be simply marching in step with purely grammatical facts that have somewhat of a background character in his own language or family of languages but are by no means universal in all languages and in no sense a common substratum of reason. Second, natural logic confuses agreement about subject matter, attained through use of language, with knowledge of the linguistic process by which agreement is attained: i.e., with the province of the despised (and to its notion superfluous) grammarian. Two fluent speakers, of English let us say, quickly reach a point of assent about the subject matter of their speech; they agree about what their language refers to. One of them, A, can give directions that will be carried out by the other, B, to A's complete satisfaction. Because they thus understand each other so perfectly, A and B, as natural logicians, suppose they must of course know how it is all done. They think, e.g., that it is simply a matter of choosing words to express thoughts. If you ask A to explain how he got B's agreement so readily, he will simply repeat to you, with more or less elaboration or abbreviation, what he said to B. He has no notion of the process involved. The amazingly complex system of linguistic patterns and classifications, which A and B must have in common before they can adjust to each other at all, is all background to A and B.

These background phenomena are the province of the grammarian — or of the linguist, to give him his more modern name as a scientist. The word linguist in common, and especially newspaper, parlance means something entirely different, namely, a person who can quickly attain agreement about subject matter with different people speaking a number of different languages. Such a person is better termed a polyglot or a multilingual. Scientific linguists have long understood that ability to speak a language fluently does not necessarily confer a linguistic knowledge of it, i.e., understanding of its background phenomena and its systematic processes and structure, any more than ability to play a good game of billiards confers or requires any knowledge of the laws of mechanics that operate upon the billiard table.

The situation here is not unlike that in any other field of science. All real scientists have their eyes primarily on background phenomena that cut very little ice, as such, in our daily lives; and yet their studies have a way of bringing out a close relation between these unsuspected realms of fact and such decidedly foreground activities as transporting goods, preparing food, treating the sick, or growing potatoes, which in time may become very much modified, simply because of pure scientific investigation in no way concerned with these brute matters themselves. Linguistics presents a quite similar case; the background phenomena with which it deals are involved in all our foreground activities of talking and of reaching agreement, in all reasoning and arguing of cases, in all law, arbitration, conciliation, contracts, treaties, public opinion, weighing of scientific theories, formulation of scientific results. Whenever agreement or assent is arrived at in human affairs, and whether or not mathematics or other specialized symbolisms are made part of the procedure, *this agreement is reached by linguistic processes, or else it is not reached.*

As we have seen, an overt knowledge of the linguistic processes by which agreement is attained is not necessary to reaching some sort of agreement, but it is certainly no bar thereto; the more complicated and difficult the matter, the more such knowledge is a distinct aid, till the point may be reached – I suspect the modern world has about arrived at it – when the knowledge becomes not only an aid but a necessity. The situation may be likened to that of navigation. Every boat that sails is in the lap of planetary forces; yet a boy can pilot his small craft around a harbor without benefit of geography, astronomy, mathematics, or international politics. To the captain of an ocean liner, however, some knowledge of all these subjects is essential.

When linguists became able to examine critically and scientifically a large number of languages of widely different patterns, their base of reference was expanded; they experienced an interruption of phenomena hitherto held universal, and a whole new order of significances came into their ken. It was found that the background linguistic system (in other words, the grammar) of each language is not merely a reproducing instrument for voicing ideas but rather is itself the shaper of ideas, the program and guide for the individual's mental activity, for his analysis of impressions, for his synthesis of his mental stock in trade. Formulation of ideas is not an independent process, strictly rational in the old sense, but is part of a particular grammar, and differs, from slightly to greatly, between different grammars. We dissect nature along lines laid down by our native languages. The categories and types that we isolate from the world of phenomena we do not find there because they stare every observer in the face; on the contrary, the world is presented in a kaleidoscopic flux of impressions which has to be organized by our minds – and this means largely by the linguistic systems in our minds. We cut nature up, organize it into concepts, and ascribe significances as we do, largely because we are parties to an agreement to organize it in this way – an agreement that holds throughout our speech community and is codified in the patterns of our language. The agreement is, of course, an implicit and unstated one, *but its terms are absolutely obligatory*; we cannot talk at all except by subscribing to the organization and classification of data which the agreement decrees.

This fact is very significant for modern science, for it means that no individual is free to describe nature with absolute impartiality but is constrained to certain modes of interpretation even while he thinks himself most free. The person most nearly free in such respects would be a linguist familiar with very many widely different linguistic systems. As yet no linguist is in any such position. We are thus introduced to a new principle of relativity, which holds that all observers are not led by the same physical evidence to the same picture of the universe, unless their linguistic backgrounds are similar, or can in some way be calibrated.

This rather startling conclusion is not so apparent if we compare only our modern European languages, with perhaps Latin and Greek thrown in for good measure. Among these tongues there is a unanimity of major pattern which at first seems to bear out natural logic. But this unanimity exists only because these tongues are all Indo-European dialects cut to the same basic plan, being historically transmitted from what was long ago one speech community; because the modern dialects have long shared in building up a common culture; and because

much of this culture, on the more intellectual side, is derived from the linguistic back grounds of Latin and Greek. Thus this group of languages satisfies the special case of the clause beginning "unless" in the statement of the linguistic relativity principle at the end of the preceding paragraph. From this condition follows the unanimity of description of the world in the community of modern scientists. But it must be emphasized that "all modern Indo-European-speaking observers" is not the same thing as "all observers." That modern Chinese or Turkish scientists describe the world in the same terms as Western scientists means, of course, only that they have taken over bodily the entire Western system of rationalizations, not that they have corroborated that system from their native posts of observation.

When Semitic, Chinese, Tibetan, or African languages are contrasted with our own, the divergence in analysis of the world becomes more apparent; and, when we bring in the native languages of the Americas, where speech communities for many millenniums have gone their ways independently of each other and of the Old World, the fact that languages dissect nature in many different ways becomes patent. The relativity of all conceptual systems, ours included, and their dependence upon language stands revealed. That American Indians speaking only their native tongues are never called upon to act as scientific observers is in no wise to the point. To exclude the evidence which their languages offer as to what the human mind can do is like expecting botanists to study nothing but food plants and hothouse roses and then tell us what the plant world is like!

Let us consider a few examples. In English we divide most of our words into two classes, which have different grammatical and logical properties. Class I we call nouns, e.g., "house, man"; class 2, verbs, e.g., "hit, run." Many words of one class can act secondarily as of the other class, e.g., "a hit, a run," or "to man (the boat)," but, on the primary level, the division between the classes is absolute. Our language thus gives us a bipolar division of nature. But nature herself is not thus polarized. If it be said that "strike, turn, run," are verbs because they denote temporary or short-lasting events, i.e., actions, why then is "fist" a noun? It also is a temporary event. Why are "lightning, spark, wave, eddy, pulsation, flame, storm, phase, cycle, spasm, noise, emotion" nouns? They are temporary events. If "man" and "house" are nouns because they are long-lasting and stable events, i.e., things, what then are "keep, adhere, extend, project, continue, persist, grow, dwell," and so on doing among the verbs? If it be objected that "possess, adhere" are verbs because they are stable relationships rather than stable percepts, why then should "equilibrium, pressure, current, peace, group, nation, society, tribe, sister," or any kinship term be among the nouns? It will be found that an "event" to us means "what our language classes as a verb" or something analogized therefrom. And it will be found that it is not possible to define "event, thing, object, relationship," and so on, from nature, but that to define them always involves a circuitous return to the grammatical categories of the definer's language.

In the Hopi language, "lightning, wave, flame, meteor, puff of smoke, pulsation" are verbs – events of necessarily brief duration cannot be anything but verbs. "Cloud" and "storm" are at about the lower limit of duration for nouns. Hopi, you see, actually has a classification of events (or linguistic isolates) by

duration type, something strange to our modes of thought. On the other hand, in Nootka, a language of Vancouver Island, all words seem to us to be verbs, but really there are no classes 1 and 2; we have, as it were, a monistic view of nature that gives us only one class of word for all kinds of events. "A house occurs" or "it houses" is the way of saying "house," exactly like "a flame occurs" or "it burns." These terms seem to us like verbs because they are inflected for durational and temporal nuances, so that the suffixes of the word for house event make it mean long-lasting house, temporary house, future house, house that used to be, what started out to be a house, and so on.

Hopi has one noun that covers every thing or being that flies, with the exception of birds, which class is denoted by another noun. The former noun may be said to denote the class (FC-B) – flying class minus bird. The Hopi actually call insect, airplane, and aviator all by the same word, and feel no difficulty about it. The situation, of course, decides any possible confusion among very disparate members of a broad linguistic class, such as this class (FC-B). This class seems to us too large and inclusive, but so would our class "snow" to an Eskimo. We have the same word for falling snow, snow on the ground, snow packed hard like ice, slushy snow, wind-driven flying snow – whatever the situation may be. To an Eskimo, this all-inclusive word would be almost unthinkable; he would say that falling snow, slushy snow, and so on, are sensuouses and operationally different, different things to contend with; he uses different words for them and for other kinds of snow. The Aztecs go even farther than we in the opposite direction, with "cold," "ice," and "snow" all represented by the same basic word with different terminations; "ice" is the noun form; "cold," the adjectival form; and for "snow," "ice mist."

What surprises most is to find that various grand generalizations of the Western world, such as time, velocity, and matter, are not essential to the construction of a consistent picture of the universe. The psychic experiences that we class under these headings are, of course, not destroyed; rather, categories derived from other kinds of experiences take over the rulership of the cosmology and seem to function just as well. Hopi may be called a timeless language. It recognizes psychological time, which is much like Bergson's "duration," but this "time" is quite unlike the mathematical time, T, used by our physicists. Among the peculiar properties of Hopi time are that it varies with each observer, does not permit of simultaneity, and has zero dimensions; i.e., it cannot be given a number greater than one. The Hopi do not say, "I stayed five days," but "I left on the fifth day." A word referring to this kind of time, like the word day, can have no plural. [. . .]

Hopi grammar, by means of its forms called aspects and modes, also makes it easy to distinguish among momentary, continued, and repeated occurrences, and to indicate the actual sequence of reported events. Thus the universe can be described without recourse to a concept of dimensional time. How would a physics constructed along these lines work, with no T (time) in its equations? Perfectly, as far as I can see, though of course it would require different ideology and perhaps different mathematics. Of course V (velocity) would have to go too. The Hopi language has no word really equivalent to our "speed" or "rapid." What translates these terms is usually a word meaning intense or very,

accompanying any verb of motion. Here is a clue to the nature of our new physics. We may have to introduce a new term I, intensity. Every thing and event will have an I, whether we regard the thing or event as moving or as just enduring or being. Perhaps the I of an electric charge will turn out to be its voltage, or potential. We shall use clocks to measure some intensities, or, rather, some *relative* intensities, for the absolute intensity of anything will be meaningless. Our old friend acceleration will still be there but doubtless under a new name. We shall perhaps call it V, meaning not velocity but variation. Perhaps all growths and accumulations will be regarded as V's. We should not have the concept of rate in the temporal sense, since, like velocity, rate introduces a mathematical and linguistic time. Of course we know that all measurements are ratios, but the measurements of intensities made by comparison with the standard intensity of a clock or a planet we do not treat as ratios, any more than we so treat a distance made by comparison with a yardstick.

A scientist from another culture that used time and velocity would have great difficulty in getting us to understand these concepts. We should talk about the intensity of a chemical reaction; he would speak of its velocity or its rate, which words we should at first think were simply words for intensity in his language. Likewise, he at first would think that intensity was simply our own word for velocity. At first we should agree, later we should begin to disagree, and it might dawn upon both sides that different systems of rationalization were being used. He would find it very hard to make us understand what he really meant by velocity of a chemical reaction. We should have no words that would fit. He would try to explain it by likening it to a running horse, to the difference between a good horse and a lazy horse. We should try to show him, with a superior laugh, that his analogy also was a matter of different intensities, aside from which there was little similarity between a horse and a chemical reaction in a beaker. We should point out that a running horse is moving relative to the ground, whereas the material in the beaker is at rest.

One significant contribution to science from the linguistic point of view may be the greater development of our sense of perspective. We shall no longer be able to see a few recent dialects of the Indo-European family, and the rationalizing techniques elaborated from their patterns, as the apex of the evolution of the human mind, nor their present wide spread as due to any survival from fitness or to anything but a few events of history – events that could be called fortunate only form the parochial point of view of the favored parties. They, and our own thought processes with them, can no longer be envisioned as spanning the gamut of reason and knowledge but only as one constellation in a galactic expanse. A fair realization of the incredible degree of diversity of linguistic system that ranges over the globe leaves one with an inescapable feeling that the human spirit is inconceivably old; that the few thousand years of history covered by our written records are no more than the thickness of a pencil mark on the scale that measures our past experience on this planet; that the events of these recent millenniums spell nothing in any evolutionary wise, that the race has taken no sudden spurt, achieved no commanding synthesis during recent millenniums, but has only played a little with a few of the linguistic formulations and views of nature bequeathed from an inexpressibly longer past. Yet neither this feeling

nor the sense of precarious dependence of all we know upon linguistic tools which themselves are largely unknown need be discouraging to science but should, rather, foster that humility which accompanies the true scientific spirit, and thus forbid that arrogance of the mind which hinders real scientific curiosity and detachment.

L.S. Vygotsky

THOUGHT AND WORD (1934)

[. . .] Inner speech is not the interior aspect of external speech – it is a function in itself. It still remains speech, i.e., thought connected with words. But while in external speech thought is embodied in words, in inner speech words die as they bring forth thought. Inner speech is to a large extent thinking in pure meanings. It is a dynamic, shifting, unstable thing, fluttering between word and thought, the two more or less stable, more or less firmly delineated components of verbal thought. Its true nature and place can be understood only after examining the next plane of verbal thought, the one still more inward than inner speech.

That plane is thought itself. As we have said, every thought creates a connection, fulfills a function, solves a problem. The flow of thought is not accompanied by a simultaneous unfolding of speech. The two processes are not identical, and there is no rigid correspondence between the units of thought and speech. This is especially obvious when a thought process miscarries – when, as Dostoevsky put it, a thought "will not enter words."

Here one literary example will be appropriate. Gleb Uspensky's character, a poor peasant, who must address an official with some life-important issue, cannot put his thoughts into words. Embarrassed by his failure, he retreats and prays, asking the Lord "to give him a concept." This scene leaves the reader disturbed and depressed. But in its essence, the problem facing this poor and illiterate peasant is of the same kind constantly hounding thinkers and writers: How to put thoughts into words. Sometimes even the speech of Uspensky's character starts to resemble that of a poet: "I would tell you all of this, my friend, concealing nothing . . . but, you know, folks of my kind cannot talk . . . It is as if they are all here, in my head, but cannot slip from the tongue. That is our, fools', sorrow" (Gleb Uspensky, 1949, p. 184).[1]

In this fragment the watershed between thoughts and words becomes highly visible. If thoughts were identical in structure and development with speech, the case described by Uspensky would be impossible.

Thought has its own structure, and the transition from it to speech is no easy matter. The theater faced the problem of the thought behind the words before psychology did. In teaching his system of acting, Konstantin Stanislavsky required the actors to uncover the "subtext" of their lines in a play.[2] In Griboedov's comedy *Woe from Wit*, the hero, Chatsky, says to the heroine, who maintains that she has never stopped thinking of him, "Thrice blessed who believes. Believing warms the heart." Stanislavsky interpreted this as "Let us stop this talk"; but it could just as well be interpreted as "I do not believe you. You say it to comfort me," or as "Don't you see how you torment me? I wish I could believe you. That would be bliss." Every sentence that we say in real life has some kind of subtext, a thought hidden behind it. [...] Just as one sentence may express different thoughts, one thought may be expressed in different sentences. For instance, "The clock fell," in answer to the question "Why did the clock stop?" could mean, "It is not my fault that the clock is out of order; it fell." The same thought, self-justification, could take, among others, the form "It is not my habit to touch other people's things. I was just dusting here."

Thought, unlike speech, does not consist of separate units. When I wish to communicate the thought that today I saw a barefoot boy in a blue shirt running down the street, I do not see every item separately; the boy, the shirt, its blue color, his running, the absence of shoes. I conceive of all this in one thought, but I put it into separate words. A speaker often takes several minutes to disclose one thought. In his mind the whole thought is present at once, but in speech it has to be developed successively. A thought may be compared to a cloud shedding a shower of words. Precisely because thought does not have its automatic counterpart in words, the transition from thought to word leads through meaning. In our speech, there is always the hidden thought, the subtext. Because a direct transition from thought to word is impossible, there have always been laments about the inexpressibility of thought:

> How shall the heart express itself?
> How shall another understand?
> (F. Tiutchev)

or

> If only soul might speak without words!
> (A. Fet)

To overcome this problem, new paths from thought to word leading through new word meanings must be cut. Velemir Khlebnikov compared his futuristic poetry with the construction of roads connecting one valley to another.[3]

Experience teaches us that thought does not express itself in words, but rather realizes itself in them. Sometimes such realization cannot be accomplished, as in the case of Uspensky's character. We must ask, Does this character know what he is going to think about? Yes, but he does it as one who wants to remember something but is unable to. Does he start thinking? Yes, but again he does it as one who is absorbed by remembering. Does he succeed in turning his thought into a process? No. The problem is that thought is mediated by signs

externally, but it also is mediated internally, this time by word meanings. Direct communication between minds is impossible, not only physically but psychologically. Communication can be achieved only in a roundabout way. Thought must first pass through meanings and only then through words.

We come now to the last step in our analysis of inner planes of verbal thought. Thought is not the superior authority in this process. Thought is not begotten by thought; it is engendered by motivation, i.e., by our desires and needs, our interests and emotions. Behind every thought there is an affective-volitional tendency, which holds the answer to the last "why" in the analysis of thinking. A true and full understanding of another's thought is possible only when we understand its affective-volitional basis. We shall illustrate this by an example already used: the interpretation of parts in a play. Stanislavsky, in his instructions to actors, listed the motives behind the words of their parts for A. Griboedov's *Woe from Wit*, act I:

Text of the Play	*Parallel Motives*
SOPHYA:	
O, Chatsky, but I am glad you've come	Tries to hide her confusion.
CHATSKY:	
You are glad, that's very nice; But gladness such as yours not easily one tells. It rather seems to me, all told, That making man and horse catch cold I've pleased myself and no one else	Tries to make her feel guilty by teasing her. Aren't you ashamed of yourself! Tries to force her to be frank.
LIZA:	
There, sir, and if you'd stood on the same landing here Five minutes, no, not five ago You'd heard your name clear as clear. You say, Miss! Tell him it was so.	Tries to calm him. Tries to help Sophya in a difficult situation.
SOPHYA:	
And always so, no less, no more. No, as to that, I'm sure you can't reproach me.	Tries to reassure Chatsky. I am not guilty of anything!
CHATSKY:	
Well, let's suppose it's so. Thrice blessed who believes. Believing warms the heart.	Let us stop this conversation; etc.

To understand another's speech, it is not sufficient to understand his words – we must understand his thought. But even that is not enough – we must also know its motivation. No psychological analysis of an utterance is complete until that plane is reached.

We have come to the end of our analysis; let us survey its results. Verbal thought appeared as a complex, dynamic entity, and the relation of thought and word within it as a movement through a series of planes. Our analysis followed the process from the outermost plane to the innermost plane. In reality, the development of verbal thought takes the opposite course: from the motive that engenders a thought to the shaping of the thought, first in inner speech, then in meanings of words, and finally in words. It would be a mistake, however, to imagine that this is the only road from thought to word. The development may stop at any point in its complicated course: an infinite variety of movements to and fro, of ways still unknown to us, is possible. A study of these manifold variations lies beyond the scope of our present task.

Our investigation followed a rather unusual path. We wished to study the inner workings of thought and speech, hidden from direct observation. Meaning and the whole inward aspect of language, the side turned toward the person, not toward the outer world, have been so far an almost unknown territory. No matter how they were interpreted, the relations between thought and word were always considered constant, established forever. Our investigation has shown that they are, on the contrary, delicate, changeable relations between processes, which arise during the development of verbal thought. We did not intend to, and could not, exhaust the subject of verbal thought. We tried only to give a general conception of the infinite complexity of this dynamic structure – a conception starting from experimentally documented facts.

To association psychology, thought and word were united by external bonds, similar to the bonds between two nonsense syllables. Gestalt psychology introduced the concept of structural bonds, but, like the older theory, did not account for the specific relations between thought and word. All the other theories grouped themselves around two poles – either the behaviorist concept of thought as speech minus sound or the idealistic view, held by the Würzburg school and Bergson, that thought could be "pure," unrelated to language, and that it was distorted by words. Tiutchev's "A thought once uttered is a lie" could well serve as an epigraph for the latter group. Whether inclining toward pure naturalism or extreme idealism, all these theories have one trait in common – their antihistorical bias. They study thought and speech without any reference to their developmental history.

Only a historical theory of inner speech can deal with this immense and complex problem. The relation between thought and word is a living process; thought is born through words. A word devoid of thought is a dead thing:

> . . . and like bees in the deserted hive
> The dead words have a rotten smell.
> (N. Gumilev)

But thought that fails to realize itself in words also remains a "Stygian shadow" (O. Mandelstam). Hegel considered word as a Being animated by thought. This Being is absolutely essential for our thinking.

The connection between thought and word, however, is neither preformed nor constant. It emerges in the course of development, and itself evolves. To the biblical "In the beginning was the Word," Goethe makes Faust reply, "In the beginning was the deed." The intent here is to detract from the value of the word, but we can accept this version if we emphasize it differently: In the *beginning* was the deed. The word was not the beginning – action was there first; it is the end of development, crowning the deed.

We cannot close our study without mentioning the perspectives that our investigation opens up. This is even more momentous a problem than that of thinking; what I mean is the problem of consciousness. We studied the inward aspects of speech, which were as unknown to science as the other side of the moon. We tried to establish the connection between word and object, word and reality. We attempted to study experimentally the dialectics of transition from perception to thinking, and to show that a generalized reflection of reality is the basic characteristic of words. This aspect of the word brings us to the threshold of a wider and deeper subject, i.e., the problem of the relation between word and consciousness. If perceptive consciousness and intellectual consciousness reflect reality differently, then we have two different forms of consciousness. *Thought and speech turn out to be the key to the nature of human consciousness.*

If language is as old as consciousness itself, and if language is a practical consciousness-for-others and, consequently, consciousness-for-myself, then not only one particular thought but all consciousness is connected with the development of the word. The word is a thing in our consciousness, as Ludwig Feuerbach put it, that is absolutely impossible for one person, but that becomes a reality for two. The word is a direct expression of the historical nature of human consciousness.

Consciousness is reflected in a word as the sun in a drop of water. A word relates to consciousness as a living cell relates to a whole organism, as an atom relates to the universe. A word is a microcosm of human consciousness.

Notes

1 Gleb Uspensky, *Izbrannye proizvedeniia* [Collected Works], Moscow, 1949. [Eds]
2 Konstantin Stanislavsky (1863–1938), Russian stage director and theoretician of the theater. His notes for actors connected with the production of *Woe from Wit* are published in *Creating a Role*, New York: Theater Art Books, 1961.
3 Velemir Khlebnikov (1885–1922), Russian poet-futurist, innovator of language. See his *Snake Train: Poetry and Prose*, Ann Arbor: Ardis, 1976.

Sigmund Freud

SLIPS OF THE TONGUE (1901)

The ordinary (linguistic) material which we use for talking in our native language appears to be protected against being forgotten; but it succumbs all the more frequently to another disturbance, which is known as a 'slip of the tongue'. The slips of the tongue that we observe in normal people give an impression of being the preliminary stages of the so-called 'paraphasias' that appear under pathological conditions.[1]

This is a subject on which I find myself in the exceptional position of being able to acknowledge the value of a previous work. In 1895 R. Meringer and C. Mayer published a study on 'Slips in Speaking and Reading'.[2] Their lines of approach differ widely from my own. One of the authors, who acts as spokesman in the text, is in fact a philologist, and it was his linguistic interests which led him to attempt to discover the rules that govern the making of slips of the tongue. He hoped to be able to conclude from these rules that there exists 'a certain mental mechanism, in which the sounds of a word, or of a sentence, and the (whole) words as well, are mutually linked and connected in a quite peculiar way' (p. 10).

The examples of slips of the tongue collected by the authors are first grouped by them in purely descriptive categories. They are classed as *transpositions* (e.g. 'the Milo of Venus' instead of 'the Venus of Milo'); *pre-sonances* or *anticipations* (e.g. '*es war mir auf der Schwest . . . auf der Brust so schwer*'[3]); *post-sonances* or *perseverations* (e.g. '*ich fordere Sie auf, auf das Wohl unseres Chefs aufzustossen*' instead of '*anzustossen*');[4] *contaminations* (e.g. '*er setzt sich auf den Hinterkopf*', combined from '*er setzt sich einen Kopf auf*' and '*er stellt sich auf die Hinterbeine*');[5] and *substitutions* (e.g. '*ich gebe die Präparate in den Briefkasten*' instead of '*Brütkasten*').[6] There are in addition to these main categories a few others which are less important (or less significant from our own point of view). In the above arrangement into groups it makes no difference whether the transposition, distortion, amalgamation, etc., is concerned with single sounds in a word, with syllables, or with complete words forming part of the intended sentence.

To explain the various kinds of slips of the tongue he had observed, Meringer postulates that different spoken sounds have a different psychical valency. When we innervate the first sound in a word or the first word in a sentence, the excitatory process already extends to the later sounds and the following words, and in so far as these innervations are simultaneous with one another they can exercise a modifying influence on one another. The excitation of the sound that is psychically more intense anticipates other excitations or perseverates after them, and in this way disturbs the less valent process of innervation. The question has therefore to be decided which sounds in a word have the highest valency. Here is Meringer's view: 'If we want to know which sound in a word has the highest intensity, we must observe ourselves when we are searching for a forgotten word, e.g. for a name. Whichever [sound] is the first to come back into consciousness is in every case the one that had the greatest intensity before the word was forgotten' (p. 160). 'The sounds which are of high valency are the initial sound in the root syllable, and the initial sound in the word, and the accentuated vowel or vowels' (p. 162).

I cannot help contradicting him here. Whether the initial sound of the name is one of the elements of highest valency in a word or not, it is certainly untrue that in a forgotten word it is the first to return to consciousness. The rule stated above is therefore inapplicable. If we observe ourselves while searching for a forgotten name, we are comparatively often obliged to express a conviction that it begins with a particular letter. This conviction proves to be unfounded just as often as not. Indeed, I should like to assert that in the majority of cases the initial sound which we announce is a wrong one. In our example of 'Signorelli' [7] [...], in fact, the substitute names had lost the initial sound and the essential syllables: it was precisely the less valent pair of syllables – *elli* – which returned to memory in the substitute name Botticelli.

How little attention[8] is paid by the substitute names to the initial sound of the missing name may be learned, for instance, from the following case:

> One day I found it impossible to recall the name of the small country of which *Monte Carlo* is the chief town. The substitute names for it ran: *Piedmont, Albania, Montevideo, Colico*. *Albania* was soon replaced in my mind by *Montenegro*; and it then occurred to me that the syllable 'Mont' (pronounced 'Mon') was found in all the substitute names except the last. Thus it was easy for me, starting from the name of Prince Albert [the ruling Prince], to find the forgotten name *Monaco*. *Colico* gives a pretty close imitation of the sequence of syllables and the rhythm of the forgotten name.[9]

If we allow ourselves to suppose that a mechanism similar to that which has been demonstrated for the forgetting of names could also play a part in the phenomena of slips of the tongue, we are led to form a more deeply based judgement of instances of the latter. The disturbance in speaking which is manifested in a slip of the tongue can in the first place be caused by the influence of another component of the same speech – by an anticipatory sound, that is, or by a perseveration – or by another formulation of the ideas contained within the sentence

or context that it is one's intention to utter. This is the type to which all the above examples borrowed from Meringer and Mayer belong. The disturbance could, however, be of a second kind, analogous to the process in the Signorelli case; it could result from influences *outside* this word, sentence or context, and arise out of elements which are not intended to be uttered and of whose excitation we only learn precisely through the actual disturbance. What these two ways in which slips of the tongue arise have in common would be the simultaneity of the interfering excitation; what differentiates them would be the position of the excitation inside or outside the sentence or context. The difference does not at first appear great in so far as it concerns certain deductions that can be made from the symptomatology of slips of the tongue. It is clear, however, that only in the former case is there any prospect of drawing conclusions from the phenomena of slips of the tongue about a mechanism which links sounds and words with one another so that they mutually influence their articulation – conclusions, that is, such as the philologist hoped to arrive at from studying slips of the tongue. In the case of interference from influences *outside* the same sentence or context of what is being said, it would be above all a matter of getting to know what the interfering elements are – after which the question would arise whether the mechanism of this disturbance, too, can reveal the supposed laws of speech formation.

Meringer and Mayer cannot be said to have overlooked the possibility that disturbances of speech may be the result of 'complicated psychical influences', of elements outside the same word, sentence or sequence of spoken words. They were bound to observe that the theory which asserts that sounds are of unequal psychical valency is strictly speaking only adequate for explaining sounddisturbances, together with sound-anticipations and perseverations. Where worddisturbances cannot be reduced to sound-disturbances (as, for instance, in substitutions and contaminations of words), they have not hesitated to look *outside* the intended context for the cause of the slip – a procedure which they justify by some good examples. I quote the following passages:

'Ru. was speaking of occurrences which, within himself, he pronounced to be "*Schweinereien* [disgusting, literally, piggish]". He tried, however, to express himself mildly, and began: 'But then facts came to "*Vorschwein*" . . .'[10] Mayer and I were present and Ru. confirmed his having thought "*Schweinereien*". The fact that this word which entered his thoughts was betrayed in "Vorschwein" and suddenly became operative is sufficiently explained by the similarity of the words' (p. 62).

'Just as in contaminations, so also – and probably to a much higher degree – in substitutions an important role is played by "floating" or "wandering" speech images. Even if they are beneath the threshold of consciousness they are still near enough to be operative, and can easily be brought into play by any resemblance they may have to the complex that is to be spoken. When this is so they cause a deviation in the train of words or cut across it. "Floating" or "wandering" speech images are often, as we have said, stragglers following after speech processes which have recently terminated (perseverations)' (p. 73).

'Resemblance can also cause a deviation when another, similar word lies a short way below the threshold of consciousness, *without a decision to speak it having been reached*. This is the case with substitutions. – Thus I hope that my rules

will of necessity be confirmed when they are tested. But for this it is necessary (if the speaker is someone else) *that we should obtain a clear notion of everything that was in the speaker's thoughts.* Here is an instructive case. Li., a schoolmaster, said in our presence: "Die Frau würde mir Furcht ein*l*agen."[11] I was taken aback, for the *l* struck me as inexplicable. I ventured to draw the speaker's attention to his slip in saying "*einlagen*" for "*einjagen*", upon which he at once replied: "Yes, the reason was that I thought: I should not be "*in der Lage* [in a position]", etc."'

'Here is another case. I asked R. von Schid. how his sick horse was getting on. He replied: "*Ja. das draut . . . dauert vielleicht noch einen Monat.*"[12] I could not understand the "*draut*", with an *r*, for the *r* in "*dauert*" could not possibly have had this result. So I drew his attention to it, whereupon he explained that his thought had been: "*das ist eine traurige Geschichte* [it's a *sad* story]." Thus the speaker had two answers in his mind and they had been intermixed'.

It is pretty obvious that the consideration of 'wandering' speech images which lie below the threshold of consciousness and are not intended to be spoken, and the demand for information about everything that had been in the speaker's mind, are procedures which constitute a very close approach to the state of affairs in our 'analyses'. We too are looking for unconscious material; and we even look for it along the same path, except that, in proceeding from the ideas that enter the mind of the person who is being questioned to the discovery of the disturbing element, we have to follow a longer path, through a complicated series of associations.

Notes

1 Freud had discussed 'paraphasia' as a symptom of organic brain disorders in his book *On Aphasia* (1891, London and New York, pp. 1953, 13 ff.); but he had also pointed out there that the *symptom* of paraphasia in such disorders 'does not differ from the incorrect use and the distortion of words which the healthy person can observe in himself in states of fatigue or divided attention or under the influence of disturbing affects'.

2 R. Meringer with C. Mayer, *Versprechen und Verlesen, eine Psychologisch-Linguistische Studie,* Vienna, 1895. [Eds]

3 The intended phrase was: 'it lay so heavily on my breast (*Brust*).' The substituted '*Schwest*' is a non-existent word.

4 'I call on you to *hiccough to* the health of our Principal' instead of '*drink to*'.

5 'He stands on the back of his head' (a meaningless phrase) combined from 'He is obstinate' (literally, 'he puts on a head') and 'He gets on his hind legs'.

6 'I put the preparation into the letter-box' instead of 'incubator', literally 'hatching-box'.

7 See Freud's essay, 'The Forgetting of Proper Names', in *The Psychopathology of Everyday Life,* London: Penguin, 1960, pp. 37–52. [Eds]

8 This paragraph and the next were added in 1907, six years after the rest of the chapter was written.

9 This example was used later by Freud in the sixth of his *Introductory Lectures* (1910–17). He states there (in a slightly different and perhaps more lucid

account of the episode) that the replacement of *Albania* by *Montenegro* was probably due to the contrast between black and white; and that it was thoughts connected with *Munich* – which is also *Monaco* in Italian – which had caused him to forget the name.

10 Ru. intended to say 'came to *'light'* ' and should have used the word *'Vorschein'*. Instead he used the meaningless word *'Vorschwein'*.

11 He intended to say: 'The lady would strike (*einjagen*) terror into me.' But instead of *'einjagen'* he said *'einlagen'*, which is a non-existent verb – though *'Lage'* is a familiar noun meaning 'position'.

12 What he intended to say was: 'Well, it will last (*dauert*) another month perhaps.' Instead of *'dauert'* he used the meaningless word *'draut'*.

Jacques Lacan

THE SIGNIFICATION OF THE PHALLUS (1958)

[...] What is the link between the murder of the father and the pact of the primordial law, if it is included in that law that castration should be the punishment for incest?

It is only on the basis of the clinical facts that any discussion can be fruitful. These facts reveal a relation of the subject to the phallus that is established without regard to the anatomical difference of the sexes, and which, by this very fact, makes any interpretation of this relation especially difficult in the case of women. This problem may be treated under the following four headings:

1 from this 'why', the little girl considers herself, if only momentarily, as castrated, in the sense of deprived of the phallus, by someone, in the first instance by her mother, an important point, and then by her father, but in such a way that one must recognize in it a transference in the analytic sense of the term;

2 from this 'why', in a more primordial sense, the mother is considered, by both sexes, as possessing the phallus, as the phallic mother;

3 from this 'why', correlatively, the signification of castration in fact takes on its (clinically manifest) full weight as far as the formation of symptoms is concerned, only on the basis of its discovery as castration of the mother;

4 these three problems lead, finally, to the question of the reason, in development, for the phallic stage. We know that in this term Freud specifies the first genital maturation: on the one hand, it would seem to be characterized by the imaginary dominance of the phallic attribute and by masturbatory *jouissance* and, on the other, it localizes this *jouissance* for the woman in the clitoris, which is thus raised to the function of the phallus. It therefore seems to exclude in both sexes, until the end of this stage, that is, to the decline of the Oedipal stage, all instinctual mapping of the vagina as locus of genital penetration.

This ignorance is suspiciously like *méconnaissance* in the technical sense of the term – all the more so in that it is sometimes quite false. Does this not bear out the fable in which Longus shows us the initiation of Daphnis and Chloe subordinated to the explanations of an old woman?

Thus certain authors have been led to regard the phallic stage as the effect of a repression, and the function assumed in it by the phallic object as a symptom. The difficulty begins when one asks, *what* symptom? Phobia, says one, perversion, says another, both says a third. It seems in the last case that nothing more can be said: not that interesting transmutations of the object of a phobia into a fetish do not occur, but if they are interesting it is precisely on account of the difference of their place in the structure. It would be pointless to demand of these authors that they formulate this difference from the perspectives currently in favour, that is to say, in terms of the object relation. Indeed, there is no other reference on the subject than the approximate notion of part-object, which – unfortunately, in view of the convenient uses to which it is being put in our time, has never been subjected to criticism since Karl Abraham introduced it.

[. . .]

It is on the basis of the following bet – which I lay down as the principle of a commentary of Freud's work that I have pursued during the past seven years – that I have been led to certain results: essentially, to promulgate as necessary to any articulation of analytic phenomena the notion of the signifier, as opposed to that of the signified, in modern linguistic analysis. Freud could not take this notion, which postdates him, into account, but I would claim that Freud's discovery stands out precisely because, although it set out from a domain in which one could not expect to recognize its reign, it could not fail to anticipate its formulas. Conversely, it is Freud's discovery that gives to the signifier/signified opposition the full extent of its implications: namely, that the signifier has an active function in determining certain effects in which the signifiable appears as submitting to its mark, by becoming through that passion the signified.

This passion of the signifier now becomes a new dimension of the human condition in that it is not only man who speaks, but that in man and through man *it* speaks (*ça parle*), that his nature is woven by effects in which is to be found the structure of language, of which he becomes the material, and that therefore there resounds in him, beyond what could be conceived of by a psychology of ideas, the relation of speech.

In this sense one can say that the consequences of the discovery of the unconscious have not yet been so much as glimpsed in theory, although its effects have been felt in praxis to a greater degree than perhaps we are aware of, if only in the form of effects of retreat.

It should be made clear that this advocacy of man's relation to the signifier as such has nothing to do with a 'culturalist' position in the ordinary sense of the term, the position in which Karen Horney, for example, was anticipated in the dispute concerning the phallus by a position described by Freud himself as a feminist one. It is not a question of the relation between man and language as a social phenomenon, there being no question even of something resembling the ideo-

logical psychogenesis with which we are familiar, and which is not superseded by peremptory recourse to the quite metaphysical notion, which lurks beneath its question-begging appeal to the concrete, conveyed so pitifully by the term 'affect'.

It is a question of rediscovering in the laws that govern that other scene (*ein andere Schauplatz*), which Freud, on the subject of dreams, designates as being that of the unconscious, the effects that are discovered at the level of the chain of materially unstable elements that constitutes language: effects determined by the double play of combination and substitution in the signifier, according to the two aspects that generate the signified, metonymy and metaphor; determining effects for the institution of the subject. From this test, a topology, in the mathematical sense of the term, appears, without which one soon realizes that it is impossible simply to note the structure of a symptom in the analytic sense of the term.

It speaks in the Other, I say, designating by the Other the very locus evoked by the recourse to speech in any relation in which the Other intervenes. If *it* speaks in the Other, whether or not the subject hears it with his ear, it is because it is there that the subject, by means of a logic anterior to any awakening of the signified, finds its signifying place. The discovery of what it articulates in that place, that is to say, in the unconscious, enables us to grasp at the price of what splitting (*Spaltung*) it has thus been constituted.

The phallus reveals its function here. In Freudian doctrine, the phallus is not a phantasy, if by that we mean an imaginary effect. Nor is it as such an object (part-, internal, good, bad, etc.) in the sense that this term tends to accentuate the reality pertaining in a relation. It is even less the organ, penis or clitoris, that it symbolizes. And it is not without reason that Freud used the reference to the simulacrum that it represented for the Ancients.

For the phallus is a signifier, a signifier whose function, in the intrasubjective economy of the analysis, lifts the veil perhaps from the function it performed in the mysteries. For it is the signifier intended to designate as a whole the effects of the signified, in that the signifier conditions them by its presence as a signifier.

Let us now examine the effects of this presence. In the first instance, they proceed from a deviation of man's needs from the fact that he speaks, in the sense that in so far as his needs are subjected to demand, they return to him alienated. This is not the effect of his real dependence (one should not expect to find here the parasitic conception represented by the notion of dependence in the theory of neurosis), but rather the turning into signifying form as such, from the fact that it is from the locus of the Other that its message is emitted.

That which is thus alienated in needs constitutes an *Urverdrängung* (primal repression), an inability, it is supposed, to be articulated in demand, but it reappears in something it gives rise to that presents itself in man as desire (*das Begehren*). The phenomenology that emerges from analytic experience is certainly of a kind to demonstrate in desire the paradoxical, deviant, erratic, eccentric, even scandalous character by which it is distinguished from need. This fact has been too often affirmed not to have been always obvious to moralists worthy of the name. The Freudianism of earlier days seemed to owe its status to this fact. Paradoxically, however, psychoanalysis is to be found at the head of an ever-

present obscurantism that is still more boring when it denies the fact in an ideal of theoretical and practical reduction of desire to need.

This is why we must articulate this status here, beginning with *demand*, whose proper characteristics are eluded in the notion of frustration (which Freud never used).

Demand in itself bears on something other than the satisfactions it calls for. It is demand of a presence or of an absence – which is what is manifested in the primordial relation to the mother, pregnant with that Other to be situated *within* the needs that it can satisfy. Demand constitutes the Other as already possessing the 'privilege' of satisfying needs, that it is to say, the power of depriving them of that alone by which they are satisfied. This privilege of the Other thus outlines the radical form of the gift of that which the Other does not have, namely, its love.

In this way, demand annuls (*aufhebt*) the particularity of everything that can be granted by transmuting it into a proof of love, and the very satisfactions that it obtains for need are reduced (*sich erniedrigt*) to the level of being no more than the crushing of the demand for love (all of which is perfectly apparent in the psychology of child-rearing, to which our analyst-nurses are so attached).

It is necessary, then, that the particularity thus abolished should reappear *beyond* demand. It does, in fact, reappear there, but preserving the structure contained in the unconditional element of the demand for love. By a reversal that is not simply a negation of the negation, the power of pure loss emerges from the residue of an obliteration. For the unconditional element of demand, desire substitutes the 'absolute' condition: this condition unties the knot of that element in the proof of love that is resistant to the satisfaction of a need. Thus desire is neither the appetite for satisfaction, nor the demand for love, but the difference that results from the subtraction of the first from the second, the phenomenon of their splitting (*Spaltung*).

One can see how the sexual relation occupies this closed field of desire, in which it will play out its fate. This is because it is the field made for the production of the enigma that this relation arouses in the subject by doubly 'signifying' it to him: the return of the demand that it gives rise to, as a demand on the subject of the need – an ambiguity made present on to the Other in question in the proof of love demanded. The gap in this enigma betrays what determines it, namely, to put it in the simplest possible way, that for both partners in the relation, both the subject and the Other, it is not enough to be subjects of need, or objects of love, but that they must stand for the cause of desire.

This truth lies at the heart of all the distortions that have appeared in the field of psychoanalysis on the subject of the sexual life. It also constitutes the condition of the happiness of the subject: and to disguise the gap it creates by leaving it to the virtue of the 'genital' to resolve it through the maturation of tenderness (that is to say, solely by recourse to the Other as reality), however well intentioned, is fraudulent nonetheless. It has to be said here that the French analysts, with their hypocritical notion of genital oblativity, opened the way to the moralizing tendency, which, to the accompaniment of its Salvationist choirs, is now to be found everywhere.

In any case, man cannot aim at being whole (the 'total personality' is another

of the deviant premises of modern psychotherapy), while ever the play of displacement and condensation to which he is doomed in the exercise of his functions marks his relation as a subject to the signifier.

The phallus is the privileged signifier of that mark in which the role of the logos is joined with the advent of desire.

It can be said that this signifier is chosen because it is the most tangible element in the real of sexual copulation, and also the most symbolic in the literal (typographical) sense of the term, since it is equivalent there to the (logical) copula. It might also be said that, by virtue of its turgidity, it is the image of the vital flow as it is transmitted in generation.

All these propositions merely conceal the fact that it can play its role only when veiled, that is to say, as itself a sign of the latency with which any signifiable is struck, when it is raised (*aufgehoben*) to the function of signifier.

The phallus is the signifier of this *Aufhebung* itself, which it inaugurates (initiates) by its disappearance. That is why the demon of Αἰδώς (*Scham*, shame) arises at the very moment when, in the ancient mysteries, the phallus is unveiled (cf. the famous painting in the *Villa di Pompei*).

It then becomes the bar which, at the hands of this demon, strikes the signified, marking it as the bastard offspring of this signifying concatenation.

Thus a condition of complementarity is produced in the establishment of the subject by the signifier – which explains the *Spaltung* in the subject and the movement of intervention in which that 'splitting' is completed.

Namely:

1 that the subject designates his being only by barring everything he signifies, as it appears in the fact that he wants to be loved for himself, a mirage that cannot be dismissed as merely grammatical (since it abolishes discourse);
2 that the living part of that being in the *urverdrängt* (primally repressed) finds its signifier by receiving the mark of the *Verdrängung* (repression) of the phallus (by virtue of which the unconscious is language).

The phallus as signifier gives the ratio of desire (in the sense in which the term is used in music in the 'mean and extreme ratio' of harmonic division).

I shall also be using the phallus as an algorithm, so if I am to help you to grasp this use of the term I shall have to rely on the echoes of the experience that we share – otherwise, my account of the problem could go on indefinitely.

The fact that the phallus is a signifier means that it is in the place of the Other that the subject has access to it. But since this signifier is only veiled, as ratio of the Other's desire, it is this desire of the Other as such that the subject must recognize, that is to say, the other in so far as he is himself a subject divided by the signifying *Spaltung*.

The emergences that appear in psychological genesis confirm this signifying function of the phallus.

Thus, to begin with, the Kleinian fact that the child apprehends from the outset that the mother 'contains' the phallus may be formulated more correctly.

But it is in the dialectic of the demand for love and the test of desire that development is ordered.

The demand for love can only suffer from a desire whose signifier is alien to it. If the desire of the mother *is* the phallus, the child wishes to be the phallus in order to satisfy that desire. Thus the division immanent in desire is already felt to be experienced in the desire of the Other, in that it is already opposed to the fact that the subject is content to present to the Other what in reality he may *have* that corresponds to this phallus, for what he has is worth no more than what he does not have, as far as his demand for love is concerned because that demand requires that he be the phallus.

Clinical experience has shown us that this test of the desire of the Other is decisive not in the sense that the subject learns by it whether or not he has a real phallus, but in the sense that he learns that the mother does not have it. This is the moment of the experience without which no symptomatic consequence (phobia) or structural consequence (*Penisneid*) relating to the castration complex can take effect. Here is signed the conjunction of desire, in that the phallic signifier is its mark, with the threat or nostalgia of lacking it.

Of course, its future depends on the law introduced by the father into this sequence.

But one may, simply by reference to the function of the phallus, indicate the structures that will govern the relations between the sexes.

Let us say that these relations will turn around a 'to be' and a 'to have', which, by referring to a signifier, the phallus, have the opposed effect, on the one hand, of giving reality to the subject in this signifier, and, on the other, of derealizing the relations to be signified.

This is brought about by the intervention of a 'to seem' that replaces the 'to have', in order to protect it on the one side, and to mask its lack in the other, and which has the effect of projecting in their entirety the ideal or typical manifestations of the behaviour of each sex, including the act of copulation itself, into the comedy.

These ideals take on new vigour from the demand that they are capable of satisfying, which is always a demand for love, with its complement of the reduction of desire to demand.

Paradoxical as this formulation may seem, I am saying that it is in order to be the phallus, that is to say, the signifier of the desire of the Other, that a woman will reject an essential part of femininity, namely, all her attributes in the masquerade. It is for that which she is not that she wishes to be desired as well as loved. But she finds the signifier of her own desire in the body of him to whom she addresses her demand for love. Perhaps it should not be forgotten that the organ that assumes this signifying function takes on the value of a fetish. But the result for the woman remains that an experience of love, which, as such (cf. above), deprives her ideally of that which the object gives, and a desire which finds its signifier in this object, converge on the same object. That is why one can observe that a lack in the satisfaction proper to sexual need, in other words, frigidity, is relatively well tolerated in women, whereas the *Verdrängung* (repression) inherent in desire is less present in women than in men.

In the case of men, on the other hand, the dialectic of demand and desire engenders the effects – and one must once more admire the sureness with which

Freud situated them at the precise articulations on which they depended – of a specific depreciation (*Erniedrigung*) of love.

If, in effect, the man finds satisfaction for his demand for love in the relation with the woman, in as much as the signifier of the phallus constitutes her as giving in love what she does not have – conversely, his own desire for the phallus will make its signifier emerge in its persistent divergence towards 'another woman' who may signify this phallus in various ways, either as a virgin or as a prostitute. There results from this a centrifugal tendency of the genital drive in love life, which makes impotence much more difficult to bear for him, while the *Verdrängung* inherent in desire is more important.

Yet it should not be thought that the sort of infidelity that would appear to be constitutive of the male function is proper to it. For if one looks more closely, the same redoubling is to be found in the woman, except that the Other of Love as such, that is to say, in so far as he is deprived of what he gives, finds it difficult to see himself in the retreat in which he is substituted for the being of the very man whose attributes she cherishes.

One might add here that male homosexuality, in accordance with the phallic mark that constitutes desire, is constituted on the side of desire, while female homosexuality, on the other hand, as observation shows, is orientated on a disappointment that reinforces the side of the demand for love. These remarks should really be examined in greater detail, from the point of view of a return to the function of the mask in so far as it dominates the identifications in which refusals of demand are resolved.

The fact that femininity finds its refuge in this mask, by virtue of the fact of the *Verdrängung* inherent, in the phallic mark of desire, has the curious consequence of making virile display in the human being itself seem feminine.

Correlatively, one can glimpse the reason for a characteristic that had never before been elucidated, and which shows once again the depth of Freud's intuition: namely, why he advances the view that there is only one *libido*, his text showing that he conceives it as masculine in nature. The function of the phallic signifier touches here on its most profound relation: that in which the Ancients embodied the Νοῦς and the Λογὸς.

LANGUAGE AND GENDER

There is a Chinese word for the female *I* – which is 'slave'. Break the women with their own tongue.

(Maxine Hong Kingston, *The Woman Warrior,* 1981: 49)

IN HIS CRITIQUE OF Saussure's model of the sign, Lacan offers up the example of two identical doors, one marked 'ladies', the other 'gentlemen', in order to indicate the way in which the sign is traversed by sexual difference (Lacan 1977: 151). The implication of his argument is that to take up a position in language, in other words, to become a subject, is to line up in front of one door or the other. The problem is, of course, that these particular doors are not equal, for whilst one signifies social authority, the other signifies marginalisation. Indeed, in producing an account of the role of language in the formation of subjectivity in which the phallus is held to be the privileged signifier within the symbolic order, Lacan's work suggests that those who lack the phallus must have a different – if not negative – relationship to language. However, Lacanian psychoanalysis offers only one way of addressing this question of the role of language in the production and maintenance of both gender differences and hierarchies. The relationship between language and gender is the central concern of all the extracts in this section, although the issue is examined from a number of perspectives, both theoretical and empirical. It is important to underline in this respect that although the texts here can all be described as feminist interventions within this field of enquiry, they represent very different positions and approaches. This reflects the diversity within feminist theory and the absence of a single, or unified, feminist position on language.

The extract taken from Dale Spender's work *Man Made Language* sets out to address and account for sexism in language. The kind of use – or abuse – of language with which Spender is concerned ranges from the use of his/he, or 'man' and 'mankind', as generic terms for both men and women, to syntactic rules. Her argument is – quite literally – that language is man-made. 'Males', she argues, 'as the dominant group, have produced language, thought and reality'. To support this claim, she traces the historical development of prescriptive grammatical rules which she contends were not simply the product of an ideologically neutral impulse to codify language use, but part and parcel of a concerted effort by men to reinforce and reproduce male dominance. The model of language with which she works is directly influenced by the 'linguistic determinism' of the 'Sapir–Whorf' hypothesis, illustrated in the piece by Whorf in the previous section. 'Males', she suggests, constructed the language in such a way as to embed within it categories of thought which served their purposes and which were prejudicial to women. What they

achieved by so doing, she argues, was to set up a linguistic and conceptual system which would effectively entrap women, in that both men and women would use the man-made language and thereby continue to internalise and reproduce the gender hierarchy which it had been designed to maintain.

Spender's argument is not without its problems. Her founding claim that language *is* sexist has been challenged on the grounds that it fails to differentiate between the ideological – or sexist – character of language use in specific contexts and the structure of language *per se*. Equally, the notion of linguistic determinism at the core of her argument cannot readily account for the kind of challenge to dominant social meanings which characterises political modes of enquiry such as feminism. In this respect, it is interesting to consider Spender's argument in the light of Voloshinov's notion of the 'multiaccentuality' of the sign. (See the section, 'Theorising the Sign').

Robin Lakoff's 'Talking like a Lady' sets out to address the 'gendering' of language through an empirical study of the different ways in which men and women engage in conversation. Considering examples such as lexical variation and tag questions, she tries to show the way in which at the levels of both semantics and syntax, meaning and structure, spoken language has built into it gender distinctions which are then inculcated in the socialisation of the child. Her argument is that our patterns of speech and engagement in social intercourse reflect and reproduce deeply embedded social inequalities between the sexes. She suggests, for instance, that the kind of tag-questions which characterise women's speech ('I think that's really interesting – don't you?') reflect in their hesitancy women's lack of social and cultural authority. However, many of Lakoff's assumptions about the modes and substance of female conversation are contentious, particularly her suggestion that only women and homosexuals concern themselves with the subtleties of interior decoration and the discrimination of colours such as lilac and mauve. Some of her arguments also appear rather out-dated in the context of contemporary notions of linguistic propriety. Certainly prohibitions around swearing – the notion that men may say 'shit' but ladies should say 'oh dear' – seem to have relaxed somewhat; this may, however, be a sign that there have been genuine changes in practice in what is a relatively short time.

In direct contrast to the empirical methodology adopted by Lakoff is the work of Hélène Cixous which considers the relationship between language and gender from a radically different theoretical point of view. The essay is not so much a criticism as a critique (not only an evaluation but also an investigation of the foundations) of the phallocentric tradition. Her work takes up Lacan's argument that male and female subjects have a different relationship to the symbolic order. According to Cixous, Western thought is structured by a range of binary oppositions – for instance, male/female, language/silence, light/dark – in which the first term is privileged, or valued more highly than the latter. Her argument is that this array of oppositions is related to the 'founding' binary of man/woman in which the former term represents activity and the latter, passivity and 'otherness'. For Cixous, then, the symbolic order is 'phallocentric', a structure which is centred upon the 'phallus' and which, therefore, marginalises women. Female sexuality and the female body,

she contends, cannot be represented in the symbolic by virtue of the fact that within this phallocentric system, female sexuality is defined *solely* in relation to the phallus.

It is in this context that Cixous develops the notion of *écriture féminine*, a type of writing which she suggests is multiple, fluid, flowing and unstable in contrast to the fixity of the phallocentric symbolic order. This form of writing involves a return to the female body, to the 'white ink' of the mother's milk. It is also, crucially, a poetic language. Realist prose, she suggests, attempts to fix meaning, whereas in poetry, meaning is less stable. It is important to note, however, that *écriture féminine* does not simply refer to a particular kind of writing by women. Cixous discusses the 'feminine' in both a literal and a metaphorical way; it refers both to women and to a particular position in – or relationship to – the symbolic order. Men can therefore produce *écriture féminine*. The work of Mallarmé is often cited in this regard. Indeed one criticism of Cixous has been that all her examples of *écriture féminine* have been produced by male writers. It is interesting in this respect to read Cixous's work alongside the extract by Kristeva presented in the section on 'Language and Creativity'.

The last two extracts in this section differ from those preceding in that they bring into question the very category of 'woman' itself. In one sense, this is to ask whether the notion of a universal female experience is viable, given the very significant differences between women. Riley, for instance, explores the emergence of the category 'woman' in historical terms in order to challenge its political and theoretical validity as a term which seemingly speaks for the experiences of all women, past and present. Her argument is that the notion of 'woman' serves to deflect our attention away from the multiple subject positions which women may occupy and denies the historical and cultural contingency of experiences of oppression. If we understand female experience as unified, or if we write as if all women are oppressed in the same manner, and to the same degree, how are we to understand the differences between the life-histories of a middle-class, white woman and a working-class African-American woman? In a sense this is another instance of a form of analysis which pays careful attention to the historical specificity of language and recalls again Williams' comment on the relation between historical semiotics and cultural materialism (see Introduction to 'Language in History').

Judith Butler's argument is a critique of the foundationalist basis of identity politics; that is to say, a politics which is grounded upon a given identity, here 'woman'. Like Riley, Butler questions the plausibility of the notion of 'woman' as a universal category, arguing instead that we need to understand 'woman' as multiple rather than singular, discontinuous rather than stable, or 'given'. For Butler, gender is an 'act' or a 'performance', produced through the repetition of a set of norms or codes rather than a 'core' or essential identity. This suggests that gender identification requires a good deal of labour, or praxis – meaning the labour in which we engage in order to reproduce ourselves – in order to be maintained. This clearly has the advantage of bringing to the fore the repetitive labour which underpins identity – the way in which constitutive norms have to be constantly repeated. It is also a challenge to the idea of a subject which chooses, since she suggests that

subjectivity itself is an effect of the same process. The implications of both Riley's and Butler's arguments for feminism are radical. If we reject the concept of 'woman', if we cannot speak of, or for 'woman', on what basis can a feminist politics be forged?

Further reading

Women's speech

Lakoff, R. (1975) *Language and Woman's Place*, New York: Harper and Row.

Dubois, B.L. and I. Crouch (1975) 'The Question of Tag Questions in Women's Speech: They Don't Really Use More of Them, Do They?', *Language in Society*, 4, pp. 289–94.

Crosby, F. and L. Nyquist (1977) 'The Female Register: An Empirical Study of Lakoff's Hypothesis', *Language in Society*, 6, pp. 313–22.

Kramer, C. (1974) 'Women's Speech: Separate But Unequal?', *Quarterly Journal of Speech* 60, pp. 14–24.

Cameron, D. (1985) *Feminism and Linguistic Theory*, London: Macmillan, chapter 3.

Montgomery, M. (1995) *An Introduction to Language and Society*, 2nd edn., London: Routledge, chapter 8.

Kipers, P. S. (1987) 'Gender and Topic', *Language in Society* 16, pp. 543–57.

Coates, J. (1986) *Women, Men and Language*, London: Longman.

—— (1996) *Women Talk: Conversations Between Women Friends*, Oxford: Basil Blackwell.

Jones, D. (1980) 'Gossip: Notes on Women's Oral Culture', *Women's Studies International Quarterly* 3, pp. 193–8; [repr. in D. Cameron (ed.) *The Feminist Critique of Language: A Reader*, London: Routledge, 1990, pp. 242–50].

Tannen, D. (1990) *You Just Don't Understand: Men and Women in Conversation*, New York: William Morrow.

Linguistic determinism

Spender, D. (1980) *Man Made Language*, London: Routledge & Kegan Paul.

Black, M. and R. Coward (1981) 'Linguistic, Social and Sexual Relations: A Review of Dale Spender's *Man Made Language*', *Screen Education* 39, pp. 69–85.

Assiter, A. (1983) 'Did Man Make Language?', *Radical Philosophy*, 34, pp. 25–29.

Miller, C. and K. Swift, (1979) *Words and Women*, Harmondsworth, Penguin.

Daly, M. (1978) *Gyn/Ecology: The Metaethics of Radical Feminism*, Boston, MA: Beacon Press.

Ardener, S. (1978) *Defining Females: The Nature of Females in Society*, London: John Wiley.

—— (ed). (1975) *Perceiving Women*, London: Dent.

Kramarae, C. (1981) *Women and Men Speaking*, Rowley, MA: Newbury House.

Cameron, D. (1985) *Feminism and Linguistic Theory*, London: Macmillan, chapter 6.

Smith, P. M. (1979) 'Sex Markers in Speech', in K. Scherer and H. Giles (eds) *Social Markers in Speech*, Cambridge: Cambridge University Press.

Schulz, M.R. (1975) 'The Semantic Derogation of Women', in B. Thorne and N. Henley (eds) *Language and Sex: Difference and Dominance*, Rowley, MA: Newbury House; [repr. in *The Feminist Critique of Language: A Reader*, ed. D. Cameron, London: Routledge, 1990, pp. 134–47].

French feminisms

Cixous, H. and C. Clément (1986) *The Newly Born Woman*, trans. B. Wing, Manchester: Manchester University Press.

Marks, E. and I. Courtivron (eds) (1981) *New French Feminisms: An Anthology*, Brighton: Harvester Wheatsheaf.

Moi, T. (1985) *Sexual/Textual Politics: Feminist Literary Theory*, London: Methuen, chapters 6–8.

Moi, T. (ed.) (1987) *French Feminist Thought: A Reader*, Oxford: Basil Blackwell.

Kristeva, J. (1986) *The Kristeva Reader*, ed. T. Moi, Oxford: Blackwell.

Duchen, C. (ed.) (1986) *French Connections*, London: Hutchinson.

Cameron, D. (1985) *Feminism and Linguistic Theory*, London: Macmillan, chapter 7.

Jacobus, M. (1979) 'The Difference of View', in M. Jacobus (ed.) *Women Writing and Writing About Women*, London: Croom Helm, pp. 10–21.

Gallop, J. (1982) *Feminism and Psychoanalysis: The Daughter's Seduction*, Ithaca, NY: Cornell University Press.

Shiach, M. (1991) *Hélène Cixous: A Politics of Writing*, London: Routledge.

Feminism and postmodernism

Butler, J. (1990) *Gender Trouble: Feminism and the Subversion of Identity*, New York: Routledge.

—— (1993) *Bodies That Matter: On the Discursive Limits of 'Sex'*, New York: Routledge.

—— (1997) *Excitable Speech: Contemporary Scenes of Politics*, London: Routledge.

Benhabib, S. (1992) *Situating the Self: Gender, Community and Postmodernism in Contemporary Ethics*, Cambridge: Polity.

Benhabib, S., J. Butler, D. Cornell and N. Fraser (1994) *Feminist Contentions: A Philosophical Exchange*, London: Routledge.

Butler, J. and J. Scott (eds) (1992) *Feminists Theorize the Political*, London: Routledge.

Fraser, N. and L. Nicholson (1988) 'Social Criticism Without Philosophy: An Encounter Between Feminism and Postmodernism', in A. Ross (ed.) *Universal Abandon? The Politics of Postmodernism*, Edinburgh: Edinburgh University Press.

Riley, D. (1988) *'Am I That Name?': Feminism and the Category of 'Women' in History*, Basingstoke: Macmillan.

Lovibond, S. (1989) 'Feminism and Postmodernism', *New Left Review*, 178 pp. 5–28.

Grosz, E. (1994) *Volatile Bodies: Toward a Corporeal Feminism*, London: Allen & Unwin.

—— (1995) *Space, Time and Perversion: The Politics of Bodies*, London: Allen & Unwin.

Nicholson, L. (ed.) (1990) *Feminism/Postmodernism*, London: Routledge.

Language and gender

Tannen, D. (1994) *Gender and Discourse*, New York: Oxford University Press.

Cameron, D. (1985) *Feminism and Linguistic Theory*, London: Macmillan.

—— (ed.) (1998) *The Feminist Critique of Language: A Reader*, 2nd edn., London: Routledge, Introduction.

—— (1997) 'Theoretical Debates in Feminist Linguistics: Questions of Sex and Gender', in R. Wodak (ed.) *Gender and Discourse*, London: Sage, pp. 21–36.

Romaine, S. (1994) *Language in Society: An Introduction to Sociolinguistics*, Oxford: Oxford University Press, chapter 4.

Kaplan, C. (1986) *Sea Changes: Culture and Feminism*, London: Verso, chapter 4.

Mills, S. (1995) *Feminist Stylistics*, London: Routledge, chapter 2 and introduction.

Smith, P.M. (1985) *Language, the Sexes and Society*, Oxford: Blackwell.

Thorne, B. and N. Henley (eds) (1975) *Language and Sex: Difference and Dominance*, Rowley, MA: Newbury House.

Thorne, B., C. Kramarae and N. Henley (eds) (1983) *Language, Gender and Society*, Cambridge: Newbury House.

Cameron, D. and J. Coates (eds.) (1988) *Women in Their Speech Communities*, London: Longman.

Graddol, D. and J. Swann (1989) *Gender Voices*, Oxford: Basil Blackwell.

Hall, K. and M. Bucholtz (1995) *Gender Articulated: Language and the Socially Constructed Self*, New York: Routledge.

Cheshire, J. and P. Trudgill (eds) (1998) *The Sociolinguistics Reader, Vol. 2: Gender and Discourse*, London: Arnold, Part 1.

Dale Spender

LANGUAGE AND REALITY: WHO MADE THE WORLD? (1980)

[. . .] Language is *not* neutral. It is not merely a vehicle which carries ideas. It is itself a shaper of ideas, it is the programme for mental activity (Whorf, 1976). In this context it is nothing short of ludicrous to conceive of human beings as capable of grasping things as they really are, of being impartial recorders of their world. For they themselves, or some of them, at least, have created or constructed that world and they have reflected themselves within it.

Human beings cannot impartially describe the universe because in order to describe it they must first have a classification system. But, paradoxically, once they have that classification system, once they have a language, *they can see only certain arbitrary things*.

Such an understanding is not confined to linguistics. The sciences of physiology and biology have also helped to substantiate – sometimes inadvertently – the false nature of impartiality or objectivity. Evidence gathered from these disciplines demonstrates that we ourselves come into the process of organizing and describing the universe. Unfortunately for those advocates of the human capacity to 'grasp things as they really are' there is one basic flaw in their argument – they have failed to take into account that the brain can neither see nor hear:

> To speak metaphorically, the brain is quite blind and deaf, it has
> no direct contact with light or sound, but instead has to acquire all its
> information about the state of the outside world in the form of pulses
> of bio-electrical activity pumped along bundles of nerve fibres from the
> external surface of the body, its interface with the environment.
>
> (F. Smith, 1971: 82)

The brain too, has to interpret: it too can only deal in symbols and never know the 'real' thing. And the programme for encoding and decoding those

symbols, for translating and calculating, is set up by the language which we possess. What we *see* in the world around us depends in a large part on the principles we have encoded in our language:

> each of us has *to learn to see*. The growth of every human being is a slow process of learning 'the rules of seeing', without which we could not in any ordinary sense see the world around us. There is no reality of familiar shapes, colours and sounds to which we merely open our eyes. The information that we receive through our senses from the material world around us has to be interpreted according to certain human rules, before what we ordinarily call 'reality' forms.
>
> (Williams, 1975 : 33).

When one principle that has been encoded in our language (and thought) is that of sexism, the implications for 'reality' can readily be seen. So too can the implications for 'objectivity', because 'scientific method' has been frequently accepted as being 'above' fallible human processes and, because its truths have been paraded as incontestable, many individuals have had little confidence in their own experience when this has clashed with prevailing scientific 'truths'.

[. . .]

When there are a sexist language and sexist theories culturally available, the observation of reality is also likely to be sexist. It is by this means that sexism can be perpetuated and reinforced as new objects and events, new data, have sexist interpretations projected upon them. Science is no more free of this bias than any other explanatory activity.

It is this recognition that human beings are part of the process of constructing reality and knowledge which has led Dwight Bolinger (1975) to 'reinterpret' our past and to assert that our history can validly be viewed *not* as the progressive intuiting of nature but as exteriorizing a way of looking at things as they are circumscribed by our language. Once certain categories are constructed within the language, we proceed to organize the world according to those categories. We even fail to see evidence which is not consistent with those categories.

This makes language a paradox for human beings: it is both a creative and an inhibiting vehicle. On the one hand it offers immense freedom for it allows us to 'create' the world we live in; that so many different cultures have created so many different 'worlds' is testimony to this enormous and varied capacity (Berger and Luckmann, 1972, have categorized this aspect of language as 'world openness' p. 69). But on the other hand we are restricted by that creation, limited to its confines, and, it appears, we resist, fear and dread any modifications to the structures we have initially created, even though they are 'arbitrary', approximate ones. It is this which constitutes a language *trap*.

It could be said that out of nowhere we invented sexism, we created the arbitrary and approximate categories of male-as-norm and female as deviant. A most original, imaginative creation. But, having constructed these categories in our language and thought patterns, we have now been trapped for we are most reluctant to organize the world any other – less arbitrary or imperfect – way.

Indeed, it could even be argued that the trap which we have made is so pervasive that we cannot envisage a world constructed on any other lines.

It is, however, at this point that feminist insights into language, thought and reality, are differentiated. While it could be said that we invented sexism from out of nowhere and utilized the principle in encoding reality, I doubt that feminists would make such a statement. While it could be argued that it was mere accident that 'objectivity' and the 'scientific method' came to acquire their meritorious[1] status and while such a discussion could occur without reference to gender, I also doubt whether feminists would completely accept such an explanation. The distinctive and additional feature of feminist analysis of language, thought and reality is that feminists assert that we did *not* create these categories or the means of legitimating them. [. . .] I would reiterate that it has been the dominant group – in this case, males – who have created the world, invented the categories, constructed sexism and its justification and developed a language trap which is in their interest.

Given that language is such an influential force in shaping our world, it is obvious that those who have the power to make the symbols and their meanings are in a privileged and highly advantageous position. They have, at least, the potential to order the world to suit their own ends, the potential to construct a language, a reality, a body of knowledge in which they are the central figures, the potential to legitimate their own primacy and to create a system of beliefs which is beyond challenge (so that their superiority is 'natural' and 'objectively' tested). The group which has the power to ordain the structure of language, thought and reality has the potential to create a world in which they are the central figures, while those who are not of their group are peripheral and therefore may be exploited.

In the patriarchal order this potential has been realized.

Males, as the dominant group, have produced language, thought and reality. Historically it has been the structures, the categories and the meanings which have been invented by males – though not of course by *all* males – and they have then been validated by reference to other males. In this process women have played little or no part. It has been male subjectivity which has been the source of those meanings, including the meaning that their own subjectivity is objectivity. Says Dorothy Smith: 'women have largely been excluded from the work of producing forms of thought and the images and symbols in which thought is expressed and realised' (1978: 281–2), and feminists would state unequivocally that this has been no accident.

[. . .]

The circumstantial evidence

The evidence for the relationship between sexism and language, and males, has been largely circumstantial: there *is* sexism in the language, it *does* enhance the position of males, and males *have* had control over the production of cultural forms. It therefore seems credible to assume that males have encoded sexism into the language to consolidate their claims of male supremacy. While personally

convinced of the legitimacy of this argument, I have also recognized the desirability of being able to provide concrete examples of the process at work. Actually to document the introduction by males of some aspect of sexism into the language, to indicate the way in which males systematically proceeded to embed some form of sexism into language, thought and reality would be to put the discussion of sexism and language on a very different plane. Because I could see the advantages of being able to provide specific instances of male 'intervention', I was more than ready to begin such a search: the problem was, where does one begin?

Although it is not possible to go back to the beginning (earlier than any written records), it is possible to start with sexist examples and to work backwards in the hope of finding records which could pinpoint the introduction by males of specific sexist usages, structures or meanings. The language as it exists today can become the starting point for investigation and using the language itself as a source of evidence is not without precedence. Anthropologists, for example, have long known the value of language structure in 'cracking the code' of another society even if they have not adopted a comparable approach to their own. Whereas the almost inaccessible meanings of other cultures have sometimes been revealed by clues provided by the language structure, few efforts have been made to locate or interpret any clues which might reveal some of the 'hidden' meanings of our own. That there is no Hebrew word in the old testament for *Goddess*, for example, provides a clue to the meaning of a deity in those times – at least, among those who were engaged in the task of writing (Stone, 1977: 7), but that there is no word in the English language for a strong female [. . .] does not seem to have been a factor which has interested many language scholars who wish to know more about our rules for making sense of the world.

Undoubtedly our own meanings are partially hidden from us and it is difficult to have access to them. We may use the English language our whole lives without ever noticing the distortions and omissions; we may never become aware that there is no symbol for women's strength. But although it is not always easy to get outside this language trap, to get outside the limitations of one's own language, it is not impossible. There are clues, if one is prepared to look for them.

Whereas the semantic base of the language is intangible and sometimes difficult to 'catch', the structure of the language is more concrete and more readily traced. When I became interested in locating examples of the male introduction of sexism, I had no preferences for either semantics or structure. While I traced the *meanings* of many different words I could not find more than circumstantial evidence that they were the product of male efforts (dictionary-makers, of course, being primarily male), but in tracing some of the *structures* of the language I was able to find numerous decrees, written down by males, which were directed towards ensuring male primacy within the language. Thanks to the zealous efforts of the prescriptive grammarians, there are accounts of males introducing sexism into the language.

[. . .]

To me, it seemed perfectly clear that the use of *man* and *he* as terms to denote a male, but on occasion to encompass a female, was an example of a sexist linguistic structure. Initially I saw it as a convenient means for making women

invisible, for *blanketing* them under a male term. I also saw it as a means of creating difficulties for women because representing them with a male symbol on some occasions made this particular linguistic structure ambiguous for them. They were required to ascertain to whom this symbol referred, whereas no such problem existed for males who can never be ambiguous in such structures. If males are present, then males are named, but women are sometimes included in that male name. In order to know the meaning of a particular utterance, such as 'man must work in order to eat', women had to have additional information to determine whether they were included. No man needs to seek further information to establish whether men are included in a reference such as 'love is important for women', for if men were intended to be encompassed the statement would be 'love is important for men'! The use of *man* and *he* to refer also to a woman only creates difficulties for women – which is probably why linguists have never seriously addressed this problem.

Those understandings of the sexist nature of *man* and *he* now seem, in retrospect, to be very elementary and very crude. But that was the point at which I started. I began by trying to cultivate the position of an outsider and by asking myself questions about the significance of *man* and *he* in the English language. What are the implications of a society which has a language based on the premise that the world is male unless proven otherwise? What is the result of eliminating the symbol of woman from the language? What are the effects of making a common linguistic structure ambiguous for half the population?

[...]

He/man language

The rationalization that 'man embraces woman' is a relatively recent one in the history of our language. It was a practice that was virtually unknown in the fifteenth century. The first record we appear to have is that of a Mr Wilson in 1553 who insisted that it was more *natural* to place the man *before* the woman, as for example in male and female, husband and wife, brother and sister, son and daughter. Implicit in his insistence that males take precedence is the belief that males 'come first' in the natural order, and this is one of the first examples of a male arguing for not just the superiority of males but that this superiority should be reflected in the structure of the language.

Thomas Wilson was writing for an almost exclusively male audience, and an upper-class or educated male audience at that. Those who were going to read his words of wisdom – and to confirm or refute them – were men who were interested in grammar and rhetoric. Judging from the success of this particular ploy, it appears that Mr Wilson's audience appreciated the 'logic' of this particular rationale, and accepted it.

If females had been familiar with this decree – which seems unlikely, given that females of all classes were systematically denied access to education – they might have protested that the so-called natural order posited by Mr Wilson did not appear so unquestionably natural to them. But women were not included in

the production of grammatical rules and their views on the logic of this usage go unrecorded. Their muted state is reproduced.

The records of 1646 reveal that the concept of the natural precedence of males having encountered no opposition – from males – has actually gained ground. According to one scholarly grammarian, Joshua Poole, it was not only natural that the male should take 'pride of place' it was also *proper* because, in his line of reasoning, the male gender was the *worthier* gender. He seems to have offered little evidence for his claim, but his male colleagues do not appear to have disputed it.

The seal was set on male superiority, however, when in 1746 John Kirkby formulated his 'Eighty Eight Grammatical Rules'. These rules, the product of Mr Kirkby's own imagination, contained one that indicated the esteem in which he held females: Rule Number Twenty One stated that the male gender was *more comprehensive* than the female.

This represents a significant departure from the simple proposition that males are more important. It is a move towards the concept that male is the universal category, that male is the norm. The *Oxford English Dictionary* defines *comprehensive* as 'including much', so Mr Kirkby was arguing that man included much more than woman because man was more comprehensive and this, according to Mr Kirkby's reasoning, should be encoded within the languages for all to comply with. As he could not have been arguing that there were more men than women, he must have been using some criteria other than number for his evidence of the more comprehensive nature of man. One is left with the conclusion that Mr Kirkby believed that each man represented much more than each woman and that it was legitimate to encode this personal belief in the structure of the language and to formulate a grammatical rule which would put the users of the language in the 'wrong' if they did not adhere to this belief.

That each man included much more than each woman was a personal opinion that Mr Kirkby was entitled to hold. It was his generation of meaning and it reflects his own perspective on the world and his assessment of his own place within that world. The activity which he was engaging in is one which human beings engage in constantly every day of their lives as they attempt to project meaning into their existence. But Mr Kirkby was a member of the dominant group and had the opportunity – experienced by few – of making his subjective meanings the decreed reality.

He handed down Rule Number Twenty One to a male world of grammarians who were not averse to sharing his assumptions about the centrality of the male and who were not reluctant to insist that 'nonmales' – or, as it has become in Mr Kirkby's rule, 'minus males' – also share these assumptions. There is an example of one sex encoding the language to enhance its own image while the other sex is obliged to use this language which diminishes, or conflicts with its image.

Rule Number Twenty One is one man's bias, verified by the bias of other men, and imposed upon women. They did not participate in its production, they do not benefit from its use. It was a sexist principle encoded in the language by males and which today exerts a considerable influence over thought and reality by preserving the categories of male and minus male.

During Mr Kirkby's time, most people did not modify their language use to accommodate his rule. Although he wrote for such a select audience, even many males remained oblivious to his rule. It may have served to reinforce hierarchical distinctions among those who 'knew' that the use of *he/man* included women on the 'grammatically objective grounds' that *he/man* was more comprehensive, but it was not taken up avidly by the whole population. But the rule was there, it had been recorded, and it was extremely useful for the nineteenth-century grammarians who vehemently took it up and insisted on rigid adherence to this rule in the name of grammatical correctness – another invention of the dominant group which legitimates their prejudice!

Before the zealous practices of the nineteenth-century prescriptive grammarians, the common usage was to use *they* for sex-indeterminable references. It still is common usage, even though 'grammatically incorrect': for example, it is not uncommon to say 'Anyone can play if *they* learn' or 'Everyone has *their* rights'. Then – and now – when the sex of a person is unknown, speakers may use *they*, rather than the supposedly correct *he* in their reference.

To the grammarians, however, this was incorrect and intolerable. When the sex is unknown the speaker should use *he* – because it is the more comprehensive term. It is also, of course, the term which makes males visible, and this is not just a coincidence.

Users of a language are, however, sometimes reluctant to make changes which are decreed from above [...] and it is interesting to note just how much effort has been expended on trying to coerce speakers into using *he/man* as generic terms. As Ann Bodine (1975) has noted, using *they* as a singular is still alive and well, 'despite almost two centuries of vigorous attempts to analyze and regulate it out of existence' on the ostensible grounds that it is incorrect. And what agencies the dominant group has been able to mobilize in this task! Bodine goes on to say that the survival of *they* as a singular 'is all the more remarkable considering the weight of virtually the entire educational and publishing establishment has been behind the attempt to eradicate it' (p. 131). One is led to ask who it is who is resisting this correctness?

But the history of *he/man* does not end here. It has not just been the educational and publishing establishment that has worked towards establishing its primacy. The male grammarians who were incensed with the 'misuse' of *they*, were instrumental in securing the 1850 Act of Parliament which legally insisted that *he* stood for *she* (Bodine, 1975)!

The introduction and legitimation of *he/man* was the result of deliberate policy and was consciously intended to promote the primacy of the male as a category. If there are people today who are unaware of the significance of *he/man*, I do not think that some of the male grammarians who promoted its use were quite so unaware. The tradition of men talking to men, of men appealing to like-thinking men for validation of their opinions and prejudices, is one which can be traced in the writings of grammarians, and one which continues today. There is still a closed circle. We have inherited men's grammatical rules, and as Julia Stanley says (1975 : 3):

> these 'fixed and arbitrary rules' date from the first attempts to write
> English grammars in the sixteenth century and the usage that is still

perpetuated in modern textbooks merely reflects the long tradition of male presumption and arrogance ... When a contemporary writer L.E. Sissman says that the sentence '*Everyone* knows *he* has to decide for *himself*' is both 'innocuous' and 'correct', he is merely appealing for authority to the men who have gone before him.

We cannot appeal to the women who have gone before. As a muted group we have no record of their thoughts – or of their objections – on this topic.

As the dominant group, males were in the position to encode forms which enhanced their status, to provide the justification for those forms, and to legitimate those forms. At no stage of this process were females in a position to promote alternatives, or even to disagree. To my knowledge there has never been an influential female grammarian and there were certainly no female Members of Parliament to vote against the 1850 Act. The production of this linguistic form – and the effects it has had on thought and reality – has been in the hands of males.

It is worth remembering this when encountering the resistance to changes which feminists are seeking. Currently, when they are trying to eliminate this practice of using *man* to symbolize *woman*, they often meet the objection that they are 'tampering' with the language. If one accepts that the language is the property of males then this objection is no doubt valid. But if the objection is based on the understanding that the language is pure and unadulterated then it is not at all valid. Feminists are simply doing what males have done in the past: they are trying to produce their *own* linguistic forms which do not diminish them. In this case it requires the removal of an 'artificial' and unjustifiable rule, invented by some male grammarians and sanctioned by other males, in the interest of promoting their own primacy. Feminists are trying to remove the 'tamperings' of males who have gone before.

[...]

Note

1 At this point I consulted the *Concise Oxford English Dictionary* to find out if the word I wanted was meritorious or meritricious. Obviously it is meritorious: meretricious (the closest entry to my feeling for meretricious) is defined as 'of, befitting a harlot'. Now where does that one come from!

References

Berger, Peter L. and Thomas Luckmann, 1972, *The Social Construction of Reality*, Penguin, London.
Bodine, Ann, 1975, 'Androcentrism in prescriptive grammar: singular *they*, sex indefinite *he* and *he* or *she*', *Language in Society* 4, no. 2, pp. 129–56.
Bolinger, Dwight, 1975, *Aspects of Language*, Harcourt, Brace, Jovanovich, New York, 2nd ed.

Carrol, John B. (ed.), 1976, *Language, Thought and Reality: Selected Writings of Benjamin Lee Whorf*, MIT Press, Cambridge, Mass.

Smith, Dorothy, 1978, *The Everyday World as Problematic: A Feminist Sociology*, Northeastern University, Boston.

Smith, Frank, 1971, *Understanding Reading: A Psycholinguistic Analysis of Reading and Learning to Read*, Holt, Rinehart & Winston, New York.

Stanley, Julia, 1975, 'Sexist grammar' paper presented to South Eastern Conference of Linguistics, Atlanta, Georgia, 7 November.

Stone, Merlin, 1977, *The Paradise Papers: the Suppression of Women's Rites*, Virago, London.

Whorf, Benjamin Lee, 1976, *see* Carrol, John B. (ed.).

Williams, Raymond, 1975, *The Long Revolution*, Penguin, London.

Robin Lakoff

TALKING LIKE A LADY (1975)

"Women's language" shows up in all levels of the grammar of English. We find differences in the choice and frequency of lexical items; in the situations in which certain syntactic rules are performed; in intonational and other supersegmental patterns. As an example of lexical differences, imagine a man and a woman both looking at the same wall, painted a pinkish shade of purple. The woman may say (1):

(1) The wall is mauve,

with no one consequently forming any special impression of her as a result of the words alone; but if the man should say (1), one might well conclude he was imitating a woman sarcastically or was a homosexual or an interior decorator. Women, then, make far more precise discriminations in naming colors than do men; words like *beige, ecru, aquamarine, lavender,* and so on are unremarkable in a woman's active vocabulary, but absent from that of most men. I have seen a man helpless with suppressed laughter at a discussion between two other people as to whether a book jacket was to be described as "lavender" or "mauve." Men find such discussion amusing because they consider such a question trivial, irrelevant to the real world.

We might ask why fine discrimination of color is relevant for women, but not for men. A clue is contained in the way many men in our society view other "unworldly" topics, such as high culture and the Church, as outside the world of men's work, relegated to women and men whose masculinity is not unquestionable. Men tend to relegate to women things that are not of concern to them, or do not involve their egos. Among these are problems of fine color discrimination. We might rephrase this point by saying that since women are not expected to make decisions on important matters, such as what kind of job to hold, they are relegated the noncrucial decisions as a sop. Deciding whether to name a color "lavender" or "mauve" is one such sop.

If it is agreed that this lexical disparity reflects a social inequity in the position of women, one may ask how to remedy it. Obviously, no one could seriously recommend legislating against the use of the terms "mauve" and "lavender" by women, or forcing men to learn to use them. All we can do is give women the opportunity to participate in the real decisions of life.

Aside from specific lexical items like color names, we find differences between the speech of women and that of men in the use of particles that grammarians often describe as "meaningless." There may be no referent for them, but they are far from meaningless: they define the social context of an utterance, indicate the relationship the speaker feels between himself and his addressee, between himself and what he is talking about.

As an experiment, one might present native speakers of standard American English with pairs of sentences, identical syntactically and in terms of referential lexical items, and differing merely in the choice of "meaningless" particle, and ask them which was spoken by a man, which a woman. Consider:

> (2) (a) Oh dear, you've put the peanut butter in the refrigerator again.
> (b) Shit, you've put the peanut butter in the refrigerator again.

It is safe to predict that people would classify the first sentence as part of "women's language," the second as "men's language." It is true that many self-respecting women are becoming able to use sentences like (2)(b) publicly without flinching, but this is a relatively recent development, and while perhaps the majority of Middle America might condone the use of (b) for men, they would still disapprove of its use by women. (It is of interest, by the way, to note that men's language is increasingly being used by women, but women's language is not being adopted by men, apart from those who reject the American masculine image (for example, homosexuals). This is analogous to the fact that men's jobs are being sought by women, but few men are rushing to become housewives or secretaries. The language of the favored group, the group that holds the power, along with its nonlinguistic behavior, is generally adopted by the other group, not vice versa. In any event, it is a truism to state that the "stronger" expletives are reserved for men, and the "weaker" ones for women.)

Now we may ask what we mean by "stronger" and "weaker" expletives. (If these particles were indeed meaningless, none would be stronger than any other.) The difference between using "shit" (or "damn," or one of many others) as opposed to "oh dear," or "goodness," or "oh fudge" lies in how forcefully one says how one feels – perhaps, one might say, choice of particle is a function of how strongly one allows oneself to feel about something, so that the strength of an emotion conveyed in a sentence corresponds to the strength of the particle. Hence in a really serious situation, the use of "trivializing" (that is, "women's") particles constitutes a joke, or at any rate, is highly inappropriate. (In conformity with current linguistic practice, throughout this work an asterisk (*) will be used to mark a sentence that is inappropriate in some sense, either because it is syntactically deviant or used in the wrong social context.)

(3) (a) *Oh fudge, my hair is on fire.
 (b) *Dear me, did he kidnap the baby?

As children, women are encouraged to be "little ladies." Little ladies don't scream as vociferously as little boys, and they are chastized more severely for throwing tantrums or showing temper: "high spirits" are expected and therefore tolerated in little boys; docility and resignation are the corresponding traits expected of little girls. Now, we tend to excuse a show of temper by a man where we would not excuse an identical tirade from a woman: woman are allowed to fuss and complain, but only a man can bellow in rage. It is sometimes claimed that there is a biological basis for this behavior difference, though I don't believe conclusive evidence exists that the early differences in behavior that have been observed are not the results of very different treatment of babies of the two sexes from the beginning; but surely the use of different particles by men and women is a learned trait, merely mirroring nonlinguistic differences again, and again pointing out an inequity that exists between the treatment of men, and society's expectations of them, and the treatment of women. Allowing men stronger means of expression than are open to women further reinforces men's position of strength in the real world: for surely we listen with more attention the more strongly and forcefully someone expresses opinions, and a speaker unable – for whatever reason – to be forceful in stating his views is much less likely to be taken seriously. Ability to use strong particles like "shit" and "hell" is, of course, only incidental to the inequity that exists rather than its cause. But once again, apparently accidental linguistic usage suggests that women are denied equality partially for linguistic reasons, and that an examination of language points up precisely an area in which inequity exists. Further, if someone is allowed to show emotions, and consequently does, others may well be able to view him as a real individual in his own right, as they could not if he never showed emotion. Here again, then, the behavior a woman learns as "correct" prevents her from being taken seriously as an individual, and further is considered "correct" and necessary for a woman precisely because society does *not* consider her seriously as an individual.

Similar sorts of disparities exist elsewhere in the vocabulary. There is, for instance, a group of adjectives which have, besides their specific and literal meanings, another use, that of indicating the speaker's approbation or admiration for something. Some of these adjectives are neutral as to sex of speaker: either men or women may use them. But another set seems, in its figurative use, to be largely confined to women's speech. Representative lists of both types are below:

neutral	women only
great	adorable
terrific	charming
cool	sweet
neat	lovely
	divine

As with the color words and swear words already discussed, for a man to stray into the "women's" column is apt to be damaging to his reputation, though

here a woman may freely use the neutral words. But it should not be inferred from this that a woman's use of the "women's" words is without its risks. Where a woman has a choice between the neutral words and the women's words, as a man has not, she may be suggesting very different things about her own personality and her view of the subject matter by her choice of words of the first set or words of the second.

(4) (a) What a terrific idea!
 (b) What a divine idea!

It seems to me that (a) might be used under any appropriate conditions by a female speaker. But (b) is more restricted. Probably it is used appropriately (even by the sort of speaker for whom it was normal) only in case the speaker feels the idea referred to to be essentially frivolous, trivial, or unimportant to the world at large – only an amusement for the speaker herself. Consider, then, a woman advertising executive at an advertising conference. However feminine an advertising executive she is, she is much more likely to express her approval with (4) (a) than with (b), which might cause raised eyebrows, and the reaction: "That's what we get for putting a woman in charge of this company."

On the other hand, suppose a friend suggests to the same woman that she should dye her French poodles to match her cigarette lighter. In this case, the suggestion really concerns only her, and the impression she will make on people. In this case, she may use (b), from the "woman's language." So the choice is not really free: words restricted to "woman's language" suggest that concepts to which they are applied are not relevant to the real world of (male) influence and power.

One may ask whether there really are no analogous terms that are available to men – terms that denote approval of the trivial, the personal; that express approbation in terms of one's own personal emotional reaction, rather than by gauging the likely general reaction. There does in fact seem to be one such word: it is the hippie invention "groovy," which seems to have most of the connotations that separate "lovely" and "divine" from "great" and "terrific" excepting only that it does not mark the speaker as feminine or effeminate.

(5) (a) What a terrific steel mill!
 (b) *What a lovely steel mill! (male speaking)
 (c) What a groovy steel mill!

I think it is significant that this word was introduced by the hippies, and, when used seriously rather than sarcastically, used principally by people who have accepted the hippies' values. Principal among these is the denial of the Protestant work ethic: to a hippie, something can be worth thinking about even if it isn't influential in the power structure, or moneymaking. Hippies are separated from the activities of the real world just as women are – though in the former case it is due to a decision on their parts, while this is not uncontroversially true in the case of women. For both these groups, it is possible to express approval of things in a personal way – though one does so at the risk of losing one's

credibility with members of the power structure. It is also true, according to some speakers, that upper-class British men may use the words listed in the "women's" column, as well as the specific color words and others we have categorized as specifically feminine, without raising doubts as to their masculinity among other speakers of the same dialect. (This is not true for lower-class Britons, however.) The reason may be that commitment to the work ethic need not necessarily be displayed: one may be or appear to be a gentleman of leisure, interested in various pursuits, but not involved in mundane (business or political) affairs, in such a culture, without incurring disgrace. This is rather analogous to the position of a woman in American middle-class society, so we should not be surprised if these special lexical items are usable by both groups. This fact points indeed to a more general conclusion. These words aren't, basically, "feminine"; rather, they signal "uninvolved," or "out of power." Any group in a society to which these labels are applicable may presumably use these words; they are often considered "feminine," "unmasculine," because women are the "uninvolved," "out of power" group *par excellence*.

Another group that has, ostensibly at least, taken itself out of the search for power and money is that of academic men. They are frequently viewed by other groups as analogous in some ways to women – they don't really work, they are supported in their frivolous pursuits by others, what they do doesn't really count in the real world, and so on. The suburban home finds its counterpart in the ivory tower: one is supposedly shielded from harsh realities in both. Therefore it is not too surprising that many academic men (especially those who emulate British norms) may violate many of these sacrosanct rules I have just laid down: they often use "women's language." Among themselves, this does not occasion ridicule. But to a truck driver, a professor saying, "What a lovely hat!" is undoubtedly laughable, all the more so as it reinforces his stereotype of professors as effete snobs.

When we leave the lexicon and venture into syntax, we find that syntactically too women's speech is peculiar. To my knowledge, there is no syntactic rule in English that only women may use. But there is at least one rule that a woman will use in more conversational situations than a man. (This fact indicates, of course, that the applicability of syntactic rules is governed partly by social context – the positions in society of the speaker and addressee, with respect to each other, and the impression one seeks to make on the other.) This is the rule of tag-question formation.[1]

A tag, in its usage as well as its syntactic shape (in English) is midway between an outright statement and a yes-no question: it is less assertive than the former, but more confident than the latter. Therefore it is usable under certain contextual situations: not those in which a statement would be appropriate, nor those in which a yes-no question is generally used, but in situations intermediate between these.

One makes a statement when one has confidence in his knowledge and is pretty certain that his statement will be believed; one asks a question when one lacks knowledge on some point and has reason to believe that this gap can and will be remedied by an answer by the addressee. A tag question, being intermediate between these, is used when the speaker is stating a claim, but lacks full confidence in the truth of that claim. So if I say

(6) Is John here?

I will probably not be surprised if my respondent answers "no"; but if I say

(7) John is here, isn't he?

instead, chances are I am already biased in favor of a positive answer, wanting only confirmation by the addressee. I still want a response from him, as I do with a yes-no question; but I have enough knowledge (or think I have) to predict that response, much as with a declarative statement. A tag question, then, might be thought of as a declarative statement without the assumption that the statement is to be believed by the addressee: one has an out, as with a question. A tag gives the addressee leeway, not forcing him to go along with the views of the speaker.

There are situations in which a tag is legitimate, in fact the only legitimate sentence form. So, for example, if I have seen something only indistinctly, and have reason to believe my addressee had a better view, I can say:

(8) I had my glasses off. He was out at third, wasn't he?

Sometimes we find a tag question used in cases in which the speaker knows as well as the addressee what the answer must be, and doesn't need confirmation. One such situation is when the speaker is making "small talk," trying to elicit conversation from the addressee:

(9) Sure is hot here, isn't it?

In discussing personal feelings or opinions, only the speaker normally has any way of knowing the correct answer. Strictly speaking, questioning one's own opinions is futile. Sentences like (10) are usually ridiculous.

(10) *I have a headache, don't I?

But similar cases do, apparently, exist, in which it is the speaker's opinions, rather than perceptions, for which corroboration is sought, as in (11):

(11) The way prices are rising is horrendous, isn't it?

While there are of course other possible interpretations of a sentence like this, one possibility is that the speaker has a particular answer in mind – "yes" or "no" – but is reluctant to state it baldly. It is my impression, though I do not have precise statistical evidence, that this sort of tag question is much more apt to be used by women than by men. If this is indeed true, why is it true?

These sentence types provide a means whereby a speaker can avoid committing himself, and thereby avoid coming into conflict with the addressee. The problem is that, by so doing, a speaker may also give the impression of not being really sure of himself, of looking to the addressee for confirmation, even of

having no views of his own. This last criticism is, of course, one often leveled at women. One wonders how much of it reflects a use of language that has been imposed on women from their earliest years.

[...]

Note

1 Within the lexicon itself, there seems to be a parallel phenomenon to tag-question usage, which I refrain from discussing in the body of the text because the facts are controversial and I do not understand them fully. The intensive *so*, used where purists would insist upon an absolute superlative, heavily stressed, seems more characteristic of women's language than of men's, though it is found in the latter, particularly in the speech of male academics. Consider, for instance, the following sentences:

 (a) I feel *so* unhappy!
 (b) That movie made me *so* sick!

Men seem to have the least difficulty using this construction when the sentence is unemotional, or nonsubjective – without reference to the speaker himself:

 (c) That sunset is *so* beautiful!
 (d) Fred is *so* dumb!

 Substituting an equative like *so* for absolute superlatives (like *very, really, utterly*) seems to be a way of backing out of committing oneself strongly to an opinion, rather like tag questions (cf. discussion below, in the text). One might hedge in this way with perfect right in making aesthetic judgments; as in (c), or intellectual judgments, as in (d). But it is somewhat odd to hedge in describing one's own mental or emotional state; who, after all, is qualified to contradict one on this? To hedge in this situation is to seek to avoid making any strong statement: a characteristic, as we have noted already and shall note further, of women's speech.

Hélène Cixous

THE LAUGH OF THE MEDUSA (1975)

I shall speak about women's writing: about *what it will do*. Woman must write her self: must write about women and bring women to writing, from which they have been driven away as violently as from their bodies – for the same reasons, by the same law, with the same fatal goal. Woman must put herself into the text – as into the world and into history – by her own movement.

The future must no longer be determined by the past. I do not deny that the effects of the past are still with us. But I refuse to strengthen them by repeating them, to confer upon them an irremovability the equivalent of destiny, to confuse the biological and the cultural. Anticipation is imperative.

Since these reflections are taking shape in an area just on the point of being discovered, they necessarily bear the mark of our time – a time during which the new breaks away from the old, and, more precisely, the (feminine) new from the old (*la nouvelle de l'ancien*). Thus, as there are no grounds for establishing a discourse, but rather an arid millennial ground to break, what I say has at least two sides and two aims: to break up, to destroy; and to foresee the unforeseeable, to project.

I write this as a woman, toward women. When I say "woman," I'm speaking of woman in her inevitable struggle against conventional man; and of a universal woman subject who must bring women to their senses and to their meaning in history. But first it must be said that in spite of the enormity of the repression that has kept them in the "dark" – that dark which people have been trying to make them accept as their attribute – there is, at this time, no general woman, no one typical woman. What they have *in common* I will say. But what strikes me is the infinite richness of their individual constitutions: you can't talk about *a* female sexuality, uniform, homogeneous, classifiable into codes – any more than you can talk about one unconscious resembling another. Women's imaginary is inexhaustible, like music, painting, writing: their stream of phantasms is incredible.

I have been amazed more than once by a description a woman gave me of a

world all her own which she had been secretly haunting since early childhood. A world of searching, the elaboration of a knowledge, on the basis of a systematic experimentation with the bodily functions, a passionate and precise interrogation of her erotogeneity. This practice, extraordinarily rich and inventive, in particular as concerns masturbation, is prolonged or accompanied by a production of forms, a veritable aesthetic activity, each stage of rapture inscribing a resonant vision, a composition, something beautiful. Beauty will no longer be forbidden.

I wished that that woman would write and proclaim this unique empire so that other women, other unacknowledged sovereigns, might exclaim: I, too, overflow; my desires have invented new desires, my body knows unheard-of songs. Time and again I, too, have felt so full of luminous torrents that I could burst – burst with forms much more beautiful than those which are put up in frames and sold for a stinking fortune. And I, too, said nothing, showed nothing; I didn't open my mouth, I didn't repaint my half of the world. I was ashamed. I was afraid, and I swallowed my shame and my fear. I said to myself: You are mad! What's the meaning of these waves, these floods, these outbursts? Where is the ebullient, infinite woman who, immersed as she was in her naiveté, kept in the dark about herself, led into self-disdain by the great arm of parental-conjugal phallocentrism, hasn't been ashamed of her strength? Who, surprised and horrified by the fantastic tumult of her drives (for she was made to believe that a well-adjusted normal woman has a . . . divine composure), hasn't accused herself of being a monster? Who, feeling a funny desire stirring inside her (to sing, to write, to dare to speak, in short, to bring out something new), hasn't thought she was sick? Well, her shameful sickness is that she resists death, that she makes trouble.

And why don't you write? Write! Writing is for you, you are for you; your body is yours, take it. I know why you haven't written. (And why I didn't write before the age of twenty-seven.) Because writing is at once too high, too great for you, it's reserved for the great – that is for "great men"; and it's "silly." Besides, you've written a little, but in secret. And it wasn't good, because it was in secret, and because you punished yourself for writing, because you didn't go all the way, or because you wrote, irresistibly, as when we would masturbate in secret, not to go further, but to attenuate the tension a bit, just enough to take the edge off. And then as soon as we come, we go and make ourselves feel guilty – so as to be forgiven; or to forget, to bury it until the next time.

Write, let no one hold you back, let nothing stop you: not man; not the imbecilic capitalist machinery, in which publishing houses are the crafty, obsequious relayers of imperatives handed down by an economy that works against us and off our backs; and not *yourself*. Smug-faced readers, managing editors, and big bosses don't like the true texts of women – female-sexed tests. That kind scares them.

I write woman: woman must write woman. And man, man. So only an oblique consideration will be found here of man; it's up to him to say where his masculinity and femininity are at: this will concern us once men have opened their eyes and seen themselves clearly.[1]

Now women return from afar, from always: from "without," from the heath where witches are kept alive; from below, from beyond "culture"; from their

childhood which men have been trying desperately to make them forget, condemning it to "eternal rest." The little girls and their "ill-mannered" bodies immured, well-preserved, intact unto themselves, in the mirror. Frigidified. But are they ever seething underneath! What an effort it takes – there's no end to it – for the sex cops to bar their threatening return. Such a display of forces on both sides that the struggle has for centuries been immobilized in the trembling equilibrium of a deadlock.

Here they are, returning, arriving over and again, because the unconscious is impregnable. They have wandered around in circles, confined to the narrow room in which they've been given a deadly brainwashing. You can incarcerate them, slow them down, get away with the old Apartheid routine, but for a time only. As soon as they begin to speak, at the same time as they're taught their name, they can be taught that their territory is black: because you are Africa, you are black. Your continent is dark. Dark is dangerous. You can't see anything in the dark, you're afraid. Don't move, you might fall. Most of all, don't go into the forest. And so we have internalized this horror of the dark.

Men have committed the greatest crime against women. Insidiously, violently, they have led them to hate women, to be their own enemies, to mobilize their immense strength against themselves, to be the executants of their virile needs. They have made for women an antinarcissism! A narcissism which loves itself only to be loved for what women haven't got! They have constructed the infamous logic of antilove.

We the precocious, we the repressed of culture, our lovely mouths gagged with pollen, our wind knocked out of us, we the labyrinths, the ladders, the trampled spaces, the bevies – we are black and we are beautiful.

We're stormy, and that which is ours breaks loose from us without our fearing any debilitation. Our glances, our smiles, are spent; laughs exude from all our mouths; our blood flows and we extend ourselves without ever reaching an end; we never hold back our thoughts, our signs, our writing; and we're not afraid of lacking.

What happiness for us who are omitted, brushed aside at the scene of inheritances; we inspire ourselves and we expire without running out of breath, we are everywhere!

From now on, who, if we say so, can say no to us? We've come back from always.

It is time to liberate the New Woman from the Old by coming to know her – by loving her for getting by, for getting beyond the Old without delay, by going out ahead of what the New Woman will be, as an arrow quits the bow with a movement that gathers and separates the vibrations musically, in order to be more than her self.

I say that we must, for, with a few rare exceptions, there has not yet been any writing that inscribes femininity; exceptions so rare, in fact, that, after plowing through literature across languages, cultures, and ages[2] one can only be startled at this vain scouting mission. It is well known that the number of women writers (while having increased very slightly from the nineteenth century on) has always been ridiculously small. This is a useless and deceptive fact unless from

their species of female writers we do not first deduct the immense majority whose workmanship is in no way different from male writing, and which either obscures women or reproduces the classic representations of women (as sensitive – intuitive – dreamy, etc.)[3]

Let me insert here a parenthetical remark. I mean it when I speak of male writing. I maintain unequivocally that there is such a thing as *marked* writing; that, until now, far more extensively and repressively than is ever suspected or admitted, writing has been run by a libidinal and cultural – hence political, typically masculine – economy; that this is a locus where the repression of women has been perpetuated, over and over, more or less consciously, and in a manner that's frightening since it's often hidden or adorned with the mystifying charms of fiction; that this locus has grossly exaggerated all the signs of sexual opposition (and not sexual difference), where woman has never *her* turn to speak – this being all the more serious and unpardonable in that writing is precisely *the very possibility of change*, the space that can serve as a springboard for subversive thought, the precursory movement of a transformation of social and cultural structures.

Nearly the entire history of writing is confounded with the history of reason, of which it is at once the effect, the support, and one of the privileged alibis. It has been one with the phallocentric tradition. It is indeed that same self-admiring, self-stimulating, self-congratulatory phallocentrism.

With some exceptions, for there have been failures – and if it weren't for them, I wouldn't be writing (I woman, escapee) – in that enormous machine that has been operating and turning out its "truth" for centuries. There have been poets who would go to any lengths to slip something by at odds with tradition – men capable of loving love and hence capable of loving others and of wanting them, of imagining the woman who would hold out against oppression and constitute herself as a superb, equal, hence "impossible" subject, untenable in a real social framework. Such a woman the poet could desire only by breaking the codes that negate her. Her appearance would necessarily bring on, if not revolution – for the bastion was supposed to be immutable – at least harrowing explosions. At times it is in the fissure caused by an earthquake, through that radical mutation of things brought on by a material upheaval when every structure is for a moment thrown off balance and an ephemeral wildness sweeps order away, that the poet slips something by, for a brief span, of woman. Thus did Kleist expend himself in his yearning for the existence of sister-lovers, maternal daughters, mother-sisters, who never hung their heads in shame. Once the palace of magistrates is restored, it's time to pay: immediate bloody death to the uncontrollable elements.

But only the poets – not the novelists, allies of representationalism. Because poetry involves gaining strength through the unconscious and because the unconscious, that other limitless country, is the place where the repressed manage to survive: women, or as Hoffmann would say, fairies.

She must write her self, because this is the invention of a *new insurgent* writing which, when the moment of her liberation has come, will allow her to carry out the indispensable ruptures and transformations in her history, first at two levels that cannot be separated.

1 Individually. By writing her self, woman will return to the body which has
been more than confiscated from her, which has been turned into the
uncanny stranger on display – the ailing or dead figure, which so often turns
out to be the nasty companion, the cause and location of inhibitions. Cen-
sor the body and you censor breath and speech at the same time.

Write your self. Your body must be heard. Only then will the immense
resources of the unconscious spring forth. Our naphtha will spread,
throughout the world, without dollars – black or gold – nonassessed val-
ues that will change the rules of the old game.

To write. An act which will not only "realize" the decensored relation
of woman to her sexuality, to her womanly being, giving her access to her
native strength; it will give her back her goods, her pleasures, her organs,
her immense bodily territories which have been kept under seal; it will tear
her away from the superegoized structure in which she has always occupied
the place reserved for the guilty (guilty of everything, guilty at every turn:
for having desires, for not having any; for being frigid, for being "too hot";
for not being both at once; for being too motherly and not enough; for
having children and for not having any; for nursing and for not nursing . . .)
– tear her away by means of this research, this job of analysis and illumi-
nation, this emancipation of the marvelous text of her self that she must
urgently learn to speak. A woman without a body, dumb, blind, can't pos-
sibly be a good fighter. She is reduced to being the servant of the militant
male, his shadow. We must kill the false woman who is preventing the live
one from breathing. Inscribe the breath of the whole woman.

2 An act that will also be marked by woman's *seizing* the occasion to *speak*,
hence her shattering entry into history, which has always been based *on her
suppression*. To write and thus to forge for herself the antilogos weapon. To
become *at will* the taker and initiator, for her own right, in every symbolic
system, in every political process.

It is time for women to start scoring their feats in written and oral lan-
guage.

Every woman has known the torment of getting up to speak. Her heart
racing at times entirely lost for words, ground and language slipping away
– that's how daring a feat, how great a transgression it is for a woman to
speak – even just open her mouth – in public. A double distress, for even
if she transgresses, her words fall almost always upon the deaf male ear,
which hears in language only that which speaks in the masculine.

It is by writing, from and toward women, and by taking up the challenge of
speech which has been governed by the phallus, that women will confirm women
in a place other than that which is reserved in and by the symbolic, that is, in a
place other than silence. Women should break out of the snare of silence. They
shouldn't be conned into accepting a domain which is the margin or the harem.

Listen to a woman speak at a public gathering (if she hasn't painfully lost her
wind). She doesn't "speak," she throws her trembling body forward; she lets go
of herself, she flies; all of her passes into her voice, and it's with her body that
she vitally supports the "logic" of her speech. Her flesh speaks true. She lays

herself bare. In fact, she physically materializes what she's thinking; she signifies it with her body. In a certain way she *inscribes* what she's saying, because she doesn't deny her drives the intractable and impassioned part they have in speaking. Her speech, even when "theoretical" or political, is never simple or linear or "objectified," generalized: she draws her story into history.

There is not that scission, that division made by the common man between the logic of oral speech and the logic of the text, bound as he is by his antiquated relation – servile, calculating – to mastery. From which proceeds the niggardly lip service which engages only the tiniest part of the body, plus the mask.

In women's speech, as in their writing, that element which never stops resonating, which, once we've been permeated by it, profoundly and imperceptibly touched by it, retains the power of moving us – that element is the song: first music from the first voice of love which is alive in every woman. Why this privileged relationship with the voice? Because no woman stockpiles as many defenses for countering the drives as does a man. You don't build walls around yourself, you don't forgo pleasure as "wisely" as he. Even if phallic mystification has generally contaminated good relationships, a woman is never far from "mother" (I mean outside her role functions: the "mother" as nonname and as source of goods). There is always within her at least a little of that good mother's milk. She writes in white ink.

Notes

1 Men still have everything to say about their sexuality, and everything to write. For what they have said so far, for the most part, stems from the opposition activity/passivity from the power relation between a fantasized obligatory virility meant to invade, to colonize, and the consequential phantasm of woman as a "dark continent" to penetrate and to "pacify." (We know what "pacify" means in terms of scotomizing the other and misrecognizing the self.) Conquering her, they've made haste to depart from her borders, to get out of sight, out of body. The way man has of getting out of himself and into her whom he takes not for the other but for his own, deprives him, he knows, of his own bodily territory. One can understand how man, confusing himself with his penis and rushing in for the attack, might feel resentment and fear of being "taken" by the woman, of being lost in her, absorbed or alone.

2 I am speaking here only of the place "reserved" for women by the Western world.

3 Which works, then, might be called feminine? I'll just point out some examples: one would have to give them full readings to bring out what is pervasively feminine in their significance. Which I shall do elsewhere. In France (have you noted our infinite poverty in this field? – the Anglo-Saxon countries have shown resources of distinctly greater consequence), leafing through what's come out of the twentieth century – and it's not much – the only inscriptions of femininity that I have seen were by Colette, Marguerite Duras, . . . and Jean Genet.

Denise Riley

DOES A SEX HAVE A HISTORY? (1988)

> *Desdemona*: Am I that name, Iago?
> *Iago*: What name, fair lady?
> *Desdemona*: Such as she says my lord did say I was.
> (William Shakespeare, *Othello*,
> Act IV, Scene II, l. 622)

The black abolitionist and freed slave, Sojourner Truth, spoke out at the Akron convention in 1851, and named her own toughness in a famous peroration against the notion of woman's disqualifying frailty. She rested her case on her refrain 'Ain't I a woman?' It's my hope to persuade readers that a new Sojourner Truth might well – except for the catastrophic loss of grace in the wording – issue another plea: 'Ain't I a fluctuating identity?' For both a concentration on and a refusal of the identity of 'women' are essential to feminism. This its history makes plain.

The volatility of 'woman' has indeed been debated from the perspective of psychoanalytic theory; her fictive status has been proposed by some Lacanian work,[1] while it has been argued that, on the other hand, sexual identities are ultimately firmly secured by psychoanalysis.[2] From the side of deconstruction, Derrida among others has advanced what he calls the 'undecidability' of woman.[3] I want to sidestep these debates to move to the ground of historical construction, including the history of feminism itself, and suggest that not only 'woman' but also 'women' is troublesome – and that this extension of our suspicions is in the interest of feminism. That we can't bracket off either Woman, whose capital letter has long alerted us to her dangers, or the more modest lower-case 'woman', while leaving unexamined the ordinary, innocent-sounding 'women'.

This 'women' is not only an inert and sensible collective; the dominion of fictions has a wider sway than that. The extent of its reign can be partly revealed by looking at the crystallisations of 'women' as a category. To put it schematically: 'women' is historically, discursively constructed, and always relatively to

other categories which themselves change; 'women' is a volatile collectivity in which female persons can be very differently positioned, so that the apparent continuity of the subject of 'women' isn't to be relied on; 'women' is both synchronically and diachronically erratic as a collectivity, while for the individual, 'being a woman' is also inconstant, and can't provide an ontological foundation. Yet it must be emphasised that these instabilities of the category are the *sine qua non* of feminism, which would otherwise be lost for an object, despoiled of a fight, and, in short, without much life.

But why should it be claimed that the constancy of 'women' can be undermined in the interests of feminism? If Woman is in blatant disgrace, and woman is transparently suspicious, why lose sleep over a straightforward descriptive noun, 'women'? Moreover, how could feminism gain if its founding category is also to be dragged into the shadows properly cast by Woman? And while, given the untidiness of word use, there will inevitably be some slippery margins between 'woman' and 'women', this surely ought not to worry any level-headed speaker? If the seductive fraud of 'woman' is exposed, and the neutral collectivity is carefully substituted, then the ground is prepared for political fights to continue, armed with clarity. Not woman, but women – then we can get on with it.

It is true that socialist feminism has always tended to claim that women are socially produced in the sense of being 'conditioned' and that femininity is an effect. But 'conditioning' has its limits as an explanation, and the 'society' which enacts this process is a treacherously vague entity. Some variants of American and European cultural and radical feminism do retain a faith in the integrity of 'women' as a category. Some proffer versions of a female nature or independent system of values, which, ironically, a rather older feminism has always sought to shred to bits,[4] while many factions flourish in the shade cast by these powerful contemporary naturalisms about 'women'. Could it be argued that the only way of avoiding these constant historical loops which depart or return from the conviction of women's natural dispositions, to pacifism for example, would be to make a grander gesture – to stand back and announce that there *aren't any* 'women'? And then, hard on that defiant and initially absurd-sounding assertion, to be scrupulously careful to elaborate it – to plead that it means that all definitions of gender must be looked at with an eagle eye, wherever they emanate from and whoever pronounces them, and that such a scrutiny is a thoroughly feminist undertaking. The will to support this is not blandly social-democratic, for in no way does it aim to vault over the stubborn harshness of lived gender while it queries sexual categorisation. Nor does it aim at a glorious indifference to politics by placing itself under the banner of some renewed claim to androgyny, or to a more modern aspiration to a 'post-gendered subjectivity'. But, while it refuses to break with feminism by naming itself as a neutral deconstruction, at the same time it refuses to identify feminism with the camp of the lovers of 'real women'.

Here someone might retort that there are real, concrete women. That what Foucault did for the concept of 'the homosexual' as an invented classification just cannot be done for women, who indubitably existed long before the nineteenth century unfolded its tedious mania for fresh categorisations. That historical con-

structionism has run mad if it can believe otherwise. How can it be overlooked that women are a natural as well as a characterised category, and that their distinctive needs and sufferings are all too real? And how could a politics of women, feminism, exist in the company of such an apparent theoreticist disdain for reality, which it has mistakenly conflated with ideology as if the two were one?

A brief response would be that unmet needs and sufferings do not spring from a social reality of oppression, which has to be posed against what is said and written about women – but that they spring from the ways in which women are positioned, often harshly or stupidly, *as* 'women'. This positioning occurs both in language, forms of description, and what gets carried out, so that it is misleading to set up a combat for superiority between the two. Nor, on the other hand, is any complete identification between them assumed.

It is true that appeals to 'women's' needs or capacities do not, on their own, guarantee their ultimately conservative effects any more than their progressivism; a social policy with innovative implications may be couched in a deeply familial language, as with state welfare provision at some periods. In general, which female persons under what circumstances will be heralded as 'women' often needs some effort of translation to follow; becoming or avoiding being named as a sexed creature is a restless business.

Feminism has intermittently been as vexed with the urgency of disengaging from the category 'women' as it has with laying claim to it; twentieth-century European feminism has been constitutionally torn between fighting against over-feminisation and against under-feminisation, especially where social policies have been at stake. Certainly the actions and the wants of women often need to be fished out of obscurity, rescued from the blanket dominance of 'man', or 'to be made visible'. But that is not all. There are always too many invocations of 'women', too much visibility, too many appellations which were better dissolved again – or are in need of some accurate and delimiting handling. So the precise specifying of 'women' for feminism might well mean occasionally forgetting them – or remembering them more accurately by refusing to enter into the terms of some public invocation. At times feminism might have nothing to say on the subject of 'women' – when their excessive identification would swallow any opposition, engulfing it hopelessly.

This isn't to imply that every address to 'women' is bad, or that feminism has some special access to a correct and tolerable level of feminisation. Both these points could generate much debate. What's suggested here is that the volatility of 'women' is so marked that it makes feminist alliances with other tendencies as difficult as they are inescapable. A political interest may descend to illuminate 'women' from almost anywhere in the rhetorical firmament, like lightning. This may happen against an older, slower backdrop of altering understandings as to what sexual characterisations are, and a politician's fitful concentration on 'women' may be merely superimposed on more massive alterations of thought. To understand all the resonances of 'women', feminist tactics would need to possess not only a great elasticity for dealing with its contemporary deployments, but an awareness of the long shapings of sexed classifications in their post-1790s upheavals.

This means that we needn't be tormented by a choice between a political

realism which will brook no nonsense about the uncertainties of 'women', or deconstructionist moves which have no political allegiances. No one needs to believe in the solidity of 'women'; doubts on that score do not have to be confined to the giddy detachment of the academy, to the semiotics seminar rooms where politics do not tread. There are alternatives to those schools of thought which in saying that 'woman' is fictional are silent about 'women', and those which, from an opposite perspective, proclaim that the reality of women is yet to come, but that this time, it's we, women, who will define her. Instead of veering between deconstruction and transcendence, we could try another train of speculations: that 'women' is indeed an unstable category, that this instability has a historical foundation, and that feminism is the site of the systematic fighting-out of that instability – which need not worry us.

It might be feared that to acknowledge any semantic shakiness inherent in 'women' would plunge one into a vague whirlpool of 'postgendered' being, abandoning the cutting edges of feminism for an ostensibly new but actually well-worked indifference to the real masteries of gender, and that the known dominants would only be strengthened in the process. This could follow, but need not. The move from questioning the presumed ahistoricity of sexed identities does not have to result in celebrating the carnival of diffuse and contingent sexualities. Yet this question isn't being proposed as if, on the other hand, it had the power to melt away sexual antagonism by bestowing a history upon it.

What then is the point of querying the constancy of 'men' or 'women'? Foucault has written, 'The purpose of history, guided by genealogy, is not to discover the roots of our identity but to commit itself to its dissipation.'[5] This is terrific – but, someone continues to ask, whatever does feminism want with dissipated identities? Isn't it trying to consolidate a progressive new identity of women who are constantly mis-defined, half-visible in their real differences? Yet the history of feminism has also been a struggle against over-zealous identifications; and feminism must negotiate the quicksands of 'women' which will not allow it to settle on either identities or counter-identities, but which condemn it to an incessant striving for a brief foothold. The usefulness of Foucault's remark here is, I think, that it acts as a pointer to history. It's not that our identity is to be dissipated into airy indeterminacy, extinction; instead it is to be referred to the more substantial realms of discursive historical formation. Certainly the indeterminacy of sexual positionings can be demonstrated in other ways, most obviously perhaps by comparative anthropology with its berdache, androgynous and unsettling shamanistic figures. But such work is often relegated to exoticism, while psychoanalytic investigations reside in the confined heats of clinical studies. It is the misleading familiarity of 'history' which can break open the daily naturalism of what surrounds us.

There are differing temporalities of 'women', and these substitute the possibility of being 'at times a woman' for eternal difference on the one hand, or undifferentiation on the other. This escapes that unappetising choice between 'real women' who are always solidly in the designation, regardless, or post-women, no-longer-women, who have seen it all, are tired of it, and prefer evanescence. These altering periodicities are not only played out moment by moment for the

individual person, but they are also historical, for the characterisations of 'women' are established in a myriad mobile formations.

Feminism has recognised this temporality in its preoccupation with the odd phenomenology of possessing a sex, with finding some unabashed way of recognising aloud that which is privately obvious – that any attention to the life of a woman, if traced out carefully, must admit the degree to which the effects of lived gender are at least sometimes unpredictable, and fleeting. The question of how far anyone can take on the identity of being a woman in a thoroughgoing manner recalls the fictive status accorded to sexual identities by some psychoanalytic thought. Can anyone fully inhabit a gender without a degree of horror? How could someone 'be a woman' through and through, make a final home in that classification without suffering claustrophobia? To lead a life soaked in the passionate consciousness of one's gender at every single moment, to will be a sex with a vengeance – these are impossibilities, and far from the aims of feminism.

But if being a woman is more accurately conceived as a state which fluctuates for the individual, depending on what she and/or others consider to characterise it, then there are always different densities of sexed being in operation, and the historical aspects are in play here. So a full answer to the question, 'At this instant, am I a woman as distinct from a human being?', could bring into play three interrelated reflections. First, the female speaker's rejections of, adoptions of, or hesitations as to the rightness of the self description at that moment; second, the state of current understandings of 'women', embedded in a vast web of description covering public policies, rhetorics, feminisms, forms of sexualisation or contempt; third, behind these, larger and slower subsidings of gendered categories, which in part will include the sedimented forms of previous characterisations, which once would have undergone their own rapid fluctuations.

Why is this suggestion about the consolidations of a classification any different from a history of ideas about women? Only because in it nothing is assumed about an underlying continuity of real women, above whose constant bodies changing aerial descriptions dance. If it's taken for granted that the category of women simply refers, over time, to a rather different content, a sort of Women Through the Ages approach, then the full historicity of what is at stake becomes lost. We would miss seeing the alterations in what 'women' are posed against, as well as established by – Nature, Class, Reason, Humanity and other concepts – which by no means form a passive backdrop to changing conceptions of gender. That air of a wearyingly continuous opposition of 'men' and 'women', each always identically understood, is in part an effect of other petrifications.

To speculate about the history of sexual consolidations does not spring from a longing for a lost innocence, as if 'once', as John Donne wrote,[6]

> Difference of sex no more wee knew
> Than our Guardian Angells doe

Nor is it a claim made in the hope of an Edenic future; to suggest that the polarity of the engaged and struggling couple, men and women, isn't timeless, is not a gesture towards reconciliation, as if once the two were less mercilessly

distinguished, and may be so again if we could stop insisting on divisive difference, and only love each other calmly enough. My supposition here – and despite my disclaimer, it may be fired by a conciliatory impulse – is rather that the arrangement of people under the banners of 'men' or 'women' are enmeshed with the histories of other concepts too, including those of 'the social' and 'the body'. And that this has profound repercussions for feminism.

It follows that both theories about the timelessness of the binary opposition of sexual antagonism and about the history of ideas of women could be modified by looking instead at the course of alignments into gendered categories. Some might object that the way to deal with the monotonous male/female opposition would be to substitute democratic differences for the one difference, and to let that be an end to it. But this route, while certainly economical, would also obliterate the feverish powers exercised by the air of eternal polarity, and their overwhelming effects. Nor does that pluralising move into 'differences' say anything about their origins and precipitations.

I've written about the chances for a history of alterations in the collectivity of 'women'. Why not 'men' too? It's true that the completion of the project outlined here would demand that, and would not be satisfied by studies of the emergence of patriarchs, eunuchs, or the cult of machismo, for example; more radical work could be done on the whole category of 'men' and its relations with Humanity. But nothing will be ventured here, because the genesis of these speculations is a concern with 'women' as a condition of and a trial to feminist history and politics. Nor will the term 'sexual difference' appear as an analytic instrument, since my point is neither to validate it nor to completely refuse it, but to look instead at how changing massifications of 'men' and 'women' have thrown up such terms within the armoury of contemporary feminist thought.

How might this be done? How could the peculiar temporality of 'women' be demonstrated? Most obviously, perhaps, by the changing relations of 'woman' and her variants to the concept of a general humanity. The emergence of new entities after the Enlightenment and their implicatedness with the collectivity of women – like the idea of 'the social'. The history of an increasing sexualisation, in which female persons become held to be virtually saturated with their sex which then invades their rational and spiritual faculties; this reached a pitch in eighteenth-century Europe. Behind this, the whole history of the idea of the person and the individual, including the extents to which the soul, the mind, and the body have been distinguished and rethought, and how the changing forms of their sexualisation have operated. For the nineteenth century, arguments as to how the concept of class was developed in a profoundly gendered manner, and how it in turn shaped modern notions of 'women'.[7] These suggestions could proliferate endlessly; in these pages I have only offered sketches of a couple of them.

What does it mean to say that the modern collectivity of women was established in the midst of other formations? Feminism's impulse is often, not surprisingly, to make a celebratory identification with a rush of Women onto the historical stage. But such 'emergences' have particular passages into life; they are the tips of an iceberg. The more engaging question for feminism is then what lies beneath. To decipher any collision which tosses up some novelty, you must know the nature of the various pasts that have led up to it, and allow to these their

full density of otherness. Indeed there are no moments at which gender is utterly unvoiced. But the ways in which 'women' will have been articulated in advance of some prominent 'emergence' of the collectivity will differ, so what needs to be sensed is upon what previous layers the newer and more formalised outcropping has grown.

The grouping of 'women' as newly conceived political subjects is marked in the long suffrage debates and campaigns, which illustrate their volatile alignments of sexed meaning. Demands for the franchise often fluctuated between engagement with and disengagement from the broad category of Humanity – first as an abstraction to be exposed in its masculine bias and permeated, and then to be denounced for its continual and resolute adherence, after women had been enfranchised, to the same bias. An ostensibly unsexed Humanity, broken through political pressures of suffragist and antisuffragist forces into blocs of humans and women, men and women, closed and resealed at different points in different nations. In the history of European socialism, 'men' have often argued their way to universal manhood suffrage through a discourse of universal rights. But for women to ascend to being numbered among Humanity, a severe philosophical struggle to penetrate this category has not eliminated the tactical need to periodically break again into a separately gendered designation. The changing fate of the ideal of a non-sexed Humanity bears witness to its ambiguity.

[. . .]

Notes

1 See Jacqueline Rose, 'Introduction – II', in J. Mitchell and J. Rose (eds), *Feminine Sexuality, Jacques Lacan and the École Freudienne*, London: Macmillan, 1982.

2 See Stephen Heath, 'Male Feminism', *Dalhousie Review*, no. 64, 2 (1986).

3 Jacques Derrida, *Spurs; Nietzsche's Styles*, Chicago: University of Chicago Press, 1978, pp. 51, 55.

4 See arguments in Lynne Segal, *Is the Future Female? Troubled Thoughts on Contemporary Feminism*, London: Virago, 1987.

5 Michel Foucault, 'Nietzsche, Genealogy, History', in *Language, Counter-Memory, Practice: Selected Essays and Interviews*, Donald F. Bouchard and Sherry Simon (eds and trans.), Ithaca: Cornell University Press, 1977, p. 162.

6 John Donne, 'The Relique', *Poems*, London, 1633.

7 See Joan Scott, 'L'Ouvrière! Mot Impie, Sordide . . .': Women Workers in the Discourse of French Political Economy (1840–1860)', in P. Joyce (ed.), *The Historical Meanings of Work*, Cambridge University Press, 1987.

Judith Butler

FROM PARODY TO POLITICS (1990)

I began with the speculative question of whether feminist politics could do with-
out a "subject" in the category of women. At stake is not whether it still makes
sense, strategically or transitionally, to refer to women in order to make repre-
sentational claims on their behalf. The feminist "we" is always and only a phan-
tasmatic construction, one that has its purposes, but which denies the internal
complexity and indeterminacy of the term and constitutes itself only through the
exclusion of some part of the constituency that it simultaneously seeks to repre-
sent. The tenuous or phantasmatic status of the "we," however, is not cause for
despair or, at least, it is not *only* cause for despair. The radical instability of the
category sets into question the *foundational* restrictions on feminist political the-
orizing and opens up other configurations, not only of genders and bodies, but
of politics itself.

 The foundationalist reasoning of identity politics tends to assume that an
identity must first be in place in order for political interests to be elaborated and,
subsequently, political action to be taken. My argument is that there need not be
a "doer behind the deed," but that the "doer" is variably constructed in and
through the deed. This is not a return to an existential theory of the self as con-
stituted through its acts, for the existential theory maintains a prediscursive struc-
ture for both the self and its acts. It is precisely the discursively variable
construction of each in and through the other that has interested me here.

 The question of locating "agency" is usually associated with the viability of
the "subject," where the "subject" is understood to have some stable existence
prior to the cultural field that it negotiates. Or, if the subject is culturally con-
structed, it is nevertheless vested with an agency, usually figured as the capacity
for reflexive mediation, that remains intact regardless of its cultural embedded-
ness. On such a model, "culture" and "discourse" *mire* the subject, but do not
constitute that subject. This move to qualify and enmire the preexisting subject
has appeared necessary to establish a point of agency that is not fully *determined*
by that culture and discourse. And yet, this kind of reasoning falsely presumes

(a) agency can only be established through recourse to a prediscursive "I," even if that "I" is found in the midst of a discursive convergence, and (b) that to be *constituted* by discourse is to be *determined* by discourse, where determination fore-closes the possibility of agency.

Even within the theories that maintain a highly qualified or situated subject, the subject still encounters its discursively constituted environment in an oppo-sitional epistemological frame. The culturally enmired subject negotiates its con-structions, even when those constructions are the very predicates of its own identity. In Beauvior, for example, there is an "I" that does its gender, that becomes its gender, but that "I," invariably associated with its gender, is never-theless a point of agency never fully identifiable with its gender. That *cogito* is never fully *of* the cultural world that it negotiates, no matter the narrowness of the ontological distance that separates that subject from its cultural predicates. The theories of feminist identity that elaborate predicates of color, sexuality, eth-nicity, class, and ablebodiedness invariably close with an embarrassed "etc." at the end of the list. Through this horizontal trajectory of adjectives, these positions strive to encompass a situated subject, but invariably fail to be complete. This failure, however, is instructive: what political impetus is to be derived from the exasperated "etc." that so often occurs at the end of such lines? This is a sign of exhaustion as well as of the illimitable process of signification itself. It is the *sup-plément*, the excess that necessarily accompanies any effort to posit identity once and for all. This illimitable *et cetera*, however, offers itself as a new departure for feminist political theorizing.

If identity is asserted through a process of signification, if identity is always already signified, and yet continues to signify as it circulates within various inter-locking discourses, then the question of agency is not to be answered through recourse to an "I" that preexists signification. In other words, the enabling con-ditions for an assertion of "I" are provided by the structure of signification, the rules that regulate the legitimate and illegitimate invocation of that pronoun, the practices that establish the terms of intelligibility by which that pronoun can cir-culate. Language is not an *exterior medium or instrument* into which I pour a self and from which I glean a reflection of that self. The Hegelian model of self-recognition that has been appropriated by Marx, Lukacs, and a variety of con-temporary liberatory discourses presupposes a potential adequation between the "I" that confronts its world, including its language, as an object, and the "I" that finds itself as an object in that world. But the subject/object dichotomy, which here belongs to the tradition of Western epistemology, conditions the very prob-lematic of identity that it seeks to solve.

What discursive tradition establishes the "I" and its "Other" in an epistemo-logical confrontation that subsequently decides where and how questions of knowability and agency are to be determined? What kinds of agency are fore-closed through the positing of an epistemological subject precisely because the rules and practices that govern the invocation of that subject and regulate its agency in advance are ruled out as sites of analysis and critical intervention? That the epistemological point of departure is in no sense inevitable is naively and per-vasively confirmed by the mundane operations of ordinary language – widely doc-umented within anthropology – that regard the subject/object dichotomy as a

strange and contingent, if not violent, philosophical imposition. The language of appropriation, instrumentality, and distanciation germane to the epistemological mode also belong to a strategy of domination that pits the "I" against an "Other" and, once that separation is effected, creates an artificial set of questions about the knowability and recoverability of that Other.

As part of the epistemological inheritance of contemporary political discourses of identity, this binary opposition is a strategic move within a given set of signifying practices, one that establishes the "I" in and through this opposition and which reifies that opposition as a necessity, concealing the discursive apparatus by which the binary itself is constituted. The shift from an *epistemological* account of identity to one which locates the problematic within practices of *signification* permits an analysis that takes the epistemological mode itself as one possible and contingent signifying practice. Further, the question of *agency* is reformulated as a question of how signification and resignification work. In other words, what is signified as an identity is not signified at a given point in time after which it is simply there as an inert piece of entitative language. Clearly, identities *can* appear as so many inert substantives; indeed, epistemological models tend to take this appearance as their point of theoretical departure. However, the substantive "I" only appears as such through a signifying practice that seeks to conceal its own workings and to naturalize its effects. Further, to qualify as a substantive identity is an arduous task, for such appearances are rule-generated identities, ones which rely on the consistent and repeated invocation of rules that condition and restrict culturally intelligible practices of identity. Indeed, to understand identity as a *practice*, and as a signifying practice, is to understand culturally intelligible subjects as the resulting effects of a rule-bound discourse that inserts itself in the pervasive and mundane signifying acts of linguistic life. Abstractly considered, language refers to an open system of signs by which intelligibility is insistently created and contested. As historically specific organizations of language, discourses present themselves in the plural, coexisting within temporal frames, and instituting unpredictable and inadvertent convergences from which specific modalities of discursive possibilities are engendered.

As a process, signification harbors within itself what the epistemological discourse refers to as "agency." The rules that govern intelligible identity, i.e., that enable and restrict the intelligible assertion of an "I," rules that are partially structured along matrices of gender hierarchy and compulsory heterosexuality, operate through *repetition*. Indeed, when the subject is said to be constituted, that means simply that the subject is a consequence of certain rule-governed discourses that govern the intelligible invocation of identity. The subject is not *determined* by the rules through which it is generated because signification is *not a founding act, but rather a regulated process of repetition* that both conceals itself and enforces its rules precisely through the production of substantializing effects. In a sense, all signification takes place within the orbit of the compulsion to repeat; "agency," then, is to be located within the possibility of a variation on that repetition. If the rules governing signification not only restrict, but enable the assertion of alternative domains of cultural intelligibility, i.e., new possibilities for gender that contest the rigid codes of hierarchical binarisms, then it is only *within* the practices of repetitive signifying that a subversion of identity becomes possi-

ble. The injunction *to be* a given gender produces necessary failures, a variety of incoherent configurations that in their multiplicity exceed and defy the injunction by which they are generated. Further, the very injunction to be a given gender takes place through discursive routes: to be a good mother, to be a heterosexually desirable object, to be a fit worker, in sum, to signify a multiplicity of guarantees in response to a variety of different demands all at once. The coexistence or convergence of such discursive injunctions produces the possibility of a complex reconfiguration and redeployment; it is not a transcendental subject who enables action in the midst of such a convergence. There is no self that is prior to the convergence or who maintains "integrity" prior to its entrance into this conflicted cultural field. There is only a taking up of the tools where they lie, where the very "taking up" is enabled by the tool lying there.

What constitutes a subversive repetition within signifying practices of gender? I have argued ("I" deploy the grammar that governs the genre of the philosophical conclusion, but note that it is the grammar itself that deploys and enables this "I," even as the "I" that insists itself here repeats, redeploys, and – as the critics will determine contests the philosophical grammar by which it is both enabled and restricted) that, for instance, within the sex/gender distinction, sex poses as "the real" and the "factic," the material or corporeal ground upon which gender operates as an act of cultural *inscription*. And yet gender is not written on the body as the torturing instrument of writing in Kafka's "In the Penal Colony" inscribes itself unintelligibly on the flesh of the accused. The question is not: what meaning does that inscription carry within it, but what cultural apparatus arranges this meeting between instrument and body, what interventions into this ritualistic repetition are possible? The "real" and the "sexually factic" are phantasmatic constructions – illusions of substance – that bodies are compelled to approximate, but never can. What, then, enables the exposure of the rift between the phantasmatic and the real whereby the real admits itself as phantasmatic? Does this offer the possibility for a repetition that is not fully constrained by the injunction to reconsolidate naturalized identities? Just as bodily surfaces are enacted *as* the natural, so these surfaces can become the site of a dissonant and denaturalized performance that reveals the performative status of the natural itself.

Practices of parody can serve to reengage and reconsolidate the very distinction between a privileged and naturalized gender configuration and one that appears as derived, phantasmatic, and mimetic – a failed copy, as it were. And surely parody has been used to further a politics of despair, one which affirms a seemingly inevitable exclusion of marginal genders from the territory of the natural and the real. And yet this failure to become "real" and to embody "the natural" is, I would argue, a constitutive failure of all gender enactments for the very reason that these ontological locales are fundamentally uninhabitable. Hence, there is a subversive laughter in the pastiche-effect of parodic practices in which the original, the authentic, and the real are themselves constituted as effects. The loss of gender norms would have the effect of proliferating gender configurations, destabilizing substantive identity, and depriving the naturalizing narratives of compulsory heterosexuality of their central protagonists: "man" and "woman." The parodic repetition of gender exposes as well the illusion of gender identity as an intractable depth and inner substance. As the effects of a subtle and politically

enforced performativity, gender is an "act," as it were, that is open to splittings, self-parody, self-criticism, and those hyperbolic exhibitions of "the natural" that, in their very exaggeration, reveal its fundamentally phantasmatic status.

I have tried to suggest that the identity categories often presumed to be foundational to feminist politics, that is, deemed necessary in order to mobilize feminism as an identity politics, simultaneously work to limit and constrain in advance the very cultural possibilities that feminism is supposed to open up. The tacit constraints that produce culturally intelligible "sex" ought to be understood as generative political structures rather than naturalized foundations. Paradoxically, the reconceptualization of identity as an *effect*, that is, as *produced* or *generated*, opens up possibilities of "agency" that are insidiously foreclosed by positions that take identity categories as foundational and fixed. For an identity to be an effect means that it is neither fatally determined nor fully artificial and arbitrary. That the *constituted* status of identity is misconstrued along these two conflicting lines suggests the ways in which the feminist discourse on cultural construction remains trapped within the unnecessary binarism of free will and determinism. Construction is not opposed to agency; it is the necessary scene of agency, the very terms in which agency is articulated and becomes culturally intelligible. The critical task for feminism is not to establish a point of view outside of constructed identities; that conceit is the construction of an epistemological model that would disavow its own cultural location and, hence, promote itself as a global subject, a position that deploys precisely the imperialist strategies that feminism ought to criticize. The critical task is, rather, to locate strategies of subversive repetition enabled by those constructions, to affirm the local possibilities of intervention through participating in precisely those practices of repetition that constitute identity and, therefore, present the immanent possibility of contesting them.

This theoretical inquiry has attempted to locate the political in the very signifying practices that establish, regulate, and deregulate identity. This effort, however, can only be accomplished through the introduction of a set of questions that extend the very notion of the political. How to disrupt the foundations that cover over alternative cultural configurations of gender? How to destabilize and render in their phantasmatic dimension the "premises" of identity politics?

This task has required a critical genealogy of the naturalization of sex and of bodies in general. It has also demanded a reconsideration of the figure of the body as mute, prior to culture, awaiting signification, a figure that cross-checks with the figure of the feminine, awaiting the inscription-as-incision of the masculine signifier for entrance into language and culture. From a political analysis of compulsory heterosexuality, it has been necessary to question the construction of sex as binary, as a hierarchical binary. From the point of view of gender as enacted, questions have emerged over the fixity of gender identity as an interior depth that is said to be externalized in various forms of "expression." The implicit construction of the primary heterosexual construction of desire is shown to persist even as it appears in the mode of primary bisexuality. Strategies of exclusion and hierarchy are also shown to persist in the formulation of the sex/gender distinction and its recourse to "sex" as the prediscursive as well as the priority of sexuality to culture and, in particular, the cultural construction of sexuality as the prediscursive. Finally, the epistemological paradigm that presumes the priority of

the doer to the deed establishes a global and globalizing subject who disavows its own locality as well as the conditions for local intervention.

If taken as the grounds of feminist theory or politics, these "effects" of gender hierarchy and compulsory heterosexuality are not only misdescribed as foundations, but the signifying practices that enable this metaleptic misdescription remain outside the purview of a feminist critique of gender relations. To enter into the repetitive practices of this terrain of signification is not a choice, for the "I" that might enter is always already inside: there is no possibility of agency or reality outside of the discursive practices that give those terms the intelligibility that they have. The task is not whether to repeat, but how to repeat or, indeed, to repeat and, through a radical proliferation of gender, *to displace* the very gender norms that enable the repetition itself. There is no ontology of gender on which we might construct a politics, for gender ontologies always operate within established political contexts as normative injunctions, determining what qualifies as intelligible sex, invoking and consolidating the reproductive constraints on sexuality, setting the prescriptive requirements whereby sexed or gendered bodies come into cultural intelligibility. Ontology is, thus, not a foundation, but a normative injunction that operates insidiously by installing itself into political discourse as its necessary ground.

The deconstruction of identity is not the deconstruction of politics; rather, it establishes as political the very terms through which identity is articulated. This kind of critique brings into question the foundationalist frame in which feminism as an identity politics has been articulated. The internal paradox of this foundationalism is that it presumes, fixes, and constrains the very "subjects" that it hopes to represent and liberate. The task here is not to celebrate each and every new possibility *qua* possibility, but to redescribe those possibilities that *already* exist, but which exist within cultural domains designated as culturally unintelligible and impossible. If identities were no longer fixed as the premises of a political syllogism, and politics no longer understood as a set of practices derived from the alleged interests that belong to a set of ready-made subjects, a new configuration of politics would surely emerge from the ruins of the old. Cultural configurations of sex and gender might then proliferate or, rather, their present proliferation might then become articulable within the discourses that establish intelligible cultural life, confounding the very binarism of sex, and exposing its fundamental unnaturalness. What other local strategies for engaging the "unnatural" might lead to the denaturalization of gender as such?

LANGUAGE AND SEXUALITY

'To write – the act that will "realise" the uncensored relationship of woman to her sexuality, to her women-being giving her back access to her own forces; that will return her goods, her pleasures, her organs, her vast bodily territories ...'

(Hélène Cixous, 'Sorties', in H. Cixous and H. Clément, *The Newly Born Woman*, 1986: 97)

AS WE SAW IN the previous section, 'Language and Gender', for Hélène Cixous, the form of writing she terms *écriture féminine* involves a return to the pleasures of the female body and the realisation of a female centred sexuality. Her work thus posits an inextricable relationship between language and sexuality, presenting *écriture féminine* as sexually liberatory in its potential. The extracts offered in this section are all concerned with the relationship between language and sexuality, although they offer very different perspectives upon this area.

The first piece in the section by Luce Irigaray shares a great deal with the piece by Cixous in the previous section. Like Cixous, Irigaray emphasises the need for women to challenge the 'phallocentricism' of the symbolic order by producing a 'woman-centred' language, and asserts the creative and emancipatory potential of a language which expresses female sexuality. For Irigaray, this kind of female language emerges from the libidinal impulses and diffuse sexuality of the female body. In the extract here, the labia operate as a sign of female auto-eroticism, free of the need of any external object for satisfaction, of an 'other' for fulfilment. And this in turn is held to underpin a female language which is multiple and fluid; opposed to and beyond the control of the authority of patriarchal discourse. In this respect, it is worth considering the style of Irigaray's essay in detail since it appears to embody, so to speak, the attempt to create an alternative mode of representation. However, Irigaray's representation of femininity is often challenged by other feminist critics on the grounds of its biological essentialism. It has been argued that the way in which she writes about and characterises the female body courts the danger of confirming, albeit positively, the kinds of arguments which have been used against women in the past; the notion, for instance, that women are irrational is a familiar sexist claim. Her grounding of a female language in an essential sexuality also marks her departure from the work of Cixous. For Cixous, *écriture féminine* is a kind of discourse which can be produced by both men and women, whereas for Irigaray, only women can produce a female language.

The other pieces in this section address the relationship between language and sexuality in specific social, cultural and historical contexts. The discussion by the novelist Edmund White of the discourse of homosexuality in the 1970s centres upon the word 'gay' and attempts to analyse how a political vocabulary emerges

out of the process of political struggle. This is another example of the consideration of the way in which language not simply reflects social change (the evidence for which is provided by semantic change) but plays a role in effecting it. Here the sign 'gay' has shifted its signification, but the alteration is not restricted solely to that particular sign; a whole set of other terms necessarily shift – sometimes clearly, sometimes almost imperceptibly. And this returns us to Saussure's concept of the value which signs have: any change in one sign, particularly in a discursive field such as this, brings about a shift in the value of the others. White's arguments now seem dated, given the reappropriation of 'queer' as a sign of sexual dissidence; but again this is instructive, and points to the sensitivity of language as an index of historical change. These are good examples of Voloshinov's formulation of the multiaccentuality of signs: signs which at one point in history were accented with hatred, have been taken back to become signs of defiance and pride.

This sensitivity to the powers of language – its capacity to liberate and imprison – is developed in Hortense Spillers' essay, which also links back to the piece by Riley in the previous section. Here Spillers insists on the specificity of historical analysis, in this case with regard to both the silencing and figuration of African-American women. She traces the way in which in terms of symbolic power (a theoretical term used by Bourdieu as we will see in Part Three) African-American women are 'unvoiced'; their sexuality surrounded by silence or figured in derogatory ways. It is significant that Spillers' criticism is not directed simply at exclusions or negative representations rendered by white and black men, she also argues that Anglo-American (white) feminism has made African-American women 'invisible' too. This again highlights the way feminist debates in this area are extremely complex; it also brings us back to a problem which we have seen in earlier discussions of what 'woman' means. And in her stress on the problematics of a particular, historically loaded vocabulary, including terms such as 'minorities', 'blacks' and 'other', she contests the adequacy of such language. This is of course part of a larger difficulty explored in various texts included in the *Reader*: the necessity of finding, or forging, a language adequate to our historical and political needs.

In other discursive areas there seems to be no problem whatsoever in finding an enormous range of lexical items; it is worth considering, when looking back on the texts in this section, where the silences are held to lie and where words seems to be abundant. Cameron's essay details an informal survey among American college students who were divided into female and male groups and asked to list as many names for the penis as they could. The type of stylistic analysis employed here links back to Schulz's piece on the derogation of women, and indeed to White's essay in this section. Apart from the sheer number of such terms, what the extract explores is the extent to which these names are indicative of wider cultural assumptions about masculinity and femininity. It also calls into question any straightforward relationship between these phallic signifiers and the reproduction of patriarchal ideology. It might be interesting to see if similar exercises carried out in different contexts replicate the results. What the extract also points to is a striking form of linguistic creativity and the interplay between cultural norms and linguistic innovation, an issue which re-emerges in Part Two of the *Reader*.

Further reading

Female sexuality

Irigaray, L. (1985) *This Sex Which Is Not One*, trans. C. Porter with C. Burke, Ithaca, NY: Cornell University Press.

Cixous, H. (1991) *Coming to Writing and Other Essays*, ed. D. Jenson, trans. A. Liddle and S. Sellers, Hemel Hempstead: Harvester Wheatsheaf.

Cixous, H. and C. Clément (1986) *The Newly Born Woman*, trans. B. Wing, Manchester: Manchester University Press.

Kristeva, J. (1986) *The Kristeva Reader*, ed. T. Moi, Oxford: Blackwell.

—— (1980) *Desire in Language: A Semiotic Approach to Literature and Art*, ed. L.S. Roudiez, trans. T. Gora, A. Jardine and L.S. Roudiez, New York: Columbia University Press.

Lacan, J. (1982) *Feminine Sexuality: Jacques Lacan and the École Freudienne*, ed. J. Mitchell and J. Rose, trans. J. Rose, London: Macmillan.

Mitchell, J. (1982) 'Introduction – I', in J. Lacan, *Feminine Sexuality: Jacques Lacan and the École Freudienne*, ed. J. Mitchell and J. Rose, trans. J. Rose, Basingstoke: Macmillan, pp. 1–26.

Moi, T. (1985) *Sexual/Textual Politics: Feminist Literary Theory*, London: Methuen.

Silverman, D. and B. Torode (1980) *The Material Word: Theories of Language and its Limits*, London: Routledge & Kegan Paul, chapter 13.

Rose, J. (1986) *Sexuality in the Field of Vision*, London: Verso.

Segal, L. (1994) *Straight Sex: The Politics of Pleasure*, London: Virago.

Sexuality, discourse and the body

Foucault, M. (1978) *The History of Sexuality: An Introduction*, trans. R. Hurley, London: Penguin.

—— (1985) *The Use of Pleasure: Volume 2 of the History of Sexuality*, trans. R. Hurley, London: Penguin.

—— (1986) *The Care of the Self: Volume 3 of the History of Sexuality*, trans. R. Hurley, London: Penguin.

—— (1977) *Language, Counter-Memory, Practice: Selected Essays and Interviews*, ed. D.F. Bouchard, Oxford: Basil Blackwell.

Bristow, J. (ed). (1997) *Sexuality*, London: Routledge, chapter 4.

Rubin, G. (1993) 'Thinking Sex: Notes for a Radical Theory of the Politics of Sexuality', in H. Abelove, M.A. Barale and D.M. Halperin (eds) *The Lesbian and Gay Studies Reader*, New York: Routledge.

Butler, J. (1990) *Gender Trouble: Feminism and the Subversion of Identity*, New York: Routledge.

—— (1993) *Bodies That Matter: On the Discursive Limits of 'Sex'*, New York: Routledge.

Fraser, N. (1989) *Unruly Practices: Power, Discourse and Gender in Contemporary Social Theory*, Cambridge: Polity.

Grosz, E. (1994) *Volatile Bodies: Toward a Corporeal Feminism*, London: Allen and Unwin.

—— (1995) *Space, Time and Perversion: The Politics of Bodies*, London: Allen and Unwin.

Weeks, J. (1985) *Sexuality and its Discontents: Meanings, Myths and Modern Sexualities*, London: Routledge, chapter 7.

Diamond, I. and L. Quinby (eds) (1988) *Feminism and Foucault: Reflections on Resistance*, Boston, MA: Northeastern University Press.

Harvey, K. and C. Shalom, (eds) (1997) *Language and Desire: Encoding Sex, Romance and Intimacy* London: Routledge.

Johnson, S. and H. Meinhof (eds) (1997) *Language and Masculinity,* Oxford: Blackwell.

Gay and lesbian studies

Abelove, H., M.A. Barale and D.M. Halperin (eds) (1993) *The Lesbian and Gay Studies Reader,* New York: Routledge.

Fuss, D. ed (1991) *Inside/Out: Lesbian Theories, Gay Theories,* New York: Routledge.

Bristow, J. (1997) *Sexuality,* London: Routledge.

—— (1992) *Sexual Sameness: Textual Difference in Lesbian and Gay Writing,* London: Routledge.

Segal, L. (1994) *Straight Sex: The Politics of Pleasure,* London: Virago, chapter 5.

Weeks, J. (1977) *Coming Out: Homosexual Politics in Britain from the Nineteenth Century to the Present,* London: Quartet.

—— (1986) *Sexuality,* London: Tavistock.

Dollimore, J. (1991) *Sexual Dissidence: Augustine to Wilde, Freud to Foucault,* Oxford: Clarendon.

Castle, T. (1993) *The Apparitional Lesbian: Female Homosexuality and Modern Culture,* New York: Columbia University Press.

Sedgwick, E.K. (1990) *Epistemology of the Closet,* Berkeley, CA: University of California Press.

Sinfield, A. (1994) *The Wilde Century: Effeminacy, Oscar Wilde and the Queer Moment,* London: Cassell.

Luce Irigaray

WHEN OUR LIPS SPEAK TOGETHER (1977)

If we keep on speaking the same language together, we're going to reproduce the same history. Begin the same old stories all over again. Don't you think so? Listen: all round us, men and women sound just the same. The same discussions, the same arguments, the same scenes. The same attractions and separations. The same difficulties, the same impossibility of making connections. The same ... Same ... Always the same.

If we keep on speaking sameness, if we speak to each other as men have been doing for centuries, as we have been taught to speak, we'll miss each other, fail ourselves. Again ... Words will pass through our bodies, above our heads. They'll vanish, and we'll be lost. Far off, up high. Absent from ourselves: we'll be spoken machines, speaking machines. Enveloped in proper skins, but not our own. Withdrawn into proper names, violated by them. Not yours, not mine. We don't have any. We change names as men exchange us, as they use us, use us up. It would be frivolous of us, exchanged by them, to be so changeable.

How can I touch you if you're not there? Your blood has become their meaning. They can speak to each other, and about us. But what about us? Come out of their language. Try to go back through the names they've given you. I'll wait for you, I'm waiting for myself. Come back. It's not so hard. You stay here, and you won't be absorbed into familiar scenes, worn-out phrases, routine gestures. Into bodies already encoded within a system. Try to pay attention to yourself. To me. Without letting convention, or habit, distract you.

For example: 'I love you' is addressed by convention or habit to an enigma – an other. An other body, an other sex. I love you: I don't quite know who, or what. 'I love' flows away, is buried, drowned, burned, lost in a void. We'll have to wait for the return of 'I love.' Perhaps a long time, perhaps forever. Where has 'I love' gone? What has become of me? 'I love' lies in wait for the other.

Has he swallowed me up? Spat me out? Taken me? Left me? Locked me up? Thrown me out? What's he like now? No longer (like) me? When he tells me 'I love you,' is he giving me back? Or is he giving himself in that form? His? Mine? The same? Another? But then where am I, what have I become?

When you say I love you – staying right here, close to you, close to me – you're saying I love myself. You don't need to wait for it to be given back; neither do I. We don't owe each other anything. That 'I love you' is neither gift nor debt. You 'give' me nothing when you touch yourself, touch me, when you touch yourself again through me. You don't give yourself. What would I do with you, with myself, wrapped up like a gift? You keep our selves to the extent that you share us. You find our selves to the extent that you trust us. Alternatives, oppositions, choices, bargains like these have no business between us. Unless we restage their commerce, and remain within their order. Where 'we' has no place.

[. . .]

But how can I put 'I love you' differently? I love you, my indifferent one? That still means yielding to their language. They've left us only lacks, deficiencies, to designate ourselves. They've left us their negative(s). We ought to be – that's already going too far – indifferent.

Indifferent one, keep still. When you stir, you disturb their order. You upset everything. You break the circle of their habits, the circularity of their exchanges, their knowledge, their desire. Their world. Indifferent one, you mustn't move, or be moved, unless they call you. If they say 'come,' then you may go ahead. Barely. Adapting yourself to whatever need they have, or don't have, for the presence of their own image. One step, or two. No more. No exuberance. No turbulence. Otherwise you'll smash everything. The ice, the mirror. Their earth, their mother. And what about your life? You must pretend to receive it from them. You're an indifferent, insignificant little receptacle, subject to their demands alone.

So they think we're indifferent. Doesn't that make you laugh? At least for a moment, here and now? *We* are *indifferent?* (If you keep on laughing that way, we'll never be able to talk to each other. We'll remain absorbed in their words, violated by them. So let's try to take back some part of our mouth to speak with.) Not different; that's right. Still . . . No, that would be too easy. And that 'not' still keeps us separate so we can be compared. Disconnected that way, no more 'us'? Are we alike? If you like. It's a little abstract. I don't quite understand 'alike.' Do you? Alike in whose eyes? in what terms? by what standard? with reference to what third? I'm touching you, that's quite enough to let me know that you are my body.

I love you: our two lips cannot separate to let just *one* word pass. A single word that would say 'you,' or 'me.' Or 'equals'; she who loves, she who is loved. Closed and open, neither ever excluding the other, they say they both love each other. Together. To produce a single precise word, they would have to stay apart. Definitely parted. Kept at a distance, separated by *one word*.

But where would that word come from? Perfectly correct, closed up tight, wrapped around its meaning. Without any opening, any fault. 'You.' 'Me.' You may laugh . . . Closed and faultless, it is no longer you or me. Without lips, there is no more 'us.' The unity, the truth, the propriety of words comes from their lack of lips, their forgetting of lips. Words are mute, when they are uttered once and for all. Neatly wrapped up so that their meaning – their blood – won't escape. Like the children of men? Not ours. And besides, do we need, or want, children? What for? Here and now, we are close. Men and women have children to embody their closeness, their distance. But we?

I love you, childhood. I love you who are neither mother (forgive me, mother, I prefer a woman) nor sister. Neither daughter nor son. I love you – and where I love you, what do I care about the lineage of our fathers, or their desire for reproductions of men? Or their genealogical institutions? What need have I for husband or wife, for family, persona, role, function? Let's leave all those to men's reproductive laws. I love you, your body, here and now. I/you touch you/me, that's quite enough for us to feel alive.

Open your lips; don't open them simply. I don't open them simply. We – you I – are neither open nor closed. We never separate simply: *a single word* cannot be pronounced, produced, uttered by our mouths. Between our lips, yours and mine, several voices, several ways of speaking resound endlessly, back and forth. One is never separable from the other. You/I: we are always several at once. And how could one dominate the other? impose her voice, her tone, her meaning? One cannot be distinquished from the other; which does not mean that they are indistinct. You don't understand a thing? No more than they understand you.

Speak, all the same. It's our good fortune that your language isn't formed of a single thread, a single strand or pattern. It comes from everywhere at once. You touch me all over at the same time. In all senses. Why only one song, one speech, one text at at time? To seduce, to satisfy, to fill one of my 'holes'? With you, I don't have any. We are not lacks, voids awaiting sustenance, plenitude, fulfillment from the other. By our lips we are women: this does not mean that we are focused on consuming, consummation, fulfillment.

Kiss me. Two lips kissing two lips: openness is ours again. Our 'world.' And the passage from the inside out, from the outside in, the passage between us, is limitless. Without end. No knot or loop, no mouth ever stops our exchanges. Between us the house has no wall, the clearing no enclosure, language no circularity. When you kiss me, the world grows so large that the horizon itself disappears. Are we unsatisfied? Yes, if that means we are never finished. If our pleasure consists in moving, being moved, endlessly. Always in motion: openness is never spent nor sated.

We haven't been taught, nor allowed, to express multiplicity. To do that is to speak improperly. Of course, we might – we were supposed to? – exhibit one 'truth' while sensing, with-holding, muffling another. Truth's other side – its

complement? its remainder? – stayed hidden. Secret. Inside and outside, we were not supposed to be the same. That doesn't suit their desires. Veiling and unveiling: isn't that what interests them? What keeps them busy? Always repeating the same operation, every time. On every woman.

You/I become two, then, for their pleasure. But thus divided in two, one outside, the other inside, you no longer embrace yourself, or me. Outside, you try to conform to an alien order. Exiled from yourself, you fuse with everything you meet. You imitate whatever comes close. You become whatever touches you. In your eagerness to find yourself again, you move indefinitely far from yourself. From me. Taking one model after another, passing from master to master, changing face, form, and language with each new power that dominates you. You/we are sundered; as you allow yourself to be abused, you become an impassive travesty. You no longer return indifferent; you return closed, impenetrable.

Speak to me. You can't? You no longer want to? You want to hold back? Remain silent? White? Virginal? Keep the inside self to yourself? But it doesn't exist without the other. Don't tear yourself apart like that with choices imposed on you. *Between us*, there's no rupture between virginal and nonvirginal. No event that makes us women. Long before your birth, you touched yourself, innocently. Your/my body doesn't acquire its sex through an operation. Through the action of some power, function, or organ. Without any intervention or special manipulation, you are a woman already. There is no need for an outside; the other already affects you. It is inseparable from you. You are altered forever, through and through. That is your crime, which you didn't commit: you disturb their love of property.

How can I tell you that there is no possible evil in your sexual pleasure – you who are a stranger to good(s). That the fault only comes about when they strip you of your openness and close you up, marking you with signs of possession; then they can break in, commit infractions and transgressions and play other games with the law. Games in which they – and you? – speculate on your whiteness. If we play along, we let ourselves be abused, destroyed. We remain indefinitely distant from ourselves to support the pursuit of their ends. That would be our flaw. If we submit to their reasoning, we are guilty. Their strategy, intentional or not, is calculated to make us guilty.

[...]

If you/I hesitate to speak, isn't it because we are afraid of not speaking well? But what is 'well' or 'badly'? With what are we conforming if we speak 'well'? What hierarchy, what subordination lurks there, waiting to break our resistance? What claim to raise ourselves up in a worthier discourse? Erection is no business of ours: we are at home on the flatlands. We have so much space to share. Our horizon will never stop expanding; we are always open. Stretching out, never ceasing to unfold ourselves, we have so many voices to invent in order to express all of us everywhere, even in our gaps, that all the time there is will not be enough. We can never complete the circuit, explore our periphery: we have so many dimensions. If you want to speak 'well,' you pull yourself in, you become narrower as you rise. Stretching upward, reaching higher, you pull yourself away

from the limitless realm of your body. Don't make yourself erect, you'll leave us. The sky isn't up there: it's between us.

And don't worry about the 'right' word. There isn't any. No truth between our lips. There is room enough for everything to exist. Everything is worth exchanging, nothing is privileged, nothing is refused. Exchange? Everything is exchanged, yet there are no transactions. Between us, there are no proprietors, no purchasers, no determinable objects, no prices. Our bodies are nourished by our mutual pleasure. Our abundance is inexhaustible: it knows neither want nor plenty. Since we give each other (our) all, with nothing held back, nothing hoarded, our exchanges are without terms, without end. How can I say it? The language we know is so limited...

Why speak? you'll ask me. We feel the same things at the same time. Aren't my hands, my eyes, my mouth, my lips, my body enough for you? Isn't what they are saying to you sufficient? I could answer 'yes,' but that would be too easy. Too much a matter of reassuring you/us.

If we don't invent a language, if we don't find our body's language, it will have too few gestures to accompany our story. We shall tire of the same ones, and leave our desires unexpressed, unrealized. Asleep again, unsatisfied, we shall fall back upon the words of men – who, for their part, have 'known' for a long time. But *not our body*. Seduced, attracted, fascinated, ecstatic with our becoming, we shall remain paralyzed. Deprived of *our movements*. Rigid, whereas we are made for endless change. Without leaps or falls, and without repetition.

Keep on going, without getting out of breath. Your body is not the same today as yesterday. Your body remembers. There's no need for *you* to remember. No need to hold fast to yesterday, to store it up as capital in your head. Your memory? Your body expresses yesterday in what it wants today. If you think: yesterday I was, tomorrow I shall be, you are thinking: I have died a little. Be what you are becoming, without clinging to what you might have been, what you might yet be. Never settle. Let's leave definitiveness to the undecided; we don't need it. Our body, right here, right now, gives us a very different certainty. Truth is necessary for those who are so distanced from their body that they have forgotten it. But their 'truth' immobilizes us, turns us into statues, if we can't loose its hold on us. If we can't defuse its power by trying to say, right here and now, how we are moved.

You are moving. You never stay still. You never stay. You never 'are.' How can I say 'you,' when you are always other? How can I speak to you? You remain in flux, never congealing or solidifying. What will make that current flow into words? It is multiple, devoid of causes, meanings, simple qualities. Yet it cannot be decomposed. These movements cannot be described as the passage from a beginning to an end. These rivers flow into no single, definitive sea. These streams are without fixed banks, this body without fixed boundaries. This unceasing mobility. This life – which will perhaps be called our restlessness, whims, pretenses, or lies. All this remains very strange to anyone claiming to stand on solid ground.

Edmund White

THE POLITICAL VOCABULARY
OF HOMOSEXUALITY (1980)

[...] No one I know has any real information about the origins of the word *gay*;
the research all remains to be done. Those who dislike the word assume that it
is synonymous with *happy* or *lighthearted* and that its use implies that homosexu-
als regard heterosexuals, by contrast, as "grim." But *gay* has had many meanings,
including "loose" and "immoral," especially in reference to a prostitute (a whore-
house was once called a "gay house"). In the past one asked if a woman was "gay,"
much as today one might ask if she "swings." The identification of *gay* with
"immoral" is further strengthened by the fact that *queen* (a male homosexual) is
almost certainly derived from *queen* (the Elizabethan word for prostitute).

In American slang at the turn of the century, a "gay cat" was a younger, less
experienced man who attached himself to an older, more seasoned vagrant or
hobo; implicit in the relationship between gay cat and hobo was a sexual liaison.
Yet another slang meaning of *gay* is "fresh," "impertinent," "saucy" (not so very
distant from "immoral"). In French *gai* can mean "spicy" or "ribald." My hunch
(and it's only a hunch) is that the word may turn out to be very old, to have
originated in France, worked its way to England in the eighteenth century and
thence to the colonies in America. It has died out in Europe and England and is
now being reintroduced as a new word from the United States. But this is only
speculation.

If the exact etymology is vague, no wonder; the word served for years as a
shibboleth, and the function of a shibboleth is to exclude outsiders. Undoubtedly
it has had until recently its greatest vogue among Americans. In England, the
standard slang word has been *queer*. In Bloomsbury *bugger* was the preferred term,
presumably because it was salty and vulgar enough to send those rarefied souls
into convulsions of laughter. One pictures Virginia Woolf discussing "buggery"
with Lytton Strachey; how they must have relished the word's public school,
criminal and eighteenth-century connotations.

Today heterosexuals commonly object to *gay* on the grounds that it has ruined for them the ordinary festive sense of the word; one can no longer say, "How gay I feel!" It seems frivolous, however, to discuss this semantic loss beside the political gain the word represents for American homosexuals. An English novelist visiting the States, after boring everyone by saying she felt gay life was actually sad (an observation she presented as though it were original), proceeded to call gay men "queer," which I presume is less offensive in England than in America (a few older Americans use the word).

Many homosexuals object to *gay* on other grounds, arguing that it's too silly to designate a life-style, a minority or a political movement. But, as the critic Seymour Kleinberg has mentioned in his introduction to *The Other Persuasion: Short Fiction about Gay Men and Women*, "For all its limitations, 'gay' is the only unpompous, unpsychological term acceptable to most men and women, one already widely used and available to heterosexuals without suggesting something pejorative." *Gay* is, moreover, one of the few words that does not refer explicitly to sexual activity. One of the problems that has beleaguered gays is that their identity has always been linked to sexual activity rather than to affectional preference. The word *gay* (whatever its etymology) at least does not *sound* sexual.

In any event, *gay* is so workable a word that in the last ten years it has shifted from being just an adjective to being both an adjective and a noun. One now says, "Several gays were present," though such a construction sounds awkward to older American homosexuals. Just as Fowler in *A Guide to Modern English Usage* (1983) objects to *human* as a noun and prefers *human being*, so many homosexuals still prefer *gay person* or *gay man*.

The connection between feminism and gay liberation has been strong for a decade; though now it has broken down. Because of this break, the word *gay* now generally refers to homosexual men alone. Homosexual women prefer to be called *lesbians*, pure and simple. Most lesbian radicals feel they have more in common with the feminist movement than with gay liberation. Since political lesbians tend to resent a male spokesman, I have confined most of my remarks in this essay to the gay male experience which, in any event, is more within my range of competence and understanding.

This fairly recent rupture, however, should not obscure the debt that gay liberation owes to feminism. The members of both movements, for instance, regard their inner experiences as political, and for both gays and feminists the function of consciousness-raising sessions has been to trace the exact contours of their oppression. Women and gay men, as the argument goes, have been socialized into adopting restricting roles that are viewed with contempt by heterosexual men (despite the fact that these very roles reinforce the values of a virilist society). Accordingly, at least one aspect of feminism and gay liberation has been to end the tyranny of stereotyped behavior. Much of this stereotyping, of course, is perpetuated by the victimized themselves. Many women have a low opinion of other women, and many gays are quick to ridicule other gays.

For example, political gays have fought the use of the feminine gender when employed by one homosexual man of another. In the past a regular feature of gay male speech was the production of such sentences as: "Oh, *her*! She'd do anything to catch a husband. . . ." in which the "she" is Bob or Jim. This routine gen-

der substitution is rapidly dying out, and many gay men under twenty-five fail to practice it or even to understand it. This linguistic game has been attacked for two reasons: first, because it supposedly perpetuates female role playing among some gay men; and second, because it is regarded in some quarters as hostile to women. Since one man generally calls another "she" in an (at least mildly) insulting context, the inference is that the underlying attitude must be sexist: to be a woman is to be inferior.

Following the same line, a large segment of the lesbian and gay male population frowns on drag queens, who are seen as mocking women, all the more so because they get themselves up in the most *retardataire* female guises (show girls, prostitutes, sex kittens, Hollywood starlets).

This rejection of transvestites has been harsh and perhaps not well thought out. As long ago as 1970, Kate Millett in *Sexual Politics* saw the drag queen in quite another light – as a useful subversive:

> ...as she minces along a street in the Village, the storm of outrage an insouciant queen in drag may call down is due to the fact that she is both masculine and feminine at once – or male, but feminine. She has made gender identity more than frighteningly easy to lose, she has questioned its reality at a time when it has attained the status of a moral absolute and a social imperative. She has defied it and actually suggested its negation. She has dared obloquy, and in doing so has challenged more than the taboo on homosexuality, she has uncovered what the source of this contempt implies – the fact that sex role is sex rank.

Anyone familiar with drag knows that it is an *art* of impersonation, not an act of deception, still less of ridicule. The drag queen performing in a night club, for instance, is often careful to reveal his true masculinity (deep voice, flat chest, short hair) at some point in his performance; such a revelation underscores the achievements of artifice. Since, in addition, most gay transvestites are from the working class and many are either black or Puerto Rican, discrimination against them may be both snobbish and racist. The greatest irony is that the *Stonewall Resistance* itself and many other gay "street actions" were led by transvestites.

As for why drag queens have singled out prostitutes and show girls to imitate, the explanation may be at least partially historical. In Jonathan Katz's *Gay American History*, one discovers a clue. Testimony given to the New York police in 1899 has this to say of male prostitutes: "These men that conduct themselves there – well, they act effeminately; most of them are painted and powdered; they are called Princess this and Lady So and So and the Duchess of Marlboro, and get up and sing as women, and dance; ape the female character; call each other sisters and take people out for immoral purposes."

Obviously, then, many of the early drag queens actually were prostitutes. Others may have found that the world of the theater and prostitution was the only one where overt homosexuals were welcome. Or perhaps the assertive make-believe of such women, purveyors of sex and fantasy, seemed naturally related to the forbidden pleasures of gay men. Or perhaps the assault on

convention staged by prostitutes and performers appealed to gay men because it was a gaudy if ambiguous expression of anger. In any event, this legacy can still be faintly heard in gay speech today, though less and less often ("Don't be such a cunt," "Look, bitch, don't cross me," "Go, girl, shake that money-maker" and in a vagueness about proper names and the substitution of the generic *darling* or *Mary*). Much more hardy is a small but essential vocabulary derived from prostitute's slang, including: *trick* (a casual sex partner as a noun, to have quickie sex as a verb); *box* (the crotch); *trade* (one-sided sex); *number* (a sex partner); *john* (a paying customer); *to hustle* (to sell sex); *to score* or *to make out* (to find sex) and so on. Few young gays, however, know the origins of these words, and certain locutions borrowed from prostitutes have been modified in order to obscure their mercenary connotations. For instance, few homosexuals still say, "I'd like to turn that trick." Instead, they say, "I'd like to trick with him." That homosexual slang should be patterned after the slang of prostitutes suggests that in the past the only homosexual men who dared talk about their sexual tastes and practices either were prostitutes themselves or lived in that milieu. Curiously, that vocabulary has flourished among gay men who have never dreamed of selling sex.

In the past, feminization, at least to a small and symbolic degree, seemed a necessary initiation into gay life; we all thought we had to be a bit *nelly* (effeminate) in order to be truly gay. Today almost the opposite seems to be true. In any crowd it is the homosexual men who are wearing beards, army fatigues, checked lumberjack shirts, work boots and T-shirts and whose bodies are conspicuously built up. Ironically, at a time when many young heterosexual men are exploring their androgyny by living with women in platonic amicability and by stripping away their masculine stoicism and toughness, young gays are busy arraying themselves in these castoffs and becoming cowboys, truckers, telephone linemen, football players (in appearance and sometimes also in reality).

This masculinization of gay life is now nearly universal. Flamboyance has been traded in for a sober, restrained manner. Voices are lowered, jewelry is shed, cologne is banished and, in the decor of houses, velvet and chandeliers have been exchanged for functional carpet and industrial lights. The campy queen who screams in falsetto, *dishes* (playfully insults) her friends, swishes by in drag is an anachronism; in her place is an updated Paul Bunyan.

Personal advertisements for lovers or sex partners in gay publications call for men who are "macho," "butch," "masculine" or who have a "straight appearance." The advertisements insist that "no femmes need apply." So extreme is this masculinization that it has been termed "macho fascism" by its critics. They point out that the true social mission of liberated homosexuals should be to break down, not reinforce, role-playing stereotypes. Gay men should exemplify the dizzying rewards of living beyond gender. But they have betrayed this promise and ended up by aping the most banal images of conventionally "rugged" men – or so the anti-macho line would have it.

In the heady early days of gay liberation, certainly, apologists foresaw the speedy arrival of a unisex paradise in which gay angels, dressed in flowing garments and glorying in shoulder-length, silken hair, would instruct heterosexual men in how to discard their cumbersome masculinity and ascend to the heights of androgyny. Paradoxically, today it is the young straights who wear their hair

long and style it daily, who deck themselves out in luxurious fabrics and gold fil-
aments, who cover their bodies with unguents, dive into a padded conversation
pit and squirm about in "group gropes" (in which, mind you, lesbianism may be
encouraged for its entertainment value to male spectators but never the swains
shall meet). Simultaneously but elsewhere, crew-cut gays, garbed in denim and
rawhide, are manfully swilling beer at a country and western bar and, each alone
in the crowd, tapping a scuffed boot to Johnny Cash's latest.

Another objection to the masculinization of gay life is that it has changed a
motley crew of eccentrics into a highly conformist army of clones. Whereas gays
in the past could be slobs or bohemians or Beau Brummels or aesthetes striking
"stained glass attitudes" or tightly closeted businessmen in gray flannel suits, today
this range of possibility has been narrowed to a uniform look and manner that is
uninspiredly butch. The flamboyance and seediness and troubling variety of gay
life (a variety that once embraced all the outcasts of society, including those who
were not gay) have given way to a militant sameness.

This argument, I think, ignores our historical moment. In the past gay men
embraced the bias of the oppressor that identified homosexuality with effeminacy,
degeneracy, failure. To have discovered that this link is not necessary has released
many homosexuals into a forceful assertion of their masculinity, normality, suc-
cess – an inevitable and perhaps salutary response. Moreover, the conformism of
gay life, I suspect, is more on the level of appearance than reality. The butch
look is such a successful get-up for cruising that some sort of "natural selection"
in mating has made it prevail over all other costumes. But this look does not pre-
clude the expression of individuality, of tenderness and zaniness, in conversation
and private behavior.

Yet another thought occurs to me. In the past many homosexuals despised
each other and yearned for even the most fleeting and unsatisfactory sexual (or
even social) contact with straight men. Some gays considered sex with other
homosexuals pointless and pitiable, a poor second best, and thirsted for the font
of all value and authenticity, a "real" (i.e., straight) man. Today, fortified by gay
liberation, homosexuals have become those very men they once envied and
admired from afar.

The apotheosis of the adult macho man has meant that the current heart-
throb in gay pornography – and in actual gay cruising situations – is no longer
the lithe youth of nineteen but rather the prepossessing stud of thirty-five. The
ephebe with hyacinthine curls has given way to the bald marine drill sergeant,
and Donatello's *David* demurs to Bernini's.

The change has affected the language of approbation. In the past one admired
a "boy" who was "beautiful" or "pretty" or "cute." Now one admires a man who
is "tough" or "virile" or "hot." Perhaps no other word so aptly signals the new
gay attitudes as *hot*. Whereas *beautiful* in gay parlance characterizes the face first
and the body only secondarily, *hot* describes the whole man, but especially his
physique. One may have a lantern jaw or an assymmetrical nose or pockmarked
skin and still be "hot," whereas the signs of the "beautiful" face are regular fea-
tures, smooth skin, suave coloring – and youth. The "hot" man may even fail to
have an attractive body; his appeal may lie instead in his wardrobe, his manner,
his style. In this way "hotness" is roughly equivalent to "presence" with an accent

on the sexy rather than the magisterial sense of that word. In addition, "hot" can, like the Italian *simpatico*, modify everything from people to discos, from cars to clothing. Gay chartered cruises promise a "hot" vacation and designers strive after a "hot" look. If an attractive man strolls by, someone will murmur, "That's hot." The "that" in place of "he" may be an acknowledgment that the person is as much a package as a human being, though more likely the impersonal pronoun is a last echo of the old practice (now virtually abandoned) of referring to a one-time-only sex partner as an "it" (as in, "The trick was fine in bed, but I had to throw it out this morning – couldn't get it to shut up").

Gay male culture, as though in flight from its effeminate past, is more and more gravitating towards the trappings of sadomasochism. The big-city gay man of today no longer clusters with friends around a piano at a bar to sings songs from musicals; now he goes to a leather and western bar to play pool and swill beer. Gay men belong to motorcycle clubs or engage in anonymous sex in back-rooms, those dimly lit penetralia behind the normally sociable bar.

The popularity of sado-masochistic sex has introduced new words into the gay vocabulary – as well as their domesticated, more casual variants. The original terms, such as *slave* and *master*, must have seemed too absurd, too theatrical, not quite plausible, too ... well, *embarrassing*. It is socially awkward to ask a stranger if he wants to be your "slave" for the night. The word invokes dungeons, chains, pornographic novels of the eighteenth century – a sort of period claptrap. As a result, nearly every word in the original vocabulary has found its more conversational, more up-to-date euphemism. "Sado-masochism" itself has thus become "S and M" or, more recently and innocuously, "rough stuff." Bondage and discipline is now "B and D." "Sadist" and "masochist" have become "top man" and "bottom man." The way to ask someone to be your slave, therefore, is "Are you into a bottom scene?" Similarly, sexual aggression kept on the level of fantasy is a "head trip," whereas to want physical abuse is to be "into pain." And the "dungeon" has become the "game room."

Interestingly, gay men, usually so fastidious about staying *au courant*, are willing to utter outmoded hippy words from the drug culture of the sixties such as *scene, trip* and *into* if those words enable periphrases that stand in for the still more ludicrous vocabulary of classical sadism.

I have tried to point out that gay male culture and language have registered a shift in taste away from effeminacy to masculinity and from youth to maturity. But now a larger question might be posed: has the status of – and the need for – a private language itself become less important to homosexuals?

I think it has. In the past homosexuality was regarded with such opprobrium and homosexuals remained so inconspicuous that we faced some difficulty in detecting one another. A familiar game was to introduce into an otherwise normal conversation a single word that might seem innocent enough except to the initiated ("I went to a very lively and gay party last night"). If that risk was greeted with words from the same vocabulary ("I'm afraid the party I went to was a real drag; everyone acted like royalty," i.e., "queens"), a contact was established. Two businessmen could thus identify themselves to one another in the midst of a heterosexual gathering.

But the value of a private language was not merely practical. It also allowed

gays to name everything anew, to appropriate experience in terms that made sense only to the few. Sailors became "sea food," "chicken" (always singular) were teenage boys and so on – there is a whole book, *The Queen's Vernacular*, that lists these words. Equally amusing and subversive was the pleasure of referring to a revered public leader as "Miss Eisenhower," or to oneself (as Auden does at the end of an otherwise serious poem) as "Miss Me." When gay frustration had no outlet in action it could find expression only in language. But even in language the impulse had become sour and self-destructive through long suppression; its target was more often other gays than straights or in the fiction that respectable straights were actually outrageous queens. In self-satire lies the reflexive power of thwarted anger. Gay identity, now rehearsed nightly in thronged discos and in a myriad of gay bars, was once much more tenuous. It was an illegitimate existence that took refuge in language, the one system that could swiftly, magically, topple values and convert a golf-playing general into a co-conspirator in a gingham frock and turn a timid waiter into a queen for a night – or at least into the Duchess of Marlboro.

Now that homosexuals have no need for indirection, now that their suffering has been eased and their place in society adumbrated if not secured, the suggestion has been made that they will no longer produce great art. There will be no liberated Prousts, the argument goes, an idea demonstrated by pointing to the failure of *Maurice* in contrast to Forster's heterosexual novels. A review of my novel, *Nocturnes for the King of Naples*, claimed that it was not as strong as my earlier, "straight" *Forgetting Elena* precisely because I no longer need to resort to the pretense of heterosexuality.

This position strikes me as strange and unexamined. Proust, of course, *did* write at length about homosexual characters – in fact, one of the complaints against his novel is that so many characters implausibly turn out to be homosexual. *Maurice*, I suspect, is a failure not because it is homosexual but because it is a rather exalted, sentimentalized masturbation fantasy. When he wrote *Maurice*, Forster had even less knowledge of the homosexual than of the heterosexual world, and he was forced back on his day dreams rather than on his observations from life. It is not for me to judge the merits of my own books, but what strikes me as most "homosexual" about *Nocturnes* is not the content so much as the technique, one that uses endless dissolves of time and geography, as though the same party were being reassembled over decades and on different continents, something like that "marvellous party" in the Noel Coward song. Anyone who has experienced the enduring and international links of gay life will recognize how the technique is a formal equivalent to the experience.

Unless one accepts the dreary (and unproved) Freudian notion that art is a product of sublimated neuroses, one would not predict that gay liberation would bring an end to the valuable art made by homosexuals. On the contrary, liberation should free gays from tediously repetitious works that end in madness or suicide, that dwell on the "etiology" of the characters' homosexuality (shadowy Dad, suffocating Mom, beloved, doomed, effeminate Cousin Bill) and that feature long, static scenes in which Roger gently weeps over Hank's mislaid hiking boot. Now a new range of subject matter has opened up to gays, much of it comic; Feydeau, after all, would have loved gay life, since every character can

cheat with every other and the mathematical possibilities of who may be hiding under the bed (if not in the closet) have been raised geometrically. Still more importantly, gay liberation means that not so many talentless souls need to continue lingering about in the sacred precincts (i.e., the gay ghetto) of high culture. Finally they are free to pursue all those other occupations they once feared to enter – electrical engineering, riding the range, plumbing. The association between homosexuals and the arts, I suspect, suited some of us but not most; the great majority of gays are as reassuringly philistine as the bulk of straights.

Hortense J. Spillers

INTERSTICES: A SMALL DRAMA OF WORDS (1984)

[. . .] Sexuality is the locus of great drama – perhaps the fundamental one – and, as we know, wherever there are actors, there are scripts, scenes, gestures, and reenactments, both enunciated and tacit. Across the terrain of feminist thought, the drama of sexuality is a dialectic with at least one missing configuration of terms. Whatever my mother, niece, and I might say and do about our sexuality (the terms of kinship are also meant collectively) remains an unarticulated nuance in various forms of public discourse as though we were figments of the great invisible empire of womankind. In a very real sense, black American women are invisible to various public discourse, and the state of invisibility for them has its precedent in an analogy on any patriarchal symbolic mode that we might wish to name. However we try not to call up men in this discussion we know full well, whether we like it or not, that these "they" do constitute an element of woman-scenery. For instance, in my attempt to lay hold of non-fictional texts – of any discursively rendered experience concerning the sexuality of black women in the United States, authored by themselves, for themselves – I encountered a disturbing silence that acquires, paradoxically, the status of contradiction. With the virtually sole exception of Calvin Hernton's *Sex and Racism in America* and less than a handful of very recent texts by black feminist and lesbian writers,[1] black women are the beached whales of the sexual universe, unvoiced, misseen, not doing, awaiting *their* verb. Their sexual experiences are depicted, but not often by them, and if and when by the subject herself, often in the guise of vocal music, often in the self-contained accent and sheer romance of the blues.

My survey, however, is mostly limited to some of the non-fictional texts on sexuality because I wish to examine those rhetorical features of an intellectual/symbolic structure of ideas that purport to describe, illuminate, reveal, and valorize the *truth* about its subject. Fictional texts, which transport us to another world of symbols altogether, are much beyond the scope of this essay and the

central tenets of its argument. The non-fictional feminist work along a range of issues is the privileged mode of feminist expression at the moment, and its chief practitioners and revisionists are Anglo-American women/feminists in the academy. The relative absence of African-American women/feminists, in and out of the academic community, from this visionary company, is itself an example of the radically divergent historical situations that intersect with feminism. Such absence quite deliberately constitutes the hidden and implicit critique of this essay. The non-fictional feminist text is, to my mind, the empowered text – not fiction – and I would know how power works in the guise of feminist exposition when "sexuality" is its theme. If the African-American women's community is relatively "word-poor" in the critical/argumentative displays of symbolic power, then the silence surrounding their sexuality is most evident in the structure of values I am tracing. It is, then, ironical that some of the words that tend to break silence here are, for whatever their purpose, male-authored.

Hernton's *Sex and Racism in America* proposes to examine the psychological make-up of America's great sexual quartet – the black female, the black male, the white female, the white male – and the historical contexts in which these overlapping complexities work. Each of his chapters provides a study of collective aspects of psyche as Hernton seeks insight into the deep structure of sexual fantasies that operate at the subterranean level of being. The chapter on the black female interlards anonymous personal witness with the author's historical survey of the black female's social and political situation in the United States. We can call Hernton's text a dialectical/discursive analysis of the question and compare it with words from aspects of oral tradition.

As an example of a spate of discourse that portrays black women as a sexual reality, we turn to the world of "toasts," or the extended and elaborate male oratorical display under the ruse of ballad verse. This form of oral narrative projects a female figure most usually poised in an antipathetic, customarily unflattering, sexual relationship to the male.[2] These long oral narratives, which black men often learn in their youth and commit to memory, vary from place to place and time to time, describing contests of the male sexual will to power. Several versions of "The Titanic,"[3] for instance, project a leading character named "Shine" as the great race/sex man, who not only escapes from the ill-fated maiden voyage of the celebrated ship, but also ends up in a Harlem nightclub, after the disaster, drinking Seagram's Seven and boasting his exploits. Within this community of male-authored texts, the female is appropriately grotesque, tendentiously heterosexual, and olympically comparable in verbal prowess to the male, whom she must sexually best in the paradigmatic battle of the ages – that between the sexes. Relevant to the hyperbolic tall tale, comedian Rudy Moore's version of the battle of the sexes depicts evenly-matched opponents, with the world "making book" on one side of the contest, or the other. The agents literally "screw" for days in language far bolder than mine. But we already know beforehand, according to the wisdom of Chaucer's Wife of Bath, the outcome of the tale that the lion did not write. The woman in the "toasts" is properly subdued, or, more exactly in the latter-day versions of phallic dominance, "tooled" into oblivion.

So, here are two textual instances – Hernton's sympathetic account of the black female and the subject from the point of view of the people's oral poetry.

Both instances insinuate quite different, though gratuitously related, versions of female sexuality. The correspondences are crucial. In the world of "toasts," "roasts," and "boasts," in the universe of unreality and exaggeration, the black female is, if anything, a creature of sex, but *sexuality* touches her nowhere. In the universe of "clean" discourse and muted analysis, to which we relegate Hernton's book, the black woman is reified into a status of non-being. In any comparison with white women in the sexual fantasies of black men, black women flunk – in truth, they barely register as fantastic impressibility – because of the ravages of the "Peculiar Institution." The latter was not the ideal workshop for refining the feminine sensibilities, Hernton argues. We infer from his reading that the black woman disappears as a legitimate subject of female sexuality. In all fairness to Hernton, however, we are obligated to point out his own acknowledgment of the silence that has been imposed on black American women:

> Out of the dark annals of man's inhumanity to woman, the epic of the black woman's ordeal in America is yet to be written But the change is just beginning, and the beginning is fraught with hazards.[4]

My own interpretation of the historical narrative concerning the lives of black American women is in accord with Hernton's: their enslavement relegated them to the marketplace of the flesh, an act of commodifying so thoroughgoing that the daughters labor even now under the outcome.[5] Slavery did not transform the black female into an embodiment of carnality at all, as the myth of the black woman would tend to convince us, nor, alone, the primary receptacle of a highly-rewarding generative act. She became instead the principal point of passage between the human and the non-human world. Her issue became the focus of a cunning difference – visually, psychologically, ontologically – as the route by which the dominant male decided the distinction between humanity and "other." At this level of radical discontinuity in the "great chain of being," black is vestibular to culture. In other words, the black person mirrored for the society around her and him what a human being was *not*. Through this stage of the bestial, the act of copulating travels eons before culture incorporates it, before the concept of sexuality can reclaim and "humanize" it.[6] Neither the picture I am drawing here, nor its symbolic interpretation, is unheard of to our understanding of American and New-World history. If, however, it is a stunning idea in its ritual repetition, none the less, then that is because the black female remains exotic, her history transformed into a pathology turned back on the subject in tenacious blindness.

That this unthinkably vast and criminal fraud created its own contradictions and evasions within the creating brain ultimately does not concern us. The point is that neither we, nor Hernton, can easily approach the subtleties of a descriptive apparatus that would adequately account for the nexus *dis-effected* in this case between female gender and color. The rift translates into unthinkable acts, unspeakable practices. I am not identifying here the black female as the focal point of cultural and political inferiority. I do not mean to pose the black female as an object of the primitive, uxoricidal nightmares, or interrupted nocturnal

emissions (elevated to the status of form) as in a Henry Miller or Norman Mailer. The structure of unreality that the black woman must confront originates in the historical moment when language ceases to speak, the historical moment at which hierarchies of power (even the ones to which some women belong) simply run out of terms because the empowered meets in the black female the veritable nemesis of degree and difference. Having encountered what they understand as chaos, the empowered need not name further, since chaos is sufficient naming within itself. I am not addressing the black female in her historical apprentice-ship as inferior being, but, rather, the paradox of non-being. Under the sign of this particular historical order, black female and black male are absolutely equal. We note with quiet dismay, for instance, the descriptive language of affirmative-action advertisements, or even certain feminist analyses, and sense once again the historic evocation of chaos: The collective and individual "I" lapses into a cul-de-sac, falls into the great black hole of meaning, wherein there are only "women," and "minorities," "blacks" and "other."

I wish to suggest that the lexical gaps I am describing here are manifest along a range of symbolic behavior in reference to black women and that the absence of sexuality as a structure of distinguishing terms is solidly grounded in the neg-ative aspects of symbol-making. The latter, in turn, are wed to the abuses and uses of history, and how it is perceived. The missing word – the interstice – both as that which allows us to speak about and that which enables us to speak at all – shares in this case, a common border with another country of symbols – the iconographic. Judy Chicago's exhibit, "Dinner Party," for example, in the artist's tribute to women, had a place set at table for the black female. Sojourner Truth is their representative symbol, and as the female figures around her are imagined through ingenious variations on the vagina, *she* is inscribed by three faces. As Alice Walker comments: "There is of course a case to be made for being 'personified' by a face rather than by a vagina, but that is not what this show [was] about."[7]

The point of the example is self-evident. The excision of the female genitalia here is a symbolic castration. By effacing the genitals, Chicago not only abrogates the disturbing sexuality of her subject, but also hopes to suggest that her sexual being did not exist to be denied in the first place. Truth's "femaleness," then, sustains an element of drag. In fact, she is merged here with a notion of sexual neutrality whose features, because they have not yet been defined, could assume any form, or none at all – in either case, the absence of articulation. Ironically, Sojourner Truth's piercing, rhetorical, now-famous question on the floor of the second annual Convention of Women's Rights in Akron, 1852 – "Ain't I a woman?" – anticipates the "atmosphere" of the artist's deepest assumptions.[8] The displacement of a vagina by a face invites protracted psychological inquiry,[9] but it is enough to guess, almost too much to bear guessing, that if Sojourner, in the female artist's mind, does not have the necessary female equipment, then its absence might be expressed in a face whose orifices are still searching for a *proper* role in relationship to the female body.

While there are numerous references to the black woman in the universe of signs, many of them perverted, the prerogatives of sexuality are refused her because the concept of sexuality originates in, stays with, the dominative mode

of culture and its elaborate strategies of thought and expression. As a substitute term for "race" and "racism," I would borrow Edward Said's "dominative mode"[10] because the latter, not unlike "patriarchy," moves us closer to the heart of the lion's den. We would discover the ways and means of power in its intellectual and contemplative fulfillment – those places where most of us do not think to look because the intellectual enterprise, the lie goes, is so "objective" and so "disinterested" that it has little to do with what impresses the brain and the heart, to say nothing of what the legs straddle. If we are "intellectualizing" the issue away, which feminists used to say we ought not do, yet, interestingly enough, have done most of the time, then we mean to "intellectualize" exactly, since the questions about woman-sex and the practices of exclusion that demarcate it are among the more impressive intellectual stunts of our time.

We would argue that sexuality as a term of power belongs to the empowered. Feminist thinking often appropriates the term in its own will to discursive power in a sweeping, patriarchist, symbolic gesture that reduces the human universe of women to its own image. The process might be understood as a kind of deadly metonymic playfulness – a part of the universe of women speaks for the whole of it. The structure of values, the spectacle of symbols under which we presently live and have our being – in short, the theme of domination and subordination – is practiced, even pursued, in many of the leading feminist documents of scholarship this past decade or so. We can, then, affiliate sexuality – that term that flirts with the concealment of the activity of sex by way of an exquisite dance of textual priorities and successions, revisions and corrections – with the very project and destiny of power.

Through the institutionalization of sexual reference in the academy, in certain public forums; in the extensive responses to Freud and Lacan; in the eloquent textual discontinuities with the Marquis de Sade and D.H. Lawrence, sexual meaning in the feminist universe of academic discourse threatens to lose its living and palpable connection to training in the feelings and to become, rather, a mode of theatre for the dominating mythologies. The discourse of sexuality seems another way, in its present practices, that the world divides decisively between the haves/have-nots, those who may speak and those who may not, those who, by choice or the accident of birth, benefit from the dominative mode, and those who do not. Sexuality describes another type of discourse that splits the world between the "West and the Rest of Us."

Black American women in the public/critical discourse of feminist thought have no acknowledged sexuality because they enter the historical stage from quite another angle of entrance from that of Anglo-American women. Even though my remarks are addressed specifically to feminists, I do not doubt that the different historical occasions implicated here have dictated sharp patterns of divergence not only in living styles, but also ways of speaking between black and white American women, without modification. We must have refinement in the picture at the same time that we recognize that *history* has divided the empire of women against itself. As a result, black American women project in their thinking about the female circumstance and their own discourse concerning it an apparently divergent view from feminist thinking on the issues. I am not comfortable with the "black-woman/feminist" opposition that this argument apparently cannot

avoid. I am also not cheered by what seems a little noticed elision of meaning – when we say "feminist" without an adjective in front of it, we mean, of course, white women, who, as a category of social and cultural agents, fully occupy the territory of feminism. Other communities of women, overlapping feminist aims, are noted, therefore, by some qualifying term. Alice Walker's "Coming Apart" addresses this linguistic and cultural issue forthrightly and proposes the term, "womanist" for black women and as a way to dissolve these apparently unavoidable locutions.[11] The disparities that we observe in this case are *symptomatic* of the problem and are a part of the problem. Because black American women do not participate, as a category of social and cultural agents, in the legacies of symbolic power, they maintain no allegiances to a strategic formation of texts, or ways of talking about sexual experience, that even remotely resemble the paradigm of symbolic domination, except that such paradigm has been their concrete disaster.

We hope to show in time how African-American women's peculiar American encounter, in the specific symbolic formation we mean, differs in both degree and kind from Anglo-American women's. We should not be at all surprised that difference among women is the case, but I am suggesting that in order to anticipate a more definitive social criticism, feminist thinkers, whom African-American women must confront in greater number on the issues, must begin to take on the dialectical challenge of determining *in the discourse* the actual realities of American women in their pluralistic ways of being. By "actual," I do not intend to mean, or even deny, some superior truth about life outside books, but, rather, to say that feminist discourse can risk greater truth by examining its profoundest symbolic assumptions, by inquiring into the herstory of American women with a sharpened integrity of thought and feeling. We are, after all, talking about words, as we realize that by their efficacy we are damned or released. Furthermore, by talking about words as we have seen them marshalled in the discussion, we hope to provide more clues to the duplicitous involvement of much of feminist thinking with the mythological fortunes (words and images) of patriarchal power. By doing so, I believe that we understand more completely the seductive means of power at whatever point it involves women.

[. . .]

Notes

1 Calvin C. Hernton, *Sex and Racism in America*, New York, Grove, 1965, pp. 121–68. I should point out that while the following texts actually do not specifically address the question of black female sexuality, many of their concerns intersect the issues, especially the three essays under "Sexuality and Sexual Attitudes" in Gloria I. Joseph and Jill Lewis (eds), *Common Differences: Conflicts in Black and White Feminist Perspectives*, New York, Anchor, 1981, pp. 151–274. Other points of reference touching sex-related questions in the African-American women's community include Tracey A. Gardner's "Racism in Pornography and the Women's Movement" and Luisah Teish's "Quiet Subversion" in Laura Lederer (ed.), *Take Back the Night: Women on Pornography,*

New York, William Morrow, 1980; Lorraine Bethel and Barbara Smith (eds), *Conditions Five – The Black Women's Issue*, 1979.

2 Dennis Wepman, Ronald B. Newman, and Murray B. Binderman (eds), *The Life: The Lore and Folk Poetry of the Black Hustler* in The Folklore and Folklife Series, gen. ed. Kenneth S. Goldstein, Philadelphia, University of Pennsylvania Press, 1976, pp. 20–150. The Wepman text provides mostly a collection of narratives in the tradition. A more comprehensive and useful perspective on the meanings and transformations of this type of oral narrative is supplied by Roger D. Abrahams in his important study, *Deep Down in the Jungle: Negro Narrative Folklore from the Streets of Philadelphia*, Hatboro, Pennsylvania, Folklore Associates, 1964.

3 Ibid., pp. 111–23. Different versions of "The Titanic" are given by Abrahams in demonstration of the "oikotype," the local variations that an oral narrative achieves when it reaches a specific area (pp. 10ff). The expurgated version of the narrative, reprinted in the Hughes collection, *The Book of Negro Folklore*, might be advantageously compared with Abrahams's. Langston Hughes and Arna Bontemps (eds), New York, Dodd, Mead, 1958, pp. 366–7.

4 Hernton, *Sex and Racism in America*, op. cit., p. 166.

5 Two recent additions to the women's studies library inquire into the black female's economic exploitation and its political and historical significance: Angela Y. Davis, *Women, Race, and Class*, New York, Random House, 1981; Bell Hooks, *Ain't I A Woman: Black Women and Feminism,* Boston, South End Press, 1981.

6 Winthrop Jordan's *White Over Black: American Attitudes Toward the Negro, 1550–1812* (Baltimore, Penguin, 1969) is virtually unique in its systematic exploration of the concept of race in its European symbolic and geopolitical origins. An analysis of cultural vestibularity in its symbolic contours is the aim of Henry Louis Gates's "Binary Oppositions" in chap. 1 of *Narrative of the Life of Frederick Douglass, An American Slave Written by Himself,* in Dexter Fisher and Robert B. Stepto (eds), *Afro-American Literature: The Reconstruction of Instruction,* New York, Modern Language Association, 1979, pp. 212–32.

7 Alice Walker, "One Child of One's Own: A Meaningful Digression Within the Work(s) – An Excerpt", Gloria T. Hull, Patricia Bell Scott, and Barbara Smith (eds), *All the Women Are White, All the Blacks Are Men, But Some of Us Are Brave: Black Women's Studies*, Old Westbury, New York, Feminist Press, 1981, pp. 42–3.

8 For a recent account of this famous story from the annals of the historic women's movement, the reader might consult chap. 5 of Hooks's *Ain't I A Woman,* op. cit., pp. 159–60.

9 Freud's notes on the "frequency with which sexual repression makes use of transpositions from a lower to an upper part of the body" were for me a surprising find in connection with this point. He specifically names the replacement of the genitals by the face as a dynamic "in the symbolism of unconscious thinking," "The Dream Work", *The Interpretation of Dreams*, trans. James Strachey, New York, Avon, 1966, p. 422. I do not claim to know the artist's mind and might guess that she was thinking of a Freudian "reading" of her subjects, giving her viewers the benefit of the doubt, or that they knew their Freud. But beyond this exhibit, we might wonder, on the other hand, if the entire culture is involved in an intricate calculus of sexual repressions that both

identifies the black person with "wild" sex and at the same time suppresses the name in reference to her and him.

10 Edward Said, *Orientalism*, New York, Vintage, 1979, p. 28. Said adopts the term from Raymond Williams in *Culture and Society, 1780–1950*, London, Chatto & Windus, 1958, p. 376.

11 Alice Walker in Lederer, *Take Back the Night*, op. cit., p. 100.

Deborah Cameron

NAMING OF PARTS
Gender, culture, and terms for the penis
among American college students (1995)

Feminist commentators on language have noted in many contexts that the world has been "named" from a male and male-dominant perspective and that lexicogrammatical features in languages often reveal important underlying cultural (male) assumptions. Some feminists, following the theories of Benjamin Lee Whorf, believe these features are not simply reflections of a prior social reality but mechanisms whereby that reality is continually naturalized and reproduced (Spender 1980; Elgin 1985).

In a well-known application of this general thesis, Schulz (1975) and Stanley (1977) have examined from a historical perspective the elaboration of the English lexicon in the area of terms denoting women as prostitutes. They argue that the existence of a very large number of items in this lexicon indicates the cultural salience of the equation "woman = prostitute," while the insulting or dysphemistic character of many items bears witness to (and reinforces) the culture's negative attitudes to women and to sex.

At the College of William and Mary in the spring of 1990, I conducted a seminar on the topic of language and gender in which this feminist approach to the lexicon was discussed at some length. As we pursued the argument, a male student commented that he and his roommates had once sat down and generated 110 synonyms for the "male member." This was not a class assignment, but an informal leisure activity. A woman student responded that she had engaged in a similar activity with her friends, though their score was "only" about 75 terms.

My interest was piqued by this exchange. I wondered why college students apparently consider the activity of listing penis terms interesting and enjoyable. I also wondered what an analysis of the terms themselves might tell us about American English and – in the light of feminist claims such as those of Stanley

and Schulz – American culture. I suggested to the students concerned that they repeat the exercise, this time recording the results for further analysis. [...]

Methodology. The data to be analyzed were collected through participant observation. Two students, one male and one female, participated in a replication of the original spontaneous exercise with their immediate peer groups (in the men's case, the same people who had earlier participated for fun; in the women's case, because more time had elapsed since the initial activity, a minimally overlapping set). The two groups involved differed in terms of gender but were otherwise relatively homogeneous; they were unmarried college students aged 18–21, who were middle class, almost all white (in the case of the males, all white), and predominantly heterosexual. These already-existing friendship groups, it is important to point out, were single-sex: the investigators believed that the activity they wished to observe, listing synonyms for *penis*, would not naturally take place except in single-sex groups of intimate friends. Thus, to work with randomly selected or grouped informants, or to carry out interviews one-on-one, would have been unnatural and probably self-defeating. (It should, however, be noted that in this instance the activity was not totally natural and spontaneous: the informants were told that the investigator was recording for research purposes.)

Strict controls were not placed upon the data-collecting process. The investigators introduced and structured the exercise in whatever way they found most appropriate, both for putting the informants at ease and for maximizing the number of items produced. In practice, for reasons both good and interesting, this meant that the female and male investigator structured things differently.

The female investigator encouraged general discussion of sexual practices and attitudes as well as the production of lexical items; this seems to reflect general norms of all-female talk (Coates 1986), such as establishing trust and intimacy, approaching topics from a personal/relational perspective, and so on. The male investigator by contrast (and similarly, reflecting putative norms of all-male talk, such as a more distanced and impersonal approach to topics) encouraged competition within the group to produce more and better terms. It also seems that the men were more interested in the naming game *qua* game.

This gender difference in subcultural style must also have affected the data, explaining at least in part, for example, why the males produced almost three times as many items overall as the females did. Another obvious consequence was to favor the competitive production by males of many unusual, idiosyncratic, and perhaps even newly coined words. (Whether the terms are attested in the standard dictionaries of slang does not show conclusively what their provenance is, given the domain and the campus subculture in question; nor is attestation a concern of the present analysis.)

In summary, then, this was not a representative sampling of American English speakers, nor in all probability a representative sampling of vocabulary items in common usage among the narrow social group from which the sample was drawn. Let me observe, then, that the study was not designed as an exhaustive survey of terms for the penis in current American English, but rather aimed to address the following questions:

1 Are the penis terms produced by these college students indicative, as one
 might expect from a feminist perspective, of underlying conceptual and cul-
 tural assumptions concerning gender and sexuality?
2 Do the terms and their underlying assumptions differ according to the gen-
 der of the producers?

As far as the primary aim is concerned, it does not matter whether some of
the terms are coinages rather than attested usages. What is of interest, rather, is
whether novel coinages manifest the same underlying logic as attested items,
always assuming such a logic can be discovered; whether, in other words, there
are constraints on the creation of new terms. If so, this constitutes strong sup-
porting evidence for the existence (among speakers, rather than simply as a *post
hoc* analytic construct) of an underlying cultural and conceptual system governing
the structure of this lexicon.

When data collection was completed, the listings obtained were analyzed by
grouping them in semantic categories. Preliminary categorization was done by the
student investigators and reflected their intuitions as participants as well as dis-
cussions they had had with other participants during data collection. This pre-
liminary analysis established basic category sets which were later refined. Where
a problem arose at a later stage of how to assign or interpret a specific term, the
student investigators were consulted once again. (For example, is *meat spear* a
weaponry term or a food term? I relied on participant intuitions to clarify that
it is a weaponry term – though with links to the "food" category.)[1]

The male group

This group consisted of four roommates (including the student investigator), aged
20 and 21, whose relationship went back a number of years. All were white, mid-
dle class, and professedly heterosexual. They completed the exercise in the living
room of their house, and in 30 minutes generated 144 terms. The investigator felt
that this was an arbitrary cut-off point: many more terms could have been pro-
duced, but they would have been variations on already-established themes.

The themes themselves were not difficult to pick out. A small number of
categories account for the overwhelming majority of the 144 items. For these
men, the penis is recurrently metaphorized as a person, an animal, a tool, a
weapon, or a foodstuff. Let us examine these metaphors in more detail now.

Personifying the penis

In England, there is a popular cartoon character named "Wicked Willie" (*willie*
"penis" is common in British English), who is, in fact, a penis. He first appeared
in a book titled *Man's Best Friend*. The underlying conceit is that men secretly
regard their penis as an individual in its own right (and one to whom they are
deeply attached). Though the cartoon is a joke, it presumably speaks to a widely
recognized, culturally constructed experience of the penis as uncontrollable
Other, with a life of its own.

This perception has its serious, not to say problematic, aspects in myths about male sexuality and rape (to which men sometimes claim they are driven by irresistable physical urges). It is also expressed metaphorically in the 38 items on the male group's list which give the penis some kind of personal name.

There are three main subcategories of personal names. The first and most numerous are respect titles and address forms for authority figures. They include *Kimosabe* (Tonto's address term for the Lone Ranger), *his Excellency, your Majesty, the chief, the commissioner, the mayor*, and *the judge*. Also in this category are a number of items which denote symbols of personal authority, such as *scepter, rod of lordship, Excalibur*, and *hammer of the gods*. They are included here because they stand metonymically for (divine or royal) persons. Though *Excalibur* and *hammer of the gods* might have been classified as a weapon and a tool respectively, and these are not coincidental associations, the primary significance of these terms lies in their association with authority figures.

That association itself has two possible interpretations, both of which may be valid at the same time. One is that, as with the cartoon mentioned above, men are ruled by their genitals. The other, more Freudian, is that the penis in some metonymic sense is the man – it is his "rod of lordship" through whose symbolic power he himself rules.

A second and related subcategory is that of names which refer to the protagonists of myth, legend. TV, and comic books: *Genghis Khan, Cyclops* (the penis is recurrently named as "one-eyed"), *The Hulk, Cylon, The Lone Ranger, The Purple Avenger* (again, *purple* may be added to many items: the comic book character is simply called "The Avenger"), *Mac the Knife*, and *Kojak* (suggested presumably by that character's bald head). To be appropriate in this category, the name must refer to someone heroic or masterful or warlike – *Tonto* and *Gandhi* would not be good names for the penis. Many of these terms are typical in being appropriate in a number of different ways. For example, *Cyclops* connotes gigantic size as well as one-eyedness and mythic status: *Mac the Knife* contains a weaponry term.

The third subcategory is different, since the names in it connote intimacy rather than authority: *Dick, Peter, Percy, John Thomas, Johnson*, and the jocular appellation *Mr. Happy*.

The beast in man: animal names

There were 15 animal names in the list. Five, echoing the second subcategory of personal names, denoted mythical or fictional animals: *King Kong, Simba, King of the Jungle, The Dragon*, and *Cujo* (a rabid dog in a Stephen King thriller). Five, predictably, named snakes: *snake, one-eyed trouser snake, python, cobra*, and *anaconda*; a related term was *eel*. Four named other animals: *hog, weasel, hairy hound of hedonism*, and – in a different vein – *beast of burden*.

Man, the tool user

The semantic category of tools, implements, and machinery accounted for no fewer than 19 terms. Some were apt simply because of shape (*pole, pipe, garden*

hose); others invoked the motion of the penis in erection (*hydraulics, crank, gearshift*). The largest number, however, made metaphoric reference to the active role of the penis in sexual intercourse: *screwdriver, drill, jackhammer, chisel, lawn-mower, hedgetrimmer*, and *fuzzbuster*. It is prototypically the female body and genitals that are screwed, drilled, hammered, trimmed, and busted in these somewhat sadistic metaphors, a fact which may indicate a thematic link with the fourth major category, weaponry and war.

Sex as a weapon

The association of the penis with weapons of destruction has been much analyzed and deplored in feminist writing. (For a good illustration in the domain of "nuke-speak," the language of nuclear defense technology, see Cohn 1989.) It is certainly apparent in 15 items on the male group's list.

Most weaponry terms for the penis ring the changes on three types of weapon: guns (*spoo gun, squirt gun, love pistol, passion rifle*), spears or knives (*meat spear, lightsabre*), and missiles (*pink torpedo, heat-seeking moisture missile*). There are other terms which do not directly name weapons but which clearly evoke warfare and destruction, such as *stealth bomber, destroyer*, and a series of terms involving the word *helmet* (*polished helmet, shiny helmet, purple helmeted love warrior*). The helmet presumably is a fanciful allusion to the shape and position of the glans, but its military connotations are clear (especially in the last item).

One notable feature of this whole category is the persistent collocation of "love" and "war" terms (*passion rifle, love warrior*), which presumably indicates the metaphorical linking of sex and violence much discussed by feminists in relation to cultural norms of masculinity.

Consuming passions: the penis as food

There are 15 food terms in the male group's list, and according to the student investigator, the male informants find this category the most "demeaning and disgusting." The list can be subcategorized into three classes of foods.

The first, represented by *love popsicle* and *lucky charm blow pop*, has licking and sucking (thus, fellatio) as its theme. Most of the fifteen fall into a second class of terms denoting meat (especially sausage or pork): *wiener, wienie, wienerschnitzel* (I take this as an elaboration on *wiener* rather than a reference to breaded veal cutlets), *vienna sausage, Oscar Meyer, piece of pork, tube steak*, and *Whopper*. Many of the sausage terms are insulting because they connote small size. The anomalous item, in a class by itself and also unequivocally an insult, is *noodle* (thin, pale, and flaccid).

Women and other taboo sexualities

Surprisingly few terms in the list make direct reference to women and their (real or mythical) experience of the penis. They are invoked implicitly in the "tool" terms, as we have seen; and there is also a small group of "sport and leisure" terms implicitly naming women's vaginas as "holes" and "caves" (*cavedweller, slimy*

spelunker, 5-iron, ace in the hole). Somewhat less offensive are three terms referring to female pleasure: *pussy pleaser, leaning tower of please-her,* and *wife's best friend.*

Except for the food category, there are also few terms making reference to explicit sexual preferences and practices other than heterosexual vaginal intercourse. Apart from the two fellatio-related terms above, there are two references to anal sex, *rectum wrecker* and *anal intruder:* and one to masturbation, *wanker.*

Phonaesthesia

It will already be clear that whatever the metaphorical significance of the items listed by the male group, they also manifest a certain aesthetic pleasure in creative play with language (cf. *hairy hound of hedonism* and *heat-seeking moisture missile*). There is one category where this pleasure is foregrounded, since the terms in it are not metaphors but rather phonaesthetic items meaning little other than just "penis" to their users. They include such perennials as *dick, prick, cock, dork, dong, wang,* and Yiddish loans *schmuck* and *schlong.*

Miscellaneous items

Only about 20 of the 144 male terms are left unclassified by the preceding seven categories. At least two discernable themes emerge in this miscellaneous remnant: body parts (*third leg, main vein, bone*) and references to size or shape (*tube o'thrills, sweaty cigar, love horn, thunder log, thunder stick, shaft, stump, ten-incher, monolith*). Only one term, *special purpose,* seems incapable of being grouped in any way at all.

Discussion

The metaphors the male group apparently use to organize their lexicon of terms referring to the penis recapitulate well-worn themes and conventions having to do with cultural prescriptions for masculinity (both sexuality and, even more saliently, gender-identity). The penis inspires awe (*your Majesty*) but also fondness (*John Thomas*). It is for fun (*hairy hound of hedonism*) but also a ravening beast (*Cujo*). It dominates and destroys (*rod of lordship, Genghis Khan, stealth bomber, jack-hammer*) but is sometimes ridiculous (*squirt-gun*) and provokes anxiety about size and performance (*noodle, wienie, beast of burden*).

When young men sit down together and compete to produce these lexical items, what exactly are they doing? Feminist scholars like Schulz and Stanley would doubtless say that they are reproducing and revalidating pernicious assumptions that exist in heterosexist, male-dominated culture. The phallus must act, dominate, avenge itself on the female body. It is a symbol of authority to which we all must bow down. Its animal desires are uncontrollable; it has a life of its own. Above all, it matters enough to be named in 144 different ways (almost all of them positively evaluated by the namers) – enough that naming it is a game college students choose to play.

I have no quarrel with this feminist argument so far as it goes. Indeed, I would endorse it, for the reproduction of certain social meanings, which are

indeed pernicious, is the primary accomplishment of the male students' activity. But I would also wish to draw attention to the other things that are accomplished in this naming of parts.

First, it is clear that the young men are playing creatively with language. Their game, which manifests an aesthetic as well as a social/sexual impulse, gives a social function to linguistic creativity. A different group of men (or the same men under other circumstances) might bring these impulses together in a similar way using a different expressive form – writing poetry or rock lyrics, for instance. This game gives a social sanction to linguistic creativity among young men who define the alternatives as threatening to their masculinity.

Second, though I do not want to argue for the subversiveness of the game the men are playing, I do think they are not simply reproducing myths and stereotypes. They are also recognizing them as myths and stereotypes; and to a significant extent, they are laughing at them. The humor in their terminology is self-evident, and as the game goes on, the metaphors grow more absurdly exaggerated, threatening to deflate the self-importance of the male member by turning it into a complete joke.

Finally, however, this is no more than a threat. Like all jokes, this one masks serious anxieties – in this case about masculinity and sexuality. Even if the men are problematizing the symbolic value of the penis and poking fun at it, they must in the end reaffirm the values they have dared to joke about. When a man suggests so baroque a term as, say, *purple helmeted love warrior* for his penis, he partly distances himself from the metaphors of penis-as-hero and sex-as-war; but partly, too, he recirculates those metaphors.

The female group

This group consisted of eight students who lived in the same dorm and were friends of the investigator. All but one were white, all were middle class, and the investigator reported that all were heterosexual, though it is not clear that every woman in the group volunteered information on her sexual orientation. (All of the men, by contrast, had insisted explicitly and repeatedly on their heterosexuality). The women were asked first "What do you think of the male genitals?" Once discussion had got underway and a tone of intimacy and female solidarity had been established, the investigator followed up with "Can you think of names and phrases you use or have heard used to describe it [the penis]?"

Although this form of questioning left open the possibility that women would produce terms they knew passively but did not use themselves (a possibility also in the male group, since the investigator imposed no restriction on production of lexical items), it seems from the list that the women – perhaps influenced by the prior discussion – did focus primarily on terms they associated with women's perceptions of the penis. Fifty terms in all were elicited. (This is a reduction of the original number, "around 75," whereas the men "improved" their score from 110 to 144. As I observed above, the women were less interested in the game and found its format less congenial, nor did they compete as keenly. One might expect, too, that the penis itself would be of greater interest and concern to men).

There is some overlap between the women's list and the men's, but there is also a striking difference. The women's utilizes fewer and less clearly defined categories. This is not simply a function of their having produced far fewer items overall. The categories that do not appear or are poorly represented in their list are not random omissions. Rather, they are exactly those categories a feminist critical of male sexual aggression would indict most severely: authority symbols, ravening beasts, tools, and weapons. One might generalize by saying that women find the penis endearing, ridiculous, and occasionally disgusting, but not awe-inspiring or dangerous.

Names

The nine personal names in the female group's list are all in the "intimacy" sub-category except for one: *Eisenhower*. The others include *John Thomas, Ralph, Fred, Peter-dinkie*, and *Buddy*. There are no chiefs, excellencies, hulks, or rods of lordship.

Animals

There are no animal names comparable to those in the male group's list, and only two references to animals: *animal length* and *visions of horses*.

Tools

The only term in this category is the prosaic *tool*.

Weaponry and war

The women produced three terms in this category: *Atlas rocket, mission-seeker*, and – a very slight variation on the male group's term – *purple-helmeted warrior of love*. All three of these were regarded by women informants as humorous.

Food

Wiener and *(rigid) tube steak* appear in the list, as they do in the male group's list. The only other food-term is *biscuit*, referring to hard dog-biscuits rather than soft Southern biscuits.

Romancing the bone

The women generated four terms that had no equivalent in the male group's list, all taken from the stock euphemisms of romance fiction, a genre with which men are less familiar (or less willing to admit familiarity). They all fit into the frame "She felt his ——— against her." They are *throbbing manhood, swelling passion, swelling hardness*, and *growing desire*. A related euphemistic term was *family jewels*.

Long, thin, hard, and/or useless things

While this is not a well-defined category, women listed eight items denoting the penis in terms of its size, shape, and hardness (there were several similar terms in the male list's "miscellaneous" category). For example, *pencil, icicle, boner, poker, pulsating pole, blood-engorged pole*, and – nonmetaphorically – *long muscular expansion* and *full-length*. The reference to blood in *blood-engorged pole* is *not* a totally isolated example, but is repeated in the list's most overtly contemptuous item, *vaginal blood fart*. This seems to betray a certain disgust with the clinical details of the genitals of both sexes. The *fart* element of it also links thematically to two other terms whose main informing metaphor is superfluity or uselessness: *third leg* (which also appears in the male group's list) and *fifth appendage*.

Nonsense terms

The largest single category of terms for the women is nonsense terms, like the phonaesthetic terms in the male group's list (except that it is less clear in the women's case that the point lies in the sound rather than the sense). Some of the terms are the same as the men's: *dork, schmuck*, and *wanger*. *Dick* and *prick* are, however, more elaborated (*dickhead, dickwad, prickola*). In addition there are two terms which have other uses apart from denoting the penis: *doodads* (which recalls the "uselessness" motif of *third leg*) and *dingaling*. More usually used to mean "an eccentric or crazy person," this item was deployed as a suggestive euphemism for "penis" in the Chuck Berry hit song "My Ding-a-Ling."

Finally, there is the rather appealing word *tallywacker*. While informants treated this as a humorous nonsense word, it may in fact have a semantic/metaphorical aptness in addition: the *OED* defines *tally* as "a stick ... marked with notches to represent the amount of a debt or payment." The notched stick or gun or bedpost representing a man's sexual conquests (the stick and gun also clearly represent his penis) is a well-known image in the culture.

When the investigator asked them to say which terms were insulting, the women picked mainly words from this category (they also picked *wiener* and *tool*). This might seem curious when they could have picked *vaginal blood fart*, for instance, but it seems women conceptualized "insulting" differently from men. For men, an insult was to the penis itself – insult terms connoted softness, small-ness, poor performance. For the women, an insult was a term for the penis used to refer to the whole man. Thus they thought it insulting to call a man a *dork* but merely odd to call him a *pencil*.

Women do not, then, perceive the penis as a separate and insultable entity to the same degree as men do. However, they both recognize and use the value men place upon their genitals. As one informant said, "I'm not really referring to his dick but to him. ... It's just an easy way to make a guy feel bad ... because that's what defines his existence, or else at least guys feel that way."

Discussion

The interesting thing about the female list is the women informants' near total rejection of the male conceptual schema. The names have no mythic or heroic

status; the comparisons with objects (*pole, pencil*) lack the implication of active aggression found in *screwdriver* and *jackhammer*; even the weaponry terms are innocent of the "search and destroy" motif in *stealth bomber* or *heat-seeking moisture missile*. There are no ravening beasts and no references to masturbation, anal intercourse, or fellatio.[2]

The result of this female resistance to certain metaphorical categories found in the men's lexicon is a list which is less elaborate, less creative aesthetically, and less highly structured in terms of a few productive metaphors. The women, unlike the men, do not have clear formulae for producing more and more terms. Of course, it is likely that they are familiar with many of the terms collected in the male group; this study did not investigate how each group responded to the other's list, though it would have been interesting to do so. But in terms of lexical production there are suggestive gender differences; and one thing they might suggest is a mismatch in the most important concepts young men and women students use to organize their thinking as well as their talk about the penis.

Dangerous metaphors: what categories reveal about the culture

This analysis began with the claims of feminist language scholars like Muriel Schulz and Julia Penelope Stanley, who have drawn to some extent on Whorfian views about the relation of language to thought and culture.[3] That there are so many terms available to represent the penis, and that they are organized around metaphors such as penis-as-hero, animal, tool, weapon, and so on, is interpretable from this perspective not merely as a reflection of male-dominated cultural norms and values but as one important way in which those values are defined for speakers of American English.

Whorfians argue, then, that all experience, even when it seems natural and fundamental, is organized though its representation in languages. In the case we are concerned with here, the lexicon of penis terms, a Whorfian would say that the male genitals are understood and experienced in terms of the conventionalized metaphors available to represent them.

There is, however, an alternative possibility and a competing account, in which the metaphors express linguistically (and in logical, patterned ways) a prior, bodily experience of the penis. This is the argument advanced – though not specifically in relation to penis terms – by Lakoff and Johnson (1980), which deserves consideration here.

Lakoff and Johnson point out that metaphor does not live only in the elevated domains of literary discourse but in everyday language generally, right down to the most banal cliché. In their opinion, this suggests that the human mind has a propensity to organize some experiences in terms of others, and more specifically that abstract and complex experiences are frequently expressed in terms of basic physiological processes.

A conventional statement like *my anger rose until I was boiling with rage* depends on a number of metaphorical comparisons. The body is a container; emotions are

substances; anger is hot (it boils, simmers, seethes, burns, flares); hot substances expand – if they are liquids, rise – within a container. The comparisons follow a systematic logic and are not coincidental. For example, anger is usually conceptualized as a hot substance because one of the reflexes of anger is a rise in bodily temperature.

One can imagine a treatment of some penis metaphors in these terms. For example, it is a physiological fact about the penis that its erections are not always within a man's conscious control. It seems to have a "will of its own." Does this have some bearing on the "penis-as-a-separate-person" category of terms? Or the wild animal terms, given that humans often label as "animal" bodily impulses not subject to control by the mind? Other physiological facts that might underline important categories of items referring to the penis include its active (moving, penetrating, thrusting) role in sexual intercourse (the "tool" metaphor) and the fact that it discharges liquid at the climactic moment of sex (the "weapons" which discharge, guns; or explode, rockets, missiles).

But this will not do entirely. The physiological basis suggested for the personal name metaphor does not fully explain why, among men, such names are often those of mythical and/or authority figures. The proposed basis for the weapon metaphor may explain guns and missiles, but not spears and, even less, helmeted warriors.

It is interesting, too, that only some physiological facts appear to be culturally validated. For example, it is also a fact that the penis is extremely vulnerable to injury and pain, requiring special protection when men play sports or fight. Yet there are no terms in either list making reference to this particular bodily experience. We talk conventionally about the lordly, striving, uncontrollable penis, but not the vulnerable penis.

Furthermore, it is evident that ways of conceptualizing the penis are not universal, as one might expect them to be if they were grounded in the physiology of the organ. The question of size, for example – in our culture and in this study bigger means better – is dealt with differently by other societies. Thus among the !Kung of Botswana, the expression that is glossed in English as "big genitals" is unequivocally an insult, which can be used by and against either sex. If there were a !Kung equivalent of wienie it would be a compliment, since small-to-moderate penis size is valued (Shostak 1983). Our metaphors are more cultural than natural; they also reflect the realities of power.

I have mentioned the work of Lakoff and Johnson not merely to find fault with it, however, but to point out its very considerable value if divested of its universalist, physiologically grounded claims and made more sensitive to issues of power, especially the power vested in some social groups to define reality for the society as a whole.

In his more recent work, Lakoff (1987) has taken a step in the right direction. He notes, for instance, a (cultural rather than natural) metaphorical link in the English language between lust and anger: both of them are understood in terms of the metaphorical categories "heat," "hunger," "wild animals," "war" (409–15). Lakoff suggests that this influences our perceptions of rape, making it acceptable or justifiable in some instances. He finds it "sad that we appear to have no metaphors for a healthy mutual lust" (415).[4]

Although Lakoff correctly observes that both men and women may share these perceptions, he does not observe that the perceptions and their linguistic manifestations emanate from a profoundly unequal culture in which the power to define reality has historically resided mostly with men. Whatever metaphorical categories may reveal about the mind, feminists are right to insist that they reveal at least as much about the culture and the social relations within which human minds are formed.

All the metaphorical correlates of lust and anger mentioned by Lakoff are also present in the lexicon of penis terms (especially and significantly the male group's lexicon). However elegant this lexicon may be as an expression of students' linguistic creativity, I too find it sad that when young people attempt to define the reality of the penis as a symbol of gender and sexual identity, the metaphorical categories available to them are so limited, predictable, and stereotypical. The women may reject certain metaphors which the men endorse, but their list offers no real alternatives. The vision the men's list offers is banal and yet terrible, an experience of masculinity as dominance, femininity as passivity, and sex as conquest.

[...]

Notes

1 Both my classifications and many of the comments I make on specific terms (e.g., whether they are felt by the group to be negative or positive, ironic or serious, and what associations they evoke and what relationships exist among them) rest not only on the words lists themselves but also on supplementary information provided *en passant* by informants or deliberately elicited from them. The activity of producing terms was accomplished by a great deal of discussion in both groups, as participants responded to each other by expressing approval, disgust, incomprehension, etc., and both investigators intervened where necessary to extend and clarify these comments.

2 It could be argued that the food terms used by the women – *weiner, rigid tube steak*, and *biscuit* – are references to fellatio. However, the informants themselves (both male and female) rejected fellatio as the primary association for terms referring to meat products. The men made a distinction between items like *weiner, tube steak* (not primary fellatio references) and items like *love popsicle* (definitely fellatio references). Why this should be is unclear.

3 Schulz also makes use of the rather biologistic argument that men suffer from "womb envy," envy of women's unique creative power, their strength, and their longevity. Men's need to put women down (also perhaps their linguistic creativity in doing it) stems from perceived inferiority and substitutes for women's "real" (biological) power. I have always found this argument puzzling – men after all are social superordinates – and while the terms examined here do suggest some male anxiety, they do not really support the idea that men seriously regard themselves as inferior beings.

4 In fact, it has been a standard argument since the eighteenth century, at least, that lust and anger are linked in a natural, physiological way; the mechanisms of bodily arousal are similar if not identical in both cases. Sade, for instance,

believed this, and so did the early sexologists, notably Krafft-Ebing. However, Lakoff for some reason fails to take up this argument.

References

Coates, Jennifer (1986) *Women, Men and Language*, London: Longman.

Cohn, Carol (1989) "Sex and Death in the Rational World of Defense Intellectuals," *Feminist Theory in Practice and Process*, ed. Micheline R. Malson, Jean F. O'Barr, Sarah Westphal-Wihl, and Mary Wyer, Chicago: U. of Chicago P.

Elgin, Suzette Haden (1985) *Native Tongue*, London: Women's Press.

Lakoff, George (1987) *Women, Fire, and Dangerous Things: What Categories Reveal About The Mind*, Chicago: U. of Chicago P.

Lakoff, George and Johnson Mark (1980), *Metaphors We Live By*, Chicago: U. of Chicago P.

Schulz, Muriel (1975) "The Semantic Derogation of Woman," *Language and Sex: Difference and Dominance*, ed. Barrie Thorne and Nancy Henley, Rowley, MA: Newbury.

Shostak, Marjorie (1983) *Nisa: The Life and Words of a !Kung Woman*, New York: Vintage.

Spender, Dale (1980) *Man Made Language*, London: Routledge.

Stanley, Julia Penelope (1977) "Paradigmatic Woman: The Prostitute," *Papers in Language Variation: SAMLA-ADS Collection*, ed. David L. Shores and Carol P. Hines. U. of Alabama, pp. 303–21.

PART TWO

Unity and diversity in language

ORDER AND DIFFERENCE

Language is power, life and the instrument of culture, the instrument of
domination and liberation.
(Angela Carter, 'Notes from the Front Line', in Michelene Wandor (ed.),
On Gender and Writing, 1983: 77)

THIS PART OF THE *Reader* considers a range of texts which address the
relationships between unifying norms, standards and forms of order in lan-
guage, and linguistic forms of difference and variation. It will be important to note
how these relationships alter and adapt in distinct contexts; how they can best be
understood at times from a theoretical perspective, and on other occasions from a
more historically grounded standpoint. Again, as in the extracts in Part One, the
question of the relationship between 'structure and agency' remains an important
concern, particularly in considering the political implications of order and differ-
ence in language. Are forms of order – or unity – in language synonymous with
forms of social oppression, or is order necessary if meaning is to be produced at
all? These are the kinds of questions which are raised in the following sections.

The opening section concentrates on the question of order and difference from
three distinctive theoretical starting points. Mukařovský belonged to the Linguistic
Circle of Prague which was founded in 1926; the model of language used by its
members was based on Saussurean principles. Not least of the striking things about
that fact is that we see how rapidly Saussure's ideas spread across Europe (the
Course in Linguistics was only published in 1916); it can only be a matter of con-
jecture to wonder what might have happened if the work which was being under-
taken in Eastern Europe (for example that of the Prague Circle – of Jakobson say,
or the Vitebsk School, to which Voloshinov and Bakhtin contributed) had migrated
to the West earlier. Mukařovský's interest was in the relationship between linguis-
tic norms and standards in language and the deviations from these norms which
occur in poetic or literary language. His structural analysis, which reveals his debt
to Saussure, evaluates and orders forms of creative language with regard to their
proximity to the standard (linguistic structure or 'langue' in Saussure's terms) thus
indicating the inseparability of the unifying and diversifying functions of language.
What is noteworthy about this model is its relation to the forms of poetic and

literary innovation which it seeks to explicate, as it privileges the linguistic play which characterises modernist experimentation. The notion of experimental poetic language as a politically radical form appears again later in the section on language and creativity; the standard language will be looked at in the section on language, class and education.

Foucault's essay 'The Discourse on Language' is a translation of a lecture entitled 'L'Ordre du Discours', which might more helpfully and faithfully have been rendered as 'The Order of Discourse'. In it he focuses on the ways in which discourses, structured systems of language around particular areas of knowledge – examples might include sexuality, truth, or madness – are organised in specific ways: to delimit, permit, enable, prevent and so on. That is to say, discourses, which are ordered according to their own internal and external rules, determine who may speak, and who may not, whose voice is to count, and whose is to be held to be worthless, what they can speak about, and what they must not, and how they may speak about a particular subject. Foucault argues that these rules do not simply order discourse in practice, but rather they are also the preconditions of its appearance. There are clear parallels here with the work of Saussure (though Foucault denied vehemently the charge that his work was structuralist) and also the Sapir–Whorf hypothesis (see 'Language and Subjectivity').

In the text given here, the examples of discourses which Foucault gives concern truth and falsehood, reason and madness. It may help to understand the concept of discourse if we think of a couple of examples. Why, for instance, is it that we are not supposed to 'speak ill' of the dead? Or how do we know not to approach a stranger to ask if they know anybody who has died recently? It is not *natural* either to do or not to do these things. For Foucault the answer is that these are the results of a particular discursive order – here that which surrounds death. Another way of making sense of this is to consider the different prohibitions and practices different cultures may have around death and mourning. For instance, the fact that in some cultures white is a signifier of mourning may seem 'unnatural' or counter-intuitive to those who wear black at funerals. Again, the point is not that one colour is more suitable than the other but that different discursive orders constitute a sense of the 'natural', the 'intuitive' or the normative in distinct ways. Breaking the rules of a discourse can be funny, and one form of comedy relies precisely upon doing so. But there is a darker side too: as we saw in the claim by Spillers in the last section of Part One, there is a discourse around 'woman' which operates to exclude and thus to perpetuate oppression. Indeed for Foucault the productions of discourse are inextricably bound up with relations of power; not, however, power which can be ascribed to individual subjects, but power understood as an effect of discourse. This brings us back to the question of agency which we saw in Part One. It is worth considering the implications of Foucault's argument in this regard. To what degree does his model of discourse allow for resistance and contestation?

Derrida's essay treats the process of signification through a critique of Saussure's model of sign and structure; in particular the claim that in language there are no positive terms, only differences. This leads him to problematise the key Saussurean concepts of sign and structure on the grounds of their unconscious

'logocentrism'. 'Logocentrism' is simply a term which refers to any form of thought which is founded upon something stable (a referent) which is beyond language and which acts as a guarantor, or fixed point, of meaning for that form of thought: God for theology, transcendental truth for reason. The point being that there is nothing which can act in that way since there is nothing which can be 'outside' language in that sense. Derrida argues that Saussure's model is anti-logocentric in that meaning is held to be produced by means of linguistic structure, the differential relations between signs, rather than by a 'truthful' reference to the world and its contents. However, Derrida identifies a form of logocentrism in Saussure's privileging of speech over writing in that he assumes that speech directly expresses an independent thought, or meaning, or intention (in the way that writing is said not to because of its 'impersonal' form). Derrida's concept of 'différance' is a term derived from the French 'différer', which means both to defer and to differ; it is used to express the idea that signification can never be fully achieved or arrived at. This is because meaning, to return to Saussure's model, does not exist within the sign itself, but is an effect of the differential relations between signs; it cannot, therefore, ultimately be fixed or stabilised.

Further reading

Mukařovský and the Prague School

Mukařovský, J. (1964) 'The Aesthetics of Language', in *A Prague School Reader on Esthetics, Literary Structure and Style*, ed. and trans. P. L. Garvin, Washington, DC: Georgetown University Press, pp. 31–69.
—— (1982) 'Structuralism in Aesthetics and in Literary Studies', in P. Steiner (ed.) *The Prague School: Selected Writings 1929–1946*, Austin: University of Texas Press, pp. 65–82.
Havránek, B. (1964) 'The Functional Differentiation of the Standard Language', in *A Prague School Reader on Esthetics, Literary Structure and Style*, ed. and trans. P. L. Garvin, Washington, DC: Georgetown University Press, pp. 3–16.
Steiner, P. (1978) 'The Conceptual Basis of Prague Structuralism', in L. Matejka (ed.) *Sound, Sign and Meaning: Quinquagenary of the Prague Linguistic Circle*, Ann Arbor: University of Michigan Press, pp. 351–85.
—— (1982) 'The Roots of Structuralist Aesthetics', in P. Steiner (ed.) *The Prague School: Selected Writings 1929–1946*, Austin: University of Texas Press, pp. 174–219.
Matejka, L. (1978) 'The Prague Linguistic Circle: A Collage', in L. Matejka (ed.) *Sound, Sign and Meaning: Quinquagenary of the Prague Linguistic Circle*, Ann Arbor: University of Michigan Press, pp. ix–xxxiv.
Garvin, P. L. (ed.) (1964) *A Prague School Reader on Esthetics, Literary Structure and Style*, Washington DC: Georgetown University Press.
Vachek, J. (ed.) (1964) *A Prague School Reader in Linguistics*, Bloomington: University of Indiana Press.
Fried, V. (ed.) (1972) *The Prague School of Linguistics and Language Teaching*, London: Oxford University Press.
Timpanaro, S. (1975) 'Structuralism and Its Successors', in *On Materialism*, trans. L. Garner, London: New Left Books, pp. 135–219.

Foucault, discourse and power

Foucault, M. (1977) *Language, Counter-Memory, Practice: Selected Essays and Interviews,* ed. D.F. Bouchard, Oxford: Basil Blackwell.
—— (1978) *The History of Sexuality: An Introduction,* trans. R. Hurley, London: Penguin.
Sarup, M. (1993) *An Introductory Guide to Post-Structuralism and Postmodernism,* 2nd edn., Hemel Hempstead: Harvester Wheatsheaf, chapter 3.
Sheridan, A. (1980) *Michel Foucault: The Will to Truth,* London: Tavistock.
Dreyfus, H. and P. Rabinow (1982) *Michel Foucault: Beyond Structuralism and Hermeneutics,* Brighton: Harvester Press.
Fairclough, N. (1992) *Discourse and Social Change,* Cambridge: Polity, chapter 2.
Mills, S. (1997) *Discourse,* London: Routledge.
Frow, J. (1986) *Marxism and Literary History,* Oxford: Blackwell, chapters 2–3.
McNay, L. (1992) *Foucault and Feminism; Power, Gender and the Self,* Cambridge: Polity.
Fraser, N. (1989) *Unruly Practices: Power, Discourse and Gender in Contemporary Social Theory,* Cambridge: Polity.

Derrida and poststructuralism

Derrida, J. (1976) *Of Grammatology,* trans. G.C. Spivak, Baltimore, MD: Johns Hopkins University Press.
—— (1978) *Writing and Difference,* trans. A. Bass, London: Routledge.
—— (1991) *A Derrida Reader: Between the Blinds,* ed. P. Kamuf, Hemel Hempstead: Harvester Wheatsheaf.
Sarup, M. (1993) *An Introductory Guide to Post-Structuralism and Postmodernism,* 2nd edn., Hemel Hempstead: Harvester Wheatsheaf, chapter 2.
Jefferson, A. (1986) 'Structuralism and Post-Structuralism', in A. Jefferson and D. Robey (eds) *Modern Literary Theory: A Comparative Introduction,* 2nd edn., London: Batsford.
Norris, C. (1982) *Deconstruction: Theory and Practice,* London: Methuen, chapter 2.
—— (1987) *Derrida,* London: Fontana.
Culler, J. (1983) *On Deconstruction: Theory and Criticism after Structuralism,* London: Routledge & Kegan Paul.
Leitch, V. (1983) *Deconstructive Criticism: An Advanced Introduction,* London: Hutchinson.
Ryan, M. (1982) *Marxism and Deconstruction: A Critical Articulation,* Baltimore, MD: Johns Hopkins University Press.
Young, R. (1981) 'Post-Structuralism: An Introduction', in R. Young (ed.) *Untying the Text: A Post-Structuralist Reader,* London: Routledge & Kegan Paul, pp. 1–28.
Dews, P. (1987) *Logics of Disintegration: Post-Structuralist Thought and the Claims of Critical Theory,* London: Verso.

Jan Mukařovský

STANDARD LANGUAGE AND POETIC LANGUAGE (1932)

The problem of the relationship between standard language and poetic language can be considered from two standpoints. The theorist of poetic language poses it somewhat as follows: is the poet bound by the norms of the standard? Or perhaps: how does this norm assert itself in poetry? The theorist of the standard language, on the other hand, wants to know above all to what extent a work of poetry can be used as data for ascertaining the norm of the standard. In other words, the theory of poetic language is primarily interested in the differences between the standard and poetic language, whereas the theory of the standard language is mainly interested in the similarities between them. It is clear that with a good procedure no conflict can arise between the two directions of research; there is only a difference in the point of view and in the illumination of the problem. Our study approaches the problem of the relationship between poetic language and the standard from the vantage point of poetic language. Our procedure will be to subdivide the general problem into a number of special problems.

The first problem, by way of introduction, concerns the following: what is the *relationship* between the extension of *poetic language* and that of the *standard*, between the places of each in the total system of the whole of language? Is poetic language a special brand of the standard, or is it an independent formation? Poetic language cannot be called a brand of the standard, if for no other reason than that poetic language has at its disposal, from the standpoint of lexicon, syntax, etc., all the forms of the given language – often of different developmental phases thereof. There are works in which the lexical material is taken over completely from another form of language than the standard (thus, Villon's or Rictus' slang poetry in French literature). Different forms of the language may exist side by side in a work of poetry (for instance, in the dialogues of a novel dialect or slang, in the narrative passages the standard). Poetic language finally also has some of its own lexicon and phraseology as well as some grammatical forms, the so-called poetisms such as *zor* [gaze], *oř* [steed], *pláti* [be aflame], 3rd p. sg. *mův* [can; cf.

English -th] (a rich selection of examples can be found in the ironic description of "moon language" in [Svatopluk] Čech's [1846–1908, a realist] *Výlet pana Broučka do měsíce* [Mr. Brouček's Trip to the Moon]). Only some schools of poetry, of course, have a positive attitude towards poetisms (among them the Lumír Group including Svatopluk Čech), others reject them.

Poetic language is thus not a brand of the standard. This is not to deny the close connection between the two, which consists in the fact that, for poetry, the standard language is the background against which is reflected the esthetically intentional distortion of the linguistic components of the work, in other words, the intentional violation of the norm of the standard. Let us, for instance, visualize a work in which this distortion is carried out by the interpenetration of dialect speech with the standard; it is clear, then, that it is not the standard which is perceived as a distortion of the dialect, but the dialect as a distortion of the standard, even when the dialect is quantitatively preponderant. The violation of the norm of the standard, its systematic violation, is what makes possible the poetic utilization of language; without this possibility there would be no poetry. The more the norm of the standard is stabilized in a given language, the more varied can be its violation, and therefore the more possibilities for poetry in that language. And on the other hand, the weaker the awareness of this norm, the fewer possibilities of violation, and hence the fewer possibilities for poetry. Thus, in the beginnings of Modern Czech poetry, when the awareness of the norm of the standard was weak, poetic neologisms with the purpose of violating the norm of the standard were little different from neologisms designed to gain general acceptance and become a part of the norm of the standard, so that they could be confused with them.

[. . .]

This relationship between poetic language and the standard, one which we could call negative, also has its positive side which is, however, more important for the theory of the standard language than for poetic language and its theory. Many of the linguistic components of a work of poetry do not deviate from the norm of the standard because they constitute the background against which the distortion of the other components is reflected. The theoretician of the standard language can therefore include works of poetry in his data with the reservation that he will differentiate the distorted components from those that are not distorted. An assumption that all components have to agree with the norm of the standard would, of course, be erroneous.

The second special question which we shall attempt to answer concerns the different *function* of the two forms of language. This is the core of the problem. The function of poetic language consists in the maximum of foregrounding of the utterance. Foregrounding is the opposite of automatization, that is, the deautomatization of an act; the more an act is automatized, the less it is consciously executed; the more it is foregrounded, the more completely conscious does it become. Objectively speaking: automatization schematizes an event; foregrounding means the violation of the scheme. The standard language in its purest form, as the language of science with formulation as its objective, avoids foregrounding (*aktualisace*): thus, a new expression, foregrounded because of its newness, is

immediately automatized in a scientific treatise by an exact definition of its meaning. Foregrounding is, of course, common in the standard language, for instance, in journalistic style, even more in essays. But here it is always subordinate to communication: its purpose is to attract the reader's (listener's) attention more closely to the subject matter expressed by the foregrounded means of expression.

[. . .] In poetic language, foregrounding achieves maximum intensity to the extent of pushing communication into the background as the objective of expression and of being used for its own sake; it is not used in the services of communication, but in order to place in the foreground the act of expression, the act of speech itself. The question is then one of how this maximum of foregrounding is achieved in poetic language. The idea might arise that this is a quantitative effect, a matter of the foregrounding of the largest number of components, perhaps of all of them together. This would be a mistake, although only a theoretical one, since in practice such a complete foregrounding of all the components is impossible.

[. . .]

The devices by which poetic language achieves its maximum of foregrounding must, therefore, be sought elewhere than in the quantity of foregrounding components. They consist in the consistency and systematic character of foregrounding. The consistency manifests itself in the fact that the reshaping of the foregrounded component within a given work occurs in a stable direction; thus, the deautomatization of meanings in a certain work is consistently carried out by lexical selection (the mutual interlarding of contrasting areas of the lexicon), in another equally consistently by the uncommon semantic relationship of words close together in the context. Both procedures result in a foregrounding of meaning, but differently for each. The systematic foregrounding of components in a work of poetry consists in the gradation of the interrelationships of these components, that is, in their mutual subordination and superordination. The component highest in the hierarchy becomes the dominant. All other components, foregrounded or not, as well as their interrelationships, are evaluated from the standpoint of the dominant. The dominant is that component of the work which sets in motion, and gives direction to, the relationships of all other components. The material of a work of poetry is intertwined with the interrelationships of the components even if it is in a completely unforegrounded state. Thus, there is always present, in communicative speech as well, the potential relationship between intonation and meaning, syntax, word order, or the relationship of the word as a meaningful unit to the phonetic structure of the text, to the lexical selection found in the text, to other words as units of meaning in the context of the same sentence. It can be said that each linguistic component is linked directly or indirectly, by means of these multiple interrelationships, in some way to every other component. In communicative speech these relationships are for the most part merely potential, because attention is not called to their presence and to their mutual relationship. It is, however, enough to disturb the equilibrium of this system at some point and the entire network of relationships is slanted in a certain

direction and follows it in its internal organization: tension arises in one portion of this network (by consistent unidirectional foregrounding), while the remaining portions of the network are relaxed (by automatization perceived as an intentionally arranged background). This internal organization of relationships will be different in terms of the point affected, that is, in terms of the dominant. More concretely: sometimes intonation will be governed by meaning (by various procedures), sometimes, on the other hand, the meaning structure will be determined by intonation; sometimes again, the relationship of a word to the lexicon may be foregrounded, then again its relationship to the phonetic structure of the text. Which of the possible relationships will be foregrounded, which will remain automatized, and what will be the direction of foregrounding – whether from component A to component B or vice versa, all this depends on the dominant.

The dominant thus creates the unity of the work of poetry. It is, of course, a unity of its own kind, the nature of which in esthetics is usually designated as "unity in variety," a dynamic unity in which we at the same time perceive harmony and disharmony, convergence and divergence. The convergence is given by the trend towards the dominant, the divergence by the resistance of the unmoving background of unforegrounded components against this trend. Components may appear unforegrounded from the standpoint of the standard language, or from the standpoint of the poetic canon, that is, the set of firm and stable norms into which the structure of a preceding school of poetry has dissolved by automatization, when it is no longer perceived as an indivisible and undissociable whole. In other words, it is possible in some cases for a component which is foregrounded in terms of the norms of the standard, not to be foregrounded in a certain work because it is in accord with the automatized poetic canon. Every work of poetry is perceived against the background of a certain tradition, that is, of some automatized canon with regard to which it constitutes a distortion. The outward manifestation of this automatization is the ease with which creation is possible in terms of this canon, the proliferation of epigones, the liking for obsolescent poetry in circles not close to literature. Proof of the intensity with which a new trend in poetry is perceived as a distortion of the traditional canon is the negative attitude of conservative criticism which considers deliberate deviations from the canon errors against the very essence of poetry.

The background which we perceive behind the work of poetry as consisting of the unforegrounded components resisting foregrounding is thus dual: the norm of the standard language and the traditional esthetic canon. Both backgrounds are always potentially present, though one of them will predominate in the concrete case. In periods of powerful foregrounding of linguistic elements, the background of the norm of the standard predominates, while in periods of moderate foregrounding, that of the traditional canon dominates. If the latter has strongly distorted the norm of the standard, then its moderate distortion may, in turn, constitute a renewal of the norm of the standard, and this precisely because of its moderation. The mutual relationships of the components of the work of poetry, both foregrounded and unforegrounded, constitute its *structure*, a dynamic structure including both convergence and divergence and one that constitutes an

undissociable artistic whole, since each of its components has its value precisely in terms of its relation to the totality.

It is thus obvious that the possibility of distorting the norm of the standard, if we henceforth limit ourselves to this particular background of foregrounding, is indispensable to poetry. Without it, there would be no poetry. To criticize the deviations from the norm of the standard as faults, especially in a period which, like the present, tends towards a powerful foregrounding of linguistic components, means to reject poetry. It could be countered that in some works of poetry, or rather in some genres, only the "content" (subject matter) is foregrounded, so that the above remarks do not concern them. To this it must be noted that in a work of poetry of any genre there is no fixed border, nor, in a certain sense, any essential difference between the language and the subject matter. The subject matter of a work of poetry cannot be judged by its relationship to the extralinguistic reality entering into the work; it is rather a component of the semantic side of the work (we do not want to assert, of course, that its relationship to reality can not become a factor of its structure, as for instance in realism). The proof of this statement could be given rather extensively; let us, however, limit ourselves to the most important point: the question of truthfulness does not apply in regard to the subject matter of a work of poetry, nor does it even make sense. Even if we posed the question and answered it positively or negatively as the case may be, the question has no bearing on the artistic value of the work; it can only serve to determine the extent to which the work has documentary value. If in some work of poetry there is emphasis on the question of truthfulness (as in [Vladislav] Vančura's [1891–1942, a modern author] short story *Dobrá míra* [The Good Measure]), this emphasis only serves the purpose of giving the subject matter a certain semantic coloration. The status of subject matter is entirely different in case of communicative speech. There, a certain relationship of the subject matter to reality is an important value, a necessary prerequisite. Thus, in the case of a newspaper report the question whether a certain event has occurred or not is obviously of basic significance.

The subject matter of a work of poetry is thus its largest semantic unit. In terms of being meaning, it has certain properties which are not directly based on the linguistic sign, but are linked to it insofar as the latter is a general semiological unit (especially its independence of any specific signs, or sets of signs, so that the same subject matter may without basic changes be rendered by different linguistic devices, or even transposed into a different set of signs altogether, as in the transposition of subject matter from one art from to another), but this difference in properties does not affect the semantic character of the subject matter. It thus holds, even for works and genres of poetry in which the subject matter is the dominant, that the latter is not the "equivalent" of a reality to be expressed by the work as effectively (for instance, as truthfully) as possible, but that it is a part of the structure, is governed by its laws, and is evaluated in terms of its relationship to it. If this is the case, then it holds for the novel as well as for the lyrical poem that to deny a work of poetry the right to violate the norm of the standard is equivalent to the negation of poetry. It cannot be said of the novel that here the linguistic elements are the esthetically indifferent expression

of content, not even if they appear to be completely devoid of foregrounding: the structure is the total of all the components, and its dynamics arises precisely from the tension between the foregrounded and unforegrounded components. There are, incidentally, many novels and short stories in which the linguistic components are clearly foregrounded. Changes effected in the interest of correct language would thus, even in the case of prose, often interfere with the very essence of the work.

Michel Foucault

THE DISCOURSE ON LANGUAGE (1970)

[...] Here then is the hypothesis I want to advance, tonight, in order to fix the terrain – or perhaps the very provisional theatre – within which I shall be working. I am supposing that in every society the production of discourse is at once controlled, selected, organised and redistributed according to a certain number of procedures, whose role is to avert its powers and its dangers, to cope with chance events, to evade its ponderous, awesome materiality.

In a society such as our own we all know the rules of *exclusion*. The most obvious and familiar of these concerns what is *prohibited*. We know perfectly well that we are not free to say just anything, that we cannot simply speak of anything, when we like or where we like; not just anyone, finally, may speak of just anything. We have three types of prohibition, covering objects, ritual with its surrounding circumstances, the privileged or exclusive right to speak of a particular subject; these prohibitions interrelate, reinforce and complement each other, forming a complex web, continually subject to modification. I will note simply that the areas where this web is most tightly woven today, where the danger spots are most numerous, are those dealing with politics and sexuality. It is as though discussion, far from being a transparent, neutral element, allowing us to disarm sexuality and to pacify politics, were one of those privileged areas in which they exercised some of their more awesome powers. In appearance, speech may well be of little account, but the prohibitions surrounding it soon reveal its links with desire and power. This should not be very surprising, for psychoanalysis has already shown us that speech is not merely the medium which manifests – or dissembles – desire; it is also the object of desire. Similarly, historians have constantly impressed upon us that speech is no mere verbalisation of conflicts and systems of domination, but that it is the very object of man's conflicts.

But our society possesses yet another principle of exclusion; not another prohibition, but a division and a rejection. I have in mind the opposition: reason and folly. From the depths of the Middle Ages, a man was mad if his speech could not be said to form part of the common discourse of men. His words were

considered nul and void, without truth or significance, worthless as evidence, inadmissible in the authentification of acts or contracts, incapable even of bringing about transubstantiation – the transformation of bread into flesh – at Mass. And yet, in contrast to all others, his words were credited with strange powers, of revealing some hidden truth, of predicting the future, of revealing, in all their naivete, what the wise were unable to perceive. It is curious to note that for centuries, in Europe, the words of a madman were either totally ignored or else were taken as words of truth. They either fell into a void – rejected the moment they were proffered – or else men deciphered in them a naive or cunning reason, rationality more rational than that of a rational man. At all events, whether excluded or secretly invested with reason, the madman's speech did not strictly exist. It was through his words that one recognised the madness of the madman; but they were certainly the medium within which this division became active; they were neither heard nor remembered. No doctor before the end of the eighteenth century had ever thought of listening to the content – how it was said and why – of these words; and yet it was these which signalled the difference between reason and madness. Whatever a madman said, it was taken for mere noise; he was credited with words only in a symbolic sense, in the theatre, in which he stepped forward, unarmed and reconciled, playing his role: that of masked truth.

Of course people are going to say all that is over and done with, or that it is in the process of being finished with, today; that the madman's words are no longer on the other side of this division; that they are no longer nul and void, that, on the contrary, they alert us to the need to look for a sense behind them, for the attempt at, or the ruins of some '*œuvre*'; we have even come to notice these words of madmen in our own speech, in those tiny pauses when we forget what we are talking about. But all this is no proof that the old division is not just as active as before; we have only to think of the systems by which we decipher this speech; we have only to think of the network of institutions established to permit doctors and psychoanalysts to listen to the mad and, at the same time, enabling the mad to come and speak, or, in desperation, to withhold their meagre words; we have only to bear all this in mind to suspect that the old division is just as active as ever, even if it is proceeding along different lines and, via new institutions, producing rather different effects. Even when the role of the doctor consists of lending an ear to this finally liberated speech, this procedure still takes place in the context of a hiatus between listener and speaker. For he is listening to speech invested with desire, crediting itself – for its greater exultation or for its greater anguish – with terrible powers. If we truly require silence to cure monsters, then it must be an attentive silence, and it is in this that the division lingers.

It is perhaps a little risky to speak of the opposition between true and false as a third system of exclusion, along with those I have mentioned already. How could one reasonably compare the constraints of truth with those other divisions, arbitrary in origin if not developing out of historical contingency – not merely modifiable but in a state of continual flux, supported by a system of institutions imposing and manipulating them, acting not without constraint, nor, without an element, at least, of violence?

Certainly, as a proposition, the division between true and false is neither arbitrary, nor modifiable, nor institutional, nor violent. Putting the question in different terms, however – asking what has been, what still is, throughout our discourse, this will to truth which has survived throughout so many centuries of our history; or if we ask what is, in its very general form, the kind of division governing our will to knowledge – then we may well discern something like a system of exclusion (historical, modifiable, institutionally constraining) in the process of development.

It is, undoubtedly, a historically constituted division. For, even with the sixth century Greek poets, true discourse – in the meaningful sense – inspiring respect and terror, to which all were obliged to submit, because it held sway over all and was pronounced by men who spoke as of right, according to ritual, meted out justice and attributed to each his rightful share; it prophesied the future, not merely announcing what was going to occur, but contributing to its actual event, carrying men along with it and thus weaving itself into the fabric of fate. And yet, a century later, the highest truth no longer resided in what discourse *was*, nor in what it *did*: it lay in what was *said*. The day dawned when truth moved over from the ritualised act – potent and just – of enunciation to settle on what was enunciated itself: its meaning, its form, its object and its relation to what it referred to. A division emerged between Hesiod and Plato, separating true discourse from false; it was a new division for, henceforth, true discourse was no longer considered precious and desirable, since it had ceased to be discourse linked to the exercise of power. And so the Sophists were routed.

This historical division has doubtless lent its general form to our will to knowledge. Yet it has never ceased shifting: the great mutations of science may well sometimes be seen to flow from some discovery, but they may equally be viewed as the appearance of new forms of the will to truth. In the nineteenth century there was undoubtedly a will to truth having nothing to do, in terms of the forms examined, of the fields to which it addressed itself, nor the techniques upon which it was based, with the will to knowledge which characterised classical culture. Going back a little in time, to the turn of the sixteenth and seventeenth centuries – and particularly in England – a will to knowledge emerged which, anticipating its present content, sketched out a schema of possible, observable, measurable and classifiable objects; a will to knowledge which imposed upon the knowing subject – in some ways taking precedence over all experience – a certain position, a certain viewpoint, and a certain function (look rather than read, verify rather than comment), a will to knowledge which prescribed (and, more generally speaking, all instruments determined) the technological level at which knowledge could be employed in order to be verifiable and useful (navigation, mining, pharmacopoeia). Everything seems to have occurred as though, from the time of the great Platonic division onwards, the will to truth had its own history, which is not at all that of the constraining truths: the history of a range of subjects to be learned, the history of the functions of the knowing subject, the history of material, technical and instrumental investment in knowledge.

But this will to truth, like the other systems of exclusion, relies on institutional support: it is both reinforced and accompanied by whole strata of practices such as pedagogy – naturally – the book-system, publishing, libraries, such as the

learned societies in the past, and laboratories today. But it is probably even more profoundly accompanied by the manner in which knowledge is employed in a society, the way in which it is exploited, divided and, in some ways, attributed. It is worth recalling at this point, if only symbolically, the old Greek adage, that arithmetic should be taught in democracies, for it teaches relations of equality, but that geometry alone should be reserved for oligarchies, as it demonstrates the proportions within inequality.

Finally, I believe that this will to knowledge, thus reliant upon institutional support and distribution, tends to exercise a sort of pressure, a power of constraint upon other forms of discourse – I am speaking of our own society. I am thinking of the way Western literature has, for centuries, sought to base itself in nature, in the plausible, upon sincerity and science – in short, upon true discourse. I am thinking, too, of the way economic practices, codified into precepts and recipes – as morality, too – have sought, since the eighteenth century, to found themselves, to rationalise and justify their currency, in a theory of wealth and production; I am thinking, again, of the manner in which such prescriptive ensembles as the Penal Code have sought their bases or justifications. For example, the Penal Code started out as a theory of Right; then, from the time of the nineteenth century, people looked for its validation in sociological, psychological, medical and psychiatric knowledge. It is as though the very words of the law had no authority in our society, except insofar as they are derived from true discourse.

[...]

I believe we can isolate another group: internal rules, where discourse exercises its own control; rules concerned with the principles of classification, ordering and distribution. It is as though we were now involved in the mastery of another dimension of discourse: that of events and chance.

In the first place, commentary. I suppose, though I am not altogether sure, there is barely a society without its major narratives, told, retold and varied; formulae, texts, ritualised texts to be spoken in well-defined circumstances; things said once, and conserved because people suspect some hidden secret or wealth lies buried within. In short, I suspect one could find a kind of gradation between different types of discourse within most societies: discourse 'uttered' in the course of the day and in casual meetings, and which disappears with the very act which gave rise to it; and those forms of discourse that lie at the origins of a certain number of new verbal acts, which are reiterated, transformed or discussed; in short, discourse which *is spoken* and remains spoken, indefinitely, beyond its formulation, and which remains to be spoken. We know them in our own cultural system: religious or juridical texts, as well as some curious texts, from the point of view of their status, which we term 'literary'; to a certain extent, scientific texts also.

What is clear is that this gap is neither stable, nor constant, nor absolute. There is no question of there being one category, fixed for all time, reserved for fundamental or creative discourse, and another for those which reiterate, expound and comment. Not a few major texts become blurred and disappear, and commentaries sometimes come to occupy the former position. But while the

details of application may well change, the function remains the same, and the principle of hierarchy remains at work.

[. . .]

For the time being, I would like to limit myself to pointing out that, in what we generally refer to as commentary, the difference between primary text and secondary text plays two interdependent roles. On the one hand, it permits us to create new discourses *ad infinitum*: the top-heaviness of the original text, its permanence, its status as discourse ever capable of being brought up to date, the multiple or hidden meanings with which it is credited, the reticence and wealth it is believed to contain, all this creates an open possibility for discussion. On the other hand, whatever the techniques employed, commentary's only role is to say *finally*, what has silently been articulated *deep down*. It must — and the paradox is ever-changing yet inescapable — say, for the first time, what has already been said, and repeat tirelessly what was, nevertheless, never said. The infinite rippling of commentary is agitated from within by the dream of masked repetition: in the distance there is, perhaps, nothing other than what was there at the point of departure: simple recitation. Commentary averts the chance element of discourse by giving it its due: it gives us the opportunity to say something other than the text itself, but on condition that it is the text itself which is uttered and, in some ways, finalised. The open multiplicity, the fortuitousness, is transferred, by the principle of commentary, from what is liable to be said to the number, the form, the masks and the circumstances of repetition. The novelty lies no longer in what is said, but in its reappearance.

I believe there is another principle of rarefaction, complementary to the first: the author. Not, of course, the author in the sense of the individual who delivered the speech or wrote the text in question, but the author as the unifying principle in a particular group of writings or statements, lying at the origins of their significance, as the seat of their coherence. This principle is not constant at all times. All around us, there are sayings and texts whose meaning or effectiveness has nothing to do with any author to whom they might be attributed: mundane remarks, quickly forgotten; orders and contacts that are signed, but have no recognisable author; technical prescriptions anonymously transmitted. But even in those fields where it is normal to attribute a work to an author — literature, philosophy, science — the principle does not always play the same role; in the order of scientific discourse, it was, during the Middle Ages, indispensable that a scientific text be attributed to an author, for the author was the index of the work's truthfulness. A proposition was held to derive its scientific value from its author. But since the seventeenth century this function has been steadily declining; it barely survives now, save to give a name to a theorem, an effect, an example or a syndrome. In literature, however, and from about the same period, the author's function has become steadily more important. Now, we demand of all those narratives, poems, dramas and comedies which circulated relatively anonymously throughout the Middle Ages, whence they come, and we virtually insist they tell us who wrote them. We ask authors to answer for the unity of the works published in their names; we ask that they reveal, or at least display the hidden sense pervading their work; we ask them to reveal their

personal lives, to account for their experiences and the real story that gave birth to their writings. The author is he who implants, into the troublesome language of fiction, its unities, its coherence, its links with reality.

I know what people are going to say: 'But there you are speaking of the author in the same way as the critic reinvents him after he is dead and buried, when we are left with no more than a tangled mass of scrawlings. Of course, then you have to put a little order into what is left, you have to imagine a structure, a cohesion, the sort of theme you might expect to arise out of an author's consciousness or his life, even if it is a little fictitious. But all that cannot get away from the fact the author existed, erupting into the midst of all the words employed, infusing them with his genus, or his chaos'.

Of course, it would be ridiculous to deny the existence of individuals who write, and invent. But I think that, for some time, at least, the individual who sits down to write a text, at the edge of which lurks a possible *œuvre*, resumes the functions of the author. What he writes and does not write, what he sketches out, even preliminary sketches for the work, and what he drops as simple mundane remarks, all this interplay of differences is prescribed by the author-function. It is from his new position, as an author, that he will fashion – from all he might have said, from all he says daily, at any time – the still shaky profile of his *œuvre*.

Commentary limited the hazards of discourse through the action of an *identity* taking the form of *repetition* and *sameness*. The author principle limits this same chance element through the action of an *identity* whose form is that of *individuality* and the *I*.

But we have to recognise another principle of limitation in what we call, not sciences, but 'disciplines'. Here is yet another relative, mobile principle, one which enables us to construct, but within a narrow framework.

The organisation of disciplines is just as much opposed to the commentary-principle as it is to that of the author. Opposed to that of the author, because disciplines are defined by groups of objects, methods, their corpus of propositions considered to be true, the interplay of rules and definitions, of techniques and tools: all these constitute a sort of anonymous system, freely available to whoever wishes, or whoever is able to make use of them, without there being any question of their meaning or their validity being derived from whoever happened to invent them. But the principles involved in the formation of disciplines are equally opposed to that of commentary. In a discipline, unlike in commentary, what is supposed at the point of departure is not some meaning which must be rediscovered, nor an identity to be reiterated; it is that which is required for the construction of new statements. For a discipline to exist, there must be the possibility of formulating – and of doing so *ad infinitum* – fresh propositions.

But there is more, and there is more, probably, in order that there may be less. A discipline is not the sum total of all the truths that may be uttered concerning something; it is not even the total of all that may be accepted, by virtue of some principle of coherence and systematisation, concerning some given fact or proposition. Medicine does not consist of all that may be truly said about disease; botany cannot be defined by the sum total of the truths one could say about plants. There are two reasons for this, the first being that botany and medicine,

like other disciplines, consist of errors as well as truths, errors that are in no way residuals, or foreign bodies, but having their own positive functions and their own valid history, such that their roles are often indissociable from that of the truths. The other reason is that, for a proposition to belong to botany or pathology, it must fulfil certain conditions, in a stricter and more complex sense than that of pure and simple truth: at any rate, other conditions. The proposition must refer to a specific range of objects; from the end of the seventeenth century, for example, a proposition, to be 'botanical', had to be concerned with the visible structure of plants, with its system of close and not so close resemblances, or with the behavior of its fluids; (but it could no longer retain, as had still been the case in the sixteenth century, references to its symbolic value or to the virtues and properties accorded it in antiquity). But without belonging to any discipline, a proposition is obliged to utilise conceptual instruments and techniques of a well-defined type; from the nineteenth century onwards, a proposition was no longer medical – it became 'non-medical', becoming more of an individual fantasy or item of popular imagery – if it employed metaphorical or qualitative terms or notions of essence (congestion, fermented liquids, dessicated solids); in return, it could – it had to – appeal to equally metaphorical notions, though constructed according to a different functional and physiological model (concerning irritation, inflammation or the decay of tissue). But there is more still, for in order to belong to a discipline, a proposition must fit into a certain type of theoretical field. Suffice it to recall that the quest for primitive language, a perfectly acceptable theme up to the eighteenth century, was enough, in the second half of the nineteenth century, to throw any discourse into, I hesitate to say error, but into a world of chimera and reverie – into pure and simple linguistic monstrosity.

Within its own limits, every discipline recognises true and false propositions, but it repulses a whole teratology of learning. The exterior of a science is both more, and less, populated than one might think: certainly, there is immediate experience, imaginary themes bearing on and continually accompanying immemorial beliefs; but perhaps there are no errors in the strict sense of the term, for error can only emerge and be identified within a well-defined process; there are monsters on the prowl, however, whose forms alter with the history of knowledge. In short, a proposition must fulfil some onerous and complex conditions before it can be admitted within a discipline; before it can be pronounced true or false it must be, as Monsieur Canguilhem might say, 'within the true'.

[...]

It is always possible one could speak the truth in a void; one would only be in the true, however, if one obeyed the rules of some discursive 'policy' which would have to be reactivated every time one spoke.

Disciplines constitute a system of control in the production of discourse, fixing its limits through the action of an identity taking the form of a permanent reactivation of the rules.

We tend to see, in an author's fertility, in the multiplicity of commentaries and in the development of a discipline so many infinite resources available for the creation of discourse. Perhaps so, but they are nonetheless principles of

constraint, and it is probably impossible to appreciate their positive, multiplicatory role without first taking into consideration their restrictive, constraining role.

There is, I believe, a third group of rules serving to control discourse. Here, we are no longer dealing with the mastery of the powers contained within discourse, nor with averting the hazards of its appearance; it is more a question of determining the conditions under which it may be employed, of imposing a certain number of rules upon those individuals who employ it, thus denying access to everyone else. This amounts to a rarefaction among speaking subjects: none may enter into discourse on a specific subject unless he has satisfied certain conditions or if he is not, from the outset, qualified to do so. More exactly, not all areas of discourse are equally open and penetrable; some are forbidden territory (differentiated and differentiating) while others are virtually open to the winds and stand, without any prior restrictions, open to all.

[. . .]

The most superficial and obvious of these restrictive systems is constituted by what we collectively refer to as ritual; ritual defines the qualifications required of the speaker (of who in dialogue, interrogation or recitation, should occupy which position and formulate which type of utterance); it lays down gestures to be made, behaviour, circumstances and the whole range of signs that must accompany discourse; finally, it lays down the supposed, or imposed significance of the words used, their effect upon those to whom they are addressed, the limitations of their constraining validity. Religious discourse, juridical and therapeutic as well as, in some ways, political discourse are all barely dissociable from the functioning of a ritual that determines the individual properties and agreed roles of the speakers.

A rather different function is filled by 'fellowships of discourse', whose function is to preserve or to reproduce discourse, but in order that it should circulate within a closed community, according to strict regulations, without those in possession being dispossessed by this very distribution. An archaic model of this would be those groups of Rhapsodists, possessing knowledge of poems to recite or, even, upon which to work variations and transformations. But though the ultimate object of this knowledge was ritual recitation, it was protected and preserved within a determinate group, by the, often extremely complex, exercises of memory implied by such a process. Apprenticeship gained access both to a group and to a secret which recitation made manifest, but did not divulge. The roles of speaking and listening were not interchangeable.

Few such 'fellowships of discourse' remain, with their ambiguous interplay of secrecy and disclosure. But do not be deceived; even in true discourse, even in the order of published discourse, free from all ritual, we still find secret-appropriation and non-interchangeability at work. It could even be that the act of writing, as it is institutionalised today, with its books, its publishing system and the personality of the writer, occurs within a diffuse, yet constraining, 'fellowship of discourse'. The separateness of the writer, continually opposed to the activity of all other writing and speaking subjects, the intransitive character he lends to his discourse, the fundamental singularity he has long accorded to 'writing', the

affirmed dissymmetry between 'creation' and any use of linguistic systems – all this manifests in its formulation (and tends moreover to accompany the interplay of these factors in practice) the existence of a certain 'fellowship of discourse'. But there are many others, functioning according to entirely different schemas of exclusivity and disclosure: one has only to think of technical and scientific secrets, of the forms of diffusion and circulation in medical discourse, of those who have appropriated and economic or political discourse.

At first sight, 'doctrine' (religious, political, philosophical) would seem to constitute the very reverse of a 'fellowship of discourse'; for among the latter, the number of speakers were, if not fixed, at least limited, and it was among this number that discourse was allowed to circulate and be transmitted. Doctrine, on the other hand, tends to diffusion: in the holding in common of a single ensemble of discourse that individuals, as many as you wish, could define their reciprocal allegiance. In appearance, the sole requisite is the recognition of the same truths an the acceptance of a certain rule – more or less flexible – of conformity with validated discourse. If it were a question of just that, doctrines would barely be any different from scientific disciplines, and discursive control would bear merely on the form of content of what was uttered, and not on the speaker. Doctrinal adherence, however, involves both speaker and the spoken, the one through the other. The speaking subject is involved through, and as a result of, the spoken, as is demonstrated by the rules of exclusion and the rejection mechanism brought into play when a speaker formulates one, or many, inassimilable utterances; questions of heresy and unorthodoxy in no way arise out of fanatical exaggeration of doctrinal mechanisms; they are a fundamental part of them. But conversely, doctrine involves the utterances of speakers in the sense that doctrine is, permanently, the sign, the manifestation and the instrument of a prior adherence – adherence to a class, to a social or racial status, to a nationality or an interest, to a struggle, a revolt, resistance or acceptance. Doctrine links individuals to certain types of utterance while consequently barring them from all others. Doctrine effects a dual subjection, that of speaking subjects to discourse, and that of discourse to the group, at least virtually, of speakers.

Finally, on a much broader scale, we have to recognise the great cleavages in what one might call the social appropriation of discourse. Education may well be, as of right, the instrument whereby every individual, in a society like our own, can gain access to any kind of discourse. But we well know that in its distribution, in what it permits and in what it prevents, it follows the well-trodden battle-lines of social conflict. Every educational system is a political means of maintaining or of modifying the appropriation of discourse, with the knowledge and the powers it carries with it.

I am well aware of the abstraction I am performing when I separate, as I have just done, verbal rituals, 'fellowships of discourse', doctrinal groups and social appropriation. Most of the time they are linked together, constituting great edifices that distribute speakers among the different types of discourse, and which appropriate those types of discourse to certain categories of subject. In a word, let us say that these are the main rules for the subjection of discourse. What is an educational system, after all, if not a ritualisation of the word; if not a qualification of some fixing of roles for speakers; if not the constitution of a (diffuse)

doctrinal group; if not a distribution and an appropriation of discourse, with all its learning and its powers? What is 'writing' (that of 'writers') if not a similar form of subjection, perhaps taking rather different forms, but whose main stresses are nonetheless analogous? May we not also say that the judicial system, as well as institutionalised medicine, constitute similar systems for the subjection of discourse?

Jacques Derrida

SEMIOLOGY AND GRAMMATOLOGY
Interview with Julia Kristeva (1968)

KRISTEVA: Semiology today is constructed on the model of the sign and its corre-
lates: *communication* and *structure*. What are the "logocentric" and ethnocentric lim-
its of these models, and how are they incapable of serving as the basis for a
notation attempting to escape metaphysics?

DERRIDA: All gestures here are necessarily equivocal. And supposing, which I do
not believe, that someday it will be possible *simply* to escape metaphysics, the
concept of the sign will have marked, in this sense, a simultaneous impediment
and progress. For if the sign, by its root and its implications, is in all its aspects
metaphysical, if it is in systematic solidarity with stoic and medieval theology, the
work and the displacement to which it has been submitted – and of which it also,
curiously, is the instrument – have had *delimiting* effects. For this work and dis-
placement have permitted the critique of how the concept of the sign belongs to
metaphysics, which represents a simultaneous *marking* and *loosening* of the limits
of the system in which this concept was born and began to serve, and thereby
also represents, to a certain extent, an uprooting of the sign from its own soil.
This work must be conducted as far as possible, but at a certain point one
inevitably encounters "the logocentric and ethnocentric limits" of such a model.
At this point, perhaps, the concept is to be abandoned. But this point is very dif-
ficult to determine, and is never pure. All the heuristic and critical resources of
the concept of the sign have to be exhausted, and exhausted equally in all
domains and contexts. Now, it is inevitable that not only inequalities of devel-
opment (which will always occur), but also the necessity of certain contexts, will
render strategically indispensable the recourse to a model known elsewhere, and
even at the most novel points of investigation, to function as an obstacle.

To take only one example, one could show that a semiology of the Saus-
surean type has had a double role. *On the one hand*, an absolutely decisive criti-
cal role:

1 It has marked, against the tradition, that the signified is inseparable from the signifier, that the signified and signifier are the two sides of one and the same production. Saussure even purposely refused to have this opposition or this "two-sided unity" conform to the relationship between soul and body, as had always been done. "This two-sided unity has often been compared to the unity of the human person, composed of a body and a soul. The comparison is hardly satisfactory." (*Cours de linguistique générale*, p. 145)[1]

2 By emphasizing the *differential* and *formal* characteristics of semiological functioning, by showing that it "is impossible for sound, the material element, itself to belong to language" and that "in its essence it [the linguistic signifier] is not at all phonic" (p. 164); by desubstantializing both the signified content and the "expressive substance" – which therefore is no longer in a privileged or exclusive way phonic – by making linguistics a division of general semiology (p. 33), Saussure powerfully contributed to turning against the metaphysical tradition the concept of the sign that he borrowed from it.

And yet Saussure could not confirm this tradition in the extent to which he continued to use the concept of the sign. No more than any other, this concept cannot be employed in both an absolutely novel and an absolutely conventional way. One necessarily assumes, in a non-critical way, at least some of the implications inscribed in its system. There is at least one moment at which Saussure must renounce drawing all the conclusions from the critical work he has undertaken, and that is the not fortuitous moment when he resigns himself to using the word "sign," lacking anything better. After having justified the introduction of the words "signified" and "signifier," Saussure writes: "As for *sign*, if we retain it, it is because we find nothing else to replace it, everyday language suggesting no other" (pp. 99–100). And, in effect, it is difficult to see how one could evacuate the *sign* when one has begun by proposing the opposition signified/signifier.

Now, "everyday language" is not innocent or neutral. It is the language of Western metaphysics, and it carries with it not only a considerable number of presuppositions of all types, but also presuppositions inseparable from metaphysics, which, although little attended to, are knotted into a system. This is why *on the other hand:*

1 The maintenance of the rigorous distinction – an essential and juridical distinction – between the *signans* and the *signatum*, the equation of the *signatum* and the concept (p. 99)[2] inherently leaves open the possibility of thinking a *concept signified in and of itself*, a concept simply present for thought, independent of a relationship to language, that is of a relationship to a system of signifiers. By leaving open this possibility – and it is inherent even in the opposition signifier/signified, that is in the sign – Saussure contradicts the critical acquisitions of which we were just speaking. He accedes to the classical exigency of what I have proposed to call a "transcendental signified," which in and of itself, in its essence, would refer to no signifier, would exceed the chain of signs, and would no longer itself function as a signifier. On the contrary, though, from the moment that one questions the possibility of such a transcendental signified, and that one rec-

ognizes that every signified is also in the position of a signifier,[3] the distinction between signified and signifier becomes problematical at its root. Of course this is an operation that must be undertaken with prudence for: (a) it must pass through the difficult deconstruction of the entire history of metaphysics which imposed, and never will cease to impose upon semiological science in its entirety this fundamental quest for a "transcendental signified" and a concept independent of language; this quest not being imposed from without by something like "philosophy," but rather by everything that links our language, our culture, our "system of thought" to the history and system of metaphysics; (b) nor is it a question of confusing at every level, and in all simplicity, the signifier and the signified. That this opposition or difference cannot be radical or absolute does not prevent it from functioning, and even from being indispensable within certain limits — very wide limits. For example, no translation would be possible without it. In effect, the theme of a transcendental signified took shape within the horizon of an absolutely pure, transparent, and unequivocal translatability. In the limits to which it is possible, or at least *appears* possible, translation practices the difference between signified and signifier. But if this difference is never pure, no more so is translation, and for the notion of translation we would have to substitute a notion of *transformation:* a regulated transformation of one language by another, of one text by another. We will never have, and in fact have never had, to do with some "transport" of pure signifieds from one language to another, or within one and the same language, that the signifying, instrument would leave virgin and untouched.

2 Although he recognized the necessity of putting the phonic substance between brackets ("What is essential in language, we shall see, is foreign to the phonic character of the linguistic sign" (p. 21). "In its essence it [the linguistic signifier] is not at all phonic" (p. 164)), Saussure, for essential, and essentially metaphysical, reasons had to privilege speech, everything that links the sign to *phonē*. He also speaks of the "natural link" between thought and voice, meaning and sound (p. 46). He even speaks of "thought-sound" (p. 156). I have attempted elsewhere to show what is traditional in such a gesture, and to what necessities it submits. In any event, it winds up contradicting the most interesting critical motive of the *Course*, making of linguistics the regulatory model, the "pattern" for a general semiology of which it was to be, by all rights and theoretically, only a part. The theme of the arbitrary, thus, is turned away from its most fruitful paths (formalization) toward a hierarchizing teleology: "Thus it can be said that entirely arbitrary signs realize better than any others the ideal of the semiological process; this is why language, the most complex and most widespread of the systems of expression, is also the most characteristic one of them all; in this sense linguistics can become the *general pattern for all semiology*, even though language is only a particular system" (p. 101). One finds exactly the same gesture and the same concepts in Hegel. The contradiction between these two moments of the *Course* is also marked by Saussure's recognizing elsewhere that "it is not spoken language that is natural to man, but the faculty of constituting a language, that is, a system of distinct signs . . .," that

is, the possibility of the *code* and of *articulation*, independent of any sub-stance, for example, phonic substance.

3 The concept of the sign (signifier/signified) carries within itself the neces-sity of privileging the phonic substance and of setting up linguistics as the "pattern" for semiology. *Phonē*, in effect, is the signifying substance *given to consciousness* as that which is most intimately tied to the thought of the sig-nified concept. From this point of view, the voice is consciousness itself. When I speak, not only am I conscious of being present for what I think, but I am conscious also of keeping as close as possible to my thought, or to the "concept," a signifier that does not fall into the world, a signifier that I hear as soon as I emit it, that seems to depend upon my pure and free spontaneity, requiring the use of no instrument, no accessory, no force taken from the world. Not only do the signifier and the signified seem to unite, but also, in this confusion, the signifier seems to erase itself or to become transparent, in order to allow the concept to present itself as what it is, referring to nothing other than its presence. The exteriority of the sig-nifier seems reduced. Naturally this experience is a lure, but a lure whose necessity has organized an entire structure, or an entire epoch; and on the grounds of this epoch a semiology has been constituted whose concepts and fundamental presuppositions are quite precisely discernible from Plato to Husserl, passing through Aristotle, Rousseau, Hegel, etc.

4 To reduce the exteriority of the signifier is to exclude everything in semi-otic practice that is not psychic. Now, only the privilege accorded to the phonetic and linguistic sign can authorize Saussure's proposition according to which the "linguistic sign is therefore a two-sided *psychic* entity" (p. 99). Supposing that this proposition has a rigorous sense in and of itself, it is difficult to see how it could be extended to every sign, be it phonetic-linguistic or not. It is difficult to see therefore, except, precisely, by mak-ing of the phonetic sign the "pattern" for all signs, how general semiology can be inscribed in a psychology. However, this is what Saussure does: "One can thus conceive of a science that would study the life of signs at the heart of social life; it would form a part of social psychology, and con-sequently of general psychology; we will name it semiology (from the Greek *sēmeion*, "sign"). It would teach what signs consist of, what laws reg-ulate them. Since it does not yet exist, one cannot say what it will be; but it has a right to exist, its place is determined in advance. Linguistics is only a part of this general science, the laws that semiology will discover will be applicable to linguistics, and the latter will find itself attached to a well defined domain in the set of human facts. It is for the psychologist to deter-mine the exact place of semiology" (p. 33).

Of course modern linguists and semioticians have not remained with Saussure, or at least with this Saussurean "psychologism." The Copenhagen School and all of American linguistics have explicitly criticized it. But if I have insisted on Saus-sure, it is not only because even those who criticize him recognize him as the founder of general semiology and borrow most of their concepts from him; but above all because one cannot simply criticize the "psychologistic" usage of the

concept of the sign. Psychologism is not the poor usage of a good concept, but is inscribed and prescribed within the concept of the sign itself, in the equivocal manner of which I spoke at the beginning. This equivocality, which weighs upon the model of the sign, marks the "semiological" project itself and the organic totality of its concepts, in particular that of *communication*, which in effect implies a *transmission charged with making pass, from one subject to another, the identity* of a *signified* object, of a *meaning* or of a *concept* rightfully separable from the process of passage and from the signifying operation. Communication presupposes subjects (whose identity and presence are constituted before the signifying operation) and objects (signified concepts, a thought meaning that the passage of communication will have neither to constitute, nor, by all rights, to transform). *A* communicates *B* to *C*. Through the sign the emitter communicates something to a receptor, etc.

The case of the concept of *structure*, that you also bring up, is certainly more ambiguous. Everything depends upon how one sets it to work. Like the concept of the sign – and therefore of semiology – it can simultaneously confirm and shake logocentric and ethnocentric assuredness. It is not a question of junking these concepts, nor do we have the means to do so. Doubtless it is more necessary, from within semiology, to transform concepts, to displace them, to turn them against their presuppositions, to reinscribe them in other chains, and little by little to modify the terrain of our work and thereby produce new configurations; I do not believe in decisive ruptures, in an unequivocal "epistemological break," as it is called today. Breaks are always, and fatally, reinscribed in an old cloth that must continually, interminably be undone. This interminability is not an accident or contingency; it is essential, systematic, and theoretical. And this in no way minimizes the necessity and relative importance of certain breaks, of the appearance and definition of new structures . . .

KRISTEVA: What is the *gram* as a "new structure of nonpresence"? What is *writing as différance*? What rupture do these concepts introduce in relation to the key concepts of semiology – the (phonetic) *sign* and *structure*? How does the notion of *text* replace, in grammatology, the linguistic and semiological notion of what is *enounced*?

DERRIDA: The reduction of writing – as the reduction of the exteriority of the signifier – was part and parcel of phonologism and logocentrism. We know how Saussure, according to the traditional operation that was also Plato's, Aristotle's, Rousseau's, Hegel's, Husserl's, etc., excludes writing from the field of linguistics – from language and speech – as a phenomenon of exterior representation, both useless and dangerous: "The linguistic object is not defined by the combination of the written word and the spoken word, the latter alone constituting this object" (p. 45); "writing is foreign to the internal system [of language]" (p. 44); "writing veils our view of language: it does not clothe language, but travesties it" (p. 51). The tie of writing to language is "superficial," "factitious." It is "bizarre" that writing, which should only be an "image," "usurps the principal role" and that "the natural relationship is inversed" (p. 47). Writing is a "trap," its action is "vicious" and "tyrannical," its misdeeds are monstrosities, "teratological cases," "linguistics should put them under observation in a special compartment" (p. 54), etc. Naturally, this representativist conception of writing

("Language and writing are two distinct sign systems; the unique *raison d'être* of the second is to *represent* the first" (p. 45) is linked to the practice of phonetic-alphabetic writing, to which Saussure realizes his study is "limited" (p. 48). In effect, alphabetical writing seems to present speech, and at the same time to erase itself before speech. Actually, it could be shown, as I have attempted to do, that there is no purely phonetic writing, and that phonologism is less a consequence of the practice of the alphabet in a given culture than a certain ethical or axio-logical *experience* of this practice. Writing *should* erase itself before the plenitude of living speech, perfectly represented in the transparence of its notation, imme-diately present for the subject who speaks it, and for the subject who receives its meaning, content, value.

Now, if one ceases to limit oneself to the model of phonetic writing, which we privilege only by ethnocentrism, and if we draw all the consequences from the fact that there is no purely phonetic writing (by reason of the necessary spac-ing of signs, punctuation, intervals, the differences indispensable for the func-tioning of graphemes, etc.), then the entire phonologist or logocentrist logic becomes problematical. Its range of legitimacy becomes narrow and superficial. This delimitation, however, is indispensable if one wants to be able to account, with some coherence, for the principle of difference, such as Saussure himself recalls it. This principle compels us not only not to privilege one substance – here the phonic, so called temporal, substance – while excluding another – for example, the graphic, so called spatial, substance – but even to consider every process of signification as a formal play of differences. That is, of traces.

Why traces? And by what right do we reintroduce grammatics at the moment when we seem to have neutralized every substance, be it phonic, graphic, or oth-erwise? Of course it is not a question of resorting to the same concept of writ-ing and of simply inverting the dissymmetry that now has become problematical. It is a question, rather, of producing a new concept of writing. This concept can be called *gram* or *différance*. The play of differences supposes, in effect, syntheses and referrals which forbid at any moment, or in any sense, that a simple element be *present* in and of itself, referring only to itself. Whether in the order of spo-ken or written discourse, no element can function as a sign without referring to another element which itself is not simply present. This interweaving results in each "element" – phoneme or grapheme – being constituted on the basis of the trace within it of the other elements of the chain or system. This interweaving, this textile, is the *text* produced only in the transformation of another text. Noth-ing, neither among the elements nor within the system, is anywhere ever simply present or absent. There are only, everywhere, differences and traces of traces. The gram, then, is the most general concept of semiology – which thus becomes grammatology – and it covers not only the field of writing in the restricted sense, but also the field of linguistics. The advantage of this concept – provided that it be surrounded by a certain interpretive context, for no more than any other con-ceptual element it does not signify, or suffice, by itself – is that in principle it neutralizes the phonologistic propensity of the "sign," and *in fact counterbalances* it by liberating the entire scientific field of the "graphic substance" (history and sys-tems of writing beyond the bounds of the West) whose interest is not minimal, but which so far has been left in the shadows of neglect.

The gram as *différance*, then, is a structure and a movement no longer conceivable on the basis of the opposition presence/absence. *Différance* is the systematic play of differences, of the traces of differences, of the *spacing* by means of which elements are related to each other. This spacing is the simultaneously active and passive (the *a* of *différance* indicates this indecision as concerns activity and passivity, that which cannot be governed by or distributed between the terms of this opposition)[3] production of the intervals without which the "full" terms would not signify, would not function. It is also the becoming-space of the spoken chain – which has been called temporal or linear; a becoming-space which makes possible both writing and every correspondence between speech and writing, every passage from one to the other.

The activity or productivity connoted by the *a* of *différance* refers to the generative movement in the play of differences. The latter are neither fallen from the sky nor inscribed once and for all in a closed system, a static structure that a synchronic and taxonomic operation could exhaust. Differences are the effects of transformations, and from this vantage the theme of *différance* is incompatible with the static, synchronic, taxonomic, ahistoric motifs in the concept of *structure*. But it goes without saying that this motif is not the only one that defines structure, and that the production of differences, *différance*, is not astructural: it produces systematic and regulated transformations which are able, at a certain point, to leave room for a structural science. The concept of *différance* even develops the most legitimate principled exigencies of "structuralism."

Language, and in general every semiotic code – which Saussure defines as "classifications" – are therefore effects, but their cause is not a subject, a substance, or a being somewhere present and outside the movement of *différance*. Since there is no presence before and outside semiological *différance*, one can extend to the system of signs in general what Saussure says of language: "Language is necessary for speech to be intelligible and to produce all its effects; but speech is necessary for language to be established; historically, the fact of speech always comes first." There is a circle here, for if one rigorously distinguishes language and speech, code and message, schema and usage, etc., and if one wishes to do justice to the two postulates thus enunciated, one does not know where to begin, nor how something can begin in general, be it language or speech. Therefore, one has to admit, before any dissociation of language and speech, code and message, etc. (and everything that goes along with such a dissociation), a systematic production of differences, the *production* of a system of differences – a *différance* – within whose effects one eventually, by abstraction and according to determined motivations, will be able to demarcate a linguistics of language and a linguistics of speech, etc.

Nothing – no present and in-*different* being – thus precedes *différance* and spacing. There is no subject who is agent, author, and master of *différance*, who eventually and empirically would be overtaken by *différance*. Subjectivity – like objectivity – is an effect of *différance*, an effect inscribed in a system of *différance*. This is why the *a* of *différance* also recalls that spacing is temporization, the detour and postponement by means of which intuition, perception, consummation – in a word, the relationship to the present, the reference to a present reality, to a *being* – are always *deferred*. Deferred by virtue of the very principle of difference

which holds that an element functions and signifies, takes on or conveys meaning, only by referring to another past or future element in an economy of traces. This economic aspect of *différance*, which brings into play a certain not conscious calculation in a field of forces, is inseparable from the more narrowly semiotic aspect of *différance*. It confirms that the subject, and first of all the conscious and speaking subject, depends upon the system of differences and the movement of *différance*, that the subject is not present, nor above all present to itself before *différance*, that the subject is constituted only in being divided from itself, in becoming space, in temporizing, in deferral; and it confirms that, as Saussure said, "language [which consists only of differences] is not a function of the speaking subject." At the point at which the concept of *différance*, and the chain attached to it, intervenes, all the conceptual oppositions of metaphysics (signifier/signified; sensible/intelligible; writing/speech; passivity/activity; etc.) – to the extent that they ultimately refer to the presence of something present (for example, in the form of the identity of the subject who is present for all his operations, present beneath every accident or event, self-present in its "living speech," in its enunciations, in the present of objects and acts of its language, etc.) – become nonpertinent. They all amount, at one moment or another, to a subordination of the movement of *différance* in favor of the presence of a value or a *meaning* supposedly antecedent to *différance*, more original than it, exceeding and governing it in the last analysis. This is still the presence of what we called above the "transcendental signified."

Notes

1 Ferdinand de Saussure, *Cours de linguistique générale*, ed. C. Bally and A. Sechehaye (Paris: Payot, 1955).

2 J.D. That is, the intelligible. The difference between the signifier and the signified has always reproduced the difference between the sensible and the intelligible. And it does so no less in the twentieth century than in its stoic origins. "Modern structuralist thought has clearly established this: language is a system of signs, and linguistics is an integral part of the science of signs, *semiotics* (or to use Saussure's terms, *semiology*). The medieval definition - *aliquid stat pro aliquo* - resuscitated by our epoch has shown itself to be still valid and fruitful. Thereby, the constitutive mark of every sign in general, of the linguistic sign in particular, resides in its double character: every linguistic unity is biparite, and comports two aspects: one sensible and the other intelligible - on the one hand, the *signans* (Saussure's *signifier*), and on the other, the *signatum* (the *signified*)" (Roman Jakobson *Essais de linguistique generale* [Paris: Editions de Minuit, 1963], p.162.)

3 Ed. N. See *De la grammatologie* [Paris: Editions de Minuit, 1963], pp.196-8.

4 T. N. In other words, *difference* combines and confuses "differing" and "deferring" in both their active and passive senses.

LANGUAGE COMMUNITIES

> It is evident therefore that unity of speech is essential to the unity of a
> people. Community of language is a stronger bond than identity of reli-
> gion or government.
> (G. P. Marsh, *The Origin and History of the English Language and the*
> *Literature it Embodies,* 1862: 221)

PERHAPS THE MOST OBVIOUS instances of unity and diversity within language occur around the question of national languages and the production of standard forms of the vernacular. However, the self-evidence of this observation has to be grounded in its historical roots. For the concepts of both national languages and, to a lesser degree, standard languages, are very much a product of the history of the West after the Renaissance; though it is true that once established, these concepts spread with remarkable speed – usually as a result of colonialism as we shall see. With regard to what became known as the 'modern' languages – the vernacular languages of Western Europe – the positing of a standard or official language is inextricably tied to the production of hierarchies of discourse which privilege the usage of one or more socially dominant group, or groups, over and above the language of the lower classes, dialects, and other forms of variation. We saw in Part One how Saussure's conceptualisation of the speech circuit led him to formulate a model of linguistic structure, or *langue*, which takes for granted a linguistic community figured as a kind of democratic organisation in which all language-users have free and equal access to the language. Bourdieu described it as the spectre of linguistic communism which haunts linguistic theory; it was to appear in the work of one of the most influential theorists of language in the second half of the twentieth century, Noam Chomsky, as the 'ideal speaker-hearer' living in a 'completely homogeneous speech-community'. (Chomsky 1965:3). What the model ignores of course is the fact that both access to the language, and the creation of meaning, take place within communities and societies which are riven by social conflict. It may be useful to look back here to the work of Voloshinov, particularly his concept of multiaccentuality, and that of Foucault, in his account of the ordering of discourse.

The first piece in this section, by Karl Vossler, argues that there is an essential link between language, community and nationhood. As was indicated in the general introduction, the idea that language provides a kind of mental bond was not a twentieth-century invention; Moryson had declared in the seventeenth century that 'all nations have thought nothing more powerful to unite minds than the Community of language'. But the relationship between language, mind and identity only began to be theorised properly in the nineteenth and twentieth centuries; twentieth-century examples of this linkage are given in Part One. Vossler explores this connection and simply takes it as given: the French language, French thought and

French national character come as a package which cannot be separated. The implications of this need to be thought through quite carefully, as it suggest that a person whose first language, or 'experienced language' as Vossler puts it, is Punjabi, for example, cannot be English or Scottish or British (it is important to remember that 'British' denotes legal status as well as a form of identity). In another context it is worth considering how Vossler's formulation stands up when faced with a multi-lingual community like the United States of America. Vossler extends the idea of this link between language, thought and identity by saying that our feelings for our 'experienced language' vary between love and pride, and that the defence of our language is a matter of preserving our tribal, racial and national characteristics. The implications of this also have to be considered.

It is important to recognise, however, the relationship, which is felt and experienced as well as postulated theoretically, between language and cultural belonging. In this respect it is interesting to note that, in the 1980s, there were many political commentators who declared with confidence that nationalism was dead and nations a thing of the past (superseded by transnational bodies such as the European Union, or the globalising forces of capitalism). The breakdown of the Soviet Union and its consequent division into nations offers evidence of the mistaken nature of such an analysis – as does the re-unification of East and West Germany. The catastrophic dismembering of former Yugoslavia and the horrors it brought in its wake evince the dangers of underestimating the powers of nationalism.

Leonard Bloomfield, whose work dominated American linguistics in the twenty years before the appearance of Chomsky's transformational-generative theory of language in the late 1950s, gives an account of the complex nature of speech-communities and the problems which this raises for the linguist. He recognises that there is, in fact, no straightforward correlation between the speakers of a national language, the members of a speech-community, the members of a political community, and so on. As so often in the study of language, attempting to draw limits, to circumscribe and define, causes serious theoretical and practical difficulties. Which is, of course, why Saussure began by attempting to do precisely that – to designate the object of study; without that preliminary demarcation, in his view, the science of language was simply not possible. Bloomfield draws attention to the fact that one particular language may be shared by groups of people divided from each other geographically or politically, for example in distinct nation-states. On the other hand, a language spoken within the borders of a single nation-state may have a number of forms in accordance with the social and regional differences which prevail. Nonetheless, despite his emphasis on diversity, Bloomfield's account does presuppose the existence of a norm from which varieties depart; unsurprisingly, the examples which he works with are the 'modern' languages of Europe and the United States.

For Bakhtin, on the other hand, such a normative, or standardised, form of language is never something which simply exists in and of itself, a product of nature almost. Rather it has to be actively produced by forces of cultural unification and centralisation, which, as the text shows, take various forms in specific historical contexts. A standard or unitary language then for Bakhtin is not so much given as created, and it has to be constantly policed in order to maintain its appearance as

a thing of nature and its power as an oppressive cultural force in its own right (Voloshinov's comments on how uni-accentual meanings are also guarded in this way are relevant here). For the forces of unification are at the same time the forces of division, operating to suppress or marginalise those other forces in language and culture which work against the attempt to forge unity from diversity. Bakhtin calls these decentralising tendencies the centrifugal forces (as opposed to the centripetal forces which try to eradicate difference in the name of unity). In the study of language, centrifugal forces include not just the kind of social and geographical variation which we find in dialects of class and region, but the potentially infinite variety of forms of language which emerge in social life, each with its own rules and functions. In Bakhtin's schema these centrifugal forms are evidence of what he calls heteroglossia, that is to say, ineradicable difference, the fact that even the most unified, standardised language or culture is shot through with otherness and historical relativity. He views heteroglossia as a democratising agent in a world of closed, static, hierarchical and oppressive forces; given his personal history (writing in the Soviet Union under Stalinism) it would be surprising if he had argued otherwise. But the preference for heteroglot forms over centralising, monoglot forms, always and everywhere, has its own dangers.

This question is taken up in the extract from the work of Gramsci, who was primarily a political activist and theorist but whose thought was deeply influenced by the model of language which he studied for his doctorate (spatial linguistics). He suggested that there are historical situations in which forms of unity and centralisation may in fact be preferable to diversity, and may actually function as a force which contributes to the liberation of the oppressed and marginalised. Working within his own background in Italian linguistics, and the historical context of Italian political and cultural unification, Gramsci's argument is that the Italian working class would be unable to mobilise politically if it remained divided linguistically. Therefore the forging of a national standard language, and thus the codification of grammatical norms, is politically desirable in order that an effective emancipatory project be undertaken. A similar example can be found in British history: in the 1790s, Tory pamphleteers issued political pamphlets addressed to the working classes in dialect, which was a reactionary act given that political petitions to parliament were turned down precisely on the grounds of their inferior language. What Gramsci's argument demonstrates is the need to historicise the important insights of Bakhtin regarding the constant struggle between centralising and decentralising forces in language. That provides us with a useful tool for the analysis not only of the historical formation of national languages, but also, as we shall see in the following sections of the *Reader*, with strategies of resistance to linguistic and cultural hegemony in colonial and postcolonial contexts.

Further reading

Vossler

Vossler, K. (1932) *The Spirit of Language in Civilisation*, trans. O.Oeser, London: Kegan Paul, pp. 107–97, 217–34.

Iordan, I. (1937) *An Introduction to Romance Linguistics, its Schools and Scholars*, rev. and trans. J.Orr, London: Methuen, pp. 86–127.

Hall, R.A. Jr (1963) *Idealism in Romance Linguistics*, Ithaca, NY: Cornell University Press, p. 36–46.

Voloshinov, V.N. (1986) *Marxism and the Philosophy of Language*, trans. L. Matejka and I.R.Titunik, Cambridge, MA: Harvard University Press, pp. 48–52, 83–98.

Christmann, H.H. (1981) 'Idealism' in R. Posner and J.N. Green (eds) *Trends in Romance Linguistics and Philology, Volume 2: Synchronic Romance Linguistics*, The Hague: Mouton, pp. 259–67.

Uitti, K.D. (1969) *Linguistics and Literary Theory*, Englewood Cliffs, NJ: Prentice-Hall, pp. 126–31.

Malmberg, M. (1964) *New Trends in Linguistics: An Orientation*, trans. E. Carney, Stockholm: Lund, pp. 69–74.

Leroy, M (1967) *The Main Trends in Modern Linguistics*, trans. G. Price, Oxford: Basil Blackwell, pp. 100–11.

Ivic, M. (1965) *Trends in Linguistics*, trans. M. Heppel, The Hague: Mouton, pp. 89–97.

Speech communities

Wardhaugh, R. (1992) *An Introduction to Sociolinguistics*, 2nd edn., Oxford: Basil Blackwell, chapter 5.

Montgomery, M. (1995) *An Introduction to Language and Society*, 2nd edn., London: Routledge, chapters 3–5, 9.

Romaine, S. (1982) 'What is a Speech Community?', in S. Romaine (ed.) *Sociolinguistic Variation in Speech Communities*, London: Edward Arnold, pp. 13–24.

Gumperz, J.J. (1971) *Language in Social Groups*, ed. and intro. A.S. Dil, Stanford, CA: Stanford University Press, pp. 97–128.

—— (1972) 'Introduction', in J. J. Gumperz and D. Hymes (eds) *Directions in Sociolinguistics: The Ethnography of Communication*, New York: Holt, Reinhart & Winston, pp. 1–25.

Hymes, D. (ed.) (1974) *Foundations in Sociolinguistics: An Ethnographic Approach*, Philadelphia: University of Pennsylvania Press.

Milroy, J. and L. Milroy (1992) *Authority in Language: Investigating Language Prescription and Standardisation*, 2nd edn., London: Routledge & Kegan Paul, chapter 5

Trudgill, P. and J. Cheshire (eds) (1998) *The Sociolinguistics Reader, Volume 1: Multilingualism and Variation*, London: Arnold.

Saussure, F. de (1960) *Course in General Linguistics*, ed. C. Bally and A. Sechehaye, trans. W. Baskin, London: Peter Owen, pp. 11–15.

Chomsky, N. (1965) *Aspects of the Theory of Syntax*, Cambridge, MA: M.I.T. Press, pp. 3–7.

Bakhtin

Bakhtin, M.M. (1981) *The Dialogic Imagination: Four Essays*, ed. M. Holquist, trans. C. Emerson and M. Holquist, Austin: University of Texas Press.

—— (1986) *Speech Genres and Other Late Essays*, ed. C. Emerson and M. Holquist, trans. V.W. McGee, Austin: University of Texas Press.

Dentith, S. (1995) *Bakhtinian Thought: An Introductory Reader*, London: Routledge, pp. 22–40

Crowley, T. (1996) *Language in History: Theories and Texts*, London: Routledge, chapter 2.
—— (1989) 'Bakhtin and the History of the Language', in K. Hirschkop and D. Shepherd (eds) *Bakhtin and Cultural Theory*, Manchester: Manchester University Press, pp. 68–90.
Hirschkop, K. (1986) 'Bahktin, Discourse and Democracy', *New Left Review* 160, pp. 92–113.
—— (1989) 'Introduction: Bakhtin and Cultural Theory', in K. Hirshkop and D. Shepherd (eds) *Bakhtin and Cultural Theory*, Manchester: Manchester University Press, pp. 1–38.
—— (1999) *Mikhail Bakhtin: An Aesthetic for Democracy*, Oxford: Oxford University Press.
Vice, S. (1997) *Introducing Bakhtin*, Manchester: Manchester University Press, chapters 1–3.
Holquist, M. (1990) *Dialogism: Bakhtin and his World*, London: Routledge, chapter 3.
White, A. (1984), 'Bakhtin, Sociolinguistics and Deconstruction', in F. Gloversmith (ed.) *The Theory of Reading*, Brighton: Harvester, pp. 123–46.
—— (1987–88) 'The Struggle Over Bakhtin', *Cultural Critique* 8, pp. 217–41.
Young, R. (1986) 'Back to Bakhtin', *Cultural Critique* 2, pp. 71–92.

Gramsci

Gramsci, A. (1985) *Selections from Cultural Writings*, ed. D. Forgacs and G. Nowell-Smith, trans. W. Boelhower, London: Lawrence & Wishart.
Salamini, L. (1981) *The Sociology of Political Praxis: An Introduction to Gramsci's Theory*, London: Routledge & Kegan Paul, pp. 181–96.
Brandist, C. (1996) 'Gramsci, Bakhtin and the Semiotics of Hegemony', *New Left Review* 216, pp. 94–109.
Holub, R. (1992) *Antonio Gramsci: Beyond Marxism and Postmodernism*, London: Routledge, pp. 126–40.
Steinberg, J. (1987) 'The Historian and the *Questione della Lingua*' in P. Burke and R. Porter (eds) *The Social History of Language*, Cambridge: Cambridge University Press, pp. 198–209.
Crowley, T. (1987) 'Language and Hegemony: Principles, Morals and Pronunciation', *Textual Practice* 1(3), pp. 278–96.
—— (1996) *Language in History: Theories and Texts*, London: Routledge, pp. 40–53.

Unity and diversity

Wardhaugh, R. (1987) *Languages in Competition: Dominance, Diversity and Decline*, Oxford: Blackwell, chapter 2.
—— (1992) *An Introduction to Sociolinguistics*, 2nd edn., Oxford: Basil Blackwell, chapters 2, 4, 6.
Ferguson, C. A. (1959) 'Diglossia', *Word* 15, pp. 325–40 [repr. in P. P Giglioli (ed.) *Language and Social Context: Selected Readings*, Harmondsworth: Penguin, pp. 232–51].
Fishman, J. A. (1972) 'The Sociology of Language', in P. P. Giglioli (ed.) *Language and Social Context: Selected Readings*, Harmondsworth: Penguin, pp. 45–58.
Milroy, J. and L. Milroy (1992) *Authority in Language: Investigating Language Prescription and Standardisation*, 2nd edn., London: Routledge & Kegan Paul, chapter 4.

Gumperz, J.J. (1971) *Language in Social Groups,* ed. and intro. A.S. Dil, Stanford, CA: Stanford University Press.

Giglioli, P. P. (ed.) (1972) *Language and Social Context: Selected Readings,* Harmondsworth: Penguin.

Pride, J.B. and J. Holmes (eds) (1972) *Sociolinguistics: Selected Readings,* Harmondsworth: Penguin.

Crowley, T. (1989) *The Politics of Discourse: The Standard Language Question in British Cultural Debates,* London: Macmillan.

Leith, D. (1997) *A Social History of English,* 2nd edn., London: Routledge.

Honey, J. (1997) *Language is Power: The Story of Standard English and Its Enemies,* London: Faber & Faber.

Karl Vossler

LANGUAGE COMMUNITIES (1925)

[…]An empirical language community, such as that of the Greeks, the Latins, the French, the Germans, is […] held together by the will to work at a common language material as the special instrument of mutual understanding. Since all men possess in their ears and tongue the natural organs of speech, the particular linguistic equipment that distinguishes these peoples from one another has to be sought elsewhere than in the human senses. It is to be found in the Latin, Greek, French, German tongue, not in the tongue as such; that is, not in the instruments, but in the instrumentation of language. Human language is instrumentated differently by the Frenchman and the German. For instance, the former will emphasize something syntactically, where the latter uses a gesture or an intonation; where the one uses the future, the other uses the present; where one needs the subjunctive or a partitive article, the other is content with the indicative, or will dispense with an article[1] The Frenchman not only uses a different vocabulary, different syntactic and phonetic systems, but even allocates their parts to speaker and listener, writer and reader in a different way to ours, expecting the speaker or writer to analyse his thought in a manner which we leave to the listener or reader, and so on. All these differences are historically conditioned; but in the final instance they are connected with the type of mind predominating in that particular language community, that is, with 'the national character'.

That there is a connection between national character, mental disposition, and language is as yet questioned by most philologists, or at any rate dismissed as scientifically unprovable. As a matter of fact it is not a question of natural or even of historical causal connections, but of a phenomenological relation. The French language, that is, the French instrumentation of linguistic thought, is not in any way the consequence of their mental disposition or their national character.

Between these two factors there is no connection, no causal chain, no mediation, because there is no separation, no tension between them; they are one and the same thing. The French do not speak French because they have a French

attitude, type of mind, or character, but simply because they *speak*. Their language becomes French, not because of some outside influence, but because of themselves; and through their speech, whatever and however it be, their national character is embodied and realized in what we call the French language. The same national character manifests itself in other and essentially different ways as well, such as the economic, political, judicial, moral, or scientific attitudes of the French. It can take on as many forms of reality or aspects as there are departments of life. Each of these facets shows a different picture of one and the same thing, and each represents in its *own* way the whole thing, the whole Frenchman – from one specific side, of course, by limiting the point of view to that which is due to the observer and not to the object, except in so far as observation has to mould itself to the object. The French language, therefore, is the *whole* of the French mind; but only in the light of language, that is, in the light of human language *as a whole*. The Frenchman says nothing that falls out of the framework of his language, nothing that is not significant for his mental disposition and his method of instrumentation, or that has not got a French form. Even when he incorporates foreign words they become French to him; and when he learns English or Chinese, he does it on a French basis. Through practice and habituation he may achieve citizenship in any number of languages; but his spiritual home remains French, which he may deny or forget, but which he can no more lose than he can lose the experiences of his childhood.

Many languages can be studied and acquired, but only that one can be immediately experienced which was used at the time at which one worked one's way from the state of an infant to that of a member of a language community. The concept of a national language as an experienced language, as opposed to a foreign language which has been learnt or a technical language which has been agreed upon, rests on the natural fact that this ascent occurs only once in the lifetime of each person.

[. . .]

'Experienced language', therefore, on the one hand has the subjective, limited, and natural affective value of childhood: on the other, a value of achievement, which is objective, spiritual, and has a general human significance. In the concept of a national language these two values and aspects rival each other. We love the English language as the experience of our childhood and the gift of our fathers and mothers; but we also value it as a cultural possession or capital, in which the achievements of the English spirit are invested and bear interest. Our natural predilection is for the dialect of our home; our objective judgment is more partial to the written language. We look on the former with the fondness we have for a series of successful youthful escapades; of the latter we are proud, as of the achievements of manhood.

National feeling, then, is dependent on national language, and oscillates between love and pride. The value we attach to our national language is our national pride. It is our whole, undiminished, undivided, complete national pride, but concentrated on language only.

If an ancient Greek or Roman, or a Christian of the Middle Ages were to descend

to our present vale of tears and observe that we destroy each other not only for the sake of wealth and power, but even for the sake of which languages are to predominate in this or that frontier state, our cultural ancestors would be considerably astonished.

Wars and laws and prohibitions about language, such as we have experienced in Alsace Lorraine, Belgium, Schleswig Holstein, Poland, Czecho Slovakia, and the Tirol – to mention only the immediate neighbourhood of Germany – were unknown in the past. In Naples, for instance, the Greek language was allowed to exist during the whole of the Roman world empire. Greek inscriptions are found there as late as the seventh century AD. When the emperors came on a visit, they willingly deferred to the Greek style of life of the country. The emperor Claudius had Greek plays performed there. We know similar things about the other coastal towns of southern Italy. In the senate at Syracuse, Cicero, a Roman official, spoke Greek; and if his compatriots took this amiss, it was because of a proper regard for Roman dignity, and not through language intolerance. The Romans never made war on the languages of the countries conquered by them. Evidently they were not as childish and as childishly enamoured of their mother tongue as the nations of to-day; but they felt all the more certain, proud, and untroubled about their cultural superiority. Once the sway of Roman law had been ruthlessly established in Spain and Gaul, the sway of the Latin tongue was allowed to establish itself peacefully and gently. Hence Iberian in Spain and Celtic in Gaul died a natural and painless death. As far as we know there was no struggle and no complaint.

To-day, I suppose, no language in Europe will allow itself to be extinguished as quietly. Provincialisms and dialects at most can still occasionally dissolve in this sickly and consumptive manner – and even then sorrowful philologists will stand at the sick bed. They die peacefully and without resisting, like those ancient languages of the Iberians and Gauls, largely because their extinction brings with it the entrance into a higher, culturally superior language community. But even this is not always the case. In Ireland the old language of the country, which has sunk to the status of a dialect, still defends itself as well as it can against English; in Switzerland Rhæto-Romanic resists German, and, in its fight against its nordic assailant, borrows weapons from its southern neighbour, and so is becoming italianized. Why does Rhæto-Romanic, in so far as it makes the effort at all, defend itself only feebly against Italian, which is also a menace to its existence? Because Rhæto-Romanic knows or feels that it is related to Italian. That is the important point; the feeling of racial similarity, the sense of nationality.

A language is defended more obstinately the more alive the feeling and the clearer the consciousness that it is a matter of preserving one's own tribal, racial, and national characteristics.

[...]

Since at the present time we mostly see national languages around us, we have become accustomed to think of race and language as being inseparably interwoven. When a census of the races inhabiting Austria was taken, language was the sole criterion; and, in fact, there was no other reliable characteristic. Those who spoke German, that is, professed to German as their usual language,

belonged to the German race; those who spoke Italian or Polish were classified as Italians or Poles in the racial, not the national sense. In doubtful cases a national language is like a church – one can belong to it, and also change it. That language binds us into nations is a natural *historical* fact, but not a *law* of nature.

Not every language community is at the same time a community of peoples. A language can bring men together in a hundred different kinds of communities. Latin to begin with was the language of the Latin race. In the course of time it became the language of the Roman state, then the language of the Catholic church, and finally the paper language of scholars. Similarly there are trade languages, like English overseas, criminal languages like *Rotwelsch* (thieves' language), unnatural, artificial world languages like Volapük and Esperanto, and finally as many special languages as there are special interests that bind men into castes and professions. In the Spain of the Middle Ages an artificial Galicio-Portuguese language existed beside Castilian up to the fifteenth century, but was reserved exclusively for the love lyrics of the court. King Alfonso el Sabio wrote his prose works in Castilian, his love lyrics in Galician, and a specially noble kind of love song in Provençal, according to the interests of the readers to whom he was addressing himself. How many languages fill the air of a modern city like Vienna, Constantinople, Cairo, New York, or Chicago. In such places men are bred who become as characterless in language intercourse as money is in trade. The Viennese plutocrat who hankers after money and 'culture', will speak Czech with his maid, Hungarian with his coachman, French with his mistress, Italian with his music master, English with his governess, and, if he has time and is in the mood, German with his family. This would almost lead one to believe that it is the nature of language not to have a being of its own, with its own purpose and value, but to have value merely as a medium of exchange.

In a certain sense it is true that the predominance or victory of one language over another is determined by the interplay of forces of the practical factors that arise from time to time. Research has given us numerous examples that show how language frontiers are determined and shifted by military, political, ecclesiastical, and economic needs, and how the weaker interest must always give way to the stronger. In Switzerland, a free and peaceful country, in which attempts are no longer made to advance this or that language by military or administrative compulsion, the movement of languages is determined solely by economic factors. The routes of communication decide the matter. The Gotthard railway carries German into the Tessin, the Simplon line takes Romance to the North, the federal lines and the line Basle-Biel, again, are routes along which German advances against French. In Wallis, however, French enters from the West by means of the railway, whilst German, which has to come from the East by means of the stage-coach, can make hardly any progress.[2]

But once a people has had its sense of nationality awakened and stands guard over its national language, all trade routes, needs and necessities, and all compulsory measures of police, state, or church must fail. That was seen in Poland. When their civic freedom and unity had been taken from the Poles and shattered, they sang Polish songs. They clung to their language as the last sign, security, and symbol of their national character and unity. The more rigidly they were prohibited from using their language in public, the prouder, deeper, more

war-like, and religious became their love for it. Now it showed to the full its spiritual value to the community, and it was spoken and tended for its own sake alone, for the sake of the Polish sentiment, in defiance of all external oppression. Since every word could now lead to prison or banishment, every Polish sound became part of the national fame; to the brother a greeting from the soul, a gesture of defiance to the enemy. Here we see in divine nakedness what so many politicians – and not only politicians, but even philologists – do not see: the ideal form urge, and the instinct for self-preservation that are immanent in every language, in so far as it is in any way the expression of spiritual characteristics and a spiritual community. To many of our German brothers who have fallen under an iniquitous foreign yoke, their language has become the last, dearest, and tenderest pledge of national memories and hopes. Since its more concrete supports in every-day intercourse have been shattered or undermined, it no longer has any other value than that of focussing common hopes and aspirations. It retreats into private, family and social life; and if it is no longer tended there, it has to die. Hence the request of the German nation to German society at home and abroad, that its language must be tended and protected. It is a purely political demand, not a moral or religious one. Nevertheless it is addressed to the moral and religious forces of our conscience and our metaphysical will; for if it is to be achieved here and now, it must appeal to the forces beyond us. A demand that is made on our social behaviour without political pressure, but with metaphysical power, is called a debt of honour. The sense of honour is the spiritual instinct of self-preservation; for in the communities of men and of peoples the man who is without honour is dead.

So there is, in fact, a national, linguistic sense of honour, or at any rate there should and must be one, since and as long as there are national wars about languages and attempts at throttling them. If a man is robbed of his earthly home, he finds a spiritual home in his mother tongue, which is everywhere and always present to his senses, and can therefore at some time again become concrete and have an earthly home. This is true of national and political, as well as of religious and sectarian communities. For example, the more the Jews were persecuted, the more closely they clung to the language of their synagogue, protected the lyrical soul and the ancient writings of Hebrew as the home of their beliefs, and barricaded themselves behind them. In a similar way a poet, filled with his emotions, shuts himself off from the demands and the turmoil of the world, in order to become an inner ear to these emotions, and their purest and clearest voice. It is true of every feeling, and therefore also of national feeling, that, when it has been excluded from every other refuge, language will become the spiritual fortress from which it will break out and conquer its environment when the times are propitious. The man who denies or gives up this last refuge and sally-port of his home sentiments, is without honour; he is dead to the community in which he received his first experience of human language.

[. . .]

Notes

1 Examples of such differences in instrumentation have been historically explained and didactically well chosen by Ferdinand Sommer in his book, *Vergleichende Syntax der Schulsprachen*, Leipzig, 1921. (German, English, French, Greek, and Latin.)

2 Morf, *Aus Dichtung und Sprache der Romanen*, II, 1911, p. 258 ff.

Leonard Bloomfield

SPEECH-COMMUNITIES (1933)

A speech-community is a group of people who interact by means of speech. All the so-called higher activities of man – our specifically human activities – spring from the close adjustment among individuals which we call society, and this adjustment, in turn, is based upon language; the speech-community, therefore, is the most important kind of social group. Other phases of social cohesion, such as economic, political, or cultural groupings, bear some relation to the grouping by speech-communities, but do not usually coincide with it; cultural features, especially, are almost always more widespread than any one language. Before the coming of the white man, an independent Indian tribe which spoke a language of its own, formed both a speech-community and a political and economic unit; as to religion and general culture, however, it resembled neighboring tribes. Under more complex conditions there is less correlation between language and the other groupings. The speech-community which consists of all English-speaking people is divided into two political communities: the United States and the British Empire, and each of these is in turn subdivided; economically, the United States and Canada are more closely united than politically; culturally, we are part of a great area which radiates from western Europe. On the other hand, even the narrowest of these groups, the political United States, includes persons who do not speak English: American Indians, Spanish-speakers in the Southwest, and linguistically unassimilated immigrants. Colonial occupation, as in the Philippines or India, puts a speech-community into political and economic dependence upon a foreign speech-community. In some countries the population is divided into several speech-communities that exist together without local division: a town in Poland consists of Polish-speaking and German-speaking people; by religion, the former are Catholics, the latter Jews, and, until quite recently, very few persons in either group troubled themselves to understand the other group's language.

I have said nothing about biological grouping, because this does not, like the other groupings, depend upon language for its existence. Most matings, of course, take place between persons of like speech, so that a speech-community

is always something of an inbred group; the exceptions, however, are very many, both in the mating of persons of different speech, one of whom usually acquires the other's language, and, what is more important, in the assimilation into a speech-community of whole groups of foreigners, such as immigrants, conquered people, or captives. These deviations are so many that, if we had records, we should doubtless find very few persons whose ancestors of a few generations ago all spoke the same language. What concerns us most, however, is the fact that the features of a language are not inherited in the biologic sense. A child cries out at birth and would doubtless in any case after a time take to gurgling and babbling, but the particular language he learns is entirely a matter of environment. An infant that gets into a group as a foundling or by adoption, learns the language of the group exactly as does a child of native parentage; as he learns to speak, his language shows no trace of whatever language his parents may have spoken. Whatever hereditary differences there may be in the structure of the larynx, mouth, lips, and so on, of normal human beings, it is certain that these differences are not such as to affect the actions which make up language. The child learns to speak like the persons round him. The first language a human being learns to speak is his *native language*; he is a *native speaker* of this language.

[...]

The difficulty or impossibility of determining in each case exactly what people belong to the same speech-community, is not accidental, but arises from the very nature of speech-communities. If we observed closely enough, we should find that no two persons – or rather, perhaps, no one person at different times – spoke exactly alike. To be sure, within a relatively homogeneous set of speakers – say, the native speakers of English in the Middle Western part of the United States – the habits of speech are far more uniform than the needs of communication would demand. We see the proof of this when an outsider – say, a Southerner or an Englishman or a foreigner who has mastered English – comes into our midst: his speech may be so much like ours as to cause not the slightest difficulty in communication, and yet strikingly noticeable on account of inessential differences, such as "accent" and "idiom." Nevertheless there are great differences even among the native members of such a relatively uniform group as Middle Western American, and, as we have just seen, even greater differences within a speech-community (e.g. English) as a whole. These differences play a very important part in the history of languages; the linguist is forced to consider them very carefully, even though in some of his work he is forced provisionally to ignore them. When he does this, he is merely employing the method of abstraction, a method essential to scientific investigation, but the results so obtained have to be corrected before they can be used in most kinds of further work.

The difference between speakers is partly a matter of bodily make-up and perhaps of purely personal habit; we recognize our friends by their voices from the next room and over the telephone. Some people are more talented for speech than others: they remember more words and turns of phrase, apply them better to the situation, and combine them in more pleasing style; the extreme case is the literary genius. Sometimes convention assigns certain speech-forms to certain speakers, as when the soldier, the well-trained servant, and the child in certain

schools, learn to say *sir* or *ma'm* to certain persons, who do not reciprocate. Some exclamations, such as *Goodness gracious!* or *Dear me!* are largely reserved for the use of women. In some communities very different speech-forms are conventional for the sexes. The classical instance is that of the Carib Indians; a recently authenticated one is the language of the Yana Indians in northern California. Examples of Yana words are:

	MEN'S LANGUAGE	WOMEN'S LANGUAGE
"fire"	*'auna*	*'auh*
"my fire"	*'aunija*	*'au'nich'*
"deer"	*bana*	*ba'*
"grizzly-bear"	*t'en'na*	*t'et'*

The differences between the two sets of Yana forms can be stated by means of a fairly complex set of rules.

The most important differences of speech within a community are due to differences in *density of communication*. The infant learns to speak like the people round him. [...] Every speaker's language, except for personal factors which we must here ignore, is a composite result of what he has heard other people say.

Imagine a huge chart with a dot for every speaker in the community, and imagine that every time any speaker uttered a sentence, an arrow were drawn into the chart pointing from his dot to the dot representing each one of his hearers. At the end of a given period of time, say seventy years, this chart would show us the density of communication within the community. Some speakers would turn out to have been in close communication: there would be many arrows from one to the other, and there would be many series of arrows connecting them by way of one, two, or three intermediate speakers. At the other extreme there would be widely separated speakers who had never heard each other speak and were connected only by long chains of arrows through many intermediate speakers. If we wanted to explain the likeness and unlikeness between various speakers in the community, or, what comes to the same thing, to predict the degree of likeness for any two given speakers, our first step would be to count and evaluate the arrows and series of arrows connecting their dots. We shall see in a moment that this would be only the first step; the reader of this book, for instance, is more likely to repeat a speech-form which he has heard, say, from a lecturer of great fame, than one which he has heard from a street-sweeper.

The chart we have imagined is impossible of construction. An insurmountable difficulty, and the most important one, would be the factor of time: starting with persons now alive, we should be compelled to put in a dot for every speaker whose voice had ever reached anyone now living, and then a dot for every speaker whom these speakers had ever heard, and so on, back beyond the days of King Alfred the Great, and beyond earliest history, back indefinitely into the primeval dawn of mankind: our speech depends entirely upon the speech of the past.

Since we cannot construct our chart, we depend instead upon the study of indirect results and are forced to resort to hypothesis. We believe that the differences in density of communication within a speech-community are not only

personal and individual, but that the community is divided into various systems of sub-groups such that the persons within a sub-group speak much more to each other than to persons outside their sub-group. Viewing the system of arrows as a network, we may say that these sub-groups are separated by *lines of weakness* in this net of oral communication. The lines of weakness and, accordingly, the differences of speech within a speech-community are *local* – due to mere geographic separation – and *non-local*, or as we usually say, *social*. In countries over which a speech-community has recently spread and settled, the local differences are relatively small, as, say, in the United States (especially the western part) or Russia; in countries that have been long settled by the same speech-community the local differences are much greater, as, say, in England, where English has been spoken for some 1500 years, or in France where Latin (now called French) has been spoken for two thousand years.

We shall examine first the simpler case, as it appears in the United States. The most striking line of cleavage in our speech is one of social class. Children who are born into homes of privilege, in the way of wealth, tradition, or education, become native speakers of what is popularly known as "good" English; the linguist prefers to give it the non-committal name of *standard* English. Less fortunate children become native speakers of "bad" or "vulgar" or, as the linguist prefers to call it, *non-standard* English. For instance, *I have none, I haven't any, I haven't got any* are standard ("good") English, but *I ain't got none* is non-standard ("bad") English.

These two main types of American English are by no means treated alike. The standard forms are used in school, in church, and in all discourse that officially concerns the whole community, as in law-courts and legislative assemblies. All our writing (except by way of jest) is based on the standard forms, and these forms are registered in grammars and dictionaries and presented in text-books to foreigners who want to learn our language. Both groups of speakers, standard and non-standard, agree in calling the standard forms "good" or "correct" and non-standard forms "bad," "incorrect," "vulgar," or even, "not English." The speaker of standard English does not trouble himself to learn the non-standard forms, but very many speakers of non-standard English try to use the standard forms. A native of the less favored group who acquires prestige, say, in the way of wealth or political eminence, is almost sure to learn, as well as may be, the standard forms of speech; in fact, noticeable lapses in this respect – even a single *I seen it* or *I done it* – may endanger his newly acquired position.

[. . .]

Within the standard language, further, there are differences that obviously depend upon density of communication: different economic classes – say, the very rich and the so-called "middle class" in its various gradations – differ in speech. Then there are differences of education, in the way both of family tradition and of schooling. These differences are crossed by less important divisions of technical occupation: different kinds of craftsmen, merchants, engineers, lawyers, physicians, scientists, artists, and so on, differ somewhat in speech. Sports and hobbies have at least their own vocabulary. The factor of age-groups will concern us later; it is a tremendous force, but works almost unseen, and

scarcely appears on the level that now concerns us, except perhaps in young people's fondness for slang.

The most stable and striking differences, even in the United States and even in our standard language, are geographic. In the United States we have three great geographic types of standard English: New England, Central-Western and Southern. Within these types there are smaller local differences: speakers of standard English from older-settled parts of the country can often tell a fellow-speaker's home within fairly narrow limits. In matters of pronunciation, especially, the range of standard English in America is wide: greatly different pronunciations, such as those, say, of North Carolina and Chicago, are accepted equally as standard. Only from the stage do we demand a uniform pronunciation, and here our actors use a British type rather than an American. In England there are similar regional types, but they are not granted equal value. The highest social recognition is given to the "public school" English of the south. The innumerable gradations from this towards the decidedly provincial types of standard, enjoy less prestige as they depart from the most favored type. The social recognition of a speaker of standard English from Scotland or Yorkshire or Lancashire, depends in part upon how closely his pronunciation approaches the upper-class southern type. In England, but scarcely in the United States, provincial colorings of standard English are tied up with differences of social level.

Non-standard speech shows greater variety than standard. The higher the social position of the non-standard speaker, the more nearly does he approach the standard language. At the top are the transitional speakers who use an almost standard form of speech, with only a sprinkling of non-standard forms, and perhaps a pronunciation with too provincial a twang. At the bottom are the unmistakably rustic or proletarian speakers who make no pretense at using standard forms.

Apart from this continuous gradation, various groups of non-standard speakers have their own speech-forms. Occupational groups, such as fishermen, dairy workers, bakers, brewers, and so on, have, at any rate, their own technical language. Especially, minor groups who are in any way cut off from the great mass, use clearly-marked varieties of speech. Thus, sea-faring men used to speak their own type of non-standard English. Tramps and some kinds of law-breakers have many speech-forms of their own; so do circus people and other wandering entertainers. Among non-standard speakers of German, Christians and Jews, and in some places Catholics and Protestants, differ in many of their linguistic forms. If the special group is at odds with the rest of the community, it may use its peculiarities of speech as a *secret* dialect, as do the English-speaking Gipsies. Criminals in various countries have also developed such secret dialects.

The greatest diversity in non-standard speech, however, is geographic. The geographic differences, which we hear even in the standard English of the United States, are more audible when we listen to non-standard speakers. In remote districts within the older-settled parts of the country these local characteristics are very pronounced, to the point where we may describe them as *local dialects*.

In older-settled speech-communities, the type exemplified by France, or by the British part of the English-speaking group, local dialects play a much greater part. In such communities the non-standard language can be divided, roughly, to

be sure, and without a sharp demarcation, into *sub-standard* speech, intelligible at least, though not uniform, throughout the country, and *local dialect*, which differs from place to place to such an extent that speakers living some distance apart may fail to understand each other. Sub-standard speech, in such countries, belongs to the "lower middle class" – to the more ambitious small tradesfolk, mechanics, or city workmen – and the local dialects are spoken by the peasants and the poorest people of the towns.

The local dialects are of paramount importance to the linguist, not merely because their great variety gives him work to do, but because the origin and history of the standard and sub-standard types of speech can be understood only in the light of the local dialects. Especially during the last decades, linguists have come to see that *dialect geography* furnishes the key to many problems.

In a country like France, Italy, or Germany – better studied in this respect than England – every village or, at most, every group of two or three villages, has its own local dialect. The differences between neighboring local dialects are usually small, but recognizable. The villagers are ready to tell in what way their neighbors' speech differs from theirs, and often tease their neighbors about these peculiarities. The difference from place to place is small, but, as one travels in any one direction, the differences accumulate, until speakers, say from opposite ends of the country, cannot understand each other, although there is no sharp line of linguistic demarcation between the places where they live. Any such geographic area of gradual transitions is called a *dialect area*.

[. . .]

The speakers' attitude toward local dialects differs somewhat in different countries. In England the local dialects have little prestige; the upper-class speaker does not bother with them and the native speaker of a local dialect who rises socially will try to cast it off, even if only in exchange for some form of sub-standard speech. The Germans, on the other hand, have developed, within the last century, a kind of romantic fondness for local dialects. While the middle-class speaker, who is not quite sure of his social position, will shy away from them, some upper-class Germans make it a point to speak the local dialect of their home. In German Switzerland this goes farthest: even the upper-class Swiss, who is familiar with standard German, uses local dialect as the normal medium of communication in his family and with his neighbors.

The main types of speech in a complex speech-community can be roughly classed as follows:

1 *literary standard*, used in the most formal discourse and in writing (example: *I have none*);
2 *colloquial standard*, the speech of the privileged class (example: *I haven't any* or *I haven't got any* – in England only if spoken with the southern "public school" sounds and intonation);
3 *provincial standard*, in the United States probably not to be differentiated from (2), spoken by the "middle" class, very close to (2), but differing slightly from province to province (example: *I haven't any* or *I haven't got*

any, spoken, in England, with sounds or intonations that deviate from the "public school" standard);

4 *sub-standard*, clearly different from (1), (2), and (3), spoken in European countries by the "lower middle" class, in the United States by almost all but the speakers of type (2–3), and differing topographically, without intense local difference (example: *I ain't got none*);

5 *local dialect*, spoken by the least privileged class; only slightly developed in the United States; in Switzerland used also, as a domestic language, by the other classes; differs almost from village to village; the varieties so great as often to be incomprehensible to each other and to speakers of (2–3–4) (Example: *a hae nane*).

Our survey of differences within a speech-community has shown us that the members of a speech-community may speak so much alike that anyone can understand anyone else, or may differ so much that persons who live some distance apart may fail to understand each other. The former case is illustrated by an Indian tribe of a few hundred persons, the latter by a farflung speech community like English, where an American and a dialect-speaking Yorkshireman, for instance, do not understand each other's speech. Actually, however, we can draw no line between the two cases, because there are all kinds of gradations between understanding and failing to understand. Whether the American and the Yorkshireman understand each other, may depend on the intelligence of the two individuals concerned, upon their general experience with foreign dialects or languages, upon their disposition at the moment, upon the extent to which the situation clarifies the value of the speech-utterance, and so on. Again, there are endless gradations between local and standard speech; either or both persons may make concessions which aid understanding, and these concessions will usually run in the direction of the standard language.

All this prevents our drawing a plain line round the borders of many a speech community. The clear cases are those where two mutually unintelligible languages abut on each other, as do, say, English and Spanish in our Southwest. Here each person's native language – if, for simplicity sake, we ignore the languages of Indians and recent immigrants – is either English or Spanish, and we can draw an imaginary line, a *language boundary*, which will separate the English-speakers from the Spanish-speakers. This language boundary will of course not appear as a simple and fixed line between two topographically solid communities. There will be English-speaking settlements thrown out, in the shape of *speech-islands*, into totally Spanish surroundings, and, vice versa, Spanish speech-islands surrounded by English-speaking communities. Families and individuals of either group will be found living among the other and will have to be enclosed in a separate little circle of our language boundary. Our language boundary, then, consists not only of a great irregular line, but also of many little closed curves around speech-islands, some of which contain only a single family or a single person. In spite of its geometrical complexity and of its instability from day to day, this language boundary at any rate represents a plain distinction. It is true that linguistic scholars have found enough resemblance between English and Spanish to prove beyond a doubt that these languages are

related, but the resemblance and relationship are too distant to affect the question with which we are here concerned.

[. . .]

The purely relative nature of this distinction appears more plainly in other cases. We speak of French and Italian, of Swedish and Norwegian, of Polish and Bohemian as separate languages, because these communities are politically separate and use different standard languages, but the differences of local speech-forms at the border are in all these cases relatively slight and no greater than the differences which we find within each of these speech-communities. The question comes down to this: what degree of difference between adjoining speech-forms justifies the name of a language border? Evidently, we cannot weigh differences as accurately as all this. In some cases, certainly, our habits of nomenclature will not apply to linguistic conditions. The local dialects justify no line between what we call German and what we call Dutch-Flemish: the Dutch-German speech area is linguistically a unit, and the cleavage is primarily political; it is linguistic only in the sense that the political units use different standard languages. In sum, the term *speech-community* has only a relative value. The possibility of communication between groups, or even between individuals, ranges all the way from zero up to the most delicate adjustment. It is evident that the intermediate degrees contribute very much to human welfare and progress.

Mikhail Bakhtin

UNITARY LANGUAGE (1934–5)

[...] Philosophy of language, linguistics and stylistics (i.e., such as they have come down to us) have all postulated a simple and unmediated relation of speaker to his unitary and singular "own" language, and have postulated as well a simple realization of this language in the monologic utterance of the individual. Such disciplines actually know only two poles in the life of language, between which are located all the linguistic and stylistic phenomena they know: on the one hand, the system of a *unitary language*, and on the other the *individual* speaking in this language.

Various schools of thought in the philosophy of language, in linguistics and in stylistics have, in different periods (and always in close connection with the diverse concrete poetic and ideological styles of a given epoch), introduced into such concepts as "system of language," "monologic utterance," "the speaking *individuum*," various differing nuances of meaning, but their basic content remains unchanged. This basic content is conditioned by the specific sociohistorical destinies of European languages and by the destinies of ideological discourse, and by those particular historical tasks that ideological discourse has fulfilled in specific social spheres and at specific stages in its own historical development.

These tasks and destinies of discourse conditioned specific verbal-ideological movements, as well as various specific genres of ideological discourse, and ultimately the specific philosophical concept of discourse itself – in particular, the concept of poetic discourse, which had been at the heart of all concepts of style.

The strength and at the same time the limitations of such basic stylistic categories become apparent when such categories are seen as conditioned by specific historical destinies and by the task that an ideological discourse assumes. These categories arose from and were shaped by the historically *aktuell* forces at work in the verbal-ideological evolution of specific social groups; they comprised

the theoretical expression of actualizing forces that were in the process of creating a life for language.

These forces are *the forces that serve to unify and centralize the verbal-ideological world*.

Unitary language constitutes the theoretical expression of the historical processes of linguistic unification and centralization, an expression of the centripetal forces of language. A unitary language is not something given (*dan*) but is always in essence posited (*zadan*) – and at every moment of its linguistic life it is opposed to the realities of heteroglossia. But at the same time it makes its real presence felt as a force for overcoming this heteroglossia, imposing specific limits to it, guaranteeing a certain maximum of mutual understanding and crystalizing into a real, although still relative, unity – the unity of the reigning conversational (everyday) and literary language, "correct language."

A common unitary language is a system of linguistic norms. But these norms do not constitute an abstract imperative; they are rather the generative forces of linguistic life, forces that struggle to overcome the heteroglossia of language, forces that unite and centralize verbal-ideological thought, creating within a heteroglot national language the firm, stable linguistic nucleus of an officially recognized literary language, or else defending an already formed language from the pressure of growing heteroglossia.

What we have in mind here is not an abstract linguistic minimum of a common language, in the sense of a system of elementary forms (linguistic symbols) guaranteeing a *minimum* level of comprehension in practical communication. We are taking language not as a system of abstract grammatical categories, but rather language conceived as ideologically saturated, language as a world view, even as a concrete opinion, insuring a *maximum* of mutual understanding in all spheres of ideological life. Thus a unitary language gives expression to forces working toward concrete verbal and ideological unification and centralization, which develop in vital connection with the processes of sociopolitical and cultural centralization.

Aristotelian poetics, the poetics of Augustine, the poetics of the medieval church, of "the one language of truth," the Cartesian poetics of neoclassicism, the abstract grammatical universalism of Leibniz (the idea of a "universal grammar"), Humboldt's insistence on the concrete – all these, whatever their differences in nuance, give expression to the same centripetal forces in socio-linguistic and ideological life; they serve one and the same project of centralizing and unifying the European languages. The victory of one reigning language (dialect) over the others, the supplanting of languages, their enslavement, the process of illuminating them with the True Word, the incorporation of barbarians and lower social strata into a unitary language of culture and truth, the canonization of ideological systems, philology with its methods of studying and teaching dead languages, languages that were by that very fact "unities," Indo-European linguistics with its focus of attention, directed away from language plurality to a single proto-language – all this determined the content and power of the category of "unitary language" in linguistic and stylistic thought, and determined its creative, style-shaping role in the majority of the poetic genres that coalesced in the channel formed by those same centripetal forces of verbal-ideological life.

But the centripetal forces of the life of language, embodied in a "unitary language," operate in the midst of heteroglossia. At any given moment of its evolution, language is stratified not only into linguistic dialects in the strict sense of the word (according to formal linguistic markers, especially phonetic), but also – and for us this is the essential point – into languages that are socio-ideological: languages of social groups, "professional" and "generic" languages, languages of generations and so forth. From this point of view, literary language itself is only one of these heteroglot languages – and in its turn is also stratified into languages (generic, period-bound and others). And this stratification and heteroglossia, once realized, is not only a static invariant of linguistic life, but also what insures its dynamics: stratification and heteroglossia widen and deepen as long as language is alive and developing. Alongside the centripetal forces, the centrifugal forces of language carry on their uninterrupted work; alongside verbal-ideological centralization and unification, the uninterrupted processes of decentralization and disunification go forward.

Every concrete utterance of a speaking subject serves as a point where centrifugal as well as centripetal forces are brought to bear. The processes of centralization and decentralization, of unification and disunification, intersect in the utterance; the utterance not only answers the requirements of its own language as an individualized embodiment of a speech act, but it answers the requirements of heteroglossia as well; it is in fact an active participant in such speech diversity. And this active participation of every utterance in living heteroglossia determines the linguistic profile and style of the utterance to no less a degree than its inclusion in any normative-centralizing system of a unitary language.

Every utterance participates in the "unitary language" (in its centripetal forces and tendencies) and at the same time partakes of social and historical heteroglossia (the centrifugal, stratifying forces).

Such is the fleeting language of a day, of an epoch, a social group, a genre, a school and so forth. It is possible to give a concrete and detailed analysis of any utterance, once having exposed it as a contradiction-ridden, tension-filled unity of two embattled tendencies in the life of language.

The authentic environment of an utterance, the environment in which it lives and takes shape, is dialogized heteroglossia, anonymous and social as language, but simultaneously concrete, filled with specific content and accented as an individual utterance.

At the time when major divisions of the poetic genres were developing under the influence of the unifying, centralizing, centripetal forces of verbal-ideological life, the novel – and those artistic-prose genres that gravitate toward it – was being historically shaped by the current of decentralizing, centrifugal forces. At the time when poetry was accomplishing the task of cultural, national and political centralization of the verbal-ideological world in the higher official socio-ideological levels, on the lower levels, on the stages of local fairs and at buffoon spectacles, the heteroglossia of the clown sounded forth, ridiculing all "languages" and dialects; there developed the literature of the *fabliaux* and *Schwänke* of street songs, folksayings, anecdotes, where there was no language-center at all, where there was to be found a lively play with the "languages" of poets, scholars,

monks, knights and others, where all "languages" were masks and where no language could claim to be an authentic, incontestable face.

Heteroglossia, as organized in these low genres, was not merely heteroglossia *vis-à-vis* the accepted literary language (in all its various generic expressions), that is, *vis-à-vis* the linguistic center of the verbal-ideological life of the nation and the epoch, but was a heteroglossia consciously opposed to this literary language. It was parodic, and aimed sharply and polemically against the official languages of its given time. It was heteroglossia that had been dialogized.

Linguistics, stylistics and the philosophy of language that were born and shaped by the current of centralizing tendencies in the life of language have ignored this dialogized heteroglossia, in which is embodied the centrifugal forces in the life of language. For this very reason they could make no provision for the dialogic nature of language, which was a struggle among socio-linguistic points of view, not an intra-language struggle between individual wills or logical contradictions. Moreover, even intra-language dialogue (dramatic, rhetorical, cognitive or merely casual) has hardly been studied linguistically or stylistically up to the present day. One might even say outright that the dialogic aspect of discourse and all the phenomena connected with it have remained to the present moment beyond the ken of linguistics.

Stylistics has been likewise completely deaf to dialogue. A literary work has been conceived by stylistics as if it were a hermetic and self-sufficient whole, one whose elements constitute a closed system presuming nothing beyond themselves, no other utterances. The system comprising an artistic work was thought to be analogous with the system of a language, a system that could not stand in a dialogic interrelationship with other languages. From the point of view of stylistics, the artistic work as a whole – whatever that whole might be – is a self-sufficient and closed authorial monologue, one that presumes only passive listeners beyond its own boundaries. Should we imagine the work as a rejoinder in a given dialogue, whose style is determined by its interrelationship with other rejoinders in the same dialogue (in the totality of the conversation – then traditional stylistics does not offer an adequate means for approaching such a dialogized style. The sharpest and externally most marked manifestations of this stylistic category – the polemical style, the parodic, the ironic – are usually classified as rhetorical and not as poetic phenomena. Stylistics locks every stylistic phenomenon into the monologic context of a given self-sufficient and hermetic utterance, imprisoning it, as it were, in the dungeon of a single context; it is not able to exchange messages with other utterances; it is not able to realize its own stylistic implications in a relationship with them; it is obliged to exhaust itself in its own single hermetic context.

Linguistics, stylistics and the philosophy of language – as forces in the service of the great centralizing tendencies of European verbal-ideological life – have sought first and foremost for *unity* in diversity. This exclusive "orientation toward unity" in the present and past life of languages has concentrated the attention of philosophical and linguistic thought on the firmest, most stable, least changeable and most mono-semic aspects of discourse – on the *phonetic* aspects first of all – that are furthest removed from the changing socio-semantic spheres of discourse. Real ideologically saturated "language consciousness," one that participates in

actual heteroglossia and multi-languagedness, has remained outside its field of vision. It is precisely this orientation toward unity that has compelled scholars to ignore all the verbal genres (quotidian, rhetorical, artistic-prose) that were the carriers of the decentralizing tendencies in the life of language, or that were in any case too fundamentally implicated in heteroglossia. The expression of this hetero- as well as polyglot consciousness in the specific forms and phenomena of verbal life remained utterly without determinative influence on linguistics and stylistic thought.

Therefore proper theoretical recognition and illumination could not be found for the specific feel for language and discourse that one gets in stylizations, in *skaz*, in parodies and in various forms of verbal masquerade, "not talking straight," and in the more complex artistic forms for the organization of contradiction, forms that orchestrate their themes by means of languages – in all characteristic and profound models of novelistic prose, in Grimmelshausen, Cervantes, Rabelais, Fielding, Smollett, Sterne and others.

The problem of stylistics for the novel inevitably leads to the necessity of engaging a series of fundamental questions concerning the philosophy of discourse, questions connected with those aspects in the life of discourse that have had no light cast on them by linguistic and stylistic thought – that is, we must deal with the life and behavior of discourse in a contradictory and multi-languaged world.

[. . .]

Linguistics and the philosophy of language acknowledge only a passive understanding of discourse, and moreover this takes place by and large on the level of common language, that is, it is an understanding of an utterance's *neutral signification* and not its *actual meaning*.

The linguistic significance of a given utterance is understood against the background of language, while its actual meaning is understood against the background of other concrete utterances on the same theme, a background made up of contradictory opinions, points of view and value judgments – that is, precisely that background that, as we see, complicates the path of any word toward its object. Only now this contradictory environment of alien words is present to the speaker not in the object, but rather in the consciousness of the listener, as his apperceptive background, pregnant with responses and objections. And every utterance is oriented toward this apperceptive background of understanding, which is not a linguistic background but rather one composed of specific objects and emotional expressions. There occurs a new encounter between the utterance and an alien word, which makes itself felt as a new and unique influence on its style.

A passive understanding of linguistic meaning is no understanding at all, it is only the abstract aspect of meaning. But even a more concrete *passive* understanding of the meaning of the utterance, an understanding of the speaker's intention insofar as that understanding remains purely passive, purely receptive, contributes nothing new to the word under consideration, only mirroring it, seeking, at its most ambitious, merely the full reproduction of that which is already given in the word – even such an understanding never goes beyond the boundaries of the word's context and in no way enriches the word. Therefore, insofar as the speaker operates with such a passive understanding, nothing new

can be introduced into his discourse; there can be no new aspects in his discourse relating to concrete objects and emotional expressions. Indeed the purely negative demands, such as could only emerge from a passive understanding (for instance, a need for greater clarity, more persuasiveness, more vividness and so forth), leave the speaker in his own personal context, within his own boundaries; such negative demands are completely immanent in the speaker's own discourse and do not go beyond his semantic or expressive self-sufficiency.

In the actual life of speech, every concrete act of understanding is active: it assimilates the word to be understood into its own conceptual system filled with specific objects and emotional expressions, and is indissolubly merged with the response, with a motivated agreement or disagreement. To some extent, primacy belongs to the response, as the activating principle: it creates the ground for understanding, it prepares the ground for an active and engaged understanding. Understanding comes to fruition only in the response. Understanding and response are dialectically merged and mutually condition each other; one is impossible without the other.

Thus an active understanding, one that assimilates the word under consideration into a new conceptual system, that of the one striving to understand, establishes a series of complex inter-relationships, consonances and dissonances with the word and enriches it with new elements. It is precisely such an understanding that the speaker counts on. Therefore his orientation toward the listener is an orientation toward a specific conceptual horizon, toward the specific world of the listener; it introduces totally new elements into his discourse; it is in this way, after all, that various different points of view, conceptual horizons, systems for providing expressive accents, various social "languages" come to interact with one another. The speaker strives to get a reading on his own word, and on his own conceptual system that determines this word, within the alien conceptual system of the understanding receiver; he enters into dialogical relationships with certain aspects of this system. The speaker breaks through the alien conceptual horizon of the listener, constructs his own utterance on alien territory, against his, the listener's, apperceptive background.

[. . .]

Language – like the living concrete environment in which the consciousness of the verbal artist lives – is never unitary. It is unitary only as an abstract grammatical system of normative forms, taken in isolation from the concrete, ideological conceptualizations that fill it, and in isolation from the uninterrupted process of historical becoming that is a characteristic of all living language. Actual social life and historical becoming create within an abstractly unitary national language a multitude of concrete worlds, a multitude of bounded verbal-ideological and social belief systems; within these various systems (identical in the abstract) are elements of language filled with various semantic and axiological content and each with its own different sound.

Literary language – both spoken and written – although it is unitary not only in its shared, abstract, linguistic markers but also in its forms for conceptualizing these abstract markers, is itself stratified and heteroglot in its aspect as an expressive system, that is, in the forms that carry its meanings.

This stratification is accomplished first of all by the specific organisms called *genres*. Certain features of language (lexicological, semantic, syntactic) will knit together with the intentional aim, and with the overall accentual system inherent in one or another genre: oratorical, publicistic, newspaper and journalistic genres, the genres of low literature (penny dreadfuls, for instance) or, finally, the various genres of high literature. Certain features of language take on the specific flavor of a given genre: they knit together with specific points of view, specific approaches, forms of thinking, nuances and accents characteristic of the given genre.

In addition, there is interwoven with this generic stratification of language a *professional* stratification of language, in the broad sense of the term "professional": the language of the lawyer, the doctor, the businessman, the politician, the public education teacher and so forth, and these sometimes coincide with, and sometimes depart from, the stratification into genres. It goes without saying that these languages differ from each other not only in their vocabularies; they involve specific forms for manifesting intentions, forms for making conceptualization and evaluation concrete. And even the very language of the writer (the poet or novelist) can be taken as a professional jargon on a par with professional jargons.

What is important to us here is the intentional dimensions, that is, the denotative and expressive dimension of the "shared" language's stratification. It is in fact not the neutral linguistic components of language being stratified and differentiated, but rather a situation in which the intentional possibilities of language are being expropriated: these possibilities are realized in specific directions, filled with specific content, they are made concrete, particular, and are permeated with concrete value judgments; they knit together with specific objects and with the belief systems of certain genres of expression and points of view peculiar to particular professions. Within these points of view, that is, for the speakers of the language themselves, these generic languages and professional jargons are directly intentional – they denote and express directly and fully, and are capable of expressing themselves without mediation; but outside, that is, for those not participating in the given purview, these languages may be treated as objects, as typifactions, as local color. For such outsiders, the intentions permeating these languages become *things*, limited in their meaning and expression; they attract to, or excise from, such language a particular word – making it difficult for the word to be utilized in a directly intentional way, without any qualifications.

But the situation is far from exhausted by the generic and professional stratification of the common literary language. Although at its very core literary language is frequently socially homogeneous, as the oral and written language of a dominant social group, there is nevertheless always present, even here, a certain degree of social differentiation, a social stratification, that in other eras can become extremely acute. Social stratification may here and there coincide with generic and professional stratification, but in essence it is, of course, a thing completely autonomous and peculiar to itself.

Social stratification is also and primarily determined by differences between the forms used to convey meaning and between the expressive planes of various belief systems – that is, stratification expresses itself in typical differences in ways used to conceptualize and accentuate elements of language, and stratification may

not violate the abstractly linguistic dialectological unity of the shared literary language.

What is more, all socially significant world views have the capacity to exploit the intentional possibilities of language through the medium of their specific concrete instancing. Various tendencies (artistic and otherwise), circles, journals, particular newspapers, even particular significant artistic works and individual persons are all capable of stratifying language, in proportion to their social significance; they are capable of attracting its words and forms into their orbit by means of their own characteristic intentions and accents, and in so doing to a certain extent alienating these words and forms from other tendencies, parties, artistic works and persons.

Every socially significant verbal performance has the ability – sometimes for a long period of time, and for a wide circle of persons – to infect with its own intention certain aspects of language that had been affected by its semantic and expressive impulse, imposing on them specific semantic nuances and specific axiological overtones; thus, it can create slogan-words, curse-words, praise-words and so forth.

In any given historical moment of verbal-ideological life, each generation at each social level has its own language; moreover, every age group has as a matter of fact its own language, its own vocabulary, its own particular accentual system that, in their turn, vary depending on social level, academic institution (the language of the cadet, the high school student, the trade school student are all different languages) and other stratifying factors. All this is brought about by socially typifying languages, no matter how narrow the social circle in which they are spoken. It is even possible to have a family jargon define the societal limits of a language, as, for instance, the jargon of the Irtenevs in Tolstoy, with its special vocabulary and unique accentual system.

And finally, at any given moment, languages of various epochs and periods of socio-ideological life cohabit with one another. Even languages of the day exist: one could say that today's and yesterday's socio-ideological and political "day" do not, in a certain sense, share the same language; every day represents another socio-ideological semantic "state of affairs," another vocabulary, another accentual system, with its own slogans, its own ways of assigning blame and praise. Poetry depersonalizes "days" in language, while prose, as we shall see, often deliberately intensifies difference between them, gives them embodied representation and dialogically opposes them to one another in unresolvable dialogues.

Thus, at any given moment of its historical existence, language is heteroglot from top to bottom: it represents the co-existence of socio-ideological contradictions between the present and the past, between differing epochs of the past, between different socio-ideological groups in the present, between tendencies, schools, circles and so forth, all given a bodily form. These "languages" of heteroglossia intersect each other in a variety of ways, forming new socially typifying "languages."

Each of these "languages" of heteroglossia requires a methodology very different from the others; each is grounded in a completely different principle for marking differences and for establishing units (for some this principle is functional, in other it is the principle of theme and content, in yet others it is,

properly speaking, a socio-dialectological principle). Therefore, languages do not *exclude* each other, but rather intersect with each other in many different ways (the Ukrainian language, the language of the epic poem, of early Symbolism, of the student, of a particular generation of children, of the run-of-the-mill intellectual, of the Nietzschean and so on). It might even seem that the very word "language" loses all meaning in this process – for apparently there is no single plane on which all these "language" might be juxtaposed to one another.

In actual fact, however, there does exist a common plane that methodologically justifies our juxtaposing them: all languages of heteroglossia, whatever the principle underlying them and making each unique, are specific points of view on the world, forms for conceptualizing the world in words, specific world views, each characterized by its own objects, meanings and values. As such they all may be juxtaposed to one another, mutually supplement one another, contradict one another and be interrelated dialogically. As such they encounter one another and co-exist in the consciousness of real people – first and foremost, in the creative consciousness of people who write novels. As such, these languages live a real life, they struggle and evolve in an environment of social heteroglossia. Therefore they are all able to enter into the unitary plane of the novel, which can unite in itself parodic stylizations of generic languages, various forms of stylizations and illustrations of professional and period-bound languages, the languages of particular generations, of social dialects and others (as occurs, for example, in the English comic novel). They may all be drawn in by the novelist for the orchestration of his themes and for the refracted (indirect) expression of his intentions and values.

This is why we constantly put forward the referential and expressive – that is, intentional – factors as the force that stratifies and differentiates the common literary language, and not the linguistic markers (lexical coloration, semantic overtones, etc.) of generic languages, professional jargons and so forth – markers that are, so to speak, the sclerotic deposits of an intentional process, signs left behind on the path of the real living project of an intention, of the particular way it imparts meaning to general linguistic norms. These external markers, linguistically observable and fixable, cannot in themselves be understood or studied without understanding the specific conceptualization they have been given by an intention.

Discourse lives, as it were, beyond itself, in a living impulse (*napravlennost'*) toward the object; if we detach ourselves completely from this impulse all we have left is the naked corpse of the word, from which we can learn nothing at all about the social situation or the fate of a given word in life. *To study the word as such, ignoring the impulse that reaches out beyond it, is just as senseless as to study psychological experience outside the context of that real life toward which it was directed and by which it is determined.*

By stressing the intentional dimension of stratification in literary language, we are able, as has been said, to locate in a single series such methodologically heterogeneous phenomena as professional and social dialects, world views and individual artistic works, for in their intentional dimension one finds that common plane on which they can all be juxtaposed, and juxtaposed dialogically. The whole matter consists in the fact that there may be, between "languages," highly

specific dialogic relations; no matter how these languages are conceived, they may all be taken as particular points of view on the world. However varied the social forces doing the work of stratification – a profession, a genre, a particular tendency, an individual personality – the work itself everywhere comes down to the (relatively) protracted and socially meaningful (collective) saturation of language with specific (and consequently limiting) intentions and accents. The longer this stratifying saturation goes on, the broader the social circle encompassed by it and consequently the more substantial the social force bringing about such a stratification of language, then the more sharply focused and stable will be those traces, the linguistic changes in the language markers (linguistic symbols), that are left behind in language as a result of this social force's activity – from stable (and consequently social) semantic nuances to authentic dialectological markers (phonetic, morphological and others), which permit us to speak of particular social dialects.

As a result of the work done by all these stratifying forces in language, there are no "neutral" words and forms – words and forms that can belong to "no one"; language has been completely taken over, shot through with intentions and accents. For any individual consciousness living in it, language is not an abstract system of normative forms but rather a concrete heteroglot conception of the world. All words have the "taste" of a profession, a genre, a tendency, a party, a particular work, a particular person, a generation, an age group, the day and hour. Each word tastes of the context and contexts in which it has lived its socially charged life; all words and forms are populated by intentions. Contextual overtones (generic, tendentious, individualistic) are inevitable in the word.

As a living, socio-ideological concrete thing, as heteroglot opinion, language, for the individual consciousness, lies on the borderline between oneself and the other. The word in language is half someone else's. It becomes "one's own" only when the speaker populates it with his own intention, his own accent, when he appropriates the word, adapting it to his own semantic and expressive intention. Prior to this moment of appropriation, the word does not exist in a neutral and impersonal language (it is not, after all, out of a dictionary that the speaker gets his words!), but rather it exists in other people's mouths, in other people's contexts, serving other people's intentions: it is from there that one must take the word, and make it one's own. And not all words for just anyone submit equally easily to this appropriation, to this seizure and transformation into private property: many words stubbornly resist, others remain alien, sound foreign in the mouth of the one who appropriated them and who now speaks them; they cannot be assimilated into his context and fall out of it; it is as if they put themselves in quotation marks against the will of the speaker. Language is not a neutral medium that passes freely and easily into the private property of the speaker's intentions; it is populated – overpopulated – with the intentions of others. Expropriating it, forcing it to submit to one's own intentions and accents, is a difficult and complicated process.

We have so far proceeded on the assumption of the abstract-linguistic (dialectological) unity of literary language. But even a literary language is anything but a closed dialect. Within the scope of literary language itself there is already a more or less sharply defined boundary between everyday conversational language

and written language. Distinctions between genres frequently coincide with dialectological distinctions (for example, the high – Church Slavonic – and the low – conversational – genres of the eighteenth century); finally, certain dialects may be legitimized in literature and thus to a certain extent be appropriated by literary language.

As they enter literature and are appropriated to literary language, dialects in this new context lose, of course, the quality of closed socio-linguistic systems; they are deformed and in fact cease to be that which they had been simply as dialects. On the other hand, these dialects, on entering the literary language and preserving within it their own dialectological elasticity, their other-languagedness, have the effect of deforming the literary language; it, too, ceases to be that which it had been, a closed socio-linguistic system. Literary language is a highly distinctive phenomenon, as is the linguistic consciousness of the educated person who is its agent; within it, intentional diversity of speech [*raznorečivost'*] (which is present in every living dialect as a closed system) is transformed into diversity of language [*raznojazyčie*]; what results is not a single language but a dialogue of languages.

The national literary language of a people with a highly developed art of prose, especially if it is novelistic prose with a rich and tension-filled verbal-ideological history, is in fact an organized microcosm that reflects the macrocosm not only of national heteroglossia, but of European heteroglossia as well. The unity of a literary language is not a unity of a single, closed language system, but is rather a highly specific unity of several "languages" that have established contact and mutual recognition with each other (merely one of which is poetic language in the narrow sense). Precisely this constitutes the peculiar nature of the methodological problem in literary language.

Concrete socio-ideological language consciousness, as it becomes creative – that is, as it becomes active as literature – discovers itself already surrounded by heteroglossia and not at all a single, unitary language, inviolable and indisputable. The actively literary linguistic consciousness at all times and everywhere (that is, in all epochs of literature historically available to us) comes upon "languages," and not language. Consciousness finds itself inevitably facing the necessity of *having to choose a language*. With each literary-verbal performance, consciousness must actively orient itself amidst heteroglossia, it must move in and occupy a position for itself within it, it chooses, in other words, a "language." Only by remaining in a closed environment, one without writing or thought, completely off the maps of socio-ideological becoming, could a man fail to sense this activity of selecting a language and rest assured in the inviolability of his own language, the conviction that his language is predetermined.

Antonio Gramsci

NORMATIVE GRAMMAR (1929–35)

How many forms of grammar can there be?

Several, certainly. There is the grammar 'immanent' in language itself, by which one speaks 'according to grammar' without knowing it, as Molière's character produced prose without knowing it.[1] Nor does this point seem useless because Panzini (*Guida alla Grammatica italiana*, 18° migliaio) seems not to distinguish between this 'grammar' and the 'normative', written one which he intends to speak about and which seems to be for him the only possible grammar there can be. The preface to the first edition is full of inanities, which are however significant in someone who writes (and is considered a specialist) on grammatical matters, like the statement 'we can write and speak even without grammar'.

Besides the 'immanent grammar' in every language, there is also in reality (i.e., even if not written) a 'normative' grammar (or more than one). This is made up of the reciprocal monitoring, reciprocal teaching and reciprocal 'censorship' expressed in such questions as 'What did you mean to say?', 'What do you mean?', 'Make yourself clearer', etc., and in mimicry and teasing. This whole complex of actions and reactions come together to create a grammatical conformism, to establish 'norms' or judgements of correctness or incorrectness. But this 'spontaneous' expression of grammatical conformity is necessarily disconnected, discontinuous and limited to local social strata or local centres. (A peasant who moves to the city ends up conforming to urban speech through the pressure of the city environment. In the country, people try to imitate urban speech; the subaltern classes try to speak like the dominant classes and the intellectuals, etc.)

One could sketch a picture of the 'normative grammar' that operates spontaneously in every given society, in that this society tends to become unified both territorially and culturally, in other words it has a governing class whose function is recognized and followed. The number of 'immanent or spontaneous grammars' is incalculable and, theoretically, one can say that each person has a

grammar of his own. Alongside this actual 'fragmentation', however, one should also point out the movements of unification, with varying degrees of amplitude both in terms of territory and 'linguistic volume'. Written 'normative grammars' tend to embrace the entire territory of a nation and its total 'linguistic volume', to create a unitary national linguistic conformism. This, moreover, places expressive 'individualism' at a higher level because it creates a more robust and homogeneous skeleton for the national linguistic body, of which every individual is the reflection and interpreter.

Historical as well as normative grammars. But it is obvious that someone who writes a normative grammar cannot ignore the history of the language of which he wishes to propose an 'exemplary phase' as the 'only' one worthy to become, in an 'organic' and 'totalitarian' way, the 'common' language of a nation in competition and conflict with other 'phases' and types or schemes that already exist (connected to traditional developments or to the inorganic and incoherent attempts of forces which, as we have seen, act continuously on the spontaneous 'grammars' immanent in the language). Historical grammar cannot but be 'comparative': an expression that, analysed thoroughly, indicates the deep-seated awareness that the linguistic fact, like any other historical fact, cannot have strictly defined national boundaries, but that history is always 'world history' and that particular histories exist only within the frame of world history. Normative grammar has other ends, even though the national language cannot be imagined outside the frame of other languages that exert an influence on it through innumerable channels which are often difficult to control. (Who can control the linguistic innovations introduced by returning emigrants, travellers, readers of foreign newspapers and languages, translators, etc.?)

Written normative grammar, then, always presupposes a 'choice', a cultural tendency, and is thus always an act of national-cultural politics. One might discuss the best way to present the 'choice' and the 'tendency' in order to get them accepted willingly, that is, one might discuss the most suitable means to obtain the goal; but there can be no doubt that there is a goal to be reached, that adequate and suitable means are needed, in other words that we are dealing with a political act.

Questions: what is the nature of this political act, and is it going to raise oppositions of 'principle', a *de facto* collaboration, opposition to the details, etc.? If one starts from the assumption of centralizing what already exists in a diffused, scattered but inorganic and incoherent state, it seems obvious that an opposition on principle is not rational. On the contrary, it is rational to collaborate practically and willingly to welcome everything that may serve to create a common national language, the non-existence of which creates friction particularly in the popular masses among whom local particularisms and phenomena of a narrow and provincial mentality are more tenacious than is believed. In other words, it is a question of stepping up the struggle against illiteracy. There is already *de facto* opposition in the resistance of the masses to shedding their particularistic habits and ways of thinking, a stupid resistance caused by the fanatical advocates of international languages. It is clear that with this set of problems the question of the national struggle of a hegemonic culture against other nationalities or residues of nationalities cannot be discussed.

[...]

Sources of diffusion of linguistic innovations in the tradition and of a national linguistic conformism in the broad national masses

(1) The education system; (2) newspapers; (3) artistic writers and popular writers; (4) the theatre and sound films; (5) radio; (6) public meetings of all kinds, including religious ones; (7) the relations of 'conversation' between the more educated and less educated strata of the population (a question which is perhaps not given all the attention it deserves is that of the 'words' in verse learnt by heart in the form of songs, snatches of operas, etc. It should be noted that the people do not bother really to memorize these words, which are often strange, antiquated and baroque, but reduce them to kinds of nursery rhymes that are only helpful for remembering the tune); (8) the local dialects, understood in various senses (from the more localized dialects to those which embrace more or less broad regional complexes: thus Neapolitan for southern Italy, the dialects of Palermo and Catania for Sicily).

Since the process of formation, spread and development of a unified national language occurs through a whole complex of molecular processes, it helps to be aware of the entire process as a whole in order to be able to intervene actively in it with the best possible results. One need not consider this intervention as 'decisive' and imagine that the ends proposed will all be reached in detail, i.e. that one will obtain a *specific* unified language. One will obtain a *unified language*, if it is a necessity, and the organized intervention will speed up the already existing process. What this language will be, one cannot foresee or establish: in any case, if the intervention is 'rational', it will be organically tied to tradition, and this is of no small importance in the economy of culture.

Manzonians and 'classicists'. They had a type of language which they wanted to make prevail. It is not correct to say that these discussions were useless and have not left traces in modern culture, even if the traces are modest. Over the last century a unified culture has in fact been extended, and therefore also a common unified language. But the entire historical formation of the Italian nation moved at too slow a pace. Every time the question of the language surfaces, in one way or another, it means that a series of other problems are coming to the fore: the formation and enlargement of the governing class, the need to establish more intimate and secure relationships between the governing groups and the national-popular mass, in other words to reorganize the cultural hegemony. [...]

Different kinds of normative grammar

For schools. For so-called educated people. The difference is due in reality to the reader's or pupil's different level of intellectual development and to the different technique needed to teach or increase the organic knowledge of the national language for those children who cannot be taught without a certain peremptory

and authoritarian rigidity ('You have to say it this way') and for the 'others' who need rather to be 'persuaded' to make them freely accept a given solution as the best (shown to be the best for attaining the goal which is proposed and shared, when it is shared). Furthermore, one must not forget that in the traditional study of normative grammar, other elements of the general teaching programme, such as certain elements of formal logic, have been inserted. One might debate whether this insertion is or is not opportune, whether the study of formal logic is justified or not (it seems to be, and it also seems justifiable to attach it to the study of grammar, rather than to arithmetic, etc., because of its natural resemblance and because together with grammar the study of formal logic is made relatively more lively and easier), but the question itself must not be evaded.

Historical and normative grammars

Taking normative grammar to be a political act and taking this starting-point as the only one from which one can 'scientifically' justify its existence and the enormous amount of patience needed to learn it (all the effort required to form hundreds of thousands of recruits, of the most disparate origins and mental preparation, into a homogeneous army capable of moving and acting in a disciplined and united manner, all the 'practical and theoretical lessons' on the regulations, etc.), one needs to posit its relationship to historical grammar. The failure to define this relationship explains many inconsistencies of normative grammars. We are dealing with two distinct and in part different things, like history and politics, but they cannot be considered independently, any more than politics and history. Besides, since the study of languages as a cultural phenomenon grew out of political needs (more or less conscious and consciously expressed), the needs of normative grammar have exerted an influence on historical grammar and on its 'legislative conceptions' (or at least this traditional element has reinforced, during the last century, the application of the positivist-naturalist method to the study of the history of languages conceived as the 'science of language').

[. . .]

Grammar and technique

Does grammar involve the same question as 'technique' in general? Is grammar only the technical aspect of language? At all events, are the idealists (especially the Gentilians) justified in their arguments about the uselessness of grammar and its exclusion from the schools? If one speaks (expresses oneself with words) in a manner which is historically determined by nations and linguistic areas, can one dispense with teaching this 'historically determined manner'? Granted that traditional normative grammar was inadequate, is this a good reason for teaching no grammar at all, for not being in the least concerned with speeding up the process of learning the particular way of speaking of a certain linguistic area, and rather leaving 'the language to be learnt through living it', or some other expression of this

sort. [...] All in all, this is a 'liberalism' of the most bizarre and eccentric stripe. [...]

Does a technique have to be learnt 'systematically'? In practice, the technique of the village artisan has been set against that of Ford. Think of the variety of ways in which 'industrial technique' is learnt: artisanally, during factory work itself, watching how others work (and hence wasting more time and energy and learning only partially); in professional schools (where the whole trade is systematically learnt, even though some of the notions one learns will be applied very rarely in one's lifetime, if ever); by combining various methods, with the Taylor-Ford system which created a new kind of qualification and a skill limited to certain factories, or even to specific machines and stages of the production process.

Normative grammar, which by abstraction only can be considered as divorced from the living language, tends to make one learn the entire organism of the language in question and to create a spiritual attitude that enables one always to find one's way around the linguistic environment. [...] If grammar is excluded from education and is not 'written', it cannot thereby be excluded from 'real life', as I have already pointed out elsewhere. The only thing excluded is the unitarily organized intervention in the process of learning the language. In practice the national-popular mass is excluded from learning the educated language, since the highest level of the ruling class, which traditionally speaks standard Italian, passes it on from generation to generation, through a slow process that begins with the first stutterings of the child under the guidance of its parents, and continues through conversation (with its 'this is how one says it', 'it must be said like this', etc.) for the rest of one's life. In reality, one is 'always' studying grammar (by imitating the model one admires, etc.). [...]

Note

1 The character is M. Jourdain in *Le Bourgeois Gentilhomme* Act II scene 4.

ENGLISHES

I feel that the English language will be able to carry the weight of my African experience. But it will have to be a new English.

(Chinua Achebe, *Morning Yet on Creation Day*, 1975: 62)

THE THEORETICAL POSITIONS OUTLINED in the previous section are followed here by a variety of perspectives on the ways in which a hegemonic, global language, English, is pluralised both by way of its dissemination through colonial imposition, and by dint of its prestige and cultural authority. Another way of approaching this question would be to ask: who does a language belong to? We have already seen a number of responses to this question, here the answers are inflected differently.

In his *Dissertations on the English Language* Noah Webster, the American lexicographer, had called on Americans to establish a 'system of our own, in language as well as government' (1789: 20). At this time, an 'Americanism', used in Britain to refer to a word believed to be of American origin, was still a sign of poor taste or inferior education; it was based on 'Scotticism', also of eighteenth-century origin. One hundred and fifty years later, however, Mencken was confidently asserting that 'English English', so to speak, would have to follow American English. Rather than the old cultural nationalist model of language as the authenticating foundation of national identity, here it is the use of the same but different language which guarantees identity. It is worth while thinking about the causes of this change, how it is manifested in the present, and how it is still resisted in British culture today.

At the end of his piece Mencken refers to the use of the English language in Ireland, particularly to a form of the language which was being consciously forged as a literary medium by writers of the Celtic Twilight at the end of the nineteenth century: Hiberno-English (or Anglo-Irish as it is often misleadingly called). And the complex and fraught issue of language-politics in Ireland is the subject of Tom Paulin's 'A New Look at the Language Question'. Written in a climate of war, and of a bitterly divided country, he addresses the problem of linguistic and cultural difference: specifically, how can linguistic forms which appear to belong to particular groups, and thus to bear loyalties, be recognised and reconciled? He explores the production of Irish Englishes, forms of non-standard English which live outside the codification and classificatory systems of the dictionary. He argues too for the forging and recording of what is currently a 'fragmented speech' as a way of contributing to the development of a broad and diverse linguistic and cultural community. Interestingly, the *Belfast Agreement* (1998) between the differing parties in Northern Ireland, and the Irish and British Governments, contains a pledge

to respect and protect linguistic diversity, including, within Northern Ireland, 'the Irish language, Ulster-Scots and the languages of the various ethnic communities'.

Gramsci considered the 'Question of the Language' in his observations on Dante's *De vulgari eloquentia* (a theoretical justification of the Italian vernacular against Latin). And it is interesting to explore the idea that what happened to Latin has now happened to English: once an imperial language, now fragmented into a set of vernacular languages. It is also worth noting that like Webster, Paulin argues for the compiling of dictionaries: centripetal, centralising, unifying records of the language. As we saw in the previous section, the politics of language need to be historicised before judgment can be passed.

The pieces by Dabydeen and Brathwaite are concerned with the English of the Caribbean, in particular the way in which 'English English' has been creatively appropriated in both orature and literature. The hegemony of an English language tied to a specific form of cultural identity has been re-negotiated in this process and the *necessarily* oppressive entrenchment of English within the social and cultural life of a post-colonial people is brought into question. For both writers this is presented as a struggle to find a language adequate to describe the cultural experience of their community in words which are, to quote Joyce, at once 'familiar and foreign'. This is an attempt, in other words, to reconnect language and culture, though with the complication of having to use the language which had a part in making the rupture in the first place. For Dabydeen, this work on language is a strategy of resistance and challenge to the dominance and forms of social and cultural authority bound up with standard written English, a process in which words become weapons turned back on the colonisers. Connected to this is Brathwaite's sense of the disjunction between Afro-Caribbean cultural experience and those English literary forms, styles and traditions propagated as norms through the colonial education system. He describes this project as trying to catch the 'experience of the hurricane' through the development of new poetic forms over and against traditional forms such as that of the pentameter.

Writing in the *Proceedings of the Philological Society* in 1838, Guest declared that English was 'rapidly becoming the great medium of civilisation, the language of law and literature to the Hindoo, of commerce to the African, of religion to the scattered islands of the Pacific'. (Guest 1838: 703). Kachru's essay reflects on the partial truth of that historical claim and considers the ways in which English has operated in India in both the colonial and post-colonial contexts. While acknowledging the historical legacy of English as the language of colonial power, and Guest's arrogant assuredness confirms that, Kachru also looks at how the elite language, with its promise of prestige, learning, and advancement, was eventually used against the Empire: English was the language of resurgent Indian nationalism in the early twentieth century. He explores too the ways in which, in the post-colonial situation, the functions of English have shifted: paradoxically, English has become a neutral language in contexts in which native Indian languages carry religious, ethnic and therefore political connotations. One of his most intriguing suggestions, however, is that by now the English language in India has been Indianised; or as the old terminology had it, 'gone native'.

Further reading

American English

Mencken, H.L. (1936) *The American Language,* 2 vols, New York: Alfred A. Knopf.

Strevens, P. (1972) *British and American English,* London: Collier.

Simpson, D. (1986) *The Politics of American English 1776–1850,* Oxford: Oxford University Press.

Ferguson, C. & S.B. Heath (eds) (1981) *Language in the United States of America,* Cambridge: Cambridge University Press.

Quirk, R. (1972) *The English Language and Images of Matter,* Oxford: Oxford University Press, pp. 1–31.

McDavid, R. (1980) *Varieties of American English,* Stanford: Stanford University Press.

Labov, W. (1972) *Language in the Inner City: Studies in the Black English Vernacular,* Oxford: Blackwell.

Lippi-Green, R. (1997) *English with an Accent: Language, Ideology and Discrimination in the United States,* New York: Routledge.

Smith, R.B. and D.M. Lance (1979) 'Standard and Disparate Varieties of English in the United States: Educational and Sociopolitical Implications', *International Journal of the Sociology of Language,* 21, pp. 127–40.

Britain and Ireland

Trudgill, P. (ed.) (1984) *Language in the British Isles,* Cambridge: Cambridge University Press.

Lockwood, W.B. (1975) *Languages of the British Isles Past and Present,* London: Deutsch.

Price, G. (1984) *The Languages of Britain,* London: Edward Arnold.

McArthur, T. (1998) *The English Languages,* Cambridge: Cambridge University Press, chapter 6.

Aitken, A.J. (1984) 'Scots and English in Scotland', in P. Trudgill (ed.) *Language in the British Isles,* Cambridge: Cambridge University Press.

Aitken, A.J. and T. McArthur (eds) (1979) *The Languages of Scotland,* Edinburgh: W. & R. Chambers.

Harris, J. (1991) 'Ireland', in J. Cheshire (ed.) *English Around the World: Sociolinguistic Perspectives,* Cambridge: Cambridge University Press, pp. 37–46.

Ó Muirithe, D. (ed.) (1977) *The English Language in Ireland,* Dublin: Mercier Press.

Adamson, I. (1982) *The Identity of Ulster: The Land, the Language and the People,* Belfast: Pretani Press, chapter 9.

Montgomery, M. (1995) *An Introduction to Language and Society,* 2nd edn., London: Routledge, chapter 4.

Sutcliffe, D. (1982) *Black British English,* Oxford: Basil Blackwell.

Sutcliffe, D. and A. Wong (eds) (1986) *The Language of Black Experience: Cultural Expression Through Word and Sound in the Caribbean and Black Britain,* Oxford: Basil Blackwell.

Linguistic Minorities Project (1995) *The Other Languages of England,* London: Routledge & Kegan Paul.

English worldwide

Cheshire, J. ed. (1991) *English Around the World: Sociolinguistic Perspectives,* Cambridge: Cambridge University Press.

Bailey, R.W. and M. Görlach (eds.) (1982) *English as a World Language*, Ann Arbor: University of Michigan Press.

Kachru, B.J. (ed.) (1983) *The Other Tongue*, Oxford, Pergamon Institute.

—— (1986) *The Alchemy of English: The Spread, Functions and Models of Non-Native Englishes*, Oxford: Pergamon Institute.

Platt, J., H. Weber and M.L. Ho (1984) *The New Englishes*, London: Routledge & Kegan Paul.

García, O. and R. Otheguy (eds) (1989) *English Across Cultures: Cultures Across English*, Berlin: Mouton de Gruyter.

Ashcroft, B., G. Griffiths and H. Tiffin (1989) *The Empire Writes Back: Theory and Practice in Post-Colonial Literatures*, London: Routledge, intro and chapter 2.

Görlach, M. (1995) *More Englishes: New Studies in Varieties of English*, Amsterdam: John Benjamins.

Wardhaugh, R. (1992) *An Introduction to Sociolinguistics*, 2nd edn., Oxford: Basil Blackwell.

Burchfield, R.W. (ed.) (1994) *The Cambridge History of the English Language, Volume 5: English in Britain and Overseas (Origin and Development)*, Cambridge: Cambridge University Press.

Pidgins and creoles

McArthur, T. (1998) *The English Languages*, Cambridge: Cambridge University Press, chapter 7.

Wardhaugh, R. (1987) *Languages in Competition: Dominance, Diversity and Decline*, Oxford: Blackwell, chapter 3.

Romaine, S. (1994) *Language in Society: An Introduction to Sociolinguistics*, Oxford: Oxford University Press, chapter 6.

—— (1988) *Pidgin and Creole Languages*, London: Longman.

Holm, J. (1988) *Pidgins and Creoles*, Cambridge: Cambridge University Press.

Hymes, D. (ed.) (1971) *Pidginization and Creolization of Languages*, Cambridge: Cambridge University Press.

Todd, L. (1984) *Modern Englishes: Pidgins and Creoles*, Oxford: Basil Blackwell.

—— (1990) *Pidgins and Creoles*, 2nd edn., London: Routledge.

H.L. Mencken

ENGLISH OR AMERICAN? (1936)

Because of the fact that the American form of English is now spoken by three times as many persons as all the British forms taken together, and by at least twenty times as many as the standard Southern English, and because, no less, of the greater resilience it shows, and the greater capacity for grammatical and lexical growth, and the far greater tendency to accommodate itself to the linguistic needs and limitations of foreigners – because of all this it seems to me very likely that it will determine the final form of the language. For the old control of English over American to be reasserted is now quite unthinkable; if the two dialects are not to drift apart entirely English must follow in American's tracks. This yielding seems to have begun; the exchanges from American into English, as we have seen, grow steadily larger and more important than the exchanges from English into American. John Richard Green, the historian, discerning the inevitable half a century ago, expressed the opinion, amazing and unpalatable then, that the Americans were already "the main branch of the English people." It is not yet wholly true; a cultural timorousness yet shows itself; there is still a class, chiefly of pedagogues and of social aspirants, which looks to England as the Romans long looked to Greece. But it is not the class that is shaping the national language, and it is not the class that is carrying it beyond the national borders. The Americanisms that flood the English of Canada are not borrowed from the dialects of New England Loyalists and fashionable New Yorkers, but from the common speech that has its sources in the native and immigrant proletariat and that displays its gaudiest freightage in the newspapers.

The impact of this flood is naturally most apparent in Canada, whose geographical proximity and common interests completely obliterate the effects of English political and social dominance. The American flat *a* has swept the whole country, and American slang is everywhere used; turn to any essay on Canadianisms,[1] and you will find that nine-tenths of them are simply Americanisms. No doubt this is chiefly due to the fact that the Canadian newspapers are all supplied with news by the American press associations, and thus fall inevitably into the

habit of discussing it in American terms. "The great factor that makes us write and speak alike," says a recent writer on American speech habits,[2] "is the indefinite multiplication of the instantaneous uniformity of the American daily, . . . due to a non-sectional, continental exchange of news through the agency of the various press associations." In this exchange Canada shares fully. Its people may think as Britons, but they must perforce think in American.

More remarkable is the influence that American has exerted upon the speech of Australia and upon the crude dialects of Oceanica and the Far East. One finds such obvious Americanisms as *tomahawk*, *boss*, *bush*, *go finish* (= *to die*) and *pickaninny* in Beach-la-Mar[3] and more of them in Pidgin English. The common trade speech of the whole Pacific, indeed, tends to become American rather than English. An American correspondent at Oxford sends me some curious testimony to the fact. Among the Britishers he met there was one student who showed an amazing familiarity with American words and phrases. The American, asking him where he had lived in the United States, was surprised to hear that he had never been here at all. All his Americanisms had been picked up during his youth in a Chinese sea-port, where his father was the British Consul. The English of Australia, though it is Cockney in pronunciation and intonation,[4] becomes increasingly American in vocabulary. In a glossary of Australianisms compiled by the Australian author, C. T. Dennis,[5] I find the familiar verbs and verb-phrases, *to beef*, *to biff*, *to bluff*, *to boss*, *to break away*, *to chase one's self*, *to chew the rag*, *to chip in*, *to fade away*, *to get it in the neck*, *to back and fill*, *to plug along*, *to get sore*, *to turn down* and *to get wise*; the substantives, *dope*, *boss*, *fake*, *creek*, *knockout-drops* and *push* (in the sense of *crowd*); the adjectives, *hitched* (in the sense of *married*) and *tough* (as before *luck*), and the adverbial phrases, *for keeps* and *going strong*. Here, in direct competition with English locutions, and with all the advantages on the side of the latter, American is making steady progress. Moreover, the Australians,[6] following the Americans, have completely obliterated several old niceties of speech that survive in England – for example, the distinction between *will* and *shall*. "An Australian," says a recent writer,[7] "uses the phrase *I shall* about as often as he uses the accusative *whom*. Usually he says *I will* or *I'll*; and the expectant *we shall see* is the only ordinary *shall* locution which I can call to mind." But perhaps it is Irish influence that is visible here, and not American.

"This American language," says a recent observer, "seems to be much more of a pusher than the English. For instance, after eight years' occupancy of the Philippines it was spoken by 800,000, or 10 per cent, of the natives, while after an occupancy of 150 years of India by the British, 3,000,000, or one per cent, of the natives speak English."[8] I do not vouch for the figures. They may be inaccurate, in detail, but they at least state what seems to be a fact. Behind that fact are phenomena which certainly deserve careful study, and, above all, study divested of unintelligent prejudice. The attempt to make American uniform with English has failed ingloriously; the neglect of its investigation is an evidence of snobbishness that is a folly of the same sort. It is useless to dismiss the growing peculiarities of the American vocabulary and of grammar and syntax in the common speech as vulgarisms beneath serious notice. Such vulgarisms have a way of intrenching themselves, and gathering dignity as they grow familiar. "There are but few forms in use," says Lounsbury, "which, judged by a standard previously

existing, would not be regarded as gross barbarisms."⁹ Each language, in such matters, is a law unto itself, and each vigorous dialect, particularly if it be spoken by millions, is a law no less. "It would be as wrong," says Sayce, "to use *thou* for the nominative *thee* in the Somersetshire dialect as it is to say *thee art* instead of *you are* in the Queen's English." American has suffered severely from the effort to impose an impossible artificiality upon it, but it has survived the process, and soon or late there must be a formal abandonment of the pedagogical effort to bring it into agreement with Southern English. "It has had held up to it," says Prof. Ayres, "silly ideals, impossible ideals, ignorant dogmatisms, and for the most part it wisely repudiates them all."¹⁰ The American Academy of Arts and Letters still pleads for these silly ideals and ignorant dogmatisms, and the more stupid sort of schoolmasters echo the plea, but meanwhile American goes its way. In England its progress is not unmarked. Dr. Robert Bridges and the Society for Pure English seek to bring about the precise change in standard English that American shows spontaneously. Maybe the end will be two dialects – standard English for pedants, and American for the world.

As yet, American suffers from the lack of a poet bold enough to venture into it, as Chaucer ventured into the despised English of his day, and Dante into the Tuscan dialect, and Luther, in his translation of the Bible, into peasant German. Walt Whitman made a half attempt and then drew back; Lowell, perhaps, also heard the call, but too soon; in our own time, young Mr. Weaver has shown what may be done tomorrow, and Carl Sandburg and Sherwood Anderson have also made experiments. The Irish dialect of English, vastly less important than the American, has already had its interpreters – Douglas Hyde, John Millington Synge and Augusta Gregory – with what extraordinary results we all know.¹¹ Here we have writing that is still indubitably English, but English rid of its artificial restraints and broken to the less self-conscious grammar and syntax of a simple and untutored folk. Synge, in his preface to "The Playboy of the Western World," tells us how he got his gipsy phrases "through a chink in the floor of the old Wicklow house where I was staying, that let me hear what was being said by the servant girls in the kitchen." There is no doubt, he goes on, that "in the happy ages of literature striking and beautiful phrases were as ready to the story-teller's or the playwright's hand as the rich cloaks and dresses of his time. It is probable that when the Elizabethan dramatist took his ink-horn and sat down to his work he used many phrases that he had just heard, as he sat at dinner, from his mother or his children."

The result, in the case of the neo-Celts, is a dialect that stands incomparably above the tight English of the grammarians – a dialect so naïve, so pliant, so expressive, and, adeptly managed, so beautiful that even purists have begun to succumb to it, and it promises to leave lasting marks upon English style. The American dialect has not yet come to that stage. In so far as it is apprehended at all it is only in the sense that Irish-English was apprehended a generation ago – that is, as something uncouth and comic. But that is the way that new dialects always come in – through a drum-fire of cackles. Given the poet, there may suddenly come a day when our *theirns* and *would'a hads* will take on the barbaric stateliness of the peasant locutions of old Maurya in "Riders to the Sea." They seem grotesque and absurd today because the folks who use them seem grotesque

and absurd. But that is a too facile logic and under it is a false assumption. In all human beings, if only understanding be brought to the business, dignity will be found, and that dignity cannot fail to reveal itself, soon or late, in the words and phrases with which they make known their hopes and aspirations and cry out against the meaninglessness of life.

Notes

1 For example, Geikie's or Lighthall's.
2 Harvey M. Watts: Need of Good English Growing as World Turns to Its Use, New York *Sun*, Nov. 19, 1919.
3 *Cf.* Beach-la-Mar, by William Churchill, former United States consul-general in Samoa and Tonga. The pamphlet is published by the Carnegie Institution of Washington.
4 *Cf.* The Australian Accent, *Triad* (Sydney), Nov. 10, 1920, p. 37.
5 *Doreen and the Sentimental Bloke*; New York, 1916.
6 It is a pity that American has not borrowed the Australian invention *wowser*. Says a writer in the Manchester *Guardian*: "*Wowser*, whether used as an adjective or a substantive, covers everyone and everything that is out of sympathy with what some people consider *la joie de vivre*. A *wowser*, as a person, is one who desires to close public-houses, prevent *shouting* (Australese for treating), and so on – in short, one who intends to limit the opportunities 'of all professions that go the primrose way to the everlasting bonfire.'" In the United States fully 99 per cent of all the world's *wowsers* rage and roar, and yet we have no simple word to designate them.
7 *English*, Sept., 1919, p. 167.
8 *The American Language*, by J. F. Healy; Pittsburgh, 1910, p. 6.
9 *History of the English Language*, p. 476.
10 *Cambridge History of American Literature*, vol. iv, p. 566.
11 The Sicilian dialect of Italian was brought to dignity in the same way by the late Giovanni Verga, author of the well-known *Cavalleria Rusticana*. See Giovanni Verga and the Sicilian Novel, by Carlo Linati, *Dial*, Aug., 1921, p. 150 *ff.*

Tom Paulin

A NEW LOOK AT THE LANGUAGE QUESTION (1983)

The history of a language is often a story of possession and dispossession, territorial struggle and the establishment or imposition of a culture. Arguments about the 'evolution' or the 'purity' of a language can be based on a simplistic notion of progress or on a doctrine of racial stereotypes. Thus a Spenserian phrase which Samuel Johnson employs in the famous preface to his dictionary – 'the wells of English undefiled' – is instinct with a mystic and exclusive idea of nationhood. It defines a language and a culture in terms of a chimerical idea of racial purity. But Johnson doesn't profess this idea either visibly or aggressively, and in the less well-known essay which follows his preface he comments on the historical sources of the English language. Reflecting on the extinction of the ancient British language, he remarks:

> ...it is scarcely possible that a nation, however depressed, should have been mixed in considerable numbers with the Saxons without some communication of their tongue, and therefore it may, with great reason, be imagined that those who were not sheltered in the mountains, perished by the sword.

Anglo-Saxon society was among the very first European societies to establish a tradition of vernacular prose. However, for several centuries after the Norman conquest English was regarded as a rude and uncultivated tongue. At the beginning of the fourteenth century, the chronicler Robert of Gloucester notes with concern that English is spoken only by 'lowe men'. He remarks that England is the only country in the world that doesn't 'hold' to its own speech, and implies that such a situation is unnatural. Here he is clearly influenced by the English nationalism which developed after the crown lost Normandy early in the thirteenth century. French, however, continued to be the official language of

England until a parliamentary statute of 1362 stated that all law suits must be conducted in English. French was displaced and the English language returned from a form of internal exile.

The English language was first brought to Ireland by the followers of Strongbow's Norman invaders in the twelfth century. Norman French and English became established as vernacular languages, though their speakers gradually crossed over to Irish. Attempts were made to resist this process – for example in the statutes of Kilkenny (1366) – but the Irishing of the settlers was completed by the Reformation which united the 'Old English' with the native Irish against the Protestant 'New English'. And as Alan Bliss has shown, the Cromwellian Settlement of the 1650s was to be crucial to the history of the English language in Ireland. With the exception of Ulster, the English spoken in most parts of Ireland today is descended from the language of Cromwell's planters. The result, according to Diarmaid Ó Muirithe, is 'a distinctive Irish speech – Anglo-Irish or Hiberno-English, call it what you will'.

In England, the English language reached a peak of creative power during the Elizabethan and Jacobean periods when writers formed sentences by instinct or guesswork rather than by stated rule. In time it was felt that the language was overseeded and in need of more careful cultivation. Writers began to argue that the absence of a standard of 'correct' English created an ugly and uncivilised linguistic climate, and Dryden remarked that he sometimes had to translate an idea into Latin before he could decide on the proper way of expressing it in English. In *A Discourse Concerning Satire* he noted, 'we have yet no prosodia, not so much as a tolerable dictionary, or a grammar, so that our language is in a manner barbarous'. Dryden's neoclassicism had an epic scope and power and like Virgil's Aeneas he wished to found a new *civitas* in a country damaged by violence and conflict. He argued that in order to properly regulate and refine the language England must have an academy modelled on the Académie Française. His criticism of the state of the language was developed by Swift in *A Proposal for Correcting, Improving, and Ascertaining the English Tongue*, which was addressed to Robert Harley, the Lord High Treasurer of England, and published in 1712. Although Swift strategically avoided mentioning the idea of an academy, it is clear that he intended his readers to make that deduction. Only an academy would be capable of 'ascertaining and fixing our language for ever, after such alterations are made in it as shall be thought requisite'.

Swift's proposal appears to be innocent of political interest, but a Whig paper, the *Medley*, detected Jacobitism in his preference for the Romance languages over the Saxon on the grounds that he was opposed to any 'new addition of Saxon words by bringing over the Hanover family'. According to his Whig critic, Swift wished to hasten 'a new invasion by the Pretender and the French, because that language has more Latin words than the Saxon'. Partly as a result, the idea of an academy came to be regarded as essentially unpatriotic, and it was on these grounds that Johnson took issue with Swift's 'petty treatise'. In the preface to his dictionary he remarks that he does not wish 'to see dependence multiplied' and hopes that 'the spirit of English liberty' will hinder or destroy any attempt to set up an academy in England. Although Matthew Arnold revived Swift's proposal in a provocative essay entitled 'The Literary Influence of

Academies', the idea of an academic legislature for the language was effectively extinguished by Johnson's preface.

Johnson's argument is insular, aggressive and somewhat sentimental, yet there can be no doubt that he is expressing an ingrained cultural hostility to state intervention in the language. Johnson believed that a dictionary could perform the function of correcting English better than an academy could, and he argued that the organic nature of language ought to be respected. It was both misguided and tyrannical to attempt to freeze the English language artificially as Swift had suggested.

Johnson's English patriotism and his anarchistic conservatism inform his view of the language, and in accordance with his libertarian principles he avoids imposing any guide to pronunciation in his dictionary. Swift, however, advocated a standard English pronunciation and in an essay 'On Barbarous Denominations in Ireland' he criticised the Scottish accent and most English regional accents as 'offensive'. He also observed that an Irish accent made 'the deliverer ... ridiculous and despised', and remarked that 'from such a mouth, an Englishman expects nothing but bulls, blunders, and follies'. For Swift, a standard English accent is a platonic ideal which will give dignity and self-respect to anyone who acquires it. He is therefore rejecting a concept of 'Hiberno-English' or 'Anglo-Irish' and is advocating a unified culture which embraces both Britain and Ireland. This ideal of complete integration still has its supporters, but it must now be apparent that a Unionist who retains a marked Irish accent is either an unconscious contradiction or a subversive ironist.

[...]

In Ireland, the English language has traditionally been regarded as an imposed colonial tongue, and Irish as the autochthonous language of the island. British policy was hostile to Irish and in 1904, for example, a Commissioner of National Education wrote to Douglas Hyde: 'I will use all my influence, as in the past, to ensure that Irish as a spoken language shall die out as quickly as possible.' However, as Seán De Fréine has argued, the movement away from Irish in the nineteenth century was not the product of 'any law or official regulation'. Instead it was the result of a 'social self-generated movement of collective behaviour among the people themselves'. English was the language of power, commerce and social acceptance, and the Irish people largely accepted Daniel O'Connell's view that Gaelic monolingualism was an obstacle to freedom. Particularly after the Famine, parents encouraged their children to learn English as this would help them make new lives in America.

Although the conflict between English and Irish can be compared to the struggle between Anglo-Saxon and Old British, such an analogy conceals the ironies and complexities of the problem. This is because the English language in Ireland, like English in America, became so naturalised that it appeared to be indigenous. The Irish language, however, was not completely suppressed or rejected, and it became central to the new national consciousness which formed late in the nineteenth century. As a result of the struggle for independence it was reinstated as the national language of a country which comprised three provinces and three counties of the four ancient provinces of Ireland. It forms an

important part of the school syllabus in the Irish Republic, is on the syllabus of schools administered by the Roman Catholic Church in Northern Ireland, and is absent from the curricula of Northern Irish state schools.

Traditionally, a majority of Unionist Protestants have regarded the Irish language as belonging exclusively to Irish Catholic culture. Although this is a misapprehension, it helps to confirm the essentially racist ethic which influences some sections of Unionist opinion and which is also present in the old-fashioned nationalist concept of the 'pure Gael'. As a result, Unionist schools are monolingual while non-Unionist schools offer some counterbalance to English monolingualism. Put another way, state education in Northern Ireland is based on a pragmatic view of the English language and a shortsighted assumption of colonial status, while education in the Irish Republic is based on an idealistic view of Irish which aims to conserve the language and assert the cultural difference of the country.

Although there are scholarly studies of 'Hiberno English' and 'Ulster English',[1] the language appears at present to be in a state of near anarchy. Spoken Irish English exists in a number of provincial and local forms, but because no scholar has as yet compiled a *Dictionary of Irish English* many words are literally homeless. They live in the careless richness of speech, but they rarely appear in print. When they do, many readers are unable to understand them and have no dictionary where they can discover their meaning. The language therefore lives freely and spontaneously as speech, but it lacks any institutional existence and so is impoverished as a literary medium. It is a language without a lexicon, a language without form. Like some strange creature of the open air, it exists simply as *Geist* or spirit.

Here, a fundamental problem is the absence of a classic style of discursive prose. Although Yeats argues for a tradition of cold, sinewy and passionate Anglo-Irish prose, this style is almost defunct now. Where it still exists it appears both bottled and self-conscious, and no distinctive new style has replaced it. Contributors to the *Irish Times* – Owen Dudley Edwards, for example – tend to write in a slack and blathery manner, while the *Belfast Newsletter* offers only a form of rasping businessman's prose. The *Irish Press* differs from the *Irish Times* in having an exemplary literary editor, but its copy-editing is not of a high standard.[2] And although Irish historians often like to congratulate themselves on their disinterested purity, a glance at the prose of F.S.L. Lyons reveals a style drawn from the claggy fringes of local journalism.[3]

Perhaps the alternative to a style based on assorted Deasyisms[4] is a form of ideal, international English? Samuel Beckett's prose is a repudiation of the provincial nature of Hiberno-English in favour of a stateless language which is an English passed through the Cartesian rigours of the French language. In its purity, elegance and simplicity, Beckett's language is a version of the platonic standard which Swift recommended nearly three centuries ago in his *Proposal*. Paradoxically, though, Beckett's language is both purer than Swift's and yet inhabited by faint, wistful presences which emanate from Hiberno-English.

Most people, however, demand that the language which they speak have a much closer contact with their native or habitual climate. Here, dialect is notable for its intimacy and for the bonds which it creates among speakers. Standard speech frequently gives way to dialect when people soothe or talk to small

children, and sexual love, too, is often expressed through dialect words. Such words are local and 'warm', while their standard alternatives can be regarded as coldly public and extra-familial. Often a clash is felt between the intimacy of dialect – from which a non-standard accent is inseparable – and the demands of a wider professional world where standard speech and accent are the norm. For English people such tensions are invariably a product of the class system, but in Ireland they spring from more complex loyalties (listeners to the 1982 Reith lectures will have noticed how Denis Donoghue's accent oscillates between educated southern speech and a slight Ulster ululation).

If Donoghue speaks for a partitioned island, G.B. Thompson speaks for a divided culture:

> As to the content of the book I must confess to being ill-equipped to comment on it. I am not a serious student of dialect, and any knowledge I have of the subject comes from the fact that as a native of County Antrim my first 'language' was the Ulster-Scots dialect of the area, described elsewhere in this book by G.B. Adams and by my fellow townsman Robert Gregg. Eventually, like so many others before and since, I was 'educated' to the point where I looked upon dialect as merely a low-class, ungrammatical way of speaking. The essays in this book, therefore, have been a revelation to me, and I find myself hoping that my experience will be shared by others who have not as yet come to realise the full significance of Ulster dialect, but who may still see it as merely a source of humour and the language of Ulster's folk plays – the kitchen comedies. That it can be, and often is, incomparably humorous is undeniable, but it also makes for eloquence of power and beauty, and if this book were to do no more than help raise the popular conception of our dialect above the level of the after-dinner story it would serve a useful purpose.[5]

This statement was made in 1964 and with hindsight we can see in it a slight movement of consciousness towards the separatist idea which is now held by a significant section of 'loyalist' opinion. Nearly twenty later, Ian Adamson has offered an account of language which is wholly separatist in intention. It is a response to the homeless or displaced feeling which is now such a significant part of the loyalist imagination, and its historical teleology points to an independent Ulster where socialist politics have replaced the sectarian divisions of the past.

Adamson is in some ways the most interesting of recent loyalist historians because he writes from the dangerous and intelligent edges of that consciousness. In 'The Language of Ulster' Adamson argues that the province's indigenous language – Old British – was displaced by Irish, just as Irish was later displaced by English. In this way he denies an absolute territorial claim to either community in Northern Ireland and this allows him to argue for a concept of 'our homeland' which includes both communities. His account of an ancient British, or Cruthin, people is a significant influence on the UDA's Ulster nationalism and has helped shape that organisation's hostility to the British state.

Where the IRA seeks to make a nation out of four provinces, the UDA

aspires to make six counties of one province into an independent nation. Official Unionism, on the other hand, tries to conserve what remains of the Act of Union and clings to a concept of nationality which no longer satisfies many of the British people with whom the Unionists wish to identify. This can now be observed in England where the movement of opinion against Cruise missiles and the continuing demonstration at Greenham Common exemplify that alternative English nationalism which is expressed in Blake's vision of Albion and reflected in the writings of E.P. Thompson. Despite the recent election, this visionary commitment is still a powerful force within English society and it is connected with the shift in public opinion in favour of withdrawal from Northern Ireland.

Adamson's historical myth necessarily involves the concept of a national language, and he is deeply conscious of the need to prove that he speaks a language which is as indigenous – or as nearly indigenous – as Irish. He argues:

> Neither Ulster Lallans nor Ulster English are 'foreign' since the original dialects were modified in the mouths of the local Gaelic speakers who acquired them and eventually, after a bilingual period, lost their native tongue. These modified dialects were then gradually adopted by the Scottish and English settlers themselves, since the Irish constituted the majority population. The dialect of Belfast is a variety of Ulster English, so that the people of the Shankill Road speak English which is almost a literal translation of Gaelic.

Adamson's argument is obviously vulnerable and yet it forms part of a worthwhile attempt to offer a historical vision which goes beyond traditional barriers. The inclusive and egalitarian nature of his vision also ensures that it lacks the viciousness of the historical myth which was purveyed by the notorious Tara organisation, blessed by the Reverend Martin Smyth and other leading Unionists.

In *The Identity of Ulster* Adamson reveals that the loyalist community he speaks for is conscious of itself as a 'minority people'. Like the Irish language, Lallans – or Ulster Scots – is threatened by the English language and Adamson calls for the preservation of both languages within an Independent Ulster. However, a hostile critic would argue that Adamson's work springs from a sentimental and evasive concept of 'ould decency'. Although the leaders of the main political parties in the Irish Republic have paid at least lip service to the idea of a 'pluralist' state with safeguards for minorities, it is clear that most loyalists distrust them almost as much as they distrust British politicians. Adamson therefore offers an alternative to both the Irish Republic and the United Kingdom. But one of the weaknesses in his argument is an uncertainty about the status and the nature of the English language in Ireland. He sees Ulster Scots as oppressed by educated 'Ulster English' – the provincial language of Official Unionism, for example – but he lacks a concept of Irish English. This is because Adamson, like G.B. Thompson, is unwilling to contemplate the all-Ireland context which a federal concept of Irish English would necessarily express. Such a concept would redeem many words from that too-exclusive, too-local usage which amounts to a kind of introverted neglect. Many words which now appear simply gnarled, or which 'make strange' or seem opaque to most readers, would be released into the

shaped flow of a new public language. Thus in Ireland there would exist three fully-fledged languages – Irish, Ulster Scots and Irish English. Irish and Ulster Scots would be preserved and nourished, while Irish English would be a form of modern English which draws on Irish, the Yola and Fingallian dialects, Ulster Scots, Elizabethan English, Hiberno-English, British English and American English. A confident concept of Irish English would substantially increase the vocabulary and this would invigorate the written language. A language that lives lithely on the tongue ought to be capable of becoming the flexible written instrument of a complete cultural idea.

Until recently, few Irish writers appear to have felt frustrated by the absence of a dictionary which might define those words which are in common usage in Ireland, but which do not appear in the *OED*. This is probably because most writers have instinctively moulded their language to the expectations of the larger audience outside Ireland. The result is a language which lives a type of romantic, unfettered existence – no dictionary accommodates it, no academy regulates it, no common legislative body speaks it, and no national newspaper guards it. Thus the writer who professes this language must either explain dialect words tediously in a glossary or restrict his audience at each particular 'dialectical' moment. A writer who employs a word like 'geg' or 'gulder' or Kavanagh's lovely 'gobshite', will create a form of closed, secret communication with readers who come from the same region. This will express something very near to a familial relationship because every family has its hoard of relished words which express its members' sense of kinship. These words act as a kind of secret sign and serve to exclude the outside world. They constitute a dialect of endearment within the wider dialect.

In the case of some northern Irish writers – John Morrow, for example – dialect words can be over-used, while southern Irish writers sometimes appear to have been infected by Frank Delaney's saccharine gabbiness. However, the Irish writer who excludes dialect words altogether runs the risk of wilfully impoverishing a rich linguistic resource. Although there might be, somewhere, a platonic Unionist author who believes that good prose should always be as close as possible to Standard British English, such an aspiration must always be impossible for any Irish writer. This is because the platonic standard has an actual location – it isn't simply free and transcendental – and that location is the British House of Commons. There, in moments of profound crisis, people speak exclusively 'for England'. On such occasions, all dialect words are the subject of an invisible exclusion-order and archaic Anglo-Norman words like 'treason' and 'vouch' are suddenly dunted into a kind of life.

There may exist, however, a type of modern English which offers an alternative to Webster's patriotic argument (Imagist poetry, for example, is written in a form of minimal international English). Beckett's language is obviously a form of this cosmopolitan English and some Irish writers would argue that this is the best available language. By such an argument, it is perfectly possible to draw on, say, French and Irish without being aligned with a particular concept of society. For creative writers this can adumbrate a pure civility which should not be pressed into the service of history or politics.

This is not the case with discursive writers who must start from a concept

of civil duty and a definite cultural affiliation. Discursive prose is always committed in some sense or other and it is dishonest to pretend that it isn't. Historiography and literary criticism are related to journalism, however much historians of the new brahmin school resist such an 'impure' relation. Indeed, a language can live both gracefully and intensely in its literary and political journalism. Unfortunately, the establishment of a tradition of good critical prose, like the publication of *A Dictionary of Irish English* or the rewriting of the Irish Constitution, appear to be impossible in the present climate of confused opinions and violent politics. One of the results of this enormous cultural impoverishment is a living, but fragmented speech, untold numbers of homeless words, and an uncertain or a derelict prose.

Notes

1 Notably by Alan Bliss and John Braidwood. Professor Braidwood is at present compiling an Ulster Dialect Dictionary. A dictionary of Hiberno-English, which was begun under the auspices of the Royal Irish Academy, has been abandoned due to lack of funds.
2 E.g. 'Born in Rathdrum, Co. Wicklow, where her father was a flour miller, she was educated privately and later at a convent school but, when her father died, when she was 14, she was told that she would have to learn to earn her own living.' Obituary of Maire Comerford in the *Irish Press*, 16 December 1982.
3 E.g. 'Nevertheless, the university remained the objective and as Charles settled into harness his work and even, apparently, his manners, improved and we learn of village cricket (he was that valuable commodity, a good wicket-keeper-batsman) and of frequent invitations to dances. And at last Cambridge materialized.' *Charles Stewart Parnell*, Chapter 1.
4 See Mr Deasy's letter about foot-and-mouth disease in the Nestor section of *Ulysses*.
5 Preface to *Ulster Dialects: An Introductory Symposium*.

References

Adams, G.B. (ed.) (1964) *Ulster Dialects: An Introductory Symposium*.
Adamson, Ian (1982) 'The Language of Ulster' in *The Identity of Ulster*.
Baugh, A.C. (1965) *A History of the English Language*.
Bliss, Alan (1979) *Spoken English in Ireland: 1600–1740*.
Braidwood, John (1969) 'Ulster and Elizabethan English' in *Ulster Dialects The Ulster Dialect Lexicon*.
Fowler, H.W. (1965) *A Dictionary of Modern English Usage*.
Hulbert, James Root (1965) *Dictionaries British and American*.
Johnson, Samuel (1755) Preface to *A Dictionary of the English Language*. 'The History of the English Language' in *A Dictionary of the English Language*
Mencken, H.L. (1937) *The American Language*.
Milroy, James (1981) *Regional Accents of English: Belfast* (1981)

Murray, James A. H. (1900) *The Evolution of English Lexicography*.

Murray, K.M. Elisabeth (1977) *Caught in the Web of Words: James Murray and the Oxford English Dictionary*.

Ó Muirithe, Diarmaid (ed.) (1977) *The English Language in Ireland*.

Pepper, John (1977) *What a Thing to Say*.

Swift, Jonathan (1712) *A Proposal for Correcting, Improving, and Ascertaining the English Tongue*.

Thompson, G.B. (1969) Preface to *Ulster Dialects*.

Webster, Noah (1783) *The American Spelling Book*.

—— (1789) *Dissertations on the English Language*.

David Dabydeen

ON NOT BEING MILTON: NIGGER TALK IN ENGLAND TODAY (1990)

It's hard to put two words together in creole without swearing. Words are spat out from the mouth like live squibs, not pronounced with elocution. English diction is cut up, and this adds to the abruptness of the language: *what* for instance becomes *wha* (as in *whack*), the splintering making the language more barbaric. Soft vowel sounds are habitually converted: the English tend to be polite in *war*, whereas the creole *warre* produces an appropriate snarling sound; *scorn* becomes *scaan, water wata*, and so on.

In 1984 I published a first collection of poems entitled *Slave Song*, written in a Caribbean creole and dealing with the Romance of the Cane, meaning the perverse eroticism of black labor and the fantasy of domination, bondage, and sado-masochism. The British Empire, as the Thistlewood Diaries show, was as much a pornographic as an economic project.[1] The subject demanded a language capable of describing both a lyrical and a corrosive sexuality. The creole language is angry, crude, energetic. The canecutter chopping away at the crop bursts out in a spate of obscene words, a natural gush from the gut.

In the preface to *Slave Song* I speak of the brokenness of the language which reflects the brokenness and suffering of its original users. Its potential as a naturally tragic language is there in its brokenness and rawness, which is like the rawness of a wound. If one has learnt and used Queen's English for some years, the return to creole is painful, almost nauseous, for the language is uncomfortably raw. One has to shed one's protective sheath of abstracts and let the tongue move freely in blood again.

In writing *Slave Song* I had no Caribbean literary models to imitate, since I knew none. Apart from early childhood in Guyana I was brought up in England and no Caribbean literature was taught in schools. So I was wholly ignorant of the creole poetry of Edward Brathwaite or Claude McKay, the latter influenced by the balladry of Burns. What in fact triggered off *Slave Song* were the years

spent as an undergraduate at Cambridge reading English literature. There was the discovery of the "gaudy and inane phraseology" of much of eighteenth-century poetry, the wrapping of stark experiences in a napkin of poetic diction. James Grainger's poem *The Sugar Cane*, for instance, in which the toil of plantation life is erased or converted into pastoral. Instead of *overseer* Grainger uses the term "Master Swain"; instead of *slaves*, "assistant planters." The black condition is further embellished by calling the slaves "Afric's sable progeny." Grainger's poem is a classic example in English poetry of the refusal to call a spade a spade. Then there were all those antislavery pieces in a highfalutin Miltonic rhetoric and cadence, in which the poets used the black experience merely as a vehicle for lofty, moral pronouncements on good and evil. Or Coleridge's Greek Ode against slavery, which won him the Browne Gold Medal at Cambridge: the African here is subject to the exercise of classical erudition.

The real discovery, however, was of medieval alliterative verse. Reading *Sir Gawain and the Green Knight* was a startling moment. The sheer naked energy and brutality of the language, its "thew & sinew," reminded me immediately of the creole of my childhood. John of Trevisa, a fourteenth-century translator, described the alliterative poetry of the North of England as "harsh, piercing and formless." This quality of lawlessness and the primarily oral form of delivery bore a curious resemblance to Guyanese creole. I began to see, albeit naively, the ancient divide between north and south in Britain, the Gawain poet standing in opposition to Chaucer in terms of a native idiom versus an educated, relaxed poetic line tending towards the form of the iambic pentameter. The north/south divide is of course evocative of the divide between the so-called Caribbean periphery and the metropolitan center of London. London is supposed to provide the models of standard English, and we in the Caribbean our dialect versions.

The comparison between England and the modern Caribbean is not altogether fanciful, for in a sense we West Indians live in the Middle Ages in terms of rudimentary material resources. The British Empire was after all a feudal structure with robber barons and serfs. Transportation by horse, mule, or canoe, peasant farming, manual labor, villages lying in patches of land encircled by bush in the way that dense forest lay just outside English castle walls, these features and others of Guyana's countryside conjure up medieval life. And if, as Johan Huizinga states in *The Waning of the Middle Ages*, the sound of church bells dominated the air of England, so too in Guyana is religion a vital, noisy force. And out of this matrix of spirit and earth is born a language that is both lyrical and barbaric. But the very unsystematic and unscientific nature of the language which is a source of strength to writers like myself is cause for summary dismissal or parody for others. Peter Porter, for instance, speaks dismissively of the "difficulty" of understanding creole; presumably Porter has no time for Shakespeare or Joyce either. In *Slave Song*, in anticipation of such automatic responses, I clothed the creole poems in an elaborate set of "notes" and "translations" as an act of counterparody, in the way that Eliot had annotated his *Waste Land* supposedly for the benefit of his lazier readers. The more common English response to creole, however, is to be found from Alan Coren's pen. Coren in 1975 published the second volume of the collected thoughts of Idi Amin, which had been

appearing in *Punch* magazine for some months. In the introduction Amin is made to reveal the burden of words:

> One trouble wid de bes' seller business: you gittin' boun' to de wheel o'fire. No sooner you dishin' out one giant masterpiece to de gobblin' pubberlic, they comin' round yo' premises an' hammerin' on de door fo' de nex'. "Come on out, John Milton!" de mob yellin', "We know you' in there! We jus' finishin' de *Parachute Lost* an' we twiddlin' de thums, wot about dis year's jumbo pome you lazy bum?"
>
> It hardly surprisin' E.N. Fleming packin' up de Jane Bond racket an' turnin' to de penicillin business. Dam sight easier scrapin' de mold off bread an' floggin' it up de chemist than bashin' de fingers flat day an' nights on de Olivetti an' wonderin' where yo' nex' plot comin' f'om.
>
> Natcherly, de same happenin' wid de present writer. Las' year, de astoundin' fust book hittin' de shops, an' befo' anyone know wot happenin' de made fans smashin' down de premises o'W.H. Smith an' carryin' de amazin' tomes off by de crate! De pubberlisher rushin' out four impressions in four munce, an' still de cravin' not satisfied. "It no good", de pubberlisher informin' me. "Only one way to shut de slaverin' buggers' gobs, yo' imperial majesty: you havin' to cobble together another great milestone in de history o' literature, how about Wensdy week?"
>
> So here I sittin, shovin' de affairs o'state on one side, an' puttin' together a noo volume o'de famous weekly bulletins f'om downtown Kampala, Hub o'de Universe.

Two ancient images of black people emerge from Coren's pen. First, the sense that they are scientifically illiterate. This idea can be traced back to seventeenth- and eighteenth-century European writings which describe African societies as being devoid of intellectual capacities ("No ingenious manufacture amongst them, no arts, no sciences," as David Hume declared). They squat in mud huts and gnaw bones. They know neither compass nor telescope. European literature is littered with blacks like Man Friday, who falls to earth to worship Crusoe's magical gun, or the savage in Conrad's steamship who acted as fireman. [...]

Second, the sense that they are linguistically illiterate. Just as they are ignorant of the rules of scientific formulae, so they are ignorant of the rules of grammar. Their language is mere broken, stupid utterance. Again this view of black expression is firmly entrenched in European conceptualization. In seventeenth-century travel literature and anthropological writings the bestiality of the natives is reflected in their language. Sir Thomas Herbert in 1634 suggested that Africans and apes mated with each other, the evidence for this being that African speech sounded "more like that of Apes than Men ... their language is rather apishly than articulately founded." Many passages focus on the monstrosity of their organs of speech as well as their organs of propagation. Whilst John Ogilby (1670) is writing about the "large propagators" sported by the men of Guinea, and Richard Jobson (1623) on male Mandingoes being "furnished with such members as are

after a sort burdensome unto them," William Strachey (1612) focuses on their "great big lips and wide mouths." Thick lips and monstrously misshapen mouths, sometimes, as in the case of the anthropophagi, located in their chests, indicated an inability to make proper speech. When we find eloquent and civilized blacks in English literature of the period, as in the case of Mrs. Aphra Behn's Oroonoko, their physical features are more European than African: "His mouth, the finest shaped that could be seen; far from those great turn'd lips which are so natural to the rest of the Negroes."

In the eighteenth century, which was the Age of Slavery as well as the Age of the Dictionary, such attitudes to Africans were sustained, the link between barbarism and lack of speech made explicit. *Spectator* No. 389 of May 1712 described Hottentots as "Barbarians, who are in every respect scarce one degree above Brutes, having no language among them but a confused Gabble, which is neither well understood by themselves or others." Given the centrality of the Word in eighteenth-century English civilization (Pope's "What oft was thought, but ne'er so well expressed"; Hogarth's *Conversation Pieces*; Steele's *Tatler*; Johnson's *Dictionary*), the apparent wordlessness of the Africans was deemed to be incontrovertible evidence of their barbarism.

The equation between African and animal, sustained by the issue of language, which gave moral validity to the slave trade, continued in the nineteenth century, the Age of Imperialism and Anthropometrics. Africans' skulls, lips, teeth, and mouths were scrupulously measured by leading white scientists to reveal black cultural and moral primitivism and therefore the necessity of continuing colonial rule. Science underpinned the imperial process. It was also quite obvious, however, that Africans had language, and this posed a problem to white conceptualization since language was an undeniable *human* characteristic. Professor Bernth Lindfors illustrates the problem by reference to the case of the San people of South Africa, a group of whom were brought to Britain between 1846 and 1850 to be displayed at circuses and fairgrounds.[2] The speech of the San visitors was their most noticeable feature: 70 percent of it consisted of a set of implosive consonants, commonly called "clicks," which were absent from the English phonological system. Lindfors states that "the number and variety of these click consonants, complicated still further by subtle vowel colourings and significant variations in tone make it, from the phonetic point of view, among the world's most complex languages." To the Victorians, however, hardly interested in such analysis, San speech merely sounded like animal noises. The *Liverpool Chronicle* reported that "the language resembles more the cluck of turkeys than the speech of human beings" (5 December 1846), and the *Era* described the language as "wholly incomprehensible, for nobody can interpret it ... The words are made up of coughs and clucks, such as a man uses to his nag. Anything more uncivilised can scarcely be conceived" (6 June 1847). Even when admission of the humanity of the San people was grudgingly conceded, the classics of white literature were raised against them: the *Observer* wrote that "their distinguishing characteristic as men is their use of language, but besides that, they have little in common ... with that race of beings which boasts of a Newton and a Milton" (21 June 1847). The science of Newton and the literature of Milton are sufficient to put black people in their place. Idi Amin's (Alan Coren's) reference to Milton is

not a loose one. Milton's ornate, highly structured, Latinate expressions, so unattractive to modern tastes influenced by Eliot and Yeats, are still the exemplars of English civilization against which the barbaric, broken utterances of black people are judged.

In January 1978 Margaret Thatcher made a speech broadcast on prime-time television which reinforced the notions of "otherness" so prevalent in British writings on blacks. It was rhetoric which decimated the neo-fascist National Front party as an electoral force by winning the far-right of the Tory party:

> If we went on as we are, then by the end of the century there would be four million people of the New Commonwealth or Pakistan here. Now that is an awful lot and I think it means that people are really rather afraid that this country might be swamped by people with a different culture. And you know, the British character has done so much for democracy, for law, and done so much throughout the world, that if there is a fear that it might be swamped, people are going to react and be rather hostile to those coming in.

Her pronouncement, however, was very outdated, for the native British some four decades earlier had already exhibited "rather hostile" (note how the upper-class term "rather" softens the sinisterness of "hostile" and "afraid") behavior towards fellow black citizens. In September 1948, two months after the first boatload of postwar West Indian immigrants arrived on the *S.S. Empire Windrush*, race riots broke out in the streets of England. A decade later, in 1958, antiblack riots erupted in Nottingham and in the Notting Hill area of London, with gangs of white teenagers engaged in "nigger hunting," the working-class version of fox-hunting. In the next decade onwards, communal violence based on Catholic-Protestant/Irish-English hostilities became a daily feature of British life. The killing of civilians, policemen, soldiers, politicians, and one member of the Royal Family dominated television screens. In the eighties, race riots in Bristol, Liverpool, and London (the old slave ports) led to the police use of plastic bullets for the first time on the British mainland. Today, even Home Office statistics reveal that the number of physical racial attacks on black people runs into the thousands annually, while the nighttime burning down of homes is a routine experience for some immigrant communities. When E. P. Thompson declared that "England is the last colony of the British Empire," it was to such neo-colonial violence and communal strife that he was referring.

One of the many ways in which young British blacks have resisted white domination is in the creation of a patois evolved from the West Indian creole of their parents. The poetry that has emerged from the black communities is expressed in the language of this patois, and one of its greatest exponents is Linton Kwesi Johnson:

> Shock-black bubble-doun-beat bouncing
> rock-wise tumble-doun sound music:
> foot-drop find drum, blood story,

> bass history is a moving
> > is a hurting black story.
> > > ("Reggae Sounds")[3]

Johnson's poetry is recited to music from a reggae band. The paraphernalia of sound systems, amplifiers, speakers, microphones, electric guitars, and the rest which dominates the stage and accompanies what one critic has dismissed as "jungle-talk" is a deliberate "misuse" of white technology. "Sound systems," essential to "dub-poetry," are often homemade contraptions, cannibalized parts of diverse machines reordered for black expression. This de/reconstruction is in itself an assertive statement, a denial of the charge of black incapacity to understand technology. The mass-produced technology is remade for self-use in the way that the patois is a "private" reordering of "standard" English. The deliberate exploitation of high-tech to serve black "jungle-talk" is a reversal of colonial history. Caliban is tearing up the pages of Prospero's magic book and repasting it in his own order, by his own method, and for his own purpose.

[. . .]

In March 1931 a new Trinidadian journal, *The Beacon*, attempted to instigate a movement for "local" literature, encouraging writing that was authentic to the West Indian landscape and to the daily speech of its inhabitants. "We fail utterly to understand," an editorial of January/February 1932 commented on the quality of short stories received for publication, "why anyone should want to see Trinidad as a miniature Paradiso, where gravediggers speak like English M.P.'s." Emphasis was placed on the use of creole, and on a realistic description of West Indian life, for political and aesthetic reasons. To write in creole was to validate the experience of black people against the contempt and dehumanizing dismissal by white people. Celebration of blackness necessitated celebration of black language, for how could black writers be true to their blackness using the language of their colonial masters? The aesthetic argument was bound up with this political argument, and involved an appreciation of the energy, vitality, and expressiveness of creole, an argument that Edward Brathwaite has rehearsed in his book *The History of the Voice* (1984). For Brathwaite the challenge to West Indian poets was how to shatter the frame of the iambic pentameter which had prevailed in English poetry from the time of Chaucer onwards. The form of the pentameter is not appropriate to a West Indian environment: "The hurricane does not roar in pentameters. And that's the problem: how do you get a rhythm which approximates the *natural* experience, the *environmental* experience?"[4] The use of creole, or Nation language, as he terms it, involves recognition of the vitality of the oral tradition surviving from Africa, the earthiness of proverbial folk speech, the energy ergy and power of gestures which accompany oral delivery, and the insistence of the drumbeat to which the living voice responds.

England today is the largest West Indian island after Jamaica and Trinidad – there are over half a million of us here – and our generation is confronted by the same issues that Brathwaite and other writers faced in their time. If a writer was to be recognized, the pressure then was to slavishly imitate the expressions of the Mother Country. Hence the vague Miltonic cadence of Walter Mac M. Lawrence,

one of our early Guyanese writers, in describing, quite inappropriately, the native thunder of the Kaiteur Falls:

> And falling in splendour sheer down from the heights
> that should gladden the heart of our eagle to scan,
> That lend to the towering forest beside thee the semblance
> of shrubs trimmed and tended by man –
> That viewed from the brink where the vast, amber volume
> that once was a stream cataracts into thee,
> Impart to the foothills surrounding the maelstrom beneath
> thee that rage as this troublous sea.[5]

Brathwaite and others eventually rescued us from this cascade of nonsense sounds. The pressure now is also towards mimicry. Either you drop the epithet "black" and think of yourself as a "writer" (a few of us foolishly embrace this position, desirous of the status of "writing" and knowing that "black" is blighted) – that is, you cease dwelling on the nigger/tribal/nationalistic theme, you cease *folking* up the literature, and you become "universal" – or else you perish in the backwater of small presses, you don't get published by the "quality" presses, and you don't receive the corresponding patronage of media-hype. This is how the threat against us is presented. Alison Daiches, summarizing these issues, puts them in a historical context: the pressure is to become a mulatto and house-nigger (Ariel) rather than stay a field-nigger (Caliban).[6]

I cannot feel or write poetry like a white man, however, much less serve him. And to become mulattos, black people literally have to be fucked (and fucked up) first. Which brings us back to the pornography of Empire. I feel that I am different, not wholly, but sufficiently for me to want to contemplate that which is other in me, that which owes its life to particular rituals of ancestry. I know that the concept of "otherness" is the fuel of white racism and dominates current political discourse, from Enoch Powell's "In these great numbers blacks are, and remain, alien here. With the growth of concentrated numbers, their alienness grows not by choice but by necessity," to Margaret Thatcher's "swamped by people of a different culture." I also know that the concept of "otherness" pervades English literature, from Desdemona's fatal attraction to the body of alien experience in preference to the familiarity of her own culture to Marlow's obsession with the thought that Africans are in one sense alien but in a more terrible sense the very capacities within Europeans for the gratification of indecent pleasures. But these are not my problems[5]. I'm glad to be peculiar, to modify the phrase. I'd prefer to be simply peculiar, and to get on with it, to live and write accordingly, but gladness is a forced response against the weight of insults, a throwing off of white men's burdens.

As to "universality," let Achebe have the last word, even if in the most stylish of English:

> In the nature of things the work of a Western writer is automatically informed by universality. It is only others who must strain to achieve it. So-and-so's work is universal; he has truly arrived! As though uni-

versality were some distant bend in the road which you may take if you travel out far enough in the direction of Europe or America, if you put adequate distance between yourself and your home. I should like to see the word "universal" banned altogether from discussion of African literature until such a time as people cease to use it as a synonym for the narrow, self-serving parochialism of Europe, until their horizon extends to include all the world.[7]

Notes

1 Thomas Thistlewood was a small landowner in Western Jamaica during the eighteenth century. He chronicles the daily life around him until his death in 1786. A selection of his writings can be found in *In Miserable Slavery: Thomas Thistlewood in Jamaica, 1750–1786*, ed. Douglas Hall (London, 1988).

2 Bernth Lindfors. "The Hottentot Venus" (paper given at London University's International Conference on the History of Blacks in Britain, 1981).

3 L. K. Johnson, *Dread Beat and Blood* (London, 1975), p. 56.

4 E. Brathwaite, *The History of the Voice* (London, 1984), p. 10.

5 Walter Mac M. Lawrence, cited in M. Gilkes, *Creative Schizophrenia: The Caribbean Cultural Challenge* (University of Warwick, Centre for Caribbean Studies, Third Walter Rodney Memorial Lecture, 1986), p. 3.

6 Alison Daiches, in *Third World Impact*, ed. A. Ali (London, 1988), p. 74.

7 C. Achebe, *Hopes and Impediments* (Oxford, 1988) p. 52.

Edward K. Brathwaite

NATION LANGUAGE (1984)

What I am going to talk about this morning is language from the Caribbean, the process of using English in a different way from the 'norm'. English in a new sense as I prefer to call it. English in an ancient sense. English in a very traditional sense. And sometimes not English at all, but *language*.

I start my thoughts, taking up from the discussion that developed after Dennis Brutus's[1] very excellent presentation. Without logic, and through instinct, the people who spoke with Dennis from the floor yesterday brought up the question of language. Actually, Dennis's presentation had nothing to do with language. He was speaking about the structural condition of South Africa. But instinctively people recognized that the structural condition described by Dennis had very much to do with language. He didn't concentrate on the language aspect of it because there wasn't enough time and because it was not his main concern. But it was interesting that your instincts, not your logic, moved you toward the question of the relationship between language and culture, language and structure. In his case, it was English as spoken by Africans, and the native languages as spoken by Africans.

We in the Caribbean have a similar kind of plurality: we have English, which is the imposed language on much of the archipelago. It is an imperial language, as are French, Dutch and Spanish. We also have what we call creole English, which is a mixture of English and an adaptation that English took in the new environment of the Caribbean when it became mixed with the other imported languages. We have also what is called *nation language*, which is the kind of English spoken by the people who were brought to the Caribbean, not the official English now, but the language of slaves and labourers, the servants who were brought in by the conquistadors. Finally we have the remnants of ancestral languages still persisting in the Caribbean. There is Amerindian, which is active in certain parts of Central America but not in the Caribbean because the Amerindians are here a destroyed people, and their languages were practically destroyed. We have Hindi, spoken by some of the more traditional East Indians who live in

the Caribbean, and there are also varieties of Chinese.[2] And, miraculously, there are survivals of African languages still persisting in the Caribbean. So we have that spectrum – that prism – of languages similar to the kind of structure that Dennis described for South Africa. Now, I have to give you some kind of background to the development of these languages, the historical development of this plurality, because I can't take it for granted that you know and understand the history of the Caribbean.

The Caribbean is a set of islands stretching out from Florida in a mighty curve. You must know of the Caribbean at least from television, at least now with hurricane David[3] coming right into it. The islands stretch out on an arc of some two thousand miles from Florida through the Atlantic to the South American coast, and they were originally inhabited by Amerindian people: Taino, Siboney, Carib, Arawak. In 1492 Columbus 'discovered' (as it is said) the Caribbean, and with that discovery came the intrusion of European culture and peoples and a fragmentation of the original Amerindian culture. We had Europe 'nationalizing' itself into Spanish, French, English and Dutch so that people had to start speaking (and *thinking*) four metropolitan languages rather than possibly a single native language. Then with the destruction of the Amerindians, which took place within 30 years of Columbus' discovery (one million dead a year) it was necessary for the Europeans to import new labour bodies into the area. And the most convenient form of labour was the labour on the edge of the *slave* trade winds, the labour on the edge of the hurricane, the labour on the ledge of Africa. And so Ashanti, Congo, Yoruba, all that mighty coast of western Africa was imported into the Caribbean. And we had the arrival in our area of a new language structure. It consisted of many languages but basically they had a common semantic and stylistic form.[4] What these languages had to do, however, was to submerge themselves, because officially the conquering peoples – the Spaniards, the English, the French, and the Dutch – insisted that the language of public discourse and conversation, of obedience, command and conception should be English, French, Spanish or Dutch. They did not wish to hear people speaking Ashanti or any of the Congolese languages. So there was a submergence of this imported language. Its status became one of inferiority. Similarly, its speakers were slaves. They were conceived of as inferiors – non-human, in fact. But this very submergence served an interesting intercultural purpose, because although people continued to speak English as it was spoken in Elizabethan times and on through the Romantic and Victorian ages, that English was, nonetheless, still being influenced by the underground language, the submerged language that the slaves had brought. And that underground language was itself constantly transforming itself into new forms. It was moving from a purely African form to a form which was African but which was adapted to the new environment and adapted to the cultural imperative of the European languages. And it was influencing the way in which the English, French, Dutch, and Spaniards spoke their own languages. So there was a very complex process taking place which is now beginning to surface in our literature.

Now, as in South Africa (and any area of cultural imperialism for that matter), the educational system of the Caribbean did not recognize the presence of these various languages. What our educational system did was to recognize and maintain

the language of the conquistador – the language of the planter, the language of the official, the language of the anglican preacher. It insisted that not only would English be spoken in the anglophone Caribbean, but that the educational system would carry the contours of an English heritage. Hence, as Dennis said, Shakespeare, George Eliot, Jane Austen – British literature and literary forms, the models which had very little to do really, with the environment and the reality of non-Europe – were dominant in the Caribbean educational system.

It was a very surprising situation. People were forced to learn things which had no relevance to themselves. Paradoxically, in the Caribbean (as in many other 'cultural disaster' areas), the people educated in this system came to know more, even today, about English kings and queens than they do about our own national heroes, our own slave rebels, the people who helped to build and to destroy our society. We are more excited by their literary models, by the concept of, say, Sherwood Forest and Robin Hood than we are by Nanny of the Maroons,[5] a name some of us didn't even know until a few years ago. And in terms of what we write, our perceptual models, we are more conscious (in terms of sensibility) of the falling of snow, for instance – the models are all there for the falling of the snow – than of the force of the hurricanes which take place every year. In other words, we haven't got the syllables, the syllabic intelligence, to describe the hurricane, which is our own experience, whereas we can describe the situation that we are in.

> The day the first snow fell I floated to my birth
> of feathers falling by my window; touched earth
> and melted, touched again and left a little touch of light
> and everywhere we touched till earth was white.[6]

This is why there were (are?) Caribbean children who, instead of writing in their 'creole' essays 'the snow was falling on the playing fields of Shropshire' (which is what our children literally were writing until a few years ago, below drawings they made of white snowfields and the corn-haired people who inhabited such a landscape), wrote: '*the snow was falling on the canefields*'[7] trying to have both cultures at the same time.

What is even more important, as we develop this business of emergent language in the Caribbean, is the actual rhythm and the syllables, the very software, in a way, of the language. What English has given us as a model for poetry, and to a lesser extent prose (but poetry is the basic tool here), is the pentameter: 'The cúrfew tólls the knéll of párting dáy'. There have, of course, been attempts to break it. And there were other dominant forms like, for example *Beowulf* (c. 750), *The Seafarer* and what Langland (?1332–?1400) had produced:

> For trewthe telleth that loue is triacle of hevene;
> May no synne be on him sene that useth that spise,
> And alle his werkes he wrougte with loue as him liste

or, from *Piers the Plowman* (which does not make it into *Palgrave's Golden Treasury* which we all had to 'do' at school) the haunting prologue:

> In a somer seson whan soft was the sonne
> I shope me into shroudes as I a shepe were

which has recently inspired Derek Walcott with his first major nation language effort:

> In idle August, while the sea soft,
> and leaves of brown islands stick to the rim
> of this Caribbean, I blow out the light
> by the dreamless face of Maria Concepcion
> to ship as a seaman on the schooner *Flight*.[8]

But by the time we reach Chaucer (1345–1400) the pentameter prevails. Over in the New World, the Americans – Walt Whitman – tried to bridge or to break the pentameter through a cosmic movement, a large movement of sound. cummings tried to fragment it. And Marianne Moore attacked it with syllabics. But basically the pentameter remained, and it carries with it a certain kind of experience, which is not the experience of a hurricane. The hurricane does not roar in pentameters. And that's the problem: how do you get a rhythm which approximates the *natural* experience, the *environmental* experience?

[. . .]

It is *nation language* in the Caribbean that, in fact, largely ignores the pentameter. Nation language is the language which is influenced very strongly by the African model, the African aspect of our New World/Caribbean heritage. English it may be in terms of some of its lexical features. But in its contours, its rhythm and timbre, its sound explosions, it is not English, even though the words, as you hear them, might be English to a greater or lesser degree. And this brings us back to the question that some of you raised yesterday: can English be a revolutionary language? And the lovely answer that came back was: *it is not English that is the agent. It is not language, but people, who make revolutions.*

I think, however, that language does really have a role to play here, certainly in the Caribbean. But it is an English which is not the standard, imported, educated English, but that of the submerged, surrealist experience and sensibility, which has always been there and which is now increasingly coming to the surface and influencing the perception of contemporary Caribbean people. It is what I call, as I say, nation language. I use the term in contrast to dialect. The word 'dialect' has been bandied about for a long time, and it carries very pejorative overtones. Dialect is thought of as 'bad English'. Dialect is 'inferior English'. Dialect is the language used when you want to make fun of someone. Caricature speaks in dialect. Dialect has a long history coming from the plantation where people's dignity is distorted through their language and the descriptions which the dialect gave to them. Nation language, on the other hand, is the *submerged* area of that dialect which is much more closely allied to the African aspect of experience in the Caribbean. It may be in English: but often it is in an English which is like a howl, or a shout or a machine-gun or the wind or a wave. It is also like the blues. And sometimes it is English and African at the same time.

[. . .]

Now I'd like to describe for you some of the characteristics of our nation language. First of all, it is from, as I've said, an oral tradition. The poetry, the culture itself, exists not in a dictionary but in the tradition of the spoken word. It is based as much on sound as it is on song. That is to say, the noise that it makes is part of the meaning, and if you ignore the noise (or what you would *think* of as noise, shall I say) then you lose part of the meaning. When it is written, you lose the sound or the noise, and therefore you lose part of the meaning. Which is, again, why I have to have a tape recorder for this presentation. I want you to get the sound of it, rather than the sight of it.

In order to break down the pentameter, we discovered an ancient form which was always there, the calypso.[9] This is a form that I think nearly everyone knows about. It does not employ the iambic pentameter. It employs dactyls. It therefore mandates the use of the tongue in a certain way, the use of sound in a certain way. It is a model that we are moving naturally towards now. Compare:

> IP: To be or not to be, that is the question

> KAISO: The stone had skidded arc'd and bloomed into islands
> Cuba San Domingo
> Jamaica Puerto Rico[10]

But not only is there a difference in syllabic or stress pattern, there is an important difference in shape of intonation. In the Shakespeare (IP above), the voice travels in a single forward plane towards the horizon of its end. In the Kaiso, after the skimming movement of the first line, we have a distinct variation. The voice dips and deepens to describe an intervallic pattern. And then there are more ritual forms like *kumina*, like *shango*, the religious forms,[11] which I won't have time to go into here, but which begin to disclose the complexity that is possible with nation language.

The other thing about nation language is that it is part of what may be called *total expression*, a notion which is not unfamiliar to you because you are coming back to that kind of thing now. Reading is an isolated, individualistic expression. The oral tradition on the other hand demands not only the griot but the audience to complete the community; the noise and sounds that the maker makes are responded to by the audience and are returned to him. Hence we have the creation of a continuum where meaning truly resides. And this *total expression* comes about because people be in the open air, because people live in conditions of poverty ('unhouselled') because they come from a historical experience where they had to rely on their very breath rather than on paraphernalia like books and museums and machines. They had to depend on *immanence*, the power within themselves, rather than the technology outside themselves.

[. . .]

Notes

1 Dennis Brutus, the South African poet-and-activist-in-exile. His presentation preceded mine at this Conference and was part of a Third World segment: Azanian Caribbean and Navajo.

2 No one, as far as I know, has yet made a study of the influence of Asiatic languages on the contemporary Caribbean, and even the African impact is still in its study's infancy. For aspects of (anglophone) Caribbean cultural development relevant to this study, see my *Contradictory Amens: Cultural Diversity and Integration in the Caribbean* (Savacou Publications, Mona, 1974). For individual territories, see Baxter (1970), Brathwaite (1979), Nettleford (1978), Seymour (1977). See also Norman E. Whitten and John F. Szwed (eds.), *Afro-American Anthropology* (New York & London 1970).

3 This talk was presented at Harvard University, Cambridge, Massachusetts, late in August 1979. Hurricanes ravage the Caribbean and the southern coasts of the United States every summer. David (1979) was followed by Allen (1980) one of the most powerful on record.

4 See Alan Lomax, 'Africanisms in New World Negro music: a cantometric analysis', *Research and Resources of Haiti* (New York 1969), *The Haitian Potential* (New York 1975); Mervyn Alleyne, 'The linguistic continuity of Africa in the Caribbean', *Black Academy Review* 1 (4), Winter 1970, pp. 3–16 and *Comparative Afro-American: an Historical-Comparative Study of English-based Afro-American Dialects of the New World* (Ann Arbor 1980).

5 The Maroons were Africans / escaped slaves who, throughout Plantation America, set up autonomous societies, as a result of successful runaway and/or rebellion in 'marginal', certainly inaccessible, areas outside European influence. See Richard Price (ed.), *Maroon Societies* (New York 1973). Nanny of the Maroons, an ex-Ashanti (?) Queen Mother, is regarded as one of the greatest of the Jamaica freedom fighters. See Brathwaite, *Wars of Respect* (Kingston 1977).

6 Edward Kamau Brathwaite, 'The day the first snow fell', *Delta* (Cambridge, England [1951]), *Other Exiles* (London 1975), p.7.

7 I am indebted to Anne Walmsley, editor of the anthology *The Sun's Eye* (London 1968) for this example. For experiences of teachers trying to cope with West Indian English in Britain, see Chris Searle, *The Forsaken Lover: White Words and Black People* (London 1972) and *Okike* (15 August 1979).

8 Derek Walcott, 'The schooner *Flight*', *The Star-Apple Kingdom* (New York 1979; London 1980), p.3. Langland's prelude *to Piers* is often 'softened' into 'In somer season, whan soft was the sonne / I shope me in shroudes as I shepe were', which places it closer to Walcott – and to the pentameter.

9 The calypso (kaiso) is well treated, in historical and musicological perspective in *Caribbean Quarterly 4* (1956) and by J. D. Elder (1970) and Errol Hill (1972). But it is Gordon Rohlehr, a critic and Reader in English at the UW1, St Augustine, Trinidad, who apart from a few comments by C.L.R. James and Derek Walcott, is almost the only major Caribbean writer to have dealt with its literary aspects and with the relationship between kaiso (and reggae) and literature. Among his articles: 'Sparrow and the language of calypso', *CAM Newsletter* 2(1967), *Savacou* 2 (Sept 1970); 'Calypso and morality', *Moko* 17 June 1969; 'The calypso as rebellion', *S.A.G.* 3(1970); 'Sounds and Pressure: Jamaican Blues', *Cipriani Labour College Review*, (Jan 1970); 'Calypso and politics', *Moko* 29 Oct 1971; 'Forty years of calypso', *Tapia 3*, 17 Sept, 8 Oct 1972: 'Samuel Selvon and the language of the people' in Edward Baugh (ed.) *Critics on Caribbean Literature (London 1978), from* 'The folk in Caribbean literature', *Tapia* 17 Dec 1972.

10 Brathwaite, 'Caribbean theme: a calypso', CQ4: 3&4(1956)p.246; *Rights of Passage* (1967: as 'Calypso'), p.48; sung by the author on Argo DA101(1969), PLP1110(1972).

11 See G. E. Simpson, *Religious Cults of the Caribbean* (Rio Piedras 1970); Honor Ford-Smith, 'The performance aspect of kumina ritual', Seminar Paper, Dept of English, UWI, Mona (1976).

Braj B. Kachru

THE ALCHEMY OF ENGLISH (1986)

English as a language of power

The monarchy of Britain may have at one time claimed "divine rights," but those rights were never extended to the language of the monarchs. The power of English is, therefore, of a more worldly nature – in what Quirk *et al.* (1972 : 2) have termed the "vehicular load" of a language, which English carries as the "primary medium for twentieth-century science and technology." The other, equally important, markers of that power of English are its demographic distribution, its native and non-native users across cultures, its use in important world forums, and its rich literary tradition.

The power of English, then, resides in the domains of its use, the roles its users can play, and – attitudinally – above all, how others view its importance. On all these counts, English excels other world languages. One would not have foreseen this situation easily in the sixteenth century, though even in 1599 Samuel Daniel, a minor poet, fantasized about the "treasures of our language" going to "the strange shores." The questions Daniel asked (in his poem *Musophilus*) then have been fully answered and realized in the succeeding four centuries:

> And who, in time, knows wither we may vent
> The treasures of our tongue, to what strange shores
> This gain of our best glory shall be sent,
> To enrich unknowing nations with our stores?
> What worlds in the yet unformed Occident
> May come refined with the accents that are ours?
> Or who can tell for what great work in hand
> The greatness of our style is now ordained?
> What powers it shall bring in, what spirits command,
> What thoughts let out, what humours keep restrained,

> What mischief it may powerfully withstand,
> And what fair ends may thereby be attained?

Perhaps one could not take these rhetorical questions too seriously before the full impact of William Shakespeare, Ben Jonson, and others who make the Elizabethan period the glory of the English language. The exploits of the Raj had not yet unfolded; the "alien shores" were still not part of the Empire. As John Dryden lamented in 1693, the English language possessed "no prosodia, not so much as a tolerable dictionary or a grammar, so that our language is in a manner barbarous" (quoted in Baugh and Cable, 1978: 255). The picture had changed little for almost a century from 1582 when, in the words of Richard Mulcaster, English was "of small reach," extending "no further than this Island of ours, nay not there over all" (quoted in Kachru and Quirk, 1981: xiv). But that cynicism was short-lived, as the following centuries were to prove.

Today the linguistic vision of Samuel Daniel has been realized, the English language is a tool of power, domination, and elitist identity, and of communication across continents. Although the era of the "White man's burden" has practically ended in a political sense, and the Raj has retreated to native shores, the linguistic and cultural consequences of imperialism have changed the global scene. The linguistic ecology of, for example, Africa and Asia is not the same. English has become an integral part of this new complex sociolinguistic setting. The colonial Englishes were essentially acquired and used as non-native second languages, and after more than two centuries, they continue to have the same status. The *non-nativeness* of such varieties is not only an attitudinally significant term, but it also has linguistic and sociolinguistic significance (see Kachru, 1984a).

English as a colonial language

The political power of the British (and Americans in the Philippines or Puerto Rico) gave to them as colonists a lot of political stature, requiring them to adopt a pose fitting their status. The white man's language became a *marker* of his power. Englishmen became different persons while functioning in Asia and Africa. The sahibs in the colonies underwent a change facilitated by the new-found prestige of their native language. What was true of the Indian scene was also true in other parts of the world, and E. M. Forster (1952 [1924]) captured it well in *A Passage to India*. Referring to the Englishmen in India, two of the novel's characters say,

> India likes gods.
> And Englishmen like posing as gods.

The English language was part of the pose and the power. Indians, Africans, and others realized it and accepted it. Therefore, it is not surprising that when a native tried to adopt the same pose – that is, to speak the same language, particularly with the sahib's accent – it made the sahib uncomfortable.

The term "*non-native*" Englishes is used here, following my earlier use of the

term (Kachru, 1965, and later) for those transplanted varieties of English that are acquired primarily as second languages. In such a context, whatever other motivations there may be, English is used as a tool of power to cultivate a group of people who will identify with the cultural and other norms of the political elite. In India, T. B. Macaulay, in his often-quoted *Minute*, dreamt of developing a culturally distinct group who would form "a class who may be interpreters between us and those whom we govern, a class of persons, Indians in blood and colour, English in taste in opinion, in morals and in intellect" (cited in Sharp, 1920–1922: I, 116).

Almost at the same time, another English-speaking nation, the United States, "set out to Americanize Puerto Rico with a vengence during the first fifty years of its occupation" (Zentella, 1981:219). The US government's view, as Zentella observes, was presented by Victor Clark, the Commissioner of Education:

> if the schools became American and the teachers and students were guided by the American spirit, then the island would be essentially American in sympathies, opinions, and attitudes toward government.

The year 1898 saw American power extend in another direction as well – to the Philippines, where "the mock battle of Manila Bay marked the end of 300 years of Spanish and the beginning of American colonial domination." The US attitude toward this colony was no different from the one toward Puerto Rico. President McKinley (1843–1901) is reported to have said the American duty toward the newly acquired colony should be "to educate the Filipinos and uplift and civilize and Christianize them to fit the people for the duties of citizenship" (quoted in Beebe and Beebe 1981: 322).

Such views had been expressed a little earlier in South Asia by colonizers from the other side of the Atlantic. Charles Grant believed that

> the true curse of darkness is the introduction of light. The Hindoos err, because they are ignorant and their errors have never fairly been laid before them. The communication of our light and knowledge to them, would prove the best remedy for their disorders.
> (Grant, 1812–1813: 60–61)

In what was then known as Ceylon (now renamed Sri Lanka) the same pattern was repeated. In 1827 Sir Edward Barnes (the governor of Sri Lanka from 1824–1831) laid the foundation of a "Christian Institution":

> to give a superior education to a number of young persons who from their ability, piety, and good conduct were likely to prove fit persons in communicating a knowledge of Christianity to their countrymen.
> (Barnes, 1932:43).

In imparting such education, the governor, as Ruberu says (1962:158–159),

did not desire any association with or support from the American missionaries who were then present in Sri Lanka. Therefore, a letter was sent to the American missionaries on the island saying that "the means we possess in our own country for the conversion of our heathen subjects to Christianity are in the Lieutenant Governor's opinion fully adequate to all purposes" (quoted by Ruberu, 1962:158). This was said much before Rudyard Kipling's (1865–1936) call to

> Take up the White man's burden –
> Send forth the best ye breed –
> Go bind your sons to exile
> To serve your captives' need.

In these statements English is associated with a power more subtle than mere wordly success: it is considered to be a tool of "civilization" and "light". Provision of that tool is perceived as a colonizer's contribution – and duty – to the well-being of the inhabitants of newly acquired colonies. According to this view, then, language can open the gates for the emancipation of souls. And here we find a subtle parallel to the power attributed to the Sanskrit texts.

Along with its "other-worldly" reward, English also provided an earthy bonus as a medium for understanding technology and scientific development. For more pensive minds, it made available the literary treasures of the European languages. To newly "awakened" Asian and African minds, that literature in itself was a revelation. Macaulay had already warned the insecure among them that

> I have no knowledge of either Sanskrit or Arabic. But I have done what I could to form a correct estimate of their value ... I am quite ready to take the Oriental learning at the valuation of the Orientalists themselves. I have never found one amongst them who could deny that a single shelf of a good European library was worth the whole native literature of India and Arabia.
>
> (Sharp, 1920: 22)

The Industrial Revolution's technological impact and the cultural dimensions of the Renaissance clearly brought before non-Western intellectuals the accomplishments of the West. The ambitious among the colonized viewed English as their main tool with which to emulate such accomplishments.

Slowly the new political reality bestowed the socially and administratively dominant roles on the newly installed language. Ultimately the legal system, the national media, and important professions were conducted in English. The medium was associated with the message of medical miracles and of technology. There already existed an ambitious (albeit small) group who wanted to acquire English for "mathematics, natural philosophy, chemistry, anatomy, and other useful sciences, which the natives of Europe have carried to a degree of perfection" (Raja Rammohan Roy (quoted in Kachru, 1969, 1978b: 482)). For this purpose Roy was pleading that the "European gentlemen of talent and education" be appointed "to instruct the natives of India."

Eventually the small number of Indians, Africans, or Filipinos who became

skilled in such professional roles became the symbols of what was termed "Westernization" (or, to use a neutral term, "modernization"). The "brown sahibs" seemed to feel solidarity, at least attitudinally, with the "white sahibs." Whether or not this feeling was reciprocated or exploited, the fact remains that a linguistic tool of power was steadily being shared. The domains of language use defined the power and prestige of language. English acquired a strong non-native base, and the local languages slowly lost the battle for prestige and power.

The elite language was eventually used against the Englishmen, against their roles and their intentions; it became the language of resurgence of nationalism, and political awakening at one level. And now the colonized, like Caliban (Shakespeare, *The Tempest*), were sometimes heard to say,

> You taught me language and my profit on't
> Is, I know how to curse! The red plague rid you
> For learning me your language.

There are some who consider it a "grotesque perversion of the truth" that English "was imposed on a subject people by a set of foreign rulers for the sake of carrying on their alien government" (Chaudhuri, 1976 : 89). The word "imposed" is tricky here, for what was attitudinally prestigious and pragmatically desirable and rewarding did not need imposition: Power seems to have a way of creating its linguistic base.

The linguistic and cultural pluralism in Africa and South Asia contributed to the spread of English, and helped foster its retention even after the colonial period ended. The nationalist awakening needed a pan-national medium for a resurgence; the medium chosen was, ironically, the "alien" language. And there were reasons, both cultural and linguistic, for that choice.

True, Indian leaders like Mohandas K. Gandhi (1869–1948) were struggling to create consensus for a mutually acceptable native variety as the national language (Desai, 1964), but their message to the elite was expressed in English. By the 1920s, English had become the language of political discourse, intranational administration, and law, and it was associated with liberal thinking. These roles, and such an attitude toward English, maintained its power over local languages even after the colonial period ended.

Acquiring domains of power

Ease in acquiring domains of power is not necessarily related to the number of a language's users. The number of bilinguals able to use English in non-native contexts has always been limited: in South Asia for example, it has not exceeded 3 percent of the literate population.[1] However, that small segment of the population controls domains that have professional prestige; therefore, these people are considered worthy of emulation. One might say that they control certain types of knowledge that ambitious parents would like their children to possess. And whose parents are not ambitious?

In India, only Sanskrit, English, Hindi, and to some extent Persian have

acquired pan-Indian intranational functions. The domains of Sanskrit are restricted, and the proficiency in it limited, except in the case of some professional pandits. The cause of Hindi was not helped by the controversy between Hindi, Urdu, and Hindustani. Support for Hindustani almost ended with independence; after the death of its ardent and influential supporter, Gandhi, very little was heard about it. The enthusiasm and near euphoria of the supporters of Hindi were not channeled in a constructive (and realistic) direction, especially after the 1940s. The result is that English continues to be a language both of power and of prestige (Kachru, 1976b; K. Sridhar, 1982).

For governments, English thus serves at least two purposes. First, it continues to provide a linguistic tool for the administrative cohesiveness of a country (as in South Asia and parts of Africa). Second, at another level, it provides a language of wider communication (national and international). The enthusiasm for English is not unanimous, or even widespread. The disadvantages of using it are obvious: Cultural and social implications accompany the use of an external language. But the native languages are losing in this competition (see, e.g., Apte 1976; Das Gupta 1969, 1970).

English does have one clear advantage, attitudinally and linguistically: it has acquired a *neutrality* in a linguistic context where native languages, dialects, and styles sometimes have acquired undesirable connotations. Whereas native codes are functionally marked in terms of caste, religion, region, and so forth, English has no such "markers," at least in the non-native context. It was originally the foreign (alien) ruler's language, but that drawback is often overshadowed by what it can do for its users. True, English is associated with a small and elite group; but it is in their role that the *neutrality* of a language becomes vital (e.g., for Tamil speakers in Tamil Nadu, or Bengali speakers in the West Bengal). In India the most widely used language is Hindi (46 percent) and its different varieties (e.g., Hindustani, Urdu) have traditionally been associated with various factions: Hindi with the Hindus; Urdu with the Muslims; and Hindustani with the maneuvering political pandits who could not create a constituency for it. While these attitudinal allocations are not necessarily valid, this is how the varieties have been perceived and presented. English, on the other hand, is not associated with any religious or ethnic faction.

Whatever the limitations of English, it has been perceived as the language of power and opportunity, free of the limitations that the ambitious attribute to the native languages.

Attitudinal neutrality and power

In several earlier studies it has been shown (Kachru, 1978a and 1982a) that in *code-mixing*, for example, English is being used to *neutralize* identities one is reluctant to express by the use of native languages or dialects. "Code-mixing" refers to the use of lexical items or phrases from one code in the stream of discourse of another. Neutralization thus is a linguistic strategy used to "unload" a linguistic item from its traditional, cultural, and emotional connotations by avoiding its use and choosing an item from another code. The borrowed item has referential

meaning, but no cultural connotations in the context of the specific culture (Kachru, 1982a). This is not borrowing in the sense of filling a lexical gap, as I have discussed in Kachru, 1982a and 1983a (p. 195–197). Let me repeat some of those examples here. In Kashmiri the native word *mɔnd* ("widow") invokes the traditional connotations associated with widowhood. Its use is restricted to abuses and curses, not occurring in "polished" conversation. *vedvā*) (Hindi *vidhwā*) or English *widow* is preferred by the Hindus. In Tamil, as shown by Annamalai (1978) *maccaan* and *attimbeer* reveal the caste identity of the speaker – not desirable in certain situations. Therefore, one uses English *brother-in-law*, instead. English *rice* is neutral compared with *saadam* or *soru* (purist) in Tamil. A lexical item may be associated with a specific style in the native language as are *manaivi* (formal) and *penḍiṭṭi* (colloquial) in Tamil, but the English equivalent *wife* has no style restrictions.

In such contexts, then, the power of neutralization is associated with English in two ways. First, English provides – with or without "mixing" – an additional code that has referential meaning but no cultural overtones or connotations. Thus the types of linguistic features (especially lexicalization) that mark *granthika* (classical) versus *vyāvahārika* (colloquial) in Telugu, *sādhubhaṣa* (literary) versus *cɔlitbhasa* (colloquial) in Bengali, and Hindu versus Muslim Kashmiri, are obscured by using English or by lexicalization from English, English neutralizes discourse in terms of "identity," providing another identity. The bilingual (or multilingual) speaker can use codes for an identity shift: to obscure one identity and bring into the foreground another. Second, such use of English develops new code-mixed varieties of languages (Kachru, 1978). Lexicalization from English is particularly preferred in the contexts of kinship, taboo items, science and technology, or in discussing sex organs and death. What Moag (1982 : 276) terms the "social neutrality" of English in the case of Fiji is applicable in almost all the countries where English is used as a nonnative language. In the Fijian context, Tongans and Fijians,

> find English the only safe medium in which to address those of higher status. English not only hides their inability in the specialized vernacular registers, but also allows them to meet traditional superiors on a more or less equal footing.

[. . .]

Post-colonial period

Since independence, the controversy about English has taken new forms. Its "alien" power base is less an issue; so is its Englishness or Americanness in a cultural sense. The English language is not perceived as necessarily imparting only Western traditions. The medium is non-native, but the message is not. In several Asian and African countries, English now has national and international functions that are both distinct and complementary. English has thus acquired a new power base and a new elitism. The domains of English have been restructured. The result is that one more frequently, and very eloquently, hears people ask, Is

English really a non-native ("alien") language for India, for Africa, and for South-east Asia.?[2]

In the case of India one wonders: has India played the age-old trick on English, too, of nativizing it and acculturating it – in other words, Indianizing it? The Indian writer and philosopher Raja Rao (1978:421) associates power with English which, in his mind is equal to if not greater than Sanskrit, when he says,

> Truth, said a great Indian sage, is not the monopoly of the Sanskrit language. Truth can use any language, and the more universal, the better it is. If metaphysics is India's primary contribution to world civilization, as we believe it is, then must she use the most universal language for her to be universal ... And as long as the English language is universal, it will always remain Indian ... It would then be correct to say as long as we are Indian – that is, not nationalists, but truly Indians of the Indian psyche – we shall have the English language with us and amongst us, and not as a guest or friend, but as one of our own, of our caste, our creed, our sect and our tradition.

These new power bases in Africa or in Asia have called into question the traditionally accepted, externally normative standards for the institutionalized varieties. The new varieties have their own linguistic and cultural ecologies or sociocultural contexts. The adaptation to these new ecologies has given non-native Englishes new identities. That the recognition of such an identity has implications for the local languages was pointed out by Halliday *et al.* (1964). In the case of India, for example, they felt that those who favor English as a model "should realize that in doing so they may be helping to prop up the fiction that English is the language of Indian culture and thus be perpetuating the diminished status of the Indian languages." The warning was too late. By 1964, English had already become a vital part of the Indian linguistic repertoire. What was "fiction" in the 1960s has now become a reality in the 1980s.

The wider implications of this change in the ecology of world Englishes are significant: The new nativized (non-native) varieties have acquired an ontological status and developed localized norms and standards. Purists find that the situation is getting out of hand (see, e.g. Prator, 1968); they are uncomfortable that the native speakers' norms are not universally accepted. There are others who feel that a pragmatic approach is warranted and that a "monomodel" approach for English in the world context is neither applicable nor realistic. (Kachru, 1982c and 1984a provide a detailed discussion of this topic.)

The extended non-native uses of English also raise serious theoretical issues, both in sociolinguistic and linguistic research. These are not necessarily related to the questions of "power," but to language analysis and description. It seems that linguists' traditional preoccupation with the monolingual "native speaker" is now being questioned – and rightly so. Does one need a new perspective and a new theoretical and descriptive technique for writing bilinguals' or multilinguals' grammars? Such probing questions are the result of the spread of English, and of the alchemy that English uses for changing itself, and for "Englishizing" the non-Western languages with which it has prolonged contact (discussed by Ferguson,

1978, 1982a; Kachru, 1984a). What we see here is that the "power" of English has deeper implications, going beyond what we see on the surface.

One might say that contemporary English does not have just one defining context but many – across cultures and languages. This is also true of the growing new literatures in English. The concepts of "British literature" or "American literature" represent only a part of the spectrum. The new traditions – really not so new – must be incorporated into the tradition of "literature in English" (Narasimhaiah, ed. 1978).

The power bases for English today exist on almost all continents. This unprecedented linguistic situation, therefore, needs new understanding and pragmatics. In each context the English language is manipulated differently, as a medium of power, control, authority, and cohesion. English has therefore acquired intranationally and internationally most important roles. In each English-using country, these roles are in the hands of a small portion of the total population. If this linguistic power is wielded without sensitivity, without understanding, English becomes a language for oppression (Ansre, 1979).

The alchemy of English (present and future), then does not only provide social status, it also gives access to attitudinally and materially desirable domains of power and knowledge. It provides a powerful linguistic tool for manipulation and control. In addition, this alchemy of English has left a deep mark on the languages and literature of the non-Western world. English has thus caused transmutation of languages, equipping them in the process for new societal, scientific, and technological demands. The process of Englishization has initiated stylistic and thematic innovations, and has "modernized" registers. The power of English is so dominant that a new caste of English-using speech fellowships has developed across cultures and languages. It may be relatively small, but it is powerful, and its values and perspectives are not necessarily in harmony with the traditional values of these societies. In the past, the control and manipulation of international power have never been in the hands of users of one language group. Now we see a shift of power from the traditional caste structure; in the process, a new caste has developed. In this sense, English has been instrumental in a vital social change, and not only in that of language and literatures.

One might ask, does one see signs of change in the international power of English? We have seen that legislation or educational planning in, for example, Africa or Asia, has failed to accomplish this change fully. One reason for failure is that such a change entails changing attitudes toward a language and initiating effective policies to provide a power base for other languages. This has not happened, and the consequences are that in many respects the roots of English are deeper now than they were during the period of political colonization. English continues to be used as an alchemy for language modernization and social change. It continues to provide unprecedented power for mobility and advancement to those native and non-native users who possess it as a linguistic tool.

But there are murmurs that cannot be ignored: these are not necessarily heard from the purists or from traditional anti-English groups. An appropriate question is often heard now: How does one "domesticate modernization"? Perhaps one answer is that there is a need for "a circumscription of domestic use of English" (Jernudd, 1981 : 50). Such an approach, Jernudd believes, will "liberate

English for use as a truly international language, a role that today is tarnished by the misuse of English to prevent the economic, sociopolitical, and cultural advancement of those who do not possess it."

In more and more countries, as in India, English is also perceived by some as the language of oppression, as yet another way to exclude large populations from participation in vital national decision-making processes, and from various educational, political, and scientific domains. In other words, the argument goes, English has introduced a "language bar" in regions that are still fighting against the traditional "caste bar" or "tribal bar." This reaction to English is particularly reflected in the non-English-language press, political pamphleteering, party manifests, and in uncontrollable language riots that take place in different parts of the world.

In India, as elsewhere, politicians of different hues exploit the language issues and invariably paralyze the educational and administrative systems. However, the more pragmatic among them see to it that their own children, and other loved ones, are able to get an English education. Is this, then, a case of linguistic schizophrenia? The answer is: Yes. Thus, in anti-English circles, there is one policy for the home and another for outside; the language policy is designed for specific consumers.

However, for the present this fact remains: As Quirk *et al.* (1972) observe, the real power of English is in its "vehicular load," in the attitude toward the language, and in the deep and increasing belief in its power of alchemy linguistically to transmute an individual and a speech community.

Notes

1 This percentage is misleading, since in actual numbers it includes over 28 million people – indeed, a large segment of the world's population. The number of English speakers in South Asia is greater than the English speaking population of three English speaking countries: Australia, Canada, and New Zealand.

2 For a detailed discussion of each area and for bibliographical references see. e.g. for South Asia, Lal, 1969; R. Rao, 1978a; Kandiah, 1981; Kachru, 1983a; for Africa see relevant chapters in Kachru, ed. 1982 and Chishimba, 1983; Magura, 1984; for Southeast Asia, see Llamzon, 1969 and 1983; Marasigan, 1981; Platt and Weber, 1980; Tay and Gupta, 1983; Wong, 1981 and 1983; Richard, 1982 and Chutisilp, 1984; for a discussion of American English and other Englishes see Kachru, 1981a.

References

Alatis, James E. (ed.). 1978. *International Dimensions of Bilingual Education*. Monograph series on language and linguistics. Washington, D.C.: Georgetown University Press.

Annamalai, E. (1978) "The Anglicized Indian languages: a case of code-mixing." *International Journal of Dravidian Linguistics* 7(2): 239–47.

Ansre, Gilbert (1979) "Four rationalizations for maintaining European languages in Africa." *African Languages/Languages Africaines* 5(2): 10–17.

Apte, M. L. (1976) "Language controversies in the Indian Parliament (Lok Sabha); 1952–1960." In William M. O'Barr and J.F. O'Barr (eds.), *Language and Politics*. The Hague: Mouton. pp. 213–234.

Barnes, Sir Edward (1932) *The History of Royal College*. Colombo.

Baugh, Albert C. (1935 [1978]) *A History of the English Language*. New York: Appleton-Century Crofts. [Revised edition (with Thomas Cable), 1978. Englewood Cliffs, NJ: Prentice-Hall.]

Chaudhuri, Nirad C. (1976) "The English language in India – past, present and future." In Alistair Niven (ed.), 1976. pp. 89–106.

Chutisilp, Ponpimol (1984) "A sociolinguistic study of an additional language: English in Thailand." Unpublished doctoral dissertation, University of Illinois, Urbana.

Chishimba, Maurice M. (1983) "African varieties of English: text in context." Unpublished doctoral dissertation, University of Illinois, Urbana.

Das Gupta, Jyotirindra (1969) "Official language problems and policies in South Asia." In T. A. Sebeok (ed.), 1969. pp. 578–596.

Das Gupta, Jyotirindra (1970) *Language Conflict and National Development: Group Politics and National Language Policy in India*. Berkeley: University of California Press.

Ferguson, Charles A. (1978) "Multilingualism as object of linguistic description." In Braj B. Kachru (ed.), 1978. pp. 97–105.

Ferguson, Charles A. (1982a) "Foreword." In Braj B. Kachru (ed.), 1982 pp. vii-xi.

Ferguson, Charles A. and Shirley B. Heath (eds.) (1981) *Language in the USA*. London: Cambridge University Press.

Fishman, Joshua A. (ed.) (1978) *Advances in the Study of Societal Multilingualism*. The Hague: Mouton.

Fishman, Joshua A., Charles A. Ferguson, and Jyotirinda Das Gupta (eds.) (1968) *Language Problems in Developing Nations*. New York: John Wiley and Sons, Inc.

Grant, Charles (1912–13) "Observations on the state of society among the Asiatic subjects of Great Britain, particularly with respect to morals, and on the means of improving it." [Written chiefly in 1792. Ordered by the House of Commons to be printed, 15 June 1813.] London: *General Appendix to Parliamentary Papers* 1812–13. Vol. 10. No. 282.

Greenbaum, Sidney (ed.) (1985) *The English Language Today*. Oxford Pergamon Press.

Halliday, Michael A. K., Angus McIntosh, and Peter Strevens. (1964) *The Linguistic Sciences and Language Teaching*. London: Longman.

Kachru, Braj B. (1965) "The *Indianness* in Indian English." *Word*. 21:391–410. [A revised version in Braj B. Kachru, 1983a. pp. 128–144.]

Kachru, Braj B. (1969) "English in South Asia." In T. Sebeok (ed.), 1969. pp. 627–678. [A revised version in Joshua A. Fishman (ed.), 1978. pp. 477–551. A further updated version in Braj B. Kachru, 1983a. pp. 17–65.]

Kachru, Braj B. (1976b) "Models of English for the Third World: White man's linguistic burden or language pragmatics?" *TESOL Quarterly* 10:221–239.

Kachru, Braj B. (1978a) "Code-mixing as a communicative strategy in India." In James E. Alatis (ed.), 1978. pp. 107–124. [A revised version in Braj B. Kachru, 1983a. pp. 193–207.]

Kachru, Braj B. (1978b) "English in South Asia." In Joshua A. Fishman (ed.), 1978. pp. 477–551. (A revised version of Kachru, 1969).

Kachru, Braj B. (ed.) (1978) *Linguistics in the Seventies: Directions and Prospects.* Special issue of *Studies in the Linguistic Sciences* **8**(2), Fall 1978. Urbana: Department of Linguistics, University of Illinois.

Kachru, Braj B. (1981b) "American English and other Englishes." In Charles A. Ferguson and Shirley B. Heath (eds.), 1981. pp. 21–43.

Kachru, Braj B. (1982c) "Models for non-native Englishes." In Braj B. Kachru (ed.), 1982. pp. 31–57.

Kachru, Braj B. (1983a) *The Indianization of English: The English Language in India.* Delhi: Oxford University Press.

Kachru, Braj B. (1984a) "Institutionalized second language varieties." In Greenbaum (ed.), 1985.

Kachru, Braj B. and Randolph Quirk (1981a) "Introduction." In Larry E. Smith (ed.), 1981. pp. 13–20.

Kachru, Braj B. (ed.) (1982) *The Other Tongue: English Across Cultures.* Urbana: University of Illinois Press. (Paperback edition, Pergamon Press, Oxford 1983).

Kandiah, Thiru (1981) "Lankan English schizoglossia." *English World-Wide: a Journal of Varieties of English* **2**(1):63–81.

Lal, P. (1969) *Modern Indian Poetry in English: An Anthology and a Credo.* Calcutta: Writers Workshop.

Llamzon, Teodoro A. (1969) *Standard Filipino English.* Manila:Ateneo University Press.

Llamzon, Teodoro A. (1983) "Essential features of new varieties of English." In R. B. Noss (ed.), 1983. pp. 92–109.

Magura, Benjamin J. (1984) "Style and meaning in Southern African English: a sociolinguistic study." Unpublished doctoral dissertation, University of Illinois, Urbana.

Marasigan, Elizabeth (1981) "Creolized English in the Philippines." Paper presented at the Sixteenth Regional Seminar: Varieties of English and their Implications for English Language Teaching in Southeast Asia. SEAMEO Regional Language Centre, Singapore. April 20–24, 1981.

Narasimhaiah, C. D. (ed.) (1978) *Awakened Conscience: Studies in Commonwealth Literature.* Delhi: Sterling Publishers.

Niven, Alistair (ed.) (1976) *The Commonwealth Writer Overseas: Themes of Exile and Expatriation.* Bruxelles: Librarie Marcel Didier S. A.

Noss, R. B. (ed.) (1983) *Varieties of English in Southeast Asia.* Singapore SEAMEO Regional Language Centre.

Platt, John and Heidi Weber (1980) *English in Singapore and Malaysia: Status: Features: Functions.* Kuala Lumpur: Oxford University Press.

Prator, Clifford (1968) "The British Heresy in TESL." In Joshua A. Fishman, Charles A. Ferguson, and Jyotirindra Das Gupta (eds.), 1968. pp. 459–476.

Quirk, Randolph, Sidney Greenbaum, Geoffrey Leech and Jan Svartvik (1972) *A Grammar of Contemporary English.* London: Longman.

Rao, Raja (1978a) "The caste of English." In C.D. Narasimhaiah (ed.), pp. 420–422.

Rao, Raja (1978b) *The Policeman and the Rose.* Delhi: Oxford University Press.

Richards, Jack C. (1982) "Singapore English: Rhetorical and Communicative Styles." In Braj B. Kachru (ed.), 1982. pp. 154–167.

Ruberu, Ranjit (1962) *Education in Colonial Ceylon.* Kandy: Kandy Printers.

Sebeok, Thomas A. (eds.). (1969) *Current Trends in Linguistics.* Vol. 5. The Hague: Mouton.

Sharp, Henry (ed.) (1920). *Selections from Educational Records.* Calcutta: Bureau of Education, Government of India.

Smith, Larry E. (ed.) (1981) *English for Cross-Cultural Communication.* London Macmillan and Co.

Sridhar, Kamal K. (1982a) "English in a South Indian urban context." In Braj B. Kachru (ed.), 1982, pp. 141–153.

Sridhar, Kamal K. (1982b) "Functional distribution of Hindi vis-à-vis other languages in South India." Paper presented at the South Asian Languages Roundtable at Syracuse University, May 20–23, 1982.

Tay, Mary W. J. and Anthea F. Gupta (1983) "Toward a description of standard Singapore English." In R. B. Noss (ed.), 1983. pp. 173–189.

Wong, Irene F. H. (1981) "English in Malaysia." In Larry E. Smith (ed.), 1981. pp. 94–107.

Wong, Irene F. H. (1983) "Simplification features in the structure of colloquial Malaysian English." In R. B. Noss (ed.), 1983. pp. 125–149.

Zentella, Ana Celia (1981) "Language variety among Puerto Ricans." In Charles A. Ferguson and Shirley B. Heath (eds.), 1981. pp. 218–238.

LANGUAGE AND CREATIVITY

> There is a sense of reality about children which makes them rejoice to
> discover that there is also a reality about words, that they are not
> merely arbitrary signs, but living powers.
> (R.C. Trench, *On the Study of Words*, 1851: 26)

I N THE PREVIOUS SECTION the issue of creativity was explored within
a post colonial context. One of the issues raised in these pieces is how to make
an instrument of domination a tool of liberation. That is to say, how can a hege-
monic language such as English be appropriated and re-made creatively in order to
express the cultural experience of those who have suffered the consequences of the
imposition of English as one of the vehicles of colonial oppression. This is the same
problem which which was raised earlier with reference to language and gender,
though of course it faces any group which has been dispossessed linguistically. It is
a topic to which we will return in the section on 'Language and colonialism'.

In this section the links between language and creativity are considered by way
of a number of accounts which look at the relationship between poetic or creative
language and standard, normative language; the texts of Croce and Bakhtin are
important in this regard. And as with the work of these two writers, the extracts by
Ricoeur, Kristeva and Vinokur present themselves as politically engaged in their
accounts of linguistic play and formal innovation as the means to contest dominant
cultural meanings and social discourses.

The work of Roman Jakobson (one of the founders of the Prague Circle, to
which Mukařovský also belonged) was highly influential within linguistic and liter-
ary studies. His structuralist theory of linguistic functions proposed that any text
can have one of six distinct but related functions which relate to the six factors
present in any communicative act: addresser, addressee, context, code, contact and
message. One of the most striking features of Jakobson's theory is its extension
beyond literary material. He refuses to distinguish between different kinds of texts
and brings the same mode of analysis to bear upon both everyday language and lit-
erary texts, analysing them according to the functions which structure them. This
is a good example of the way in which linguistic analysis can problematise the
boundaries between different orders of discourse. It also facilitates a form of semi-
otic analysis which can identify the specific properties and structuration of the
poetic or literary text, and to foreground its relationship with wider social
discourses.

Ricoeur's essay draws upon structuralist theory but also moves significantly
away from it. For Ricoeur, language is normative and regulatory, but creativity pre-
cisely relies upon the existence of such fixed codes. Unlike Bakhtin, who seems at

times to think that any normativity is inherently oppressive, Ricoeur sees language as creative in ways which are over and against the order and restrictions imposed by structuration. Perhaps his most notable theoretical stress, however, is on the sign laden, narratological existence of humanity, which he takes to be a given. In his account, we live in and through signs, and the major part of the creating of both the self and the world around it is the telling of stories. The inventiveness of language and the infinite potential of narratives are central to his theory; it must be noted, however, that Ricouer sees creativity as social and cultural rather than simply an individual activity (and it is this which distinguishes his account from subjectivist accounts such as that of Croce).

The extract from the work of Kristeva brings to the fore what she sees as the radical potential of poetic (creative) language to disrupt both social and linguistic conventions. Her essay identifies two 'modalities', the semiotic and the symbolic, which she presents as both requisite and inseparable within the signifying process. The semiotic is defined as a pre-linguistic feminine space which precedes the constitution of the subject, achieved, as in Lacan's model, by way of entry into the symbolic order of language. Her account sees signification as a process which is predicated on the interaction of both a unifying, ordered structure – the symbolic – and a disruptive, diverse signifying space – the semiotic. She locates poetic language (in particular modernist texts) as the places at which the semiotic makes an incursion into the order and conventions of the symbolic order. The idea of the semiotic as being feminine links back to the work of Cixous and Irigaray; her formulation of the constitutive role of language in the construction of subjectivity can be read with the texts in the 'Language and subjectivity' section.

The work of Vinokur, translated here for the first time, was produced in the historical context of political upheaval and social transformation following upon the Russian Revolution of 1917. Unlike the Russian formalists, who claimed to be able to identify literary language by an analysis of formal features, Vinokur, like Jakobson, emphasises the continuities between the normative aspects of everyday language and literary or poetic language. By way of a consideration of the Russian futurists, he also points to the political uses which linguistic invention – at the level of syntax rather than vocabulary – can serve in the creation of an emancipatory political culture.

Further reading

Jakobson

Jakobson, R. (1987) *Language in Literature*, ed. K. Pomorska and S. Rudy, Cambridge, MA: Harvard University Press.
Culler, J. (1975) *Structuralist Poetics: Structuralism, Linguistics and the Study of Literature*, London: Routledge & Kegan Paul, pp. 55–74.
Todorov, T. (1982) *Theories of the Symbol*, trans. C. Porter, Oxford: Basil Blackwell, chapter 10.
Tambling, J. (1988) *What is Literary Language?*, Milton Keynes: Open University Press, chapter 4.
Hawkes, T. (1977) *Structuralism and Semiotics*, London: Methuen, pp. 76–87.

Linguistics and literary language

Robey, D. (1986) 'Modern Linguistics and the Language of Literature', in A. Jeferson and D. Robey (eds) *Modern Literary Theory: A Comparative Introduction*, 2nd edn., London: Batsford, pp. 46–72.
Uitti, K.D. (1969) *Linguistics and Literary Theory*, Englewood Cliffs, NJ: Prentice-Hall.
Chapman, R. (1974) *Linguistics and Literature: An Introduction to Literary Stylistics*, London: Edward Arnold.
Tambling, J. (1988) *What is Literary Language?*, Milton Keynes: Open University Press.
Hawkes, T. (1977) *Structuralism and Semiotics*, London: Methuen, chapter 3.
Fowler, R. (1986) *Linguistic Criticism*, Oxford: Oxford University Press.
Culler, J. (1975) *Structuralist Poetics: Structuralism, Linguistics and the Study of Literature*, London: Routledge & Kegan Paul.
Lodge, D. (1977) *The Modes of Modern Writing: Metaphor, Metonymy, and the Typology of Modern Literature*, London: Edward Arnold, Part 2.
Fabb, N., D. Attridge, A. Durant, and C. MacCabe (eds) (1987) *The Linguistics of Writing: Arguments Between Language and Literature*, Manchester: Manchester University Press.

Kristeva

Kristeva, J. (1984) *Revolution in Poetic Language*, trans. M. Waller, New York: Columbia University Press.
—— (1980) *Desire in Language: A Semiotic Approach to Literature and Art*, ed. L.S. Roudiez, trans. T. Gora, A. Jardine and L.S. Roudiez, New York: Columbia University Press.
Lewis, P. E. (1974) 'Revolutionary Semiotics', *Diacritics* 4(3), pp. 28–32.
Moi, T. (1985) *Sexual/Textual Politics: Feminist Literary Theory*, London: Methuen, chapter 8.
Lechte, J. (1990) *Julia Kristeva*, London: Routledge.
Rose, J. (1986) *Sexuality in the Field of Vision*, London: Verso.

Constructivism, futurism and formalism

Lawton, A. (ed.) (1988) *Russian Futurism Through its Manifestoes, 1912–1928*, trans. A. Lawton and H. Eagle, Ithaca, NY: Cornell University Press.

Bann, S. and J.E. Bowlt (eds) (1973) *Russian Formalism: A Collection of Articles and Texts in Translation*, Edinburgh: Scottish Academic Press.

Lemon, L.T. and M.J. Reis (eds) (1965) *Russian Formalist Criticism: Four Essays*, Lincoln & London: University of Nebraska Press.

Hirschkop, K. (1990) 'Short Cuts Through the Long Revolution: The Russian Avant-Garde and the Modernization of Language', *Textual Practice*, 4(3) pp. 428–41.

Steiner, P. (1984) *Russian Formalism: A Metapoetics*, Ithaca, NY: Cornell University Press.

Erlich, V. (1965) *Russian Formalism: History – Doctrine*, New Haven, CT: Yale Universtiy Press.

Bennett, T. (1979) *Formalism and Marxism*, London: Methuen.

Jameson, F. (1972) *The Prison-House of Language: A Critical Account of Structuralism and Russian Formalism*, Princeton, NJ: Princeton University Press.

Bakhtin, M.M. and P. N. Medvedev (1978) *The Formal Method in Literary Scholarship: A Critical Introduction to Sociological Poetics*, trans. A.J. Wehrle, Baltimore: Johns Hopkins University Press.

Roman Jakobson

LINGUISTICS AND POETICS (1960)

I have been asked for summary remarks about poetics in its relation to linguistics. Poetics deals primarily with the question, *What makes a verbal message a work of art?* Because the main subject of poetics is the *differentia specifica* of verbal art in relation to other arts and in relation to other kinds of verbal behavior, poetics is entitled to the leading place in literary studies.

Poetics deals with problems of verbal structure, just as the analysis of painting is concerned with pictorial structure. Since linguistics is the global science of verbal structure, poetics may be regarded as an integral part of linguistics.

[. . .]

Literary studies, with poetics as their focal portion, consist like linguistics of two sets of problems: synchrony and diachrony. The synchronic description envisages not only the literary production of any given stage but also that part of the literary tradition which for the stage in question has remained vital or has been revived. Thus, for instance, Shakespeare on the one hand and Donne, Marvell, Keats, and Emily Dickinson on the other are experienced by the present English poetic world, whereas the works of James Thomson and Longfellow, for the time being, do not belong to viable artistic values. The selection of classics and their reinterpretation by a novel trend is a substantial problem of synchronic literary studies. Synchronic poetics, like synchronic linguistics, is not to be confused with statics; any stage discriminates between more conservative and more innovatory forms. Any contemporary stage is experienced in its temporal dynamics, and, on the other hand, the historical approach both in poetics and in linguistics is concerned not only with changes but also with continuous, enduring, static factors. A thoroughly comprehensive historical poetics or history of language is a superstructure to be built on a series of successive synchronic descriptions.

Insistence on keeping poetics apart from linguistics is warranted only when the field of linguistics appears to be illicitly restricted, for example, when the sentence is viewed by some linguistics as the highest analyzable construction or

when the scope of linguistics is confined to grammar alone or uniquely to non-semantic questions of external form or to the inventory of denotative devices with no reference to free variations. Voegelin has clearly pointed out the two most important and related problems which face structural linguistics, namely, a revision of "the monolithic hypothesis of language" and a concern with "the inter-dependence of diverse structures within one language." No doubt, for any speech community, for any speaker, there exists a unity of language, but this over-all code represents a system of interconnected subcodes; each language encompasses several concurrent patterns which are each characterized by a different function.

Obviously we must agree with Sapir (1921) that, on the whole, "ideation reigns supreme in language ...", but this supremacy does not authorize linguistics to disregard the "secondary factors." The emotive elements of speech which, as Joos (1950) is prone to believe, cannot be described "with a finite number of absolute categories," are classified by him "as non-linguistic elements of the real world." Hence, "for us they remain vague, protean, fluctuating phenomena," he concludes, "which we refuse to tolerate in our science". Joos is indeed a brilliant expert in reduction experiments, and his emphatic requirement for an "expulsion" of the emotive elements "from linguistic science" is a radical experiment in reduction – *reductio ad absurdum*.

Language must be investigated in all the variety of its functions. Before discussing the poetic function we must define its place among the other functions of language. An outline of these functions demands a concise survey of the constitutive factors in any speech event, in any act of verbal communication. The ADDRESSER sends a MESSAGE to the ADDRESSEE. To be operative the message requires a CONTEXT referred to ("referent" in another, somewhat ambiguous, nomenclature), seizable by the addressee. and either verbal or capable of being verbalized; a CODE fully, or at least partially, common to the addresser and addressee (or in other words, to the encoder and decoder of the message); and, finally, a CONTACT, a physical channel and psychological connection between the addresser and the addressee, enabling both of them to enter and stay in communication. All these factors inalienably involved in verbal communication may be schematized as follows:

CONTEXT

ADDRESSER MESSAGE ADDRESSEE

CONTACT

CODE

Each of these six factors determines a different function of language. Although we distinguish six basic aspects of language, we could, however, hardly find verbal messages that would fulfill only one function. The diversity lies not in a monopoly of some one of these several functions but in a different hierarchical order of functions. The verbal structure of a message depends primarily on the predominant function. But even though a set (*Einstellung*) toward the referent, an orientation toward the CONTEXT – briefly the so-called REFERENTIAL, "denotative," "cognitive" function – is the leading task of numerous messages, the

accessory participation of the other functions in such messages must be taken into account by the observant linguist.

The so-called EMOTIVE or "expressive" function, focused on the ADDRESSER, aims a direct expression of the speaker's attitude toward what he is speaking about. It tends to produce an impression of a certain emotion whether true or feigned: therefore, the term "emotive," launched and advocated by Marty (1908) has proved to be preferable to "emotional." The purely emotive stratum in language is presented by the interjections. They differ from the means of referential language both by their sound pattern (peculiar sound sequences or even sounds elsewhere unusual) and by their syntactic role (they are not components but equivalents of sentences). "*Tut! Tut!* said McGinty": the complete utterance of Conan Doyle's character consists of two suction clicks. The emotive function, laid bare in the interjections, flavors to some extent all our utterances, on their phonic, grammatical, and lexical level. If we analyze language from the standpoint of the information it carries, we cannot restrict the notion of information to the cognitive aspect of language. A man, using expressive features to indicate his angry or ironic attitude, conveys ostensible information, and evidently this verbal behavior cannot be likened to such nonsemiotic, nutritive activities as "eating grapefruit" (despite Chatman's bold simile). The difference between [big] and the emphatic prolongation of the vowel [bi:g] is a conventional, coded linguistic feature like the difference between the short and long vowel in such Czech pairs as [vi] "you" and [vi:] "knows," but in the latter pair the differential information is phonemic and in the former emotive. As long as we are interested in phonemic invariants, the English/i/and/i:/appear to be mere variants of one and the same phoneme, but if we are concerned with emotive units, the relation between the invariant and variants is reversed: length and shortness are invariants implemented by variable phonemes. Saporta's surmise that emotive difference is a nonlinguistic feature, "attributable to the delivery of the message and not to the message," arbitrarily reduces the informational capacity of messages.

[. . .]

Orientation toward the ADDRESSEE, the CONATIVE function, finds its purest grammatical expression in the vocative and imperative, which syntactically, morphologically, and often even phonemically deviate from other nominal and verbal categories. The imperative sentences cardinally differ from declarative sentences: the latter are and the former are not liable to a truth test. When in O'Neill's play *The Fountain*, Nano, "(in a fierce tone of command)," says "Drink!" – the imperative cannot be challenged by the question "is it true or not?" which may be, however, perfectly well asked after such sentences as "one drank," "one will drink," "one would drink." In contradistinction to the imperative sentences, the declarative sentences are convertible into interrogative sentences: "did one drink?" "will one drink?" "would one drink?"

The traditional model of language as elucidated particularly by Bühler (1933) was confined to these three functions – emotive, conative, and referential – and the three apexes of this model – the first person of the addresser, the second person of the addressee, and the "third person," properly – someone or some-

thing spoken of. Certain additional verbal functions can be easily inferred from this triadic model.[. . .] We observe, however, three further constitutive factors of verbal communication and three corresponding functions of language.

There are messages primarily serving to establish, to prolong, or to discontinue communication, to check whether the channel works ("Hello, do you hear me?"), to attract the attention of the interlocutor or to confirm his continued attention ("Are you listening?" or in Shakespearean diction, "Lend me your ears!" – and on the other end of the wire "Um-hum!"). This set for CONTACT, or in Malinowski's terms PHATIC function (1953), may be displayed by a profuse exchange of ritualized formulas, by entire dialogues with the mere purport of prolonging communication. Dorothy Parker caught eloquent examples: " 'Well!' the young man said. 'Well!' she said. 'Well, here we are,' he said. 'Here we are,' she said, 'Aren't we?' 'I should say we were,' he said, 'Eeyop! Here we are.' 'Well!' she said. 'Well!' he said, 'well.' " The endeavor to start and sustain communication is typical of talking birds; thus the phatic function of language is the only one they share with human beings. It is also the first verbal function acquired by infants; they are prone to communicate before being able to send or receive informative communication.

A distinction has been made in modern logic between two levels of language, "object language" speaking of objects and "metalanguage" speaking of language. But metalanguage is not only a necessary scientific tool utilized by logicians and linguists; it plays also an important role in our everyday language. Like Molière's Jourdain who used prose without knowing it, we practice metalanguage without realizing the metalingual character of our operations. Whenever the addresser and/or the addressee need to check up whether they use the same code, speech is focused on the CODE: it performs a METALINGUAL (i.e., glossing) function. "I don't follow you – what do you mean?" asks the addressee, or in Shakespearean diction, "What is't thou say'st?" And the addresser in anticipation of such recapturing questions inquires: Do you know what I mean?" Imagine such an exasperating dialogue: "The sophomore was plucked." "But what is *plucked?*" "*Plucked* means the same as *flunked*." "And *flunked?*" "*To be flunked* is *to fail in an exam*." "And what is *sophomore?*" persists the interrogator innocent of school vocabulary. "*A sophomore* is (or means) a *second-year student*." All these equational sentences convey information merely about the lexical code of English; their function is strictly metalingual. Any process of language learning, in particular child acquisition of the mother tongue, makes wide use of such metalingual operations; and aphasia may often be defined as a loss of ability for metalingual operations.

We have brought up all the six factors involved in verbal communication except the message itself. The set (*Einstellung*) toward the MESSAGE as such, focus on the message for its own sake, is the POETIC function of language. This function cannot be productively studied out of touch with the general problems of language, and, on the other hand, the scrutiny of language requires a thorough consideration of its poetic function. Any attempt to reduce the sphere of poetic function to poetry or to confine poetry to poetic function would be a delusive oversimplification. Poetic function is not the sole function of verbal art but only its dominant, determining function, whereas in all other verbal activities it acts as a subsidiary, accessory constituent. This function, by promoting the palpability of

signs, deepens the fundamental dichotomy of signs and objects. Hence, when dealing with poetic function, linguistics cannot limit itself to the field of poetry.

"Why do you always say *Joan and Margery*, yet never *Margery and Joan?* Do you prefer Joan to her twin sister?" "Not at all, it just sounds smoother." In a sequence of two coordinate names, as far as no rank problems interfere, the precedence of the shorter name suits the speaker, unaccountably for him, as a well-ordered shape of the message.

A girl used to talk about "the horrible Harry." "Why horrible?" "Because I hate him." "But why not *dreadful, terrible, frightful, disgusting?*" "I don't know why, but *horrible* fits him better." Without realizing it, she clung to the poetic device of paronomasia.

The political slogan "I like Ike" /ay layk ayk/, succinctly structured, consists of three monosyllables and counts three diphthongs /ay/, each of them symmetrically followed by one consonantal phoneme, / ... l ... k ... k/. The make-up of the three words presents a variation: no consonantal phonemes in the first word, two around the diphthong in the second, and one final consonant in the third. A similar dominant nucleus /ay/ was noticed by Hymes in some of the sonnets of Keats. Both cola of the trisyllabic formula "I like/Ike" rhyme with each other, and the second of the two rhyming words is fully included in the first one (echo rhyme). /layk/ − /ayk/, a paronomastic image of a feeling which totally envelops its object. Both cola alliterate with each other, and the first of the two alliterating words is included in the second: /ay/ − /ayk/, a paronomastic image of the loving subject enveloped by the beloved object. The secondary, poetic function of this electional catch phrase reinforces its impressiveness and efficacy.

As we said, the linguistic study of the poetic function must overstep the limits of poetry, and, on the other hand, the linguistic scrutiny of poetry cannot limit itself to the poetic function. The particularities of diverse poetic genres imply a differently ranked participation of the other verbal functions along with the dominant poetic function. Epic poetry, focused on the third person, strongly involves the referential function of language; the lyric, oriented toward the first person, is intimately linked with the emotive function; poetry of the second person is imbued with the conative function and is either supplicatory or exhortative, depending on whether the first person is subordinated to the second one or the second to the first.

Now that our cursory description of the six basic functions of verbal communication is more or less complete, we may complement our scheme of the fundamental factors by a corresponding scheme of the functions:

REFERENTIAL

EMOTIVE POETIC CONATIVE

PHATIC

METALINGUAL

What is the empirical linguistic criterion of the poetic function? In particular, what is the indispensable feature inherent in any piece of poetry? To answer

this question we must recall the two basic modes of arrangement used in verbal behavior, *selection* and *combination*. If "child" is the topic of the message, the speaker selects one among the extant, more or less similar, nouns like child, kid, youngster, tot, all of them equivalent in a certain respect, and then, to comment on this topic, he may select one of the semantically cognate verbs – sleeps, dozes, nods, naps. Both chosen words combine in the speech chain. The selection is produced on the base of equivalence, similarity and dissimilarity, synonymity and antonymity, while the combination, the build up of the sequence, is based on contiguity. *The poetic function projects the principle of equivalence from the axis of selection into the axis of combination.* Equivalence is promoted to the constitutive device of the sequence. In poetry one syllable is equalized with any other syllable of the same sequence; word stress is assumed to equal word stress, as unstress equals unstress; prosodic long is matched with long, and short with short; word boundary equals word boundary, no boundary equals no boundary; syntactic pause equals syntactic pause, no pause equals no pause. Syllables are converted into units of measure, and so are morae or stresses.

It may be objected that metalanguage also makes a sequential use of equivalent units when combining synonymic expressions into an equational sentence: $A = A$ ("*Mare is the female of the horse*"). Poetry and metalanguage, however, are in diametrical opposition to each other: in metalanguage the sequence is used to build an equation, whereas in poetry the equation is used to build a sequence.

[...]

To sum up, the analysis of verse is entirely within the competence of poetics, and the latter may be defined as that part of linguistics which treats the poetic function in its relationship to the other functions of language. Poetics in the wider sense of the word deals with the poetic function not only in poetry, where this function is superimposed upon the other functions of language, but also outside of poetry, when some other function is superimposed upon the poetic function.

[...]

References

Bühler, K. (1933) "Die Axiomatik der Sprachwissenschaft," *Kant-Studien* 38, pp. 19–90.

Joos, M. (1950) "Description of language design," *Journal of the Acoustical Society of America* 22, pp. 701–08.

Malinowski, B. (1953) "The problem of meaning in primitive languages," in C.K. Ogden and I.A. Richards, *The Meaning of Meaning*, New York and London.

Marty, A. (1908) *Untersuchungen zur Grundlegung der allgemeinen Grammatik und Sprachphilosophie*, Vol. 1, Halle.

Sapir, E. (1921) *Language*, New York.

Paul Ricoeur

THE CREATIVITY OF LANGUAGE (1981)

RICHARD KEARNEY: How do your recent works on metaphor (*La Métaphore vive*, 1975) and narrativity (*Temps et récit*, 1983) fit into your overall programme of philosophical hermeneutics?

PAUL RICOEUR: In *La Métaphore vive* (*The Rule of the Metaphor*) I tried to show how language could extend itself to its very limits forever discovering new resonances within itself. The term *vive* (living) in the title of this work is all important, for it was my purpose to demonstrate that there is not just an epistemological and political imagination, but also, and perhaps more fundamentally, a *linguistic* imagination which generates and regenerates meaning through the living power of metaphoricity. *La Métaphore vive* investigated the resources of rhetoric to show how language undergoes creative mutations and transformations. My work on narrativity, *Temps et récit*, develops this inquiry into the inventive power of language. Here, the analysis of narrative operations in a literary text, for instance, can teach us how we formulate a new structure of 'time' by creating new modes of plot and characterization. My chief concern in this analysis is to discover how the act of *raconter*, of telling a story, can transmute *natural* time into a specifically *human* time, irreducible to mathematical, chronological 'clock time'. How is narrativity, as the construction or deconstruction of paradigms of story-telling, a perpetual search for new ways of expressing human time, a production or creation of meaning? That is my question.

RK: How would you relate this hermeneutics of narrativity to your former phenomenology of existence?

PR: I would say, borrowing Wittgenstein's term, that the 'language-game' of narration ultimately reveals that the meaning of human existence is itself narrative. The implications of narration as a retelling of history are considerable. For history is not only the story (*histoire*) of triumphant kings and heroes, of the powerful; it is also the story of the powerless and dispossessed. The history of the vanquished dead crying out for justice demands to be told. As Hannah Arendt

points out, the meaning of human existence is not just the power to change or master the world, but also the ability to be remembered and recollected in narrative discourse, to be *memorable*. These existential and historical implications of narrativity are very far-reaching, for they determine what is to be 'preserved' and rendered 'permanent' in a culture's sense of its own past, of its own 'identity'.

RK: Could you outline some such implications for a political rereading of the past? How, for example, would it relate to a Marxist interpretation?

PR: Just as novelists choose a certain plot (*intrigue*) to order the material of their fiction into a narrative sequence, so too historians order the events of the past according to certain choices of narrative structure or plot. While history has traditionally concerned itself with the plot of kings, battles, treaties and the rise and fall of empires, one finds alternative readings emerging from the nineteenth century onwards whose narrative selection focuses on the story of the victims – the plot of suffering rather than that of power and glory. Michelet's romantic historiography of the 'people' was a case in point. And a more obvious and influential example is the Marxist rereading of history according to the model of the class struggle which champions the cause of the oppressed workers. In such ways, the normal narrative ordering of history is reversed and the hero is now the 'slave' rather than the 'master' as before; a new set of events and facts are deemed to be relevant and claim our attention; the relations of labour and production take precedence over the relations between kings and queens. But here again one must remain critical lest the new heroes of history become abstractions in their turn, thus reducing an alternative 'liberating' plot to another reified version of events which might only deepen the illusion that history somehow unfolds of its own accord independently of the creative powers of the labouring human subject. After such a manner, Marxism as an ideology of liberation, of the powerless, can easily become – as happened with the German Social Democrats or with Stalin – an ideology which imposes a new kind of oppressive power: the proletariat thus ceases to be a living human community of subjects and becomes instead an impersonal, abstracted concept in a new system of scientific determinism.

RK: Is narrative language primarily an intentionality of subjective consciousness, as phenomenology argued; or is it an objective and impersonal structure which predetermines the subjective operations of consciousness, as structuralism maintained?

PR: It is both at once. The invaluable contribution made by structuralism was to offer an exact scientific description of the codes and paradigms of language. But I do not believe that this excludes the creative expression of consciousness. The creation of meaning in language comes from the specifically *human* production of new ways of expressing the objective paradigms and codes made available by language. With the same grammar, for example, we can utter many novel and different sentences. Creativity is always governed by objective linguistic codes which it continually brings to their limit in order to invent something new. Whereas I drew from the objective codes of rhetoric in my analysis of the creative power of metaphor, in my study of narrativity I refer to the linguistic structures

disclosed by the Russian formalists, the Prague school and more recently by the structuralism of Lévi-Strauss and Genette. My philosophical project is to show how human language is *inventive* despite the objective limits and codes which govern it, to reveal the diversity and potentiality of language which the erosion of the everyday, conditioned by technocratic and political interests, never ceases to obscure. To become aware of the metaphorical and narrative resources of language is to recognize that its flattened or diminished powers can always be rejuvenated for the benefit of all forms of language usage.

RK: Can your research on narrativity also be considered as a search for a shared meaning beyond the multiplicity of discourses? In other words, does the act of narrating history render it universal and common to all men?

PR: This problem of unity and diversity is central to narrativity and can be summarized in terms of the two following, conflicting interpretations. In the *Confessions* Augustine tells us that the 'human body is undone', that human existence is in discord in so far as it is a temporal rupturing and exploding of the present in contrast to the eternal presence of God. To this Augustinian reading of human existence as *dispersion*, I would oppose Aristotle's theory of tragedy in *The Poetics* as a way of *unifying* existence by retelling it. Narrativity can be seen in terms of this opposition: the discordance of time (*temps*) and the concordance of the tale (*récit*). This is a problem which faces all historians, for example. Is history a narrative tale which orders and constructs the fragmentary, empirical facts offered by sociology? Can history divorce itself from the narrative structure of the tale, in its rapprochement to sociology, without ceasing to be history? It is interesting that even Fernand Braudel, who champions the sociological approach to history in his preface to *The Mediterranean in the Time of Philippe II*, still retains the notion of history as temporal duration; he stops short of espousing atemporal paradigms, *à la* Lévi-Strauss, for that would spell the demise of history. Lévi-Strauss's social anthropology can afford to dispense with history since it is only concerned with 'cold societies': societies without historical or diachronic development, whose customs and norms – the incest taboo, for example – are largely unaffected by temporal change. History begins and ends with the reciting of a tale (*récit*); and its intelligibility and coherence rest upon this recital. My task is to show how the narrative structures of history and of the story (i.e. of the novel or fiction) operate in a parallel fashion to create new forms of human time, and therefore new forms of human community, for creativity is also a social and cultural act; it is not confined to the individual.

[...]

RK: In Study 8 of *La Métaphore vive* you raised the complex philosophical problem of 'reference' in language. How does narrativity relate to this problem of reference?

PR: This question brings us to the intersection between history, which claims to deal with what actually happens, and the novel, which is of the order of fiction. Reference entails a conjunction of history and fiction. And I reckon that my chances of demonstrating the validity of reference are better in an analysis of nar-

rativity than in one of metaphoricity. Whereas it is always difficult to identify the referent of poetic or metaphorical discourse, the referent of narrative discourse is obvious – the order of human action. Now of course human action itself is charged with fictional entities such as stories, symbols, rites, etc. As Marx pointed out in *The German Ideology*, when men produce their existence in the form of *praxis* they represent it to themselves in terms of fiction, even at the limit in terms of religion (which for Marx is the model of ideology). There can be no praxis which is not already symbolically structured in some way. Human action is always figured in signs, interpreted in terms of cultural traditions and norms. Our narrative fictions are then added to this primary interpretation or figuration of human action; so that narrative is a redefining of what is already defined, a reinterpretation of what is already interpreted. The referent of narration, namely human action, is never raw or immediate reality but an action which has been symbolized and resymbolized over and over again. Thus narration serves to displace anterior symbolizations on to a new plane, integrating or exploding them as the case may be. If this were not so, if literary narrative, for example, were closed off from the world of human action, it would be entirely harmless and inoffensive. But literature never ceases to challenge our way of reading human history and praxis. In this respect, literary narrative involves a creative use of language often ignored by science or by our everyday existence. Literary language has the capacity to put our quotidian existence into question; it is *dangerous* in the best sense of the word.

RK: But is not the hermeneutic search for mediated and symbolized meaning a way of escaping from the harsh, empirical reality of things, is it not always working at one remove from life?

PR: Proust said that if play was cloistered off in books, it would cease to be formidable. Play is formidable precisely because it is loose in the world, planting its mediations everywhere, shattering the illusion of the immediacy of the real. The problem for a hermeneutics of language is not to rediscover some pristine immediacy but to mediate again and again in a new and more creative fashion. The mediating role of imagination is forever at work in lived reality (*le vécu*). There is *no lived reality, no human or social reality, which is not already represented* in some sense. This imaginative and creative dimension of the social, this *imaginaire social*, has been brilliantly analysed by Castoriadis in his book, *L'Institution imaginaire de la société*. Literature supplements this primary representation of the social with its own narrative representation, a process which Dagonier calls 'iconographic augmentation'. But literature is not the only way in which fiction can iconographically mediate human reality. There is also the mediating role of models in science or of utopias in political ideologies. These three modes of fictional mediation – literary, scientific and political – effectuate a metaphorization of the real, a creation of new meaning.

RK: Which returns us to your original question: what is the meaning of creativity in language and how does it relate to the codes, structures or laws imposed by language?

PR: Linguistic creativity constantly strains and stretches the laws and codes of language

that regulate it. Roland Barthes described these regulating laws as 'fascist' and urged the writer and critic to work at the limits of language, subverting its constraining laws, in order to make way for the free movement of *desire*, to make language festive. But if the narrative order of language is replete with codes, it is also capable of creatively violating them. Human creativity is always in some sense a response to a regulating order. The imagination is always working on the basis of already established laws and it is its task to make them function creatively, either by applying them in an original way or by subverting them; or indeed both – what Malraux calls 'regulated deformation'. There is no function of imagination, no *imaginaire*, that is not structuring or structured, that is not said or about-to-be-said in language. The task of hermeneutics is to charter the unexplored resources of the to-be-said on the basis of the already-said. Imagination never resides in the unsaid.

[. . .]

Julia Kristeva

REVOLUTION IN POETIC LANGUAGE (1974)

The phenomenological subject of enunciation

[...] Despite their variations, all modern linguistic theories consider language a strictly 'formal' object – one that involves syntax or mathematicization. Within this perspective, such theories generally accept the following notion of language. For Zellig Harris, language is defined by: (1) the arbitrary relation between signifier and signified, (2) the acceptance of the sign as a substitute for the extra-linguistic, (3) its discrete elements and (4) its denumerable, or even finite, nature.[1] But with the development of Chomskyan generative grammar and the logico-semantic research that was articulated around and in response to it, problems arose that were generally believed to fall within the province of 'semantics' or even 'pragmatics', and raised the awkward question of the *extra linguistic*. But language [*langage*] – modern linguistics' self-assigned object[2] – lacks a subject or tolerates one only as a *transcendental ego* (in Husserl's sense or in Benveniste's more specifically linguistic sense),[3] and defers any interrogation of its (always already dialectical because translinguistic) 'externality'.

Two trends in current linguistic research do attend to this 'externality' in the belief that failure to elucidate it will hinder the development of linguistic theory itself. Although such a lacuna poses problems [...] for 'formal' linguistics, it has always been a particular problem for semiotics, which is concerned with specifying the functioning of signifying practices such as art, poetry and myth that are irreducible to the 'language' object.

1 The first of these two trends addresses the question of the so-called 'arbitrary' relation between signifier and signified by examining signifying systems in which this relation is presented as 'motivated'. It seeks the principle of this motivation in the Freudian notion of the unconscious in so far as the theories of drives [*pulsions*] and primary processes (displacement and condensation) can connect 'empty signifiers' to psychosomatic functionings, or can at least link them in a sequence of metaphors and metonymies; though undecidable, such a sequence replaces 'arbitrariness' with

'articulation'. The discourse of analysands, language 'pathologies' and artistic, particularly poetic, systems are especially suited to such an exploration.[4] Formal linguistic relations are thus connected to an 'externality' in the psychosomatic realm, which is ultimately reduced to a fragmented substance [*substance morcelée*] (the body divided into erogenous zones) and articulated by the developing ego's connections to the three points of the family triangle. Such a linguistic theory, clearly indebted to the positions of the psychoanalytic school of London and Melanie Klein in particular, restores to formal linguistic relations the dimensions (instinctual drives) and operations (displacement, condensation, vocalic and intonational differentiation) that formalistic theory excludes. Yet for want of a dialectical notion of the *signifying process* as a whole, in which significance puts the subject in process/on trial [*en procès*], such considerations, no matter how astute, fail to take into account the syntactico-semantic functioning of language. Although they rehabilitate the notion of the fragmented body – pre-Oedipal but always already invested with semiosis – these linguistic theories fail to articulate its transitional link to the post-Oedipal subject and his always symbolic and/or syntactic language.

2 The second trend, more recent and widespread, introduces within theory's own formalism a 'layer' of *semiosis*, which had been strictly relegated to pragmatics and semantics. By positing a *subject of enunciation* (in the sense of Benveniste, Culioli, etc.), this theory places logical modal relations, relations of presupposition and other relations between interlocutors within the speech act, in a very deep 'deep structure'. This *subject of enunciation*, which comes directly from Husserl and Benveniste (see n. 3), introduces, through categorial intuition, both *semantic fields* and *logical* – but also *intersubjective* – *relations*, which prove to be both intra- and translinguistic.[5]

[. . .]

To summarize briefly what we shall elucidate later, the two trends just mentioned designate *two modalities* of what is, for us, the same signifying process. We shall call the first '*the semiotic*' and the second '*the symbolic*'. These two modalities are inseparable within the *signifying process* that constitutes language, and the dialectic between them determines the type of discourse (narrative, metalanguage, theory, poetry, etc.) involved; in other words, so-called 'natural' language allows for different modes of articulation of the semiotic and the symbolic. On the other hand, there are non-verbal signifying systems that are constructed exclusively on the basis of the semiotic (music, for example). But, as we shall see, this exclusivity is relative, precisely because of the necessary dialectic between the two modalities of the signifying process, which is constitutive of the subject. Because the subject is always *both* semiotic *and* symbolic, no signifying system he produces can be either 'exclusively' semiotic or 'exclusively' symbolic, and is instead necessarily marked by an indebtedness to both.

The semiotic *chora* ordering the drives

We understand the term 'semiotic' in its Greek sense: σημεῖον = distinctive mark, trace, index, precursory sign, proof, engraved or written sign, imprint,

trace, figuration. This etymological reminder would be a mere archaeological embellishment (and an unconvincing one at that, since the term ultimately encompasses such disparate meanings) were it not for the fact that the preponderant etymological use of the word, the one that implies a *distinctiveness*, allows us to connect it to a precise modality in the signifying process. This modality is the one Freudian psychoanalysis points to in postulating not only the *facilitation* and the structuring *disposition* of drives, but also the so-called *primary processes* which displace and condense both energies and their inscription. Discrete quantities of energy move through the body of the subject who is not yet constituted as such and, in the course of his development, they are arranged according to the various constraints imposed on this body – always already involved in a semiotic process – by family and social structures. In this way the drives, which are 'energy' charges as well as 'psychical' marks, articulate what we call a *chora*: a non-expressive totality formed by the drives and their stases in a motility that is as full of movement as it is regulated.

We borrow the term *chora*[6] from Plato's *Timaeus* to denote an essentially mobile and extremely provisional articulation constituted by movements and their ephemeral stases. We differentiate this uncertain and indeterminate *articulation* from a *disposition* that already depends on representation, lends itself to phenomenological, spatial intuition and gives rise to a geometry. Although our theoretical description of the *chora* is itself part of the discourse of representation that offers it as evidence, the *chora*, as rupture and articulations (rhythm), precedes evidence, verisimilitude, spatiality and temporality. Our discourse – all discourse – moves with and against the *chora* in the sense that it simultaneously depends upon and refuses it. Although the *chora* can be designated and regulated, it can never be definitely posited: as a result, one can situate the *chora* and, if necessary, lend it a topology, but one can never give it axiomatic form.[7]

The *chora* is not yet a position that represents something for someone (i.e., it is not a sign); nor is it a *position* that represents someone for another position (i.e., it is not yet a signifier either); it is, however, generated in order to attain to this signifying position. Neither model nor copy, the *chora* precedes and underlies figuration and thus specularization, and is analogous only to vocal or kinetic rhythm. We must restore this motility's gestural and vocal play (to mention only the aspect relevant to language) on the level of the socialized body in order to remove motility from ontology and amorphousness[8] where Plato confines it in an apparent attempt to conceal it from Democritean rhythm. The theory of the subject proposed by the theory of the unconscious will allow us to read in this rhythmic space, which has no thesis and no position, the process by which significance is constituted. Plato himself leads us to such a process when he calls this receptacle or *chora* nourishing and maternal,[9] not yet unified in an ordered whole because deity is absent from it. Though deprived of unity, identity or deity, the *chora* is nevertheless subject to a regulating process [*réglementation*], which is different from that of symbolic law but nevertheless effectuates discontinuities by temporarily articulating them and then starting over, again and again.

The *chora* is a modality of significance in which the linguistic sign is not yet articulated as the absence of an object and as the distinction between real and symbolic. We emphasize the regulated aspect of the *chora*: its vocal and gestural

organization is subject to what we shall call an objective *ordering* [*ordonnancement*], which is dictated by natural or socio-historical constraints such as the biological difference between the sexes or family structure. We may therefore posit that social organization, always already symbolic, imprints its constraint in a mediated form which organizes the *chora* not according to a *law* (a term we reserve for the symbolic) but through an *ordering*.[10] What is this mediation?

According to a number of psycholinguists, 'concrete operations' precede the acquisition of language, and organize pre-verbal semiotic space according to logical categories, which are thereby shown to precede or transcend language. From their research we shall retain not the principle of an operational state[11] but that of a pre-verbal functional state that governs the connections between the body (in the process of constituting itself as a body proper), objects and the protagonists of family structure.[12] But we shall distinguish this functioning from symbolic operations that depend on language as a sign system – whether the language [*langue*] is vocalized or gestural (as with deaf-mutes). The kinetic functional stage of the *semiotic* precedes the establishment of the sign; it is not, therefore, cognitive in the sense of being assumed by a knowing, already constituted subject. The genesis of the *functions*[13] organizing the semiotic process can be accurately elucidated only within a theory of the subject that does not reduce the subject to one of understanding, but instead opens up within the subject this other scene of pre-symbolic functions. The Kleinian theory expanding upon Freud's positions on the drives will momentarily serve as a guide.

Drives involve pre-Oedipal semiotic functions and energy discharges that connect and orient the body to the mother. We must emphasize that 'drives' are always already ambiguous, simultaneously assimilating and destructive; this dualism, which has been represented as a tetrad[14] or as a double helix, as in the configuration of the DNA and RNA molecule,[15] makes the semiotized body a place of permanent scission. The oral and anal drives, both of which are oriented and structured around the mother's body,[16] dominate this sensorimotor organization. The mother's body is therefore what mediates the symbolic law organizing social relations and becomes the ordering principle of the semiotic *chora*,[17] which is on the path of destruction, aggressivity and death. For although drives have been described as disunited or contradictory structures, simultaneously 'positive' and 'negative', this doubling is said to generate a dominant 'destructive wave' that is drive's most characteristic trait: Freud notes that the most instinctual drive is the death drive.[18] In this way, the term 'drive' denotes waves of attack against stases, which are themselves constituted by the repetition of these charges; together, charges and stases lead to no identity (not even that of the 'body proper') that could be seen as a result of their functioning. This is to say that the semiotic *chora* is no more than the place where the subject is both generated and negated, the place where his unity succumbs before the process of charges and stases that produce him. We shall call this process of charges and stases a *negativity* to distinguish it from negation, which is the act of a judging subject.

Checked by the constraints of biological and social structures, the drive charge thus undergoes stases. Drive facilitation, temporarily arrested, marks *discontinuities* in what may be called the various material supports [*matériaux*] susceptible to semiotization: voice, gesture, colours. Phonic (later phonemic),

kinetic or chromatic units and differences are the marks of these stases in the drives. Connections or *functions* are thereby established between these discrete marks which are based on drives and articulated according to their resemblance or opposition, either by slippage or by condensation. Here we find the principles of metonymy and metaphor indissociable from the drive economy underlying them.

Although we recognize the vital role played by the processes of displacement and condensation in the organization of the semiotic, we must also add to these processes the relations (eventually representable as topological spaces) that connect the zones of the fragmented body to each other and also to 'external' 'objects' and 'subjects', which are not yet constituted as such. This type of relation makes it possible to specify the *semiotic* as a psychosomatic modality of the signifying process; in other words, not a symbolic modality but one articulating (in the largest sense of the word) a continuum: the connections between the (glottal and anal) sphincters in (rhythmic and intonational) vocal modulations, or those between the sphincters and family protagonists, for example.

All these various processes and relations, anterior to sign and syntax, have just been identified from a genetic perspective as previous and necessary to the acquisition of language, but not identical to language. Theory can 'situate' such processes and relations diachronically within the process of the constitution of the subject precisely because *they function synchronically within the signifying process of the subject himself*, i.e., the subject of *cogitatio*. Only in *dream* logic, however, have they attracted attention, and only in certain signifying practices, such as the *text*, do they dominate the signifying process.

It may be hypothesized that certain semiotic articulations are transmitted through the biological code or physiological 'memory' and thus form the inborn bases of the symbolic function. Indeed, one branch of generative linguistics asserts the principle of innate language universals. As it will become apparent in what follows, however, the *symbolic* – and therefore syntax and all linguistic categories – is a social effect of the relation to the other, established through the objective constraints of biological (including sexual) differences and concrete, historical family structures. Genetic programmings are necessarily semiotic: they include the primary processes such as displacement and condensation, absorption and repulsion, rejection and stasis, all of which function as innate preconditions, 'memorizable' by the species, for language acquisition.

Mallarmé calls attention to the semiotic rhythm within language when he speaks of 'The Mystery in Literature' ['Le Mystère dans les lettres']. Indifferent to language, enigmatic and feminine, this space underlying the written is rhythmic, unfettered, irreducible to its intelligible verbal translation; it is musical, anterior to judgement, but restrained by a single guarantee: syntax.

[...]

Our positing of the semiotic is obviously inseparable from a theory of the subject that takes into account the Freudian positing of the unconscious. We view the subject in language as decentring the transcendental ego, cutting through it and opening it up to a dialectic in which its syntactic and categorical understanding is merely the liminary moment of the process, which is itself always

acted upon by the relation to the other dominated by the death drive and its productive reiteration of the 'signifier'. We will be attempting to formulate the distinction between *semiotic* and *symbolic* within this perspective, which was introduced by Lacanian analysis, but also within the constraints of a practice – the *text* – which is only of secondary interest to psychoanalysis.

The thetic: rupture and/or boundary

We shall distinguish the semiotic (drives and their articulations) from the realm of signification, which is always that of a proposition or judgement, in other words, a realm of *positions*. This positionality, which Husserlian phenomenology orchestrates through the concepts of *doxa, position* and *thesis*, is structured as a break in the signifying process, establishing the *identification* of the subject and its object as preconditions of propositionality. We shall call this break, which produces the positing of signification, a *thetic* phase. All enunciation, whether of a word or of a sentence, is thetic. It requires an identification; in other words, the subject must separate from and through his image, from and through his objects. This image and objects must first be posited in a space that becomes symbolic because it connects the two separated positions, recording them or redistributing them in an open combinatorial system.

The child's first so-called holophrastic enunciations include gesture, the object and vocal emission. Because they are perhaps not yet sentences (NP–VP), generative grammar is not readily equipped to account for them. Nevertheless, they are already thetic in the sense that they separate an object from the subject, and attribute to it a semiotic fragment, which thereby becomes a signifier. That this attribution is either metaphoric or metonymic ('woof-woof' says the dog, and all animals become 'woof-woof') is logically secondary to the fact that it constitutes an *attribution*, which is to say, a positing of identity or difference, and that it represents the nucleus of judgement or proposition.

We shall say that the thetic phase of the signifying process is the 'deepest structure' of the possibility of enunciation, in other words, of signification and the proposition. [...] There is no sign that is not thetic and every sign is already the germ of a 'sentence' attributing a signifier to an object through a 'copula' that will function as a signified.[19] Stoic semiology, which was the first to formulate the matrix of the sign, had already established *this complicity between sign and sentence*, making them proofs of each other.

Modern philosophy recognizes that the right to represent the founding *thesis* of signification (sign and/or proposition) devolves upon the transcendental ego. But only since Freud have we been able to raise the question not of the origin of this thesis but rather of the process of its production. To brand the thetic as the foundation of metaphysics is to risk serving as an antechamber for metaphysics – unless, that is, we specify the way the thetic is produced in our view, the Freudian theory of the unconscious and its Lacanian development show, precisely, that thetic signification is a stage attained under certain precise conditions during the signifying process, and that it constitutes the subject without being reduced to his process precisely because it is the threshold of language. Such a standpoint

constitutes neither a reduction of the subject to the transcendental ego, nor a denial [*dénégation*] of the thetic phase that establishes signification.

The mirror and castration positing the subject as absent from the signifier

In the development of the subject, such as it has been reconstituted by the theory of the unconscious, we find the thetic phase of the signifying process, around which signification is organized, at two points: the mirror stage and the 'discovery' of castration.

The first, the mirror stage, produces the 'spatial intuition' which is found at the heart of the functioning of signification – in signs and in sentences. From that point on, in order to capture his image unified in a mirror, the child must remain separate from it, his body agitated by the semiotic motility we discussed above, which fragments him more than it unifies him in a representation. According to Lacan, human physiological immaturity, which is due to premature birth, is thus what permits any permanent positing whatsoever and, first and foremost, that of the image itself, as separate, heterogeneous, dehiscent.[20] Captation of the image and the drive investment in this image, which institute primary narcissism, permit the constitution of objects detached from the semiotic *chora*. Lacan maintains, moreover, that the specular image is the 'prototype' for the 'world of objects'.[21] Positing the imaged ego leads to the positing of the object, which is, likewise, separate and signifiable.

Thus the two separations that prepare the way for the sign are set in place. The sign can be conceived as the voice that is projected from the agitated body (from the semiotic *chora*) on to the facing *imago* or on to the object, which simultaneously detach from the surrounding continuity. Indeed, a child's first holophrastic utterances occur at this time, within what are considered the boundaries of the mirror stage (six to eighteen months). On the basis of this positing, which constitutes a *break*, signification becomes established as a digital system with a double articulation combining discrete elements. Language-learning can therefore be thought of as an acute and dramatic confrontation between positing-separating-identifying and the motility of the semiotic *chora*. Separation from the mother's body, the *fort-da* game, anality and orality, all act as a permanent negativity that destroys the image and the isolated object even as it facilitates the articulation of the semiotic network, which will afterwards be necessary in the system of language where it will be more or less integrated as a *signifier*.

Castration puts the finished touches on the process of separation that posits the subject as signifiable, which is to say, separate, always confronted by an other: *imago* in the mirror (signified) and semiotic process (signifier). As the addressee of every demand, the mother occupies the place of alterity. Her replete body, the receptacle and guarantor of demands, takes the place of all narcissistic, hence imaginary, effects and gratifications; she is, in other words, the phallus. The discovery of castration, however, detaches the subject from his dependence on the mother, and the perception of this lack [*manque*] makes the phallic function a symbolic function – *the* symbolic function. This is a decisive moment fraught with

consequences: the subject, finding his identity in the symbolic, *separates* from his fusion with the mother, *confines* his *jouissance* to the genital and transfers semiotic motility on to the symbolic order. Thus ends the formation of the thetic phase, which posits the gap between the signifier and the signified as an opening up towards every desire but also every act, including the very *jouissance* that exceeds them.[22]

At this point we would like to emphasize, without going into the details of Lacan's argument, that the phallus totalizes the effects of signifieds as having been produced by the signifier: the phallus is itself a signifier. In other words, the phallus is not given in the utterance but instead refers outside itself to a precondition that makes enunciation possible. For there to be enunciation, the *ego* must be posited in the signified, but it must do so as a function of the *subject* lacking in the signifier; a system of finite positions (signification) can only function when it is supported by a subject and on the condition that this subject is a want-to-be [*manque à être*].[23] Signification exists precisely because there is no subject in signification. The gap between the imaged ego and drive motility, between the mother and the demand made on her, is precisely the break that establishes what Lacan calls the place of the Other as the place of the 'signifier'. The subject is hidden 'by an ever purer signifier',[24] this want-to-be confers on an *other* the role of containing the possibility of signification; and this other, who is no longer the mother (from whom the child ultimately separates through the mirror stage and castration), presents itself as the place of the signifier that Lacan will call 'the Other'.

Is this to say, then, that such a theoretical undertaking transcendentalizes semiotic motility, setting it up as a transcendental signifier? In our view, this transformation of semiotic motility serves to remove it from its auto-erotic and maternal enclosure and, by introducing the signifier/signified break, allows it to produce signification. By the same token, signification itself appears as a stage of the signifying process – not so much its base as its boundary. Signification is placed 'under the sign of the pre-conscious'.[25] Ultimately, this signifier/signified transformation, constitutive of language, is seen as being indebted to, induced and imposed by the social realm. Dependence on the mother is severed, and transformed into a symbolic relation to an other, the constitution of the Other is indispensable for communicating with an other. In this way, the signifier/signified break is synonymous with social sanction: 'the first social censorship'.

Thus we view the thetic phase – the positing of the *imago*, castration and the positing of semiotic motility – as the place of the Other, as the precondition for signification, i.e., the precondition for the positing of language. The thetic phase marks a threshold between two heterogeneous realms: the semiotic and the symbolic. The second includes part of the first and their scission is thereafter marked by the break between signifier and signified. *Symbolic* would seem an appropriate term for this always split unification that is produced by a rupture and is impossible without it. Its etymology makes it particularly pertinent. The σύμβοχον is a sign of recognition: an 'object' split in two and the parts separated, but, as eyelids do, σύμβοχον brings together the two edges of that fissure. As a result, the 'symbol' is any joining, any bringing together that is a contract – one that

either follows hostilities or presupposes them – and, finally, any exchange, including an exchange of hostility.

Not only is symbolic, thetic unity divided (into signifier and signified), but this division is itself the result of a break that put a heterogeneous functioning in the position of signifier. This functioning is the instinctual semiotic, preceding meaning and signification, mobile, amorphous, but already regulated, which we have attempted to represent through references to child psychoanalysis (particularly at the pre-Oedipal stage) and the theory of drives. In the speaking subject, fantasies articulate this irruption of drives within the realm of the signifier; they disrupt the signifier and shift the metonymy of desire, which acts within the place of the Other, on to a *jouissance* that divests the object and turns back towards the auto-erotic body. That language is a defensive construction reveals its ambiguity – the death drive underlying it. If language, constituted as symbolic through narcissistic, specular, imaginary investment, protects the body from the attack of drives by making it a place – the place of the signifier – in which the body can signify itself through positions; and if, therefore, language, in the service of the death drive, is a pocket of narcissism towards which this drive may be directed, then fantasies remind us, if we had ever forgotten, of the insistent presence of drive heterogeneity.[26]

All poetic 'distortions' of the signifying chain and the structure of signification may be considered in this light: they yield under the attack of the 'residues of first symbolizations' (Lacan), in other words, those drives that the thetic phase was not able to sublate [*relever, aufheben*] by linking them into signifier and signified. As a consequence, any disturbance of the 'social censorship' – that of the signifier/signified break – attests, perhaps first and foremost, to an influx of the death drive, which no signifier, no mirror, no other and no mother could ever contain. In 'artistic' practices the semiotic – the precondition of the symbolic – is revealed as that which also destroys the symbolic, and this revelation allows us to presume something about its functioning.

Psychoanalysts acknowledge that the pre-Oedipal stages Melanie Klein discusses are 'analytically unthinkable' but not inoperative, and, furthermore, that the relation of the subject to the signifier is established and language-learning is completed only in the pre-genital stages that are set in place by the retraction of the Oedipus complex (which itself brings about initial genital maturation).[27] Thereafter, the supposedly characteristic functioning of the pre-Oedipal stages appears only in the complete, post-genital handling of language, which presupposes, as we have seen, a decisive imposition of the phallic. In other words, the subject must be firmly posited by castration so that drive attacks against the thetic will not give way to fantasy or to psychosis but will instead lead to a 'second-degree thetic', i.e., a resumption of the functioning characteristic of the semiotic *chora* within the signifying device of language. This is precisely what artistic practices, and notably poetic language, demonstrate.

Starting from and (logically and chronologically) after the phallic position and the castration that underlies it – in other words, after the Oedipus complex and especially after the regulation of genitality by the retroactive effect of the Oedipus complex in puberty – the semiotic *chora* can be read not as a failure of the thetic but instead as its very precondition. Neurotics and psychotics are defined

as such by their relationship to what we are calling the thetic. We now see why, in treating them, psychoanalysis can only conceive of semiotic motility as a disturbance of language and/or of the order of the signifier. Conversely, the refusal of the thetic phase and an attempt to hypostasize semiotic motility as autonomous from the thetic – capable of doing without it or unaware of it – can be seen as a resistance to psychoanalysis. Some therefore even contend that one can find in poetry the unfolding of this refusal of the thetic, something like a direct transcription of the genetic code – as if practice were possible without the thetic and as if a text, in order to hold together as a text, did not require a completion [*finition*], a structuration, a kind of totalization of semiotic motility. This completion constitutes a synthesis that requires the thesis of language in order to come about, and the semiotic pulverizes it only to make it a new device – for us, this is precisely what distinguishes a text as *signifying practice* from the 'drifting-into-non-sense' [*dérive*] that characterizes neurotic discourse. The distinction cannot be erased unless one puts oneself outside 'monumental history' in a transcendence which often proves to be one of the reactionary forces combining that history's discrete blocks.[28]

In this way, only the subject, for whom the thetic is not a repression of the semiotic *chora* but instead a position either taken on or undergone, can call into question the thetic so that a new disposition may be articulated. Castration must have been a problem, a trauma, a drama, so that the semiotic can return through the symbolic position it brings about. This is the crux of the matter: both the completion of the Oedipus complex and its reactivation in puberty are needed for the *Aufhebung* of the semiotic in the symbolic to give rise to a signifying *practice* that has a socio-historical function (and is not just a self-analytical discourse, a substitute for the analyst's couch). At the same time, however, this completion of the Oedipal stage and the genitality it gives rise to should not repress the semiotic, for such a repression is what sets up metalanguage and the 'pure signifier'. No pure signifier can effect the *Aufhebung* (in the Hegelian sense) of the semiotic without leaving a remainder, and anyone who would believe this myth need only question his fascination or boredom with a given poem, painting or piece of music. As a traversable boundary, the thetic is completely different from an imaginary castration that must be evaded in order to return to the maternal *chora*. It is clearly distinct as well from a castration imposed once and for all, perpetuating the well-ordered signifier and positing it as sacred and unalterable within the enclosure of the Other.[29]

[. . .]

Notes

1 See Zellig Harris, *Mathematical Structures of Language* (New York: Interscience Publishers, 1968). See also Maurice Gross and André Lentin, *Introduction to Formal Grammars*, tr. M. Salkoff (Berlin: Springer-Verlag, 1970); M.-C. Barbault and J.-P. Desclés, *Transformations formelles et théories linguistiques*, Documents de linguistique quantitative, no. 11 (Paris: Dunod, 1972).

2 On this 'object' see *Langages*, 24 (Dec. 1971), and, for a didactic, popularized account, see Julia Kristeva, *Le Langage cet inconnu* (Paris: Seuil 1981).

3 Edmund Husserl, in *Ideas: General Introduction to Pure Phenomenology*, tr. W. R. Boyce Gibson (London: Allen & Unwin, 1969), posits this subject as a subject of intuition, sure of this universally valid unity (of consciousness), a unity that is provided in *categories* itself, since transcendence is precisely the immanence of this 'Ego', which is an expansion of the Cartesian *cogito*. 'We shall consider conscious experiences', Husserl writes, '*in the concrete fullness and entirety* with which they figure in their concrete context – the *stream of experience* – and to which they are closely attached through their own proper essence. It then becomes evident that every experience in the stream which our reflexion can lay hold on has *its own essence open to intuition*, a 'content' which can be considered in its *singularity in and for itself*. We shall be concerned to grasp this individual content of the *cogitatio* in its *pure* singularity, and to describe it in its general features, excluding everything which is not to be found in the *cogitatio* as it is in itself. We must likewise describe the *unity of consciousness* which is demanded *by the intrinsic nature of the cogitationes*, and so necessarily demanded that they could not be without this unity' (p. 116). From a similar perspective, Benveniste emphasizes language's dialogical character, as well as its role in Freud's discovery. Discussing the I/you polarity, he writes: 'This polarity does not mean either equality or symmetry: "ego" always has a position of transcendence with regard to *you*.' In Benveniste, 'Subjectivity in language', *Problems in General Linguistics*, Miami Linguistics Series, no. 8, tr. Mary Elizabeth Meek (Coral Gables, Fla: University of Miami Press, 1971), p. 225. In Chomsky, the subject-bearer of syntactic synthesis is clearly shown to stem from the Cartesian *cogito*. See his *Cartesian Linguistics: A Chapter in the History of Rationalist Thought* (New York: Harper & Row, 1966). Despite the difference between this Cartesian-Chomskyan subject and the transcendental ego outlined by Benveniste and others in a more clearly phenomenological sense, both these notions of the act of understanding (or the linguistic act) rest on a common metaphysical foundation: consciousness as a synthesizing unity and the sole guarantee of Being. Moreover, several scholars – without renouncing the Cartesian principles that governed the first syntactic descriptions – have recently pointed out that Husserlian phenomenology is a more explicit and more rigorously detailed basis for such description than the Cartesian method. See Roman Jakobson, who recalls Husserl's role in the establishment of modern linguistics, 'Linguistics in relation to other sciences', in *Selected Writings* (2 vols, The Hague: Mouton, 1971), vol. II, pp. 655–96; and S.-Y. Kuroda, 'The categorical and the thetic judgement: evidence from Japanese syntax', *Foundations of Language* (Nov. 1972), 9, no. 2, pp. 153–85.

4 See the work of Ivan Fónagy, particularly 'Bases pulsionnelles de la phonation'. *Revue Française de Psychanalyse*, 34, no. 1 (January 1970), pp. 101–36, and 35, no. 4 (July 1971), pp. 543–91.

5 On the 'subject of enunciation', see Tzvetan Todorov, spec. ed. *Langages*, 17 (March 1970). Formulated in linguistics by Benveniste ('The correlations of tense in the French verb' and 'Subjectivity in language', in *Problems*, pp. 205–16 and 223–30), the notion is used by many linguists, notably Antoine Culioli, 'A propos d'opérations intervenant dans le traitement formel des langues naturelles', *Mathématiques et Sciences Humaines*, 9, no. 34 (Summer

1971), pp. 7–15; and Oswald Ducrot, 'Les indéfinis et l'énonciation'. *Langages*, 5, no. 17 (March 1970), pp. 91–111. Chomsky's 'extended standard theory' makes use of categorial intuition but does not refer to the subject of enunciation, even though the latter has been implicit in his theory ever since *Cartesian Linguistics* (1966); see his *Studies on Semantics in Generative Grammar*, Janua Linguarum, series minor, no. 107 (The Hague: Mouton, 1972).

6 The term '*chora*' has recently been criticized for its ontological essence by Jacques Derrida: *Positions*, annot. and tr. Alan Bass (Chicago: University of Chicago Press, 1981), pp. 75 and 106, n. 39.

7 Plato emphasizes that the receptacle (ὑποδοχεῖον), which is also called space (χώρα) *vis-à-vis* reason, is necessary – but not divine since it is unstable, uncertain, ever changing and becoming; it is even unnameable, improbable, bastard: 'Space, which is everlasting, not admitting destruction; providing a situation for all things that come into being but itself apprehended without the senses by a sort of bastard reasoning, and hardly an object of belief. This, indeed, is that which we look upon as in a dream and say that anything that is must needs be in some place and occupy some room . . .' (*Timaeus*, tr. Francis M. Cornford, 52a–52b). Is the receptacle a 'thing' or a mode of language? Plato's hesitation between the two gives the receptacle an even more uncertain status. It is one of the elements that antedate not only the *universe* but also *names* and even *syllables*. 'We speak . . . positing them as original principles, elements (as it were, letters) of the universe; whereas one who has ever so little intelligence should not rank them in this analogy even so low as syllables' (ibid., 48b). 'It is hard to say, with respect to any one of these, which we ought to call really water rather than fire, or indeed which we should call by any given name rather than by all the names together or by each severally, so as to use language in a sound and trustworthy way . . . Since, then, in this way no one of these things ever makes its appearance as the *same* thing, which of them can we steadfastly affirm to be *this* – whatever it may be – and not something else, without blushing for ourselves? It cannot be done' (ibid., 49b-d).

8 There is a fundamental ambiguity: on the one hand, the receptacle is mobile and even contradictory, without unity, separable and divisible: pre-syllable, pre-word. Yet, on the other hand, because this separability and divisibility antecede numbers and forms, the space or receptacle is called *amorphous*: thus its suggested rhythmicity will in a certain sense be erased, for how can one think an articulation of what is not yet singular but is nevertheless necessary? All we may say of it, then, to make it intelligible, is that it is amorphous but that it 'is of such and such a quality', not even an index or something in particular ('this' or 'that'). Once named, it immediately becomes a container that takes the place of infinitely repeatable separability. This amounts to saying that this repeated separability is 'ontologized' the moment a *name* or a *word* replaces it, making it intelligible. 'Are we talking idly whenever we say that there is such a thing as an intelligible Form of anything? Is this nothing more than a word?' (ibid., 51c). Is the Platonic *chora* the 'nominability' of rhythm (of repeated separation)?

Why then borrow an ontologized term in order to designate an articulation that antecedes positing? First, the Platonic term makes explicit an insurmountable problem for discourse: once it has been named, that functioning, even if it is presymbolic, is brought back into a symbolic position. All dis-

course can do is differentiate, by means of a 'bastard reasoning', the recep-
tacle from the motility, which, by contrast, is not posited as being 'a *certain*
something' ['une *telle*']. Secondly, this motility is the precondition for sym-
bolicity, heterogeneous to it, yet indispensable. Therefore what needs to be
done is to try to differentiate, always through a 'bastard reasoning', the spe-
cific arrangements of this motility, without seeing them as recipients of acci-
dental singularities, or a *Being* always posited in itself, or a projection of the
One. Moreover, Plato invites us to differentiate in this fashion when he
describes this motility, while gathering it into the receiving membrane. 'But
because it was filled with powers that were neither alike nor evenly balanced,
there was no equipoise in any region of it, but it was everywhere swayed
unevenly and shaken by these things and by its motion shook them in turn.
And they, being thus moved, were perpetually being separated and carried in
different directions, just as when things are shaken and winnowed by means
of winnowing baskets and other instruments for cleaning corn ... it separated
the most unlike kinds farthest apart from one another, and thrust the most
alike closest together: whereby the different kinds came to have different
regions, even before the ordered whole consisting of them came to be ...
but were altogether in such a condition as we should expect for anything
when deity is absent from it' (ibid., 52d–53b). Indefinite 'conjunctions' and
'disjunctions' (functioning, devoid of Meaning), the *chora* is governed by a
necessity that is not God's law.

9 The Platonic space or receptacle is a mother and wet nurse: 'Indeed we may
 fittingly compare the Recipient to a mother, the model to a father, and the
 nature that arises between them to their offspring' (ibid., 50d); 'Now the wet
 nurse of Becoming was made watery and fiery, received the characters of earth
 and air, and was qualified by all the other affections that go with these ...'
 ibid., 52d; translation modified.

10 'Law', which derives etymologically from *lex*, necessarily implies the act of
 judgement whose role in safeguarding society was first developed by the Roman
 law courts. 'Ordering', on the other hand, is closer to the series 'rule', 'norm'
 (from the Greek γνώμων, meaning 'discerning' [adj.], 'carpenter's square'
 [noun]), etc., which implies a numerical or geometrical necessity. On norma-
 tivity in linguistics, see Alain Rey, 'Usages, jugements et prescriptions linguis-
 tiques', *Langue Française*, 16 (Dec. 1972), p. 5. But the temporary ordering of
 the *chora* is not yet even a *rule*: the arsenal of geometry is posterior to the
 chora's motility; it fixes the *chora* in place and reduces it.

11 Operations are, rather, an act of the subject of understanding. [Hans G. Furth,
 in *Piaget and Knowledge: Theoretical Foundations* (Englewood Cliffs, NJ; Prentice-
 Hall, 1969), offers the following definition of 'concrete operations': 'Charac-
 teristic of the first stage of operational intelligence. A concrete operation
 implies underlying general systems or "groupings" such as classification, seri-
 ation, number. Its applicability is limited to objects considered as real (con-
 crete)' (p. 260) – Tr.]

12 Piaget stresses that the roots of sensorimotor operations precede language and
 that the acquisition of thought is due to the symbolic function, which, for him,
 is a notion separate from that of language *per se*. See Jean Piaget, 'Language
 and symbolic operations', in *Piaget and Knowledge*, pp. 121–30.

13 By 'function' we mean a dependent variable determined each time the

independent variables with which it is associated are determined. For our pur-
poses, a function is what links stases within the process of semiotic facilitation.

14 Such a position has been formulated by Lipot Szondi, *Experimental Diagnostic of Drives*, tr. Gertrude Aull (New York: Grune & Stratton, 1952).

15 See James D. Watson, *The Double Helix: A Personal Account of the Discovery of the Structure of DNA* (London: Weidenfeld & Nicolson, 1968).

16 Throughout her writings, Melanie Klein emphasizes the 'pre-Oedipal' phase, i.e., a period of the subject's development that precedes the 'discovery' of castration and the positing of the superego, which itself is a subject to (paternal) Law. The processes she describes for this phase correspond, *but on a genetic level*, to what we call the semiotic, as opposed to the symbolic, which underlies and conditions the semiotic. Significantly, these pre-Oedipal processes are organized through projection on to the mother's body, for girls as well as for boys: 'at this stage of development children of both sexes believe that it is the body of their mother which contains all that is desirable, especially their father's penis', *The Psycho-analysis of Children*, tr. Alix Strachey (London: Hogarth Press, 1932), p. 269. Our own view of this stage is as follows: Without 'believing' or 'desiring' any 'object' whatsoever, the subject is in the process of constituting himself vis-à-vis a non-object. He is in the process of separating from this non-object so as to make that non-object 'one' and posit himself as 'other': the mother's body is the not-yet-one that the believing and desiring subject will image as a 'receptacle'.

17 As for what situates the mother in symbolic space, we find the phallus again (see Jacques Lacan, 'La relation d'objet et les structures freudiennes', *Bulletin de Psychologie*, April 1957, pp. 426–30), represented by the mother's father, i.e., the subject's maternal grandfather (see Marie-Claire Boons, 'Le meurtre du Père chez Freud', *L'Inconscient*, 5, Jan.-March 1968, pp. 101–29).

18 Though disputed and inconsistent, the Freudian theory of drives is of interest here because of the predominance Freud gives to the death drive in both 'living matter' and the 'human being'. The death drive is transversal to identity and tends to disperse 'narcissisms' whose constitution ensures the link between structures and, by extension, life. But at the same time and conversely, narcissism and pleasure are only temporary positions from which the death drive blazes new paths [*se fraye de nouveaux passages*]. Narcissism and pleasure are therefore inveiglings and realizations of the death drive. The semiotic *chora*, converting drive discharges into stases, can be thought of both as a delaying of the death drive and as a possible realization of this drive, which tends to return to a homeostatic state. This hypothesis is consistent with the following remark: 'at the beginning of mental life', writes Freud, 'the struggle for pleasure was far more intense than later but not so unrestricted: it had to submit to frequent interruptions,' *Beyond the Pleasure Principle*, in *The Standard Edition of the Works of Sigmund Freud*, ed. James Strachey (London: Hogarth Press and the Institute of Psychoanalysis, 1953), vol. XVIII, p. 63.

19 On the matrix of the sign as the structure of a logical proof, see Emile Bréhier, *La Théorie des incorporels dans l'ancien stoicisme* (Paris: J. Vrin, 1970).

20 The fact is that the total form of the body by which the subject anticipates in a mirage the maturation of his power is given to him only as *Gestalt*, that is to say, in an exteriority in which this form is certainly more constituent than constituted, but in which it appears to him above all in a contrasting size (*un relief*

de stature) that fixes it and in a symmetry that inverts it, in contrast with the turbulent movements that the subject feels are animating him.' Lacan, 'The mirror stage as formative of the function of the I', in *Ecrits: A Selection*, tr. Alan Sheridan (New York: Norton, 1977), p. 2.

21 'The subversion of the subject and the dialectic of desire in the Freudian unconscious', *Ecrits: A Selection*, p. 319.

22 In Lacan's terminology, castration and the phallus are defined as 'position', 'localization' and 'presence': 'We know that the unconscious castration complex has the function of a knot: ... (2) in a regulation of the development that gives its *ratio* to this first role: namely, the *installation* in the subject of an unconscious *position* without which he would be unable to identify himself with the ideal type of his sex ...' ('The signification of the phallus', *Ecrits: a selection*, p. 281; emphasis added). 'We know that in this term Freud specifies the first genital maturation: on the one hand, it would seem to be characterized by the imaginary dominance of the phallic attribute and by masturbatory *jouissance* and, on the other, it *localizes* this *jouissance* for the woman in the clitoris, which is thus raised to the function of the phallus' (p. 282; emphasis added). '[The phallus] is the signifier intended to *designate* as a whole the effects of the signified, in that the signifier conditions them by its *presence* as a signifier' (p. 285; emphasis added).

23 Lacan himself has suggested the term 'want-to-be' for his neologism (*manque à être*). Other proposed translations include 'want-of-being' (Leon S. Roudiez, personal communication) and 'constitutive lack' (Jeffrey Mehlman, 'The "floating signifier": from Lévi-Strauss to Lacan', *Yale French Studies*, 48, 1972, p. 37). – Tr.

24 *Ecrits: A Selection*, p. 299.

25 Loc. cit.

26 Our definition of language as deriving from the death drive finds confirmation in Lacan: 'From the approach that we have indicated, the reader should recognize in the metaphor of the return to the inanimate (which Freud attaches to every living body) that margin beyond life that language gives to the human being by virtue of the fact that he speaks, and which is precisely that in which such a being places in the position of a signifier, not only those parts of his body that are exchangeable, but this body itself' ('The subversion of the subject and the dialectic of desire in the Freudian unconscious', *Ecrits: a selection*, p. 301). We would add that the symbolism of magic is based on language's capacity to store up the death drive by taking it out of the body. Lévi-Strauss suggests this when he writes that 'the relationship between monster and disease is internal to [the patient's] mind, whether conscious or unconscious: It is a relationship between symbol and thing symbolized, or, to use the terminology of linguists, between signifier and signified. The shaman provides the sick woman with a *language*, by means of which unexpressed and otherwise inexpressible psychic states can be immediately expressed. And it is the transition to this verbal expression – at the same time making it possible to undergo in an ordered and intelligible form a real experience that would otherwise be chaotic and inexpressible – which induces the release of the physiological process, that is, the reorganization, in a favorable direction, of the process to which the sick woman is subjected.' 'The effectiveness of symbols', in *Structural Anthropology*, 1, pp. 197–8; translation modified.

27 See Lacan, 'On a question preliminary to any possible treatment of psychosis', in *Ecrits: A Selection*, p. 197.

28 'The theory of textual writing's history may be termed "monumental history" in so far as it serves as a "ground" ["*fait fond*"] in a literal way, in relation to a "cursive", figural (teleological) history which has served at once to constitute and dissimulate a written/exterior space ... Writing "that recognizes the rupture" is therefore irreducible to the classical (representational) concept of "written text": what it writes is never more than one part of itself. It makes the rupture the intersection of two sets (two irreconcilable states of language)', Philippe Sollers writes, 'Program', in *Writing and the Experience of Limits*, ed. David Hayman, tr. Philip Barnard and David Hayman (New York: Columbia University Press, 1983), p. 7. Our reading of Lautréamont and Mallarmé will attempt to follow these principles, see *La Révolution du langage poétique* (Paris: Seuil, 1974), pp. 361–609. [This is the first of many references to the latter portion of *La Révolution du langage poétique*, which has not been translated – Tr.]

29 Indeed, even Lacanian theory, although it establishes the signifier as absolute master, makes a distinction between two modalities of the signifier represented by the two levels of the 'completed graph' (*Ecrits: A Selection*, p. 314). On the one hand, the *signifier* as 'signifier's treasure', as distinct from the *code*, 'for it is not that the univocal correspondence of a sign with something is preserved in it, but that the signifier is constituted only from a synchronic and enumerable collection of elements in which each is sustained only by the principle of its opposition to each of the others' (p. 304). Drives function within this 'treasure of the signifiers' (p. 314), which is also called a signifying 'battery'. But from that level on, and even beforehand, the subject submits to the signifier, which is also shown as a 'punctuation in which the signification is constituted as finished product' (p. 304). In this way the path from the treasure to punctuation forms a 'previous site of the pure subject of the signifier', which is not yet, however, the true place [*lieu*] of the Other. On that level, the psychotic 'dance' unfolds, the 'pretence' [*feinte*] that 'is satisfied with that previous Other', accounted for by game theory. The fact remains that this *previous site* does not exhaust the question of signification because the subject is not constituted from the code that lies in the Other, but rather from the message emitted by the Other. Only when the Other is distinguished from all other partners, unfolding as signifier and signified – and, as a result, articulating himself within an always already sentential signification and thus transmitting messages – only then are the preconditions for language ('speech') present.

At this second stage, the signifier is not just a 'treasure' or a 'battery' but a *place* [*lieu*]: 'But it is clear that Speech begins only with the passage from 'pretence' to the order of the signifier, and that the signifier requires another locus – the locus of the Other, the Other witness, the witness Other than any of the partners – for the Speech that it supports to be capable of lying, that is to say, of presenting itself as Truth' (p. 305). Only from this point will the ego start to take on various configurations. What seems problematic about this arrangement, or in any case what we believe needs further development, is the way in which the 'battery', the 'treasure' of the signifier, functions. In our opinion, game theory cannot completely account for this functioning, nor can a signification be articulated until an alterity is *distinctly posited* as such. One

cannot speak of the 'signifier' before the positing or the thesis of the Other, the articulation of which begins only with the mirror stage. But what of the previous processes that are not yet 'a site', but a *functioning*? The thetic phase will establish this functioning, as a signifying *order* (though it will not stop it) and will return in this order.

G.I. Vinokur

THE FUTURISTS – CONSTRUCTORS
OF LANGUAGE (1923)
Translated by Ken Hirschkop

Just like any other social fact, our language is an object of social transformation. The fact that in our everyday life [*byt*] we use language impulsively, in accordance with a posited, internalised social norm does not contradict this in any way. The essence of the matter is that language, as a medium of impulsive, unconscious usage, has strict limits: speech, 'under its own momentum', is transformed into a system of language when it is permeated by consciousness, as when the utterance finds itself in conditions which require the speaker to use his/her linguistic faculties rationally and purposefully. I will illustrate this with some simple examples. A conversation over the dinner table and the answer of a student on an examination, a theoretical discussion at a friend's house and an argument at a public dispute, notes in a notebook and a business letter: these, essentially, can be distinguished by reference to their use of language. While the first half of each parallel is characterised by the absence of any structured, distinct recall of the posited system of language, the realisation of the second half presupposes the overcoming of the inertia of linguistic thought, a conscious orientation to the organising elements of language. This orientation is particularly clear in the letter; in speech it is frequently concealed due to external conditions, which are overcome only temporarily and incompletely. But any kind of literary document, in the broad sense of this term – i.e., a letter, poster, newspaper or diary – no matter whether it was composed by someone who is literate or semi-literate, inevitably bears the marks of a consciousness, of a consistent interpretation of the organising moments of language as a system. In the light of this, one can see that the more complex the social conditions which determine a given utterance, the more intensive is this consciousness. From a hotel room number and discussion at a meeting, to the poetic work and oratorical speech, lies the path for the overcoming of linguistic inertia.

Thus *the culture of language* is created, a standard, which, in the final analysis, depends on the common cultural level of a given social milieu. The limits of this culture are determined, on the one hand, by the degree of literacy of the masses, and on the other, by the poetic work of a given epoch.

No matter how one defines the essence and purpose of poetry, it seems to me unarguable that the linguist has a right to analyse poetic facts as linguistic facts. If someone objects that poetic practices are determined not only by the existing linguistic system but also by general cultural-historical conditions, then one could respond by pointing out that language is one such cultural-historical condition, determined by both the pre-existing tradition and contemporary inter-relations. Any change of poetic schools is at the same time a change in the devices for the poetic organisation of linguistic material, a change in the practice of the cultural transformation of linguistic spontaneity. For the last few years much ink has been spilt to show that the system of poetic language is radically different from the system of practical language. I consider this question quite unnecessary: deciding it one way or the other does not bring us closer to the essence of the matter. To ground a linguistic investigation of the facts which accompany poetic creation, it is not at all necessary to underwrite this kind of interpretation of the word, as something self-valuable, lacking any bonds with the surrounding conditions, as material.[1] One must accept that the presence in poetry of *the culture of language* is essential, and that this leads us openly and unreservedly to the *teleological* perspective, shunned by the linguistic purists, and which the partisans of the 'autonomy' of the poetic word seek in vain to conceal (See the definition of poetry as 'an utterance with an orientation towards expression', put forward by R. Jakobson).[2] Thus, for the historian of the culture of language, the poetry of the Futurists, for the reasons given below, has a very special interest.

The language which our educated society speaks is for good reason called literary. It was actually created, in a strict sense, by our literature in the nineteenth century. Pushkin, who was still strongly drawn to the archaic tendencies of the poetry of the previous century, was distinctly conscious of the fact that his poetic mission was at the same time a cultural-linguistic mission, the mission think of Pushkinian prose.[3] 'Learning politics and philosophy have yet to be expressed in Russian', Pushkin dolefully remarked while sending the litterateurs off to bring the Russian language into the Muscovite enlightenment. Pushkin's genius took this as its task, although it was not completed: the enlightenment was legalised, it became canonical; elements of the living Russian language of broad social strata received a literary organisation, and this organisation was borrowed from literature by the educated society of the day. So, 'politics and philosophy', and 'noble passions', and together with these, literature, came to be expressed in the Russian language.

But the forms of poetry, like any other art, develop dialectically. Arising on the basis of a contradiction, created for definite reasons, between existing artistic traditions and parallel facts of everyday life, they die as soon as the contradiction is eliminated, but only so that they may reintroduce this contradiction again. The concrete artistic task, however, is solved in a different way each time. Appeals to the Moscow enlightenment are not always successful. And while Pushkin, in the course of eliminating the contradiction between the luxuriance of

the Derzhavin style and the language of the Moscow enlightenment, took the path of least resistance, by taking the second element of the contradiction, in its given concrete form, as the model for his cultural-linguistic work, the same course of action was not adopted by Russian Futurism, to whom fell an analogous mission: to eliminate the contradiction between the language of contemporary everyday life and the magical ventriloquism of the Symbolists.[4] Futurism was not limited to the role of the registrar of 'popular pronunciation': in forging a new language for poetry, it desired to exert an influence on the model it followed. Essentially speaking, it had no model in the sense that Pushkin had one.[5] Pushkin could be directed by the living model of the language of the lower social classes only because his efforts to create a culture of language served the narrow social class, which, at that time, monopolised all cultural work. When speaking simultaneously about philosophy and noble passion, Pushkin was trying to provide a language for the class to which he himself belonged, a class whom he could not lead away from the French word 'Preoccupe'.[6] But Futurism has a broader audience. In this case it is a question of a mass language. There is, as it were, no place to 'occupy'. The verses of Mayakovsky:

> The street cowers tongue-less
> It has no one to cry to or converse with

conceal a much broader meaning than one thinks, and maybe, than the poet himself thinks. It is spoken with the same genial simplicity as Pushkin's 'have yet to be expressed in Russian'. The full significance of this aphorism will reveal itself to us, if we suspend, for a minute, the habit of translating poetic utterance into the field of socio-public relations, of taking everything to be a metaphor or an allegory. We shall take this word 'language-less' literally; we will agree that this word speaks not only of the social needs of the masses, but of their linguistic needs. The street is tongue-tied, it hasn't mastered speech, it doesn't know the language it speaks, following only blind instinct. *To make a language of the street*: thus one could in the first instance formulate the linguistic task of Futurism, a task conditioned by a natural reaction against the perfumery of Symbolism and by an historically inevitable aspiration to transform the tongue-tied masses.

From this one can see that, despite the definite similarity of the conditions in which the Futurists and Pushkin had to act, the method of each poetic school had to be radically different.[7] The Futurists have not been directed by a ready-made model, they have transformed that mass conversational language from which they draw material for their linguistic creation. In this lies the greatest interest of Russian Futurism for the linguist. The culture of language consists not only of *organisation*, as was indicated above, but also of *invention*. The former anticipates the latter, but the latter, at a certain moment, inevitably demands its rights. It is time to abandon the conception of language as an inviolable sacred object, which recognises only its own internal laws and regulates its life through them alone. The question of the possibility of a conscious scientific intervention in language on the part of a speaking collective has still not really been posed. Certain individual symptoms, however, allow us to say that in the more or less near future this question will become a real one. Insofar as the doctrine that

language is a social fact and not individual expression has already become an established principle of linguistic thought, the fixing of scholarly attention on the problem of social intervention in language – the problem of linguistic politics – appears inevitable.[8] One must realise that, ultimately, our intention is not only to study language but to *make* it as well, not only to organise the elements of language, but to *invent* new connections among them. But invention is the highest form of a culture of language about which, on a mass scale, we can for the time being only dream. Invention presupposes a highly developed technique, the broadest possible assimilation of the elements and constructions of language, mass participation in the linguistic system and the free movement of the springs and levers of the linguistic mechanism. In Russia we do not have at present even the basic technical, let alone social, prerequisites for such a broad culture: the great majority of the Russian people are simply illiterate. Yes, here anything on a mass scale is patently impossible. But the Russian Futurists have shown us what is possible right now on the scale of verses and poems. And that is already a great deal. It is a *beginning*.

The Futurists were the first to undertake consciously the task of linguistic invention, to indicate the path to linguistic engineering, to pose the problem of the 'tongue-less street', and what is more, pose it as a problem simultaneously social and poetic. It would have been a mistake, however, to deduce from this engineering, in the first case, 'transrational poetry' (*zaum*).[9] Such a tendency exists among both critics and representatives of Futurism, but it is incorrect: why – I will show below; for the time being I will limit myself to pointing out a feature of Futurist word creation which is both characteristic and important for the linguist: it is not so much *lexicological* as *grammatical*. And profound linguistic invention can only be of this kind, for the sum of linguistic habits and practices usually defined as the 'spirit of a language' is first of all created as a linguistic system, i.e., as a complex of relations existing among the separate parts of a complicated linguistic mechanism. It should be persistently emphasised and explained that the real creation of language is not a matter of inventing neologisms but of the unusual application of suffixes, not extraordinary names but a system of words which develops according to its own laws. Futurism understands this. While the Symbolists, in the course of confronting the task facing them – the renovation of poetic language – were rummaging around in the historical annals and magical tracts of the Middle Ages (indeed an amazing example of this method is Bryusov's latest book, 'Dali', where the use of archival dust reaches the absurd), and were constructing their poetry out of 'strange' words and already existing grammar, the poetry of Futurism directed its cultural-linguistic searches to the thick of the linguistic material, discovering there elements which were suitable for independent cultivation. It is hardly necessary to cite here, once again, Khlebnikov's 'Incantation by Laughter'; it is too well known. Grammatical creation is presented there in an utterly naked form: the formal possibilities of the word 'to laugh/laughter' [*smekh*] are detailed almost exhaustively. But there is something to which we must turn our attention. I have had to listen to remarks such as the following, in the form of objections to the authenticity of Futurist word creation: what kind of word creation is it, when ordinary and familiar suffixes are taken and attached to the wrong words? But that is exactly the point:

grammatical creation is not material creation. It ends up providing you not with new linguistic elements but with new linguistic *relations*. And, of course, these relations are created according to the method of analogy[10]: *dubrava* provides Khlebnikov with the model for words such as *metava* and *letava*, *trushchoba* for *vol'noba* and *zvenoba*, *begun* for *mogun* and *vladun*, etc.[11] The analogy, however, is not always so naively straightforward. In other Futurists, the poetic work of whom does not have the completely laboratory-like, albeit brilliant, character of Khlebnikov's, grammatical creation is not so naked, and its elements must be fished out the depths of the material. One could even look to Mayakovsky from this point of view. His grammar is not detailed, but it is essentially complex and inventive. It can be shown to be even more complex than Khlebnikov's precisely because it is not nakedly constructed on the basis of parallel purely verbal comparisons. Thus, in the prologue to 'A Cloud in Trousers', we meet, in the second stanza, with *vyzhirevshi*, but this word is not immediately compared with anything, and only in the eleventh line, by means of the word *vyvernuts*, provides an indirect indication for the possibility of the construction of this analogy, whereas *izizdevyayus* in the fourth stanza seems to hang in the air, and an attempt to make some connection between the given formation and the system as a whole requires us to turn to the other pages of Mayakovsky's poetry.[12]

[. . .]

[My] references to the poetry of the Futurists are by no means intended to establish some kind of model for mass linguistic construction. That will be determined not by the laboratory material of poets but socially, by linguistic needs, the theoretical calculation of which will be worked out scientifically, while their solution is worked out by the masters of the word, the poets. Our examples, however, are revealing in regard to principles: they disclose the direction in which linguistic engineering is generally possible, and they demonstrate *how* the principles of the linguistic work of the poets can be meaningful for everyday life.

In approaching, in this manner, the posing of the question of the word as something which has the nature of a product, we have still not clarified for ourselves the role of 'transrational language' in this regard. It is all the more necessary to speak about 'transrational language', given that the representation of this phenomenon which has been created for us is extremely confused and almost incomprehensible. We must clear up the place and the nature of 'transrational language' once and for all, precisely and definitively. Of course, 'transrational language' cannot really be called *language*, and in this regard the defenders of 'transrationality' as some kind of 'international' language, and its violent opponents, who cry 'nonsense!', are equally ridiculous. Ridiculous, because neither one nor the other touches on the key point. Allow me to explain. 'Transrational language' is a *contradictio in adjecto* [contradiction in terms]. Someone once made the wise remark that language must necessarily be 'rational'. This is unarguable, for the very concept of *language* presupposes the concept of *meaning*. Thus 'transrational' verse as such is asocial, for it is incomprehensible and meaningless. Moreover, 'transrational language' is *not even a language of sounds* as some have tried to establish. It is not even the 'ringing of bells' of Trediakov. Above we

demonstrated how a language of sounds was possible, in which a grammatical consciousness lay on the surface. After long experience, contemporary linguistics has finally come to the conclusion that the sound of language exists only insofar as it *signifies*, as it is related to a system. Therefore it is evident that the 'verses' of Kruchenykh, taken on their own, are pure psychology, naked individualisation, having nothing in common with a system of language as a social fact.

All this, however, would have been justified only if we had not had in mind the cultural-organising functions of language, if we had not put before us the question of the word as a production. For it is easy to demonstrate that while Kruchenykh's little books of 'verses' are an asocial fact, when it is applied to everyday life 'transrationality' suddenly loses its individualism and psychologism. In fact, many have noticed that, for instance, the names of our films are completely transrational. *Uran*, *Phantomas*, *Ars*, *The Coliseum*, *Union*, and so forth, are all words comprehensible only to the philologist, and then only when he is not a philistine.[13] These words, it would seem, do not possess any kind of social significance. Matters are no better with the names of objects of general social use. Let us take cigarettes: 'Java', 'Era', 'Zephyr', 'Cape', even 'Ambassadors' (in this case the real meaning of the word has been completely effaced), all these, in turn, are absolutely meaningless, transrational words. But they remain so only so long as they are cut off from their, so to speak, semantic existence, from their productive basis. While the word 'Uran' is incomprehensible in general, about the film *Uran* there can be no real doubts. The combination 'Java' Cigarettes likewise possesses a full social significance. Elementary considerations of linguistics show where the essence of the matter lies. 'Transrational language' as a language devoid of meaning does not have the communicative function which inheres in language generally. As a consequence, there remains for it a purely *nominative* role, and such a role it can successfully fulfil in the field of social nomenclature. Therefore is it entirely possible for there to be 'E-oo-ee' cigarettes, which would be no worse, and maybe even better than 'Cape' cigarettes.[14] If one can name a film *Ars* then with the same result one could christen a film *Zliustra*. And why, if there are 'Omega' watches, couldn't there be a 'Vo-e-o-bi' watch factory? Finally, why can you order a 'Triple Sec Cointreau' in a restaurant, and not a portion of 'Rokovovo Rococu' (literally, fatal rococo? Perhaps, fatal cocoa?)[15]

The role of transrationality in the common system of culture is so defined. In conjunction with what was said above, we can therefore look on transrational 'verses' as the results of preparatory laboratory work for the creation of a new system of elements of social denomination. From this point of view transrational creation takes on a completely specific and significant meaning. Sounds intended for the execution of social nominative work not only can be, but ought to be, meaningless. In line with this, the existing phonetic possibilities of language should be strictly controlled by the critical ear of the poet; their specific gravity demands precise calculation and this is exactly what Kruchenykh's experiments provide us with. In other words, we have here another invention, the value of which is clearer when it is based on careful distinctions between the different functions of language.

I believe that the few examples listed above are sufficient for us to assess for ourselves the significance of Futurist poetry for mass linguistic construction,

the task of which, given a certain degree of general cultural-technical development, inevitably confronts humanity. One can understand, therefore, the mutual interest binding the linguist to the Futurist poets. While not all linguists have become interested in Futurism, just as not all of them have put to themselves the question of the possibility of a special linguistic technology, this must be countered by the fact that all the Futurist poets are drawn to the theory of the word, like a plant to the sunlight. Because of that, the theories are *purely linguistic* and not either Gershenzonian in any way or like those of Andrei Bely.[16] Not the 'magic of words' but the internal mechanism of words attracts the Futurists. The Futurist word is cultured precisely according to such a principle. There is no need to violate traditions. Culture is not the crude shackles of tradition, as we know well from the social experience we have ourselves created. Culture organises, and therefore it demands expansion, it is constructed by means of contradictions. The brilliant French scholar said in passing: 'it is intolerable that only specialists are concerned with language, meaning by this only linguists'.[17] And outside of the world of scholarship, the Futurist pleiad is the first to have come close to a mastery of the 'secret' of the word. Their work, of course, is in no respects finished. It would be more true to say that it has only been outlined. Its continuation requires a synthesis of theory and practice, of the science of the word and verbal mastery. This synthesis is sketched out in the posing of the question of the culture of language. For – I shall finish as I began – language is an object of cultural transformation in our everyday social life.

Notes

1 This is a rather transparent reference to the Russian Formalist doctrine of the word as material, and the Futurist poetic idea of the self-valuable word. (Translator's note)

2 Again, a reference to the Formalists and the Futurists. Note that Vinokur was a member of the Moscow Linguistic Circle, which included Jakobson and Yuri Tynyanov. (Translator's note)

3 Vinokur is referring to Pushkin's role as the creator of a new Russian literary and conversational language in the 1820s and 1830s, when there was a shift away from the salons of the gentry towards a new kind of cultural elite, based on a new, educated middle class. As is well known, Pushkin devised this language as a compromise between the language of the court writers Derzhavin and Karamzin and the popular (educated/popular) language. (Translator's note)

4 The Symbolist poets – Andrei Bely, Konstantin Balmont, Vyacheslav Ivanov – believed that the poetic word was a symbol of a metaphysical 'higher' reality. (Translator's note)

5 Regarding the use by the Futurists of dialect words and archaisms extracted from ancient documents, it is essential to note that they did not create something on the example of the Pushkinian enlightenment. This was only a reconnaissance mission, a search for material. (Author's note)

6 This word in Roman letters in the original. The reference is to the fact that Pushkin and his generation had to devise a Russian replacement for the French

which was the usual conversational language of the Russian nobility. (Translator's note)

7 This coincidence of Pushkin and Mayakovsky should not, however, lead to a misunderstanding. The purely literary-creative points of view of both poets are not similar, but directly opposed: while Pushkin was a polisher, a canoniser, Mayakovsky and the Futurists are founders, revolutionaries. In this connection a comparison of Mayakovsky with Nekrasov, as has been put forward by B. Eikhenbaum, seems to me completely faultless. But something else interests me here. For me, in connection with the posing of the question of the culture of language, what has chief significance is the work of the poet not against the background of customary poetic forms, but against the background of language in general. This tendency to pose questions of a general-linguistic character, to take linguistic creation beyond the bounds of the properly literary, provides me with the foundation to compare Pushkin with the Futurists, in the face of all the limits necessary for such a comparison which, of course, I bear in mind. (Author's note)

8 By the doctrine of 'language as a social fact' Vinokur undoubtedly means Saussure's linguistic theory. (Translator's note)

9 Transrational poetry was the creation of Futurist poets such as Khlebnikov and Kruchenykh (although Vinokur seems to narrow the definition to include only Kruchenykh), consisting of the creation of nonsense words, often constructed on musical or 'sound' principles. (Translator's note)

10 Note that Saussure discusses the creation of new signs through analogy extensively in the *Course in General Linguistics*, and that this appears to be the one instance where existing linguistic relations (*langue*) include a pressure for some kind of innovation. (Translator's note)

11 In each case, as is clear from the context, the first word is an existing Russian word, the suffix of which is then transferred onto another root to create a neologism. (Translator's note)

12 In both examples, existing verb roots are transformed by the addition of inappropriate prefixes; in the first case the prefix *vy-* implying 'out of', perhaps similar to the English prefix *ex-*, is added to the root for the verb 'to grow fat', in the second case the prefix *iz-* meaning 'away from' is added to the word for 'to scoff'. (Translator's note)

13 The point being, that they are either invented words or foreign words. (Translator's note)

14 'E-oo-ee' is a 'transrational' word taken from one of Khlebnikov's poems, as are the suggested new names for films and commodities below, such as 'zliustra' and 'vo-e-o-bi'. (Translator's note)

15 A nonsense word combination from Kruchenykh. (Translator's note)

16 Bely was one of the Symbolist poets who wrote a great deal of critical and theoretical work, which treated the word as a semi-mystical symbol. (Translator's note)

17 The reference is to Ferdinand de Saussure (Swiss, at any rate), who makes this comment in the *Course in General Linguistics*, trans. Wade Baskin, Glasgow 1974, p. 7. (Translator's note)

Languages, cultures, communities

LANGUAGES/CULTURES

> I may learn the password but the language of the tribe will always elude
> me, won't it? The private core will always be ... hermetic, won't it?
> (Brian Friel, *Translations*, 1981: 40)

PART THREE of the *Reader* picks up on themes which have been pre-
sented earlier and explores a range of contexts in which different languages,
or forms of language, are the loci of wider social and cultural values and serve as
markers of cultural difference and social distinction. The sections present mater-
ial which is concerned with language and cultural difference, language and colo-
nialism, and language, class and education. These are areas of enquiry which, like
others covered in the *Reader*, are intellectually and politically fraught. One of the
interesting things which can be seen in the study of language represented by the
texts below, is the way in which linguistics has been an essential tool for students
of other disciplines (here anthropology and sociology). It is not simply that lan-
guage has become a dominant field of enquiry in the twentieth century, but that
the methodologies of linguistic modelling have been extended into other intellec-
tual fields.

The work of Boas, particularly the *Handbook of American Indian Languages*
(1911) was pioneering and highly influential; it established a tradition within the
study of language in America which concentrated on the links between language
and culture and which was realised in the study of the fast-disappearing native
American languages. Boas rejected simplistic definitions of 'race' and attempted to
problematise them (as did Saussure). This was important because language had
been used as one of the defining characteristics of both race and nationality in sev-
eral important texts which were later to be used by twentieth-century fascist move-
ments including the Nazis. The Comte de Gobineau's *Essay on the Inequality of the
Human Races*, 1853–5, is one example; the term 'Aryan' itself was a word coined
by the linguist Max Muller to describe the Indo-European languages in the 1850s.
Boas argues against any close correlation between race, language and culture and
emphasises instead the fact that classificatory systems which seek to differentiate
or categorise the relationships between races or cultures are always highly artifi-
cial impositions upon complex histories.

The extract from Malinowski's essay focuses on the difficulties of translation and the incommensurability of cultural difference with particular reference to what he calls 'primitive' and 'civilised' languages. He argues that any attempt to understand utterances in a different culture simply on the basis of word-for-word translation is doomed to failure. What is required for successful translation is the knowledge of a culture; without it an utterance will appear to be mere gibberish, with it comes the creation of sense. This led Malinowski to formulate the important idea of meaning being dependent upon the context of situation, which became important in the work of later philosophers/semanticists in Britain, such as Firth and Austin. His model of 'primitive' language as being local and context-bound, as opposed to 'civilised' languages which are abstract and distinct from immediate activity, is similar to the restricted and elaborated codes theory of Basil Bernstein, as we shall see in 'Language, Class and Education'. It is worth thinking about the extent to which such labels are value-laden.

Sapir's work was heavily influenced by Boas and, like that of Whorf, was conducted on the basis of research into native American languages. As with Malinowski, he took the understanding of culture to be predicated upon knowledge of a whole way of life rather than simply upon the knowledge of a language: signs are culturally complex. For Sapir, and this links back to some of the feminist debates on language, language in a sense rendered reality – it was not the tool for the expression of ideas, but the constitutive medium of knowledge. He postulated that rather than speakers being in control of their consciousness and meanings, they are in fact at the mercy of their language, trapped in the 'prison-house of language'. For that reason, he argued, linguists should, of all critics, have a relativist standpoint: they need to be aware that their own categories of thought have been derived from their language and are not universal. It is interesting in this respect to contrast his ideas with those of the other linguistic anthropologists in this section.

The work of Lévi-Strauss marks a departure from the anthropological model which was characteristic of American linguistics in the early to mid-twentieth-century. Instead his work was indebted to the structuralist mode of analysis which stemmed from Saussure's *Course in General Linguistics*. As we have seen earlier, this methodology was later to be extended to disciplines as diverse as film theory and mathematics, literature and psychoanalysis. Lévi-Strauss's argument was that language and culture are so closely intertwined that they could be studied using the same methodology. Both are concerned with the ordered, structured creation of meaning and thus both are amenable to analysis by means of the tools which Saussure's theory had provided. Like language, culture can be looked at in terms of units (signs in linguistics, constituent forms in anthropology) which are structured for the purpose of achieving signification. The examples which Lévi-Strauss considers, here kinship relations and marriage rules, are instances of systems which operate according to a determinate logic and which are thus open to structural analysis.

This form of anthropological study was, for the most part, focused upon cultures far removed from the contexts in which most analysts lived. In the work of Barthes, however, we see a new departure as the critical gaze of anthropology is

turned onto the cultural practices of the West. Again, his work is indebted to Saussure, and Barthes' mythology, defined as a sub-branch of the general theory of signs, or semiology, is an attempt to understand the ideologies which surround us in daily life: photography, newspapers, advertising for example. All, for Barthes, are systems which can be understood in terms of the creation of social and cultural sense by means of structured inter-relations. 'Myths' therefore are not untrue fictions, but ideological narratives (and this links back to the work of Ricouer) by which we live and which need to be understood. This form of analysis became highly influential in the field of cultural studies in particular.

Further reading

Anthropology and language

Hawkes, T. (1977) *Structuralism and Semiotics*, London: Methuen, chapter 2.

Hymes, D. (ed.) (1964) 'The Scope of Linguistic Anthropology: Introduction', in D. Hymes (ed.) *Language in Culture and Society: A Reader in Linguistics and Anthropology*, New York: Harper and Row, pp. 3–14.

Greenberg, J. H. (1964) 'Linguistics and Ethnology', in D. Hymes (ed.) *Language in Culture and Society: A Reader in Linguistics and Anthropology*, New York: Harper and Row, pp. 27–35.

Hoijer, H. (1961) 'Anthropological Linguistics', in C. Mohrmann, A. Sommerfelt, and J. Whatmough (eds) *Trends in European and American Linguistics 1930–1960*, Utrecht and Antwerp: Spectrum, pp. 110–27.

Henson, H. (1971) 'Early British Anthropologists and Language', in *Social Anthropology and Language*, ed. E. Ardener, London: Tavistock, pp. 3–32.

Leach, E. (1973) 'Structuralism in Social Anthropology', in D. Robey (ed.) *Structuralism: An Introduction*, Oxford: Clarendon Press, pp. 37–56.

Boas

Boas, F. (1974) *The Shaping of American Anthropology: A Franz Boas Reader*, ed. G.W. Stocking, New York: Basic Books, Part 5.

—— (1997) *Handbook of American Indian Languages, Part 1*, ed. R. Harris, London: Routledge/ Thoemmes, pp. 1–82.

Emeneau, M. (1943) 'Franz Boas as a Linguist', *American Anthropological Association Memoir* 61, pp. 35–38.

Stocking, G. (1968) *Race, Culture and Evolution: Essays in the History of Anthropology*, New York: Free Press.

Hymes, D. (ed.) (1964) *Language in Culture and Society: A Reader in Linguistics and Anthropology*, New York: Harper and Row, chapter 1.

Malinowski and context of situation

Malinowski, B. (1923) 'The Problem of Meaning in Primitive Languages', in C.K. Ogden and I.A. Richards (eds) *The Meaning of Meaning: A Study of the Influence of Language upon Thought and of the Science of Symbolism*, London: Routledge and Kegan Paul, pp. 296–336.

—— (1935) *Coral Gardens and Their Magic*, 2 vols, London: George Allen & Unwin, vol. 2, pp. 3–74.

Robins, R.H. (1971) 'Malinowski, Firth, and the "Context of Situation"', in E. Ardener (ed.) *Social Anthropology and Language*, London: Tavistock, pp. 33–46.

Firth, R. (1957) 'Ethnographic Analysis and Language with Reference to Malinowski's Views', in R. Firth (ed.) *Man and Culture: An Evaluation of the Work of Bronislaw Malinowski*, London: Routledge & Kegan Paul, pp. 93–118.

—— (1957) *Papers in Linguistics 1934–1951*, London: Oxford University Press, pp. 139–47, 177–215.

Hymes, D. (ed.) (1964) *Language in Culture and Society: A Reader in Linguistics and Anthropology*, New York: Harper and Row, chapter 6.

Sapir

Sapir, E. (1949) *Selected Writings of Edward Sapir in Language, Culture and Personality*, ed. D.G. Mandelbaum, London: Cambridge University Press, pp. 7–32, 89–103.

—— (1978) *Language: An Introduction to the Study of Speech*, London: Hart-Davis, MacGibbon, chapter 10.

Darnell, R. (1990) *Edward Sapir: Linguist, Anthropologist, Humanist*, Berkeley CA: University of California Press.

Koerner, E.F.K. ed. (1984) *Edward Sapir: Appraisals of his Life and Work*, Amsterdam: Benjamins.

Hymes, D. (ed.) (1964) *Language in Culture and Society: A Reader in Linguistics and Anthropology*, New York: Harper and Row, chapters 11 and 15.

Lévi-Strauss

Lévi-Strauss, C. (1963) *Structural Anthropology*, trans. C. Jacobson and B. Grundfest Schoepf, New York: Basic Books.

Leach, E. (1970) *Lévi-Strauss*, London: Fontana.

Sperber, D. (1979) 'Claude Lévi-Strauss', in J. Sturrock (ed.) *Structuralism and Since: From Lévi-Strauss to Derrida*, Oxford University Press, 1979, pp. 19–51.

Cook, A. (1980) *Myth and Language*, Bloomington, CA: Indiana University Press, chapter 1.

Hymes, D. (ed.) (1964) *Language in Culture and Society: A Reader in Linguistics and Anthropology*, New York: Harper and Row, chapter 4.

Hawkes, T. (1977) *Structuralism and Semiotics*, London: Methuen, pp. 32–58.

Barthes

Barthes, R. (1973) *Mythologies*, trans. A. Lavers, London: Paladin.

—— (1977) *Image–Music–Text*, trans. S. Heath, Glasgow: Fontana.

Culler, J. (1983a) *Barthes*, Glasgow: Fontana, pp. 33–41, 70–7.

Sturrock, J. (1979) 'Roland Barthes' in J. Sturrock (ed.) *Structuralism and Since: From Levi-Strauss to Derrida*, Oxford: Oxford University Press, pp. 52–80.

Storey, J. (1993) *An Introductory Guide to Cultural Theory and Popular Culture*, Hemel Hempstead: Harvester Wheatsheaf, pp. 69–85.

Harland, R. (1987) *Superstructuralism: The Philosophy of Structuralism and Post-Structuralism*, London: Methuen, chapter 5.

Lavers, A. (1982) *Roland Barthes: Structuralism and After*, Cambridge MA: Harvard University Press.

Language and culture

Wardhaugh, R. (1992) *An Introduction to Sociolinguistics*, 2nd edn., Oxford: Basil Blackwell, chapter 9.

Hymes, D. (ed.) (1964) 'The Scope of Linguistic Anthropology: Introduction', in D. Hymes (ed.) *Language in Culture and Society: A Reader in Linguistics and Anthropology*, New York: Harper and Row, pp. 3–14.

—— (1974) *Foundations in Sociolinguistics: An Ethnographic Approach*, Philadelphia: University of Pennsylvania Press, chapter 1.

Saville-Troike, M. (1982) *The Ethnography of Communication: An Introduction*, Oxford: Basil Blackwell.

Salzmann, Z. (1993) *Language, Culture and Society: An Introduction to Linguistic Anthropology*, Boulder, CO: Westview Press, chapters 8 and 10.

Henle, P. (1958) 'Language, Thought and Culture', in P. Henle (ed.) *Language, Thought and Culture*, Ann Arbor: University of Michigan Press, pp. 1–24.

Hoijer, H. (1948) 'Linguistic and Cultural Change', *Language*, 24 (4), pp. 335–45.

—— (1953) 'The Relation of Language to Culture', in A. L. Kroeber *et al.* (eds) *Anthropology Today: An Encyclopedia Inventory*, Chicago: University of Chicago Press, pp. 554–73.

Franz Boas

RACE AND LANGUAGE (1911)

Early attempts to determine the position of the American race

When Columbus started on his journey to reach the Indies, sailing westward, and discovered the shores of America, he beheld a new race of man, different in type, different in culture, different in language, from any known before that time. This race resembled neither the European types, nor the negroes, nor the better-known races of southern Asia. As the Spanish conquest of America progressed, other peoples of our continent became known to the invaders, and all showed a certain degree of outer resemblance, which led the Spaniards to designate them by the term "Indios" (Indians), the inhabitants of the country which was believed to be part of India. Thus the mistaken geographical term came to be applied to the inhabitants of the New World; and owing to the contrast of their appearance to that of other races, and the peculiarities of their cultures and their languages, they came to be in time considered as a racial unit.

The same point of view still prevailed when the discoveries included more extended parts of the New World. The people with whom the Spaniards and Portuguese came into contact in South America, as well as the inhabitants of the northern parts of North America, all seemed to partake so much of the same characteristics, that they were readily classed with the natives first discovered, and were considered as a single race of mankind.

It was only when our knowledge of the Indian tribes increased, that differences between the various types of man inhabiting our continent became known. Differences in degree of culture, as well as differences in language, were recognized at an early time. Much later came a recognition of the fact that the Indians of our continent differ in type as much among themselves as do the members of other races.

As soon as investigators began to concern themselves with these questions, the problem of the position of the natives of America among the races of mankind

came to be of considerable interest, and speculations in regard to their origin and relationships occur even in the early descriptions of the New World.

Among the earlier attempts we find particularly endeavors to prove that certain parts of the beliefs and customs of the Indians agree with those of the Old World. Such agreements were considered proof that the Indians belong to one of the races enumerated in biblical history; and the theory that they represent the lost tribes of Israel was propounded frequently, and has held its own for a long time. In a similar way were traced analogies between the languages of the New World and those of the Old World, and many investigators believe even now that they have established such relationships. Attempts were also made to prove similarities in appearance between the American races and other races, and thus to determine their position among the races of the Old World.

Classifications based on physical type, language, and customs

The problems involved in the determination of the relations of the various races have been approached from two different points of view – either the attempt has been made to assign a definite position to a race in a classificatory system of the races of man, or the history of the race has been traced as far back as available data may permit.

The attempts to classify mankind are numerous. Setting aside the classifications based on biblical tradition, and considering only those that are based on scientific discussion, we find a number of attempts based on comparisons of the anatomical characteristics of mankind, combined with geographical considerations; others are based on the discussion of a combination of anatomical and cultural characteristics – traits which are considered as characteristic of certain groups of mankind; while still others are based primarily on the study of the languages spoken by people representing a certain anatomical type.

The attempts that have thus been made have led to entirely different results. Blumenbach, one of the first scientists who attempted to classify mankind, first distinguished five races – the Caucasian, Mongolian, Ethiopian, American, and Malay. It is fairly clear that this classification is based as much on geographical as on anatomical considerations, although the description of each race is primarily an anatomical one. Cuvier distinguished three races – the white, yellow, and black. Huxley proceeds more strictly on a biological basis. He combines part of the Mongolian and American races of Blumenbach into one, assigns part of the South Asiatic peoples to the Australian type, and subdivides the European races into a dark and a light division. The numerical preponderance of the European types has evidently led him to make finer distinctions in this race, which he divides into the xanthochroic and melanochroic races. It would be easy to make subdivisions of equal value in other races. Still clearer is the influence of cultural points of view in classifications like those of Gobineau and Klemm (who distinguishes the active and passive races), according to the cultural achievements of the various types of man.

The most typical attempt to classify mankind from a consideration of both anatomical and linguistic points of view is that of Friederich Müller, who takes

as the basis of his primary divisions the form of hair, while all the minor divisions are based on linguistic considerations.

Relations between physical type, language, and customs

An attempt to correlate the numerous classifications that have been proposed shows clearly a condition of utter confusion and contradiction. If it were true that anatomical form, language, and culture are all closely associated, and that each subdivision of mankind is characterized by a certain bodily form, a certain culture, and a certain language, which can never become separated, we might expect that the results of the various investigations would show better agreement. If, on the other hand, the various phenomena which were made the leading points in the attempt at classification are not closely associated, then we may naturally expect such contradictions and lack of agreement as are actually found.

It is therefore necessary, first of all, to be clear in regard to the significance of anatomical characteristics, language, and culture, as characteristic of any subdivision of mankind.

It seems desirable to consider the actual development of these various traits among the existing races.

Permanence of physical type; changes in language and culture

At the present period we may observe many cases in which a complete change of language and culture takes place without a corresponding change in physical type. This is true, for instance, among the North American negroes, a people by descent largely African; in culture and language, however, essentially European. While it is true that certain survivals of African culture and language are found among our American negroes, their culture is essentially that of the uneducated classes of the people among whom they live, and their language is on the whole identical with that of their neighbors – English, French, Spanish, and Portuguese, according to the prevalent language in various parts of the continent. It might be objected that the transportation of the African race to America was an artificial one, and that in earlier times extended migrations and transplantations of this kind have not taken place.

The history of medieval Europe, however, shows clearly that extended changes in language and culture have taken place many times without corresponding changes in blood.

Recent investigations of the physical types of Europe have shown with great clearness that the distribution of types has remained the same for a long period. Without considering details, it may be said that an Alpine type can easily be distinguished from a north-European type on the one hand, and a south-Europeans type on the other. The Alpine type appears fairly uniform over a large territory, no matter what language may be spoken and what national culture may prevail in the particular district. The central-European Frenchmen, Germans, Italians, and Slavs are so nearly of the same type that we may safely assume a considerable degree of blood relationship, notwithstanding their linguistic differences.

Instances of similar kind, in which we find permanence of blood with far-reaching modifications of language and culture, are found in other parts of the world. As an example may be mentioned the Veddah of Ceylon, a people fundamentally different in type from the neighboring Singhalese, whose language they seem to have adopted, and from whom they have also evidently borrowed a number of cultural traits. Still other examples are the Japanese of the northern part of Japan, who are undoubtedly, to a considerable extent, Ainu in blood; and the Yukaghir of Siberia, who, while retaining to a great extent the old blood, have been assimilated in culture and language by the neighboring Tungus.

Permanence of language; changes of physical type

While it is therefore evident that in many cases a people, without undergoing a considerable change in type by mixture, have changed completely their language and culture, still other cases may be adduced in which it can be shown that a people have retained their language while undergoing material changes in blood and culture, or in both. As an example of this may be mentioned the Magyar of Europe, who have retained their old language, but have become mixed with people speaking Indo-European languages, and who have, to all intents and purposes, adopted European culture.

Similar conditions must have prevailed among the Athapascans, one of the great linguistic families of North America. The great body of people speaking languages belonging to this linguistic stock live in the northwestern part of America, while other dialects are spoken by small tribes in California, and still others by a large body of people in Arizona and New Mexico. The relationship between all these dialects is so close that they must be considered as branches of one large group, and it must be assumed that all of them have sprung from a language once spoken over a continuous area. At the present time the people speaking these languages differ fundamentally in type, the inhabitants of the Mackenzie river region being quite different from the tribes of California, and these, again, differing from the tribes of New Mexico. The forms of culture in these different regions are also quite distinct; the culture of the California Athapascans resembles that of other Californian tribes, while the culture of the Athapascans of New Mexico and Arizona is influenced by that of other peoples of that area. It seems most plausible to assume in this case that branches of this stock migrated from one part of this large area to another, where they intermingled with the neighboring people, and thus changed their physical characteristics, while at the same time they retained their speech. Without historical evidence this process can not, of course, be proved. I shall refer to this example later on.

Changes of language and type

These two phenomena – a retention of type with a change of language, and a retention of language with a change of type – apparently opposed to each other, are still very closely related, and in many cases go hand in hand. An example of

this is, for instance, the distribution of the Arabs along the north coast of Africa. On the whole, the Arab element has retained its language; but at the same time intermarriages with the native races were common, so that the descendants of the Arabs have often retained the old language and have changed their type. On the other hand, the natives have to a certain extent given up their own languages, but have continued to intermarry among themselves and have thus preserved their type. So far as any change of this kind is connected with intermixture, both types of changes must always occur at the same time, and will be classed as a change of type or a change of language, as our attention is directed to the one people or the other, or, in some cases, as the one or the other change is more pronounced. Cases of complete assimilation without any mixture of the people involved seem to be rare, if not entirely absent.

Permanence of type and language; change of culture

Cases of permanence of type and language and of change of culture are much more numerous. As a matter of fact, the whole historical development of Europe, from prehistoric times on, is one endless series of examples of this process, which seems to be much easier, since assimilation of cultures occurs everywhere without actual blood mixture, as an effect of imitation. Proof of diffusion of cultural elements may be found in every single cultural area which covers a district in which many languages are spoken. In North America, California offers a good example of this kind; for here many languages are spoken, and there is a certain degree of differentiation of type, but at the same time a considerable uniformity of culture prevails. Another case in point is the coast of New Guinea, where, notwithstanding strong local differentiations, a certain fairly characteristic type of culture prevails, which goes hand in hand with a strong differentiation of languages. Among more highly civilized peoples, the whole area which is under the influence of Chinese culture might be given as an example.

These considerations make it fairly clear that, at least at the present time, anatomical type, language, and culture have not necessarily the same fates; that a people may remain constant in type and language and change in culture; that they may remain constant in type, but change in language; or that they may remain constant in language and changes in type and culture. If this is true, then it is obvious that attempts to classify mankind, based on the present distribution of type, language, and culture, must lead to different results, according to the point of view taken; that a classification based primarily on type alone will lead to a system which represents, more or less accurately, the blood relationships of the people, which do not need to coincide with their cultural relationships; and that, in the same way, classifications based on language and culture do not need at all to coincide with a biological classification.

If this be true, then a problem like the much discussed Aryan problem really does not exist, because the problem is primarily a linguistic one, relating to the history of the Aryan languages; and the assumption that a certain definite people whose members have always been related by blood must have been the carriers of this language throughout history; and the other assumption, that a certain cul-

tural type must have always belonged to this people — are purely arbitrary ones and not in accord with the observed facts.

Hypothesis of original correlation of type, language, and culture

Nevertheless, it must be granted, that in a theoretical consideration of the history of the types of mankind, of languages, and of cultures, we are led back to the assumption of early conditions during which each type was much more isolated from the rest of mankind than it is at the present time. For this reason, the culture and the language belonging to a single type must have been much more sharply separated from those of other types than we find them to be at the present period. It is true that such a condition has nowhere been observed; but the knowledge of historical developments almost compels us to assume its existence at a very early period in the development of mankind. If this is true, the question would arise, whether an isolated group, at an early period, was necessarily characterized by a single type, a single language, and a single culture, or whether in such a group different types, different languages, and different cultures may have been represented.

The historical development of mankind would afford a simpler and clearer picture, if we were justified in assuming that in primitive communities the three phenomena had been intimately associated. No proof, however, of such an assumption can be given. On the contrary, the present distribution of languages, as compared with the distribution of types, makes it plausible that even at the earliest times the biological units may have been wider than the linguistic units, and presumably also wider than the cultural units. I believe that it may be safely said that all over the world the biological unit is much larger than the linguistic unit: in other words, that groups of men who are so closely related in bodily appearance that we must consider them as representatives of the same variety of mankind, embrace a much larger number of individuals than the number of men speaking languages which we know to be genetically related. Examples of this kind may be given from many parts of the world. Thus, the European race — including under this term roughly all those individuals who are without hesitation classed by us as members of the white race — would include peoples speaking Indo-European, Basque, and Ural-Altaic languages. West African negroes would represent individuals of a certain negro type, but speaking the most diverse languages; and the same would be true, among Asiatic types, of Siberians; among American types, of part of the Californian Indians.

So far as our historical evidence goes, there is no reason to believe that the number of distinct languages has at any time been less than it is now. On the contrary, all our evidence goes to show that the number of apparently unrelated languages has been much greater in earlier times than at present. On the other hand, the number of types that have presumably become extinct seems to be rather small, so that there is no reason to suppose that at an early period there should have been a nearer correspondence between the number of distinct linguistic and anatomical types; and we are thus led to the conclusion that

presumably, at an early time, each human type may have existed in a number of small isolated groups, each of which may have possessed a language and culture of its own.

However this may be, the probabilities are decidedly in favor of the assumption that there is no necessity to assume that originally each language and culture were confined to a single type, or that each type and culture were confined to one language: in short, that there has been at any time a close correlation between these three phenomena.

The assumption that type, language, and culture were originally closely correlated would entail the further assumption that these three traits developed approximately at the same period, and that they developed conjointly for a considerable length of time. This assumption does not seem by any means plausible. The fundamental types of man which are represented in the negroid race and in the mongoloid race must have been differentiated long before the formation of those forms of speech that are now recognized in the linguistic families of the world. I think that even the differentiation of the more important subdivisions of the great races antedates the formation of the existing linguistic families. At any rate, the biological differentiation and the formation of speech were, at this early period, subject to the same causes that are acting upon them now, and our whole experience shows that these causes not much more rapidly on language than on the human body. In this consideration lies the principal reason for the theory of lack of correlation of type and language, even during the period of formation of types and of linguistic families.

What is true of language is obviously even more true of culture. In other words, if a certain type of man migrated over a considerable area before its language assumed the form which can now be traced in related linguistic groups, and before its culture assumed the definite type the further development of which can now be recognized, there would be no possibility of ever discovering a correlation of type, language, and culture, even if it had over existed; but it is quite possible that such correlation has really never occurred.

It is quite conceivable that a certain racial type may have scattered over a considerable area during a formative period of speech, and that the languages which developed among the various groups of this racial type came to be so different that it is now impossible to prove them to be genetically related. In the same way, new developments of culture may have taken place which are so entirely disconnected with older types that the older genetic relationships, even if they existed, can no longer be discovered.

If we adopt this point of view, and thus eliminate the hypothetical assumption of correlation between primitive type, primitive language, and primitive culture, we recognize that any attempt at classification which includes more than one of these traits can not be consistent.

It may be added that the general term "culture" which has been used here may be subdivided from a considerable number of points of view, and different results again might be expected when we consider the inventions, the types of social organization, or beliefs, as leading points of view in our classification.

Artificial character of all classifications of mankind

We recognize thus that every classification of mankind must be more or loss arti-
ficial, according to the point of view selected, and here, even more than in the
domain of biology, we find that classification can only be a substitute for the gen-
esis and history of the now existing types.

Thus we recognize that the essential object in comparing different types of
man must be the reconstruction of the history of the development of their types,
their languages, and their cultures. The history of each of these various traits is
subject to a distinct set of modifying causes, and the investigation of each may
be expected to contribute data toward the solution of our problem. The biolog-
ical investigation may reveal the blood-relationships of types and their modifica-
tions under social and geographical environment. The linguistic investigation may
disclose the history of languages, the contact of the people speaking them with
other people, and the causes that led to linguistic differentiation and integration;
while the history of civilization deals with the contact of a people with neigh-
boring peoples, as well as with the history of its own achievements.

Bronislaw Malinowski

THE PROBLEM OF MEANING IN PRIMITIVE LANGUAGES (1923)

Imagine yourself suddenly transported on to a coral atoll in the Pacific, sitting in a circle of natives and listening to their conversation. Let us assume further that there is an ideal interpreter at hand, who, as far as possible, can convey the meaning of each utterance, word for word, so that the listener is in possession of all the linguistic data available. Would that make you understand the conversation or even a single utterance? Certainly not.

Let us have a look at such a text, an actual utterance taken down from a conversation of natives in the Trobriand Islands, N.E. New Guinea. In analysing it, we shall see quite plainly how helpless one is in attempting to open up the meaning of a statement by mere linguistic means; and we shall also be able to realize what sort of additional knowledge, besides verbal equivalence, is necessary in order to make the utterance significant.

I adduce a statement in native, giving under each word its nearest English equivalent:

Tasakaulo	*kaymatana*	*yakida*	
We run	front-wood	ourselves	
tawoulo	*ovanu*	*tasivila*	*tagine*
we paddle	in place	we turn	we see
soda	*isakaulo*	*ka'u'uya*	
companion ours	he runs	rear-wood	
oluvieki	*similaveta*	*Pilolu*	
behind	their sea-arm	Pilolu	

The verbatim English translation of this utterance sounds at first like a riddle or a meaningless jumble of words; certainly not like a significant, unambigu-

ous statement. Now if the listener, whom we suppose acquainted with the language, but unacquainted with the culture of the natives, were to understand even the general trend of this statement, he would have first to be informed about the situation in which these words were spoken. He would need to have them placed in their proper setting of native culture. In this case, the utterance refers to an episode in an overseas trading expedition of these natives, in which several canoes take part in a competitive spirit. This last-mentioned feature explains also the emotional nature of the utterance: it is not a mere statement of fact, but a boast, a piece of self-glorification, extremely characteristic of the Trobrianders' culture in general and of their ceremonial barter in particular.

Only after a preliminary instruction is it possible to gain some idea of such *technical terms of boasting and emulation* as *kaymatana* (front-wood) and *ka'u'uya* (rear-wood). The metaphorical use of *wood* for *canoe* would lead us into another field of language psychology, but for the present it is enough to emphasize that 'front' or 'leading canoe' and 'rear canoe' are important terms for a people whose attention is so highly occupied with competitive activities for their own sake. To the meaning of such words is added a specific emotional tinge, comprehensible only against the background of their tribal psychology in ceremonial life, commerce and enterprise.

Again, the sentence where the leading sailors are described as looking back and perceiving their companions lagging behind on the sea-arm of Pilolu, would require a special discussion of the geographical feeling of the natives, of their use of imagery as a linguistic instrument and of a special use of the possessive pronoun (*their* sea-arm Pilolu).

All this shows the wide and complex considerations into which we are led by an attempt to give an adequate analysis of meaning. Instead of translating, of inserting simply an English word for a native one, we are faced by a long and not altogether simple process of describing wide fields of custom, of social psychology and of tribal organization which correspond to one term or another. We see that linguistic analysis inevitably leads us into the study of all the subjects covered by Ethnographic field-work.

[. . .]

Besides the difficulties encountered in the translation of single words, difficulties which lead directly into descriptive ethnography, there are others, associated with more exclusively linguistic problems, which however can be solved only on the basis of psychological analysis. Thus it has been suggested that the characteristically Oceanic distinction of inclusive and exclusive pronouns requires a deeper explanation than any which would confine itself to merely grammatical relations.[1] Again, the puzzling manner in which some of the obviously correlated sentences are joined in our text by mere juxtaposition would require much more than a simple reference, if all its importance and significance had to be brought out. Those two features are well known and have been often discussed, though according to my ideas not quite exhaustively.

There are, however, certain peculiarities of primitive languages, almost entirely neglected by grammarians, yet opening up very interesting questions of savage psychology. I shall illustrate this by a point, lying on the borderland

between grammar and lexicography and well exemplified in the utterance quoted.

In the highly developed Indo-European languages, a sharp distinction can be drawn between the grammatical and lexical function of words. The meaning of a root of a word can be isolated from the modification of meaning due to accidence or some other grammatical means of determination. Thus in the word *run* we distinguish between the meaning of the root – rapid personal displacement – and the modification as to time, tense, definiteness, etc., expressed by the grammatical form, in which the word is found in the given context. But in native languages the distinction is by no means so clear and the functions of grammar and radical meaning respectively are often confused in a remarkable manner.

In the Melanesian languages there exist certain grammatical instruments, used in the flection of verbs, which express somewhat vaguely relations of time, definiteness and sequence. The most obvious and easy thing to do for a European who wishes to use roughly such a language for practical purposes, is to find out what is the nearest approach to those Melanesian forms in our languages and then to use the savage form in the European manner. In the Trobriand language, for instance, from which we have taken our above example, there is an adverbial particle *boge*, which, put before a modified verb, gives it, in a somewhat vague, manner, the meaning either of a past or of a definite happening. The verb is moreover modified by a change in the prefixed personal pronoun. Thus the root *ma* (come, move hither) if used with the prefixed pronoun of the third singular *i* – has the form *ima* and means (roughly), *he comes*. With the modified pronoun *ay* – or, more emphatical, *lay* – it means (roughly) *he came* or *he has come*. The expression *boge ayna* or *boge layma* can be approximately translated by *he has already come*, the participle *boge* making it more definite.

But this equivalence is only approximate, suitable for some practical purposes, such as trading with the natives, missionary preaching and translation of Christian literature into native languages. This last cannot, in my opinion, be carried out with any degree of accuracy. In the grammars and interpretations of Melanesian languages, almost all of which have been written by missionaries for practical purposes, the grammatical modifications of verbs have been simply set down as equivalent to Indo-European tenses. When I first began to use the Trobriand language in my field-work, I was quite unaware that there might be some snares in taking savage grammar at its face value and followed the missionary way of using native inflection.

I had soon to learn, however, that this was not correct and I learnt it by means of a practical mistake, which interfered slightly with my field-work and forced me to grasp native flection at the cost of my personal comfort. At one time I was engaged in making observations on a very interesting transaction which took place in a lagoon village of the Trobriands between the coastal fishermen and the inland gardeners.[2] I had to follow some important preparations in the village and yet I did not want to miss the arrival of the canoes on the beach. I was busy registering and photographing the proceedings among the huts, when word went round, 'they have come already' – *boge laymayse*. I left my work in the village unfinished to rush some quarter of a mile to the shore, in order to find, to my disappointment and mortification, the canoes far away, punting slowly along

towards the beach! Thus I came some ten minutes too soon, just enough to make me lose my opportunities in the village!

It required some time and a much better general grasp of the language before I came to understand the nature of my mistake and the proper use of words and forms to express the subtleties of temporal sequence. Thus the root *ma* which means *come, move hither*, does not contain the meaning, covered by our word *arrive*. Nor does any grammatical determination give it the special and temporal definition, which we express by, 'they have come, they have arrived.' The form *boge laymayse*, which I heard on that memorable morning in the lagoon village, means to a native 'they have already been moving hither' and not 'they have already come here.'

In order to achieve the spatial and temporal definition which we obtain by using the past definite tense, the natives have recourse to certain concrete and specific expressions. Thus in the case quoted, the villagers, in order to convey the fact that the canoes had arrived, would have used the word *to anchor, to moor*. 'They have already moored their canoes,' *boge aykotasi*, would have meant, what I assumed they had expressed by *boge laymayse*. That is, in this case the natives use a different root instead of a mere grammatical modification.

Returning to our text, we have another telling example of the characteristic under discussion. The quaint expression 'we paddle in place' can only be properly understood by realizing that the word *paddle* has here the function, not of describing what the crew are doing, but of indicating their immediate proximity to the village of their destination. Exactly as in the previous example the past tense of the word to come ('they have come') which we would have used in our language to convey the fact of arrival, has another meaning in native and has to be replaced by another root which expresses the idea; so here the native root *wa, to move thither*, could not have been used in (approximately) past definite tense to convey the meaning of 'arrive there,' but a special root expressing the concrete act of paddling is used to mark the spatial and temporal relations of the leading canoe to the others. The origin of this imagery is obvious. Whenever the natives arrive near the shore of one of the overseas villages, they have to fold the sail and to use the paddles, since there the water is deep, even quite close to the shore, and punting impossible. So 'to paddle' means 'to arrive at the overseas village.' It may be added that in this expression 'we paddle in place,' the two remaining words *in* and *place* would have to be retranslated in a free English interpretation by *near the village*.

With the help of such an analysis as the one just given, this or any other savage utterance can be made comprehensible. In this case we may sum up our results and embody them in a free commentary or paraphrase of the statement.

A number of natives sit together. One of them, who has just come back from an overseas expedition, gives an account of the sailing and boasts about the superiority of his canoe. He tells his audience how, in crossing the sea-arm of Pilolu (between the Trobriands and the Amphletts), his canoe sailed ahead of all others. When nearing their destination, the leading sailors looked back and saw their comrades far behind, still on the sea-arm of Pilolu.

Put in these terms, the utterance can at least be understood broadly, though for an exact appreciation of the shades and details of meaning a full knowledge

of the native customs and psychology, as well as of the general structure of their language, is indispensable.

[. . .]

Returning once more to our native utterance, it needs no special stressing that in a primitive language the meaning of any single word is to a very high degree dependent on its context. The words 'wood', 'paddle', 'place' had to be retranslated in the free interpretation in order to show what is their real meaning, conveyed to a native by the context in which they appear. Again, it is equally clear that the meaning of the expression 'we arrive near the village (of our destination)' literally: 'we paddle in place', is determined only by taking it in the context of the whole utterance. This latter again, becomes only intelligible when it is placed within its *context of situation*, if I may be allowed to coin an expression which indicates on the one hand that the conception of *context* has to be broadened and on the other that the *situation* in which words are uttered can never be passed over as irrelevant to the linguistic expression. We see how the conception of context must be substantially widened, if it is to furnish us with its full utility. In fact it must burst the bonds of mere linguistics and be carried over into the analysis of the general conditions under which a language is spoken. Thus, starting from the wider idea of context, we arrive once more at the results of the foregoing section, namely that the study of any language, spoken by a people who live under conditions different from our own and possess a different culture, must be carried out in conjunction with the study of their culture and of their environment.

But the widened conception of *context of situation* yields more than that. It makes clear the difference in scope and method between the linguistics of dead and of living languages. The material on which almost all our linguistic study has been done so far belongs to dead languages. It is present in the form of written documents, naturally isolated, torn out of any *context of situation*. In fact, written statements are set down with the purpose of being self-contained and self-explanatory. A mortuary inscription, a fragment of primeval laws or precepts, a chapter or statement in a sacred book, or to take a more modern example a passage from a Greek or Latin philosopher, historian or poet – one and all of these were composed with the purpose of bringing their message to posterity unaided, and they had to contain this message within their own bounds.

To take the clearest case, that of a modern scientific book, the writer of it sets out to address every individual reader who will peruse the book and has the necessary scientific training. He tries to influence his reader's mind in certain directions. With the printed text of the book before him, the reader, at the writer's bidding, undergoes a series of processes – he reasons, reflects, remembers, imagines. The book by itself is sufficient to direct the reader's mind to its meaning; and we might be tempted to say metaphorically that the meaning is wholly contained in or carried by the book.

But when we pass from a modern civilized language, of which we think mostly in terms of written records, or from a dead one which survives only in inscription, to a primitive tongue, never used in writing, where all the material lives only in winged words, passing from man to man – there it should be clear

at once that the conception of meaning as *contained* in an utterance is false and futile. A statement, spoken in real life, is never detached from the situation in which it has been uttered. For each verbal statement by a human being has the aim and function of expressing some thought or feeling actual at that moment and in that situation, and necessary for some reason or other to be made known to another person or persons – in order either to serve purposes of common action, or to establish ties of purely social communion, or else to deliver the speaker of violent feelings or passions. Without some imperative stimulus of the moment, there can be no spoken statement. In each case, therefore, utterance and situation are bound up inextricably with each other and the context of situation is indispensable for the understanding of the words. Exactly as in the reality of spoken or written languages, a word without *linguistic context* is a mere figment and stands for nothing by itself, so in the reality of a spoken living tongue, the utterance has no meaning except in the *context of situation*.

It will be quite clear now that the point of view of the Philologist, who deals only with remnants of dead languages, must differ from that of the Ethnographer, who, deprived of the ossified, fixed data of inscriptions, has to rely on the living reality of spoken language *in fluxu*. The former has to reconstruct the general situation – *i.e.*, the culture of a past people – from the extant statements, the latter can study directly the conditions and situations characteristic of a culture and interpret the statements through them. Now I claim that the Ethnographer's perspective is the one relevant and real for the formation of fundamental linguistic conceptions and for the study of the life of languages, whereas the Philologist's point of view is fictitious and irrelevant. For language in its origins has been merely the free, spoken *sum total* of utterances such as we find now in a savage tongue. All the foundations and fundamental characteristics of human speech have received their shape and character in the stage of development proper to Ethnographic study and not in the Philologist's domain. To define Meaning, to explain the essential grammatical and lexical characters of language on the material furnished by the study of dead languages, is nothing short of preposterous in the light of our argument. Yet it would be hardly an exaggeration to say that 99 per cent of all linguistic work has been inspired by the study of dead languages or at best of written records torn completely out of any context of situation. That the Ethnographer's perspective can yield not only generalities but positive, concrete conclusions I shall indicate at least in the following sections.

[. . .]

So far, I have dealt mainly with the simplest problems of meaning, those associated with the definition of single words and with the lexicographical task of bringing home to a European reader the vocabulary of a strange tongue. And the main result of our analysis was that it is impossible to translate words of a primitive language or of one widely different from our own, without giving a detailed account of the culture of its users and thus providing the common measure necessary for a translation. But though an Ethnographic background is indispensable for a scientific treatment of a language, it is by no means sufficient, and the problem of Meaning needs a special theory of its own. I shall try to show that,

looking at language from the Ethnographic perspective and using our conception of *context of situation*, we shall be able to give an outline of a Semantic theory, useful in the work on Primitive Linguistics, and throwing some light on human language in general.

First of all, let us try, from our standpoint, to form a view of the Nature of language. The lack of a clear and precise view of Linguistic function and of the nature of Meaning, has been, I believe, the cause of the relative sterility of much otherwise excellent linguistic theorizing. [...]

The study of the above-quoted native text has demonstrated that an utterance becomes comprehensive only when we interpret it by its context of situation. The analysis of this context should give us a glimpse of a group of savages bound by reciprocal ties of interests and ambitions, of emotional appeal and response. There was boastful reference to competitive trading activities, to ceremonial overseas expeditions, to a complex of sentiments, ambitions and ideas known to the group of speakers and hearers through their being steeped in tribal tradition and having been themselves actors in such events as those described in the narrative. Instead of giving a narrative I could have adduced linguistic samples still more deeply and directly embedded in the context of situation.

Take for instance language spoken by a group of natives engaged in one of their fundamental pursuits in search of subsistence – hunting, fishing, tilling the soil; or else in one of those activities, in which a savage tribe express some essentially human forms of energy – war, play or sport, ceremonial performance or artistic display such as dancing or singing. The actors in any such scene are all following a purposeful activity, are all set on a definite aim; they all have to act in a concerted manner according to certain rules established by custom and tradition. In this, Speech is the necessary means of communion; it is the one indispensable instrument for creating the ties of the moment without which unified social action is impossible.

Let us now consider what would be the type of talk passing between people thus acting, what would be the manner of its use. To make it quite concrete at first, let us follow up a party of fishermen on a coral lagoon, spying for a shoal of fish, trying to imprison them in an enclosure of large nets, and to drive them into small net-bags – an example which I am choosing also because of my personal familiarity with the procedure.[3]

The canoes glide slowly and noiselessly, punted by men especially good at this task and always used for it. Other experts who know the bottom of the lagoon, with its plant and animal life, are on the look-out for fish. One of them sights the quarry. Customary signs, or sounds or words are uttered. Sometimes a sentence full of technical references to the channels or patches on the lagoon has to be spoken; sometimes when the shoal is near and the task of trapping is simple, a conventional cry is uttered not too loudly. Then, the whole fleet stops and ranges itself – every canoe and every man in it performing his appointed task – according to a customary routine. But, of course, the men, as they act, utter now and then a sound expressing keenness in the pursuit or impatience at some technical difficulty, joy of achievement or disappointment at failure. Again, a word of command is passed here and there, a technical expression or explanation which serves to harmonize their behaviour towards other men. The whole

group act in a concerted manner, determined by old tribal tradition and perfectly familiar to the actors through life-long experience. Some men in the canoes cast the wide encircling nets into the water, others plunge, and wading through the shallow lagoon, drive the fish into the nets. Others again stand by with the small nets, ready to catch the fish. An animated scene, full of movement follows, and now that the fish are in their power the fishermen speak loudly, and give vent to their feelings. Short, telling exclamations fly about, which might be rendered by such words as: 'Pull in', 'Let go', 'Shift further', 'Lift the net'; or again technical expressions completely untranslatable except by minute description of the instruments used, and of the mode of action.

All the language used during such a pursuit is full of technical terms, short references to surroundings, rapid indications of change – all based on customary types of behaviour, well-known to the participants from personal experience. Each utterance is essentially bound up with the context of situation and with the aim of the pursuit, whether it be the short indications about the movements of the quarry, or references to statements about the surroundings, or the expression of feeling and passion inexorably bound up with behaviour, or words of command, or correlation of action. The structure of all this linguistic material is inextricably mixed up with, and dependent upon, the course of the activity in which the utterances are embedded. The vocabulary, the meaning of the particular words used in their characteristic technicality is not less subordinate to action. For technical language, in matters of practical pursuit, acquires its meaning only through personal participation in this type of pursuit. It has to be learned, not through reflection but through action.

Had we taken any other example than fishing, we would have reached similar results. The study of any form of speech used in connection with vital work would reveal the same grammatical and lexical peculiarities: the dependence of the meaning of each word upon practical experience, and of the structure of each utterance upon the momentary situation in which it is spoken. Thus the consideration of linguistic uses associated with any practical pursuit, leads us to the conclusion that language in its primitive forms ought to be regarded and studied against the background of human activities and as a mode of human behaviour in practical matters. We have to realize that language originally, among primitive, non-civilized peoples was never used as a mere mirror of reflected thought. The manner in which I am using it now, in writing these words, the manner in which the author of a book, or a papyrus or a hewn inscription has to use it, is a very far-fetched and derivative function of language. In this, language becomes a condensed piece of reflection, a record of fact or thought. In its primitive uses, language functions as a link in concerted human activity, as a piece of human behaviour. It is a mode of action and not an instrument of reflection.

[. . .]

Notes

1 See the important Presidential Address by the late Dr W. H. R. Rivers in the *Journal of the Royal Anthropological Institute*, Vol. LII, January–June, 1922, p. 21, and his *History of Melanesian Society*, Vol. II, p. 486.

2 It was a ceremony of the *Wasi*, a form of exchange of vegetable food for fish. See *Argonauts of the Western Pacific, – An account of native enterprise and adventure in the archipelagoes of Melanesian New Guinea*, 1922, pp. 187–189 and plate xxxvi.

3 Cf. the author's article on 'Fishing and Fishing Magic in the Trobriand Islands'. *Man*, 1918.

Edward Sapir

THE STATUS OF LINGUISTICS AS A SCIENCE (1929)

Linguistics may be said to have begun its scientific career with the comparative study and reconstruction of the Indo-European languages. In the course of their detailed researches Indo-European linguists have gradually developed a technique which is probably more nearly perfect than that of any other science dealing with man's institutions. Many of the formulations of comparative Indo-European linguistics have a neatness and a regularity which recall the formulae, or the so-called laws, of natural science. Historical and comparative linguistics has been built up chiefly on the basis of the hypothesis that sound changes are regular and that most morphological readjustments in language follow as by-products in the wake of these regular phonetic developments. There are many who would be disposed to deny the psychological necessity of the regularity of sound change, but it remains true, as a matter of actual linguistic experience, that faith in such regularity has been the most successful approach to the historic problems of language. Why such regularities should be found and why it is necessary to assume regularity of sound change are questions that the average linguist is perhaps unable to answer satisfactorily. But it does not follow that he can expect to improve his methods by discarding well tested hypotheses and throwing the field open to all manner of psychological and sociological explanations that do not immediately tie up with what we actually know about the historical behavior of language. A psychological and a sociological interpretation of the kind of regularity in linguistic change with which students of language have long been familiar are indeed desirable and even necessary. But neither psychology nor sociology is in a position to tell linguistics what kinds of historical formulations the linguist is to make. At best these disciplines can but urge the linguist to concern himself in a more vital manner than heretofore with the problem of seeing linguistic history in the larger frame work of human behavior in the individual and in society.

The methods developed by the Indo-Europeanists have been applied with marked success to other groups of languages. It is abundantly clear that they apply just as rigorously to the unwritten primitive languages of Africa and America as to the better known forms of speech of the more sophisticated peoples. It is probably in the languages of these more cultured peoples that the fundamental regularity of linguistic processes has been most often crossed by the operation of such conflicting tendencies as borrowing from other languages, dialectic blending, and social differentiations of speech. The more we devote ourselves to the comparative study of the languages of a primitive linguistic stock, the more clearly we realize that phonetic law and analogical leveling are the only satisfactory key to the unravelling of the development of dialects and languages from a common base. Professor Leonard Bloomfield's experiences with Central Algonkian and my own with Athabaskan leave nothing to be desired in this respect and are a complete answer to those who find it difficult to accept the large-scale regularity of the operation of all those unconscious linguistic forces which in their totality give us regular phonetic change and morphological readjustment on the basis of such change. It is not merely theoretically possible to predict the correctness of specific forms among unlettered peoples on the basis of such phonetic laws as have been worked out for them – such predictions are already on record in considerable number. There can be no doubt that the methods first developed in the field of Indo-European linguistics are destined to play a consistently important role in the study of all other groups of languages, and that it is through them and through their gradual extension that we can hope to arrive at significant historical inferences as to the remoter relations between groups of languages that show few superficial signs of a common origin.

It is the main purpose of this paper, however, not to insist on what linguistics has already accomplished, but rather to point out some of the connections between linguistics and other scientific disciplines, and above all to raise the question in what sense linguistics can be called a "science."

The value of linguistics for anthropology and culture history has long been recognized. As linguistic research has proceeded, language has proved useful as a tool in the sciences of man and has itself required and obtained a great deal of light from the rest of these sciences. It is difficult for a modern linguist to confine himself to his traditional subject matter. Unless he is somewhat unimaginative, he cannot but share in some or all of the mutual interests which tie up linguistics with anthropology and culture history, with sociology, with psychology, with philosophy, and, more remotely, with physics and physiology.

Language is becoming increasingly valuable as a guide to the scientific study of a given culture. In a sense, the network of cultural patterns of a civilization is indexed in the language which expresses that civilization. It is an illusion to think that we can understand the significant outlines of a culture through sheer observation and without the guide of the linguistic symbolism which makes these outlines significant and intelligible to society. Some day the attempt to master a primitive culture without the help of the language of its society will seem as amateurish as the labors of a historian who cannot handle the original documents of the civilization which he is describing.

Language is a guide to "social reality." Though language is not ordinarily

thought of as of essential interest to the students of social science, it powerfully conditions all our thinking about social problems and processes. Human beings do not live in the objective world alone, nor alone in the world of social activity as ordinarily understood, but are very much at the mercy of the particular language which has become the medium of expression for their society. It is quite an illusion to imagine that one adjusts to reality essentially without the use of language and that language is merely an incidental means of solving specific problems of communication or reflection. The fact of the matter is that the "real world" is to a large extent unconsciously built up on the language habits of the group. No two languages are ever sufficiently similar to be considered as representing the same social reality. The worlds in which different societies live are distinct worlds, not merely the same world with different labels attached.

The understanding of a simple poem, for instance, involves not merely an understanding of the single words in their average significance, but a full comprehension of the whole life of the community as it is mirrored in the words, or as it is suggested by their overtones. Even comparatively simple acts of perception are very much more at the mercy of the social patterns called words than we might suppose. If one draws some dozen lines, for instance, of different shapes, one perceives them as divisible into such categories as "straight," "crooked," "curved," "zigzag" because of the classificatory suggestiveness of the linguistic terms themselves. We see and hear and otherwise experience very largely as we do because the language habits of our community predispose certain choices of interpretation.

For the more fundamental problems of the student of human culture, therefore, a knowledge of linguistic mechanisms and historical developments is certain to become more and more important as our analysis of social behavior becomes more refined. From this standpoint we may think of language as the *symbolic guide to culture*. In another sense too linguistics is of great assistance in the study of cultural phenomena. Many cultural objects and ideas have been diffused in connection with their terminology, so that a study of the distribution of culturally significant terms often throws unexpected light on the history of inventions and ideas. This type of research, already fruitful in European and Asiatic culture history, is destined to be of great assistance in the reconstruction of primitive cultures.

The value of linguistics for sociology in the narrower sense of the word is just as real as for the anthropological theorist. Sociologists are necessarily interested in the technique of communication between human beings. From this standpoint, language facilitation and language barriers are of the utmost importance and must be studied in their interplay with a host of other factors that make for ease or difficulty of transmission of ideas and patterns of behavior. Furthermore, the sociologist is necessarily interested in the symbolic significance, in a social sense, of the linguistic differences which appear in any large community. Correctness of speech or what might be called "social style" in speech is of far more than aesthetic or grammatical interest. Peculiar modes of pronunciation, characteristic turns of phrase, slangy forms of speech, occupational terminologies of all sorts – these are so many symbols of the manifold ways in which society arranges itself and are of crucial importance for the understanding of the development of

individual and social attitudes. Yet it will not be possible for a social student to evaluate such phenomena unless he has very clear notions of the linguistic background against which social symbolisms of a linguistic sort are to be estimated.

It is very encouraging that the psychologist has been concerning himself more and more with linguistic data. So far it is doubtful if he has been able to contribute very much to the understanding of language behavior beyond what the linguist has himself been able to formulate on the basis of his data. But the feeling is growing rapidly, and justly, that the psychological explanations of the linguists themselves need to be restated in more general terms, so that purely linguistic facts may be seen as specialized forms of symbolic behavior. The psychologists have perhaps too narrowly concerned themselves with the simple psycho-physical bases of speech and have not penetrated very deeply into the study of its symbolic nature. This is probably due to the fact that psychologists in general are as yet too little aware of the fundamental importance of symbolism in behavior. It is not unlikely that it is precisely in the field of symbolism that linguistic forms and processes will contribute most to the enrichment of psychology.

All activities may be thought of as either definitely functional in the immediate sense, or as symbolic, or as a blend of the two. Thus, if I shove open a door in order to enter a house, the significance of the act lies precisely in its allowing me to make an easy entry. But if I "knock at the door," a little reflection shows that the knock in itself does not open the door for me. It serves merely as a sign that somebody is to come to open it for me. To knock on the door is a substitute for the more primitive act of shoving it open of one's own accord. We have here the rudiments of what might be called language. A vast number of acts are language acts in this crude sense. That is, they are not of importance to us because of the work they immediately do, but because they serve as mediating signs of other more important acts. A primitive sign has some objective resemblance to what it takes the place of or points to. Thus, knocking at the door has a definite relation to intended activity upon the door itself. Some signs become abbreviated forms of functional activities which can be used for reference. Thus, shaking one's fist at a person is an abbreviated and relatively harmless way of actually punching him. If such a gesture becomes sufficiently expressive to society to constitute in some sort the equivalent of an abuse or a threat, it may be looked on as a symbol in the proper sense of the word.

Symbols of this sort are primary in that the resemblance of the symbol to what it stands for is still fairly evident. As time goes on, symbols become so completely changed in form as to lose all outward connection with what they stand for. Thus, there is no resemblance between a piece of bunting colored red, white, and blue, and the United States of America – itself a complex and not easily definable notion. The flag may therefore be looked upon as a secondary or referential symbol. The way to understand language psychologically, it seems, is to see it as the most complicated example of such a secondary or referential set of symbols that society has evolved. It may be that originally the primal cries or other types of symbols developed by man had some connection with certain emotions or attitudes or notions. But a connection is no longer directly traceable between words, or combinations of words, and what they refer to.

Linguistics is at once one of the most difficult and one of the most funda-
mental fields of inquiry. It is probable that a really fruitful integration of linguistic
and psychological studies lies still in the future. We may suspect that linguistics
is destined to have a very special value for configurative psychology ("*Gestalt* psy-
chology"), for, of all forms of culture, it seems that language is that one which
develops its fundamental patterns with relatively the most complete detachment
from other types of cultural patterning. Linguistics may thus hope to become
something of a guide to the understanding of the "psychological geography" of
culture in the large. In ordinary life the basic symbolisms of behavior are densely
overlaid by cross-functional patterns of a bewildering variety. It is because every
isolated act in human behavior is the meeting point of many distinct configura-
tions that it is so difficult for most of us to arrive at the notion of contextual
and non-contextual form in behavior. Linguistics would seem to have a very
peculiar value for configurative studies because the patterning of language is to a
very appreciable extent self-contained and not significantly at the mercy of inter-
crossing patterns of a non-linguistic type.

It is very notable that philosophy in recent years has concerned itself with
problems of language as never before. The time is long past when grammatical
forms and processes can be naïvely translated by philosophers into metaphysical
entities. The philosopher needs to understand language if only to protect himself
against his own language habits, and so it is not surprising that philosophy, in
attempting to free logic from the trammels of grammar and to understand knowl-
edge and the meaning of symbolism, is compelled to make a preliminary critique
of the linguistic process itself. Linguists should be in an excellent position to assist
in the process of making clear to ourselves the implications of our terms and lin-
guistic procedures. Of all students of human behavior, the linguist should by the
very nature of his subject matter be the most relativist in feeling, the least taken
in by the forms of his own speech.

A word as to the relation between linguistics and the natural sciences. Stu-
dents of linguistics have been greatly indebted for their technical equipment to
the natural sciences, particularly physics and physiology. Phonetics, a necessary
prerequisite for all exact work in linguistics, is impossible without some ground-
ing in acoustics and the physiology of the speech organs. It is particularly those
students of language who are more interested in the realistic details of actual
speech behavior in the individual than in the socialized patterns of language who
must have constant recourse to the natural sciences. But it is far from unlikely
that the accumulated experience of linguistic research may provide more than one
valuable hint for the setting up of problems of research to acoustics and physiol-
ogy themselves.

All in all, it is clear that the interest in language has in recent years been
transcending the strictly linguistic circles. This is inevitable, for an understanding
of language mechanisms is necessary for the study of both historical problems and
problems of human behavior. One can only hope that linguists will become
increasingly aware of the significance of their subject in the general field of sci-
ence and will not stand aloof behind a tradition that threatens to become scholas-
tic when not vitalized by interests which lie beyond the formal interest in
language itself.

Where, finally, does linguistics stand as a science? Does it belong to the natural sciences, with biology, or to the social sciences? There seem to be two facts which are responsible for the persistent tendency to view linguistic data from a biological point of view. In the first place, there is the obvious fact that the actual technique of language behavior involves very specific adjustments of a physiological sort. In the second place, the regularity and typicality of linguistic processes leads to a quasi-romantic feeling of contrast with the apparently free and undetermined behavior of human beings studied from the standpoint of culture. But the regularity of sound change is only superficially analogous to a biological automatism. It is precisely because language is as strictly socialized a type of human behavior as anything else in culture and yet betrays in its outlines and tendencies such regularities as only the natural scientist is in the habit of formulating, that linguistics is of strategic importance for the methodology of social science. Behind the apparent lawlessness of social phenomena there is a regularity of configuration and tendency which is just as real as the regularity of physical processes in a mechanical world, though it is a regularity of infinitely less apparent rigidity and of another mode of apprehension on our part. Language is primarily a cultural or social product and must be understood as such. Its regularity and formal development rest on considerations of a biological and psychological nature, to be sure. But this regularity and our underlying unconsciousness of its typical forms do not make of linguistics a mere adjunct to either biology or psychology. Better than any other social science, linguistics shows by its data and methods, necessarily more easily defined than the data and methods of any other type of discipline dealing with socialized behavior, the possibility of a truly scientific study of society which does not ape the methods nor attempt to adopt unrevised the concepts of the natural sciences. It is peculiarly important that linguists, who are often accused, and accused justly, of failure to look beyond the pretty patterns of their subject matter, should become aware of what their science may mean for the interpretation of human conduct in general. Whether they like it or not, they must become increasingly concerned with the many anthropological, sociological, and psychological problems which invade the field of language.

Claude Lévi-Strauss

LINGUISTICS AND ANTHROPOLOGY (1958)

Probably for the first time, anthropologists and linguists have come together on a formal basis and for the specific purpose of confronting their respective disciplines. However, the problem was not a simple one, and it seems to me that some of the many difficulties which we have met with can be referred to the fact we were not only trying to make a confrontation of the theme of linguistics and of anthropology, but that this confrontation itself could be and had to be undertaken on several different levels, and it was extremely difficult to avoid, in the midst of the same discussion, shifting from one level to another. I shall try first of all to outline what these different levels are.

In the first place, we have spoken about the relation between *a* language and *a* culture. That is, how far is it necessary, when we try to study a culture, to know the language, or how far is it necessary to understand what is meant by the population, to have some knowledge of the culture besides the language.

There is a second level, which is not the relationship between *a* language and *a* culture, but the relationship between *language* and *culture*. And though there are also many important problems on this level, it seems to me that our discussions have not so often been placed on the second level as on the first one. For instance, I am rather struck by the fact that at no moment during our discussions has any reference been made to the behavior of culture as a whole toward language as a whole. Among us, language is used in a rather reckless way – we talk all the time, we ask questions about many things. This is not at all a universal situation. There are cultures – and I am inclined to say most of the cultures of the world – which are rather thrifty in relation to language. They don't believe that language should be used indiscriminately, but only in certain specific frames of reference and somewhat sparingly. Problems of this kind have, to be sure, been mentioned in our discussions, but certainly they have not been given the same importance as the problems of the first type.

And there is a third level, which has received still less attention. It is the relation, not between *a* language or *language* and *a* culture or *culture*, but the

relation between linguistics as a scientific discipline and anthropology. And this, which to my mind would be probably the most important level, has remained somewhat in the background during our discussions.

Now how can this be explained? The relationship between language and culture is an exceedingly complicated one. In the first place, language can be said to be a result of culture: The language which is spoken by one population is a reflection of the total culture of the population. But one can also say that language is a *part* of culture. It is one of those many things which make up a culture – and if you remember Tylor's famous definition of culture, culture includes a great many things, such as tools, institutions, customs, beliefs, and also, of course, language. And from this point of view the problems are not at all the same as from the first one. In the third place, language can be said to be a *condition* of culture, and this in two different ways: First, it is a condition of culture in a diachronic way, because it is mostly through the language that we learn about our own culture – we are taught by our parents, we are scolded, we are congratulated, with language. But also, from a much more theoretical point of view, language can be said to be a condition of culture because the material out of which language is built is of the same type as the material out of which the whole culture is built: logical relations, oppositions, correlations, and the like. Language, from this point of view, may appear as laying a kind of foundation for the more complex structures which correspond to the different aspects of culture.

This is how I see our problem from an objective point of view. But there is also a subjective point of view, which is no less important. During the discussion it appeared to me that the reasons for anthropologists' and linguists' being so eager to get together are of an entirely different nature, and that their motivations are practically contradictory. Linguists have told us over and over again during these sessions that they are somewhat afraid of the trend which is becoming predominant in their discipline – that they have felt more and more unrelated; that they have been dealing more and more with abstract notions, which many times have been very difficult to follow for the others; and that what they have been mainly concerned with, especially in structural linguistics, has no relation whatsoever to the whole culture, to the social life, to the history, of the people who speak the language; and so on. And the reason, it seems to me, for the linguists' being so eager to get closer to the anthropologists is precisely that they expect the anthropologists to be able to give back to them some of this concreteness which seems to have disappeared from their own methodological approach. And now, what about the anthropologists? The anthropologists are in a very peculiar situation in relation to linguistics. For many years they have been working very closely with the linguists, and all of a sudden it seems to them that the linguists are vanishing, that they are going on the other side of the borderline which divides the exact and natural sciences on the one hand from the human and social sciences on the other. All of a sudden the linguists are playing their former companions this very nasty trick of doing things as well and with the same sort of rigorous approach that was long believed to be the privilege of the exact and natural sciences. Then, on the side of the anthropologist there is some, let us say, melancholy, and a great deal of envy. We should like to learn from the

linguists how they succeeded in doing it how we may ourselves in our own field, which is a complex one – in the field of kinship, in the field of social organization, in the field of religion, folklore, art, and the like – use the same kind of rigorous approach which has proved to be so successful for linguistics.

[...]

If we try to formulate our problem in purely theoretical terms, then it seems to me that we are entitled to affirm that there should be some kind of relationship between language and culture, because language has taken thousands of years to develop, and culture has taken thousands of years to develop, and both processes have been taking place side by side within the same minds. Of course, I am leaving aside for the moment cases where a foreign language has been adopted by a society that previously spoke another language. We can, for the sake of argument, consider only those cases where, in an undisturbed fashion, language and culture have been able to develop together. Is it possible to conceive of the human mind as consisting of compartments separated by rigid bulkheads without anything being able to pass from one bulkhead to the other? Though, when we try to find out what these connections nections or correlations are, we are confronted with a very serious problem, or, rather, with two very serious problems.

The first problem has to do with *the level* at which to seek the correlations between language and culture, and the second one, with *the things* we are trying to correlate. I shall now give some attention to these basic distinctions.

I remember a very striking example which was given to us by F. G. Lounsbury, about the use of two different prefixes for womankind among the Oneida. Lounsbury was telling us he paid great attention to what was going on on the social level, but he could find no correlation whatsoever. Indeed, no correlation can be found on the level of behavior, because behavior, on the one hand, and categories of thought, on the other (such as would be called for to explain the use of these two different prefixes), belong to two entirely different levels. It would not be possible to try to correlate one with the other.

But I can hardly believe it a pure coincidence that this strange dichotomy of womankind should appear precisely in a culture where the maternal principle has been developed in such an extreme way as among the Iroquois. It is as if the culture had to pay a price for giving women an importance elsewhere unknown, the price being an inability to think of women as belonging to only one logical category. To recognize women, unlike most other cultures of the world, as full social beings would thus compel the culture, in exchange, to categorize that part of womankind as yet unable to play the important maternal role – such as young girls – as animals and not as humans. However, when I suggest this interpretation, I am not trying to correlate language and behavior, but two parallel ways of categorizing the same data.

Let me now give you another example. We reduce the kinship structure to the simplest conceivable element, the atom of kinship, if I may say so, when we have a group consisting of a husband, a woman, a representative of the group which has given the woman to the man – since incest prohibitions make it impossible in all societies for the unit of kinship to consist of one family, it must always

link two families, two consanguineous groups – and one offspring. Now it can be shown that, if we divide all the possible behavior between kin according to a very simple dichotomy, positive behavior and negative behavior (I know this is very unsatisfactory, but it will help me to make my point), it can be shown that a great many different combinations can be found and illustrated by specific ethnographical observations. When there is a positive relationship between husband and wife and a negative one between brother and sister, we note the presence of two correlative attitudes: positive between father and son, negative between maternal uncle and nephew. We may also find a symmetrical structure, where all the signs are inverted. It is therefore common to find arrangements of the type $\left(\begin{smallmatrix} + & - \\ + & - \end{smallmatrix}\right)$ or $\left(\begin{smallmatrix} - & + \\ - & + \end{smallmatrix}\right)$, that is, two permutations. On the other hand, arrangements of the type $\left(\begin{smallmatrix} + & - \\ - & + \end{smallmatrix}\right)$, $\left(\begin{smallmatrix} - & + \\ + & - \end{smallmatrix}\right)$ occur frequently but often are poorly developed, while those of the type $\left(\begin{smallmatrix} + & + \\ - & - \end{smallmatrix}\right)$, $\left(\begin{smallmatrix} - & - \\ + & + \end{smallmatrix}\right)$ are rare, or perhaps impossible, because they would lead to the breakdown of the group, diachronically in the first case, synchronically in the second.

Now, what connections are possible with linguistics? I cannot see any whatsoever, except only one, that when the anthropologist is working in this way he is working more or less in a way parallel to that of the linguist. They are both trying to build a structure with constituent units. But, nevertheless, no conclusions can be drawn from the repetition of the signs in the field of behavior and the repetition, let us say, of the phonemes of the language, or the grammatical structure of the language; nothing of the kind – it is perfectly hopeless.

Now let us take a somewhat more elaborate way of approaching a problem of that kind, Whorf's approach, which has been discussed so many times and which certainly must have been at the back of our minds during this discussion.[1] Whorf has tried to establish a correlation between certain linguistic structures and certain cultural structures. Why is it that the approach is unsatisfactory? It is, it seems to me, because the linguistic level as he considers it is the result of a rather sophisticated analysis – he is not at all trying to correlate an empirical impression of the language, but, rather, the result of true linguistic work (I don't know if this linguistic work is satisfactory from the point of view of the linguists, I'm just assuming it for the sake of argument) – what he is trying to correlate with this linguistic structure is a crude, superficial, empirical view of the culture itself. So he is really trying to correlate things, which belong to entirely different levels.

When we now turn to study the communication system, there are two statements that can be made. The first is that in order to build a model of the Hopi kinship system one has to use a block model, tri-dimensional. It is not possible to use a two-dimensional model. And this, incidentally, is characteristic of all the Crow-Omaha systems. Now, why is that so? Because the Hopi system makes use of three different time continuums. We have the first one, which corresponds to the mother's line (female Ego), which is a kind of time dimension that we use ourselves, that is, progressive and continuative: We have the grandmother, mother, Ego, daughter, granddaughter, and so on; it is really genealogical (see figure 1) Now, when we consider other lines, there is a different time dimension: For instance, if we take the father's mother's line, we find that, although people do belong to generations which are consecutive to each other, the same

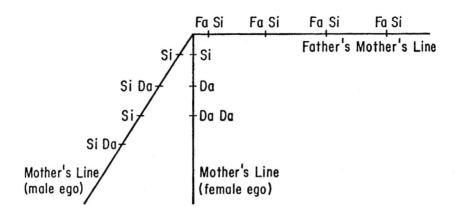

terms are consistently applied to them — that is, a woman is called "father's sister" and her daughter is still "father's sister," and so on indefinitely; this is a kind of empty time, with no change taking place whatsoever. And there is also a third dimension, which is found in the mother's line for male Ego, where individuals are alternately called "sibling" and "nephew."

Now if we consider the Zuni kinship system, these three dimensions still exist, but they are considerably reduced; they have a somewhat abortive form. And what is important is that the "straight" time framework that we have in the mother's line is replaced by a kind of "circular" framework, where we have only three terms, a term which equally means "grandmother" and "granddaughter," and then a term for "mother" and a term for "daughter" — a woman would call by the same term her grandmother and her granddaughter.

If we look now at another Pueblo system, let us say Acoma or Laguna, which are Keresan and belong to a different linguistic stock, then we find a completely new picture: the development of symmetrical terms. Two individuals who occupy symmetrical positions in relation to a third individual will call each other by the same term. This is usually called a "self-reciprocal" terminology.

When we pass from Hopi to Acoma, we have a change from a block model to a flat model, but we have other significant changes. We have a change from a time framework which has a threefold quality, through the Zuni, which is intermediate, to something quite different; it is no longer a time continuum, it is a time-space continuum, since in order to conceive of the system one individual has to think of the other individual through the intermediary of a third one.

This can be very well correlated with the different aspects of the same myths among the Hopi, Zuni, and Acoma. When we consider one myth, let us say the emergence myth, the very striking thing is that among the Hopi the entire structure of the myth is organized in a genealogical way. The different gods are conceived as husband, wife, father, grandfather, daughter, and so on, to one another, more or less as it occurs in the Greek pantheon. Among the Zuni we do not find such a developed genealogical structure. Instead we find a kind of cyclical historical structure. The history is divided into periods, and each period repeats to some extent the preceding period. Now, with the Acoma the striking fact is that most of the characters which among the Hopi or the Zuni are conceived as one person are dichotomized into different persons with antithetic attributes. This is

made clear by the fact that the emergence scene, which is so obvious in the first two cases, is preceded, and to some extent replaced, by a dual operation, in which the power from above and the power from below cooperate to create mankind. It is no longer a progressive linear movement, it is a system of polar oppositions, such as we find in the kinship system. Now if it is true that these features of the kinship system can be correlated with systems belonging to a completely different field, the field of mythology, we are entitled to ask the linguist whether or not something of the same kind does not show up in the field of language. And it would be very surprising if something – I do not know exactly what, because I am not a linguist – could not be found to exist, because if the answer should be in the negative, we should have to assume that, while fields that are so wide apart as kinship and mythology nevertheless succeed in remaining correlated, language and mythology, which are much more closely related, show no connection or no communication whatsoever.

This new formulation of the problem is, it seems to me, on a level with what the linguists are doing. The linguists are dealing in grammar with the time aspect. They discover the different ways of expressing the idea of time in a language. And we might try to compare the way of expressing time on a linguistic level with the way of expressing time on the kinship level. I do not know what the answer will be, but it is possible to discuss the problem, and it is possible in a meaningful way to answer it by "yes" or "no."

Permit me to give you another, and much more elaborate, example of the kind of analysis the anthropologist could perform to try to find common ground with the linguist. I am going to consider two social developments which have taken place in widely different parts of the world, the first in an area extending roughly from India to Ireland, the second in an area extending from Manchuria to Assam. I am certainly not saying that each of these two areas has shown exactly one kind of development, and only one. I am saying only that the developments I am referring to are well illustrated within these very vague boundaries, which, as you are well aware, correspond to some extent to the boundaries of the Indo-European languages on the one hand and the Sino-Tibetan languages on the other.

I propose to consider from three different points of view what has taken place. First, the marriage rules; next, social organization; and third, the kinship system.

Now let us consider first the marriage rules, for the sake of clarity. What we find in the Indo-European area are various systems, which in order to be properly interpreted have to be referred to a very simple type of marriage rule called the generalized form of exchange, or circular system, because any number of groups can be connected by using this rule. This corresponds roughly to what the anthropologists have called marriage with mother's brother's daughter: Group *A* is taking wives from Group *B*, Group *B* from Group *C*, and Group *C* again from Group *A*; so it is a kind of circle; you can have two groups, three groups, four, five, any number of groups; they can always be organized according to this system. This does not mean that Indo-European-speaking groups have necessarily, at one time or another, practiced marriage with mother's brother's daughter, but that most of the marriage systems in their area of occupancy belong directly or indirectly to the same family as the simpler type (see Table 1).

Table 1

	Indo-European area	Sino-Tibetan area
Marriage rules	Circular systems, either resulting directly from explicit rules or indirectly from the fact that the choice of a mate is left to probability	Circular systems, present in juxtaposition with systems of symmetrical exchange
Social organization	Numerous social units, with a complex structure (extended family type)	Few social units, with a simple structure (clan or lineage type)
Kinship system	1 subjective 2 few terms	1 objective 2 numerous terms

Now, in the field of social organization, what do we have? We have, as distinctive of the Indo-European area, something we know by the name of "extended family." What is an extended family? An extended family consists of several collateral lines; but the collateral lines should remain to some extent distinguished from one another, because if they did not – if, for instance, Extended Family *A* were marrying into *B*, and Extended Family *B* into *C*, then there would be no distinction whatsoever between an extended family and a clan. The extended family would become a kind of clan. And what keeps the different collateral lines distinct in an extended family is that there cannot exist a rule of marriage applicable to all the lines. Now this has been followed up in Indo-European kinship systems in many different ways. Some systems, which are still working in India, state that it is only the senior line which follows a rule, and that all the other lines can marry exactly as they wish within the sole limitation of prohibited degrees. When one studies certain curious features of the old Slavic kinship system, the interpretation is somewhat different: It seems that what may be called the "exemplary line" was more or less diagonal to the main one; that is, if a man married according to a given rule, then at the next generational level it would be a man of a different line, and then in the next generation a man of another different line. This does not matter. The point is that with an extended family system it is not possible for all the groups to marry according to the same rule and that a great many exceptions to any conceivable rule should take place.

Now the kinship system itself calls for very few terms and it is a subjective system. This means that all the relatives are described in relation to the subject, and the further the relative is from the subject the vaguer the terms are. We can accurately describe our relationship to our father, mother, son, daughter, brother, and sister, but even aunt or uncle is slightly vague; and when it comes to more distant relationships, we have no terms at all at our disposal; it is an egocentric system.

Let us now compare some features in the Sino-Tibetan area. Here we find two types of marriage rules: one which is the same as the one previously described, generalized exchange; and another one, which is a special form of

exchange, usually called "exchange marriage," a special form because, instead of making it possible to organize any number of groups, it can work only with two, four, six, eight – an even number – the system could not work with an odd number. And these two rules exist side by side within the area.

Now about the social organization. We do not have extended families in our second area, but we do find very simple types of the clan system, which can become complicated quantitatively (when the clan system divides into lineages), but never qualitatively, as is the case with the extended family.

As regards the kinship system, the terms are very numerous. You know, for instance, that in the Chinese kinship system the terms number several hundreds, and it is even possible to create an indefinite number of terms; any relationship can be described with accuracy, even if it is very far away from the subject. And this makes the system completely objective; as a matter of fact, Kroeber a long time ago noticed that no kinship systems are so completely different from each other as the Indo-European on the one hand and the Chinese on the other.

If we try to interpret this picture, what do we find? We find that in the Indo-European case we have a very simple structure (marriage rules), but that the elements (social organization) which must be arranged in this structure are numerous and complicated, whereas in the Sino-Tibetan case the opposite prevails: We have a very complicated structure (marriage rules), with two different sets of rules, and the elements (social organization) are few. And to the separation between the *structure* and the *elements* correspond, on the level of terminology – which is a linguistic level antithetic features as to the framework (*subjective* versus *objective*) and to the terms themselves (*numerous* versus *few*). Now it seems to me that if we formulate the situation in these terms, it is at least possible to start a useful discussion with the linguists. While I was making this chart, I could not but remember what R. Jakobson said at yesterday's session about the structure of the Indo-European language: a great discrepancy between form and substance, a great many irregularities in relation to the rules, and considerable freedom regarding the choice of means to express the same idea. Are not all of these traits similar to those we have singled out with respect to social structure?

Finally, I would say that between culture and language there cannot be *no* relations at all, and there cannot be 100 percent correlation either. Both situations are impossible to conceive. If there were no relations at all, that would lead us to assume that the human mind is a kind of jumble – that there is no connection at all between what the mind is doing on one level and what the mind is doing on another level. But, on the other hand, if the correlation were 100 percent, then certainly we should know about it and we should not be here to discuss whether it exists or not. So the conclusion which seems to me the most likely is that some kind of correlation exists between certain things on certain levels, and our main task is to determine what these things are and what these levels are. This can be done only through a close cooperation between linguists and anthropologists. I should say that the most important results of such cooperation will not be for linguistics alone or for anthropology alone, or for both; they will mostly be for an anthropology conceived in a broader way – that is, a knowledge of man that incorporates all the different approaches which can be

used and that will provide a clue to the way according to which our uninvited guest, the human mind, works.

Notes

1 Benjamin L. Whorf, *Collected Papers on Metalinguistics* (Washington: 1952); *Language, Thought, and Reality*, ed. John B. Carroll (New York: 1956).

Roland Barthes

MYTH TODAY (1957)

What is a myth, today? I shall give at the outset a first, very simple answer, which is perfectly consistent with etymology: *myth is a type of speech*.[1]

Myth is a type of speech

Of course, it is not *any* type: language needs special conditions in order to become myth: we shall see them in a minute. But what must be firmly established at the start is that myth is a system of communication, that it is a message. This allows one to perceive that myth cannot possibly be an object, a concept, or an idea; it is a mode of signification, a form. Later, we shall have to assign to this form historical limits, conditions of use, and reintroduce society into it: we must nevertheless first describe it as a form.

It can be seen that to purport to discriminate among mythical objects according to their substance would be entirely illusory: since myth is a type of speech, everything can be a myth provided it is conveyed by a discourse. Myth is not defined by the object of its message, but by the way in which it utters this message: there are formal limits to myth, there are no 'substantial' ones. Everything, then, can be a myth? Yes, I believe this, for the universe is infinitely fertile in suggestions. Every object in the world can pass from a closed, silent existence to an oral state, open to appropriation by society, for there is no law, whether natural or not, which forbids talking about things. A tree is a tree. Yes, of course. But a tree as expressed by Minou Drouet is no longer quite a tree, it is a tree which is decorated, adapted to a certain type of consumption, laden with literary self-indulgence, revolt, images, in short with a type of social *usage* which is added to pure matter.

Naturally, everything is not expressed at the same time: some objects become the prey of mythical speech for a while, then they disappear, others take their place and attain the status of myth. Are there objects which are *inevitably* a

source of suggestiveness, as Baudelaire suggested about Woman? Certainly not: one can conceive of very ancient myths, but there are no eternal ones; for it is human history which converts reality into speech, and it alone rules the life and the death of mythical language. Ancient or not, mythology can only have an historical foundation, for myth is a type of speech chosen by history: it cannot possibly evolve from the 'nature' of things.

Speech of this kind is a message. It is therefore by no means confined to oral speech. It can consist of modes of writing or of representations; not only written discourse, but also photography, cinema, reporting, sport, shows, publicity, all these can serve as a support to mythical speech. Myth can be defined neither by its object nor by its material, for any material can arbitrarily be endowed with meaning: the arrow which is brought in order to signify a challenge is also a kind of speech. True, as far as perception is concerned, writing and pictures, for instance, do not call upon the same type of consciousness; and even with pictures, one can use many kinds of reading: a diagram lends itself to signification more than a drawing, a copy more than an original, and a caricature more than a portrait. But this is the point: we are no longer dealing here with a theoretical mode of representation: we are dealing with *this* particular image, which is given for *this* particular signification. Mythical speech is made of a material which has *already* been worked on so as to make it suitable for communication: it is because all the materials of myth (whether pictorial or written) presuppose a signifying consciousness, that one can reason about them while discounting their substance. This substance is not unimportant: pictures, to be sure, are more imperative than writing, they impose meaning at one stroke, without analysing or diluting it. But this is no longer a constitutive difference. Pictures become a kind of writing as soon as they are meaningful: like writing, they call for a *lexis*.

We shall therefore take *language, discourse, speech*, etc., to mean any significant unit or synthesis, whether verbal or visual: a photograph will be a kind of speech for us in the same way as a newspaper article; even objects will become speech, if they mean something. This generic way of conceiving language is in fact justified by the very history of writing: long before the invention of our alphabet, objects like the Inca *quipu*, or drawings, as in pictographs, have been accepted as speech. This does not mean that one must treat mythical speech like language; myth in fact belongs to the province of a general science, coextensive with linguistics, which is *semiology*.

Myth as a semiological system

For mythology, since it is the study of a type of speech, is but one fragment of this vast science of signs which Saussure postulated some forty years ago under the name of *semiology*. Semiology has not yet come into being. But since Saussure himself, and sometimes independently of him, a whole section of contemporary research has constantly been referred to the problem of meaning: psycho-analysis, structuralism, eidetic psychology, some new types of literary criticism of which Bachelard has given the first examples, are no longer concerned with facts except inasmuch as they are endowed with significance. Now to

postulate a signification is to have recourse to semiology. I do not mean that semiology could account for all these aspects of research equally well: they have different contents. But they have a common status: they are all sciences dealing with values. They are not content with meeting the facts: they define and explore them as tokens for something else.

Semiology is a science of forms, since it studies significations apart from their content. I should like to say one word about the necessity and the limits of such a formal science. The necessity is that which applies in the case of any exact language. Zhdanov made fun of Alexandrov the philosopher, who spoke of '*the spherical structure of our planet.*' '*It was thought until now*', Zhdanov said, '*that form alone could be spherical.*' Zhdanov was right: one cannot speak about structures in terms of forms, and vice versa. It may well be that on the plane of 'life', there is but a totality where structures and forms cannot be separated. But science has no use for the ineffable: it must speak about 'life' if it wants to transform it. Against a certain quixotism of synthesis, quite platonic incidentally, all criticism must consent to the *ascesis*, to the artifice of analysis; and in analysis, it must match method and language. Less terrorized by the spectre of 'formalism', historical criticism might have been less sterile; it would have understood that the specific study of forms does not in any way contradict the necessary principles of totality and History. On the contrary: the more a system is specifically defined in its forms, the more amenable it is to historical criticism. To parody a well-known saying, I shall say that a little formalism turns one away from History, but that a lot brings one back to it. Is there a better example of total criticism than the description of saintliness, at once formal and historical, semiological and ideological, in Sartre's *Saint-Genet*? The danger, on the contrary, is to consider forms as ambiguous objects, half-form and half-substance, to endow form with a substance of form, as was done, for instance, by Zhdanovian realism. Semiology, once its limits are settled, is not a metaphysical trap: it is a science among others, necessary but not sufficient. The important thing is to see that the unity of an explanation cannot be based on the amputation of one or other of its approaches, but, as Engels said, on the dialectical co-ordination of the particular sciences it makes use of. This is the case with mythology: it is a part both of semiology inasmuch as it is a formal science, and of ideology inasmuch as it is an historical science: it studies ideas-in-form.[2]

Let me therefore restate that any semiology postulates a relation between two terms, a signifier and a signified. This relation concerns objects which belong to different categories, and this is why it is not one of equality but one of equivalence. We must here be on our guard for despite common parlance which simply says that the signifier *expresses* the signified, we are dealing, in any semiological system, not with two, but with three different terms. For what we grasp is not at all one term after the other, but the correlation which unites them: there are, therefore, the signifier, the signified and the sign, which is the associative total of the first two terms. Take a bunch of roses: I use it to *signify* my passion. Do we have here, then, only a signifier and a signified, the roses and my passion? Not even that: to put it accurately, there are here only 'passionified' roses. But on the plane of analysis, we do have three terms; for these roses weighted with passion perfectly and correctly allow themselves to be decomposed into roses and

passion: the former and the latter existed before uniting and forming this third object, which is the sign. It is as true to say that on the plane of experience I cannot dissociate the roses from the message they carry, as to say that on the plane of analysis I cannot confuse the roses as signifier and the roses as sign: the signifier is empty, the sign is full, it is a meaning. Or take a black pebble: I can make it signify in several ways, it is a mere signifier; but if I weigh it with a definite signified (a death sentence, for instance, in an anonymous vote), it will become a sign. Naturally, there are between the signifier, the signified and the sign, functional implications (such as that of the part to the whole) which are so close that to analyse them may seem futile; but we shall see in a moment that this distinction has a capital importance for the study of myth as semiological schema.

Naturally these three terms are purely formal, and different contents can be given to them. Here are a few examples: for Saussure, who worked on a particular but methodologically exemplary semiological system – the language or *langue* – the signified is the concept, the signifier is the acoustic image (which is mental) and the relation between concept and image is the sign (the word, for instance), which is a concrete entity.[3] For Freud, as is well known, the human psyche is a stratification of tokens or representatives. One term (I refrain from giving it any precedence) is constituted by the manifest meaning of behaviour, another, by its latent or real meaning (it is, for instance, the substratum of the dream); as for the third term, it is here also a correlation of the first two: it is the dream itself in its totality, the parapraxis (a mistake in speech or behaviour) or the neurosis, conceived as compromises, as economies effected thanks to the joining of a form (the first term) and an intentional function (the second term). We can see here how necessary it is to distinguish the sign from the signifier: a dream, to Freud, is no more its manifest datum than its latent content: it is the functional union of these two terms. In Sartrean criticism, finally (I shall keep to these three well-known examples), the signified is constituted by the original crisis in the subject (the separation from his mother for Baudelaire, the naming of the theft for Genet); Literature as discourse forms the signifier; and the relation between crisis and discourse defines the work, which is a signification. Of course, this tri-dimensional pattern, however constant in its form, is actualized in different ways: one cannot therefore say too often that semiology can have its unity only at the level of forms, not contents; its field is limited, it knows only one operation: reading, or deciphering.

In myth, we find again the tri-dimensional pattern which I have just described: the signifier, the signified and the sign. But myth is a peculiar system, in that it is a constructed from a semiological chain which existed before it: it *is a second-order semiological system*. That which is a sign (namely the associative total of a concept and an image) in the first system, becomes a mere signifier in the second. We must here recall that the materials of mythical speech (the language itself, photography, painting, posters, rituals, objects, etc.), however different at the start, are reduced to a pure signifying function as soon as they are caught by myth. Myth sees in them only the same raw material; their unity is that they all come down to the status of a mere language. Whether it deals with alphabetical or pictorial writing, myth wants to see in them only a sum of signs, a global

sign, the final term of a first semiological chain. And it is precisely this final term which will become the first term of the greater system which it builds and of which it is only a part. Everything happens as if myth shifted the formal system of the first significations sideways. As this lateral shift is essential for the analysis of myth, I shall represent it in the following way, it being understood, of course, that the spatialization of the pattern is here only a metaphor:

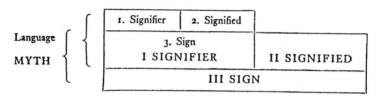

It can be seen that in myth there are two semiological systems, one of which is staggered in relation to the other: a linguistic system, the language (or the modes of representation which are assimilated to it), which I shall call the *language-object*, because it is the language which myth gets hold of in order to build its own system; and myth itself, which I shall call *metalanguage*, because it is a second language, *in which* one speaks about the first. When he reflects on a metalanguage, the semiologist no longer needs to ask himself questions about the composition of the language-object, he no longer has to take into account the details of the linguistic schema; he will only need to know its total term, or global sign, and only inasmuch as this term lends itself to myth. This is why the semiologist is entitled to treat in the same way writing and pictures: what he retains from them is the fact that they are both *signs*, that they both reach the threshold of myth endowed with the same signifying function, that they constitute, one just as much as the other, a language-object.

It is now time to give one or two examples of mythical speech. I shall borrow the first from an observation by Valéry.[4] I am a pupil in the second form in a French *lycée*. I open my Latin grammar, and I read a sentence, borrowed from Aesop or Phaedrus: *quia ego nominor leo*. I stop and think. There is something ambiguous about this statement: on the one hand, the words in it do have a simple meaning: *because my name is lion*. And on the other hand, the sentence is evidently there in order to signify something else to me. Inasmuch as it is addressed to me, a pupil in the second form, it tells me clearly: I am a grammatical example meant to illustrate the rule about the agreement of the predicate. I am even forced to realize that the sentence in no way *signifies* its meaning to me, that it tries very little to tell me something about the lion and what sort of name he has; its true and fundamental signification is to impose itself on me as the presence of a certain agreement of the predicate. I conclude that I am faced with a particular, greater, semiological system, since it is co-extensive with the language: there is, indeed, a signifier, but this signifier is itself formed by a sum of signs, it is in itself a first semiological system (*my name is lion*). Thereafter, the formal pattern is correctly unfolded: there is a signified (*I am a grammatical example*) and there is a global signification, which is none other than the correlation of the signifier and the signified; for neither the naming of the lion nor the grammatical example are given separately.

And here is now another example: I am at the barber's, and a copy of *Paris-Match* is offered to me. On the cover, a young Negro in a French uniform is saluting, with his eyes uplifted, probably fixed on a fold of the tricolour. All this is the *meaning* of the picture. But, whether naively or not, I see very well what it signifies to me: that France is a great Empire, that all her sons, without any colour discrimination, faithfully serve under her flag, and that there is no better answer to the detractors of an alleged colonialism than the zeal shown by this Negro in serving his so-called oppressors. I am therefore again faced with a greater semiological system: there is a signifier, itself already formed with a previous system (*a black soldier is giving the French salute*); there is a signified (it is here a purposeful mixture of Frenchness and militariness); finally, there is a presence of the signified through the signifier.

Before tackling the analysis of each term of the mythical system, one must agree on terminology. We now know that the signifier can be looked at, in myth, from two points of view: as the final term of the linguistic system, or as the first term of the mythical system. We therefore need two names. On the plane of language, that is, as the final term of the first system, I shall call the signifier: *meaning (my name is lion, a Negro is giving the French salute)*; on the plane of myth, I shall call it: *form*. In the case of the signified, no ambiguity is possible: we shall retain the name *concept*. The third term is the correlation of the first two: in the linguistic system, it is the *sign*; but it is not possible to use this word again without ambiguity, since in myth (and this is the chief peculiarity of the latter), the signifier is already formed by the *signs* of the language. I shall call the third term of myth the *signification*. This word is here all the better justified since myth has in fact a double function: it points out and it notifies, it makes us understand something and it imposes it on us.

[. . .]

Notes

1 Innumerable other meanings of the word 'myth' can be cited against this. But I have tried to define things, not words.

2 The development of publicity, of a national press, of radio, of illustrated news, not to speak of the survival of a myriad rites of communication which rule social appearances makes the development of a semiological science more urgent than ever. In a single day, how many really non-signifying fields do we cross? Very few, sometimes none. Here I am, before the sea; it is true that it bears no message. But on the beach, what material for semiologyl Flags, slogans, signals, sign-boards, clothes, suntan even, which are so many messages to me.

3 The notion of *word* is one of the most controversial in linguistics. I keep it here for the sake of simplicity.

4 *Tel Quel*, II, p. 191.

LANGUAGE AND COLONIALISM

You taught me language; and my profit on't
Is, I know how to curse. The red plague rid you
For learning me your language!
(William Shakespeare, *The Tempest*, I.ii. 363–5)

THE TEXTS IN THIS SECTION are closely related to those in the 'Eng-
lishes' section. What we see here is a range of responses to the imposition of a
language upon a colonised people. As with the feminist arguments around lan-
guage, there is no fixed or agreed position to which contributors to the postcolonial
debates subscribe. Writing in different contexts, against similar but specifically dis-
tinct histories, the writers take up their own stance in relation both to the colonial
language and to their own native language. One of the important things to note is
that although in certain locations the colonial language was brutally forced on to
the colonised (infamously to Africans when they were shipped to slavery), in other
places the colonised took on the colonial language because it offered the only
chance of improving their lot. It was perhaps more insidiously effective when this
occurred.

Fanon's essay is concerned with the psychic and emotional violence enacted
upon the colonised subject as a consequence of the dominance and prestige
attached to the language of the coloniser. He argues that for the colonised, the bet-
ter the acquisition of the colonial language, the nearer s/he will be to whiteness, and
therefore full human status, in the eyes of the masters. But taking on a new lan-
guage also means taking on a culture, a new way of life. And Fanon stresses the
damage which occurs to those who do cross this linguistic and cultural border. Once
crossed it appears impossible to go back again, yet those who do cross do not
belong in the 'mother-country either': they are stranded in-between cultures. This
can also happen to working-class children in their experience of education as we
will see in the final section.

The problem of what Fanon calls coming 'face to face with the language of the
civilising nation' is one which is particularly pressing for writers. The problem is
that of deciding which language should be chosen for the production of a national
literature; which would be capable of expressing the experience of both colonialism
and post-colonialism. The novelist Chinua Achebe makes a distinction between the
national language and ethnic languages; in a number of African countries, he
argues, the national language is English whereas – and he specifies Nigeria as an
example – the ethnic languages are Hausa, Ibo, Yoruba and so on. Therefore he
argues, for writers in such countries, the language to be adopted as the national

language should be English. This is a highly contentious position as we shall see, though it does relate back to Kachru's essay in Part Two, particularly when he writes of the unifying potential and neutral status of English in India. Achebe's position is quite clear: he declares that he has been given this language and that he intends to use it. But, and again this reminds us of the debates in the 'Englishes' section, he argues that by using it to write of African experiences and cultures, it will be altered; a new English will be formed.

Achebe's view is flatly contradicted by the Kenyan writer Ngũgĩ' wa Thiong'o in his essay 'The Language of African Literature'. Ngũgĩ's position is essentially that of a cultural nationalist – it is one of the ironies of imperial rule in Africa that not only were nations created where they had not previously existed, but the political formations which had accompanied nationalism in Europe were also transplanted there. Ngũgĩ argues for the complete repudiation of the colonial tongue as a medium of expression for two reasons. First, because it inscribes the colonised as irredeemably 'other' by virtue of the conceptual categories with which it is structured (this is, as we have seen, also an argument used by feminists). Second, because, he asserts, there is a symbiotic relationship between a people and their indigenous language; it follows from this, for Ngũgĩ, that it is only through this language that the colonial subject and cultural experience can be expressed both fully and authentically. It is worth considering the validity of this argument from a number of perspectives. That of an unknown postcolonial writer for example. Or a postcolonial writer, say from Nigeria, who has no other language but English. It is also interesting to note the appearance of many writers who do use English as a result of a past colonial history: Rushdie, Walcott, Heaney . . .

Further reading

Language and colonialism

Fanon, F. (1967) *The Wretched of the Earth*, trans. C. Farrington, Harmondsworth: Penguin.
——(1986) *Black Skin, White Masks*, trans. C. Markham, London: Pluto.
Achebe, C. (1975) *Morning Yet on Creation Day*, New York: Anchor Books.
——(1988) *Hopes and Impediments: Selected Essays 1965-87*, London: Heinemann.
Ngũgĩ wa Thiong'o, (1972) *Homecoming: Essays on Africa and Caribbean Literature, Culture and Politics*, London: Heinemann.
——(1986) *Decolonising the Mind: The Politics of Language in African Literature*, London: James Currey.
Killam, G. (ed.) (1973) *Africa Writers on African Writing*, London: Heinemann.
Chinweizu, J. O. and I. Madubuike (1985) *Towards the Decolonisation of African Literature*, London: Routledge.
Brathwaite, E. K. (1984) *History of the Voice: The Development of Nation Language in Anglophone Caribbean Poetry*, London: New Beacon.
Griffiths, G. (1978) *A Double Exile: African and West Indian Writing Between Two Cultures*, London: Marion Boyars.

Kaye, J. and A. Zoubir (1990) *The Ambiguous Compromise: Language, Literacy and National Identity,* London: Routledge.
Leith, D. (1997) *A Social History of English,* 2nd ed., London: Routledge, chapter 7.
Pennycook, A. (1994) *The Cultural Politics of English as an International Language,* London: Longman, chapters 3 and 8.
——— (1998) *English and the Discourses of Colonialism,* London: Routledge.
Amhad, A. (1992) *In Theory: Classes, Nations, Literatures,* London: Verso, pp. 73–94.

Britain and Ireland

Leith, D. (1997) *A Social History of English,* 2nd ed., London: Routledge, chapter 6.
Grillo, R. (1989) *Dominant Languages: Language and Hierarchy in Britain and France,* Cambridge: Cambridge University Press.
Kearney, H. (1989) *The British Isles: A History of Four Nations,* Cambridge: Cambridge University Press.
Durkacz, V. E. (1983) *The Decline of the Celtic Languages,* Edinburgh: John Donald.
Stephens, M. (1976) *Linguistic Minorities of Western Europe,* Llandysul: Gomer Press.
De Fréine, S. (1965) *The Great Silence,* Dublin: Foilseacháin Náisiúnta Teoranta.
Hindley, R. (1989) *The Death of the Irish Language: A Qualified Obituary,* London: Routledge.
Ó Cuív, B. ed. (1969) *A View of the Irish Language,* Dublin: The Stationery Office.
Heaney, S. (1988) *The Government of the Tongue,* London: Faber & Faber.

Postcolonial theory

Ashcroft, B., G. Griffiths, H. Tiffin, (1989) *The Empire Writes Back: Theory and Practice in Post-Colonial Literatures,* London: Routledge, introduction and chapter 2.
——— eds (1995) *The Post-Colonial Studies Reader,* London: Routledge.
Williams, P. and L. Chrisman eds (1993) *Colonial Discourse and Post-Colonial Theory,* Hemel Hempstead: Harvester Wheatsheaf, part 5.
Boehmer, E. (1995) *Colonial and Postcolonial Literature,* Oxford: Oxford University Press.
Loomba, A. (1998) *Colonialism/Postcolonialism,* London: Routledge.
Said, E. (1978) *Orientalism,* London: Routledge & Kegan Paul.
——— (1984) *The World, the Text, and the Critic,* London: Faber & Faber, chapters 1, 9, 12.
——— (1993) *Culture and Imperialism,* London: Chatto & Windus.
Parry, B. (1987) 'Problems in Current Theories of Colonial Discourse', *Oxford Literary Review,* 9, pp. 27–58.
Young, R. (1990) *White Mythologies: Writing History and the West,* London: Routledge.
——— (1995) *Colonial Desire: Hybridity in Theory, Culture and Race,* London: Routledge.
Gates, H.L. (ed.) (1985) *'Race', Writing and Difference,* Chicago: Chicago University Press.
——— (1987) *Figures in Black: Words, Signs and the 'Racial' Self,* Oxford: Oxford University Press.
Spivak, G.C. (1988) *In Other Words: Essays in Cultural Politics,* New York: Routledge.
Bhabha, H.K. (1994) *The Locations of Culture,* London: Routledge.

Frantz Fanon

THE NEGRO AND LANGUAGE (1952)

I ascribe a basic importance to the phenomenon of language. That is why I find it necessary to begin with this subject, which should provide us with one of the elements in the coloured man's comprehension of the dimension of *the other*. For it is implicit that to speak is to exist absolutely for the other.

The black man has two dimensions. One with his fellows, the other with the white man. A Negro behaves differently with a white man and with another Negro. That this self-division is a direct result of colonialist subjugation is beyond question. [...]

To speak means to be in a position to use a certain syntax, to grasp the morphology of this or that language, but it means above all to assume a culture, to support the weight of a civilization. Since the situation is not one-way only, the statement of it should reflect the fact. Here the reader is asked to concede certain points that, however unacceptable they may seem in the beginning, will find the measure of their validity in the facts.

The problem that we confront is this: the Negro of the Antilles will be proportionately whiter – that is, he will come closer to being a real human being – in direct ratio to his mastery of the French language. I am not unaware that this is one of man's attitudes face to face with Being. A man who has a language consequently possesses the world expressed and implied by that language. What we are getting at becomes plain: Mastery of language affords remarkable power. [...]

Every colonized people – in other words, every people in whose soul an inferiority complex has been created by the death and burial of its local cultural originality – finds itself face to face with the language of the civilizing nation; that is, with the culture of the mother country. The colonized is elevated above his jungle status in proportion to his adoption of the mother country's cultural standards. He becomes whiter as he renounces his blackness, his jungle. In the French colonial army, and particularly in the Senegalese regiments, the black officers serve first of all as interpreters. They are used to convey the master's orders to their fellows, and they, too, enjoy a certain position of honour.

[...] The Negro who knows the mother country is a demigod. In this con-
nexion I offer a fact that must have struck my compatriots. Many of them, after
stays of varying length in metropolitan France, go home to be deified. The most
eloquent form of ambivalence is adopted towards them by the native, the-one-
who-never-crawled-out-of-his-hole, the *bitaco*. The black man who has lived in
France for a length of time returns radically changed. To express it in genetic
terms, his phenotype undergoes a definitive, an absolute mutation.[1] Even before
he had gone away, one could tell from the almost aerial manner of his carriage that
new forces had been set in motion. When he met a friend or an acquaintance his
greeting was no longer the wide sweep of the arm: with great reserve our 'new
man' bowed slightly. The habitually raucous voice hinted at a gentle inner stirring
as of rustling breezes. For the Negro knows that over there in France there is a
stereotype of him that will fasten on to him at the pier in Le Havre or Marseilles:
'Ah come fom Mahtinique, it's the fuhst time Ah've eveh come to Fance.' He
knows that what the poets call the *divine gurgling* (listen to Creole) is only a halfway
house between pidgin-nigger and French. The middle class in the Antilles never
speak Creole except to their servants. In school the children of Martinique are
taught to scorn the dialect. One avoids *Creolisms*. Some families completely forbid
the use of Creole, and mothers ridicule their children for speaking it.

In any group of young men in the Antilles, the one who expresses himself
well, who has mastered the language, is inordinately feared; keep an eye on that
one, he is almost white. In France one says, 'He talks like a book.' In Martinique,
'He talks like a white man.'

The Negro arriving in France will react against the myth of the R-eating man
from Martinique. He will become aware of it, and he will really go to war against
it. He will practise not only rolling his R but embroidering it. Furtively observ-
ing the slightest reactions of others listening to his own speech, suspicious of his
own tongue – a wretchedly lazy organ – he will lock himself into his room and
read aloud for hours – desperately determined to learn *diction*.

[...]

The black man who arrives in France changes because to him the country
represents the Tabernacle; he changes not only because it is from France that he
received his knowledge of Montesquieu, Rousseau, and Voltaire, but also because
France gave him his physicians, his department heads, his innumerable little func-
tionaries – from the sergeant-major 'fifteen years in the service' to the police-
man who was born in Panissières. There is a kind of magic vault of distance, and
the man who is leaving next week for France creates round himself a magic cir-
cle in which the words *Paris, Marseille, Sorbonne, Pigalle* become the keys to the
vault. He leaves for the pier, and the amputation of his being diminishes as the
silhouette of his ship grows clearer. In the eyes of those who have come to see
him off he can read the evidence of his own mutation, his power. 'Good-bye
bandanna, good-bye straw hat...'

Now that we have got him to the dock, let him sail; we shall see him again.
For the moment, let us go to welcome one of those who are coming home. The
'newcomer' reveals himself at once; he answers only in French, and often he no
longer understands Creole. [...] He no longer understands the dialect, he talks

about the Opéra, which he may never have seen except from a distance, but above all he adopts a critical attitude towards his compatriots. Confronted with the most trivial occurrence, he becomes an oracle. He is the one who knows. He betrays himself in his speech.

[. . .]

What is the origin of this personality change? What is the source of this new way of being? Every dialect is a way of thinking, Damourette and Pichon said. And the fact that the newly returned Negro adopts a language different from that of the group into which he was born is evidence of a dislocation, a separation. Professor D. Westermann, in *The African Today* (p. 331), says that the Negroes' inferiority complex is particularly intensified among the most educated, who must struggle with it unceasingly. Their way of doing so, he adds, is frequently naive: 'The wearing of European clothes, whether rags or the most up-to-date style; using European furniture and European forms of social intercourse; adorning the Native language with European expressions; using bombastic phrases in speaking or writing a European language; all these contribute to a feeling of equality with the European and his achievements.'

On the basis of other studies and my own personal observations, I want to try to show why the Negro adopts such a position, peculiar to him, with respect to European languages. Let me point out once more that the conclusions I have reached pertain to the French Antilles; at the same time, I am not unaware that the same behaviour patterns obtain in every race that has been subjected to colonization.

[. . .]

It is said that the Negro loves to jabber; in my own case, when I think of the word *jabber* I see a gay group of children calling and shouting for the sake of calling and shouting – children in the midst of play, to the degree to which play can be considered an initiation into life. The Negro loves to jabber, and from this theory it is not a long road that leads to a new proposition: the Negro is just a child. The psychoanalysts have a fine start here, and the term *orality* is soon heard.

But we have to go further. The problem of language is too basic to allow us to hope to state it all here. Piaget's remarkable studies have taught us to distinguish the various stages in the mastery of language, and Gelb and Goldstein have shown us that the function of language is also broken into periods and steps. What interests us here is the black man confronted by the French language. We are trying to understand why the Antilles Negro is so fond of speaking French.

[. . .]

The language spoken officially is French; teachers keep a close watch over the children to make sure they do not use Creole. Let us not mention the ostensible reasons. It would seem, then, that the problem is this: in the Antilles, as in Brittany, there is a dialect and there is the French language. But this is false,

for the Bretons do not consider themselves inferior to the French people. The Bretons have not been civilized by the white man.

By refusing to multiply our elements, we take the risk of not setting a limit to our field; for it is essential to convey to the black man that an attitude of rupture has never saved anyone. While it is true that I have to throw off an attacker who is strangling me, because I literally cannot breathe, the fact remains solely on the physiological foundation. To the mechanical problem of respiration it would be unsound to graft a psychological element, the impossibility of expansion.

What is there to say? Purely and simply this: when a bachelor of philosophy from the Antilles refuses to apply for certification as a teacher on the ground of his colour I say that philosophy has never saved anyone. When someone else strives and strains to prove to me that black men are as intelligent as white men I say that intelligence has never saved anyone; and that is true, for, if philosophy and intelligence are invoked to proclaim the equality of men, they have also been employed to justify the extermination of men.

Before going any further I find it necessary to say certain things. I am speaking here, on the one hand, of alienated (duped) blacks, and, on the other, of no less alienated (duping and duped) whites. If one hears a Sartre or a Cardinal Verdier declare that the outrage of the colour problem has survived far too long, one can conclude only that their position is normal. Anyone can amass references and quotations to prove that 'colour prejudice' is indeed an imbecility and an iniquity that must be eliminated.

[. . .]

It has been said that the Negro is the link between monkey and man – meaning, of course, white man. And only on page 108 of his book[2] does Sir Alan Burns come to the conclusion that 'we are unable to accept as scientifically proved the theory that the black man is inherently inferior to the white, or that he comes from a different stock . . .' Let me add that it would be easy to prove the absurdity of statements such as this: 'It is laid down in the Bible that the separation of the white and black races will be continued in heaven as on earth, and those blacks who are admitted into the Kingdom of Heaven will find themselves separately lodged in certain of those many mansions of Our Father that are mentioned in the New Testament.' Or this: 'We are the chosen people – look at the colour of our skins. The others are black or yellow: that is because of their sins.'

Ah, yes, as you can see, by calling on humanity, on the belief in dignity, on love, on charity, it would be easy to prove, or to win the admission, that the black is the equal of the white. But my purpose is quite different: what I want to do is help the black man to free himself of the arsenal of complexes that has been developed by the colonial environment. M. Achille, who teaches at the Lycée du Parc in Lyons, once during a lecture told of a personal experience. It is a universally known experience. It is a rare Negro living in France who cannot duplicate it. Being a Catholic, Achille took part in a student pilgrimage. A priest, observing the black face in his flock, said to him, 'You go 'way big Savannah what for and come 'long us?' Very politely Achille gave him a truthful answer, and it was not the young fugitive from the Savannah who came off the worst. Everyone laughed at the exchange and the pilgrimage proceeded. But if

we stop right here we shall see that the fact that the priest spoke pidgin-nigger leads to certain observations:

1 'Oh, I know the blacks. They must be spoken to kindly; talk to them about their country; it's all in knowing how to talk to them. For instance ...' I am not at all exaggerating: a white man addressing a Negro behaves exactly like an adult with a child and starts smirking, whispering, patronizing, cozening. It is not one white man I have watched, but hundreds; and I have not limited my investigation to any one class, but, if I may claim an essentially objective position, I have made a point of observing such behaviour in physicians, policemen, employers. I shall be told, by those who overlook my purpose, that I should have directed my attention elsewhere, that there are white men who do not fit my description.

[...]

Talking to Negroes in this way gets down to their level, it puts them at ease, it is an effort to make them understand us, it reassures them ...

The physicians of the public health services know this very well. Twenty European patients, one after another, come in: 'Please sit down ... Why do you wish to consult me? ... What are your symptoms? ...' Then comes a Negro or an Arab: 'Sit there, boy ... What's bothering you? ... Where does it hurt, huh? ...' When, that is, they do not say: 'You not feel good, no?'

2 To speak pidgin to a Negro makes him angry, because he himself is a pidgin-nigger-talker. But, I will be told, there is no wish, no intention to anger him. I grant this; but it is just this absence of which, this lack of interest, this indifference, this automatic manner of classifying him, imprisoning him, primitivizing him, decivilizing him, that makes him angry.

If a man who speaks pidgin to a man of colour or an Arab does not see anything wrong or evil in such behaviour it is because he has never stopped to think.

I meet a Russian or a German who speaks French badly. With gestures I try to give him the information that he requests, but at the same time I can hardly forget that he has a language of his own, a country, and that perhaps he is a lawyer or an engineer there. In any case, he is foreign to my group, and his standards must be different.

When it comes to the case of the Negro, nothing of the kind. He has no culture, no civilization, no 'long historical past'.

This may be the reason for the strivings of contemporary Negroes: to prove the existence of a black civilization to the white world at all costs.

Willy-nilly, the Negro has to wear the livery that the white man has sewed for him. Look at children's picture magazines: Out of every Negro mouth comes the ritual 'Yassuh, boss'. It is even more remarkable in motion pictures. Most of the American films for which French dialogue is dubbed in offer the type-Negro: 'Sho' good!'

[...]

Yes, the black man is supposed to be a good nigger; once this has been laid down, the rest follows of itself. To make him talk pidgin is to fasten him to the effigy of him, to snare him, to imprison him, the eternal victim of an essence, of an *appearance* for which he is not responsible And naturally, just as a Jew who spends money without thinking about it is suspect, a black man who quotes Montesquieu had better be watched. Please understand me: watched in the sense that he is starting something. Certainly I do not contend that the black student is suspect to his fellows or to his teachers. But outside university circles there is an army of fools: what is important is not to educate them, but to teach the Negro not to be the slave of their archetypes.

That these imbeciles are the product of a psychological-economic system I will grant. But that does not get us much further along.

When a Negro talks of Marx, the first reaction is always the same: 'We have brought you up to our level and now you turn against your benefactors. Ingrates! Obviously nothing can be expected of you.' And then too there is that bludgeon argument of the plantation-owner in Africa: our enemy is the teacher.

What I am asserting is that the European has a fixed concept of the Negro, and there is nothing more exasperating than to be asked: 'How long have you been in France? You speak French so well.'

It can be argued that people say this because many Negroes speak pidgin. But that would be too easy. You are on a train and you ask another passenger: 'I beg your pardon, sir, would you mind telling me where the dining-car is?'

'Sure, fella. You go out door, see, go corridor, you go straight, go one car, go two car, go three car, you there.'

No, speaking pidgin-nigger closes off the black man; it perpetuates a state of conflict in which the white man injects the black with extremely dangerous foreign bodies. Nothing is more astonishing than to hear a black man express himself properly, for then in truth he is putting on the white world. I have had occasion to talk with students of foreign origin. They speak French badly: Little Crusoe, alias Prospero, is at ease then. He explains, informs, interprets, helps them with their studies. But with a Negro he is completely baffled; the Negro has made himself just as knowledgeable. With him this game cannot be played, he is a complete replica of the white man. So there is nothing to do but to give in.[3]

After all that has just been said, it will be understood that the first impulse of the black man is to say *no* to those who attempt to build a definition of him. It is understandable that the first action of the black man is a *reaction*, and, since the Negro is appraised in terms of the extent of his assimilation, it is also understandable why the newcomer expresses himself only in French. It is because he wants to emphasize the rupture that has now occurred. He is incarnating a new type of man that he imposes on his associates and his famliy. And so his old mother can no longer understand him when he talks to her about his *duds*, the family's *crummy joint*, the *dump* . . . all of it, of course, tricked out with the appropriate accent.

In every country of the world there are climbers, 'the ones who forget who they are', and, in contrast to them, 'the ones who remember where they came from'. The Antilles Negro who goes home from France expresses himself in

dialect if he wants to make it plain that nothing has changed. One can feel this at the dock where his family and his friends are waiting for him. Waiting for him not only because he is physically arriving, but in the sense of waiting for the chance to strike back. They need a minute or two in order to make their diagnosis. If the voyager tells his acquaintances, 'I am so happy to be back with you. Good Lord, it is hot in this country, I shall certainly not be able to endure it very long,' they know: A European has got off the ship.

In a more limited group, when students from the Antilles meet in Paris, they have the choice of two possibilities:

- either to stand with the white world (that is to say, the real world), and, since they will speak French, to be able to confront certain problems and incline to a certain degree of universality in their conclusions;
- or to reject Europe, 'Yo',[4] and cling together in their dialect, making themselves quite comfortable in what we shall call the *Umwelt* of Martinique; by this I mean – and this applies particularly to my brothers of the Antilles – that when one of us tries, in Paris or any other university city, to study a problem seriously, he is accused of self-aggrandizement, and the surest way of cutting him down is to remind him of the Antilles by exploding into dialect. This must be recognized as one of the reasons why so many friendships collapse after a few months of life in Europe.

[. . .]

It becomes evident that we were not mistaken in believing that a study of the language of the Antilles Negro would be able to show us some characteristics of his world. As I said at the start, there is a retaining-wall relation between language and group.

To speak a language is to take on a world, a culture. The Antilles Negro who wants to be white will be the whiter as he gains greater mastery of the cultural tool that language is. Rather more than a year ago in Lyon, I remember, in a lecture I had drawn a parallel between Negro and European poetry, and a French acquaintance told me enthusiastically, 'At bottom you are a white man'. The fact that I had been able to investigate so interesting a problem through the white man's language gave me honorary citizenship.

Historically, it must be understood that the Negro wants to speak French because it is the key that can open doors which were still barred to him fifty years ago. In the Antilles Negro who comes within this study we find a quest for subtleties, for refinements of language – so many further means of proving to himself that he has measured up to the culture.

[. . .]

Notes

1 By that I mean that Negroes who return to their original environments convey the impression that they have completed a cycle, that they have added to themselves something that was lacking. They return literally full of themselves.

2 Sir Alan Burns, *Colour Prejudice* (London: Allen & Unwin, 1948).

3 'I knew some Negroes in the School of Medicine ... in a word, they were a disappointment; the colour of their skin should have permitted them to give *us* the opportunity to be charitable, generous, or scientifically friendly. They were derelict in this duty, this claim on our good will. All our tearful tenderness, all our calculated solicitude were a drug on the market. We had no Negroes to condescend to, nor did we have anything to have them for; they counted for virtually as much as we in the scale of the little jobs and petty chicaneries of daily life.' Michel Salomon, 'D'un juif à des nègres,' *Présence Africaine*, No. 5, p. 776.

4 A generic term for *other people*, applied especially to Europeans.

Chinua Achebe

THE AFRICAN WRITER AND THE
ENGLISH LANGUAGE (1975)

In June 1952, there was a writers' gathering at Makerere, impressively styled: "A Conference of African Writers of English Expression". Despite this sonorous and rather solemn title it turned out to be a very lively affair and a very exciting and useful experience for many of us. But there was something which we tried to do and failed – that was to define "African Literature" satisfactorily.

Was it literature produced *in* Africa or *about* Africa? Could African literature be on any subject, or must it have an African theme? Should it embrace the whole continent or South of the Sahara, or just *Black* Africa? And then the question of language. Should it be in indigenous African languages or should it include Arabic, English, French, Portuguese, Afrikaans, etc?

In the end we gave up trying to find an answer partly – I should admit – on my own instigation. Perhaps we should not have given up so easily. It seems to me from some of the things I have since heard and read that we may have given the impression of not knowing what we were doing, or worse, not daring to look too closely at it.

A Nigerian critic, Obi Wali, writing in *Transition* 10 said: "Perhaps the most important achievement of the conference . . . is that African literature as now defined and understood leads nowhere."

I am sure that Obi Wali must have felt triumphantly vindicated when he saw the report of a different kind of conference held later at Fourah Bay to discuss African literature and the University curriculum. This conference produced a tentative definition of African literature as follows: "Creative writing in which an African setting is authentically handled or to which experiences originating in Africa are integral." We are told specifically that Conrad's *Heart of Darkness* qualifies as African literature while Graham Greene's *Heart of the Matter* fails because it could have been set anywhere outside Africa.

A number of interesting speculations issue from this definition which

admittedly is only an interim formulation designed to produce an indisputably desirable end, namely, to introduce African students to literature set in their environment. But I could not help being amused by the curious circumstance in which Conrad, a Pole, writing in English could produce African literature while Peter Abrahams would be ineligible should he write a novel based on his experiences in the West Indies.

What all this suggests to me is that you cannot cram African literature into a small, near definition. I do not see African literature as one unit but as a group of associated units – in fact the sum total of all the *national* and *ethnic* literatures of Africa.

A national literature is one that takes the whole nation for its province and has a realised or potential audience throughout its territory. In other words a literature that is written in the *national* language. An ethnic literature is one which is available only to one ethnic group within the nation. If you take Nigeria as an example, the national literature, as I see it, is the literature written in English; and the ethnic literatures are in Hausa, Ibo, Yoruba, Efik, Edo, Ijaw, etc., etc.

Any attempt to define African literature in terms which overlook the complexities of the African scene at the material time is doomed to failure. After the elimination of white rule shall have been completed, the single most important fact in Africa in the second half of the twentieth century will appear to be the rise of individual nation states. I believe that African literature will follow the same pattern.

What we tend to do today is to think of African literature as a new-born infant. But in fact what we have is a whole generation of new-born infants. Of course if you only look cursorily one infant is pretty much like another; but in reality each is already set on its own separate journey. Of course, you may group them together on the basis of anything you choose – the colour of their hair, for instance. Or you may group them together on the basis of the language they will speak or the religion of their fathers. Those would all be valid distinctions; but they could not begin to account fully for each individual person carrying, as it were, his own little, unique lodestar of genes.

Those who in talking about African literature want to exclude North Africa because it belongs to a different tradition surely do not suggest that Black Africa is anything like homogenous. What does Shabaan Robert have in common with Christopher Okigbo or Awooner-Williams? Or Mongo Beti of Cameroun and Paris with Nzekwu of Nigeria? What does the champagne-drinking upper-class Creole society described by Easmon of Sierra Leone have in common with the rural folk and fishermen of J.P. Clark's plays? Of course, some of these differences could be accounted for on individual rather than national grounds but a good deal of it is also environmental.

I have indicated somewhat off-handedly that the national literature of Nigeria and of many other countries of Africa is, or will be, written in English. This may sound like a controversial statement, but it isn't. All I have done has been to look at the reality of present-day Africa. This "reality" may change as a result of deliberate, e.g. political, action. If it does an entirely new situation will arise, and there will be plenty of time to examine it. At present it may be more profitable to look at the scene as it is.

What are the factors which have conspired to place English in the position of national language in many parts of Africa? Quite simply the reason is that these nations were created in the first place by the intervention of the British which, I hasten to add, is not saying that the peoples comprising these nations were invented by the British.

The country which we know as Nigeria today began not so very long ago as the arbitrary creation of the British. It is true, as William Fagg says in his excellent new book *Nigerian Images*, that this arbitrary action has proved as lucky in terms of African art history as any enterprise of the fortunate Princes of Serendip. And I believe that in political and economic terms too this arbitrary creation called Nigeria holds out great prospects. Yet the fact remains that Nigeria was created by the British – for their own ends. Let us give the devil his due: colonialism in Africa disrupted many things, but it did create big political units where there were small, scattered ones before. Nigeria had hundreds of autonomous communities ranging in size from the vast Fulani Empire founded by Usman dan Fodio in the North to tiny village entities in the East. Today it is one country.

Of course there are areas of Africa where colonialism divided up a single ethnic group among two or even three powers. But on the whole it did bring together many peoples that had hitherto gone their several ways. And it gave them a language with which to talk to one another. If it failed to give them a song, it at least gave them a tongue, for sighing. There are not many countries in Africa today where you could abolish the language of the erstwhile colonial powers and still retain the facility for mutual communication. Therefore those African writers who have chosen to write in English or French are not unpatriotic smart alecs with an eye on the main chance – outside their own countries. They are by-products of the same process that made the new nation states of Africa.

You can take this argument a stage further to include other countries of Africa. The only reason why we can even talk about African unity is that when we get together we can have a manageable number of languages to talk in – English, French, Arabic.

The other day I had a visit from Joseph Kariuki of Kenya. Although I had read some of his poems and he had read my novels we had not met before. But it didn't seem to matter. In fact I had met him through his poems, especially through his love poem, "Come Away My Love" in which he captures in so few words the trials and tensions of an African in love with a white girl in Britain.

> Come away my love, from streets
> Where unkind eyes divide
> And shop windows reflect our difference.

By contrast, when in 1960 I was travelling in East Africa and went to the home of the late Shabaan Robert, the Swahili poet of Tanganyika, things had been different. We spent some time talking about writing, but there was no real contact. I knew from all accounts that I was talking to an important writer, but of the nature of his work I had no idea. He gave me two books of his poems which I treasure but cannot read – until I have learnt Swahili.

And there are scores of languages I would want to learn if it were possible.

Where am I to find the time to learn the half-a-dozen or so Nigerian languages each of which can sustain a literature? I am afraid it cannot be done. These languages will just have to develop as tributaries to feed the one central language enjoying nation-wide currency. Today, for good or ill, that language is English. Tomorrow it may be something else, although I very much doubt it.

Those of us who have inherited the English language may not be in a position to appreciate the value of the inheritance. Or we may go on resenting it because it came as part of a package deal which included many other items of doubtful value and the positive atrocity of racial arrogance and prejudice which may yet set the world on fire. But let us not in rejecting the evil throw out the good with it.

Some time last year I was travelling in Brazil meeting Brazilian writers and artists. A number of the writers I spoke to were concerned about the restrictions imposed on them by their use of the Portuguese language. I remember a woman poet saying she had given serious thought to writing in French! And yet their problem is not half as difficult as ours. Portuguese may not have the universal currency of English or French but at least it is the national language of Brazil with her eighty million or so people, to say nothing of the people of Portugal, Angola, Mozambique, etc.

Of Brazilian authors I have only read, in translation, one novel by Jorge Amado who is not only Brazil's leading novelist but one of the most important writers in the world. From that one novel, *Gabriella*, I was able to glimpse something of the exciting Afro-Latin culture which is the pride of Brazil and is quite unlike any other culture. Jorge Amado is only one of the many writers Brazil has produced. At their national writers' festival there were literally hundreds of them. But the work of the vast majority will be closed to the rest of the world for ever, including no doubt the work of some excellent writers. There is certainly a great advantage to writing in a world language.

I think I have said enough to give an indication of my thinking on the importance of the world language which history has forced down our throat. Now let us look at some of the most serious handicaps. And let me say straight away that one of the most serious handicaps is *not* the one people talk about most often, namely, that it is impossible for anyone ever to use a second language as effectively as his first. This assertion is compounded of half-truth and half bogus mystique. Of course, it is true that the vast majority of people are happier with their first language than with any other. But then the majority of people are not writers. We do have enough examples of writers who have performed the feat of writing effectively in a second language. And I am not thinking of the obvious names like Conrad. It would be more germane to our subject to choose African examples.

The first name that comes to my mind is Olaudah Equiano, better known as Gustavus Vassa, the African. Equiano was an Ibo, I believe from the village of Iseke in the Orlu division of Eastern Nigeria. He was sold as a slave at a very early age and transported to America. Later he bought his freedom and lived in England. In 1789 he published his life story, a beautifully written document which, among other things, set down for the Europe of his time something of the life and habit of his people in Africa in an attempt to counteract the lies and slander invented by some Europeans to justify the slave trade.

Coming nearer to our times we may recall the attempts in the first quarter

of this century by West African nationalists to come together and press for a greater say in the management of their own affairs. One of the most eloquent of that band was the Hon. Casely Hayford of the Gold Coast. His Presidential Address to the National Congress of British West Africa in 1925 was memorable not only for its sound common sense but as a fine example of elegant prose. The governor of Nigeria at the time was compelled to take notice and he did so in characteristic style: he called Hayford's Congress "a self-selected and self-appointed congregation of educated African gentlemen". We may derive some amusement from the fact that British colonial administrators learnt very little in the following quarter of a century. But at least they *did* learn in the end – which is more than one can say for some others.

It is when we come to what is commonly called creative literature that most doubt seems to arise. Obi Wali whose article "Dead End of African Literature" I referred to, has this to say:

> ... until these writers and their Western midwives accept the fact that any true African literature must be written in African languages, they would be merely pursuing a dead end, which can only lead to sterility, uncreativity and frustration.

But far from leading to sterility the work of many new African writers is full of the most exciting possibilities.

Take this from Christopher Okigbo's "Limits":

> Suddenly becoming talkative
> like weaverbird
> Summoned at offside of
> dream remembered
> Between sleep and waking.
> I hand up my egg-shells
> To you of palm grove,
> Upon whose bamboo towers hang
> Dripping with yesterupwine
>
> A tiger mask and nude spear . . .
>
> Queen of the damp half light,
> I have had my cleansing.
> Emigrant with air-borne nose,
> The he-goat-on-heat.

Or take the poem "Night Rain" in which J. P. Clark captures so well the fear and wonder felt by a child as rain clamours on the thatch-roof at night and his mother walking about in the dark, moves her simple belongings

> Out of the run of water
> That like ants filing out of the wood
> Will scatter and gain possession
> Of the floor . . .

I think that the picture of water spreading on the floor "like ants filing out of the wood" is beautiful. Of course if you have never made fire with faggots you may miss it. But Clark's inspiration derives from the same source which gave birth to the saying that a man who brings home antridden faggots must be ready for the visit of lizards.

I do not see any signs of sterility anywhere here. What I do see is a new voice coming out of Africa, speaking of African experience in a world-wide language. So my answer to the question: *Can an African ever learn English well enough to be able to use it effectively in creative writing?* is certainly yes. If on the other hand you ask: *Can he ever learn to use it like a native speaker?* I should say, I hope not. It is neither necessary nor desirable for him to be able to do so. The price a world language must be prepared to pay is submission to many different kinds of use. The African writer should aim to use English in a way that brings out his message best without altering the language to the extent that its value as a medium of international exchange will be lost. He should aim at fashioning out an English which is at once universal and able to carry his peculiar experience. I have in mind here the writer who has something new, something different to say.The nondescript writer has little to tell us, anyway, so he might as well tell it in conventional language and get it over with. If I may use an extravagant simile, he is like a man offering a small, nondescript routine sacrifice for which a chick or less will do. A serious writer must look for an animal whose blood can match the power of his offering.

In this respect Amos Tutuola is a natural. A good instinct has turned his apparent limitation in language into a weapon of great strength – a half-strange dialect that serves him perfectly in the evocation of his bizarre world. His last book, and to my mind, his finest, is proof enough that one can make even an imperfectly learnt second language do amazing things. In this book *The Feather Woman of The Jungle* Tutuola's superb story-telling is at last cast in the episodic form which he handles best instead of being painfully stretched on the rack of the novel.

From a natural to a conscious artist: myself, in fact. Allow me to quote a small example, from *Arrow of God* which may give some idea of how I approach the use of English. The Chief Priest in the story is telling one of his sons why it is necessary to send him to church:

> I want one of my sons to join these people and be my eyes there. If there is nothing in it you will come back. But if there is something there you will bring home my share. The world is like a Mask, dancing. If you want to see it well you do not stand in one place. My spirit tells me that those who do not befriend the white man today will be saying *had we known* tomorrow.[1]

Now supposing I had put it another way. Like this for instance:

> I am sending you as my representative among these people – just to be on the safe side in case the new religion develops. One has to

move with the times or else one is left behind. I have a hunch that those who fail to come to terms with the white man may well regret their lack of foresight.

The material is the same. But the form of the one is *in character* and the other is not. It is largely a matter of instinct, but judgment comes into it too.

You read quite often nowadays of the problems of the African writer having first to think in his mother tongue and then to translate what he has thought into English. If it were such a simple, mechanical process I would agree that it was pointless – the kind of eccentric pursuit you might expect to see in a modern Academy of Lagado; and such a process could not possibly produce some of the exciting poetry and prose which is already appearing.

One final point remains for me to make. The real question is not whether Africans *could* write in English but whether they *ought to*. Is it right that a man should abandon his mother-tongue for someone else's? It looks like a dreadful betrayal and produces a guilty feeling.

But for me there is no other choice. I have been given this language and I intend to use it. I hope, though, that there always will be men, like the late Chief Fagunwa, who will choose to write in their native tongue and ensure that our ethnic literature will flourish side-by-side with the national ones. For those of us who opt for English there is much work ahead and much excitement.

Writing in the *London Observer* recently, James Baldwin said:

> My quarrel with English language has been that the language reflected none of my experience. But now I began to see the matter another way ... Perhaps the language was not my own because I had never attempted to use it, had only learned to imitate it. If this were so, then it might be made to bear the burden of my experience if I could find the stamina to challenge it, and me, to such a test.

I recognise, of course, that Baldwin's problem is not exactly mine, but I feel that the English language will be able to carry the weight of my African experience. But it will have to be a new English, still in full communion with its ancestral home but altered to suit its new African surroundings.

Note

1 Chinua Achebe, *Arrow of God*, William Heinemann, London, 1964, p. 55.

Ngũgĩ wa Thiong'o

THE LANGUAGE OF AFRICAN LITERATURE (1986)

I was born into a large peasant family: father, four wives and about twenty-eight children. I also belonged, as we all did in those days, to a wider extended family and to the community as a whole.

We spoke Gĩkũyũ as we worked in the fields. We spoke Gĩkũyũ in and outside the home. I can vividly recall those evenings of story-telling around the fireside. It was mostly the grown-ups telling the children but everybody was interested and involved. We children would re-tell the stories the following day to other children who worked in the fields picking the pyrethrum flowers, tea-leaves or coffee beans of our European and African landlords.

The stories, with mostly animals as the main characters, were all told in Gĩkũyũ. Hare, being small, weak but full of innovative wit and cunning, was our hero. We identified with him as he struggled against the brutes of prey like lion, leopard, hyena. His victories were our victories and we learnt that the apparently weak can outwit the strong. We followed the animals in their struggle against hostile nature – drought, rain, sun, wind – a confrontation often forcing them to search for forms of co-operation. But we were also interested in their struggles amongst themselves, and particularly between the beasts and the victims of prey. These twin struggles, against nature and other animals, reflected real-life struggles in the human world.

Not that we neglected stories with human beings as the main characters. There were two types of characters in such human-centred narratives: the species of truly human beings with qualities of courage, kindness, mercy, hatred of evil, concern for others; and a man-eat-man two-mouthed species with qualities of greed, selfishness, individualism and hatred of what was good for the larger co-operative community. Co-operation as the ultimate good in a community was a constant theme. It could unite human beings with animals against ogres and beasts of prey, as in the story of how dove, after being fed with castor-oil seeds, was

sent to fetch a smith working far away from home and whose pregnant wife was being threatened by these man-eating two-mouthed ogres.

There were good and bad story-tellers. A good one could tell the same story over and over again, and it would always be fresh to us, the listeners. He or she could tell a story told by someone else and make it more alive and dramatic. The differences really were in the use of words and images and the inflexion of voices to effect different tones.

We therefore learnt to value words for their meaning and nuances. Language was not a mere string of words. It had a suggestive power well beyond the immediate and lexical meaning. Our appreciation of the suggestive magical power of language was reinforced by the games we played with words through riddles, proverbs, transpositions of syllables, or through nonsensical but musically arranged words.[1] So we learnt the music of our language on top of the content. The language, through images and symbols, gave us a view of the world, but it had a beauty of its own. The home and the field were then our pre-primary school but what is important, for this discussion, is that the language of our evening teach-ins, and the language of our immediate and wider community, and the language of our work in the fields were one.

And then I went to school, a colonial school, and this harmony was broken. The language of my education was no longer the language of my culture. I first went to Kamaandura, missionary run, and then to another called Maanguuũ run by nationalists grouped around the Gĩkũyũ Independent and Karinga Schools Association. Our language of education was still Gĩkũyũ. The very first time I was ever given an ovation for my writing was over a composition in Gĩkũyũ. So for my first four years there was still harmony between the language of my formal education and that of the Limuru peasant community.

It was after the declaration of a state of emergency over Kenya in 1952 that all the schools run by patriotic nationalists were taken over by the colonial regime and were placed under District Education Boards chaired by Englishmen. English became the language of my formal education. In Kenya, English became more than a language: it was *the* language, and all the others had to bow before it in deference.

Thus one of the most humiliating experiences was to be caught speaking Gĩkũyũ in the vicinity of the school. The culprit was given corporal punishment – three to five strokes of the cane on bare buttocks – or was made to carry a metal plate around the neck with inscriptions such as I AM STUPID or I AM A DONKEY. Sometimes the culprits were fined money they could hardly afford. And how did the teachers catch the culprits? A button was initially given to one pupil who was supposed to hand it over to whoever was caught speaking his mother tongue. Whoever had the button at the end of the day would sing who had given it to him and the ensuing process would bring out all the culprits of the day. Thus children were turned into witch-hunters and in the process were being taught the lucrative value of being a traitor to one's immediate community.

The attitude to English was the exact opposite: any achievement in spoken or written English was highly rewarded; prizes, prestige, applause; the ticket to higher realms. English became the measure of intelligence and ability in the arts, the sciences, and all the other branches of learning. English

became *the* main determinant of a child's progress up the ladder of formal education.

As you may know, the colonial system of education in addition to its apartheid racial demarcation had the structure of a pyramid: a broad primary base, a narrowing secondary middle, and an even narrower university apex. Selections from primary into secondary were through an examination, in my time called Kenya African Preliminary Examination, in which one had to pass six subjects ranging from Maths to Nature Study and Kiswahili. All the papers were written in English. Nobody could pass the exam who failed the English language paper no matter how brilliantly he had done in the other subjects. I remember one boy in my class of 1954 who had distinctions in all subjects except English, which he had failed. He was made to fail the entire exam. He went on to become a turn boy in a bus company. I who had only passes but a credit in English got a place at the Alliance High School, one of the most elitist institutions for Africans in colonial Kenya. The requirements for a place at the University, Makerere University College, were broadly the same: nobody could go on to wear the undergraduate red gown, no matter how brilliantly they had performed in all the other subjects unless they had a credit – not even a simple pass! – in English. Thus the most coveted place in the pyramid and in the system was only available to the holder of an English language credit card. English was the official vehicle and the magic formula to colonial elitedom.

Literary education was now determined by the dominant language while also reinforcing that dominance. Orature (oral literature) in Kenyan languages stopped. In primary school I now read simplified Dickens and Stevenson alongside Rider Haggard. Jim Hawkins, Oliver Twist, Tom Brown – not Hare, Leopard and Lion – were now my daily companions in the world of imagination. In secondary school, Scott and G. B. Shaw vied with more Rider Haggard, John Buchan, Alan Paton, Captain W. E. Johns. At Makerere I read English: from Chaucer to T. S. Eliot with a touch of Graham Greene.

Thus language and literature were taking us further and further from ourselves to other selves, from our world to other worlds.

What was the colonial system doing to us Kenyan children? What were the consequences of, on the one hand, this systematic suppression of our languages and the literature they carried, and on the other the elevation of English and the literature it carried? To answer those questions, let me first examine the relationship of language to human experience, human culture, and the human perception of reality.

Language, any language, has a dual character: it is both a means of communication and a carrier of culture. Take English. It is spoken in Britain and in Sweden and Denmark. But for Swedish and Danish people English is only a means of communication with non-Scandinavians. It is not a carrier of their culture. For the British, and particularly the English, it is additionally, and inseparably from its use as a tool of communication, a carrier of their culture and history. Or take Swahili in East and Central Africa. It is widely used as a means of communication across many of nationalities. But it is not the carrier of a culture and history of many of those nationalities. However in parts of Kenya and Tanzania, and

particularly in Zanzibar, Swahili is inseparably both a means of communication and a carrier of the culture of those people to whom it is a mother-tongue.

Language as communication has three aspects or elements. There is first what Karl Marx once called the language of real life,[2] the element basic to the whole notion of language, its origins and development: that is, the relations people enter into with one another in the labour process, the links they necessarily establish among themselves in the act of a people, a community of human beings, producing wealth or means of life like food, clothing, houses. A human community really starts its historical being as a community of co-operation in production through the division of labour; the simplest is between man, woman and child within a household; the more complex divisions are between branches of production such as those who are sole hunters, sole gatherers of fruits or sole workers in metal. Then there are the most complex divisions such as those in modern factories where a single product, say a shirt or a shoe, is the result of many hands and minds. Production is co-operation, is communication, is language, is expression of a relation between human beings and it is specifically human.

The second aspect of language as communication is speech and it imitates the language of real life, that is communication in production. The verbal signposts both reflect and aid communication or the relations established between human beings in the production of their means of life. Language as a system of verbal signposts makes that production possible. The spoken word is to relations between human beings what the hand is to the relations between human beings and nature. The hand through tools mediates between human beings and nature and forms the language of real life: spoken words mediate between human beings and form the language of speech.

The third aspect is the written sign. The written word imitates the spoken. Where the first two aspects of language as communication through the hand and the spoken word historically evolved more or less simultaneously, the written aspect is a much later historical development. Writing is representation of sounds with visual symbols, from the simplest knot among shepherds to tell the number in a herd or the hieroglyphics among the Agĩkũyũ *gicaandi* singers and poets of Kenya, to the most complicated and different letter and picture writing systems of the world today.

In most societies the written and the spoken languages are the same, in that they represent each other: what is on paper can be read to another person and be received as that language which the recipient has grown up speaking. In such a society there is broad harmony for a child between the three aspects of language as communication. His interaction with nature and with other men is expressed in written and spoken symbols or signs which are both a result of that double interaction and a reflection of it. The association of the child's sensibility is with the language of his experience of life.

But there is more to it: communication between human beings is also the basis and process of evolving culture. In doing similar kinds of things and actions over and over again under similar circumstances, similar even in their mutability, certain patterns, moves, rhythms, habits, attitudes, experiences and knowledge emerge. Those experiences are handed over to the next generation and become the inherited basis for their further actions on nature and on themselves.

There is a gradual accumulation of values which in time become almost self-evident truths governing their conception of what is right and wrong, good and bad, beautiful and ugly, courageous and cowardly, generous and mean in their internal and external relations. Over a time this becomes a way of life distinguishable from other ways of life. They develop a distinctive culture and history. Culture embodies those moral, ethical and aesthetic values, the set of spiritual eyeglasses, through which they come to view themselves and their place in the universe. Values are the basis of a people's identity, their sense of particularity as members of the human race. All this is carried by language. Language as culture is the collective memory bank of a people's experience in history. Culture is almost indistinguishable from the language that makes possible its genesis, growth, banking, articulation and indeed its transmission from one generation to the next.

Language as culture also has three important aspects. Culture is a product of the history which it in turn reflects. Culture in other words is a product and a reflection of human beings communicating with one another in the very struggle to create wealth and to control it. But culture does not merely reflect that history, or rather it does so by actually forming images or pictures of the world of nature and nurture. Thus the second aspect of language as culture is as an image-forming agent in the mind of a child. Our whole conception of ourselves as a people, individually and collectively, is based on those pictures and images which may or may not correctly correspond to the actual reality of the struggles with nature and nurture which produced them in the first place. But our capacity to confront the world creatively is dependent on how those images correspond or not to that reality, how they distort or clarify the reality of our struggles. Language as culture is thus mediating between me and my own self; between my own self and other selves; between me and nature. Language is mediating in my very being. And this brings us to the third aspect of language as culture. Culture transmits or imparts those images of the world and reality through the spoken and the written language, that is through a specific language. In other words, the capacity to speak, the capacity to order sounds in a manner that makes for mutual comprehension between human beings is universal. This is the universality of language, a quality specific to human beings. It corresponds to the universality of the struggle against nature and that between human beings. But the particularity of the sounds, the words, the word order into phrases and sentences, and the specific manner, or laws, of their ordering is what distinguishes one language from another. Thus a specific culture is not transmitted through language in its universality but in its particularity as the language of a specific community with a specific history. Written literature and orature are the main means by which a particular language transmits the images of the world contained in the culture it carries.

Language as communication and as culture are then products of each other. Communication creates culture: culture is a means of communication. Language carries culture, and culture carries, particularly through orature and literature, the entire body of values by which we come to perceive ourselves and our place in the world. How people perceive themselves affects how they look at their culture, at their politics and at the social production of wealth, at their entire relationship to nature and to other beings. Language is thus inseparable from

ourselves as a community of human beings with a specific form and character, a specific history, a specific relationship to the world.

So what was the colonialist imposition of a foreign language doing to us children?

The real aim of colonialism was to control the people's wealth: what they produced, how they produced it and how it was distributed; to control, in other words, the entire realm of the language of real life. Colonialism imposed its control of the social production of wealth through military conquest and subsequent political dictatorship. But its most important area of domination was the mental universe of the colonised: the control, through culture, of how people perceived themselves and their relationship to the world. Economic and political control can never be complete or effective without mental control. To control a people's culture is to control their tools of self-definition in relations to others.

For colonialism this involved two aspects of the same process: the destruction or the deliberate undervaluing of a people's culture, their art, dances, religions, history, geography, education, orature and literature, and the conscious elevation of the language of the coloniser. The domination of a people's language by the languages of the colonising nations was crucial to the domination of the mental universe of the colonised.

Take language as communication. Imposing a foreign language, and suppressing the native languages as spoken and written, were already breaking the harmony previously existing between the African child and the three aspects of language. Since the new language as a means of communication was a product of and was reflecting the 'real language of life' elsewhere, it could never as spoken or written properly reflect or imitate the real life of that community. This may in part explain why technology always appears to us as slightly external, *their* product and not *ours*. The word 'missile' used to hold an alien far-away sound until. I recently learnt its equivalent in Gĩkũyũ, *ngurukuhĩ*, and it made me apprehend it differently. Learning, for a colonial child, became a cerebral activity and not an emotionally felt experience.

But since the new, imposed languages could never completely break the native languages as spoken, their most effective area of domination was the third aspect of language as communication, the written. The language of an African child's formal education was foreign. The language of the books he read was foreign. The language of his conceptualisation was foreign. Thought, in him, took the visible form of a foreign language. So the written language of a child's upbringing in the school (even his spoken language within the school compound) became divorced from his spoken language at home. There was often not the slightest relationship between the child's written world, which was also the language of his schooling, and the world of his immediate environment in the family and the community. For a colonial child, the harmony existing between the three aspects of language as communication was irrevocably broken. This resulted in the disassociation of the sensibility of that child from his natural and social environment, what we might call colonial alienation. The alienation became reinforced in the teaching of history, geography, music, where bourgeois Europe was always the centre of the universe.

This disassociation, divorce, or alienation from the immediate environment becomes clearer when you look at colonial language as a carrier of culture.

Since culture is a product of the history of a people which it in turn reflects, the child was now being exposed exclusively to a culture that was a product of a world external to himself. He was being made to stand outside himself to look at himself. *Catching Them Young* is the title of a book on racism, class, sex, and politics in children's literature by Bob Dixon. 'Catching them young' as an aim was even more true of a colonial child. The images of this world and his place in it implanted in a child take years to eradicate, if they ever can be.

Since culture does not just reflect the world in images but actually, through those very images, conditions a child to see that world in a certain way, the colonial child was made to see the world and where he stands in it as seen and defined by or reflected in the culture of the language of imposition.

And since those images are mostly passed on through orature and literature it meant the child would now only see the world as seen in the literature of his language of adoption. From the point of view of alienation, that is of seeing oneself from outside oneself as if one was another self, it does not matter that the imported literature carried the great humanist tradition of the best in Shakespeare, Goethe, Balzac, Tolstoy, Gorky, Brecht, Sholokhov, Dickens. The location of this great mirror of imagination was necessarily Europe and its history and culture and the rest of the universe was seen from that centre.

But obviously it was worse when the colonial child was exposed to images of his world as mirrored in the written languages of his coloniser. Where his own native languages were associated in his impressionable mind with low status, humiliation, corporal punishment, slow-footed intelligence and ability or downright stupidity, non-intelligibility and barbarism, this was reinforced by the world he met in the works of such geniuses of racism as a Rider Haggard or a Nicholas Monsarrat; not to mention the pronouncement of some of the giants of western intellectual and political establishment, such as Hume ('. . . the negro is naturally inferior to the whites . . .'),[3] Thomas Jefferson ('. . . the blacks . . . are inferior to the whites on the endowments of both body and mind . . .'),[4] for Hegel with his Africa comparable to a land of childhood still enveloped in the dark mantle of the night as far as the development of self-conscious history was concerned. Hegel's statement that there was nothing harmonious with humanity to be found in the African character is representative of the racist images of Africans and Africa such a colonial child was bound to encounter in the literature of the colonial languages.[5] The results could be disastrous.

In her paper read to the conference on the teaching of African literature in schools held in Nairobi in 1973, entitled 'Written Literature and Black Images',[6] the Kenyan writer and scholar Professor Mĩcere Mũgo related how a reading of the description of Gagool as an old African woman in Rider Haggard's *King Solomon's Mines* had for a long time made her feel mortal terror whenever she encountered old African women. In his autobiography *This Life* Sydney Poitier describes how, as a result of the literature he had read, he had come to associate Africa with snakes. So on arrival in Africa and being put up in a modern hotel in a modern city, he could not sleep because he kept on looking for snakes everywhere, even under the bed. These two have been able to pinpoint the origins of

their fears. But for most others the negative image becomes internalised and it affects their cultural and even political choices in ordinary living.

Thus Léopold Sédar Senghor has said very clearly that although the colonial language had been forced upon him, if he had been given the choice he would still have opted for French. He becomes lyrical in his subservience to French:

> We express ourselves in French since French has a universal vocation and since or message is also addressed to French people and others. In our languages [i.e. African languages] the halo that surrounds the words is by nature merely that of sap and blood; French words send out thousands of rays like diamonds.[7]

Senghor has now been rewarded by being anointed to an honoured place in the French Academy – that institution for safe-guarding the purity of the French language.

In Malawi, Banda has erected his own monument by way of an institution, The Kamuzu Academy, designed to aid the brightest pupils of Malawi in their mastery of English.

> It is a grammar school designed to produce boys and girls who will be sent to universities like Harvard, Chicago, Oxford, Cambridge and Edinburgh and be able to compete on equal terms with others else-where.
>
> The President has instructed that Latin should occupy a central place in the curriculum. All teachers must have had at least some Latin in their academic background. Dr Banda has often said that no one can fully master English without knowledge of languages such as Latin and French...[8]

For good measure no Malawian is allowed to teach at the academy – none is good enough – and all the teaching staff has been recruited from Britain. A Malawian might lower the standards, or rather, the purity of the English language. Can you get a more telling example of hatred of what is national, and a servile worship of what is foreign even though dead?

In history books and popular commentaries on Africa, too much has been made of the supposed differences in the policies of the various colonial powers, the British indirect rule (or the pragmatism of the British in their lack of a cultural programme!) and the French and Portuguese conscious programme of cultural assimilation. These are a matter of detail and emphasis. The final effect was the same: Senghor's embrace of French as this language with a universal vocation is not so different from Chinua Achebe's gratitude in 1964 to English – 'those of us who have inherited the English language may not be in a position to appreciate the value of the inheritance'.[9] The assumptions behind the practice of those of us who have abandoned our mother-tongues and adopted European ones as the creative vehicles of our imagination, are not different either. [...] It is the final triumph of a system of domination when the dominated start singing its virtues.

[...]

Notes

1 Example from a tongue twister: 'Kaana ka Nikoora koona koora koora: na ko koora koona kaana ka Nikoora koora koora.' I'm indebted to Wangui wa Goro for this example. 'Nichola's child saw a baby frog and ran away: and when the baby frog saw Nichola's child it also ran away.' A Gĩkũyũ speaking child has to get the correct tone and length of vowel and pauses to get it right. Otherwise it becomes a jumble of *k's* and *r's* and *na's*.

2 'The production of ideas, of conceptions, of consciousness, is at first directly interwoven with the material activity and the material intercourse of men, the language of real life. Conceiving, thinking, the mental intercourse of men, appear at this stage as the direct efflux of their material behaviour. The same applies to mental production as expressed in the language of politics, laws, morality, religion, metaphysics, etc., of a people. Men are the producers of their conceptions, ideas etc. – real, active men, as they are conditioned by a definite development of their productive forces and of the intercourse corresponding to these, up to its furthest form.' Marx and Engels, German Ideology, the first part published under the title, *Feuerbach: Opposition of the Materialist and Idealist Outlooks*, London: 1973, p. 8.

3 Quoted in Eric Williams *A History of the People of Trinidad and Tobago*, London 1964, p. 32.

4 Eric Williams, ibid., p. 31.

5 In references to Africa in the introduction to his lectures in *The Philosophy of History*, Hegel gives historical, philosophical, rational expression and legitimacy to every conceivable European racist myth about Africa. Africa is even denied her own geography where it does not correspond to the myth. Thus Egypt is not part of Africa; and North Africa is part of Europe. Africa proper is the especial home of ravenous beasts, snakes of all kinds. The African is not part of humanity. Only slavery to Europe can raise him, possibly, to the lower ranks of humanity. Slavery is good for the African. 'Slavery is in and for itself *injustice*, for the essence of humanity is *freedom*; but for this man must be matured. The gradual abolition of slavery is therefore wiser and more equitable than its sudden removal.' (Hegel *The Philosophy of History*, Dover edition, New York: 1956, pp. 91–9.) Hegel clearly reveals himself as the nineteenth-century Hitler of the intellect.

6 The paper is now in Akivaga and Gachukiah's *The Teaching of African Literature in Schools*, published by Kenya Literature Bureau.

7 Senghor, Introduction to his poems, 'Éthiopiques, le 24 Septembre 1954', in answering the question: 'Pourquoi, dès lors, écrivez-vous en français?' Here is the whole passage in French. See how lyrical Senghor becomes as he talks of his encounter with French language and French literature:

> Mais on me posera la question: 'Pourquoi, dès lors, écrivez-vous en français?' parce que nous sommes des métis culturels, parce que, si nous sentons en nègres, nous nous exprimons en français, parce que le français est une langue à vocation universelle, que notre message s'adresse *aussi* aux Français de France et aux autres hommes, parce que le français est une langue 'de gentillesse et d'honnêteté'. Qui a dit que c'était une langue grise et atone

d'ingénieurs et de diplomates? Bien sûr, moi aussi, je l'ai dit un jour, pour les besoins de ma thèse. On me le pardonnera. Car je sais ses ressources pour l'avoir goûté, mâché, enseigné, et qu'il est la langue des dieux. Ecoutez donc Corneille, Lautréamont, Rimbaud, Péguy et Claudel. Écoutez le grand Hugo. Le français, ce sont les grandes orgues qui se prêtent à tous les timbres, à tous les effets, des douceurs les plus suaves aux fulgurances de l'orage. Il est, tour à tour ou en même temps, flûte, hautbois, trompette, tamtam et même canon. Et puis le français nous a fait don de ses mots abstraits – si rares dans nos langues maternelles –, où les larmes se font pierres précieuses. Chez nous, les mots sont naturellement nimbés d'un halo de sève et de sang; les mots du français rayonnent de mille feux, comme des diamants. Des fusées qui éclairent notre nuit.

See also Senghor's reply to a question on language in an interview by Armand Guiber and published in *Présence Africaine* 1962 under the title, Leópold Sédar Senghor:

Il est vrai que le français n'est pas ma langue maternelle. J'ai commencé de l'apprendre à sept ans, par des mots comme 'confitures' et 'chocolat'. Aujourd'-hui, je pense naturellement en Français, et je comprend le Français – faut-il en avoir honte? Mieux qu'aucune autre langue. C'est dire que le Français n'est plus pour moi un 'véhicule étranger' mais la forme d'expression naturelle de ma pensée.

Ce qui m'est étrange dans le français, c'est peut-être son style: Son architecture classique. Je suis naturellement porté à gonfler d'image son cadre étroit, sans la poussée de la chaleur émotionelle.

8 *Zimbabwe Herald* August 1981.
9 Chinua Achebe 'The African Writer and the English Language' in *Morning Yet on Creation Day* p. 59.

LANGUAGE, CLASS AND EDUCATION

Mrs D'Urbeyfield habitually spoke the dialect; her daughter, who had passed the sixth Standard in the National school under a London-trained mistress, spoke two languages; the dialect at home, more or less; ordinary English abroad and to persons of quality.

(Thomas Hardy, *Tess of the D'Urbervilles*, [1891], 1985: 58)

THE TEXTS in this final section explore the ways in which language operates as the site upon which social divisions and distinctions, specifically those of class, are legitimated and reproduced in and through the education system. That is to say, how education, considered in liberal thought to be the place where people develop their capacities and change, becomes the medium which simply reinforces the inequalities which exist in the social order. For Foucault that is precisely its function: 'Every educational system is a political means of maintaining or modifying the appropriation of discourse, with the knowledge and powers it carries with it'. Whether this view of education can be sustained is an important question.

Bernstein's piece considers the different codes which he takes to characterise working-class and middle-class discourse, 'restricted' and 'elaborated' codes respectively. The restricted code is context-bound, local and particularistic; it does not provide adequate linguistic resources for the production of discourse capable of general or universal commentary. The elaborated code, on the other hand, is characterised precisely by its ability to facilitate forms of self-reflexive engagement with the world and universal concept formation. Though Bernstein does not posit a simple match between class and code, he argues that in general terms, working-class children are disempowered by educational systems. This occurs because they are required to negotiate the differences between the elaborated codes in use in academic contexts and the restricted codes which dominate in their home life. In the choice of terms Bernstein was perhaps naive, since his arguments were taken up by many on the right of the education debates and used to undermine the intelligence of working-class children and to attack particular modes of education. It is worth noting, however, that his work was designed to demonstrate exactly why many working-class children do not succeed academically compared to their middle-class peers; a situation which continues.

Labov's essay is set in opposition to the work of Bernstein. Working with working-class children in a black ghetto in New York, Labov provides an analysis of the complexity and intellectual potency which can be found in their speech. He

argues that socio-educational theories which explain the failure of these children in schools are seriously flawed and lead to both an inaccurate estimation of their intelligence and, consequently, a waste of resources. He proposes that the very methodology used by sociolinguists to produce evidence of the 'verbal deprivation' of such children is seriously flawed. First in its failure to recognise the distorting power of the formal interview, a mode which immediately favours the socially confident middle-class child. Second, in its use of criteria which find in the speech of the working-class black child precisely what sociolinguists expect to find. He argues instead that Black English Vernacular is as creative, logical and capable of meta-commentary as middle-class speech. Turning Bernstein's argument on its head, Labov describes the elaborated codes of middle-class speech as verbose and lacking in clarity.

Bourdieu addresses the manner in which the legitimate or standard language is both a product of, and carries with it, forms of social evaluation. It rests at the apex of a hierarchy of social languages which reflects the social hierarchy and forms of authority, distinguishing between speakers on the basis of the language they use. For Bourdieu, the production and reproduction of the legitimate language is one of the functions of education as it evaluates and distinguishes between forms of language (regional dialects and class-based accents for example). He argues that debates about the intrinsic qualities of particular usage (as in the dispute between Labov and Bernstein) miss the point. His conclusion is that what is at stake here is not so much whether one form of language is any clearer, or verbose, or restricted, but which is posited as the legitimate language by the workings of a linguistic market which reflects that of society in general. Whether the example of a competitive market is a fitting model for the unequal distribution of linguistic resources is a matter for discussion.

The Standard Language issue is one which has bedevilled discussions around education in Britain for almost as long as the term has existed (it was coined in 1858, in the *Proposal* for what was to become the *Oxford English Dictionary*, to refer to the dictionary-makers' object of study). It has been the source of lamentable confusion and dangerous muddle-headedness in crucial debates. In his essay Brian Cox, an important figure in these discussions since the 1960s, explores the issues of language, class and education on the basis of his role in the formulation of a national curriculum for schools in the context of a multi-cultural and ethnically diverse population. Similar questions have been faced in the United States of America in relation to the 'English-first' campaign. The quality of the debate in Britain is revealed by the distinction which Cox needs to stress between a form of pronunciation – Received Pronunciation (used by approximately two per cent of the population) – and a form of language – Standard English. Conservative cabinet ministers in the 1980s were but the latest in a long line of politicians and educationalists to have confused the two. Cox's account argues that Standard English should be perceived as a form of social and cultural empowerment for all children in Britain regardless of their class or ethnic background. It must be pointed out, however, that Cox's essay still maintains one of the most common types of confusion in this area: that between the written language and the spoken. It is quite clear what the written standard language refers to; the concept of a spoken standard

language is a different matter altogether and one which needs a good deal of research before it can be used in such important educational debates as these.

Further reading

Bernstein and linguistic disadvantage

Bernstein, B. (1964) 'Elaborated and Restricted Codes: Their Social Origin and Some Consequences', *American Anthropologist* 66.6 (2), pp. 55–69.
—— (1971) *Class, Codes and Control, Volume 1: Theoretical Studies Towards a Sociology of Language*, London: Routledge & Kegan Paul.
—— (1972) 'Social Class, Language and Socialization', in P. P. Giglioli (ed.) *Language and Social Context: Selected Readings*, Harmondsworth: Penguin, pp. 157–78.
Atkinson, P. (1985) *Language, Structure and Reproduction: An Introduction to the Sociology of Basil Bernstein*, London: Methuen.
Rosen, H. (1972) *Language and Class: A Critical Look at the Theories of Basil Bernstein*, Bristol: Falling Wall Press.
Wardhaugh, R. (1992) *An Introduction to Sociolinguistics*, 2nd edn., Oxford: Basil Blackwell, chapter 14.
Edwards, J.R. (1979) *Language and Disadvantage*, London: Arnold.
Halliday, M.A.K. (1978) *Language as Social Semiotic: The Social Interpretation of Language and Meaning*, London: Edward Arnold, chapters 4–6.

Labov and Black English Vernacular

Labov, W. (1972) *Language in the Inner City: Studies in the Black English Vernacular*, Oxford: Blackwell.
—— (1982) 'Objectivity and Commitment in Linguistic Science: The Case of the Black English Trial in Ann Arbor', *Language in Society* 11, pp. 165–201.
Montgomery, M. (1995) *An Introduction to Language and Society*, 2nd edn., London: Routledge, chapter 4.
Burling, R. (1973) *English in Black and White*, New York: Holt, Reinhart and Winston.
Dillard, J.L. (1972) *Black English: Its History and Usage in the United States*, New York: Random House.
Edwards, V.K. (1986) *Language in a Black Community*, Clevedon, Avon: Multilingual Matters.
Sutcliffe, D. (1982) *Black British English*, Oxford: Basil Blackwell.

Bourdieu and cultural capital

Bourdieu, P. (1984) *Distinction: A Social Critique of the Judgement of Taste*, trans. R. Nice, London: Routledge & Kegan Paul.
Thompson, John B. (1984) *Studies in the Theory of Ideology*, Cambridge: Polity Press, pp. 42–72.
—— (1991) 'Editor's Introduction', in P. Bourdieu, *Language and Symbolic Power*, ed. J.B. Thompson, Oxford: Polity, pp. 1–31.
Garnham, N. and R. Williams (1980) 'Pierre Bourdieu and the Sociology of Culture: An Introduction', *Media, Culture and Society* 2, pp. 209–23.
Bourdieu, P. and J-C. Passeron (1990) *Reproduction in Education, Society and Culture*, trans. R. Nice, London: Sage, pp. 107–39.

Mugglestone, L. (1995) *'Talking Proper': The Rise of Accent as a Social Symbol*, Oxford: Clarendon.

Crowley, T. (1991) *Proper English? Readings in Language, History and Cultural Identity*, London: Routledge.

Language class and education

Montgomery, M. (1995) *An Introduction to Language and Society*, 2nd edn., London: Routledge, chapters 6–7.

Romaine, S. (1994) *Language in Society: An Introduction to Sociolinguistics*, Oxford: Oxford University Press, chapter 7.

Edwards, A.D. (1976) *Language in Culture and Class*, London: Heinemann.

Stubbs, M. (1976) *Language, Schools and Classrooms*, London: Methuen.

Fairclough, N. (1989) *Language and Power*, London: Longman, chapter 9.

Crowley, T. (1989) *The Politics of Discourse: The Standard Language Question in British Cultural Debates*, London: Macmillan, chapter 7.

Cameron, D. and J. Coates, (eds) (1988) *Women in Their Speech Communities*, London: Longman, chapter 3.

Honey, J. (1983) *The Language Trap*, Middlesex: National Council for Educational Standards.

—— (1997) *Language is Power: The Story of Standard English and Its Enemies*, London: Faber & Faber.

Marenbon, J. (1987) *English Our English: The New Orthodoxy Examined*, London: Centre for Policy Studies.

Lippi-Green, R. (1997) *English with an Accent: Language, Ideology and Discrimination in the United States*, New York: Routledge.

Basil Bernstein

SOCIAL CLASS, LANGUAGE AND SOCIALIZATION (1970)

[...] I am required to consider the relationship between language and socialization. It should be clear from these opening remarks that I am not concerned with language, but with speech, and concerned more specifically with the contextual constraints upon speech. [...]

The basic agencies of socialization in contemporary societies are the family, the peer group, school and work. It is through these agencies, and in particular through their relationship to each other, that the various orderings of society are made manifest.

Now it is quite clear that given this view of socialization it is necessary to limit the discussion. I shall limit our discussion to socialization within the family, but it should be obvious that the focusing and filtering of the child's experience within the family in a large measure is a microcosm of the macroscopic orderings of society. Our question now becomes: What are the sociological factors which affect linguistic performances within the family critical to the process of socialization?

Without a shadow of doubt the most formative influence upon the procedures of socialization, from a sociological viewpoint, is social class. The class structure influences work and educational roles and brings families into a special relationship with each other and deeply penetrates the structure of life experiences within the family. The class system has deeply marked the distribution of knowledge within society. It has given differential access to the sense that the world is permeable. It has sealed off communities from each other and has ranked these communities on a scale of invidious worth. We have three components, knowledge, possibility and invidious insulation. It would be a little naïve to believe that differences in knowledge, differences in the sense of the possible, combined with invidious insulation, rooted in differential *material* well-being, would not affect the forms of control and innovation in the socializing procedures

of different social classes. I shall go on to argue that the deep structure of communication itself is affected, but not in any final or irrevocable way.

As an approach to my argument, let me glance at the social distribution of knowledge. We can see that the class system has affected the distribution of knowledge. Historically, and now, only a tiny percentage of the population has been socialized into knowledge at the level of the meta-languages of control and innovation, whereas the mass of the population has been socialized into knowledge at the level of context-tied operations.

A tiny percentage of the population has been given access to the principles of intellectual change, whereas the rest have been denied such access. This suggests that we might be able to distinguish between two orders of meaning. One we could call universalistic, the other particularistic. Universalistic meanings are those in which principles and operations are made linguistically explicit, whereas particularistic orders of meaning are meanings in which principles and operation are relatively linguistically implicit. If orders of meaning are universalistic, then the meanings are less tied to a given context. The meta-languages of public forms of thought as these apply to objects and persons realize meanings of a universalistic type. Where meanings have this characteristic then individuals have access to the grounds of their experience and can change the grounds. Where orders of meaning are particularistic, where principles are linguistically implicit, then such meanings are less context-independent and *more* context-bound, that is, tied to a local relationship and to a local social structure. Where the meaning system is particularistic, much of the meaning is embedded in the context and may be restricted to those who share a similar contextual history. Where meanings are universalistic, they are in principle available to all because the principles and operations have been made explicit, and so public.

I shall argue that forms of socialization orient the child towards speech codes which control access to relatively context-tied or relatively context-independent meanings. Thus I shall argue that elaborated codes orient their users towards universalistic meanings, whereas restricted codes orient, sensitize, their users to particularistic meanings: that the linguistic realization of the two orders are different, and so are the social relationships which realize them. Elaborated codes are less tied to a given or local structure and thus contain the potentiality of change in principles. In the case of elaborated codes the speech may be freed from its evoking social structure and it can take on an autonomy. A university is a place organized around talk. Restricted codes are more tied to a local social structure and have a reduced potential for change in principles. Where codes are elaborated, the socialized has more access to the grounds of his own socialization, and so can enter into a reflexive relationship to the social order he has taken over. Where codes are restricted, the socialized has less access to the grounds of his socialization, and thus reflexiveness may be limited in range. *One of the effects of the class system is to limit access to elaborated codes.*

I shall go on to suggest that restricted codes have their basis in condensed symbols, whereas elaborated codes have their basis in articulated symbols; that restricted codes draw upon metaphor, whereas elaborated codes draw upon rationality; that these codes constrain the contextual use of language in critical socializing contexts and in this way regulate the orders of relevance and relation which

the socialized takes over. From this point of view, change in habitual speech codes involves changes in the means by which object and person relationship are realized.

I want first to start with the notions of elaborated and restricted speech variants. A variant can be considered as the contextual constraints upon grammatical-lexical choices.

Sapir, Malinowski, Firth, Vygotsky and Luria have all pointed out from different points of view that the closer the identifications of speakers the greater the range of shared interests, the more probable that the speech will take a specific form. The range of syntactic alternatives is likely to be reduced and the lexis to be drawn from a narrow range. Thus, the form of these social relations is acting selectively on the meanings to be verbally realized. In these relationships the intent of the other person can be taken for granted as the speech is played out against a back-drop of common assumptions, common history, common interests. As a result, there is less need to raise meanings to the level of explicitness or elaboration. There is a reduced need to make explicit through syntactic choices the logical structure of the communication. Further, if the speaker wishes to individualize his communication, he is likely to do this by varying the expressive associates of the speech. Under these conditions, the speech is likely to have a strong metaphoric element. In these situations the speaker may be more concerned with how something is said, when it is said; silence takes on a variety of meanings. Often in these encounters the speech cannot be understood apart from the context, and the context cannot be read by those who do not share the history of the relationships. Thus the form of the social relationship acts selectively in the meanings to be verbalized, which in turn affect the syntactic and lexical choices. The unspoken assumptions underlying the relationship are not available to those who are outside the relationship. For these are limited, and restricted to the speakers. The symbolic form of the communication is condensed, yet the specific cultural history of the relationship is alive in its form. We can say that the roles of the speakers are communalized roles. Thus, we can make a relationship between restricted social relationships based upon communalized roles and the verbal realization of their meaning. In the language of the earlier part of this paper, restricted social relationships based upon communalized roles evoke particularistic, that is, context-tied, meanings, realized through a restricted speech variant.

Imagine a husband and wife have just come out of the cinema, and are talking about the film: 'What do you think?' 'It had a lot to say' 'Yes, I thought so too – let's go to the Millers, there may be something going there'. They arrive at the Millers, who ask about the film. An hour is spent in the complex, moral, political, aesthetic subtleties of the film and its place in the contemporary scene. Here we have an elaborated variant; the meanings now have to be made public to others who have not seen the film. The speech shows careful editing, at both the grammatical and lexical levels, It is no longer context-tied. The meanings are explicit, elaborated and individualized. Whilst expressive channels are clearly relevant, the burden of meaning inheres predominantly in the verbal channel. The experience of the listeners cannot be taken for granted. Thus each member of the group is on his own as he offers his interpretation. Elaborated variants of this

kind involve the speakers in particular role relationships, and *if you cannot manage the role, you can't produce the appropriate speech*. For as the speaker proceeds to individualize his meanings, he is differentiated from others like a figure from its ground.

The roles receive less support from each other. There is a measure of isolation. *Difference* lies at the basis of the social relationship, and is made verbally active, whereas in the other context it is *consensus*. The insides of the speaker have become psychologically active through the verbal aspect of the communication. Various defensive strategies may be used to decrease potential vulnerability of self and to increase the vulnerability of others. The verbal aspect of the communication becomes a vehicle for the transmission of individuated symbols. The 'I' stands over the 'we'. Meanings which are discrete to the speaker must be offered so that they are intelligible to the listener. Communalized roles have given way to individualized roles, condensed symbols to articulated symbols. Elaborated speech variants of this type realize universalistic meanings in the sense that they are less context-tied. Thus individualized roles are realized through elaborated speech variants which involve complex editing at the grammatical and lexical levels and which point to universalistic meanings.

Let me give another example. Consider the two following stories which Peter Hawkins, Assistant Research Officer in the Sociological Research Unit, University of London Institute of Education, constructed as a result of his analysis of the speech of middle-class and working-class five-year-old children. The children were given a series of four pictures which told a story and they were invited to tell the story. The first picture showed some boys playing football; in the second the ball goes through the window of a house; the third shows a woman looking out of the window and a man making an ominous gesture, and in the fourth the children are moving away.

Here are the two stories:

1 Three boys are playing football and one boy kicks the ball and it goes through the window the ball breaks the window and the boys are looking at it and a man comes out and shouts at them because they've broken the window so they run away and then that lady looks out of her window and she tells the boys off.

2 They're playing football and he kicks it and it goes through there it breaks the window and they're looking at it and he comes out and shouts at them because they've broken it so they run away and then she looks out and she tells them off.

With the first story the reader does not have to have the four pictures which were used as the basis for the story, whereas in the case of the second story the reader would require the initial pictures in order to make sense of the story. The first story is free of the context which generated it, whereas the second story is much more closely tied to its context. As a result the meanings of the second story are implicit, whereas the meanings of the first story are explicit. It is not that the working-class children do not have in their passive vocabulary the vocabulary used by the middle-class children. Nor is it the case that the children differ

in their tacit understanding of the linguistic rule system. Rather, what we have here are differences in the use of language arising out of a specific context. One child makes explicit the meanings which he is realizing through language for the person he is telling the story to, whereas the second child does not to the same extent. The first child takes very little for granted, whereas the second child takes a great deal for granted. Thus for the first child the task was seen as a context in which his meanings were required to be made explicit, whereas the task for the second child was not seen as a task which required such explication of meaning. It would not be difficult to imagine a context where the first child would produce speech rather like the second. What we are dealing with here are differences between the children in the way they realize in language-use apparently the same context. We could say that the speech of the first child generated universalistic meanings in the sense that the meanings are freed from the context and so understandable by all, whereas the speech of the second child generated particularistic meanings, in the sense that the meanings are closely tied to the context and would be fully understood by others only if they had access to the context which originally generated the speech.

It is again important to stress that the second child has access to a more differentiated noun phrase, but there is a restriction on its *use*. Geoffrey Turner, Linguist in the Sociological Research Unit, shows that working-class, five-year-old children in the same contexts examined by Hawkins, use fewer linguistic expressions of uncertainty when compared with the middle-class children. This does not mean that working-class children do *not* have access to such expressions, but that the eliciting speech context did not provoke them. Telling a story from pictures, talking about scenes on cards, *formally framed* contexts, do not encourage working-class children to consider the possibilities of alternate meanings and so there is a reduction in the linguistic expressions of uncertainty. Again, working-class children have access to a wide range of syntactic choices which involve the use of logical operators, 'because', 'but', 'either', 'or', 'only'. The constraints exist on the conditions for their *use*. Formally framed contexts used for eliciting context-independent universalistic meanings may evoke in the working-class child, relative to the middle-class child, restricted speech variants, because the working-class child has difficulty in managing the role relationships which such contexts require. This problem is further complicated when such contexts carry meanings very much removed from the child's cultural experience. In the same way we can show that there are constraints upon the middle-class child's use of language. Turner found that when middle-class children were asked to role-play in the picture story series, a higher percentage of these children, when compared with working-class children, initially refused. When the middle-class children were asked 'What is the man saying?' or linguistically equivalent questions, a relatively higher percentage said 'I don't know'. When this question was followed by the hypothetical question 'What do you think the man might be saying?' they offered their interpretations. The working-class children role-played without difficulty. It seems then that middle-class children at five need to have a very precise instruction to *hypothesize in that particular* context. This may be because they are more concerned here with getting their answers right or correct. When the children were invited to tell a story about some doll-like figures (a little boy, a

little girl, a sailor and a dog) the working-class children's stories were freer, longer and more imaginative than the stories of the middle-class children. The latter children's stories were tighter, constrained within a strong narrative frame. It was as if these children were dominated by what they took to be the *form* of a narrative and the content was secondary. This is an example of the concern of the middle-class child with the structure of the contextual frame. It may be worthwhile to amplify this further. A number of studies have shown that when working-class black children are asked to associate to a series of words, their responses show considerable diversity, both from the meaning and form-class of the stimulus word. Our analysis suggests this may be because the children for the following reasons are less constrained. The form-class of the stimulus word may have reduced associative significance and this would less constrain the selection of potential words *or* phrases. With such a weakening of the grammatical frame there is a greater range of alternatives as possible candidates for selection. Further, the closely controlled, middle-class, linguistic socialization of the young child may point the child towards both the grammatical significance of the stimulus word and towards a tight logical ordering of semantic space. Middle-class children may well have access to deep interpretative rules which regulate their linguistic responses in certain formalized contexts. The consequences may limit their imagination through the tightness of the frame which these interpretative rules create. [. . .] The socialization of the young in the family proceeds within a critical set of interrelated contexts. Analytically, we may distinguish four contexts.

1 The regulative context – these are authority relationships where the child is made aware of the rules of the moral order and their various backings.
2 The instructional context, where the child learns about the objective nature of objects and persons, and acquires skills of various kinds.
3 The imaginative or innovating contexts, where the child is encouraged to experiment and re-create his world on his own terms, and in his own way.
4 The interpersonal context, where the child is made aware of affective states – his own, and others.

I am suggesting that the critical orderings of a culture or subculture are made substantive – are made palpable – through the forms of its linguistic realizations of these four contexts – initially in the family and kin.

Now if the linguistic realization of these four contexts involves the predominant use of restricted speech variants, I shall postulate that the deep structure of the communication is a restricted code having its basis in communalized roles, realizing context-dependent meanings, i.e., particularistic meaning orders. Clearly the specific grammatical and lexical choices will vary from one to another.

If the linguistic realization of these four contexts involves the predominant usage of elaborated speech variants, I shall postulate that the deep structure of the communication is an elaborated code having its basis in individualized roles realizing context-independent universalistic meanings.

In order to prevent misunderstanding an expansion of the text is here

necessary. It is likely that where the code is restricted, the speech in the regulative context may well be limited to command and simple rule-announcing statements. The latter statements are not context-dependent in the sense previously given, for they announce general rules. We need to supplement the context-independent (universalistic) and context-dependent (particularistic) criteria with criteria which refer to the extent to which the speech in the regulative context varies in terms of its *contextual specificity*. If the speech is context-specific then the socializer cuts his meanings to the *specific* attributes intentions of the socialized, the specific characteristics of the problem, the specific requirements of the context. Thus the general rule may be transmitted with degrees of *contextual specificity*. When this occurs the rule is individualized (fitted to the local circumstances) in the process of its transmission. Thus with code elaboration we should expect:

1 Some developed grounds for the rule.
2 Some qualification of it in the light of the particular issue.
3 Considerable *specificity* in terms of the socialized, the context and the issue.

This does *not* mean that there would be an *absence* of command statements. It is also likely that with code elaboration the socialized would be *given* opportunities (role options) to question.

[. . .]

If we look at the linguistic realization of the regulative context in greater detail we may be able to clear up another source of possible misunderstanding. In this context it is very likely that syntactic markers of the logical distribution of meaning will be extensively used.

'If you do that, then . . .'
'Either you . . . or . . .'
'You can do that, but if . . .'
'You do that and you'll pay for it.

Thus it is very likely that all young children may well in the *regulative* context have access to a range of syntactic markers which express the logical/hypothetical, irrespective of code restriction or elaboration. However, where the code is restricted it is expected that there will be reduced specificity in the sense outlined earlier. Further, the speech in the control situation is likely to be well organized in the sense that the sentences come as wholes. The child responds to the total *frame*. However, I would suggest that the informal *instructional* contexts within the family may well be limited in range and frequency. Thus the child, of course, would have access to, and so have *available*, the hypotheticals, conditionals, disjunctives etc., but these might be rarely used in *instructional* contexts. In the same way, as we have suggested earlier, all children have access to linguistic expressions of uncertainty but they may differ in the context in which they receive and realize such expressions.

I must emphasize that because the code is restricted it does not mean that speakers at

no time will not use elaborated speech variants; only that the use of such variants will be infrequent in the socialization of the child in his family.

Now, all children have access to restricted codes and their various systems of condensed meaning, because the roles the code presupposes are universal. But there may well be selective access to elaborated codes because there is selective access to the role system which evokes its use. Society is likely to evaluate differently the experiences realized through these two codes. I cannot here go into details, but the different focusing of experience through a restricted code creates a major problem of educability only where the school produces discontinuity between its symbolic orders and those of the child. Our schools are not made for these children; why should the children respond? To ask the child to switch to an elaborated code which presupposes different role relationships and systems of meaning without a sensitive understanding of the required contexts may create for the child a bewildering and potentially damaging experience.

[. . .]

William Labov

THE LOGIC OF NON-STANDARD
ENGLISH (1969)

In the past decade, a great deal of federally sponsored research has been devoted to the educational problems of children in ghetto schools. In order to account for the poor performance of children in these schools, educational psychologists have attempted to discover what kind of disadvantage or defect they are suffering from. The viewpoint that has been widely accepted and used as the basis for large-scale intervention programs is that the children show a cultural deficit as a result of an impoverished environment in their early years. Considerable attention has been given to language. In this area the deficit theory appears as the concept of verbal deprivation. Black children from the ghetto area are said to receive little verbal stimulation, to hear very little well-formed language, and as a result are impoverished in their means of verbal expression. They cannot speak complete sentences, do not know the names of common objects, cannot form concepts or convey logical thoughts.

Unfortunately, these notions are based upon the work of educational psychologists who know very little about language and even less about black children. The concept of verbal deprivation has no basis in social reality. In fact, black children in the urban ghettos receive a great deal of verbal stimulation, hear more well-formed sentences than middle-class children, and participate fully in a highly verbal culture. They have the same basic vocabulary, possess the same capacity for conceptual learning, and use the same logic as anyone else who learns to speak and understand English.

The notion of verbal deprivation is a part of the modern mythology of educational psychology, typical of the unfounded notions which tend to expand rapidly in our educational system. In past decades linguists have been as guilty as others in promoting such intellectual fashions at the expense of both teachers and children. But the myth of verbal deprivation is particularly dangerous, because it diverts attention from real defects of our educational system to imaginary defects

of the child. As we shall see, it leads its sponsors inevitably to the hypothesis of the genetic inferiority of black children that it was originally designed to avoid.

[. . .]

Verbality

The general setting in which the deficit theory arises consists of a number of facts which are known to all of us. One is that black children in the central urban ghettos do badly in all school subjects, including arithmetic and reading. In reading, they average more than two years behind the national norm (see *New York Times*, December 3, 1968). Furthermore, this lag is cumulative so that they do worse comparatively in the fifth grade than in the first grade. Reports in the literature show that this poor performance is correlated most closely with socioeconomic status. Segregated ethnic groups seem to do worse than others – in particular, Indian, Mexican-American, and black children. Our own work in New York City confirms that most black children read very poorly; however, studies in the speech community show that the situation is even worse than has been reported. If one separates the isolated and peripheral individuals from members of central peer groups, the peer-group members show even worse reading records and to all intents and purposes are not learning to read at all during the time they spend in school.

In speaking of children in the urban ghetto areas, the term *lower class* frequently is used, as opposed to *middle class*. In the several sociolinguistic studies we have carried out, and in many parallel studies, it has been useful to distinguish a lower-class group from a working-class one. Lower-class families are typically female-based, or matrifocal, with no father present to provide steady economic support, whereas for the working-class there is typically an intact nuclear family with the father holding a semiskilled or skilled job. The educational problems of ghetto areas run across this important class distinction. There is no evidence, for example, that the father's presence or absence is closely correlated with educational achievement (e.g., Coleman *et al.* 1966). The peer groups we have studied in south-central Harlem, representing the basic vernacular culture, include members from both family types. The attack against cultural deprivation in the ghetto is overtly directed at family structures typical of lower-class families, but the educational failure we have been discussing is characteristic of both working-class and lower-class children.

This paper, therefore, will refer to children from urban ghetto areas rather than lower-class children. The population we are concerned with comprises those who participate fully in the vernacular culture of the street and who have been alienated from the school system.[1] We are obviously dealing with the effects of the caste system of American society – essentially a color-marking system. Everyone recognizes this. The question is: By what mechanism does the color bar prevent children from learning to read? One answer is the notion of cultural deprivation put forward by Martin Deutsch and others (Deutsch and associates 1967; Deutsch, Katz, and Jensen 1968). Black children are said to lack the favorable

factors in their home environment which enable middle-class children to do well in school (Deutsch and assoc. 1967; Deutsch, Katz, and Jensen 1968). These factors involve the development of various cognitive skills through verbal interaction with adults, including the ability to reason abstractly, speak fluently, and focus upon long-range goals. In their publications, these psychologists also recognize broader social factors.[2] However, the deficit theory does not focus upon the interaction of the black child with white society so much as on his failure to interact with his mother at home. In the literature we find very little direct observation of verbal interaction in the black home; most typically, the investigators ask the child if he has dinner with his parents, and if he engages in dinner-table conversation with them. He is also asked whether his family takes him on trips to museums and other cultural activities. This slender thread of evidence is used to explain and interpret the large body of tests carried out in the laboratory and in the school.

The most extreme view which proceeds from this orientation – and one that is now being widely accepted – is that lower-class black children have no language at all. The notion is first drawn from Basil Bernstein's writings that "much of lower-class language consists of a kind of incidental "emotional" accompaniment to action here and now." (Jensen 1968: 118). Bernstein's views are filtered through a strong bias against all forms of working-class behavior, so that middle-class language is seen as superior in every respect – as "more abstract, and necessarily somewhat more flexible, detailed and subtle." One can proceed through a range of such views until one comes to the practical program of Carl Bereiter, Siegfried Engelmann and their associates (Bereiter *et al.* 1966; Bereiter and Engelmann 1966). Bereiter's program for an academically oriented preschool is based upon the premise that black children must have a language with which they can learn, and the empirical finding that these children come to school without such a language. In his work with four-year-old black children from Urbana, Bereiter reports that their communication was by gestures, "single words," and "a series of badly connected words or phrases," such as *They mine* and *Me got juice*. He reports that black children could not ask questions, that "without exaggerating ... these four-year-olds could make no statements of any kind." Furthermore, when these children were asked "Where is the book?", they did not know enough to look at the table where the book was lying in order to answer. Thus Bereiter concludes that the children's speech forms are nothing more than a series of emotional cries, and he decides to treat them "as if the children had no language at all." He identifies their speech with his interpretation of Bernstein's restricted code: "the language of culturally deprived children ... is not merely an underdeveloped version of standard English, but is a basically nonlogical mode of expressive behavior" (Bereiter *et al.* 1966: 112–13). The basic program of his preschool is to teach them a new language devised by Engelmann, which consists of a limited series of questions and answers such as *Where is the squirrel? The squirrel is in the tree.* The children will not be punished if they use their vernacular speech on the play-ground, but they will not be allowed to use it in the schoolroom. If they should answer the question *Where is the squirrel?* with the illogical vernacular form *In the tree* they will be reprehended by various means and made to say, *The squirrel is in the tree.*

Linguists and psycholinguists who have worked with black children are apt to dismiss this view of their language as utter nonsense. Yet there is no reason to reject Bereiter's observations as spurious. They were certainly not made up. On the contrary, they give us a very clear view of the behavior of student and teacher which can be duplicated in any classroom. In our own work outside of adultdominated environments of school and home, we have not observed black children behaving like this. However, on many occasions we have been asked to help analyze the results of research into verbal deprivation conducted in such test situations.

[. . .]

Verbosity

There are undoubtedly many verbal skills which children from ghetto areas must learn in order to do well in the school situation, and some of these are indeed characteristic of middle-class verbal behavior. Precision in spelling, practice in handling abstract symbols, the ability to state explicitly the meaning of words, and a richer knowledge of the Latinate vocabulary, may all be useful acquisitions. But is it true that all of the middle-class verbal habits are functional and desirable in the school situation? Before we impose middle-class verbal style upon children from other cultural groups, we should find out how much of this is useful for the main work of analyzing and generalizing, and how much is merely stylistic – or even dysfunctional. In high school and college, middle-class children spontaneously complicate their syntax to the point that instructors despair of getting them to make their language simpler and clearer. In every learned journal one can find examples of jargon and empty elaboration, as well as complaints about it. Is the elaborated code of Bernstein really so "flexible, detailed and subtle" as some psychologists believe (e.g., Jensen 1969: 119)? Isn't it also turgid, redundant, bombastic, and empty? Is it not simply an elaborated style, rather than a superior code or system?[3]

Our work in the speech community makes it painfully obvious that in many ways working-class speakers are more effective narrators, reasoners, and debaters than many middle-class speakers who temporize, quality, and lose their argument in a mass of irrelevant detail. Many academic writers try to rid themselves of that part of middle-class style that is empty pretension and keep that part that is needed for precision. But the average middle-class speaker that we encounter makes no such effort; he is enmeshed in verbiage, the victim of sociolinguistic factors beyond his control.

I will not attempt to support this argument here with systematic quantitative evidence, although it is possible to develop measures which show how far middle-class speakers can wander from the point. I would like to contrast two speakers dealing with roughly the same topic – matters of belief. The first is Larry H., a fifteen-year-old core member of the Jets, being interviewed by John Lewis. Larry is one of the loudest and roughest members of the Jets, one who gives the least recognition to the conventional rules of politeness.[4] For most readers of this

book, first contact with Larry would produce some fairly negative reactions on both sides. It is probable that you would not like him any more than his teachers do. Larry causes trouble in and out of school. He was put back from the eleventh grade to the ninth, and has been threatened with further action by the school authorities.

> JL: What happens to you after you die? Do you know?
> LARRY: Yeah, I know. (What?) After they put you in the ground, your body turns into – ah – bones, an' shit.
> JL: What happens to your spirit?
> LARRY: Your spirit – soon as you die, your spirit leaves you. (And where does the spirit go?) Well, it all depends ... (On what?) You know, like some people say if you're good an' shit, your spirit goin' t'heaven ... 'n' if you bad, your spirit goin' to hell. Well, bullshit! Your spirit goin' to hell anyway, good or bad.
> JL: Why?
> LARRY: Why? I'll tell you why. 'Cause, you see, doesn' nobody really know that it's a God, y'know, 'cause I mean I have seen black gods, pink gods, white gods, all color gods and don't nobody know it's really a God An' when they be sayin' if you good, you goin' t'heaven, tha's bullshit, 'cause you ain't goin' to no heaven, 'cause it ain't no heaven for you to go to.

Larry is a paradigmatic speaker of black English vernacular as opposed to standard English. His grammar shows a high concentration of such characteristic BEV forms as negative inversion ("don't nobody know"), negative concord ("you ain't goin' to no heaven"), invariant be ("when they be sayin'"), dummy it for standard there ("it ain't no heaven"), optional copula deletion ("if you're good ... if you bad") and full forms of auxiliaries ("I have seen"). The only standard English influence in this passage is the one case of "doesn't" instead of the invariant "don't" of BEV. Larry also provides a paradigmatic example of the rhetorical style of BEV: he can sum up a complex argument in a few words, and the full force of his opinions comes through without qualification or reservation. He is eminently quotable, and his interviews give us many concise statements of the BEV point of view. One can almost say that Larry speaks the BEV culture (see CRR 3288, vol. 2: 38, 71–73, 291–92).

It is the logical form of this passage which is of particular interest here. Larry presents a complex set of interdependent propositions which can be explicated by setting out the standard English equivalents in linear order. The basic argument is to deny the twin propositions:

> (A) If you are good, (B) then your spirit will go to heaven.
> (~A) If you are bad, (C) then your spirit will go to hell.

Larry denies B and asserts that if A or ~ A, then C. His argument may be outlined as follows:

1 Everyone has a different idea of what God is like.
2 Therefore nobody really knows that God exists.
3 If there is a heaven, it was made by God.
4 If God doesn't exist, he couldn't have made heaven.
5 Therefore heaven does not exist.
6 You can't go somewhere that doesn't exist.
 (~B) Therefore you can't go to heaven.
 (C) Therefore you are going to hell.

<div align="center">[...]</div>

The reader will note the speed and precision of Larry's mental operations. He does not wander, or insert meaningless verbiage. The only repetition is 2, placed before and after 1 in his original statement. It is often said that the non-standard vernacular is not suited for dealing with abstract or hypothetical questions, but in fact speakers from the BEV community take great delight in exercising their wit and logic on the most improbable and problematical matters. Despite the fact that Larry does not believe in God and has just denied all knowledge of him, John Lewis advances the following hypothetical question:

> JL: ... but, just say that there is a God, what color is he? White or black?
> LARRY: Well, if it is a God ... I wouldn' know what color, I couldn' say, – couldn' nobody say what color he is or really would be.
> JL: But now, jus' suppose there was a God–
> LARRY: Unless'n they say ...
> JL: No, I was jus' sayin' jus' suppose there is a God, would he be white or black?
> LARRY: ... He'd be white, man.
> JL: Why?
> LARRY: Why? I'll tell you why. 'Cause the average whitey out here got everything, you dig? And the nigger ain't got shit, y'know? Y'unnerstan'? So – um – for – in order for *that* to happen, you know it ain't no black God that's doin' that bullshit.

No one can hear Larry's answer to this question without being convinced that they are in the presence of a skilled speaker with great "verbal presence of mind," who can use the English language expertly for many purposes. Larry's answer to John Lewis is again a complex argument. The formulation is not standard English, but it is clear and effective even for those not familiar with the vernacular. The nearest standard English equivalent might be: "So you know that God isn't black, because if he were, he wouldn't have arranged things like that."

The reader will have noted that this analysis is being carried out in standard English, and the inevitable challenge is: why not write in BEV, then, or in your own nonstandard dialect? The fundamental reason is, of course, one of firmly fixed social conventions. All communities agree that standard English is the proper medium for formal writing and public communication. Furthermore, it

seems likely that standard English has an advantage over BEV in explicit analysis of surface forms, which is what we are doing here. [. . .]

First, however, it will be helpful to examine standard English in its primary natural setting, as the medium for informal spoken communication of middle-class speakers.

Let us now turn to the second speaker, an upper-middle-class, college-educated black adult (Charles M.) being interviewed by Clarence Robins in our survey of adults in central Harlem.

> CR: Do you know of anything that someone can do, to have someone who has passed on visit him in a dream?
> CHARLES: Well, I even heard my parents say that there is such a thing as something in dreams, some things like that, and sometimes dreams do come true. I have personally never had a dream come true. I've never dreamt that somebody was dying and they actually died, (Mhm) or that I was going to have ten dollars the next day and somehow I got ten dollars in my pocket. (Mhm). I don't particularly believe in that, I don't think it's true. I do feel, though, that there is such a thing as – ah – witch craft. I do feel that in certain cultures there is such a thing as witchcraft, or some sort of *science* of witchcraft; I don't think that it's just a matter of believing hard enough that there is such a thing as witchcraft. I do believe that there is such a thing that a person can put himself in a state of *mind* (Mhm), or that – er – something could be given them to intoxicate them in a certain – to a certain frame of mind – that – that could actually be considered witchcraft.

Charles M. is obviously a good speaker who strikes the listener as well-educated, intelligent, and sincere. He is a likeable and attractive person, the kind of person that middle-class listeners rate very highly on a scale of job suitability and equally highly as a potential friend.[5] His language is more moderate and tempered than Larry's; he makes every effort to qualify his opinions and seems anxious to avoid any misstatements or overstatements. From these qualities emerge the primary characteristic of this passage – its verbosity. Words multiply, some modifying and qualifying, others repeating or padding the main argument. The first half of this extract is a response to the initial question on dreams, basically:

1 Some people say that dreams sometimes come true.
2 I have never had a dream come true.
3 Therefore I don't believe 1.

Some characteristic filler phrases appear here: *such a thing as, some things like that*, and *particularly*. Two examples of dreams given after 2 are afterthoughts that might have been given after 1. Proposition 3 is stated twice for no obvious reason. Nevertheless, this much of Charles M.'s response is well-directed to the point of the question. He then volunteers a statement of his beliefs about witchcraft which shows the difficulty of middle-class speakers who (a) want to express

a belief in something but (b) want to show themselves as judicious, rational, and free from superstitions. The basic proposition can be stated simply in five words: *But I believe in witchcraft*. However, the idea is enlarged to exactly 100 words and it is difficult to see what else is being said. In the following quotations, padding which can be removed without change in meaning is shown in parentheses.

1 "I (do) feel, though, that there is (such a thing as) witchcraft." *Feel* seems to be a euphemism for "believe".

2 "(I do feel that) in certain cultures (there is such a thing as witchcraft)." This repetition seems designed only to introduce the word *culture*, which lets us know that the speaker knows about anthropology. Does *certain cultures* mean "not in ours" or "not in all"?

3 "(or some sort of *science* of witchcraft.)" This addition seems to have no clear meaning at all. What is a "science" of witchcraft as opposed to just plain witchcraft?[6] The main function is to introduce the word *science*, though it seems to have no connection to what follows.

4 "I don't think that it's just (a matter of) believing hard enough that (there is such a thing as) witchcraft." The speaker argues that witchcraft is not merely a belief; there is more to it.

5 "I (do) believe that (there is such a thing that) a person can put himself in a state of mind . . . that (could actually be considered) witchcraft." Is witchcraft as a state of mind different from the state of belief, denied in 4?

6 "or that something could be given them to intoxicate them (to a certain frame of mind) . . ." The third learned word, *intoxicate*, is introduced by this addition. The vacuity of this passage becomes more evident if we remove repetitions, fashionable words and stylistic decorations:

> But I believe in witchcraft.
> I don't think witchcraft is just a belief.
>
> A person can put himself or be put in a state of mind that is witchcraft.

Without the extra verbiage and the "OK" words like *science, culture,* and *intoxicate*, Charles M. appears as something less than a first-rate thinker. The initial impression of him as a good speaker is simply our long-conditioned reaction to middle-class verbosity. We know that people who use these stylistic devices are educated people, and we are inclined to credit them with saying something intelligent. Our reactions are accurate in one sense. Charles M. is more educated than Larry. But is he more rational, more logical, more intelligent? Is he any better at thinking out a problem to its solution? Does he deal more easily with abstractions? There is no reason to think so. Charles M. succeeds in letting us know that he is educated, but in the end we do not know what he is trying to say, and neither does he.

In the previous section I have attempted to explain the origin of the myth that lower-class black children are nonverbal. The examples just given may help to account for the corresponding myth that middle-class language is in itself

better suited for dealing with abstract, logically complex, or hypothetical questions. These examples are intended to have a certain negative force. They are not controlled experiments. On the contrary, this and the preceding section are designed to convince the reader that the controlled experiments that have been offered in evidence are misleading. The only thing that is controlled is the superficial form of the stimulus. All children are asked "What do you think of capital punishment?" or "Tell me everything you can about this." But the speaker's interpretation of these requests and the action he believes is appropriate in response is completely uncontrolled. One can view these test stimuli as requests for information, commands for action, threats of punishment, or meaningless sequences of words. They are probably intended as something altogether different — as requests for display,[7] but in any case the experimenter is normally unaware of the problem of interpretation. The methods of educational psychologists used by Deutsch, Jensen, and Bereiter follow the pattern designed for animal experiments where motivation is controlled by simple methods as withholding food until a certain weight reduction is reached. With human subjects, it is absurd to believe that identical stimuli are obtained by asking everyone the same question.

Since the crucial intervening variables of interpretation and motivation are uncontrolled, most of the literature on verbal deprivation tells us nothing about the capacities of children. They are only the trappings of science, approaches that substitute the formal procedures of the scientific method for the activity itself. With our present limited grasp of these problems, the best we can do to understand the verbal capacities of children is to study them within the cultural context in which they were developed.

It is not only the black English vernacular which should be studied in this way, but also the language of middle-class children. The explicitness and precision which we hope to gain from copying middle-class forms are often the product of the test situation, and limited to it. For example, it was stated in the first part of this paper that working-class children hear more well-formed sentences than middle-class children. This statement may seem extraordinary in the light of the current belief of many linguists that most people do not speak in well-formed sentences, and that their actual speech production, or performance, is ungrammatical.[8] But those who have worked with any body of natural speech know that this is not the case. Our own studies (Labov 1966b) of the grammaticality of everyday speech show that the great majority of utterances in all contexts are complete sentences, and most of the rest can be reduced to grammatical form by a small set of editing rules. The proportions of grammatical sentences vary with class backgrounds and styles. The highest percentage of well-formed sentences are found in casual speech, and working-class speakers use more well-formed sentences than middle-class speakers. The widespread myth that most speech is ungrammatical is no doubt based upon tapes made at learned conferences, where we obtain the maximum number of irreducibly ungrammatical sequences.

It is true that technical and scientific books are written in a style which is markedly middle-class. But unfortunately, we often fail to achieve the explicitness and precision which we look for in such writing, and the speech of many middle-class people departs maximally from this target. All too often, standard

English is represented by a style that is simultaneously overparticular and vague. The accumulating flow of words buries rather than strikes the target. It is this verbosity which is most easily taught and most easily learned, so that words take the place of thoughts, and nothing can be found behind them.

When Bernstein (e.g., 1966) describes his elaborated code in general terms, it emerges as a subtle and sophisticated mode of planning utterances, where the speaker is achieving structural variety, taking the other person's knowledge into account, and so on. But when it comes to describing the actual difference between middle-class and working-class speakers (Bernstein 1966), we are presented with a proliferation of *I think*, of the passive, of modals and auxiliaries, of the first-person pronoun, of uncommon words, and so on. But these are the bench marks of hemming and hawing, backing and filling, that are used by Charles M., the devices that so often obscure whatever positive contribution education can make to our use of language. When we have discovered how much of middle-class style is a matter of fashion and how much actually helps us express ideas clearly, we will have done ourselves a great service. We will then be in a position to say what standard grammatical rules must be taught to non-standard speakers in the early grades.

[...]

Notes

1 The concept of the black English vernacular (BEV) and the culture in which it is embedded is presented in detail in CRR 3288; sections 1.2.3 and 4.1.

2 For example, in Deutsch, Katz and Jensen 1968 there is a section on "Social and Psychological Perspectives" which includes a chapter by Proshansky and Newton on "The Nature and Meaning of Negro Self-Identity" and one by Rosenthal and Jacobson on "Self-Fulfilling Prophecies in the Classroom."

3 The term *code* is central in Bernstein's (1966) description of the differences between working-class and middle-class styles of speech. The restrictions and elaborations of speech observed are labeled as codes to indicate the principles governing selection from the range of possible English sentences. No rules or detailed description of the operation of such codes are provided as yet, so that this central concept remains to be specified.

4 A direct view of Larry's verbal style in a hostile encounter is given in CRR 3288 Vol. 2:39–43. Gray's Oral Reading Test was being given to a group of Jets on the steps of a brownstone house in Harlem, and the landlord tried unsuccessfully to make the Jets move. Larry's verbal style in this encounter matches the reports he gives of himself in a number of narratives cited in section 4.8 of the report.

5 For a description of subjective reaction tests which utilize these evaluative dimensions see CRR 3288:4.6.

6 Several middle-class readers of this passage have suggested that *science* here refers to some form of control as opposed to belief. The science of witchcraft would then be a kind of engineering of mental states. Other interpretations can of course be provided. The fact remains that no such difficulties of interpretation are needed to understand Larry's remarks.

7 The concept of a request for verbal display is here drawn from a treatment of the therapeutic interview given by Alan Blum.

8 In several presentations, Chomsky has asserted that the great majority (95 percent) of the sentences which a child hears are ungrammatical. Chomsky (1965: 58) presents this notion as one of the arguments in his general statement of the nativist position: "A consideration of the character of the grammar that is acquired, the *degenerate quality and narrowly limited extent of the available data* [my emphasis], the striking uniformity of the resulting grammars, and their independence of intelligence, motivation, and emotional state, over wide ranges of variation, leave little hope that much of the structure of the language can be learned . . ."

References

Bereiter, Carl *et al.* (1966) An academically oriented pre-school for culturally deprived children, in *Pre-school Education Today*, ed. Fred M. Hechinger, New York: Doubleday.

Bereiter, Carl and Engelmann, Siegfried (1966) *Teaching Disadvantaged Children in the Pre-School*, Englewood Cliffs, NJ: Prentice-Hall.

Bernstein, Basil (1966) "Elaborated and restricted codes: their social origins and some consequences," in *The Ethnography of Communication*, J. Gumperz and D. Hymes (eds). Special publication, *American Anthropologist* 66 (6, part 2).

Chomsky, Noam (1965) *Aspects of the Theory of Syntax*, Cambridge, MA: MIT Press.

Coleman, J. S. *et al.* (1966) *Equality of Educational Opportunity*, Washington, DC: U.S. Government Printing Office.

Deutsch, Martin and associates (1967) *The Disadvantaged Child*, New York: Basic Books.

Deutsch, Martin, Katz, Irwin and Jensen, Arthur (1968) (eds) *Social Class, Race, and Psychological Development*, New York: Holt, Rinehart and Winston.

Jensen, Arthur (1969) "How much can we boost IQ and scholastic achievement?" *Harvard Educational Review* 39.

Pierre Bourdieu

THE PRODUCTION AND REPRODUCTION
OF LEGITIMATE LANGUAGE (1982)

[. . .] 'Language forms a kind of wealth, which all can make use of at once without causing any diminution of the store, and which thus admits a complete community of enjoyment; for all, freely participating in the general treasure, unconsciously aid in its preservation'.[1] In describing symbolic appropriation as a sort of mystical participation, universally and uniformly accessible and therefore excluding any form of dispossession, Auguste Comte offers an exemplary expression of the illusion of linguistic communism which haunts all linguistic theory. Thus, Saussure resolves the question of the social and economic conditions of the appropriation of language without ever needing to raise it. He does this by resorting, like Comte, to the metaphor of treasure, which he applies indiscriminately to the 'community' and the individual: he speaks of 'inner treasure', of a 'treasure deposited by the practice of speech in subjects belonging to the same community', of 'the sum of individual treasures of language', and of the 'sum of imprints deposited in each brain'.

Chomsky has the merit of explicitly crediting the speaking subject in his universality with the perfect competence which the Saussurian tradition granted him tacitly: 'Linguistic theory is concerned primarily with an *ideal speaker–listener, in a completely homogeneous speech-community, who knows its language perfectly* and is unaffected by such *grammatically irrelevant* conditions as memory limitations, distractions, shifts of attention or interest, and errors (random or characteristic) in applying his knowledge of the language in actual performance. This seems to me to have been the position of the founders of modern general linguistics, and no cogent reason for modifying it has been offered.[2] In short, from this standpoint, Chomskyan 'competence' is simply another name for Saussure's *langue*.[3] Corresponding to language as a 'universal treasure', as the collective property of the whole group, there is linguistic competence as the 'deposit' of this 'treasure' in each individual or as the participation of each member of the 'linguistic

community' in this public good. The shift in vocabulary conceals the *fictio juris* through which Chomsky, converting the immanent laws of legitimate discourse into universal norms of correct linguistic practice, sidesteps the question of the economic and social conditions of the acquisition of the legitimate competence and of the constitution of the market in which this definition of the legitimate and the illegitimate is established and imposed.[4]

Official language and political unity

As a demonstration of how linguists merely incorporate into their theory a pre-constructed object, ignoring its *social laws of construction* and masking its social genesis, there is no better example than the passage in his *Course in General Linguistics* in which Saussure discusses the relation between language and space.[5] Seeking to prove that it is not space which defines language but language which defines its space, Saussure observes that neither dialects nor languages have natural limits, a phonetic innovation (substitution of 's' for Latin 'c', for example) determining its own area of diffusion by the intrinsic force of its autonomous logic, through the set of speaking subjects who are willing to make themselves its bearers. This philosophy of history, which makes the internal dynamics of a language the sole principle of the limits of its diffusion, conceals the properly political process of unification whereby a determinate set of 'speaking subjects' is led in practice to accept the official language.

Saussure's *langue*, a code both legislative and communicative which exists and subsists independently of its users ('speaking subjects') and its uses (*parole*), has in fact all the properties commonly attributed to official language. As opposed to dialect, it has benefited from the institutional conditions necessary for its generalized codification and imposition. Thus known and recognized (more or less completely) throughout the whole jurisdiction of a certain political authority, it helps in turn to reinforce the authority which is the source of its dominance. It does this by ensuring among all members of the 'linguistic community', traditionally defined, since Bloomfield as a 'group of people who use the same system of linguistic signs',[6] the minimum of communication which is the precondition for economic production and even for symbolic domination.

To speak of *the* language, without further specification, as linguists do, is tacitly to accept the *official* definition of he *official* language of a political unit. This language is the one which, within the territorial limits of that unit, imposes itself on the whole population as the only legitimate language, especially in situations that are characterized in French as more *officielle* (a very exact translation of the word 'formal' used by English-speaking linguists).[7] Produced by authors who have the authority to write, fixed and codified by grammarians and teachers who are also charged with the task of inculcating its mastery, the language is a *code*, in the sense of a cipher enabling equivalences to be established between sounds and meanings, but also in the sense of a system of norms regulating linguistic practices.

The official language is bound up with the state, both in its genesis and in its social uses. It is in the process of state formation that the conditions are

created for the constitution of a unified linguistic market, dominated by the official language. Obligatory on official occasions and in official places (schools, public administrations, political institutions, etc.), this state language becomes the theoretical norm against which all linguistic practices are objectively measured. Ignorance is no excuse; this linguistic law has its body of jurists – the grammarians – and its agents of regulation and imposition – the teachers – who are empowered *universally* to subject the linguistic performance of speaking subjects to examination and to the legal sanction of academic qualification.

In order for one mode of expression among others (a particular language in the case of bilingualism, a particular use of language in the case of a society divided into classes) to impose itself as the only legitimate one, the linguistic market has to be unified and the different dialects (of class, region or ethnic group) have to be measured practically against the legitimate language or usage. Integration into a single 'linguistic community', which is a product of the political domination that is endlessly reproduced by institutions capable of imposing universal recognition of the dominant language, is the condition for the establishment of relations of linguistic domination.

The 'standard' language: a 'normalized' product

[...]

In the process which leads to the construction, legitimation and imposition of an official language, the educational system plays a decisive role: 'fashioning the similarities from which that community of consciousness which is the cement of the nation stems.' And Georges Davy goes on to state the function of the schoolmaster, a *maître à parler* (teacher of speaking) who is thereby also a *maître à penser* (teacher of thinking): 'He [the primary school teacher], by virtue of his function, works daily on the faculty of expression of every idea and every emotion: on language. In teaching the same clear, fixed language to children who know it only very vaguely or who even speak various dialects or *patois*, he is already inclining them quite naturally to see and feel things in the same way; and he works to build the common consciousness of the nation'.[8] The Whorfian – or, if you like, Humboldtian[9] – theory of language which underlies this view of education as an instrument of 'intellectual and moral integration', in Durkheim's sense, has an affinity with the Durkheimian theory of consensus, an affinity which is also indicated by the shift of the word 'code' from law to linguistics. The code, in the sense of cipher, that governs written language, which is identified with correct language, as opposed to the implicitly inferior conversational language, acquires the force of law in and through the educational system.[10]

The educational system, whose scale of operations grew in extent and intensity throughout the nineteenth century,[11] no doubt directly helped to devalue popular modes of expression, dismissing them as 'slang' and 'gibberish' (as can be seen from teachers' marginal comments on essays) and to impose recognition of the legitimate language. But it was doubtless the dialectical relation between the school system and the labour market – or, more precisely, between the

unification of the educational (and linguistic) market, linked to the introduction of educational qualifications valid nation-wide, independent (at least officially) of the social or regional characteristics of their bearers, and the unification of the labour market (including the development of the state administration and the civil service) – which played the most decisive role in devaluing dialects and establishing the new hierarchy of linguistic practices.[12] To induce the holders of dominated linguistic competences to collaborate in the destruction of their instruments of expression, by endeavouring for example to speak 'French' to their children or requiring them to speak 'French' at home, with the more or less explicit intention of increasing their value on the educational market, it was necessary for the school system to be perceived as the principal (indeed, the only) means of access to administrative positions which were all the more attractive in areas where industrialization was least developed. This conjunction of circumstances was found in the regions of 'dialect' (except the east of France) rather than in the *patois* regions of northern France.

Unification of the market and symbolic domination

In fact, while one must not forget the contribution which the political will to unification (also evident in other areas, such as law) makes to the *construction* of the language which linguists accept as a natural datum, one should not regard it as the sole factor responsible for the generalization of the use of the dominant language. This generalization is a dimension of the unification of the market in symbolic goods which accompanies the unification of the economy and also of cultural production and circulation. This is seen clearly in the case of the market in matrimonial exchanges, in which 'products' which would previously have circulated in the protected enclosure of local markets, with their own laws of price formation, are suddenly devalued by the generalization of the dominant criteria of evaluation and the discrediting of 'peasant values', which leads to the collapse of the value of the peasants, who are often condemned to celibacy. Visible in all areas of practice (sport, song, clothing, housing, etc.), the process of unification of both the production and the circulation of economic and cultural goods entails the progressive obsolescence of the earlier mode of production of the habitus and its products. And it is clear why, as sociolinguists have often observed, women are more disposed to adopt the legitimate language (or the legitimate pronunciation): since they are inclined towards docility with regard to the dominant usages both by the sexual division of labour, which makes them specialize in the sphere of consumption, and by the logic of marriage, which is their main if not their only avenue of social advancement and through which they circulate upwards, women are predisposed to accept, from school onwards, the new demands of the market in symbolic goods.

Thus the effects of domination which accompany the unification of the market are always exerted through a whole set of specific institutions and mechanisms, of which the specifically linguistic policy of the state and even the overt interventions of pressure groups form only the most superficial aspect. The fact that these mechanisms presuppose the political or economic unification which

they help in turn to reinforce in no way implies that the progress of the official language is to be attributed to the direct effectiveness of legal or quasi-legal constraints. (These can at best impose the acquisition, but not the generalized use and therefore the autonomous reproduction, of the legitimate language.) All symbolic domination presupposes, on the part of those who submit to it, a form of complicity which is neither passive submission to external constraint nor a free adherence to values. The recognition of the legitimacy of the official language has nothing in common with an explicitly professed, deliberate and revocable belief, or with an intentional act of accepting a 'norm'. It is inscribed, in a practical state, in dispositions which are impalpably inculcated, through a long and slow process of acquisition, by the sanctions of the linguistic market, and which are therefore adjusted, without any cynical calculation or consciously experienced constraint, to the chances of material and symbolic profit which the laws of price formation characteristic of a given market objectively offer to the holders of a given linguistic capital.[13]

The distinctiveness of symbolic domination lies precisely in the fact that it assumes, of those who submit to it, an attitude which challenges the usual dichotomy of freedom and constraint. The 'choices' of the habitus (for example, using the 'received' uvular 'r' instead of the rolled 'r' in the presence of legitimate speakers) are accomplished without consciousness or constraint, by virtue of the dispositions which, although they are unquestionably the product of social determinisms, are also constituted outside the spheres of consciousness and constraint. The propensity to reduce the search for causes to a search for responsibilities makes it impossible to see that *intimidation*, a symbolic violence which is not aware of what it is (to the extent that it implies no *act of intimidation*) can only be exerted on a person predisposed (in his habitus) to feel it, whereas others will ignore it. It is already partly true to say that the cause of the timidity lies in the relations between the situation or the intimidating person (who may deny any intimidating intention) and the person intimidated, or rather, between the social conditions of production of each of them. And little by little, one has to take account thereby of the whole social structure.

There is every reason to think that the factors which are most influential in the formation of the habitus are transmitted without passing through language and consciousness, but through suggestions inscribed in the most apparently insignificant aspects of the things, situations and practices of everyday life. Thus the modalities of practices, the ways of looking, sitting, standing, keeping silent, or even of speaking ('reproachful looks' or 'tones', 'disapproving glances' and so on) are full of injunctions that are powerful and hard to resist precisely because they are silent and insidious, insistent and insinuating. (It is this *secret code* which is explicitly denounced in the crises characteristic of the domestic unit, such as marital or teenage crises: the apparent disproportion between the violence of the revolt and the causes which provoke it stems from the fact that the most anodyne actions or words are now seen for what they are – as injunctions, intimidations, warnings, threats – and denounced as such, all the more violently because they continue to act below the level of consciousness and beneath the very revolt which they provoke.) The power of suggestion which is exerted through things and persons and which, instead of telling the child what he must

do, tells him what he is, and thus leads him to become durably what he has to be, is the condition for the effectiveness of all kinds of symbolic power that will subsequently be able to operate on a habitus predisposed to respond to them. The relation between two people may be such that one of them has only to appear in order to impose on the other, without even having to want to, let alone formulate any command, a definition of the situation and of himself (as intimidated, for example), which is all the more absolute and undisputed for not having to be stated.

The recognition extorted by this invisible, silent violence is expressed in explicit statements, such as those which enable Labov to establish that one finds the same *evaluation* of the phoneme 'r' among speakers who come from different classes and who therefore differ in their actual *production* of 'r'. But it is never more manifest than in all the corrections, whether *ad hoc* or permanent, to which dominated speakers, as they strive desperately for correctness, consciously or unconsciously subject the stigmatized aspects of their pronunciation, their diction (involving various forms of euphemism) and their syntax, or in the disarray which leaves them 'speechless', 'tongue-tied', 'at a loss for words', as if they were suddenly dispossessed of their own language.[14]

Distinctive deviations and social value

Thus, if one fails to perceive both the special value objectively accorded to the legitimate use of language and the social foundations of this privilege, one inevitably falls into one or other of two opposing errors. Either one unconsciously absolutizes that which is objectively relative and in that sense arbitrary, namely the dominant usage, failing to look beyond the properties of language itself, such as the complexity of its syntactic structure, in order to identify the basis of the value that is accorded to it, particularly in the educational market; or one escapes this form of fetishism only to fall into the naïvety *par excellence* of the scholarly relativism which forgets that the naïve gaze is not relativist, and ignores the fact of legitimacy, through an arbitrary relativization of the dominant usage, which is socially recognized as legitimate, and not only by those who are dominant.

> To reproduce in scholarly discourse the fetishizing of the legitimate language which actually takes place in society, one only has to follow the example of Basil Bernstein, who describes the properties of the 'elaborated code' without relating this social product to the social conditions of its production and reproduction, or even, as one might expect from the sociology of education, to its academic conditions. The 'elaborated code' is thus constituted as the absolute norm of all linguistic practices which then can only be conceived in terms of the logic of *deprivation*. Conversely, ignorance of what popular and educated usage owe to their objective relations and to the structure of the relation of domination between classes, which they reproduce in their own logic, leads to the *canonization* as such of the 'language' of the dominated classes. Labov leans in this direction when his

concern to rehabilitate 'popular speech' against the theorists of depri-
vation leads him to contrast the verbosity and pompous verbiage of
middle-class adolescents with the precision and conciseness of black
children from the ghettos. This overlooks the fact that, as he himself
has shown (with the example of recent immigrants who judge deviant
accents, including their own, with particular severity), the linguistic
'norm' is imposed on all members of the same 'linguistic community',
most especially in the educational market and in all formal situations
in which verbosity is often *de rigueur*.

Political unification and the accompanying imposition of an official language estab-
lish relations between *the different uses of the same language* which differ funda-
mentally from the theoretical relations (such as that between *mouton* and 'sheep'
which Saussure cites as the basis for the arbitrariness of the sign) between dif-
ferent languages, spoken by politically and economically independent groups. All
linguistic practices are measured against the legitimate practices, i.e. the practices
of those who are dominant. The probable value objectively assigned to the lin-
guistic productions of different speakers and therefore the relation which each of
them can have to the language, and hence to his own production, is defined
within the system of practically competing variants which is actually established
whenever the extra-linguistic conditions for the constitution of a linguistic mar-
ket are fulfilled.

Thus, for example, the linguistic differences between people from different
regions cease to be incommensurable particularisms. Measured *de facto* against the
single standard of the 'common' language, they are found wanting and cast into
the outer darkness of *regionalisms*, the 'corrupt expressions and mispronunciations'
which schoolmasters decry.[15] Reduced to the status of quaint or vulgar jargons,
in either case unsuitable for formal occasions, popular uses of the official language
undergo a systematic devaluation. A system of *sociologically pertinent* linguistic
oppositions tends to be constituted, which has nothing in common with the sys-
tem of *linguistically pertinent* linguistic oppositions. In other words, the differences
which emerge from the confrontation of speech varieties are not reducible to
those the linguist constructs in terms of his own criterion of pertinence. How-
ever great the proportion of the functioning of a language that is not subject to
variation, there exists, in the area of pronunciation, diction and even grammar,
a whole set of differences significantly associated with social differences which,
though negligible in the eyes of the linguist, are pertinent from the sociologist's
standpoint because they belong to a system of linguistic oppositions which is the
re-translation of a system of social differences. A structural sociology of language,
inspired by Saussure but constructed in opposition to the abstraction he imposes,
must take as its object *the relationship between the structured systems of sociologically
pertinent linguistic differences and the equally structured systems of social differences*.

The social uses of language owe their specifically social value to the fact that
they tend to be organized in systems of differences (between prosodic and artic-
ulatory or lexical and syntactic variants) which reproduce, in the symbolic order
of differential deviations, the system of social differences. To speak is to appro-
priate one or other of the expressive styles already constituted in and through

usage and objectively marked by their position in a hierarchy of styles which expresses the hierarchy of corresponding social groups. These styles, systems of differences which are both classified and classifying, ranked and ranking, mark those who appropriate them. And a spontaneous stylistics, armed with a practical sense of the equivalences between the two orders of differences, apprehends social classes through classes of stylistic indices.

In emphasizing the linguistically pertinent constants at the expense of the sociologically significant variations in order to construct that artefact which is the 'common' language, the linguist proceeds as if the *capacity to speak*, which is virtually universal, could be identified with *the socially conditioned way of realizing this natural capacity*, which presents as many variants as there are social conditions of acquisition. The competence adequate to produce sentences that are likely to be understood may be quite inadequate to produce sentences that are likely to be *listened to*, likely to be recognized as *acceptable* in all the situations in which there is occasion to speak. Here again, social acceptability is not reducible to mere grammaticality. Speakers lacking the legitimate competence are *de facto* excluded from the social domains in which this competence is required, or are condemned to silence. What is rare, then, is not the capacity to speak, which, being part of our biological heritage, is universal and therefore essentially non-distinctive,[16] but rather the competence necessary in order to speak the legitimate language which, depending on social inheritance, re-translates social distinctions into the specifically symbolic logic of differential deviations, or, in short, distinction.[17]

The constitution of a linguistic market creates the conditions for an objective competition in and through which the legitimate competence can function as linguistic capital, producing a *profit of distinction* on the occasion of each social exchange. Because it derives in part from the scarcity of the products (and of the corresponding competences), this profit does not correspond solely to the cost of training.

[. . .]

Since the profit of distinction results from the fact that the supply of products (or speakers) corresponding to a given level of linguistic (or, more generally, cultural) qualification is lower than it would be if all speakers had benefited from the conditions of acquisition of the legitimate competence to the same extent as the holders of the rarest competence,[18] it is logically distributed as a function of the chances of access to these conditions, that is, as a function of the position occupied in the social structure.

[. . .]

Added to the specific effect of distinctive rarity is the fact that, by virtue of the relationship between the system of linguistic differences and the system of economic and social differences, one is dealing not with a relativistic universe of differences capable of relativizing one another, but with a hierarchical universe of deviations with respect to a form of speech that is (virtually) universally recognized as legitimate, i.e. as the standard measure of the value of linguistic products. The dominant competence functions as linguistic capital, securing a profit of distinction in its relation to other competences only in so far as certain

conditions (the unification of the market and the unequal distribution of the chances of access to the means of production of the legitimate competence, and to the legitimate places of expression) are continuously fulfilled, so that the groups which possess that competence are able to impose it as the only legitimate one in the formal markets (the fashionable, educational, political and administrative markets) and in most of the linguistic interactions in which they are involved.[19]

It is for this reason that those who seek to defend a threatened linguistic capital, such as knowledge of the classical languages in present-day France, are obliged to wage a total struggle. One cannot save the *value* of a competence unless one saves the market, in other words, the whole set of political and social conditions of production of the producers/consumers. The defenders of Latin or, in other contexts, of French or Arabic, often talk as if the language they favour could have some value outside the market, by intrinsic virtues such as its 'logical' qualities; but, in practice, they are defending the market. The position which the educational system gives to the different languages (or the different cultural contents) is such an important issue only because this institution has the monopoly in the large-scale production of producers/consumers, and therefore in the reproduction of the market without which the social value of the linguistic competence, its capacity to function as linguistic capital, would cease to exist.

[...]

Notes

1 A. Comte, *System of Positive Polity*, 4 vols (London: Longmans Green and Co., 1875–77), vol. 2, p. 213.

2 N. Chomsky, *Aspects of the Theory of Syntax* (Cambridge, Mass.: MIT Press, 1965), p. 3 (my italics). See also N. Chomsky and M. Halle, *The Sound Pattern of English* (New York: Harper and Row, 1968), p. 3.

3 Chomsky himself makes this identification explicitly, at least in so far as competence is 'knowledge of grammar' (Chomsky and Halle, *The Sound Pattern of English*) or 'generative grammar internalized by someone' (N. Chomsky, *Current Issues in Linguistic Theory* (London and The Hague: Mouton, 1964), p. 10).

4 The fact that Habermas crowns his pure theory of 'communicative competence' – an essentialist analysis of the situation of communication – with a declaration of intentions regarding the degree of repression and the degree of development of the productive forces does not mean that he escapes from the ideological effect of absolutizing the relative which is inscribed in the silences of the Chomskyan theory of competence (J. Habermas, 'Toward a theory of communicative competence', in H. P. Dreitzel (ed.), *Recent Sociology*, no. 2 (New York: Macmillan, 1970), pp. 114–48). Even if it is purely methodological and provisional, and intended only to 'make possible' the study of 'the distortions of pure intersubjectivity', *idealization* (which is clearly seen in the use of notions such as 'mastery of the dialogue-constitutive universals' or 'speech situation determined by pure subjectivity') has the practical effect of removing from relations of communication the power relations which are implemented

within them in a transfigured form. This is confirmed by the uncritical bor-
rowing of concepts such as 'illocutionary force', which tends to locate the
power of words in words themselves rather than in the institutional conditions
of their use.

5 F. de Saussure, *Course in General Linguistics*, tr. W. Baskin (Glasgow: Collins,
 1974), pp. 199–203.

6 L. Bloomfield, *Language* (London: George Allen, 1958), p. 29. Just as Saus-
 sure's theory of language forgets that a language does not impose itself by its
 own force but derives its geographical limits from a political act of institution,
 an arbitrary act misrecognized as such (and misrecognized by the science of lan-
 guage), so Bloomfield's theory of the 'linguistic community' ignores the polit-
 ical and institutional conditions of 'intercomprehension'.

7 The adjective 'formal', which can be used to describe a language that is
 guarded, polished and tense, as opposed to one that is familiar and relaxed, or
 a person that is starchy, stiff and formalist, can also mean the same as the
 French adjective *officiel* (as in 'a formal dinner'), that is, conducted in full
 accordance with the rules, in due and proper order, by formal agreement.

8 G. Davy, *Éléments de sociologie* (Paris: Vrin, 1950), p. 233.

9 Humboldt's linguistic theory, which was generated from the celebration of
 the linguistic 'authenticity' of the Basque people and the exaltation of the
 language–nation couplet, has an intelligible relationship with the conception of
 the unifying mission of the university which Humboldt deployed in the creation
 of the University of Berlin.

10 Grammar is endowed with real legal effectiveness via the educational system,
 which places its power of certification at its disposal. If grammar and spelling
 are sometimes the object of ministerial decrees (such as that of 1900 on the
 agreement of the past participle conjugated with *avoir*), this is because, through
 examinations and the qualifications which they make it possible to obtain, they
 govern access to jobs and social positions.

11 Thus, in France, the numbers of schools and of pupils enrolled and, correla-
 tively, the volume and spatial dispersion of the teaching profession increased
 steadily after 1816 – well before the official introduction of compulsory school-
 ing.

12 This would probably explain the apparently paradoxical relationship between
 the linguistic remoteness of the different regions in the nineteenth century and
 their contribution to the ranks of the civil service in the twentieth century.
 The regions which, according to the survey carried out by Victor Duruy in
 1864, had the highest proportion of adults who could not speak French, and
 of 7- to 13-year-olds unable to read or speak it, were providing a particularly
 high proportion of civil servants in the first half of the twentieth century, a
 phenomenon which is itself known to be linked to a high rate of secondary
 schooling.

13 This means that 'linguistic customs' cannot be changed by decree as the advo-
 cates of an interventionist policy of 'defence of the language' often seem to
 imagine.

14 The 'disintegrated' language which surveys record when dealing with speakers
 from the dominated classes is thus a product of the survey relationship.

15 Conversely, when a previously dominated language achieves the status of an
 official language, it undergoes a *revaluation* which profoundly changes its users'

relationship with it. So-called linguistic conflicts are therefore not so unrealistic and irrational (which does not mean that they are directly inspired by self-interest) as is supposed by those who only consider the (narrowly defined) economic stakes. The reversal of the symbolic relations of power and of the hierarchy of the values placed on the competing languages has entirely real economic and political effects, such as the appropriation of positions and economic advantages reserved for holders of the legitimate competence, or the symbolic profits associated with possession of a prestigious, or at least unstigmatized, social identity.

16 Only the *optional* can give rise to effects of *distinction*. As Pierre Encrevé has shown, in the case of obligatory liaisons – those which are always observed by all speakers, including the lower classes – there is no room for manoeuvre. When the structural constraints of the language are suspended, as with optional liaisons, the leeway reappears, with the associated effects of distinction.

17 There is clearly no reason to take sides in the debate between the nativists (overt or not), for whom the acquisition of the capacity to speak presupposes the existence of an innate disposition, and the empiricists, who emphasize the learning process. So long as not everything is inscribed in nature and the acquisition process is something more than a simple maturation, there exist linguistic differences capable of functioning as signs of social distinction.

18 The hypothesis of equal chances of access to the conditions of acquisition of the legitimate linguistic competence is a simple *mental experiment* designed to bring to light one of the *structural effects* of inequality.

19 Situations in which linguistic productions are explicitly subjected to evaluation, such as examinations or job interviews, recall the evaluation which takes place in every linguistic exchange. Numerous surveys have shown that linguistic characteristics have a very strong influence on academic success, employment opportunities, career success, the attitude of doctors (who pay more attention to bourgeois patients and their discourse, e.g. giving them less pessimistic diagnoses), and more generally on the recipients' inclination to co-operate with the sender, to assist him or give credence to the information he provides.

Brian Cox

TEACHING STANDARD ENGLISH (1991)

Many highly educated people, including a substantial number of teachers, do not understand the difference between Received Pronunciation (RP) and Standard English. This ignorance among the general public is one good reason for including knowledge about language in the English curriculum. It is also true that many older people, who were trained rigorously in the disciplines of study fashionable before 1960, think that they know a great deal about language, but in fact imbibed many false notions from their schooling. [...] I was told that one reason why many Conservative politicians were sympathetic towards our Report was because they did not at first realise that our insistence that all children should speak and write Standard English did not involve any recommendation about RP.

Received pronunciation

Received Pronunciation is the accent, used by a minority of speakers in Britain, that developed in the nineteenth century in the public schools and universities, and was associated in the 1930s and 1940s with BBC newsreaders. The Kingman Report explained that although this accent must be the standard for foreign students of English in Britain, it is not used as the model of English pronunciation in British schools, since speakers may be rightly proud of their regional pronunciation, which identifies where they come from. The Kingman Report recommended that all children at the age of 16 should speak in Standard English, 'using their own accents (provided that these accents do not impair comprehension by other speakers of English)' (Chapter 5, p. 52). As we all know, there is still great prejudice among speakers of RP against other accents such as Cockney, and in England the correct accent is a mark of social acceptability. The English curriculum ought to help to overcome such snobbery by encouraging children to discuss their accents and to be proud of regional differences, but the task of overcoming arrogance about accents is formidable.

As John Honey shows in his *Does Accent Matter?* (1989), Received Pronunciation itself is gradually changing, and there are marked differences between what is socially acceptable in 1991 and the fashionable accents of the 1930s. All these considerations persuaded my Group to follow Kingman, and to argue forcibly, in a passage we underlined, that although children should speak Standard English, we 'do not, however, see it as the school's place to enforce the accent known as Received Pronunciation'.

Standard English and dialect

Standard English caused us enormous problems. When I submitted our first Report to Mr Baker he asked me how he should explain what was meant by Standard English to the education journalists. It was not an easy question to answer.

This first Report was read by Professor Brian Griffiths, whose duty as Prime Minister's adviser was to present it to Mrs Thatcher with his comments. He protested that we had made no recommendation that children should use Standard English. I read to him sentences from the Report such as: 'Schools have the clear responsibility to ensure that all children have full access to Standard English, given its role as an international language used throughout the world and essential for many purposes.' He reread the appropriate chapter, and acknowledged that I was right. This incident made me realise that our careful descriptions of the relationship between dialect and Standard English might be misread, and so in the final Report I insisted that we should reiterate many times that all pupils should learn, and if necessary be explicitly taught, Standard English. Unfortunately I had shut the stable door after the horse had fled.

After our first Report the tabloid journalists enjoyed themselves by writing provocative articles about how I was the professor for whom correct English did not matter. The journalists found especially useful a passage about Standard English where we explained that dialects obey their own grammatical rules. We said that non-standard forms are rarely more than a social irritant to some people, and that there are few situations where such forms could cause real communication problems. They include a small set such as: 'we was; he ain't done it; she come here yesterday; they never saw nobody; he writes really quick; theirselves etc.' These examples gave the journalists the story for which they were looking, and they used them in headlines to show that our Report was against the teaching of grammar and 'correct' English, and that we favoured a policy of 'anything goes'. At a conference at Oxford in December 1989, Professor Randolph Quirk, the famous linguist, attacked me fiercely for including material like this, which could be easily misrepresented by the press. After the furore which greeted our first Report I felt – perhaps pusillanimously – that we should excise this explanatory passage. Professor Michael Stubbs felt strongly that it should be retained, partly because journalists would draw attention to its omission, and partly because our readers needed to understand the truth about dialects. A majority of the Group agreed with Professor Stubbs, and so we retained the examples, though with additional explanatory material. On Professor Stubbs's behalf it can be said that the Report reflects a total view of society, of co-operation and

tolerance between cultural and social groups, and that to achieve this aim all teachers and pupils need to understand clearly why contempt for other people's dialects is wrong.

After our Report was published we were criticised by both left-wing and right-wing educationalists. The left argued that children who speak dialect at home could not be expected to speak Standard English, which they regarded as middle class, and that it was improper to make this an essential attainment target in a national curriculum. The right thought we were too soft on primary school children, who should be expected to speak and write Standard English as soon as they arrive in the classroom. In the rest of this chapter I will explain our thinking as clearly as I can, for there has been much misunderstanding.

The development of Standard English

The Kingman Report explains that Standard English

> developed from one of the Middle English dialects (East Midlands –
> the dialect first printed by Caxton) to become the written form used
> by all writers of English, no matter which dialect area they came
> from. It is the fact of being the written form which establishes it as
> the standard. And it is the fact of being the written form which means
> that it is used not only in Britain but by all writers of English through-
> out the world, with remarkably little variation. Since it holds this
> important role in the written form, it is also used to communicate
> across local areas and between regions in a spoken form.
>
> (paragraphs 2.32 and 2.34)

As we have seen, this spoken form may be in a variety of accents, from Devon to East Anglia, from the United States to Australia. Speakers of Standard English in different parts of the British Isles and elsewhere in the world may use the same grammar and vocabulary, but different pronunciation. For example, many speakers from the United States, Scotland or south-west England pronounce the *r* sound after the vowel in words such as *car* and *farm*; most speakers in south-east England do not. Accent refers to pronunciation. Dialect refers to vocabulary and grammar. Most people know some dialect words: for example, *bairn* for *child* in Scottish English. And dialects differ in their grammar: for example, Standard English has *I was, you were, he was, we were, they were.* Many non-standard dialects have (more regularly, as it happens) *I was, you was, he was, we was, they was.*

Standard English itself is usually analysed by linguists as a dialect of English which clearly has social prestige. This is partly because of the purposes which it now serves; it is the expected language in the education system, in other social institutions (such as the courts and business) and in almost all published writing, and it has also spread far beyond its historical base in Britain and is used as an international language in many parts of the world. Non-standard dialects of English are regional dialects: that is, they are relatively restricted in their geographical spread. Standard English used to be restricted in this way: if we look at

TEACHING STANDARD ENGLISH 481

Standard English as an historical dialect, then we find that 200 years ago it had a much smaller number of speakers in England, and had nothing like the geographical spread it has nowadays. Standard English is also a social dialect: its use is a marker of social group membership, and the relationship between standard and non-standard dialects and social class in Britain is particularly strong.

Because of its long use, especially in writing for academic and administrative purposes, the vocabulary and to some extent the sentence syntax of Standard English have been greatly elaborated. Non-standard dialects have the potential to be so developed, but for social and historical reasons they have not been. The words 'greatly elaborated' are of considerable significance. Linguists do not like to say that Standard English is 'superior' to other dialects, because all dialects have their own richness, their own specific identity. And left-wing educationalists do not like to say that the Standard English spoken by the middle classes is superior to working-class speech. But Standard English serves particular functions: for example, in the education system and in professional life, in public and formal uses, in writing and particularly in print. It is precisely because Standard English serves as a wider language of wider communication for such an extensive and important range of purposes that children must learn to use it competently. In an article on the Cox Report published in *Critical Quarterly* (Winter 1990), Gillian Brown writes:

> Standard English today differs from local dialects not only in permitting the expression of complex relationships in familiar written forms, but also in the astonishing wealth of vocabulary which has accrued to it through its intellectual and imperial history. Dialects, we should remember, are essentially local to particular parts of a particular country, and specialized for talking about local and domestic life … Many would argue that learning a school subject – geography, chemistry or English literature – entails learning the language in which that subject is expressed. Since subjects learnt at school have been codified and developed through written texts, and written texts are written in Standard English, it follows that children, to have any hope of mastering these subjects, must learn to read and write Standard English. (pp. 35–36)

If pupils do not have access to Standard English then many important opportunities are closed to them, in cultural activities, in further and higher education, and in industry, commerce and the professions. Those educationalists who deny children these opportunities are confining them to the ghetto, to a restricted discourse which will close to them access not only to the professions but also to leadership in national politics. In our democracy, Standard English confers power on its users, power to explain political issues and to persuade on a national and international stage. This right should not be denied to any child.

Standard English should not be regarded as fixed. It changes over time, just as any language does: no one nowadays speaks in the same way as the contemporaries of Chaucer or Shakespeare or even Dickens. Moreover, it varies according to style, purpose and audience: no one speaks or writes in the same way on

all occasions. Nor should Standard English be confused with 'good' English. Speakers of Standard English can use English just as 'badly' as anyone else: they can write unclear prose, use words ambiguously, and so on. Standard English and non-standard dialects have much in common. Where there are differences, it is important to understand that dialect forms are grammatical and rule-governed in non-standard dialects, but the rules are different from those of Standard English. For example, Standard English does not distinguish between *do* as a main verb and as an auxiliary verb: *He did it, did he?* Many non-standard dialects do make this distinction, which is not available in Standard English: *He done it, did he?* The non-standard dialect is not a haphazard variant, since no speakers of non-standard dialects would say *He done it, done he?* Or *He did it, done he?*

Much more difficult problems of definition arise with creole varieties of English, including creoles of Caribbean origin. These language varieties are known by various names, such as West Indian Creole, Black British English and Patois. The main points are:

- such language varieties are not random and simplified deviations from Standard English: they are highly complex and rule-governed varieties of English;
- their linguistic variation is typically greater than with other dialects of English. Speakers' use of creole varieties lie along a continuum, from varieties of creole which may well be in comprehensible to a speaker of Standard English, to varieties much closer to Standard English;
- the term 'dialects of English' is itself problematic. Whether creole varieties are termed 'dialects of' English or are regarded as languages in their own right is a political and ideological question, which concerns the social identity of groups of speakers. It is not a matter which has a simple linguistic definition.

Given this variation in language forms and use, the danger may be that teachers do not realise the extent of the variation, or that they regard the creole language forms as haphazard. They may therefore not realise those cases where there is genuine dialect interference between the pupil's home language and the language expected in the school.

Our rationale

All pupils, therefore, must be able by the age of 16 to use spoken and written Standard English; but schools have the responsibility to develop their own policies on the detail of how this should be done. Across England and Wales, schools differ greatly in their linguistic profiles. In some schools, most pupils use spoken Standard English as their native dialect; in others, most have to learn it as an additional language. Therefore it was not possible for my Working Group to prescribe a single policy which would suit all circumstances. We did, however, attempt to outline the principles which should inform school policies on the teaching of Standard English.

A coherent school policy on Standard English can be based on the different views of the main aims of English teaching:

1 a personal growth view;
2 a cross-curricular view; .
3 an adult needs view;
4 a cultural heritage view;
5 a cultural analysis view.

The first view is related to the need for the pupil's own native language or dialect to be respected: Standard English has to be treated very sensitively in schools, since dialect is so closely related to pupils' individual identity. The second and third views emphasise the importance of using Standard English for wider communication, inside and outside school. The fourth and fifth views relate to the fact that Standard English is a topic which pupils should reflect on, understand and analyse. A coherent school policy on Standard English is possible if it is recognised that all these views are legitimate.

To be effective in their teaching of Standard English, schools should teach it in ways which do not denigrate the non-standard dialects spoken by many pupils. It should not be introduced at too early a stage; teaching pupils a new dialect may be confusing when they are learning many other aspects of language use. The profound implications for pupils' relationships with their families and communities should be recognised.

There is considerable debate over when to expect pupils to use Standard English in writing. School should develop their own coherent policies, which are sensitive to their local circumstances, on exactly how and when Standard English should be taught. In general terms, we advocated that there should be explicit teaching about the nature and functions of Standard English in the top years of the primary school; that there should be the beginnings of the expectation of Standard English in written work when appropriate by the age of 11; that there should be the provision of opportunities for oral work where spoken Standard English would be a realistic expectation in the secondary school; and that all pupils should be in a position to choose to use Standard English in speech when appropriate by the age of 16. The teaching of Standard English should be related to the teaching of public, formal, written varieties of English. A main focus should be on the differences between written and spoken English. For example, written language typically has to express things more explicitly, because it has to stand on its own. If the teaching concentrates on the relationship between language forms and use, then it need not reject the language of the home. These written forms must, in any case, be taught even to those children whose native dialect is Standard English, since spoken and written Standard English differ considerably in some respects. No one uses written Standard English as his or her native dialect.

This is consistent with a general policy of widening the linguistic repertoire of pupils. It does assume, however, that teachers themselves have an accurate understanding of the differences between written Standard English, spoken Standard English and spoken local varieties of English.

The uses of Standard English should be discussed explicitly with pupils. This has considerable implications for knowledge about language. Pupils need to be able to discuss the contexts in which Standard English is obligatory and those where its use is preferable for social reasons. By and large, the pressures in favour of Standard English will be greater when the language is written, formal and public. Non-standard forms may be much more widely tolerated – and, in some cases, preferred – when the language is spoken, informal and private.

Standard English should form an important part of the teaching of knowledge about language: its historical, geographical and social distribution and the uses to which it is put (in different countries, in different areas of society, in print and in the mass media, etc.). Teachers should encourage an interest in both rural (traditional) and urban dialects of English, by contrasting local non-standard dialects with Standard English, often using pupils as the linguistic experts on the former. The grammar of both should be discussed and contrasted. Non-standard usages should be treated as objects of interest and value, and not ridiculed. Sometimes, with older pupils, it will be possible to discover the antecedents of a regional form in historical usage.

For pupils who do not have Standard English as their native dialect, teaching Standard English should draw on their knowledge of other dialects or languages. The aim is to add Standard English to the repertoire, not to replace other dialects or languages. It should also be recognised that non-standard forms are systematic and not haphazard.

Teachers should differentiate clearly between different kinds of correction, and avoid indiscriminate correction. It can only be confusing to a pupil if features of dialect are 'corrected' at the same time and in the same way as, for example, spelling errors. The latter may be due to carelessness, or to a principle which has not been grasped. But dialect features are not errors in this sense at all, but are characteristics of a pupil's native language. It is advisable to concentrate on (a) frequently occurring non-standard forms and (b) highly stigmatised forms. These will include forms of the verb *to be*, past tenses of a few highly frequent irregular verbs (e.g. *do, see*), personal pronouns and negatives.

Conclusion

To sum up, teachers need to remember that:

- all languages and dialects change over time;
- spoken and written language differ significantly.

Standard English varies stylistically according to audience, purpose and situation. The aim is the competent use of Standard English. This aim is best attained by helping pupils to understand fully the linguistic and social nature of Standard English. Pupils need to be able to produce spoken Standard English if they are to have access to many public areas of life. However, although correcting written English is relatively unproblematic, the alteration of spoken English is more difficult. Several of the principles which apply to written Standard English, such

as the clear expression of meaning, apply equally to spoken English. But the main problem is that it is far more difficult to teach a new spoken dialect because so many aspects of spoken production are automatic and below the level of conscious control.

It is therefore important to set out some principles for the learning process:

- there is little point in correcting the spoken language of pupils in any general way and as part of their routine language use because it is unlikely to have a beneficial effect: against the pressure of home and the peer group, teachers can have little hope of changing how pupils speak. Moreover, criticism of pupils' spoken language will be interpreted as criticism of their families and friends;

- if teachers concentrate on pupils' competence in written Standard English, pupils will gain sufficient knowledge of Standard English to be able to convert this into competence in spoken Standard English when appropriate. Research shows that secondary pupils do use fewer non-standard forms in talk with the teacher than they do in the playground;

- it is helpful to set up situations in which it is natural to use Standard English. Role-play may often be appropriate: in drama, or in media work (for example in producing news programmes), but also in class panel discussions, debates, etc. Standard English is the language of wider communications. It is therefore desirable to enable pupils to widen the circle of their audience: small groups within the classroom, larger groups in the class or in the school, and, for more public presentation of ideas, with pupils from other schools or with adult strangers. Pupils should be able to take the roles in which spoken Standard English is conventional: radio presenter, interviewer, expert in front of lay audience, etc.;

- if people need to learn a language for some real purpose, then they learn it. Furthermore, the desire to join a group is often very strong indeed. If pupils are motivated to learn to use spoken Standard English because they wish to adopt a social role, they will learn it if they are given the appropriate educational experiences and opportunities.

As we have seen, teaching Standard English demands great sensitivity from the teacher. It is dangerous to tell a five-year-old boy or girl that his or her mother uses language incorrectly. Adolescents are going to be embarrassed and ashamed if a teacher suggests that their dialect, which is part of their identity, must be radically changed. How to teach spoken Standard English needs continual discussion among teachers. I would not want anyone to think we had provided the final word.

BIBLIOGRAPHY

Aarsleff, H. (1982) *From Locke to Saussure: Essays on the Study of Language and Intellectual History*, Princeton: Princeton University Press.

Abelove, H., M.A. Barale and D.M. Halperin (eds) (1993) *The Lesbian and Gay Studies Reader*, New York: Routledge.

Achebe, C. (1975) *Morning Yet On Creation Day*, New York: Anchor Books.

—— (1988) *Hopes and Impediments: Selected Essays, 1965–87*, London: Heinemann.

Adamson, I. (1982) *The Identity of Ulster: The Land, the Language and the People*, Belfast: Pretani Press.

Ahmad, A. (1992) *In Theory: Classes, Nations, Literatures*, London: Verso.

Aitchison, J. (1981) *Language Change: Progress or Decay?* London: Fontana.

Aitken, A.J. (1984) 'Scots and English in Scotland', in P. Trudgill (ed.) *Language in the British Isles*, Cambridge: Cambridge University Press.

Aitken, A.J. and T. McArthur (eds) (1979) *The Languages of Scotland*, Edinburgh: W. & R. Chambers.

Albrecht, J. (1994) 'Neolinguistic School in Italy', in R.E. Asher and J.M.Y. Simpson (eds), *The Encyclopedia of Language and Linguistics*, 10 vols, Oxford and New York: Pergamon Press, vol. 5, pp. 2774–77.

Althusser, L. (1971) 'Ideology and Ideological State Apparatuses', in *Lenin and Philosophy and Other Essays*, trans. B. Brewster, London: New Left Books.

Ardener, S. (ed.) (1975) *Perceiving Women*, London: Dent.

—— (1978) *Defining Females: The Nature of Females in Society*, London: John Wiley.

Ashcroft, B., G. Griffiths and H. Tiffin (1989) *The Empire Writes Back: Theory and Practice in Post-Colonial Literatures*, London: Routledge.

—— (eds) (1995) *The Post-Colonial Studies Reader*, London: Routledge.

Assiter, A. (1983) 'Did Man Make Language?', *Radical Philosophy*, 34, pp. 25–9.

Atkinson, P. (1985) *Language, Structure and Reproduction: An Introduction to the Sociology of Basil Bernstein*, London: Methuen.

Attridge, D. (1988) *Peculiar Language: Literature as Difference from the Renaissance to James Joyce*, London: Methuen.

Bailey, R.W. and M. Görlach (eds.) (1982) *English as a World Language*, Ann Arbor: University of Michigan Press.

Bakhtin, M.M. (1981) *The Dialogic Imagination: Four Essays*, ed. M. Holquist, trans. C. Emerson and M. Holquist, Austin: University of Texas Press.

—— (1986) *Speech Genres and Other Late Essays*, ed. C. Emerson and M. Holquist, trans. V.W. McGee, Austin: University of Texas Press.

Bakhtin, M.M. and P. N. Medvedev (1978) *The Formal Method in Literary Scholarship: A Critical Introduction to Sociological Poetics*, trans. A.J. Wehrle, Baltimore: Johns Hopkins University Press.

Bann, S. and J.E. Bowlt (eds) (1973) *Russian Formalism: A Collection of Articles and Texts in Translation*, Edinburgh: Scottish Academic Press.

Barrell, J. (1983) *English Literature in History 1730–80: An Equal Wide Survey*, London: Hutchinson.

Barron, P. (1835) *Ancient Ireland*, Dublin.

Barthes, R. (1967) *Elements of Semiology*, trans. A. Lavers and C. Smith, New York: Hill and Wang.

—— (1973) *Mythologies*, trans. A. Lavers, London: Paladin.

—— (1977) *Image–Music–Text*, trans. S. Heath, Glasgow: Fontana.

—— (1988) 'Saussure, the Sign, Democracy', in *The Semiotic Challenge*, trans. R. Howard, Oxford: Basil Blackwell, pp. 151–6.

Baugh, A.C. and T. Cable (1978) *A History of the English Language*, 3rd edn., London: Routledge & Kegan Paul.

Belsey, C. (1980) *Critical Practice*, London: Methuen.

Benhabib, S. (1992) *Situating the Self: Gender, Community and Postmodernism in Contemporary Ethics*, Cambridge: Polity.

Benhabib, S., J. Butler, D. Cornell and N. Fraser (1994) *Feminist Contentions: A Philosophical Exchange*, London: Routledge.

Bennett, T. (1979) *Formalism and Marxism*, London: Methuen.

Benveniste, E. (1971) *Problems in General Linguistics*, trans. M.E. Meek, Florida: University of Miami Press.

Bernstein, B. (1964) 'Elaborated and Restricted Codes: Their Social Origin and Some Consequences', *American Anthropologist* 66.6 (2), pp. 55–69.

—— (1971) *Class, Codes and Control, Volume 1: Theoretical Studies Towards a Sociology of Language*, London: Routledge & Kegan Paul.

—— (1972) 'Social Class, Language and Socialization', in P. P. Giglioli (ed.) *Language and Social Context: Selected Readings*, Harmondsworth: Penguin, pp. 157–78.

Bhabha, H.K. (1994) *The Locations of Culture*, London: Routledge.

Black, M. and R. Coward (1981) 'Linguistic, Social and Sexual Relations: A Review of Dale Spender's *Man Made Language*', *Screen Education* 39, pp. 69–85.

Bloomfield, L. (1933) *Language*, London: George Allen & Unwin.

Boas, F. (1974) *The Shaping of American Anthropology: A Franz Boas Reader*, ed. G.W. Stocking, New York: Basic Books.

—— (1997) *Handbook of American Indian Languages*, Part 1, ed. R. Harris, London: Routledge/Thoemmes.

Boehmer, E. (1995) *Colonial and Postcolonial Literature*, Oxford: Oxford University Press.

Bonfante, G. (1947) 'The Neolinguistic Position', *Language* 23, pp. 344–75.

Bourdieu, P. (1984) *Distinction: A Social Critique of the Judgement of Taste*, trans. R. Nice, London: Routledge & Kegan Paul.

—— (1991), *Language and Symbolic Power*, ed. & intro. J.B. Thompson, trans. G. Raymond and M. Adamson, Cambridge: Polity Press.

Bourdieu, P. and J-C. Passeron (1990) *Reproduction in Education, Society and Culture*, trans. R. Nice, London: Sage.

Bowie, M. (1991) *Lacan*, London: Fontana.

Brathwaite, E.K. (1984) *History of the Voice: The Development of Nation Language in Anglophone Caribbean Poetry*, London: New Beacon.

Brandist, C. (1996) 'Gramsci, Bakhtin and the Semiotics of Hegemony', *New Left Review* 216, pp. 94–109.

Briggs, A. (1967) 'The Language of "Class" in Early Nineteenth-Century England', in A. Briggs and J. Saville (eds), *Essays in Labour History*, London: Macmillan, pp. 43–73.

—— (1979) 'The Language of "Mass" and "Masses" in Nineteenth-Century England', in D.E. Martin and D. Rubinstein (eds) *Ideology and the Labour Movement*, London: Croom Helm, pp. 62–83.

Bristow, J. (ed.) (1992) *Sexual Sameness: Textual Difference in Lesbian and Gay Writing*, London: Routledge.

—— (1997) *Sexuality*, London: Routledge.

Burchfield, R.W. (ed.) (1994) *The Cambridge History of the English Language, Volume 5: English in Britain and Overseas (Origin and Development)*, Cambridge: Cambridge University Press.

Burke, P. and R. Porter (eds) (1987) *The Social History of Language*, Cambridge: Cambridge University Press.

—— (eds) (1991) *Language, Self and Society: A Social History of Language*, Cambridge: Polity.

Burling, R. (1973) *English in Black and White*, New York: Holt, Reinhart and Winston.

Butler, J. (1990) *Gender Trouble: Feminism and the Subversion of Identity*, New York: Routledge.

—— (1993) *Bodies That Matter: On the Discursive Limits of 'Sex'*, New York: Routledge.

—— (1997) *Excitable Speech: Contemporary Scenes of Politics*, London: Routledge.

Butler, J. and J. Scott (eds) (1992) *Feminists Theorize the Political*, London: Routledge.

Butler, M. (1900) *Irishwomen and the Home Language*, Dublin: Gaelic League.

Cameron, D. (1985) *Feminism and Linguistic Theory*, London: Macmillan.

—— (1990) *The Feminist Critique of Language: A Reader*, London: Routledge.

—— (1995) *Verbal Hygiene*, London: Routledge.

—— (1995) 'The Naming of Parts: Gender, Culture and Terms for the Penis Among American College Students', in *Feminist Cultural Studies II*, ed. Terry Lovell, Cheltenham: Edward Elgar, pp. 367–83.

—— (1997) 'Theoretical Debates in Feminist Linguistics: Questions of Sex and Gender', in R. Wodak (ed.) *Gender and Discourse*, London: Sage, pp. 21–36.

—— (ed.) (1998) *The Feminist Critique of Language: A Reader*, 2nd edn., London: Routledge.

Cameron, D. and J. Coates (eds), (1988) *Women in Their Speech Communities*, London: Longman.

Carter, A. (1983) 'Notes From the Frontline', in *On Gender and Writing*, ed. M. Wandor, London: Pandora, pp. 69–77.

Castle, T. (1993) *The Apparitional Lesbian: Female Homosexuality and Modern Culture*, New York: Columbia University Press.

Chapman, R. (1974) *Linguistics and Literature: An Introduction to Literary Stylistics*, London: Edward Arnold.

Cheshire, J. (ed.) (1991) *English Around the World: Sociolinguistic Perspectives*, Cambridge: Cambridge University Press.

Cheshire, J. and P. Trudgill (eds) (1998) *The Sociolinguistics Reader, Vol. 2: Gender and Discourse*, London: Arnold.

Chinweizu, J.O. and I. Madubuike (1985) *Towards the Decolonization of African Literature*, London: Routledge.

Chomsky, N. (1965) *Aspects of the Theory of Syntax*, Cambridge, MA: M.I.T. Press.

Christmann, H.H. (1981) 'Idealism', in R. Posner & J.N. Green (eds) *Trends in Romance Linguistics and Philology, Volume 2: Synchronic Romance Linguistics*, The Hague: Mouton, pp. 259–83.

Cixous, H. (1991) *Coming to Writing and Other Essays*, ed. D. Jenson, trans. A. Liddle and S. Sellers, Hemel Hempstead: Harvester Wheatsheaf.

Cixous, H. and C. Clément (1986) *The Newly Born Woman*, trans. B. Wing, Manchester: Manchester University Press.

Coates, J. (1986) *Women, Men and Language*, London: Longman.

—— (1996) *Women Talk: Conversations Between Women Friends*, Oxford: Basil Blackwell.

Cook, A. (1980) *Myth and Language*, Bloomington, IA: Indiana University Press.

Corfield, P. J. (1991) 'Introduction: Historians and Language', in P. J. Corfield (ed.) *Language, History and Class*, Oxford: Basil Blackwell.

Coward, R. and J. Ellis (1977) *Language and Materialism: Developments in Semiology and the Theory of the Subject*, London: Routledge & Kegan Paul.

Cox, B. (1991) *Cox on Cox: An English Curriculum for the 1990s*, London: Hodder & Stoughton.

Croce, B. (1992) *The Aesthetic as the Science of Expression and of the Linguistic in General*, trans. Colin Lyas, Cambridge: Cambridge University Press.

—— (1922) *Aesthetic as Science of Expression and General Linguistic*, 2nd edn., trans. D. Ainslie, London: Macmillan.

—— (1966) 'The Philosophy of Language', in *Philosophy, Poetry, History: An Anthology of Essays*, trans. C. Sprigge, London: Oxford University Press, pp. 248–60.

Crosby, F. and L. Nyquist (1977) 'The Female Register: An Empirical Study of Lakoff's Hypothesis', *Language in Society* 6, pp. 313–22.

Crowley, T. (1987) 'Language and Hegemony: Principles, Morals and Pronunciation', *Textual Practice* 1(3), pp. 278–96.

—— (1989a) *The Politics of Discourse: The Standard Language Question in British Cultural Debates*, Basingstoke: Macmillan.

—— (1989b) 'Language in History: That Full Field', *News From Nowhere* 6, pp. 23–37.

—— (1989c) 'Bakhtin and the History of the Language', in K. Hirschkop and D. Shepherd (eds) *Bakhtin and Cultural Theory*, Manchester: Manchester University Press, pp. 68–90.

—— (1991) *Proper English? Readings in Language, History and Cultural Identity*, London: Routledge.

—— (1996) *Language in History: Theories and Texts*, London: Routledge.

—— (1999) *The Politics of Language in Ireland 1366–1922: A Sourcebook*, London: Routledge.

Culler, J. (1973) 'The Linguistic Basis of Structuralism', in D. Robey (ed.) *Structuralism: An Introduction*, Oxford: Clarendon Press, pp. 20–36.

—— (1975) *Structuralist Poetics: Structuralism, Linguistics and the Study of Literature*, London: Routledge & Kegan Paul.

—— (1976) *Saussure*, Glasgow: Fontana.

—— (1983a) *Barthes*, Glasgow: Fontana.

—— (1983b) *On Deconstruction: Theory and Criticism after Structuralism*, London: Routledge & Kegan Paul.

Dabydeen, D. (1990) 'On Not Being Milton: Nigger Talk in England Today', in *The State of the Language*, 1990s edition, ed. Christopher Ricks and Leonard Michaels, London: Faber & Faber, pp. 3–14.

Daly, M. (1978) *Gyn/Ecology: The Metaethics of Radical Feminism*, Boston, MA: Beacon Press.

Darnell, R. (1990) *Edward Sapir: Linguist, Anthropologist, Humanist*, Berkeley, CA: University of California Press.

De Fréine, S. (1965) *The Great Silence*, Dublin: Foilseacháin Náisiúnta Teoranta.

Dentith, S. (1995) *Bakhtinian Thought: An Introductory Reader*, London: Routledge.

Derrida, J. (1976) *Of Grammatology*, trans. G.C. Spivak, Baltimore, MD: Johns Hopkins University Press.

—— (1978) *Writing and Difference*, trans. A. Bass, London: Routledge.

—— (1987) *Positions*, trans. Alan Bass, London: Athlone Press.

—— (1991) *A Derrida Reader: Between the Blinds*, ed. P. Kamuf, Hemel Hempstead: Harvester Wheatsheaf.

Dews, P. (1987) *Logics of Disintegration: Post-Structuralist Thought and the Claims of Critical Theory*, London: Verso.

Diamond, I. and L. Quinby (eds) (1988) *Feminism and Foucault: Reflections on Resistance*, Boston, MA: Northeastern University Press.

Dillard, J.L. (1972) *Black English: Its History and Usage in the United States*, New York: Random House.

Dollimore, J. (1991) *Sexual Dissidence: Augustine to Wilde, Freud to Foucault*, Oxford: Clarendon.

Donlevy, A. (1742) *An Teagasg Críosduidhe do réir ceasda agus freagratha, or Christian Doctrine by way of Question and Answer*, Paris.

Dreyfus, H. and P. Rabinow (1982) *Michel Foucault: Beyond Structuralism and Hermeneutics*, Brighton: Harvester Press.

Dubois, B.L. and I. Crouch (1975) 'The Question of Tag Questions in Women's Speech: They Don't Really Use More of Them, Do They?', *Language in Society* 4, pp. 289–94.

Duchen, C. (ed.) (1986) *French Connections*, London: Hutchinson.

Durkacz, V.E. (1983) *The Decline of the Celtic Languages*, Edinburgh: John Donald.

Edwards, A.D. (1976) *Language in Culture and Class*, London: Heinemann.

Edwards, J.R. (1979) *Language and Disadvantage*, London: Arnold.

Edwards, V.K. (1986) *Language in a Black Community*, Clevedon, Avon: Multilingual Matters.

Eldridge, J. and L. Eldridge (1994) *Raymond Williams: Making Connections*, London: Routledge.

Elias, N. (1994) *The Civilising Process: The History of Manners and State Formation and Civilization*, trans. E. Jephcott, Oxford: Blackwell.

Emeneau, M. (1943) 'Franz Boas as a Linguist', *American Anthropological Association Memoir 61*, pp. 35–8.

Engler, R. (1975) 'European Structuralism: Saussure', in *Current Trends in Linguistics*, ed. T.A. Sebeok, Vol. 13: *Historiography of Linguistics*, The Hague: Mouton, pp. 829–86.

Erlich, V. (1965) *Russian Formalism: History–Doctrine*, New Haven, CT: Yale University Press.

Fabb, N., D. Attridge, A. Durant and C. MacCabe (eds) (1987) *The Linguistics of Writing: Arguments Between Language and Literature*, Manchester: Manchester University Press.

Fairclough, N. (1989) *Language and Power*, London: Longman.

—— (1992) *Discourse and Social Change*, Cambridge: Polity.

Fanon, F. (1967) *The Wretched of the Earth*, trans. C. Farrington, Harmondsworth: Penguin.

—— (1986) *Black Skin, White Masks*, trans. C. Markhamm, London: Pluto.

Ferguson, C.A. (1959) 'Diglossia', *Word* 15, pp. 325–40 [repr. in P. P. Giglioli (ed.) *Language and Social Context: Selected Readings*, Harmondsworth: Penguin, pp. 232–51].

Ferguson, C. and S.B. Heath (eds) (1981) *Language in the United States of America*, Cambridge: Cambridge University Press.

Firth, R. (1957a) *Papers in Linguistics 1934–1951*, London: Oxford University Press.

—— (1957b) 'Ethnographic Analysis and Language with Reference to Malinowski's Views', in R. Firth (ed.) *Man and Culture: An Evaluation of the Work of Bronislaw Malinowski*, London: Routledge & Kegan Paul, pp. 93–118.

Fishman, J.A. (1972) 'The Sociology of Language', in P. P. Giglioli (ed.) *Language and Social Context: Selected Readings*, Harmondsworth: Penguin, pp. 45–58.

Fishman, J.A., V.C. Nahirny, J.E. Hofman and R.G. Hayden (1966) *Language Loyalty in the United States: The Maintenance and Perpetuation of Non-English Mother Tongues by American Ethnic and Religious Groups*, The Hague: Mouton.

Forrester, J. (1980) *Language and the Origins of Psychoanalysis*, London: Macmillan.

Foucault, M. (1972) *The Archaeology of Knowledge*, trans. A. Sheridan Smith and R. Sawyer, New York: Pantheon.

—— (1977a) *Discipline and Punish: The Birth of the Prison*, trans. A. Sheridan Smith, London: Allen Lane.

—— (1977b) *Language, Counter-Memory, Practice: Selected Essays and Interviews*, ed. D.F. Bouchard, Oxford: Basil Blackwell.

—— (1978) *The History of Sexuality: An Introduction*, trans. R. Hurley, London: Penguin.

—— (1985) *The Use of Pleasure: Volume 2 of the History of Sexuality*, trans. R. Hurley, London: Penguin.

—— (1986) *The Care of the Self: Volume 3 of the History of Sexuality*, trans. R. Hurley, London: Penguin.

Fowler, R. (1986) *Linguistic Criticism*, Oxford: Oxford University Press.

Fraser, N. (1989) *Unruly Practices: Power, Discourse and Gender in Contemporary Social Theory*, Cambridge: Polity.

Fraser, N. and L. Nicholson (1988) 'Social Criticism Without Philosophy: An Encounter Between Feminism and Postmodernism', in A. Ross (ed.) *Universal Abandon? The Politics of Postmodernism*, Edinburgh: Edinburgh University Press, pp. 83–104.

Freud, S. (1922) *Introductory Lectures on Psychoanalysis*, London: George Allen & Unwin.

—— (1975) *The Psychopathology of Everyday Life*, trans. Alan Tyson, ed. James Strachey, Harmondsworth: Penguin.

Fried, V. (ed.) (1972) *The Prague School of Linguistics and Language Teaching*, London: Oxford University Press.

Friel, B. (1981) *Translations*, London: Faber & Faber.

Frow, J. (1986) *Marxism and Literary History*, Oxford: Blackwell.

Fuss, D. ed (1991) *Inside/Out: Lesbian Theories, Gay Theories*, New York: Routledge.

Gadet, F. (1989) *Saussure and Contemporary Culture*, trans. G. Elliott, London: Radius.

Gallop, J. (1982) *Feminism and Psychoanalysis: The Daughter's Seduction*, Ithaca, NY: Cornell University Press.

García, O. and R. Otheguy (eds) (1989) *English Across Cultures: Cultures Across English*, Berlin: Mouton de Gruyter.

Garnham, N. and R. Williams (1980) 'Pierre Bourdieu and the Sociology of Culture: An Introduction', *Media, Culture and Society* 2, pp. 209–23.

Garvin, P.L. (ed.) *A Prague School Reader on Esthetics, Literary Structure and Style*, Washington, DC: Georgetown University Press.

Gates, H.L. (ed.) (1985) *'Race', Writing and Difference*, Chicago: Chicago University Press.

Gates, H.L. (1987) *Figures in Black: Words, Signs and the 'Racial' Self*, Oxford: Oxford University Press.

Geeraerts, D. (1994) 'Historical Semantics', in R.E. Asher & J.M.Y. Simpson (eds) *The Encyclopedia of Language and Linguistics*, 10 vols, Oxford and New York: Pergamon Press, vol. 3, pp. 1567–70.

Giglioli, P. P. (ed.) (1972) *Language and Social Context: Selected Readings*, Harmondsworth: Penguin.

Goad, H. (1958) *Language in History*, Harmondsworth: Penguin.

Görlach, M. (1995) *More Englishes: New Studies in Varieties of English*, Amsterdam: John Benjamins.

Graddol, D. and J. Swann (1989) *Gender Voices*, Oxford: Basil Blackwell.

Gramsci, A. (1985) *Selections from Cultural Writings*, ed. D. Forgacs and G. Nowell-Smith, trans. W. Boelhower, London: Lawrence & Wishart.

Greenberg, J. H. (1964) 'Linguistics and Ethnology', in D. Hymes (ed.) *Language in Culture and Society: A Reader in Linguistics and Anthropology*, New York: Harper and Row, pp. 27–35.

Griffiths, G. (1978) *A Double Exile: African and West Indian Writing Between Two Cultures*, London: Marion Boyars.

Grillo, R. (1989) *Dominant Languages: Language and Hierarchy in Britain and France*, Cambridge: Cambridge University Press.

Grosz, E. (1990) *Jacques Lacan: A Feminist Introduction*, London: Routledge.

—— (1994) *Volatile Bodies: Toward a Corporeal Feminism*, London: Allen & Unwin.

—— (1995) *Space, Time and Perversion: The Politics of Bodies*, London: Allen & Unwin.

Guest, E. (1838) *A History of English Rhythms*, 2 vols, London.

—— (1882) *A History of English Rhythms*, 2nd edn, ed. W.W. Skeat, London.

Gumperz, J.J. (1971) *Language in Social Groups*, ed. and intro. A.S. Dil, Stanford, CA: Stanford University Press.

—— (1972) 'Introduction', in J.J. Gumperz and D. Hymes (eds) *Directions in Sociolinguistics: The Ethnography of Communication*, New York: Holt, Reinhart & Winston, pp. 1–25.

Hall, K. and M. Bucholtz (1995) *Gender Articulated: Language and the Socially Constructed Self*, New York: Routledge.

Hall Jr, R.A. (1946) 'Bartoli's "Neolinguistica"', *Language* 22, pp. 273–83.

—— (1947) 'Benedetto Croce and "Idealistic Linguistics"', *Studies in Linguistics* 6, pp. 24–35.

—— (1963) *Idealism in Romance Linguistics*, Ithaca, NY: Cornell University Press.

Halliday, M.A.K. (1978) *Language as Social Semiotic: The Social Interpretation of Language and Meaning*, London: Edward Arnold.

Hardy, T. (1985) *Tess of the D'Urbervilles*, ed. David Skilton, London: Penguin.

Harland, R. (1987) *Superstructuralism: The Philosophy of Structuralism and Post-Structuralism*, London: Methuen.

Harris, J. (1991) 'Ireland', in J. Cheshire (ed.) *English Around the World: Sociolinguistic Perspectives*, Cambridge: Cambridge University Press, pp. 37–46.

Harris, R. (1987) *Reading Saussure: A Critical Commentary on the 'Cours de linguistique générale'*, London: Duckworth.

Harris, R. and T. Taylor (1989) *Landmarks in Western Thought: The Western Tradition from Socrates to Saussure*, London: Routledge.

Harvey, K. and C. Shalom (eds) (1997) *Language and Desire: Encoding Sex, Romance and Intimacy*, London: Routledge.

Hatzfeld, H. (1958) 'Recent Italian Stylistic Theory and Stylistic Criticism', in A.G. Hatcher and K.L. Selig (eds) *Studia Philologica et Litteraria in Honorem L. Spitzer*, Bern: Francke, pp. 227–43.

Hávranek, B. (1964) 'The Functional Differentiation of the Standard Language', in *A Prague School Reader on Esthetics, Literary Structure and Style*, ed. and trans. P. L. Garvin, Washington, DC: Georgetown University Press, pp. 3–16.

Hawkes, T. (1977) *Structuralism and Semiotics*, London: Methuen.

Heaney, S. (1988) *The Government of the Tongue*, London: Faber and Faber.

Henle, P. (1958) 'Language, Thought and Culture', in P. Henle (ed.) *Language, Thought and Culture*, Ann Arbor: University of Michigan Press, pp. 1–24.

Henson, H. (1971) 'Early British Anthropologists and Language', in *Social Anthropology and Language*, ed. E. Ardener, London: Tavistock, pp. 3–32.

Hindley, R. (1989) *The Death of the Irish Language: A Qualified Obituary*, London: Routledge.

Hirschkop, K. (1986) 'Bahktin, Discourse and Democracy', *New Left Review* 160, pp. 92–113.

——— (1989) 'Introduction: Bakhtin and Cultural Theory', in K. Hirschkop & D. Shepherd (eds) *Bakhtin and Cultural Theory*, Manchester: Manchester University Press, pp. 1–38.

——— (1990) 'Short Cuts Through the Long Revolution: The Russian Avant-Garde and the Modernization of Language', *Textual Practice* 4(3), pp. 428–41.

——— (1999) *Mikhail Bakhtin: An Aesthetic for Democracy*, Oxford: Oxford University Press.

Hodge, R. and G.R. Kress (1988) *Social Semiotics*, Cambridge: Polity.

——— (1998) *Language as Ideology*, 2nd edn., London: Routledge.

Hoijer, H. (1948) 'Linguistic and Cultural Change', *Language* 24(4), pp. 335–45.

——— (1953) 'The Relation of Language to Culture', in A.L. Kroeber *et al.* (eds) *Anthropology Today: An Encyclopedia Inventory*, Chicago: University of Chicago Press, pp. 554–73.

——— (1954) 'The Sapir–Whorf Hypothesis', in H. Hoijer (ed.) *Language in Culture: Conference on the Interrelations of Language and Other Aspects of Culture*, Chicago: University of Chicago Press, pp. 92–105.

——— (1961) 'Anthropological Linguistics', in C. Mohrmann, A. Sommerfelt and J. Whatmough (eds) *Trends in European and American Linguistics 1930–1960*, Utrecht and Antwerp: Spectrum, pp. 110–27.

Holdcroft, D. (1991) *Saussure: Signs, System and Arbitrariness*, Cambridge: Cambridge University Press.

Holm, J. (1988) *Pidgins and Creoles*, Cambridge: Cambridge University Press.

Holquist, M. (1990) *Dialogism: Bakhtin and his World*, London: Routledge.

Holub, R. (1992) *Antonio Gramsci: Beyond Marxism and Postmodernism*, London: Routledge.

Honey, J. (1983) *The Language Trap*, Middlesex: National Council for Educational Standards.

——— (1997) *Language is Power: The Story of Standard English and its Enemies*, London: Faber & Faber.

Hong Kingston, M. (1981) *The Woman Warrior: Memoirs of a Girlhood Among Ghosts*, London: Picador.

Humboldt, W. von (1988) *On Language: The Diversity of Human Language Structure and its Influence on the Mental Development of Mankind*, trans. P. Heath, Cambridge: Cambridge University Press.

Hymes, D. (ed.) (1964a) *Language in Culture and Society: A Reader in Linguistics and Anthropology*, New York: Harper and Row.

—— (1964b) 'The Scope of Linguistic Anthropology: Introduction', in D. Hymes (ed.) *Language in Culture and Society: A Reader in Linguistics and Anthropology*, New York: Harper and Row, pp. 3–14.

—— (ed.) (1971) *Pidginization and Creolization of Languages*, Cambridge: Cambridge University Press.

—— (ed.) (1974) *Foundations in Sociolinguistics: An Ethnographic Approach*, Philadelphia: University of Pennsylvania Press.

Iordan, I. (1937) *An Introduction to Romance Linguistics, its Schools and Scholars*, rev. & trans. J. Orr, London: Methuen.

Irigaray, L. (1985) *This Sex Which Is Not One*, trans. C. Porter with C. Burke, Ithaca, NY: Cornell University Press.

Ivic, M. (1965) *Trends in Linguistics*, trans. M. Heppel, The Hague: Mouton.

Jacobus, M. (1979) 'The Difference of View', in M. Jacobus (ed.) *Women Writing and Writing About Women*, London: Croom Helm, pp. 10–21.

Jakobson, R. (1960) 'Closing Statement: Linguistics and Poetics', in *Style in Language*, ed. T.A. Sebeok, Cambridge, MA: M.I.T. Press, pp. 350–59.

—— (1980) 'Sign and System of Language: A Reassessment of Saussure's Doctrine', *Poetics Today*, 2(1), pp. 33–8.

—— (1987) *Language in Literature*, ed. K. Pomorska and S. Rudy, Cambridge, MA: Harvard University Press.

—— (1990) *On Language*, ed. L.R. Waugh and M. Monville-Bunston, Cambridge, MA: Harvard University Press.

Jameson, F. (1972) *The Prison-House of Language: A Critical Account of Structuralism and Russian Formalism*, Princeton, NJ: Princeton University Press.

—— (1974) 'Review of *Marxism and the Philosophy of Language* by V.N. Voloshinov', *Style* 8(3), pp. 535–43.

—— (1982) 'Imaginary and Symbolic in Lacan: Marxism, Psychoanalytic Criticism, and the Problem of the Subject', in S. Felman (ed.) *Literature and Psychoanalysis. The Question of Reading: Otherwise*, Baltimore, MD: Johns Hopkins University Press, pp. 338–95.

Jefferson, A. (1986) 'Structuralism and Post-Structuralism', in A. Jefferson and D. Robey (eds.) *Modern Literary Theory: A Comparative Introduction*, 2nd edn., London: Batsford.

Johnson, S. and H. Meinhof (eds) (1997) *Language and Masculinity*, Oxford: Blackwell.

Jones, D. (1980) 'Gossip: Notes on Women's Oral Culture', *Women's Studies International Quarterly* 3, pp. 193–8; [repr. in D. Cameron (ed.) *The Feminist Critique of Language: A Reader*, London: Routledge, 1990, pp. 242–50].

Joseph, J.E. and T.J. Taylor (1990) *Ideologies of Language*, London: Routledge.

Joyce, J. (1992) *A Portrait of the Artist as a Young Man*, Harmondsworth: Penguin.

Kachru, B.J. (ed.) (1983) *The Other Tongue*, Oxford, Pergamon Institute.

—— (1986) *The Alchemy of English: The Spread, Functions and Models of Non-Native Englishes*, Oxford: Pergamon Institute.

Kaplan, C. (1986) *Sea Changes: Culture and Feminism*, London: Verso.

Kaye, J. and A. Zoubir (1990) *The Ambiguous Compromise: Language, Literacy and National Identity*, London: Routledge.

Kearney, H. (1989) *The British Isles: A History of Four Nations*, Cambridge: Cambridge University Press.

Killam, G. (ed.) (1973) *African Writers on African Writings*, London: Heinemann.

Kipers, P. S. (1987) 'Gender and Topic', *Language in Society* 16, pp. 543–57.

Koerner, E.F.K. (1973) *Ferdinand de Saussure: Origin and Development of his Linguistic Thought in Western Studies of Language*, Braunschweig: Vieweg.

—— (ed.) (1984) *Edward Sapir: Appraisals of his Life and Work*, Amsterdam: Benjamins.

Kramarae, C. (1981) *Women and Men Speaking*, Rowley, MA: Newbury House.

Kramer, C. (1974) 'Women's Speech: Separate But Unequal?', *Quarterly Journal of Speech* 60, pp. 14–24.

Kristeva, J. (1980) *Desire in Language: A Semiotic Approach to Literature and Art*, ed. L.S. Roudiez, trans. T. Gora, A. Jardine and L.S. Roudiez, New York: Columbia University Press.

—— (1984) *Revolution in Poetic Language*, trans. M. Waller, New York: Columbia University Press.

—— (1986) *The Kristeva Reader*, ed. T, Moi, Oxford: Blackwell.

Labov, W. (1972) *Language in the Inner City: Studies in the Black English Vernacular*, Oxford: Blackwell.

—— (1982) 'Objectivity and Commitment in Linguistic Science: The Case of the Black English Trial in Ann Arbor', *Language in Society* 11, pp. 165–201.

Lacan, J. (1968) *The Language of the Self: The Function of Language in Psychoanalysis*, trans. A. Wilden, New York: Dell.

—— (1977) *Ecrits: A Selection,* trans. A. Sheridan, London: Tavistock.

—— (1982) *Feminine Sexuality: Jacques Lacan and the École Freudienne*, ed. J. Mitchell and J. Rose, trans. J.Rose, London: Macmillan.

Lakoff, R. (1975) *Language and Woman's Place*, New York: Harper and Row.

Laplanche, J. and J-B. Pontalis (1973) *The Language of Psychoanalysis*, trans. D. Nicholson-Smith, New York: Norton.

Latham, R.G. (1862) *Elements of Comparative Philology*, London.

Lavers, A. (1982) *Roland Barthes: Structuralism and After*, Cambridge, MA: Harvard University Press.

Lawton, A. (ed.) (1988) *Russian Futurism Through its Manifestoes, 1912–1928*, trans. A. Lawton and H. Eagle, Ithaca, NY: Cornell University Press.

Leach, E. (1970) *Lévi-Strauss*, London: Fontana.

—— (1973) 'Structuralism in Social Anthropology', in D. Robey (ed.) *Structuralism: An Introduction*, Oxford: Clarendon Press, pp. 37–56.

Lechte, J. (1990) *Julia Kristeva*, London: Routledge.

Leitch, V. (1983) *Deconstructive Criticism: An Advanced Introduction*, London: Hutchinson.

Leith, D. (1997) *A Social History of English*, 2nd edn., London: Routledge.

Lemon, L.T. and M.J. Reis (eds) (1965) *Russian Formalist Criticism: Four Essays*, Lincoln & London: University of Nebraska Press.

Lepschy, G.C. (1970) *A Survey of Structural Linguistics*, London: Faber & Faber.

—— (1975) 'European Structuralism: Post-Saussurean Schools', in *Current Trends in Linguistics*, ed. T.A. Sebeok, Vol. 13: *Historiography of Linguistics*, The Hague: Mouton, pp. 887–902.

Leroy, M. (1967) *The Main Trends in Modern Linguistics*, trans. G. Price, Oxford: Basil Blackwell.

Lévi-Strauss, C. (1963) *Structural Anthropology*, trans. C. Jacobson and B. Grundfest Schoepf, New York: Basic Books.

Lewis, P. E. (1974) 'Revolutionary Semiotics', *Diacritics* 4(3), pp. 28–32.

Linguistic Minorities Project (1995) *The Other Languages of England*, London: Routledge & Kegan Paul.

Lippi-Green, R. (1997) *English with an Accent: Language, Ideology and Discrimination in the United States*, New York: Routledge.

Lockwood, W.B. (1975) *Languages of the British Isles Past and Present*, London: Deutsch.

Lodge, D. (1977) *The Modes of Modern Writing: Metaphor, Metonymy, and the Typology of Modern Literature*, London: Edward Arnold.

Loomba, A. (1998) *Colonialism/Postcolonialism*, London: Routledge.

Lovibond, S. (1989) 'Feminism and Postmodernism', *New Left Review*, 178, pp. 5–28.

Lyons, J. (1973) 'Structuralism and Linguistics', in D. Robey (ed.) *Structuralism: An Introduction*, Oxford: Clarendon Press, pp. 5–19.

MacDonell, D. (1986) *Theories of Discourse*, Oxford: Basil Blackwell.

Malinowski, B. (1923) 'The Problem of Meaning in Primitive Languages', in C.K. Ogden and I.A. Richards (eds), *The Meaning of Meaning: A Study of the Influence of Language upon Thought and of the Science of Symbolism*, London: Routledge and Kegan Paul, pp. 296–336.

—— (1935) *Coral Gardens and Their Magic*, 2 vols, London: George Allen & Unwin.

Malkiel, Y. (1954–55) 'Etymology and Historical Grammar', *Romance Philology* 8, pp. 187–208.

Malmberg, B. (1964) *New Trends in Linguistics: An Orientation*, trans. E. Carney, Stockholm: Lund.

Marenbon, J. (1987) *English Our English: The New Orthodoxy Examined*, London: Centre for Policy Studies.

Marks, E. and I. Courtivron (eds) (1981) *New French Feminisms: An Anthology*, Brighton: Harvester Wheatsheaf.

Marsh, G.P. (1862) *The Origin and History of the English Language and of the Literature it Embodies*, London.

Matejka, L. (1978) 'The Prague Linguistic Circle: A Collage', in L. Matejka (ed.) *Sound, Sign and Meaning: Quinquagenary of the Prague Linguistic Circle*, Ann Arbor: University of Michigan Press, pp. ix–xxxiv.

—— (1986) 'On the First Russian Prolegomena to Semiotics', in V.N. Voloshinov, *Marxism and the Philosophy of Language*, trans. L. Matejka and I.R. Titunik, Cambridge, MA: Harvard University Press, pp. 161–74.

Mathews, W. (1882) *Words: Their Use and Abuse*, Toronto.

Mayo, B. (1955) 'Art, Language and Philosophy in Croce', *Philosophical Quarterly* 5, pp. 245–60.

McArthur, T. (1998) *The English Languages*, Cambridge: Cambridge University Press.

McDavid, R. (1980) *Varieties of American English*, Stanford: Stanford University Press.

McNay, L. (1992) *Foucault and Feminism; Power, Gender and the Self*, Cambridge: Polity.

Mencken, H.L. (1936) *The American Language*, 2 vols, New York: Alfred A. Knopf.

Miller, C. and K. Swift (1979) *Words and Women*, Harmondsworth, Penguin.

Mills, S. (1995) *Feminist Stylistics*, London: Routledge.

—— (1997) *Discourse*, London: Routledge.

Milroy, J. (1992) *Linguistic Variation and Change*, Oxford: Blackwell.

Milroy, J. and L. Milroy (1992) *Authority in Language: Investigating Language Prescription and Standardisation*, 2nd edn., London: Routledge & Kegan Paul.

Mitchell, J. (1982) 'Introduction – I', in J. Lacan, *Feminine Sexuality: Jacques Lacan and the École Freudienne*, ed. J. Mitchell and J. Rose, trans. J. Rose, London: Macmillan, pp. 1–26.

Moi, T. (1985) *Sexual/Textual Politics: Feminist Literary Theory*, London: Methuen.

—— (ed.) (1987) *French Feminist Thought: A Reader*, Oxford: Basil Blackwell.

Montgomery, M. (1995) *An Introduction to Language and Society*, 2nd edn., London: Routledge.

Moryson, F. (1903) 'Shakespeare's Europe', in C. Hughes (ed.) *Unpublished Chapters of Fynes Moryson's Itinerary*, London: Sherratt & Hughes.

Mugglestone, L. (1995) *'Talking Proper': The Rise of Accent as a Social Symbol*, Oxford: Clarendon.

MukařovskyJ. (1964) 'The Aesthetics of Language', in *A Prague School Reader on Esthetics, Literary Structure and Style*, ed. and trans. P. L. Garvin, Washington, DC: Georgetown University Press, pp. 31–69.

—— (1964) 'Standard language and poetic language', in *A Prague School Reader on Esthetics, Literary Structure and Style*, ed. and trans. Paul L. Garvin, Washington, DC: Georgetown University Press, pp. 17–23.

—— (1982) 'Structuralism in Aesthetics and in Literary Studies', in P. Steiner (ed.) *The Prague School: Selected Writings 1929–1946*, Austin: University of Texas Press, pp. 65–82.

Ngũgĩ wa Thiong'o (1972) *Homecoming: Essays on African and Caribbean Literature, Culture and Politics*, London: Heinemann.

—— (1986) *Decolonizing the Mind: The Politics of Language in African Literature*, London: James Currey.

Nicholson, L. (ed.) (1990) *Feminism/Postmodernism*, London: Routledge.

Norris, C. (1982) *Deconstruction: Theory and Practice*, London: Methuen.

—— (1987) *Derrida*, London: Fontana.

Ó Cuív, B. (ed.) (1969) *A View of the Irish Language*, Dublin: The Stationery Office.

Ogden, C.K. and I.A. Richards (1923) *The Meaning of Meaning: A Study of the Influence of Language upon Thought and of the Science of Symbolism*, London: Routledge & Kegan Paul.

Ó Muirithe, D. (ed.) (1977) *The English Language in Ireland*, Dublin: Mercier Press.

Orsini, G.N.G. (1961) *Benedetto Croce: Philospher of Art and Literary Critic*, Carbondale, ILL: Southern Illinois University Press.

Parry, B. (1987) 'Problems in Current Theories of Colonial Discourse', *Oxford Literary Review* 9, pp. 27–58.

Paul, H. (1890) *Principles of the History of Language*, trans. H.A. Strong, rev. edn., London.

Paulin, T. (1984) 'A New Look at the Language Question', in *Ireland and the English Crisis*, Newcastle: Bloodaxe.

Peirce, C.S. (1991) *Peirce on Signs: Writings on Semiotics*, ed. J. Hoopes, Chapel Hill: University of North Carolina Press.

Pennycook, A. (1994) *The Cultural Politics of English as an International Language*, London: Longman.

—— (1998) *English and the Discourses of Colonialism*, London: Routledge.

Platt, J., H. Weber and M.L. Ho (1984) *The New Englishes*, London: Routledge & Kegan Paul.

Price, G. (1984) *The Languages of Britain*, London: Edward Arnold.

Pride, J.B. and J. Holmes (eds) (1972) *Sociolinguistics: Selected Readings*, Harmondsworth: Penguin.

Quirk, R. (1972) *The English Language and Images of Matter*, Oxford: Oxford University Press.

Ricoeur, P. (1981) *Hermeneutics and the Human Sciences*, ed. and trans. J.B. Thompson, Cambridge: Cambridge University Press.

—— (1995) 'The creativity of language', in Richard Kearney, *States of Mind: Dialogues with Contemporary Thinkers on the European Mind*, Manchester: Manchester University Press, pp. 216–224.

Riley, D. (1988) *'Am I That Name?': Feminism and the Category of 'Women' in History*, Basingstoke: Macmillan.

Roberts, D.D. (1987), *Benedetto Croce and the Uses of Historicism*, Berkeley: University of California Press.

Robey, D. (1986) 'Modern Linguistics and the Language of Literature', in A. Jefferson and D. Robey (eds) *Modern Literary Theory: A Comparative Introduction*, 2nd edn., London: Batsford, pp. 46–72.

Robins, R.H. (1971) 'Malinowski, Firth, and the "Context of Situation"', in E. Ardener (ed.) *Social Anthropology and Language*, London: Tavistock, pp. 33–46.

Romaine, S. (1982) 'What is a Speech Community?', in S. Romaine (ed.) *Sociolinguistic Variation in Speech Communities*, London: Edward Arnold, pp. 13–24.

—— (1988) *Pidgin and Creole Languages*, London: Longman.

—— (1994) *Language in Society: An Introduction to Sociolinguistics*, Oxford: Oxford University Press.

Rose, J. (1986) *Sexuality in the Field of Vision*, London: Verso.

Rosen, H. (1972) *Language and Class: A Critical Look at the Theories of Basil Bernstein*, Bristol: Falling Wall Press.

Rubin, G. (1993) 'Thinking Sex: Notes for a Radical Theory of the Politics of Sexuality', in H. Abelove, M.A. Barale and D.M. Halperin (eds) *The Lesbian and Gay Studies Reader*, New York: Routledge.

Ryan, M. (1982) *Marxism and Deconstruction: A Critical Articulation*, Baltimore, MD: Johns Hopkins University Press.

Rylance, R. (1993) *Roland Barthes*, Hemel Hempstead: Harvester Wheatsheaf.

Said, E. (1978) *Orientalism*, London: Routledge & Kegan Paul.

—— (1984) *The World, the Text, and the Critic*, London: Faber & Faber.

—— (1993) *Culture and Imperialism*, London: Chatto & Windus.

Salamini, L. (1981) *The Sociology of Political Praxis: An Introduction to Gramsci's Theory*, London: Routledge & Kegan Paul.

Salzmann, Z. (1993) *Language, Culture and Society: An Introduction to Linguistic Anthropology*, Boulder, CO: Westview Press.

Sampson, G. (1980) *Schools of Linguistics: Competition and Evolution*, London: Hutchinson.

Sapir, E. (1949) *Selected Writings of Edward Sapir in Language, Culture and Personality*, ed. D.G. Mandelbaum, London: Cambridge University Press.

—— (1978) *Language: An Introduction to the Study of Speech*, London: Hart-Davis, MacGibbon.

Sarup, M. (1992) *Jacques Lacan*, Hemel Hempstead: Harvester Wheatsheaf.

—— (1993) *An Introductory Guide to Post-Structuralism and Postmodernism*, 2nd edn., Hemel Hempstead: Harvester Wheatsheaf.

Saussure, F. de (1960) *Course in General Linguistics*, ed. C. Bally and A. Sechehaye, trans. W. Baskin, London: Peter Owen.

Saussure, F. de (1964) 'Letter to Antoine Meillet' [4 January 1894], *Cahiers de Ferdinand de Saussure*, vol. 21, p. 95.

―――― (1983) *Course in General Linguistics*, ed. C. Bally and A. Sechehaye, trans. R. Harris, London: Duckworth.

Saville-Troike, M. (1982) *The Ethnography of Communication: An Introduction*, Oxford: Basil Blackwell.

Schultz, M.R. (1975) 'The Semantic Derogation of Women', in B. Thorne and N. Henley (eds) *Language and Sex: Difference and Dominance*, Rowley, MA.: Newbury House [repr. in *The Feminist Critique of Language: A Reader*, ed. D. Cameron, London: Routledge, 1990, pp. 134–147].

Sebeok, T.A. (ed.) (1960) *Style in Language*, Cambridge, MA: M.I.T. Press.

Sedgwick, E.K. (1990) *Epistemology of the Closet*, Berkeley, CA: University of California Press.

Segal, L. (1994) *Straight Sex: The Politics of Pleasure*, London: Virago.

Shakespeare, W. (1968) *The Tempest*, ed. Anne Righter, Harmondsworth: Penguin.

Sheppard, A. (1987) *Aesthetics: An Introduction to the Philosophy of Art*, Oxford: Oxford University Press.

Sheridan, A. (1980) *Michel Foucault: The Will to Truth*, London: Tavistock.

Shiach, M. (1991) *Hélène Cixous: A Politics of Writing*, London: Routledge.

Silverman, D. and B. Torode (1980) *The Material Word: Theories of Language and its Limits*, London: Routledge & Kegan Paul.

Silverman, K. (1983) *The Subject of Semiotics*, New York: Oxford University Press.

Simpson, D. (1986) *The Politics of American English 1776–1850*, Oxford: Oxford University Press.

Sinfield, A. (1994) *The Wilde Century: Effeminacy, Oscar Wilde and the Queer Moment*, London: Cassell.

Smith, O. (1984) *The Politics of Language 1791–1819*, Oxford: Clarendon Press.

Smith, P. M. (1979) 'Sex Markers in Speech', in K. Scherer and H. Giles (eds) *Social Markers in Speech*, Cambridge: Cambridge University Press.

―――― (1985) *Language, the Sexes and Society*, Oxford: Blackwell.

Smith, R.B. and D.M. Lance (1979) 'Standard and Disparate Varieties of English in the United States: Educational and Sociopolitical Implications', *International Journal of the Sociology of Language* 21, pp. 127–40.

Spender, D. (1980) *Man Made Language*, London: Routledge & Kegan Paul.

Spenser, E. (1949) *The Works of Edmund Spenser: The Prose Works*, ed. E. Greenlaw *et al.*, Baltimore, MD: Johns Hopkins University Press.

Sperber, D. (1979) 'Claude Lévi-Strauss', in J. Sturrock (ed.) *Structuralism and Since: From Lévi-Strauss to Derrida*, Oxford University Press, pp. 19–51.

Spillers, H.J. (1992) 'Interstices: a small drama of words', in *Pleasure and Danger: Exploring Female Sexuality*, ed. Carole Vance, London: Pandora, pp. 74–80.

Spitzer, L. (1943) 'Why Does Language Change?', *Modern Language Quarterly* 4, pp. 413–31.

―――― (1948a) *Essays in Historical Semantics*, New York: S.F. Vanni

―――― (1948b) 'Linguistics and Literary History', in *Linguistics and Literary History: Essays in Stylistics*, Princeton, NJ: Princeton University Press, pp. 1–39.

―――― (1956) 'The Individual Factor in Linguistic Innovations', *Cultura Neolatina* 16, pp. 71–89

Spivak, G.C. (1988) *In Other Worlds: Essays in Cultural Politics*, New York: Routledge.

Steinberg, J. (1987) 'The Historian and the *Questione della Lingua*' in P. Burke and

R. Porter (eds) *The Social History of Language*, Cambridge: Cambridge University Press, pp. 198–209.

Steiner, P. (1978) 'The Conceptual Basis of Prague Structuralism', in L. Matejka (ed.) *Sound, Sign and Meaning: Quinquagenary of the Prague Linguistic Circle*, Ann Arbor: University of Michigan Press, pp. 351–85.

—— (1982) 'The Roots of Structuralist Aesthetics', in P. Steiner (ed.) *The Prague School: Selected Writings 1929–1946*, Austin: University of Texas Press, pp. 174–219.

—— (1984) *Russian Formalism: A Metapoetics*, Ithaca, NY: Cornell University Press.

Stephens, M, (1976) *Linguistic Minorities of Western Europe*, Llandysul: Gomer Press.

Stocking, G. (1968) *Race, Culture and Evolution: Essays in the History of Anthropology*, New York: Free Press.

Storey, J. (1993) *An Introductory Guide to Cultural Theory and Popular Culture*, Hemel Hempstead: Harvester Wheatsheaf.

Strevens, P. (1972) *British and American English*, London: Collier.

Stubbs, M. (1976) *Language, Schools and Classrooms*, London: Methuen.

Sturrock, J. (1979) 'Roland Barthes' in J. Sturrock (ed.) *Structuralism and Since: From Lévi-Strauss to Derrida*, Oxford: Oxford University Press, pp. 52–80.

Sutcliffe, D. (1982) *Black British English*, Oxford: Basil Blackwell.

Sutcliffe, D. and A. Wong (eds) (1986) *The Language of Black Experience: Cultural Expression Through Word and Sound in the Caribbean and Black Britain*, Oxford: Basil Blackwell.

Tambling, J. (1988) *What is Literary Language?*, Milton Keynes: Open University Press.

Tannen, D. (1990) *You Just Don't Understand: Men and Women in Conversation*, New York: William Morrow.

—— (1994) *Gender and Discourse*, New York: Oxford University Press.

Thibault, P. J. (1997) *Re-reading Saussure: The Dynamics of Signs in Social Life*, London: Routledge.

Thompson, John B. (1984) *Studies in the Theory of Ideology*, Cambridge: Polity Press.

—— (1991) 'Editor's Introduction', in P. Bourdieu, *Language and Symbolic Power*, ed. J.B. Thompson, Oxford: Polity, pp. 1–31.

Thorne, B. and N. Henley (eds) (1975) *Language and Sex: Difference and Dominance*, Rowley, MA: Newbury House.

Thorne, B., C. Kramarae, N. Henley (eds) (1983) *Language, Gender and Society*, Cambridge: Newbury House.

Timpanaro, S. (1975) 'Structuralism and Its Successors', in *On Materialism*, trans. L. Garner, London: New Left Books, pp. 135–219.

Todd, L. (1984) *Modern Englishes: Pidgins and Creoles*, Oxford: Basil Blackwell.

—— (1990) *Pidgins and Creoles*, 2nd edn., London: Routledge.

Todorov, T. (1982) *Theories of the Symbol*, trans. C. Porter, Oxford: Basil Blackwell.

Trench, R.C. (1851) *On the Study of Words*, London.

Trudgill, P. (ed.) (1984) *Language in the British Isles*, Cambridge: Cambridge University Press.

Trudgill, P. and J. Cheshire (eds) (1998) *The Sociolinguistics Reader, Volume 1: Multilingualism and Variation*, London: Arnold.

Uitti, K.D. (1969) *Linguistics and Literary Theory*, Englewood Cliffs, NJ: Prentice-Hall.

Vachek, J. (ed.) (1964) *A Prague School Reader in Linguistics*, Bloomington: University of Indiana Press.

—— (1972) 'The Linguistic Theory of the Prague School', in V. Fried (ed.) *The Prague School of Linguistics and Language Teaching*, London: Oxford University Press, pp. 12–28.

Vice, S. (1997) *Introducing Bakhtin*, Manchester: Manchester University Press.

Voloshinov, V.N. (1983) 'Literary Stylistics', trans. N. Owen and J. Andrew, in A. Shukman (ed.) *Bakhtin School Papers*, Oxford: RPT Publications, pp. 93–152.

—— (1986) *Marxism and the Philosophy of Language*, trans. L. Matejka and I.R. Titunik, Cambridge, MA: Harvard University Press.

—— (1987) *Freudianism: A Marxist Critique*, trans., I.R. Titunik, Indianapolis: Indiana University Press.

Vossler, K. (1932) *The Spirit of Language in Civilization*, trans. O. Oeser, London: Kegan Paul.

Vygotsky, L.S. (1962) *Thought and Language*, ed. and trans. E. Haufmann and G. Vakar, Cambridge, MA: M.I.T. Press.

Wardhaugh, R. (1987) *Languages in Competition: Dominance, Diversity and Decline*, Oxford: Blackwell.

—— (1992) *An Introduction to Sociolinguistics*, 2nd edn, Oxford: Basil Blackwell.

Webster, N. (1789) *Dissertations on the English Language*, Boston, MA.

Weedon, C. (1987) *Feminist Practice and Poststructuralist Theory*, Oxford: Basil Blackwell.

Weedon, C., A. Tolson and F. Mort (1980) 'Theories of Language and Subjectivity', in *Culture, Media, Language: Working Papers in Cultural Studies, 1972–1979*, Centre for Contemporary Cultural Studies, London: Hutchinson, pp. 195–216.

Weeks, J. (1977) *Coming Out: Homosexual Politics in Britain from the Nineteenth Century to the Present*, London: Quartet.

—— (1985) *Sexuality and its Discontents: Meanings, Myths and Modern Sexualities*, London: Routledge.

—— (1986) *Sexuality*, London: Tavistock.

Wellek, R. (1960) 'Leo Spitzer (1887–1960)', *Comparative Literature* 12, pp. 310–34.

Wellek R. and A. Warren (1963) *Theory of Literature*, Harmondsworth: Penguin.

Werner, O. (1994), 'Sapir–Whorf Hypothesis', in R.E. Asher and J.M.Y. Simpson (eds) *The Encyclopedia of Language and Linguistics*, 10 vols, Oxford and New York: Pergamon Press, vol. 5, pp. 2774–77, vol. 7, pp. 3656–62.

White, A. (1984), 'Bakhtin, Sociolinguistics and Deconstruction', in F. Gloversmith (ed.) *The Theory of Reading*, Brighton: Harvester, pp. 123–46.

—— (1987–88) 'The Struggle Over Bakhtin', *Cultural Critique* 8, pp. 217–41.

White, E. (1980) 'The political vocabulary of homosexuality', in *The State of the Language*, ed. Leonard Michaels and Christopher Ricks, London: Faber & Faber, p. 237–46.

Whorf, B.L. (1956) *Language, Thought and Reality*, ed. J.B. Carroll, Cambridge, MA: M.I.T. Press.

Williams, P. and L. Chrisman (eds) (1993) *Colonial Discourse and Post-Colonial Theory*, Hemel Hempstead: Harvester Wheatsheaf.

Williams, R. (1961) *Culture and Society 1780–1950*, Harmondsworth: Penguin.

—— (1976) *Keywords: A Vocabulary of Culture and Society*, London: Fontana.

—— (1977) *Marxism and Literature*, Oxford: Oxford University Press.

—— (1979) *Politics and Letters: Interviews with New Left Review*, London: New Left Books.

——(1991) *Writing in Society*, London: Verso.

Wimsatt, W.K. and C. Brooks (1957) *Literary Criticism: A Short History*, London: Routledge & Kegan Paul.

Wittgenstein, L. (1961) *Tractatus Logico-Philosophicus*, trans. D.F. Pears and B.F. McGuinness, London: Routledge & Kegan Paul.

Wright, E. (1984) *Psychoanalytic Criticism: Theory in Practice*, London: Methuen.

Young, R. (1981) 'Post-Structuralism: An Introduction', in R. Young (ed.) *Untying the Text: A Post-Structuralist Reader*, London: Routledge & Kegan Paul, pp. 1–28.

—— (1986) 'Back to Bakhtin', *Cultural Critique* 2, pp. 71–92.

—— (1990) *White Mythologies: Writing History and the West*, London: Routledge.

—— (1995) *Colonial Desire: Hybridity in Theory, Culture and Race*, London: Routledge.

INDEX